THE ADELINE ART DICTIONARY

THE
ADELINE
ART DICTIONARY

BY

JULES ADELINE

Including terms in architecture, heraldry,
and archaeology

TRANSLATED FROM THE FRENCH

With a Supplement of New Terms by
HUGO G. BEIGEL, Ph.D.

WITH APPROXIMATELY 2,000 ILLUSTRATIONS

FREDERICK UNGAR PUBLISHING CO.
NEW YORK

Based on the French
Lexique des termes d'art
by Jules Adeline
English edition, 1891

ISBN 0-8044-3015-2

Third Printing, 1976

Printed in the United States of America

Library of Congress Catalog Card No. 65-21727

PREFACE

It would not merely be a pity, but also an actual loss if *The Adeline Art Dictionary* were doomed to oblivion. Incorporating the terms in F. W. Fairholt's *Dictionary of Terms in Art*, it is probably the most thorough and richly detailed work of its kind and format. In view of these qualities, its republication is a particularly appealing and fortunate idea.

Interest in the arts—painting, sculpture, engravings, architecture, etc.—has been increasing steadily and has reached wider and wider circles during the past twenty years. But many of those who have only recently experienced the charm of aesthetic pleasures are unaware of tradition and development in artistic expression and have remained strangers to its terminology. For them, *The Adeline Art Dictionary* will be not only a welcome source of information but also a necessary aid in establishing the connection between old and new, between artistic offspring and its antecedents.

But however valuable a book dealing with art may be, it has one shortcoming, whether it was published fifty years ago, twenty years ago, or one year ago. It is passed over by time and left behind as changes and new developments keep art alive. Adeline's original volume shares this fate. The publishers, therefore, have added a supplement (see page 423), which brings the book up-to-date and keeps its readers abreast of schools, styles, movements, and terms that have developed since the original authors put down their pens.

<div align="right">H. G. B.</div>

INTRODUCTION.

— ✦ —

ALTHOUGH Adeline's name appears on the title-page of this Dictionary, there will be found within its pages a large number of definitions and numerous illustrations which are not contained in that work. While nothing that has made M. Jules Adeline's " Lexique des Termes d'Art " so excellent an authority has been omitted, a large amount of information has been incorporated from Mr. F. W. Fairholt's " Dictionary of Terms in Art." The publishers do not doubt of the reception that will be given to a work based on these authorities, and also thoroughly revised and brought up to date by an expert who has spent some years over the task.

For instance, take the word "Academy:" First we find the origin of the word from a grove in Athens, where Plato taught, named after a local hero named Academus ; then the modern definition—any society of *litterateurs*, scientific men, or artists ; then an account of the first Academy of Art established in Europe, and so on to an account of the formation of the Institute of France. Under the separate heading of *Royal*

Academy we find a succinct account of our own Royal Academy, its foundation in 1768 by George III., and its objects. Finally, under the heading of *Academician* we are told how that name is applied in England with respect to the members of the Royal Academy.

The plan includes all such terms as are generally employed in painting, sculpture, engraving, and architecture, whether descriptive of real objects, or the principles of action which rule the mind and guide the hand of the artist. It thus comprises the Æsthetics of Art, as well as their practical results. But, as it is desirable to make this a useful hand-book for all persons interested in Art, such terms, ancient or modern, as are used in describing the contents of a museum or picture-gallery, are here explained. Thus, the technical terms for antique vases, or mediæval pottery; sacred and domestic implements; as well as for civil and military costume, armour, arms, etc., are described; everything which forms the component part of a picture, or may be included in its description; notices of the various schools of Art, and of public picture-galleries in England; an analysis of colours and artistic implements; descriptions of ornamental woods or precious stones; of the saints and their symbols; such manufacturing processes as call Art to their aid, or such terms in architecture and the cognate arts as are necessarily used in general Art.

To give a concise definition of all the terms used in Painting, Sculpture, Architecture, Etching, Engraving, Heraldry—in

fact, in everything connected with Art—that is the aim of the present book. It is not intended that with its possession the student should altogether dispense with large and exhaustive works especially devoted to the subject; but he will find within these pages definitions, concise but to the point, sufficient for all ordinary purposes, of every term connected with the theory and the practice of Art.

A DICTIONARY

OF

TERMS IN ART.

Abaculus. (Arch.) A die or small tile made of stone, glass, or a composition in imitation of stone, and used in

mosaic pavements. The illustration represents a pavement at Herculaneum composed of *abaculi.*

Abacus. (Arch.) A tablet placed upon the capital of a column, which adds to the surface of the capital and so enables it the better to support the superincumbent architrave.

Some monuments are found in Egypt in which the capital is nothing but an abacus. Other monuments, however, present beneath the abacus a capital consisting of lotus flowers or acanthus leaves. In Greek and Roman architecture the abacus varies according to the

order. In the Doric order the abacus is strong and simple in outline, while in the Ionic it is ornamented, and in the Corinthian it is curvilinear instead of straight. In the Gothic style the abacus varies according to the period. In

the Romanesque period, *i.e.* in the 12th and 13th centuries, it is square, and projects beyond the foliage of the capital; in the 13th century it is sometimes polygonal, and very often the foliage of the capital projects beyond it. There are also found, chiefly in Normandy, some abaci belonging to this

period perfectly circular in shape. In the 14th century they project less, and in the 15th their importance still more diminishes. At the Renaissance the ancient orders were restored to honour, with some modifications, and the abacus then regained the dimensions which belonged to it in the Greek and Roman orders.

Abat-jour. (Arch.) An opening in the

I

form of an air-hole, intended to admit light to basements and other places

which could only be lighted from above. [Skylight.]

Abat-son. (Arch.) Pieces of wood covered with tiles or sheets of lead placed obliquely in the windows of steeples in Gothic buildings, so as to drive downwards the sound of the bells. In the 12th and 13th centuries the *abat-son* was sometimes decorated with sheets of lead carved and otherwise ornamented.

Abat-vent. (Arch.) A term sometimes used synonymously with abat-son (*q.v.*), and also to denote the earthenware cowl or cylinder of sheet iron which is placed at the top of chimneys to turn aside currents of air which might otherwise interfere with the regular draught of the chimney.

Abat-voix. (Arch.) A canopy placed over pulpits, either architectural in character or composed of draperies embroidered with allegorical figures, as in Belgian churches. Its purpose is to deflect the sound of the voice downwards.

Abaissé. (Her.) Said of a charge, which generally occupies the centre of a shield, when it is lowered beneath the centre.

Abatement. (Her.) A mark of degradation placed on a shield. There were nine such marks, indicating nine offences, but they have entirely fallen into disuse now.

Abbatial. (Arch.) A palace, house, or church is termed *abbatial* when it forms or has formed part of the collection of buildings which constitute an abbey.

Abbey. (Arch.) In the Middle Ages considerable tracts of land were occupied by abbeys. These institutions consisted of a collection of buildings, the most important of which was a chapel, very often of vaster dimensions than the churches belonging to the territory on which the abbey was situated. In literary and artistic language the name abbey is still given to the churches which once belonged to religious communities, and by an extension of meaning to any church of a remote origin. " An ancient abbey " is a stereotyped phrase in romantic descriptions, and is applied to what are merely parish churches.

Abbozzo. (Paint.) The first dead colouring or first sketch of a picture, whether painted in monochrome or in colour.

Abezzo, Olio di. (Paint.) The oil which exudes from the *Pinus picea* of Linnæus. It is very valuable as a varnish.

Abococke. (Cost.) A hat turned up behind and coming to a peak in front. It was worn by kings and nobles in the 14th, 15th, and 16th centuries.

Abolla. (Cost.) A cloak of double cloth worn by the Romans. It was fastened by a brooch on the neck or shoulder. Originally a military garment, it came into general use about the time of Juvenal.

Abraxas stones were gems worn as amulets by the Gnostics. On them was

inscribed the mystic word 'Αβραξας, which is said to have been the name given by Basilides, a Gnostic, to the Supreme Being, the seven letters of this word, according to Greek reckoning, making up 365. In date these gems belong to the 2nd century after Christ.

Absorb. (Paint.) The canvas in oil-painting or the paper in water-colour is said to *absorb* when, owing to its grain or some flaw in its sizing, the colours cannot be perfectly laid on, but lose their intensity as soon as the surface is covered.

Abutment. (Arch.) A solid piece of masonry to support a body, which it has a tendency to thrust outwards. Examples of an *abutment* are the solid pier, against which an arch abuts, or in bridge-building the extreme pillars which connect the bridge with the river bank.

Academic. A figure is said to be *academic* when it is treated as a study, with perfect accuracy but little inspiration, or when it is over-emphasised and unnatural. A figure is *academic in pose* when its attitude is the conventional attitude of the studio, when it has not been drawn from life, and does not harmonise properly with the subject of the picture. A drawing is of *academic size* when its dimensions are those of the studies of the antique or life customarily produced in schools of art, *i.e.* a little less than half life-size.

Academician. A member of an Academic Society. In England the term is usually employed in connection with the Royal Academy (q.v.), whose members are called Royal Academicians.

Academy, a grove in Athens, where Plato taught, named after a local hero named Academus. The term was then applied to Plato's school, and later on to any society of *littérateurs*, scientific men, or artists. It also denotes a school of art, where public courses of instruction are given in drawing, painting, sculpture, and architecture. The first Academy of Art established in Europe was founded in 1345 by the Venetian painters, who formed themselves into a society called the Guild of St. Luke. In Paris, a society of St. Luke was established in 1391, which was organised in 1648 under royal patronage into the "Academy of Fine Art." In 1671 the Academy of Architecture, which had been established by Colbert, was incorporated in it, and the united institutions formed the fourth class of the Institute of France. Most of the important cities of Europe have now their Academy of Art.

Academy, Royal, was founded in London in 1768 by George III. Its first president was Sir Joshua Reynolds, and it consisted of forty members. Its object was to give art-teaching, and especially to instruct in drawing from the living model, and to hold exhibitions of English Art. It was at first located in Trafalgar Square, where the National Gallery now is, but its present head-quarters are at Burlington House.

Acanthus. (Arch.) The acanthus is

a plant of distinctly marked foliage, which is frequently found as a *motif* in architectural decoration. Its place is pre-eminently on capitals, and it serves as the distinguishing mark of the Corinthian order. Vitruvius has handed down to us a curious legend in connection with the origin of this order. According to this author, Callimachus, who flourished

3

about 440 B.C., was inspired with the idea of the Corinthian capital from seeing on a young girl's tomb a basket covered with a tile and surrounded with acanthus leaves. It is probable, however, that the invention of this capital was but a modification of *motifs* already well known in Egypt. Modern architects have employed the acanthus for purposes of ornamentation under every aspect. They have represented it as pointing downwards or upwards, and with its leaves either folded up or turned back. In fact the acanthus may be termed the classical foliage of decorative sculpture.

Accentuated Outlines. (Paint.) This expression is applied in painting or drawing to the strongly accentuated lines either of the drapery which covers the figures or of the different planes of a landscape. It is also used to indicate that the artist has by a few strong and firm lines converted a sketch drawn in rapid broken strokes into a finished drawing.

Accessories. (Paint.) The *accessories*, in a portrait for example, are the drapery, the furniture, and the ground on which the subject is represented. Theoretically speaking, the accessories are all those details which are necessary for the realisation of a scene, but which at the same time play a secondary part in the composition. They should accordingly be treated with greater soberness than the principal figure, which remains the centre of interest in the picture. If a painter, in the portrait of a woman, for instance, bestows as much care on the folds of her dress or on her lace as he does on her face, he is guilty of paying too much attention to accessories.

Accidental Lights. (Paint.) Real or fictitious combinations of light and shade. When a ray of light throws into prominence the principal part of a picture, it is necessary to connect this luminous portion with other parts of the picture by picking out with delicate touches various objects represented in it. The rays of light, illuminating the prominent parts of the

picture, produce spots of great brilliance, which increase the picturesqueness of outline of the subjects represented. In landscape, rays of light coming through masses of foliage are termed accidental.

Accolé (Her.) When two shields

are placed side by side they are said to be *accolé*. This juxtaposition indicates the alliance of two families or nations. It is equivalent to Collared (q.v.).

Accosted. (Her.) A term used of charges placed side by side.

Accoudoir. (Arch.) A French term signifying the ledge of a window or seat high enough to lean the elbow on.

Accrued. (Her.) Full-grown. Generally of a tree that has come to maturity.

Acerra. A small box used by the Romans to hold incense at sacrifices. The incense was not burned in the *acerra*,

but only taken out of it and thrown on the altar. Boxes of this kind are frequently figured on bas-reliefs, from one of which our illustration is taken.

Acetabulum. A small vase used by the Romans to hold vinegar, and employed by jugglers in playing the game of thimble-rig.

Achromatism. An achromatic lens is a complex lens

ACI *ART DICTIONARY.* ADD

which prevents the appearance of the iridescent colours seen by a person looking at an object through a single lens.

Acierage. (Engrav.) A process invented by Salmon and Garnier, and brought to perfection by Jacquin. It consists in covering copper-plates with a very fine film of steel by means of electroplating. The object of *acierage* is to obtain a metal surface with more power of resistance than ccpper, and not so likely to be worn out by the continual wiping which printing necessitates. In addition, the process can be repeated if the wear and tear of the plate render it necessary or if the artist wishes to retouch the plate. The removal or renewal of the steel coating is an operation of extreme facility.

Acinaces. A short dagger worn by the Persians, Medes, and Scythians. It was suspended round the waist and so arranged as to lie against the right thigh.

Acketon. (Cos.) A sleeveless tunic of buckram or buckskin worn under the armour, to which a reference will be found in Chaucer's " Sir Topaz." At the end of the 15th century the term was applied to defences of plate.

Acratophoron. A term used by the Greeks and Romans to denote the vessel in which unmixed wine was put on the table.

Acropolis. (Arch.) The citadel in ancient Greek towns. The acropolis was generally a lofty rock, constituting a natural fortification, which was further strengthened by the construction of walls proof against any attack. On it was built the temple consecrated to the deity under whose protection the city existed. The most famous acropolis in ancient times was that of Athens, on which stood the Propylæa, the temple of Athene Parthenos adorned by the sculptures of Pheidias, the Erechtheum, and many national monuments.

Acrostolium. A sculptured ornament, generally in the shape of a volute, which surmounted the prow of ancient galleys. It sometimes presented the form of an animal's snout, or of some defensive arm, such as a helmet or buckler.

Acroterium. (Arch.) A pedestal

placed at the corners as well as on the summit of the pediment in Greek and Roman temples. These acroteria were sometimes of great importance, and consisted of pedestals carrying figures of colossal size. We still find, in some monuments of the Romanesque period, examples of acroteria placed as end-ornaments on the gable of the apse.

Acus. A Latin term for a pin or needle. It especially denotes a pin, made of gold, silver, bronze, ivory, or wood used to fasten garments or pass through plaited hair.

Addorsed, Adorsed. (Her.) Said of

2 5

two charges when placed back to back. Thus, we say two lions addorsed. Two crescents are addorsed when their flanks are turned towards one another and their horns to the sides of the shield.

Adit. (Arch.) The entrance or approach to a building.

Adobe. Sun-dried bricks, such as are in use in Egypt and in other countries with a warm and dry climate. They were introduced into Spain from Africa, and they are found under the same name in Mexico and other parts of America.

Adrian, St. The patron saint of soldiers, is represented in art with an anvil and a sword, the former referring to his martyrdom and the latter being the attribute of a military saint.

Adze. (Sculp.) A small hatchet, one end of which serves as a hammer. It is used by sculptors for working the plaster. Carvers in wood also make use of an adze, one end of which is bevel-edged.

Aegipan. A mythological deity of the mountains and woods represented with horns and the feet of a goat. It is often met in Bacchanalian pictures.

Aegis. Originally a protection of goatskin worn by the early inhabitants of Greece. Hence it denoted the shield carried by Zeus and Athene, which was made of the skin of the goat Amalthaea and had the Gorgon's head in its centre. Later on it came to mean a breastplate worn by emperors and others.

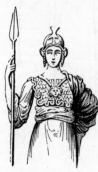

Aesculapius. In Greek mythology the God of Medicine. He is represented in ancient art as a bearded man of a type very similar to that of Zeus. He often leans upon a staff, round which is coiled a serpent, the symbol of rejuvenescence.

Aesthetics. Strictly speaking the theory of perception, but in a more exclusive sense the science of the beautiful. During the last ten years the terms *aesthete, aesthetic,* &c., have been used as slang terms referring to a sham admiration of art, which has been persistently ridiculed in certain journals and plays.

Aetos. (Arch.) The name given to the triangular pediment or gable which surmounted the portico of the Greek temple. [Pediment.]

Affronté, Affronted. (Her.) This is the converse of addorsed, and is said of two charges facing one another. It is also used in the sense of " full-faced " to the spectator. Thus a peacock affronté means a peacock with his tail expanded.

Agate. A siliceous stone of great hardness. The varieties of agate most generally employed by gem-engravers are the cornelian and sardonyx. The chrysopras is used exclusively for jewellery, while vases, pedestals, &c., of much richness are manufactured from the onyx and the numerous other varieties of agate.

Agatha, St. A martyr saint of Catania, who was tortured and put to death by Quintian, a governor of Sicily. She is represented in art as holding in one hand a palm, in the other a dish or salver, on which is a woman's breast. She wears a crown of martyrdom and a veil, and beside her lie the shears, the instrument with which her breast was cut off. The best known picture of her martyrdom is by Sebastian del Piombo, and is at the Pitti Palace.

Agnes, St. The favourite saint of the

Roman women. She refused to marry the son of the prefect of Rome, declared herself a Christian, and was put to death. In art she bears the palm of martyrdom and sometimes the book. She is also represented as crowned with olive and with a lamb by her side.

Agnus Dei. [Lamb of God.]

Agora. (Arch.) A public place where the Greeks held their assemblies and dispensed justice. It was an enclosure richly decorated with porticoes, statues, and altars.

Agrafe. (Arch.) In the art of construction an *agrafe* is a piece of iron or

copper, the purpose of which is to hold together or consolidate. In decorative architecture the *agrafe* is the keystone of an arch, the voluted ornament of which, as it were, clasps together the mouldings of the arch. By an extension of meaning the

term is applied to any decorative projection which breaks a moulding.

Aiglets. (Cost.) Tags of metal attached to the laces, and used to draw together slashed sleeves, to fasten portions of dress, or to ornament caps. They were often made of gold and other precious metals, and were cut into a variety of forms.

Aileron. (Arch.) A French term applied to the inverted consoles, placed at each side of a dormer window to take off from the hardness of the right angle formed by the roof and the vertical uprights of the dormer

window. The façades of some churches of the 17th and 18th centuries afford us examples of *ailerons* of considerable size, which serve to connect a ground floor with a first floor of much smaller dimensions.

Ailette. (Cost.) A kind of epaulette, generally made of leather, and displaying the badge of the

wearer. It was worn in the 13th and 14th centuries.

Air. (Paint.) We say that a picture lacks *air* when the figures are painted with hardness, and do not appear to be seen through the medium of the atmosphere, or when they seem stuck on to the canvas and so fail to give us the illusion of reality. We say that a portrait lacks *air* when the face is badly placed on the canvas, and when insufficient space is left in the upper part of the picture, between the head and the frame, so that the model seems stiff and cramped in pose.

Aisle. (Arch.) A division of or addition to a building. In church architecture the aisle is the lateral division which flanks the nave or choir. In Greek temples the lateral colonnade was termed an aisle (πτερὸν). In French the term also means the returning ends of a building, which we call wings (q.v.).

Alabaster. A name given to a kind of white half-transparent stone sometimes veined, which is capable of receiving a high polish, and is so soft that it can be scratched with the nail.

—, **Calcareous.** A variety of carbonate

7

of lime, milky white in colour and veined with yellow, red, or brown. It is sometimes called oriental alabaster.

Alabaster, gypseous. A variety of sulphate of lime or gypsum, quite white and half-transparent. It is also called white alabaster.

—, **Oriental.** See Alabaster, Calcareous.

—, **White.** See Alabaster, Gypseous.

Alabaster. (2.)

A small vase for holding perfumes, generally in the shape of a pear, and with or without a handle of very small dimensions. Some of the specimens now in museums are Egyptian or Phœnician in origin. In certain Greek and Etruscan tombs they have been found made of onyx.

Alæ. (Arch.) Wings. In Roman houses the alae were the two rooms which were placed one on each side of the atrium.

A la Grecque. (Arch.) An architectural ornament employed in rectilineal

moulding, which resembles twisted ribbon.

Alb. A white ecclesiastical garment, which reached to the heels and was fastened by a girdle. It was the second vestment put on by the priest. From it is derived the surplice. From the 10th to the 16th century it was richly embroidered and even ornamented with jewels round the edge.

Alban, St. Earliest British saint. He is represented as carrying his head in his hands. His attributes are a sword and a crown.

Albertotype. A process by means of which a photographic plate, when covered by chromate of potash and exposed to the influence of the light, can be inked like a lithographic stone so as to furnish prints with the roller and printer's ink.

Alcarazza. A name given to porous vessels used as water-coolers. They are found in Egypt, Asia, Spain, &c. In the present day they are manufactured in large numbers in Egypt and are rarely used twice, as their cost is trifling.

Alcazar. (Arch.) A fortified palace of the Moorish kings. The alcazars of Cordova, Seville, and Ségovie may be quoted as models of their kind. In our time the name of alcazar is given to certain theatres, music-halls, and other modern constructions of pseudo-Arabian design, the decoration of which is set off by brilliant illumination.

Alcove. (Arch.) A part of a room, often richly decorated, for the reception of a bed, which can be entirely concealed by means of folding doors or curtains, so arranged that the room does not lose its rectangular shape.

Alexis, St. The patron saint of pilgrims and beggars, is represented in a pilgrim's ragged habit. His attributes are a dish and a palm.

Alhambra. (Arch.) Palace of the Moorish kings at Granada, the interior walls of which are decorated with extraordinary profusion. The courts of Abencerages and of the Lions, surrounded by porticoes and marble colonnades, have a legendary celebrity. The name is given to modern constructions intended to serve as theatres or music-halls.

Alidade. A flat rule of metal provided at each end with plates of copper placed at right angles to the rule. These plates are pierced with longitudinal openings, across which a thread of

silk is stretched vertically. The alidade is placed on a table, and a ray of light passing through the two threads serves to determine a direction.

Alignment. A series of *menhirs* (q.v.) or blocks of stone placed in two

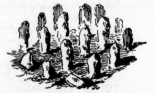

or more parallel lines, several examples of which exist in Brittany and elsewhere.

Alla Prima. (Paint.) When a picture is painted at once without retouching, it is said to be executed " alla prima." This method was followed by the Van Eycks and early Flemish painters, and later on by Rubens. In more modern times a good example of the method is Wilkie's " Preaching of John Knox."

Allecret. (Cost.) A light plate armour worn in the 16th century by French light

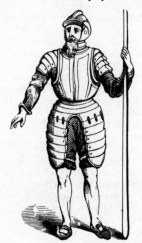

cavalry and German and Swiss infantry.

Allege. (Arch.) A very thin wall closing the lower compartment of Gothic windows. In the 15th century these leaning-places are often decorated by arcades, and in the 16th century by bas-reliefs or systems of ornament, in the centre of which is a scroll flanked by figures of children.

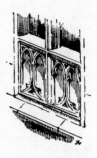

Allegory. A name given to groups or figures painted or sculptured, which represent symbolic personages. For instance, we speak of an allegory of justice, an allegorical figure of youth.

Allerions. (Her.) Small birds without claws or beaks, represented in the attitude of eagles displayed. Heralds apply the term *allerions* only to eaglets.

Almayne Rivets were originally overlapping plates of armour, but subsequently gave their name to complete suits of armour thus fastened.

Almery. (Arch.) A cupboard near the altar, in which were placed the chalices, basins, cruets, and other sacred utensils. It was either in the thickness of the wall or was made of wood.

Almond. An elliptical aureole which surrounds the representation of divine figures in the works of early painters or in Gothic glass-work. This *almond* is also termed a " gloria," or an " elliptic aureole."

Almonry. (Arch.) A room in monastic buildings used for the distribution of alms.

Almuce. (Cost.) A hood of fur, which was worn by the clergy from the 13th to 15th century during the recital of the divine office. As an ecclesiastical vestment it had little or no significance. Indeed, its primary object was to shield the officiating priest from cold. It was also worn by bachelors of canon law, and, according to Planché, in later times by ordinary laymen.

Alphege, St. An English saint who suffered martyrdom at the hands of the Danes in 1012. He is represented as a middle-aged man with a battle-axe, or a chasuble containing stones, as emblematic of his martyrdom.

Altar. The altar of an ancient temple was a table of stone or marble, on which the offerings to the presiding deity were placed, or a pedestal decorated with bas-reliefs. The altar of the Christians is a consecrated table, which was in theory the tomb of the martyrs, and at which the priest celebrates the mass. Druidical monuments, too, are as a matter of fact altars erected for the offering of human sacrifices. The altars of the 11th, 12th, and 13th centuries are quite simple. In the Gothic period the altar took the form of a small edifice elaborately adorned with screens, pinnacles, and gables. At the Renaissance it assumed the form of the entablatures of the classical orders, while in the 17th and 18th centuries it developed into a portico with pediments, brackets, and volutes, and was sometimes entirely gilded. In Italy there are still in existence—at St. Peter's at Rome for instance—altars covered with rich baldachinos.

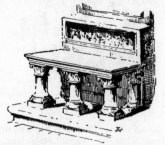

In England the altars were taken down at the Reformation about 1550; they were restored at the beginning of the reign of Queen Mary, and again removed by Queen Elizabeth. The high altar at Arundel, Sussex, is supposed to be the only original altar left in England.

Altar-back. (Arch.) The wall in which the altar-piece is set.

Altar-cloth. (Dec.) A rich stuff embroidered with gold and silk, and sometimes ornamented with precious stones, which was stretched over the altar in the early times of the Church.

Altar-piece. (Arch.) An altar decoration consisting of a panel, in the centre of which is placed, according to the period to which it belongs, a bas-relief or picture. Before the 13th century altar-pieces were movable, but after this time they were generally fixed. In the 15th century altar-pieces were often ornamented with extraordinary magnificence, while from the Renaissance to the 17th or 18th century they were conceived in an architectural

spirit as porticoes, and were decorated

with entablatures and columns, flanked by niches, in which statues were placed, and terminated by pediments and vases. Sometimes they were of sculptured wood, of marvellous workmanship and completely gilded.

Altar-screen. [Reredos.]

Alternation. A system of ornament which consists in the decoration of a surface by means of two distinct *motifs*, which repeat themselves in succession in the same order.

Alto-Relievo. (Sculp.) An Italian term signifying high-relief. Sculptured figures are said to be in *alto-relievo*, when they project entirely or almost entirely from the surface of the block from which they are cut. The metopes from the Parthenon, now among the Elgin marbles, are the best extant examples of alto-relievo.

Alura. (Arch.) A way or passage generally applied to clerestory galleries or passages on the roof along the gutters.

Amasette. (Paint.) The amasette was an instrument of wood, ivory, or horn, with which the painters of the last century mixed their colours on the palette. Nowadays the palette-knife is generally used for this purpose.

Amatito. (Paint.) A pigment prepared from red hæmatite and used by early artists in fresco-painting.

Amateur. One who, though he does not practise any branch of the fine arts, has a taste and feeling for them. The word is sometimes used in a contemptuous sense to denote an unskilled artist.

Ambrose, St. The patron saint of Milan, of which city he was bishop. In devotional pictures he is represented as wearing the pallium and mitre and carrying the episcopal crosier. His attributes are a beehive, because tradition says that when he was in his cradle a swarm of bees alighted in his mouth without harming him, and a three-thonged scourge, which he carries as the castigator of sin.

Amazons. A race of female warriors, the myths concerning whom were often illustrated by Greek artists. They are frequently represented on painted vases as habited in Persian or Scythian dress and wearing a Phrygian cap. They are always armed, carrying a bow, spear,

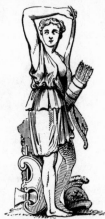

sword, or battle-axe as well as a shield, which is sometimes round, sometimes crescent shaped. They were also a favourite subject with sculptors, and Pliny tells us of a competition between Polycleitus, Pheidias, and three other sculptors for a figure of an Amazon. The cut here given is said to be a copy of the

statue produced on that occasion either by Polycleitus or Pheidias. The battle between Theseus and the Amazons is figured in the well-known bas-reliefs from the Temple of Theseus, while that between the Amazons and Centaurs is to be seen on the Phigaleian frieze. Both these series of bas-reliefs are at the British Museum.

Amber. A substance washed up by the sea in several parts of the world, but found in especially large quantities in the Baltic. Its vegetable origin is now generally admitted. It is probably the resinous product of a particular species of a coniferous tree. A picture varnish of great value is obtained from it, which was used with success by Van Eyck and the early Flemish painters, and has been employed ever since.

Amber Tone. A warm tone observed in certain paintings. An amber tint varies from a shade of pale yellow to light carmine red.

Ambo. (Arch.) A name given to pulpits in Christian *basilicæ*, and to the tribunes placed opposite one another in

the nave, from which the Epistle and Gospel were read. They ceased to be used about the end of the first half of the 13th century.

Ambulant. (Her.) Walking or *passant*.

Ambulatory. (Arch.) A part of a building suitable for walking in, such as cloisters, &c.

Amethyst. A precious stone of a violet hue.

Amice. (Cost.) The first of sacerdotal vestments, consisting of a piece of linen, which was worn on the head like a hood,

until the priest appeared at the altar and

was then thrown back (see cut). It came into use about the 7th century.

Amorini. A name given to the Cupids or small love-gods often represented in art.

Amortissement. (Arch.) A French term denoting an ornament, generally

pyramidal in form, used to terminate a building.

Amphiprostyle. (Arch.) A temple is said to be *amphiprostyle* when it has a façade of columns at each end.

Amphitheatre. In Roman architecture amphitheatres were large buildings,

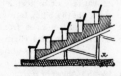

circular or elliptical in shape, with a large empty space in the middle. This space

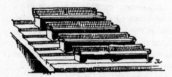

or arene was devoted to combats of gladiators or wild beasts, while the spectators sat on tiers and were protected

from the rays of the sun by an immense curtain. In modern times large halls intended for public meetings or conferences, and containing seats in tiers, where the audience sit, are called amphitheatres. The name is also given to certain parts of theatres which contain rows of seats rising one above another.

Amphora. A name given to a kind of Greek vase, two-handled, and generally of large size, which was used to hold liquids. Some amphoræ were mounted on a foot, others were not. They were often mere objects of ornament, and specimens have been found with· no hollow interior, and therefore incapable of being put to any use. The victors in the Panathenaic games were awarded an amphora as a prize. The unit of capacity among the Romans was called an amphora.

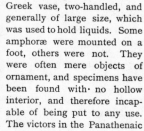

Ampul. A small vessel of clay or glass which contained consecrated oil or wine for the Eucharistic service. Such was the holy vase preserved at Rheims until the first French Revolution, which contained the sacred oil employed in the consecration of the kings of France.

Ampulla. A name given to small glass vases of globular form, which were carried by the ancients.

Amulet. A word of Eastern origin applied to objects of very varied character, which were worn round the neck to ward off illness, to turn away the· evil eye, or confer good luck on the wearer. Stones, plants, or parts of animals, such as a hyena's

tooth, served as amulets, as well as all kinds of small ornaments made of metals or precious stone and cut into grotesque forms.

Anachronism. A method of representing an event artistically, in which the order of time is violated. For instance, in mediæval representations of scriptural scenes the costume, architecture, and accessories often belong to the time of the artist, not of the event portrayed.

Anadyomene. " She who rose from the sea." The goddess Aphrodite was said to have been born among the foam of the sea, rising from which she has frequently been represented by both ancient and modern artists.

Anastatic Process. A process of reproducing in facsimile any printed page, either type or picture. The page to be copied is first moistened with dilute acid and then pressed down on a smooth plate of zinc. As the acid only affects that portion of the page which is not printed on, the result is that the part of the zinc plate which comes in contact with the unprinted portions of the page is slightly etched, while the printed portion leaves a film on the metal. The plate is then inked, and impressions struck off as in lithography. Photo-

lithography has now entirely superseded the anastatic process.

Anaglyph. A name given by the ancients to sculptures in bas-relief (q.v.).

Anastasia, St. A saint who suffered martyrdom at Rome for professing Christianity. Her attributes are the stake, the faggots, and the palm.

Anatomy. From the artistic point of view, anatomy for the sculptor and painter is the study of bodily forms and the play of muscles. The branches of anatomy most important for artists are osteology (the study of bones) and myology (the study of muscles). In addition to this they ought to possess a knowledge of the elementary principles of physiology, *i.e.* the science of the phenomena of life and the functions of the various parts of the body.

Anchor. The anchor in religious art is the symbol of hope. It is the attribute of Pope Clement, who is said to have been tied to an anchor and thrown into the sea in the year 80 A.D. It is also a charge in heraldry, which unless otherwise specified is represented in pale (q.v.) and without a cable.

Ancones. (Arch.) Supports placed in doors and other apertures under the cornice.

Andirons. Utensils of metal, placed on the hearth in old houses for the purpose of holding logs of wood and aiding in their combustion. Though generally of iron,

they are sometimes of copper, silver (as at Knole, in Kent), or even gold, and often artistically decorated. As a rule they were two in number, but at Penshurst, in Kent, a single one is found.

Andrew, St. Brother of Simon Peter and patron saint of Scotland and Russia. He suffered martyrdom A.D. 70. His attribute in art is the transverse cross, on which he is said to have been crucified.

Anelace. A short sword or dagger carried by civilians until the end of the 15th century. It was double-edged and tapered to a point. In representations of it which have come down to us on monuments and elsewhere, it is suspended from the girdle. Our cut is from a monumental brass of the time of Edward III.

Angels. The worship of angels was early introduced in the Christian Church, and they are constantly represented in devotional art. Their characteristics are the following: they are human in form and winged; they are always young and masculine, and are draped generally in white. They are the messengers of God, the rulers of the stars and elements, the guardians of the just, and the choristers of Heaven, in which last capacity they are frequently represented with various musical instruments. In Christian architecture they fill up every space; they are found on friezes, in the spandrils of arches, and as corbels; they also hold emblems, labels with inscriptions, and candlesticks. They have been represented pictorially by many artists from the earliest times down to William Blake, whose drawings of angels are full of originality and poetry. Their attributes are trumpets, flaming swords, sceptres, censers, and musical instruments.

Angle. The inclination of two straight lines to another. An angle is rectilinear when the lines which contain it are straight lines. It is called curvilinear

when it is contained by portions of curves. When one straight line standing on another straight line makes the adjacent angles equal, each of these angles is called a right angle. A right angle measures 90°. An angle of 45° (*i.e.* half a right angle) is the angle most frequently employed in architecture. Every angle

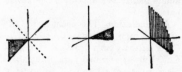

which measures less than a right angle is called an acute angle, and every angle which measures more than a right angle is called an obtuse angle. Two angles are called complementary when their sum is equal to a right angle, and supplementary when their sum is equal to two right angles.

Angle, Facial. The angle formed on the face by two straight lines drawn from

the base of the nose, the one to the base of the ear, the other to the most projecting point on the forehead. In antique statues the facial angle is generally 90°. As a general principle it may be said that intelligence is proportional to the facial angle. It is at any rate an incontestable fact that the lower one descends in the human race the more the facial angle diminishes.

Angle-shaft. (Arch.) A round moulding, either unbroken or ornamented, placed at an angle. It replaces a sharp angle, which is always fragile, by a round surface, capable of greater resistance and less likely to wear out.

Angled. (Her.) This term is used when the division of a shield forms a projection instead of a perfectly straight line. As an armorial bearing it has been used to indicate a bastard, and according to some authorities it is one of the six marks of bastardy.

Anglo-Saxon Architecture. (Arch.) The style of architecture which prevailed in England between the 6th and 11th centuries. Its chief characteristics are the following: the walls were of rubble and herring-bone work; the arches semicircular; doorways either round-arched or triangular-headed, and the windows small. The decoration was of the simplest character, and the balusters or small columns bear traces of being copied from woodwork. The tower of Sompting Church, in Sussex, is a good example of the style.

Animals, Hybrid. In ancient and mediæval art we find represented certain animals which are a combination

of different species, such as centaurs (horses with their upper part human), sphinxes (lions with human faces), &c.

Animals, Symbolic. (Arch.) Symbolic animals are those fantastic monsters with which the surface of walls was

15

covered both in ancient times and in the Middle Ages. Examples of them exist in the temple of Belhus, while the façades of our own Gothic cathedrals are sometimes entirely covered with grotesque figures, the symbolie meaning of which has been interpreted in various ways by archeologists.

Animation. (Paint.) Certain qualities of vivacity, quickness of imagination, and execution which a skilful artist can put into his work. Thus we speak of a painter having more skill than animation.

Anime is a resinous gum which is mixed with copal varnish to make it dry quicker.

Anklet. A gold ornament worn by the Egyptians, Greeks, and Romans just

above the ankle, as a bracelet is on the arm.

Anne, St. The mother of the Virgin Mary. She is frequently represented in pictures of the Holy Family, and is generally reading a book.

Annealing. To prevent glass and certain metals from becoming suddenly brittle after melting they undergo a process called *annealing*. This process consists in placing glass vessels in a hot oven, where they take several hours or even days to cool, and in heating metals again after hammering.

Annodated. (Her.) Bent like the letter S.

Annulated, Annuly. (Her.) Said of a charge which has an annulet at each extremity.

Annulet. (Her.) A ring, used either as a charge or as a mark of difference of the fifth son.

Annulets. (Arch.) Small projecting mouldings in the shape of a ring, which in the ancient orders are found at the

intersection of the shaft of the column with the capital. In Gothic monuments of the 12th and 13th centuries annulets are found distributed at different heights along the shaft of the column, so as to slightly interrupt the lines of the column and to increase its appearance of resistance.

Annunciation. This event in the life of the Virgin is frequently treated in Christian art. As a mystical subject it almost always formed part of an altarpiece, whatever its subject, being let in either in the spandrils or the predella. As an event the annunciation is a frequent subject of the early painters. The scene is laid in a house or porch, and the accessories are a pot of lilies, a basket of work, or distaff. The angel is represented as descending to earth and generally carries a lily or a sceptre, the latter being surmounted by a cross.

Antae. (Arch.) Pilasters increasing the thickness of a wall at the angles of a building. In classical architecture a temple is said to be *in antis* when the

façade is decorated by two columns of the same thickness as the pilasters or *antae*, which they help in supporting the beams and roof of the temple.

Ante-chapel. (Arch.) That portion of a chapel which lies to the west of the choir-screen.

Antefixae. (Arch.) Ornaments which

generally take the shape of a palm leaf

—or sometimes that of a mask—and form the coping of a cornice, or serve to hide the semi-cylindrical ridge-tiles or the overlapping projection of the roof. They are often of exquisite workmanship.

Antependium. Decorations placed in front of a Christian altar, such as hangings of embroidered cloth, plates of metal or panels of carved wood.

Anthony, St. A hermit who lived in the 4th century and underwent every kind of temptation. St. Anthony is generally represented as wearing the monk's habit and cowl, and his attributes are the crutch, to mark his age, and the bell and *asperges*, the instruments of exorcism. Beside him a hog, the demon of sensuality, is often figured. The temptation of St. Anthony is variously treated. In early pictures he is only confronted by a beautiful woman, but in later times he has been represented as surrounded by foul demons of every sort and shape, as in the grotesque prints of Martin Schongauer and Callot.

Anthropomorphism. The practice, universal in ancient art, of representing the gods in human guise.

Antiplastic. A term applied to certain substances, such as quartz, sand, &c., which are used in pottery to mix with the paste, in order that the *plasticity* of the aluminous silicates of which the paste consists may be diminished.

Antiquaille. A term of contempt used to denote antiques of small value or no interest.

Antiquary. In former times a man skilled in ancient lore or a collector of antiquities was called an *antiquary*. The term is only used to-day to imply contempt or to describe a vendor of curiosities. The antiquary as a learned man is now called an archeologist.

Antique. Under this designation are included Greek and Roman works of sculpture, such as statues, bas-reliefs and engraved gems. The study of the *antique* is the study of the beauty of form and the purity of outline as observed in classical works of art. In modern art schools students generally go through a course of drawing from the antique before entering the life-school.

Antiquities. Under this name are classed the ruins of buildings, monuments, arms, furniture, ornaments, all the remains in fact of ancient art. The term is especially applied to the artistic objects of the Byzantine, Gothic, and Renaissance periods, the term *antiques* being reserved for Greek and Roman works of art.

Antonine Column. A pillar erected in honour of M. Aurelius and decorated by a spiral series of reliefs, representing scenes from that Emperor's war with the Germans. It is a close imitation of

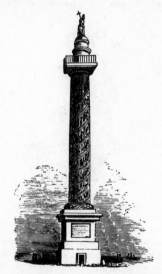

Trajan's column, to which it is artistically inferior. Its pedestal was restored in the 16th century, and a statue of St. Paul now stands on its summit. Though of little artistic merit, it is of considerable archæological value, as it

3

is our best source of information as to the costumes, arms, and equipments of both the Romans and Barbarians of the second century.

Anvil. In Christian art the attribute of St. Adrian (q.v.) and St. Eloy (q.v.).

Ape. The symbol of malice and lust. In Christian art the devil is often figured under this guise.

Aphrodite. In Greek mythology the goddess of love. In the best period of Greek art she was represented draped, but in later times nude. A celebrated picture of Apelles represented her as *Anadyomene* (q.v.), or rising from the sea. Her symbols were the dove, hare, dolphin, swan, and tortoise, besides the apple, the rose, and various other flowers and fruits.

Aplustre. A wooden ornament which surmounted the stern of a Roman galley. It was very graceful in shape,

resembling a fan or the outspread feathers of a bird. It is accordingly employed in art to symbolise a seafaring life or a naval victory.

Apodyterium. (Arch.) The room in an ancient bath, in which the bathers undressed.

Apollo. In Greek mythology the god of light, both mental and physical, and so of knowledge, music, and purity. He is generally represented in Greek art of the best period as a youthful athlete. In the art of Greek decadence the Apollo type became more effeminate. As the god of music he holds a lyre, and is represented as draped or with long flowing hair. He is also found with a bow and arrow in his hand, as killing a lizard (Sauroctonus), and as vanquishing Marsyas, whom he afterwards flayed. The symbols of Apollo are the lyre, the laurel, the wolf, swan, raven, &c.

Apollonia, St. The patroness against toothache and diseases of the teeth. She suffered a martyr's death in 250 A.D., her teeth being drawn out. Her attributes are a palm and a pair of pincers with a tooth.

Apophyge. (Arch.) A concave curve, by which the shaft of a column is connected with the projecting mouldings of the base and capital.

Apostles. In earliest time the representation of the apostles is purely emblematical, they being figured as twelve sheep. They were next represented as twelve men, all alike, each with a sheep, and later with a scroll. From the 6th century they were distinguished each by his attribute.

Apotheosis. A ceremony by which a mortal was placed among the gods. There are in existence a number of medals, paintings, and sculptures in-

tended to perpetuate the memory of this ceremony. An essential part of it was the burning of an effigy of the deceased. As the smoke ascended an eagle was let loose,

18

which was supposed to carry the soul of the dead man to heaven. Consequently on Roman coins struck in honour of an apotheosis we often find a fire burning on an altar and an eagle ascending. In the British Museum there is an apotheosis of Homer in bas-relief, which is said to date from the time of the Emperor Claudius. In modern times some painters have designed apotheoses, such as that of Charles V. by Titian, and of James I. by Rubens, the latter of which decorates the ceiling of Whitehall Chapel. This term is also used on the stage to denote the final tableau in fairy scenes or in great spectacles.

Apparels. (Cost.) A word used to denote the embroidered borders of ecclesiastical garments. They were very richly

ornamented, and often studded with gems. As a rule, they were placed round the bottom and on the waist of the vestment.

Appaumée. (Her.) Said of a hand when it is blazoned upright with the palm presented to view.

Apple. In classical art the apple was an attribute of Aphrodite. In devotional art it typifies the temptation and fall of man.

Appliqué. A general term for ornaments which are let into or fixed on to the surface of an object. For instance, a wood panel may be decorated by appliqués of bronze. The name is par-

ticularly given to candelabra, the horizontal shank of which is terminated by an ornament, fixed on a vertical surface, such as panelling, wainscoting, or pilasters.

Apse. (Arch.) The semi-circular or polygonal termination of a church, situated behind the choir. In Christian churches, which run from west to east, the apse is at the east end. In the Romanesque or Norman churches the apse generally takes the shape of a semicircle. In the 13th century it is polygonal, but flanked by chapels at its base. Though the apse is more commonly met with on the Continent, many

specimens remain in England, especially from Norman times. Good examples are to be seen in Westminster Abbey, St. Bartholomew's, Smithfield, and Gloucester Cathedral. In the latter case the apse has disappeared in the superstructure, but remains in the crypt.

Apsidal Chapels. (Arch.) Small chapels attached to the apse of a church. They are sometimes semicircular, sometimes polygonal. They are nearly always

uneven in number, the one placed at the axis of the church being as a rule considerably larger than the others, and dedicated to the Virgin. In English cathedrals this chapel is called the Lady Chapel. Apsidal chapels exist at Tewkesbury Abbey, Westminster Abbey, and in the crypt of Gloucester Cathedral.

Apteral. (Arch.) A name given to

ancient temples which have no lateral colonnades.

Aquatint. (Engrav.) A process of engraving by which sepia drawings can be reproduced with great accuracy. The copper plate, before being exposed to the action of the acid, is covered by powdered mastic. This prevents the aqua-fortis from acting upon it, and a mottled surface is thus produced.

Aquae-manalis. A vessel used in churches for washing the hands by the celebrant of the liturgy.

Aqua-fortis. Diluted nitric acid, which is used by etchers for biting in.

Aqua-marina. A gem of a green tint, often used by gem-engravers in ancient times.

Aqueduct. Constructions either above or under ground employed to conduct water. Aqueducts of Roman construction, some of which are still in existence, are absolute monuments of art, and in some cases harmonise wonderfully with the lines of the landscape. In modern times aqueducts are built from the designs of engineers, and are as a rule nothing more than water-pipes of immense girth. They are generally carried underground that they may escape the frost in winter and that the water they convey may be kept cool in summer.

Arabesque. A system of ornament consisting of wreaths of foliage and realistic or fantastic figures, combined in an absolutely capricious style, delicately interlaced and describing graceful curves.

In the Arabian style Arabesques are composed entirely of ornaments drawn from the vegetable kingdom, for representations of men and animals were forbidden by the prophet. In the style of the Renaissance Arabesques were wonderfully rich and elegant. Raphael employed this system of ornament in the decoration of the Loggia at the Vatican. It is a mistake to apply the term Arabesque to the friezes of buildings belonging to the Roman period. The regular bands of ornament in vogue at this period can only be termed foliage.

Araeostyle. (Arch.) A temple is called *araeostyle*, when the distance between its columns is more than three times the diameter of the column.

Araeosystyle. (Arch.) A term applied to an arrangement of columns set two and two together, having half a diameter for the smaller interval, and three and a half diameters for the larger.

Arbalest. The name given in the Middle Ages to the cross-bow, a weapon which was invented by the Romans in the East, and called by them *arca-balista*. It was introduced into England at the Norman Conquest, but its use was prohibited by the Church in 1139. Richard I. reintroduced the arbalest into England, and was killed by one as· a judgment, it is said, for using a prohibited weapon " in defiance of God."

Arcade. (Arch.) A series of arches, which are employed for decorative purposes chiefly in buildings of the Pointed style. The term includes the large arches and piers which in many English cathedrals separate the aisles from the nave; but it is especially applied to series of arches which decorate the

space under the windows either within or without the building. Sometimes arcades are set right against the wall, sometimes they are detached so that there is a clear space behind them. When set near the ground they frequently

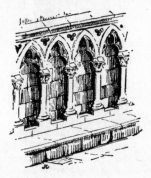

project so as to form *sedilia.* An arcade sometimes occupies the triforium space (q.v.), an instance of which may be seen in the Temple Church. Finally, as a system of ornament, small arcades are found on fonts, altars, &c.

Arch. (Arch.) An arch is a solid construction composed of separate stones or bricks, so arranged that their lower surfaces shall form the arc of a curve. The origin of the arch is unknown, but it was first brought into general use by the Romans. The earliest known instance

of an arch is in the Cloaca Maxima at Rome. The pointed arch first made its appearance in Western Europe about the end of the 12th century, and is held by some writers on architecture to have been suggested by the interlacing of round arches in arcades. In all probability, however, it was previously known, and was adopted because it was not only beautiful but practical. The arch is the distinguishing characteristic of Gothic architecture. The highest point of an arch is called the *crown* or *vertex;* the lowest line is termed the *springing line;* the spaces between the vertex and the springing line are called the *flanks.* The upper and lower surfaces of an arch are called the *extrados* and *intrados* respectively. The piers of an arch are termed *abutments* or *springing walls.* The stones of which an arch is composed are termed *voussoirs,* and the top stone of all, the *keystone.*——The term *arch* is also applied to the vault of a bridge. The highest and largest arch in a bridge is

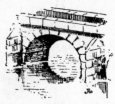

called the main arch, and occupies the centre of the bridge.

Arch, Angular. An arch formed by the

inclination of straight lines to or e another at an angle.

——, **Basket-handle.** An arch formed

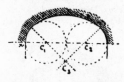

by the segments of three circles meeting each other.

——, **Byzantine.** [Arch, Horseshoe.]

——, **Catenarian.** An arch in the form of an inverted catenary, a catenary being a mechanical curve, which a flexible body of uniform density would form itself into, if freely hung from its two extremities.

——, **Contrasted.** [Arch, Ogee.]

——, **Depressed.** A flat-headed opening

21

with the angles rounded off into segments

of circles, frequently met with in the Perpendicular style of architecture.

Arch, Discharging, or **Relieving.** An arch placed over a lintel of stone, wood

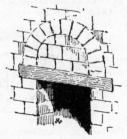

or iron, the object of which is to relieve the lintel from the weight placed upon it.

—, **Elliptic.** An arch which is in the form of a segment of an ellipse.

—, **Extradossed.** An arch the voussoirs of which are pierced, and of which the intrados and extrados (q.v.) are determined by segments of concentric circles.

—, **Four-centred.** An arch with four centres, two of which are on the springing line and two below. These four centres may be determined by describing a square

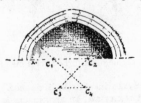

under the springing line, each of its sides being equal to one-third the springing line. This arch was characteristic of the Tudor style in England, which took its rise in the reign of Henry VII.

—, **Horse-shoe.** An arch which con-

sists of a segment of a circle, greater than a semicircle.

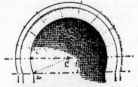

Arch, Multifoil. An arch formed of many foils or segments of circles.

—, **Ogee.** An arch with four centres, two of which are in or near the springing line, the other two above the arch. It is

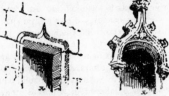

called an *ogee* arch because each of its flanks exactly resembles the contour of the ogee moulding. The monuments of the 15th and 16th century belonging

to the Perpendicular or Flamboyant style afford many examples of the ogee arch.

—, **Pointed.** An arch formed by two

22

segments of circles, which make an angle at their intersection. Pointed arches are of three kinds: 1. The *equilateral* arch, *i.e.* described from two centres, which are the whole breadth of the arch from one another, and form the arch about an equilateral triangle (illustrated at bottom of opposite page). 2. The *drop* arch, which has its radius shorter than the breadth of the arch, and is described about an obtuse-angled tri- angle. 3. The *lancet* arch, which has a radius longer than the breadth of the arch, and is described about an acute-angled triangle.

Arch, Rampant. An arch the imposts (q.v.) of which are placed at different heights. These arches have frequently

been employed in Gothic architecture and in the construction of piers from flying buttresses.

—, **Reversed.** An arch built in the reverse direction to ordinary arches.

It serves to connect separate piles of masonry, and is frequently employed to strengthen the foundations of a wall and for other structural purposes.

—, **Semicircular.** An arch in the form of a semicircle; it has its centre in the springing line.

Arch, Sloping. [Arch, Weathering.]

—, **Stilted,** or **Surmounted.** An arch enclosing a figure made up of a semicircle standing on a rectangle, the centre of the circle thus lying in the upper side of the rectangle.

—, **Surbased.** An arch is termed surbased when it is less than a semicircle, *i.e.*, when the height from its spring to its crown is less than half its span.

—, **Trefoil.** An arch formed of three foils or segments of circles.

—, **Triumphal.** A monument to commemorate a victory, consisting of one large archway flanked very often by two smaller ones, surrounded with pilasters, and decorated with allegorical bas-reliefs. Among the triumphal arches of the Roman period we may mention

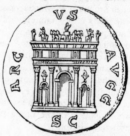

those of Trajan, Septimus Severus, Augustus, and Constantine, while among those of quite recent construction the most famous is that which stands in the Place de l'Étoile, in Paris. The latter was erected in honour of the Grande Armée, and is decorated with a fine bas-relief by Rude.

23

Arch, Tudor. [Arch, Four-centred.]

—, **Weathering.** An arch included between two planes, the one vertical, the

other oblique. It is often met with in a sustaining wall or the wall of a fortified castle.

—, **Zigzag.** An arch of which the extrados is cut into a zigzag pattern.

Archaeological. That which relates to archaeology.

Archaeologist. One who devotes himself to the study of archaeology.

Archaeology. The science of antiquity, the object of which is the study of all that relates to the arts and monuments of former times. It includes the study of the styles of every period and every people. It is also concerned in the reconstruction of the buildings, the social state, and the manners and customs of preceding generations by the documentary evidence furnished by ruins or the remains of monuments which have come down to us from early times.

Archaeology of Art is that particular branch of archaeology which is concerned with the study of the monuments of the art of antiquity, the Middle Ages, and the Renaissance. It includes the study of architecture, painting, sculpture, engraving, numismatics, *i.e.* coins and medals, iconography, *i.e.* the portraits of illustrious men, and glyptics, *i.e.* engraved stones. The archaeology of art includes the whole history of the fine arts from the most remote times.

Archaic. When a monument is said to be decidedly archaic in style, it means that it presents the characteristics of primitive art. The object of archaic studies is to discover the methods and processes of the ancients, and so to render possible the production of works not exactly like those of the ancients, but

possessing numerous points of similarity with them. We say, too, that a picture is conceived in an archaic spirit when it recalls to us some ancient work, and reminds us of the productions of generations long since passed away.

Archaism. The imitation of the methods and processes of the ancients. Archaism is a danger in the arts of design, and should seldom be employed except in the restoration and reconstruction of works of ancient art.

Archangels. The seven angels who stand in the presence of God. In Christian art they are represented with the following attributes :—*Michael* bears the sword and scales ; *Gabriel*, the lily ; *Raphael*, the pilgrim's staff and gourd ; *Uriel*, a roll and a book ; *Chamuel*, a cup and a staff ; *Zophiel*, a flaming sword ; and *Zadkiel*, the sacrificial knife.

Architect. An artist who designs a building and superintends its construction.

Architectural. That which is concerned with architecture.

Architectural Painter. A painter who only executes pictures which are architectural in subject. Among architectural painters we may mention the Dutchmen, Van der Heyden and De Witte, the Italians, Bellini and Canaletti, and the Englishman, Samuel Prout.

Architecture. The art of designing and constructing buildings. Architecture should keep in view above all things the permanence of a building and the purpose to which it is to be put. Though it belongs as much to the domain of science as to that of art, the study necessary to enable the architect to realise the conditions we have named is subordinated to the demands of art.

—, **Civil.** The art of architecture applied to the construction of civil buildings either public or private.

—, **False.** A decorative painting or theatrical decoration, which attempts to represent the relief of a real building just as it would appear at the same dis-

tance as that at which the spectator is placed from the painting or decoration.

Architecture, Military. Architecture applied to military constructions.

—, **Religious.** The art of architecture applied to religious constructions.

Architrave. (Arch.) The lower part of the entablature. The architrave is placed directly on the capital with a free bearing from column to column or pilaster to

pilaster. In the Doric order the architrave is simply one smooth block. In the Ionic order it is composed of three blocks, each jutting slightly beyond the one underneath it. Generally speaking the architrave is unornamented, so as to form a contrast to the rich decoration of the frieze. This simplicity renders it quite clear that the purpose of this portion of the entablature is to form a horizontal connection between the vertical supports of the structure.

Archivolt. (Arch.) A moulding decora-

ting an arch and corresponding exactly to the contour of the arch. In ancient architecture the archivolt only decorates one side of an arch. In buildings of the Gothic style, however, the same moulding is generally repeated on each side of the arch. The outline of the archivolt varied considerably in the different periods of Gothic architecture. In the 13th century it is of the utmost simplicity ; in

the 14th century it is decorated with astragals, and in the 15th century is deeply cut out. In the Arabian style archivolts frequently consist of stucco traceries. The term archivolt is frequently used by mediæval writers to mean a mere vault.

Archway. (Arch.) A circular opening

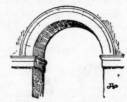

which assumes the various forms of the arch.

—, **Twin.** An opening which presents the appearance of two archways of similar

dimensions, placed side by side, or an opening formed by two semi-circles, which touch at one of their extremities.

Arcs doubleaux. [Ribs, Transverse.]

Arena. (Arch.) The space reserved in the Roman circus for races and gladiatorial combats. The term is also applied to entire buildings which are employed as circuses or amphitheatres.

Areotectonics. The application of military architecture to the construction of fortifications.

Ares. The Greek god of war. He is represented in art as a youth of powerful frame, wearing a helmet and carrying a shield and spear. A burning torch and a spear are his attributes, while he is symbolised by a vulture and a dog.

Argent. (Her.) The metal silver. **It** is generally written *ar*. In engraving

it is represented by a plain white surface.

Arm-chair. A chair with arms and a back. The arm-chairs or faldstools (q.v.) of the Middle Ages were simple in construction and easily folded up and transported. At a later period they were decorated with tapestries and, in the 14th century, often covered with a canopy. In the 15th and 16th centuries the arms were more and more ornamented. Finally in the 17th and 18th centuries arm-chairs assumed a curvilinear form; their out-

lines became more graceful and their comfort was much increased. In France, under the First Empire, they were decorated with heads of sphinxes and designed in a pseudo-classical style. The arm-chairs of to-day are, as a rule, reproductions of those of former times. If we can be said to have produced any special form of our own, it is one in which the demands of art are entirely subordinated to considerations of comfort.

Armature. (Arch.) Iron bars used for strengthening or sustaining. Architraves, for instance, with a wide free

bearing, when placed upon slender columns, are strengthened by armatures.

The term is also applied to the iron frame-work of windows.

Armed. (Her.) Provided with the natural weapons of defence. A lion is *armed* of his claws and teeth, &c. In blazoning, a knight is said to be *armed at all points* when he is completely cased in armour.

Armes Parlantes. (Her.) Under this term are included arms and crests suggested by the name of the family which bears them, and so forming a kind of rebus. Thus the coat of arms of the King of Grenada in Spain is a grenade. The families of Salmon, Sturgeon, and Lamb bear salmons, sturgeons, and lambs respectively.

Armet. A helmet of uncertain form

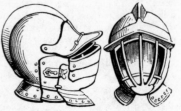

in use in the latter half of the 15th century. It was worn with or without a beaver, and the cuts here given probably represent it.

Armilausa. A sleeveless garment open at each side, worn by knights over their armour. It varied in form considerably, but always retained the name *armilausa*.

Armorial Bearings. (Her.) The devices painted on a shield which serve to distinguish families, cities, and corporations. In the 11th

26

century jousts or tournaments were in vogue in Germany, and the knights who competed adopted colours or devices. When they returned from the wars in the East the Western Christians preserved the armorial bearings, which had rendered them recognisable during the combat. That is how, according to Viollet-le-Duc, armorial bearings became hereditary like the name and property of the head of the family. Blazoning a coat of arms is giving a technical description of it. By the Art of Heraldry the rules of blazoning were set forth in the 12th century, developed in the 13th century, and finally fixed during the 14th and 15th centuries.

Armour. Defences worn by the ancients as well as by the knights and warriors of the Middle Ages. Among the Egyptians a helmet and cuirass were worn, but the shield was the most important defensive arm. The Greeks carried a shield and added greaves to the helmet and cuirass of the Egyptians. The armour of the Romans only differed in detail from that of the Greeks. In England *mail armour* was used until the time of Edward I., when a mixture of *mail and plate* began to be worn. In the time of Richard II. *plate* entirely superseded *mail*, and remained in vogue until the beginning of the 17th century, when the

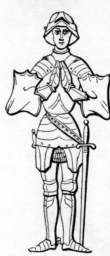

altered conditions of warfare rendered armour unnecessary.

Armourer's Art. The art of fashioning armour, which was often enriched with gold and silver work, chasing, and damascene, and was sometimes inlaid with ivory.

Arm-rest. (Arch.) A term applied to the arm of church stalls on which persons leaned their elbows. The *arm-rest* is a flat surface or ledge supported by colonnettes, ornamented consoles, or groups of figurines, often grotesque.

Arquebus or **Arcubus.** A primitive form of gun invented in the 15th and in use until the 17th century. It was the first gun fired off by the action of a trigger.

Arraché. (Her.) [Erased.]

Arrangement. (Paint.) The method in which a painter composes his figures and combines his groups.

Arras. A woven material made at Arras in France in the 14th century and used as a hanging for rooms.

Arris. (Arch.) The angle or corner formed by the intersection of two surfaces.

Arrondi. (Her.) A term applied to charges which, instead of being represented in their ordinary shape, are curved or rounded. Thus we speak of a stag's antler *arrondi*, a serpent *arrondi*, &c.

Arrow. The arrow of the Romans had a plain bronze head without a barb, the barbed head being characteristic of Asiatics. The arrows of the early

Britons were headed with flint or bone, those of the Saxons and Danes with iron. By the latter peoples they were chiefly used for the chase. The Normans used arrows with deadly effect as weapons of war, and after the conquest the English became expert bowmen, the "cloth-yard" shaft of the English yeoman being very celebrated in the Middle Ages.

Artemis. The moon-goddess and patroness of hunters. The Ephesian Artemis, of Eastern origin, is represented as wearing a mural crown with a disc, as the emblem of the full moon. Her legs are swathed and ornamented with figures of bulls, stags, bees, and flowers, and she is many-breasted. In Greek Art she generally figures as a huntress. The incident of Actaeon being turned into a stag and torn to pieces by his own hounds for gazing on Artemis in her bath, is a favourite subject both in vase-paintings and bas-reliefs. Stags and dogs were sacred to her.

Artisan. A name formerly applied to artists, but now only given to those workmen employed in various mechanical trades who possess some special skill, in which, however, invention plays no part. The artisan's business is to translate in various materials the artist's design.

Artist. One who practises the fine arts.

Artist's Proof. [Proof.]

Aryballus. An antique vase, which was used to draw liquids from vessels of a larger size, and also to hold the oil with which bathers rubbed themselves down. It was almost spherical in form with a narrowed neck and a small handle.

Ascus. An antique vase in the form of a hemisphere, having a neck and a semicircular handle. It was supposed to resemble a wine-skin in shape, and was used to hold liquids.

Ashlar. (Arch.) Stones hewn and cut square for use in buildings, opposed to rough stones straight from the quarry.

Asp. In Christian Art the asp symbolises malice. It is frequently placed beneath the feet of saints, bishops, and even

representations of Faith, Charity, &c., to indicate their triumph over evil. Our illustration is taken from the monument of a bishop in the Temple Church.

Aspectant. (Her.) Face to face.

Asperges. The rod used for sprink-

ling the holy water in the service of the Roman Catholic Church.

Asphalt. A bituminous material used as mortar by certain Eastern peoples, and employed in our times as a covering for such surfaces as walls, causeways, and roads.

Asphaltum. A brown pigment used in the arts. The best kind comes from Egypt.

Assemblage. Method of joining timber-work and carpentry. There are several methods of *assemblage*, such as

by mortise and tenon, dovetailing, &c., but the study of their peculiarities belongs rather to construction than to art.

Assumption. The assumption of the Virgin is a favourite subject with early painters. The tomb is represented below, the virgin is pictured as ascending to heaven or else as seated on a throne, while St. Thomas receives the mystic girdle.

Astragal. (Arch.) A moulding the profile of which is a semicircle, placed

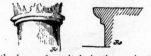

at the base of capitals in the ancient orders. Astragals are also called baguettes or beads, when the moulding consists of

an alternation of round or pearl-shaped and angular forms. They are sometimes found on Gothic capitals.

Astragalus. The name among the Greeks for the *knuckle-bone* of animals. *Astragali* were used in several games,

and boys playing at knuckle-bones (*astragalizontes*) were a favourite subject with classical sculptors.

At Bay. (Her.) A term used in describing a stag with its head down in an attitude of defence.

At Gaze. (Her.) Full-faced, said of an animal of the chase.

Atelier. A French term denoting the workroom of sculptors or painters. [Studio.]

Athenæum. A building in which the philosophers of antiquity met, and poets and orators publicly read their works. In modern times this word, like Alhambra and Alcazar (q.v.), has absolutely lost its meaning. It may now be applied to any hall where public meetings are held, and particularly to buildings where conferences take place or courses of lectures are delivered.

Athene. Among the Greeks the virgin goddess of gentleness, wisdom, and art, and above all the protectress of Athens. She is represented as fully draped and wearing the aegis, and armed with helmet, spear, and shield. The most celebrated statue of her was of gold and ivory, the work of Pheidias, which was in the Parthenon at Athens. The incidents of her birth, her contests with the giants, &c., were often represented on painted vases. The symbols of Athene are the owl, the cock, the snake, and the olive-tree.

Athletes. The combatants in the

Greek games provided Greek artists with

their finest models. Many statues of athletes have come down to us, and are marked by distinct characteristics, such as short hair, sturdy limbs, powerfully developed body, and small heads. Athletes are also often represented with their attributes on Greek vases. The study of the athletic type exercised a decided and important influence on Greek art.

Atlantes. (Arch.) The athletic male figures in a standing or kneeling posture, employed as supports in some ancient Greek temples. The word is derived from *Atlas,* whom the ancients figured as holding the earth on his shoulders. In Roman buildings these figures were called Telamones. The *tepidarium* in the public baths at Pompeii was decorated with figures of this kind.

Atrium. (Arch.) In Roman buildings the *atrium* was a central court surrounded by a colonnade, round which the smaller rooms were grouped. It was a kind of vestibule, either open to the sky or covered with a curtain. In Byzantine architecture the *atrium* is the courtyard outside a building. Such is the atrium of the mosque of St. Sophia, which is surrounded by Ionic columns and decorated with basins of jasper.

Attachment. Attachments in anatomy are the points to which the muscles or ligaments are fixed. In the language of Art we particularly mean by attachment the way in which a limb is set on the body. Thus we say a piece of sculpture has delicate attachments if the limbs are well set on the body, and that the attachments are bad when they lack style and show signs of careless study.

Attic. (Arch.) The part of the en-

tablature above the cornice. Its purpose is to hide the roof and add dignity to the design. The name attic is also given to the top story of a building when

it is only one-half or at most two-thirds of the story below it. A good specimen of an *attic* is to be seen in Somerset House in London, on the side looking towards the Strand.

Atticurge. (Arch.) A square support, such as a pedestal, pillar, or pilaster.

Attired. (Her.) As a lion is said to be *armed* (q.v.) of his claws, so animals with ornamental weapons of defence such as stags are said to be *attired.*

Attitude. (Paint.) The attitude, the pose, the movement of a figure should always be true to nature, and at the same time should afford the artist an opportunity for drawing beautiful lines.

Attributes. (Paint.) Attributes in painting are those accessories which give character to a scene or figure. In a portrait, for instance, should the model be a literary man, he should be surrounded with books, if a painter with pictures, &c. Discretion and tact must be exercised as well in the grouping of the attributes as in their choice. In decorative art we speak of a group of attributes. In this case the word *attributes* denotes the instruments and accessories characteristic of an art, a profession, or even a sport—the attributes of painting, for example, of sculpture, of fishing, of the chase, &c.

Augmentation. (Her.) An honour-

able addition granted by a sovereign for distinguished services. For instance, the Duke of Wellington was allowed to charge upon an inescutcheon the Union Jack. This was an *augmentation*.

Aureole. An aureole in the language of art is the luminous circle which surrounds the head of deities or saints represented in pictures or stained-glass windows. Sculptors, too, sometimes

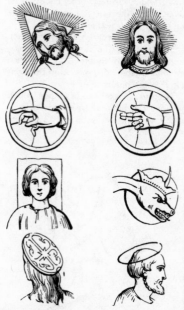

place above their figures a circle gilded or ornamented with stars to represent an aureole. In this case, however, it is generally called a nimbus.

Aureoled. (Her.) Said of sacred figures the head of which is surrounded by an aureole.

Autography. A process which consists in writing or drawing with thick ink on paper specially prepared. The drawing or writing is then transferred simply by pressure on to a lithographic

stone, and by means of another stone any number of prints can be struck off. The advantage of *autography* is that it is a process which any one can employ who can draw with pen and ink, and that the original can be exactly reproduced ; its drawback is that, except when handled by skilled specialists, the prints furnished by this process are apt to be blotchy and blurred.

Avantail. The front of a helmet which could be pushed back at pleasure. In a helmet which covered the whole

face it was a necessity, to prevent suffocation. It superseded the *nasal* of the 11th century, and itself gave way to the *visor* of the 14th century.

Aventurine. A delicate kind of glass, the peculiar brilliancy of which is due to the presence of copper filings. *Aventurine* is also the name given to a certain colour between a green and a yellow.

Axe. The attribute of St. Matthew (q v.) and St. Matthias (q.v.).

Axis. A straight line drawn through the centre of a figure in such a way that the portions of the figure lying on opposite sides of the line correspond to one another symmetrically.

Azulejo. Tiles of enamelled faience of Mauro-Spanish manufacture, used to cover the walls of buildings. The Hôtel de Cluny possesses some large plaques enamelled in this style, earlier in date than the end of the 15th century, as well as a large signboard of the factory of this Spanish pottery, which bears the inscription *Fabrica de Azulejos*.

Azure. (Her.) The tincture blue. It is generally written *az.*, and is represented in engravings by horizontal lines. The term is also used in painting to denote a fine blue tint suggesting the colour of the sky. It is obtained from copper, mercury, and lead. The name is also given to cobalt and ultramarine. In painting on enamel powdered azure is used to produce a fine turquoise tint.

B.

Bacchantes. The inspired worshippers of Bacchus, the wine-god. In every branch of ancient art they were popular as subjects. In sculpture the school of Praxiteles and Scopas was particularly attracted towards their representation. They are frequently found painted on vases, and Bacchic heads are carved in many of the finest Greek gems. They are generally represented with vine-leaves in their hair, with loose-flowing ungirt garments, and with a tiger-skin thrown over their shoulder. They carry the thyrsus, timbrels, portions of kids, and serpents. They are also known under the names of Thyades, Maenades, &c.

Bacchus. [Dionysus.]

Back. The part of a seat, either vertical or slightly sloping, against which one leans one's back — the back of a chair for instance. The term is also applied to the tapestries or decorated panels placed at the head of a bed.

Back-enamel (Dec.) Enamel applied to concave surfaces.

Back-ground. In painting the background is the space round a portrait or group of figures, which is so rendered as to appear behind them. In the treatment of back-grounds infinite variety has been shown. In the portraits of the old masters, such as Vandyke, Titian, and Rembrandt, the back-grounds only represented *space*, and were generally of a warm brown grey tone. In the hands of modern artists, however, back-grounds have become more ambitious and minute, so minute, in fact, as very often to detract from the main interest of the picture.

Back-painting. A method of giving to prints and photographs the appearance of painting on glass, by affixing them to glass and staining them with varnish colours. This process was popular in the last century with mezzotints, and has been applied of late years to photographs under the fanciful name of *crystoleum*.

Back-plate. The part of the cuirass (q.v.) which protects the back; it is fastened to the breastplate by a hinge and clasp or by leather-straps.

Back-yard. (Arch.) A courtyard which serves to light the rooms of a house, and is, generally speaking, a clear space situated at some distance from the principal façade of a building.

Baculus. A rod or staff, upon which persons are often represented as leaning in ancient works of art. The long

baculus was only borne by divinities, kings, and persons of dignity, while simple folk carried a far shorter one, as in our illustration.

Badge. (Her.) A mark of distinction, differing from both the crest and the device, which was worn during the Middle Ages, and was the origin of all armorial bearings. It was generally worn to distinguish the servants or

retainers of a feudal lord, and it is said that the Normans adopted a badge at the battle of Hastings. Nations as well as individuals have had their badges. Thus St. George's Cross and the Red Rose are the badges of England, the thistle that of Scotland, and the harp that

of Ireland. Badges worn by servants were embroidered on the back, breast, or sleeve, or executed in metal and attached to the arm. They were also used as decorations for buildings, furniture, &c.

Badgers. (Paint.) Brushes made of badger hair, broad, flat, or cylindrical in form. By means of badgers two colours freshly laid on are blended the

one with the other. They give a picture a smooth appearance, but as they destroy outline their use cannot be recommended.

Badigeon. (Paint.) A coarse method of painting. Many buildings are coated with a *badigeon* of a yellow tint. Sometimes it consists of chalk and ochre with some finely-ground freestone added to it.

Bague. (Arch.) An annular moulding encircling the shafts of pillars, either half-way between base and capital or at lesser intervals.

Baguette. (Arch.) A moulding with

a semicircular profile. In architecture plain baguettes are generally used, but for decorative purposes cabinet-makers employ baguettes ornamented with beadings, garlands, and foliage.

Bainbergs. Shin-guards introduced in the 13th century as an additional protection for the legs, and worn over chain-armour. At a later date they gave way to greaves or joints. Our illustration is from a monumental brass in Westley Waterless Church, in Cambridgeshire.

Baking. (Pot.) The operation of hardening pieces of pottery after they have been moulded by submitting them to the action of the fire. The operation is simple when the paste and the glazing require the same amount of baking. A double baking is necessary when the paste, which then becomes *biscuit* (q.v.), has to be baked at one temperature and the glazing has to be obtained at another.

Balance. (1.) The emblem of Justice, which is often represented as a female figure blind-folded and holding a balance. It is also the attribute of the archangel St. Michael, who is pictured weighing human souls in a balance.

Balance. (2.) (Paint.) A synonym for equilibrium. In a picture we say that the composition is well-balanced, or that the groups of figures have balance when the work is harmonious and when the lights and shades are in equal masses.

Balcony (Arch.) A projecting platform on the outside wall of

a building. Balconies are provided with

balustrades of wood, stone, or iron, and are supported by props of wood or iron, or in the case of more ambitious structures, by consoles of stone. In theatrical architecture the galleries which run round the theatre are called *balconies*.

Baldachino. A richly ornamented

canopy, supported by columns, suspended from the roof or projecting from the wall. The baldachino of St. Peter's at Rome, which dates from the 17th century, and is the work of Bernini, measures about a hundred feet in height, and is the largest work in bronze of its kind in the world. In addition to

monumental baldachinos, constructed of metal or wood, we find examples entirely composed of draperies tastefully arranged and of the richest textures. The seats of priests and princes, as well as altars, are frequently covered with baldachinos. The name was also given to the rectangular or circular coverings, adorned with plumes, which were placed over the beds of the Louis XIV. period.

Baldric. A broad belt attached to the shoulder and passed diagonally across the body on to the opposite hip, by which swords, daggers, &c., were suspended. It was frequently ornamented with jewels, and denoted the rank of the wearer; on battle-fields surgeons wore it, and

so were marked out for special protection.

Ball-flower. (Arch.) An ornament frequently employed in Gothic architecture, consisting of a bead or ball partially enclosed in a round cup or flower, sometimes perfectly spherical, sometimes open. The name is also given to any projecting circular decoration, either plain or ornamented.

Ballistraria. An opening in a wall in the shape of a cross. These cruciform loopholes were especially designed for the discharge of missiles from crossbows. It was possible to shoot arrows from them in several directions; on the inside they were often splayed.

Ballium, or **Bailey**. (Arch.) The area situated between the outer walls of a fortress or castle and the keep. Some mediæval castles had double ballia, an example of which is to be seen in the Tower of London.

Balteus. The baldric of the Romans, serving to support a sword or dagger.

It was generally of leather, and frequently ornamented with gold and gems. It was passed over the right shoulder and under the left.

Baluster. A part of a balustrade in the form of a small cylindrical column terminated at the neck by a hemisphere, to which it is attached by a splay. The capital and base of a baluster are en-

riched by projecting mouldings. In Renaissance buildings balusters are found of very varied form. They are sometimes even square, and their surface is often covered with sculptured reliefs.

Balusters, Interlaced. (Arch.) Are those which are connected by a system of ornamentation.

—, **False.** (Arch.) A balustrade which is not pierced.

Balustrade. The front of a gallery, composed of stone, wood, or iron. Balustrades of wood are employed in the bal-

conies and staircases of dwelling houses. Iron balustrades, of which the last century has left us some fine specimens, are used for balconies and staircases, and are often superb in design. Balustrades of stone are used in public buildings;

their form and ornament varies according to the order of architecture to which the building, in which they are introduced, belongs. In Gothic architecture balustrades sometimes bear the name of gallery, and are ornamented with interlaced mullions, resembling the tracery of the period to which they belong.

Bambino. A name given in artistic phraseology to representations of the Infant Christ wrapped in swaddling clothes and bound round by ligatures, according to the custom prevailing in Southern Europe. In Italian paintings bambini are often represented aureoled and sometimes surrounded by angels.

Bambocciata. (Paint.) A drawing or picture representing a grotesque or rustic subject, such as Teniers or Van Ostade delighted in. This class of compositions was brought into fashion by Pier van Laer, to whose nickname, *Il Bamboccio*, the pictures owe their appellation. This painter flourished in the 17th century. His humorous drawings were celebrated, while he himself was grotesque on account of a physical deformity. The word is now but seldom used.

Band. (Arch.) A continuous moulding, very slightly projecting, carried along a horizontal surface or following

the curve of an arch. It is frequently

quite flat, but in Gothic architecture

many examples of *bands* are found decorated with sculptured ornaments, and sometimes running round a whole building.

Banded. (Her.) A charge, such as a sheaf of arrows, bound with a band of a different tincture is said to be *banded* of that tincture.

Bandelet. (Arch.) A small and simple moulding, rectangular in form, and approaching more or less nearly to a square according to the height and projection which is given to it. Bandelets serve to unite mouldings, the profile of which is a curve.

Banderolle. A band of fine and wavy material, sometimes rolled up at

its ends, displaying a legend, inscription, or device. Banderolles are frequently used in decorative or allegorical compositions, where they either encircle ornaments or are held in the hands of figures who are represented as unrolling them. The name is also given to flags or banners which are carried at the funerals of distinguished persons, and which display the illustrious marriages of the deceased's ancestors.

Bandoleer. A belt of leather fitted with cases for holding cartridges. It was worn by musketeers in the 17th century.

Banner. (Her.) A square standard fixed to a vertical staff by one of its sides, or attached to the pole by the centre of its upper side, so as to hang loose. Such were the ensigns of the knights bannerets and the banners of the Church.

They were often fringed and tasselled and decorated with symbols and paintings. The national banner or standard of Great Britain is religious in character, and is made up of the three crosses of St. George, St. Andrew, and St. Patrick.

Banquette. (Arch.) A French term indicating a narrow window seat.

Baptistery. (Arch.) A circular or polygonal building placed near ancient basilicae for the performance of the rite of baptism. Later baptisteries were connected with the church by porticoes. After the 11th century baptisteries were replaced by baptismal fonts, large vessels of stone, marble or metal, very often

36

richly decorated, and covered with a movable baldachino of elaborate workmanship. These baptisteries were placed either in a chapel or near the entrance of the church. Among separate buildings serving as baptisteries that at Florence must be placed first. It is decorated with mosaics and its entrance is closed by the celebrated bronze gates of Lorenzo Ghiberti and Andreas of Pisa.

Bar. (Arch.) A name given to gateways in the walls of towns such as were erected in the Middle Ages. (Her.) An honourable ordinary, drawn horizontally, occupying one-fifth of the field ; a diminutive of the fess.

Barbadoes Tar, or **Jews' Pitch,** is really asphalte and is employed in the manufacture of the black varnish used in photography. In the process of heliogravure it is the base which is exposed to the action of the light.

Barbara, St. A virgin martyr who suffered martyrdom in the year 383 A.D., having been converted to Christianity by Origen, and so having incurred the anger of her father and the pro-consul Marcian. She is one of the patron saints of Mantua. Her chief attribute is the tower, in which she was imprisoned by her father, and in addition the sword, the palm-branch, and the crown of martyrdom. In reference to the belief that those who worshipped her should not die without the sacrament she carries a chalice. She is the patroness of fire-arms and the protectress against sudden death.

Barbe. A piece of linen worn by women in the 15th and 16th centuries, either over or under the chin, according to the station of the wearer. Ladies of high degree wore it above the chin.

Barbican. A small tower of defence, generally built in the Middle Ages at the entrance to a bridge, town, &c.

Barbotine. A kind of paste reduced to a pulp out of which certain figures may be modelled. The name is in the present age almost exclusively given to vases decorated with flowers and leaves in high relief and variously coloured.

Barded. (Her.) A term describing a charger caparisoned.

Barge-board. A broad board, generally richly carved, placed in front of a gable. It was used from the 14th century, principally in domestic architecture, or in churches with timber porches. Its chief value is decorative not structural.

Barge-course. That portion of the tiling of the roof which projects beyond the roof. The barge-board (q.v.) is placed beneath it.

Barnabas, St. Apostle and martyr, companion and fellow-traveller of St. Paul. He suffered martyrdom by stoning in Cyprus, where he was born, about the year 60 A.D. He is represented as a man of dignified presence holding a stone, the symbol of his martyrdom, and the preacher's staff : but pictures of him are seldom met with.

Baroque. A term used in decorative art to denote a class of ornamental designs, in which everything is sacrificed to give an impression of richness, meaningless display being more considered than refinement and appropriateness. [Rococo.]

Barrel-vault. (Arch.) A vault built in the shape of a surmounted arch (q.v.), its height being greater than its breadth.

The barrel-vault sometimes has the appearance of a hollow semi-cylinder. It is also called " Waggon-head Vaulting."

Barrow. A term given by archæologists to the mounds of earth heaped up in ancient times over the remains of a great warrior or otherwise distinguished person. There are many barrows in existence in England, and they are the oldest monuments which have come down to us. Among famous European barrows the three at Gamla Upsala, in Sweden, should be mentioned, which tradition asserts are the burying-places of the gods Odin, Thor, and Freya.

Barrulet. (Her.) Diminutive of *bar*, of which it is one-fifth in width.

Barry. (Her.) Said of a shield divided horizontally or barwise.

Barry-bendy. (Her.) Divided by lines horizontally and diagonally into a number of equal parts, alternating the tinctures.

Barry-pily. (Her.) Said of a shield covered with piles placed bar-wise.

Barry-wavy. (Her.) Said of a shield covered with undulating lines.

Bars Gemelles. (Her.) A term applied to beads or bars arranged two and two on a shield. When two *bars gemelles* are placed on a shield, the distance between them is always greater than the d.stance between the two charges themselves.

Bartholomew, St. Apostle and martyr, was crucified head downwards according to one account, or flayed alive according to another, at Albanopolis, in Armenia. He is represented in art as holding a knife, with reference to his cruel torture, a book, St. Matthew's Gospel, and a human skin, sometimes with the face attached to it.

Bartizan. (Arch.) A corbelled out turret of stone surmounted by a conical roof, and placed either at the angle of walls or at the summit of towers in mediæval castles. Bartizans date from the 12th century. In the 14th century they were constructed with a view to defence and pierced with loopholes, and then assumed especial importance.

Basalt. A hard compact stone of a greyish-black hue, tinged with copper colour, out of which the Egyptians carved statues and constructed palaces and temples.

Bascinet. A helmet worn during the 14th century, spherical in shape, sometimes plain, sometimes fluted. The crest of the wearer was often placed on the top. In warfare a helmet was worn over it.

Base. (Arch.) The sub-basement of a building. This projecting sub-basement is often enriched with mouldings. In the Arabian style the bases of columns generally consist of very simple mouldings.

—, **Attic.** A base consisting of two *turi* and a *scotia*. The attic base possesses considerable elegance, and is used in the Ionic, Corinthian, and Composite orders.

—, **Composite.** A base formed of wo *tori*, one *astragal*, and two *scotiae*.

—, **Continuous.** A moulding forming a base, running the whole length of a build-

ing and following the projection of the columns or pilasters which adorn a façade.

Base, Corinthian. A base consisting of two *tori*, two *astragals*, and two *scotiae*, frequently replaced by the Attic base (q.v.).

— of a pediment. The moulding of a cornice which forms at the same time the base of a pediment.

—, Doric. A base consisting of two fillets, a torus, and a plinth. Though this base bears the name of Doric, it must be added that it never occurs in ancient Greek buildings and is only characteristic of *Roman Doric*. Greek temples of the Doric order are of great purity of line— such as the Parthenon for instance—and their columns, which are remarkable for the elegance of their outline, have no other base than the flight of steps running round the building.

—, Gothic. Gothic bases are very varied in form. In the very earliest period they are rude imitations of ancient bases. In the 10th century they consisted of fillets and combinations of particular mouldings. In the 12th century the space left between the circular *torus* and the square plinth was filled by an ornament of foliage. In the 13th century this foliage ornament disappeared, the plinth became polygonal, and the *torus* sometimes projected beyond it. In the 14th century the mouldings forming the base begin to lose their height and projection, and finally in the 15th century the principal base is broken by the intersection of smaller bases. In the 16th century before the revival of the ancient orders Roman and Gothic bases are mixed. [Gothic.]

Base, Ionic. A base consisting of a torus and two scotiae separated by many smaller mouldings.

—, Tuscan. The base of the columns of the Tuscan order. It consists of a fillet, a torus, and a plinth. According to Vitruvius the height of

Tuscan base ought to be equal to half its thickness.

Base-court. In the military architecture of the Middle Ages this name was given to the courts surrounded by towers and ramparts of defence.

Basil, St. Bishop of Cæsarea, was born 328 A.D. and died 379. Artistic representations of this saint are rare. One of the mosaics at St. Peter's in Rome, designed by the French painter Subleyras, represents the most dramatic scene in St. Basil's life—the Emperor Valens, namely, swooning with rage at St. Basil's refusal to depart from the orthodox ritual and administer the rites after the custom of the Arians.

Basilica. (Arch.) Among the Greeks and Romans the basilica was a building with side aisles, a tribune, and an apse, where justice was dispensed and public business transacted. The name was afterwards given to Christian churches from the 4th to the 11th century, which were built with some modification of detail on the plan of the ancient basilica. To-day the word *basilica* is used to denote Catholic cathedrals of vast dimensions without reference to the period of their construction. The apsidal termination seen in many Gothic churches was derived from the basilica. [Apse.]

Basilidian Gems. [Abraxas Gems.]

Basilisk. A legendary creature said to have been hatched from the egg of a hen thirty years old by a toad under water. It was of enormous size, with the

body of a cock, beaked and clawed with brass, and with a tail consisting of three serpents armed with sharp points. It destroyed everything it glanced at, and could only be killed by gazing on its own reflection in a mirror, when it burst with rage. In early Christian art it is the symbol of the Spirit of Evil.

Basket. In Christian art a basket is the attribute of several saints: for instance, St. Dorothea is represented holding a basket of flowers and fruit.

Basket. (Arch.) The part of the Corinthian capital to which the acanthus leaves are applied. The term probably

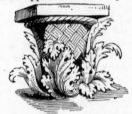

refers to the legend quoted under *Capital, Corinthian,* and is sometimes justified by the ornamentation on the capital.

Bason. A flat shallow vessel with a rim, used for various domestic and ecclesiastical purposes. In churches it was used for collecting alms, for wash-

ing the hands of the priests, and for holding the sacred vessels. Basons were made of various metals and were often richly ornamented.

Bas-relief. (Sculp.) A sculpture executed upon and attached to a flat or curved surface. Its projection from this surface is less than that of the mezzo-relievo or the high-relief. Pictorial or continuous subjects are best suited to representation in bas-relief, and the finest extant

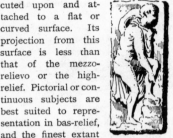

specimen of this kind of sculpture is the frieze which ran round the cella of the Parthenon, a large portion of which is now among the Elgin marbles at the British Museum.

Basterna. A kind of palanquin in the form of a covered carriage borne by two mules, one in front and one behind. It was chiefly used by women. Our illus-

tration is from a MS. of the 14th century in the British Museum, and the drawing corresponds exactly to the descriptions of the *basterna* of the ancients.

Bastide. (Arch.) This term was formerly a synonym for *bastille,* but nowadays denotes the villas and country houses of the south of France.

Bastille. (Arch.) A name given in military architecture to fortified con-

structions, either of wood or masonry, which contribute to the defence of strong-

holds. It is specially applied to the citadel erected in Paris in 1369, which was enlarged in 1383, and in 1553 comprised eight towers connected by curtains of the same height. For many years it served as the state prison, and was destroyed at the outbreak of the Revolution in 1789.

Bastion. (Arch.) An outwork placed at the angle of a fortified *enceinte*, present-

ing two faces and forming a projecting rampart on the line of defence.

Bath. A tank of oblong shape to hold water for bathing. The baths generally in use are made of zinc, but there exist many which are real works of art. Some are made of silver and richly chiselled, while others are of marble.

Baths. (Arch.) An establishment erected for the purpose of bathing. Of the baths of the ancient Greeks but little is known, but the baths of the Romans were structures of great size and magnificence. They were uniform in construction, and consisted of several chambers, of which the following were the most important. First came a courtyard, flanked by stone seats, where slaves waited for their masters to come out of the bath ; this led into the *apodyterium,* or undressing room, which communicated on one side with the *frigidarium,* or cold bath, and on the other with the *tepidarium,* or tepid chamber; beyond the latter was the *caldarium,* or hot chamber, containing the *alveus,* or hot bath, and the *laconicum,* which was heated by hot air. The *caldarium* was supported on brick pillars and was hollow underneath, the walls being furnished with flues, so that hot air might warm the whole chamber.

Baton. (Her.) A diminutive of the

bend, being one-fourth of the width of that charge.

Batter. (Arch.) The inclination given

to the outside of the wall of a building, the inside of which is perfectly vertical.

Battle-axe. A weapon which has been used in war from the earliest times. It was formed of a stone or bronze head fastened to a haft of wood. In ancient times it frequently had two edges, and was then called *bipennis.* This species of axe is generally represented in the hands of Amazons. It was never used by the Romans, who regarded it as a barbarous weapon. It was the original weapon of the British Isles, and many specimens have been found in this country which date from Druidical times. It went out of use in the 15th century. The battle-axe which had an edge on one side and a sharp point on the other was called a pole-axe. We give a representation of each of these weapons.

Battlement. (Arch.) The indented parapet which was placed upon the summit of fortified walls, and consisted of projecting portions entitled *merlons* alternating with open spaces called *crenelles.* Through these open spaces the defenders of a fortress discharged their missiles on the enemy. Corresponding to the vari-

ous periods and styles there are various kinds of battlements. Some, and these are the most common, have square merlons, in others the merlons are pointed, indented, or pyramidal-shaped, while the profile of some resembles that of wall-copings. Battlements were most often

employed in the Middle Ages. They are also found as parapets in religious buildings. In the 16th century battlements of wood were used as decoration. The word *battlement*, now applied to the entire parapet, once only designated what are now called the *merlons*.

Battle-piece. A picture belonging to that class of painting which is specially devoted to the representation of battles. One of the most famous battle-pieces in existence is the admirably executed mosaic representing the Battle of Issus discovered at Pompeii, which is particularly interesting as being a translation into mosaic of a painting by a Greek artist named Helena. Among other celebrated battle-pieces we may mention those by Wouvermans, the battles of Constantine by Raphael, and Le Brun's battles of Alexander.

Baudekyn. A term which is said to be derived from Baldeck or Babylon, and designates a woven stuff which was introduced into Europe at the time of the Crusades. Gold thread was frequently used in its manufacture, and sometimes it was richly embroidered. It was originally only used for regal garments, but afterwards for priestly vestments.

Bay. (Arch.) A rectangular or curvilinear opening in a wall. When a bay serves as a door the lower part of it is called the *groundsill*, when it serves as a window the lower part is called the *sill*. The upper part of a bay is called the *lintel* when it is horizontal, and the *arch* when it is curvilinear. In Gothic architecture the divisions formed by the arcades of nave, cloister, or gallery are called *bays*. Thus we speak of a nave of

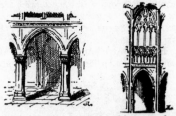

eight bays. In classical architecture the term is applied to the space between two pilasters.

Bay Window. A rectangular or polygonal window which projects from an apartment and so forms a recess. It came into use about the 14th century, and was generally found in the hall, being situated at one end of the dais. Sometimes a hall had two bay windows, one at each end of the *dais*. Good examples of bay windows are to be seen in college halls. For instance, there is a very fine one at each end of the high table at Trinity College, Cambridge.

Bayeux Tapestry. The Bayeux tapestry is one of the most interesting

monuments of the Middle Ages. It is a long roll of canvas, seventy yards long and more than half a yard wide, on

which is embroidered a representation of the conquest of England by the Normans. Tradition says it was the work of Queen Matilda, wife of William the Conqueror, and that she presented it to the cathedral of Bayeux. It is of immense value as a history of the manners, costume, armour, &c., of the 11th century, but from an artistic point of view it is entitled to little praise.

Bazaar. (Arch.) A covered oriental market, which often occupied a considerable surface of ground.

Bead. (Arch.) A system of ornament consisting of small spherical beads applied to a convex moulding. (Dec.) The term also denotes small spherical objects made of glass, amber, metal, or precious stones, perforated so that they may be

strung together. They have been used as ornaments in all times and among all people. The Greeks prized Egyptian beads above all others, and many beads have been found in Greek tombs which seem to be of Egyptian origin. From the Middle Ages onward Venetian beads were more esteemed than any others.

Beadsman. In the Middle Ages persons called *beadsmen* were paid to offer up prayers for the welfare of states or individuals. The accompanying cut represents a beadsman holding the beads and torch of his office. An order of "bedesmen" existed in Scotland. Their insignia of office were a torch and beads, as represented in the cut.

Beaked. (Her.) A term in heraldry used when a bird's beak is of a different tincture to the head.

Beak-heads. (Arch.) An ornament employed in England in the decoration of Romano-Byzantine monuments, and consisting of a series of beak-heads which project over a semicircular moulding.

Beam. (Arch.) A piece of stone or wood placed in a horizontal position for the purpose of supporting a heavy mass, is termed a *beam.* An architrave is an instance of the *beam.*

Beard. In ancient art Zeus, Poseidon, Cronus, the full-grown Hercules, Janus, and Aesculapius were represented with beards; sometimes also Dionysus, and the Indian Bacchus, called by the Romans Bacchus Barbatus, always. In Christian art the beard is the attribute of kings, patriarchs, and prophets.

Bearing. (Arch.) A term denoting the length of a piece of timber or iron placed

horizontally and upheld at each end by supports.

Beasts, Heraldic. The heraldic beasts of the 13th, 14th, and 15th century were drawn in an entirely conventional style. The object aimed at in the rendering of these figures was simplicity, it being important that the outlines should be sharp, and so easy to distinguish at a distance. According to Viollet-le-Duc the coats-of-arms of the 14th century should be preferred to all others, for it is then that the traditional forms of this decorative art are found in the greatest purity. In the 16th century the types of heraldic beasts

43

began to degenerate, for then a tendency sprang up to render animals realistically, which is clearly out of place in an art so purely conventional as that of heraldry.

Beaver. The lower part of the face-guard of the helmet, introduced in the 14th century. It could not be moved up and down, and when Shakespeare says, " He wore his beaver up," he is confusing it with the visor (q.v.).

Bed. (Arch.) A term denoting the horizontal surface of a stone ; thus we speak of the *upper* or *lower* bed.

As an article of furniture the bed has always been of importance. The Greek bed was very simple in construction, consisting simply of an oblong plank on four legs ; the material used was generally wood, and the coverings were very simple, being generally skins or long-haired woollen blankets ('ρήνεα). The Roman beds resembled the Greek in shape, but were far more costly and elaborate. They were made of rare woods, frequently inlaid with ivory and tortoise-shell, of bronze, or even silver, while their legs were carved in all kinds of fantastic shapes. The mattresses were stuffed with straw, wool, or down. The beds of the Middle Ages were generally in the form of a shallow box with raised ends. After the Norman period beds were often decorated with carvings, surmounted by canopies, and draped with beautifully embroidered stuffs. In Renaissance times beds were still works of art, but at the end of the 16th century comfort alone was aimed at, and hangings, &c., became more important than the bed itself.

Bees. In Christian art an attribute of St. Ambrose (q.v.), and generally speaking of saints celebrated for their eloquence.

Belfry. (Arch.) A tower on the outside of a town, or on a castle or church. During the Middle Ages watchers were placed in the belfry, as well as a bell on which an alarm might be sounded. The

term also denotes the timber-work inside a clock-tower.

Bell. In Christian art the attribute of St. Anthony (q.v.).

Bell. (Arch.) A term applied to the ornamented part of a capital (especially in the Corinthian order) which somewhat resembles a bell in shape. It is also termed the *basket*.

Bell Canopy. A stone or wooden structure shaped like a canopy under which a bell is placed.

Bell Cot. A small structure terminating in a spire, in which a bell is hung.

 Belled. (Her.) A term applied to figures of animals represented with a bell round their neck. Thus we say a cow gules belled in azure.

Bell Gable. A stone structure terminating in a gable and pierced with openings, in which bells may be placed.

Bell Turret. (Arch.) A pyramidal structure of several sides, shaped like a small steeple, terminating a pier or flanking the angles of a steeple. Some bell turrets of the 11th century are square ; these, however, are rare. Those of the 12th century are of delicate pro-

portions and often octagonal. After the 13th and 14th centuries they became more slender, and their arrises were ornamented with crotchets. At the Renaissance they disappeared altogether.

Belt. (Arch.) A slightly projecting band running round a tower or turret is termed a belt. The term band (q.v.) or string course, however, is now generally used.

In costume a *belt* is a cincture worn round the hips, often highly ornamented. From it were suspended the sword and dagger. In the 14th and 15th centuries it was a mark of knighthood, and so was often worn as a mere badge without any arms attached to it.

Belvedere. A covered terrace. A kind of pavilion or prospect tower placed on the roof of a building, so that

a spectator may obtain from it a widely extended view of the surrounding country.

Bema. (Arch.) A name given in ancient architecture to the orator's tribune or the proscenium of theatres. In early Christian buildings in the East it designated the pulpit, the sanctuary, and the throne of the bishop placed in the apse.

Bench. A seat to hold several persons formed of a slab of stone or wood, sometimes with and sometimes without a back. In the dwelling houses

of the Middle Ages coffers played the part of benches. Churches were not furnished with benches for the faithful until the 16th century. In the parks and gardens of the 17th century we find benches of stone or marble, elegant in outline and decorated with much skill and care. In the present practical and economic age artistic benches have been replaced by cast-iron supports, upon which planks of wood are screwed, to serve as seat and back.

Bench Table. (Arch.) The table of stone which projects from the interior wall of a building and forms a seat. In many cases a blind arcade runs along above it and the base of the columns rest upon the *bench table.*

Bend. (Her.) An ordinary, crossing the shield diagonally from dexter to sinister, and occupying when charged one-third of the shield, when uncharged one-fifth.

Bendlet. (Her.) An ordinary, half the width of the bend.

Bendy. A shield having several bends may be described as *bendy.*

Benedict, St., was born 480 A.D., and was the founder of the Benedictine order of monks. He established several monasteries, in which the strictest discipline prevailed. His attributes are a cup on a book, a raven with bread in its bill, and a sieve. He is represented as surrounded by nettles and thorns, indicative of his ascetic life, and he carries the asperges and pastoral staff.

Benetier. [Stoup.]

Benzoin. A balsam, used as an ingredient in spirit varnishes.

Beryl. A precious stone of a bluish reen tint, called also *aquamarine.* This

stone was used by the Greeks for intaglios, and was much prized by the Romans.

Bestiarium. A term used to denote poems of the 12th and 13th centuries, which created a kind of mystic zoology, and gave rise to the allegorical representation of the virtues and vices of mankind under the form of animals. It was the *bestiaria*, according to some archæologists, which inspired the enigmatical bas-reliefs which decorate so many Gothic monuments. Other writers, however, regard these reliefs as pure works of the imagination or as vague reminiscences of illiterate men, who could not understand the bestiaria, the interpretation of which is difficult even to scholars.

Beton. (Arch.) A mixture of pebbles and limestone mortar, of which the foundations of buildings are composed.

Bezants. (Her.) A subordinate charge in the shape of a disc and always of metal, *i.e.* of *or* or *argent*. There are never more than eight bezants on one shield. In architecture the term is applied to a simple ornament consisting of roundles or discs on a flat surface.

Bezants-tourteaux. (Her.) Discs, half of metal and half of colour. For instance, we speak of Bezants-tourteaux of argent and gules, vert and argent, &c.

Bezel. A metal mounting, either pierced or solid, generally in the shape of a disc, on which precious stones are fixed when they are going to be mounted in rings or other ornaments.

Biacca. (Paint.) The Italian term for white lead, used for painting in secco but not in fresco.

Biadetto. (Paint.) An Italian term for a blue pigment derived from copper. It is synonymous with bice (q.v.).

Bianco Secco. (Paint.) A white pig-

ment, prepared from slack lime and water, which is of great value in fresco painting.

Bibelots. By this term we understand any object which is used to decorate a whatnot, a chimney-piece, a sideboard, or the surface of a wall. *Bibelots* are, according to the taste of the collector, bronzes, faïence, arms, works of Chinese or Japanese art, or a thousand other curiosities. In fashionable houses all possible corners are crammed with them; they are piled one upon another or heaped up in pyramids. They form a distinct subdivision of *curiosities.* They have their own bibliography and authors devoted to their discussion, and thanks to fashion there is scarcely a house which in some degree or another is not an asylum for *bibelots.*

Bice. (Paint.) An obsolete term which once denoted a blue pigment prepared from *lapis armenius.* Green verditer is sometimes called green bice.

Bickern. The extremities of an anvil. It is on the bickern that pieces of iron are curved. Bickerns vary in form, they may be round, square, pointed, &c.

Biclinium. A hybrid word, half Latin, half Greek, denoting a couch or sofa in which two persons might sit or recline at table.

Bi-corporate. (Her.) Having two bodies joined in one.

Bidental. (Arch.) A shrine or small temple consecrated by the Roman augurs on a spot which had been struck by lightning. The name originated in the custom of sacrificing a sheep two years old in such shrines.

Bifoil. That which has two foils or arcs.

Bifrons. (Sculp.) A double-faced bust representing two persons with different features and as it were placed back to back. The distinction between the two is often lost in the upper part of the head and in the hair.

46

Biga. An antique chariot drawn by

two horses. A *biga* is often figured on the reverse of ancient coins.

Bill. A weapon used in the 14th and 15th centuries, consisting of a broad blade fixed to a long staff. Its edge was

curved like a scythe, and it was furnished with two sharp points, one at the end and the other at right angles to the blade.

Billet-moulding. (Arch.) A kind of

moulding used for decorative purposes in the Romanesque period. It consists of a bowtell (q.v.), cylindrical, square, or prismatic in form, and cut up into parts equal in size and divided by equal spaces.

Billets. (Her.) A subordinary in the shape of a small oblong figure rather longer than it is broad. They are said

to be *reversed* when they are placed on their long side. In blazoning it must be specified whether they are voided or not.

Billeté. (Her.) Said of a shield strewn with billets.

Bill-head. A kind of curved chisel. The term is also applied to other objects twisted in the shape of a sharp hook or bill-head.

Binding-joist. (Arch.) A beam or arch strengthening or doubling the resistance of a ceiling or vault.

Bipennis. An axe with two edges, used principally as a weapon of war but also as an ordinary chopping tool It was never carried as a weapon by the Romans, but Amazons and other mythical persons are figured with it in their hands. [Battle-axe.]

Birds. Representations of birds are found in the art of all peoples and ages. Among the Egyptians a bird symbolised the soul of man. Certain birds were sacred to the Greek deities, the eagle to Zeus, for instance, the peacock to Hera, the owl to Pallas Athena, &c. In Christian art birds symbolised the human soul as well as the virtues and vices of mankind. In Gothic

architecture birds are a frequent orna-
ment, and are generally symbolic. In
the Renaissance style they are purely
decorative and conventional.

Bird-bolt. (Her.) A flat-headed arrow
used as a charge in heraldry.

Bird's-eye View. A method of draw-
ing by which objects are represented
as though seen from an elevation, the
point of sight being far above the objects
represented. It is valuable principally
in depicting groups of buildings or wide
tracts of country.

Biremis. A vessel having two banks
of oars placed diagonally one above the

other. Representations of the *biremis*
are common on bas-reliefs, and one is to
be seen on Trajan's column.

Biscuit. (Pot.) A term applied to
pieces of unglazed white faïence or porce-
lain, the surface of which is neither
enamelled nor painted. The term is also
applied to the double baking which some
pieces of porcelain undergo.

Bisellium. A seat of honour which

was occupied in the Roman provinces by
magistrates and distinguished persons,
as the *sella curulis* was at Rome. Though

large enough for two, as is suggested by
its name, it was probably only used by
one, the specimens found at Pompeii
having but one footstool in the centre.

Bishop's Length. A term applied to
canvas of certain dimensions, 58 inches
by 94.

Bishop's Throne. The seat of a bishop
placed in the choir of a cathedral church
from the 12th century onwards. In
some churches in Italy there are
thrones decorated with mosaics. The
throne at Avignon is of veined white
marble, while that at Toul is of stone
and dates from the 13th century. At the
end of the 14th century stuff canopies
were replaced by canopies of sculptured
stone. In the 15th century the throne
was placed among the stalls surrounding
the choir, and the bishop's throne could
only be distinguished from the others by
the richness of its ornamentation. In
the 17th and 18th centuries bishops'
thrones were often constructed with ca-
nopies of carved wood. In early times
in England they were called bishop's
stools.

Bistre. (Paint.) A brown colour gene-
rally of a light yellowish tint. The artists
of the last century prepared it in an ex-
tremely simple way by boiling the soot
of wood in water, and have left us many
sketches in bistre, some of which are in
an admirable state of preservation.

Biting-in. (Engrav.) A term used in
etching to denote the action of nitric
acid diluted with water upon those
parts of the copper plate from which the

etching-ground or varnish has been re-
moved by the etching-needle. Before
beginning the *biting-in* the protected
surfaces of the plate are once more
coated with the etching-ground, and the

plate, if it is a small one, is plunged in a bath. If the plate is of large dimensions it is rimmed with wax and so transformed itself into a bath. In all cases feathers are necessary to burst the bubbles which form while the metal is being attacked. The acid used for this process is generally common nitric acid mixed with water in equal proportions. The process of biting-in is repeated according to the difference of depth which the artist desires to produce in his etching. The higher is the temperature of the studio the more rapid is the action of the acid. Finally, some artists use perchloride of iron for the last biting-in. The latter process enables them to obtain very deep lines, which when printed produce fine velvety blacks.

Bitumen. (Paint.) Scientifically speaking, bitumen is a hydro-carbon rich in hydrogen. It is sometimes liquid, sometimes of the consistency of pitch, and sometimes solid. The bitumen used in oil-painting produces a colour closely allied to sepia or bistre. Many of the pictures of the school of to-day, and above all those of the first half of the present century, have suffered from the use of bitumen. It contracts and cracks with atmospheric change to such an extent, that pictures in which it is employed soon deteriorate.

Bituminous. (Paint.) The tones of a picture are said to be *bituminous* when it has a reddish brown appearance.

Bizarre. That which is opposed to the canons of good taste or offensive to the cultivated eye ; capricious.

Black denotes a quality classed among colours, due to the absence or total absorption of light. Black pigments are of two kinds, they are either produced by the calcination of animal or vegetable substances, or they are found in a natural state. To the first class belong lamp black, ivory black, Indian ink ; to the second, black ochre, graphite, &c. In the art of the Middle Ages black symbolised darkness, death, mourning,

evil, falsehood, and despair. In heraldry black is termed sable (q.v.).

Black Chalk. A kind of bituminous schist or ampellite, used in the manufacture of drawing crayons.

Black-lead, also termed *plumbago* or *graphite,* is a carboniferous substance which is found in Cumberland, and is used for making lead pencils. Its name is confusing, as it contains no lead.

Bladed. (Her.) A term used when the stem or stalk is of a different tincture from the fruit or ear.

Blank. (Numis.) A disc of metal, which, after it is struck, becomes a coin.

Blanket. (Engrav.) A name given to the piece of flannel or thick cloth which is wrapped round the roller of the press when a line-engraving is to be struck off. An elasticity of pressure is thus ensured during the printing, and the sheet of paper is applied with greater force to the surface of the plate.

Blase, St. Bishop of Sebaste and martyr. He is represented in Christian art in episcopal vestments, and he holds a crozier and book and a wool-comb. From the last attribute, which was the instrument with which he is said to have been tortured, he has become the patron saint of the wool-combers.

Blasted. (Her.) Said of a trunk of a tree with its branches lopped off and without leaves.

Blazon. (Her.) The charges or devices of a coat of arms are called *blazons.* The accompanying cut represents Shakespeare's coat of arms.

Blazonry. (Her.) A knowledge of the heraldic art and of delineating coats of arms.

Blend. (Paint.) To soften tints so that they gradually diminish in intensity and *blend* with another tint or colour, which has been similarly softened. In oil-paint-

ing colours are blended by delicately softening the colours into one another, and by gently mixing them with a light brush passed over the surface. In water-colour or washed drawings tints are blended by means of fine brushes charged with colour more and more diluted with water and finally with pure water.

Blender. [Badgers.]

Blind-story. (Arch.) A name sometimes given to the triforium (q.v.) of a church. It is so called as opposed to the clerestory which is above it and is pierced with windows.

Blister. (Paint.) A term applied to parts of a picture which swell, and so become detached from the canvas or panel.

Block. (Sculp.) A mass of unhewn stone or marble. The piece of wood upon which engravers work is also called a block.

Block of buildings. (Arch.) A collection of buildings forming a compact mass. In the construction of new streets or public ways whole blocks of houses often have to disappear. We speak of a block of buildings forming the angle of a street or of a block of houses isolated by four streets.

Bloodstone. A green jasper with red spots upon it. In the Middle Ages it was held in high honour, because it was said to have been the stone which lay at the foot of the cross and received the blood which dropped from the wounds of Christ.

Blottesque. (Paint.) Painted in heavy blots or masses; a term introduced into the language of art criticism by Ruskin, who opposes it to Dureresque. It first occurs in "Modern Painters," vol. iv.

Blue. (Paint.) One of the three primary colours, which possesses the quality of *coldness.* The typical blues are Prussian blue, ultramarine, cobalt, and indigo. In the symbolism of early Christian art blue, as suggesting the sky, is symbolical of heaven and so of eternity, as well as of piety, godliness, &c. It has always been adopted as the colour of the Virgin's robe. On ceilings it is used to represent the sky.

Blue, Prussian. (Paint.) The Prussian blue used in water-colour painting is of a greenish tint, but is easily laid on and of wonderful transparency and permanence. The Prussian blue used in oil-painting is one of the colours which have the most body, and when mixed with white it produces tones of great intensity. It is a compound of iron and cyanogen, the base of prussic acid.

Blue-black. (Paint.) A cold black pigment obtained from well-burnt charcoal. When mixed with white lead it produces silvery greys.

Boar. In Christian art the boar is symbolic of sensuality and gluttony.

Board, Leather. Board, in the paste of which scraps of leather are mixed. It is used in the manufacture of ornaments which are moulded by a special process.

Boards. A term applied to a method of bookbinding, in which the sides consist of a thin board covered with linen or paper.

Boaster. (Sculp.) An instrument used for working clay or wax. Boasters vary considerably in size and form. They

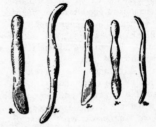

generally consist of a short piece of iron, wood, or ivory, rounded and slightly curved at one end and flat at the other.

Bodkin. A large pin, several inches in length, of gold, silver, ivory, or wood, which Greek women used to pass through their hair at the back when it was plaited and turned up. The head of the bodkin was often elaborately ornamented, sometimes even with sculptured figures.

Body-colour. (Paint.) Water-colour drawings are said to be executed in body-colour when the colour is laid on thick and mixed with Chinese white, in contradistinction to the older method of water-colour, in which the colours are laid on in transparent washes. Generally speaking a colour is said to have *body* when it possesses the quality of covering the canvas when thickly laid on.

Boldness. That quality of confidence and fearlessness which characterises the work of an artist who is thoroughly master of his art and of the material in which he works. It is at the opposite pole from tameness.

Bole, Armenian. (Gild.) An oily earth of a red colour found in Burgundy and in the neighbourhood of Paris. It enters into the composition of the material which forms the ground on objects which are to be regilt.

Bolt. A flat-headed arrow.

Boltant. (Her.) Springing forward.

Bombylios. An antique vase of small dimensions, which in shape suggests the cocoon of a silk-worm, but is more elongated. Vases of this shape were sometimes made in ancient times with so narrow an orifice that the liquid could only escape a drop at a time.

Bond. (Arch.) A term employed to denote the way in which bricks or stones are arranged. The two bonds generally used are *English Bond* and *Flemish Bond*. In the former the courses are laid alternately, consisting one of headers the other of stretchers; in the latter all the courses are alike and are made up of alternate headers and stretchers.

Bonder. (Arch.) A stone or brick

placed in a wall so that its shorter face, *i.e.* one of its ends, is alone apparent.

Bone-black. A black pigment obtained by burning bone in close vessels, kept from contact with the air.

Book. In Christian art the book is the symbol of learning, knowledge, and intelligence. It is therefore an attribute of the evangelists, apostles, bishops, and fathers. When the Holy Ghost is represented as a man he carries an open book, the tables of the law.

Border. (1) An engraved design illustrating a book, within which a white or empty space, defined by a regular or irregular outline, is left to receive the text.

Border. (2) A flat or convex moulding,

either simple or ornamented, which forms

the frame of a picture. The name is also

given to the systems of decoration which run round the edge of carpets, tapestry, hangings, pavements, &c., and form a frame for panels, mosaics, &c.

Bordering Wax. (Engrav.) Green or moulding wax which engravers use as a border to their plates, thus transforming them into a bath. Bordering wax is awkward to handle, as it is glutinous and sticks to the fingers when it is too soft. It is made into small sticks, which are flattened by the thumb, and placed vertically along the copper-plate so as to form a ledge. A key or piece of hot iron is then passed over the wax, which causes it to melt, and thus closes up all the interstices by which the acid might escape.

Bordure. (Her.) A belt at least one-sixth the size of the shield, which it completely surrounds. The *bordure* is a mark of difference of a younger son. Bordures *compony* (q.v.) indicate the number of younger sons there are in a family.

Boss. (Arch.) richly sculptured stud employed to ornament doors, &c. Bosses sometimes have a structural purpose, sometimes they are merely decorative. The bosses on the door of the Pantheon at Rome are especially famous. The term is also applied

to metal nails placed as ornaments on boxes, leather belts, &c.

It denotes in addition the rosettes or other ornaments placed at the intersection of the ribs of a vault. In the 13th century they were simply rosettes or

geometric patterns; in the 14th century they became much larger in size; and were superseded in the 15th and 16th

centuries by flat rosettes, pierced and bordered with ornaments. Sometimes we find pendants in the place of bosses. The lower surface of the pendant projects below the spring of the vault, and is generally terminated by an ornament in the form of an agrafe. In buildings of the Gothic style these bosses, which

are really pendants placed at the key of the vault, are ornamented with rosettes and foliage, and are often of considerable dimensions.

The term *boss* in armour denotes the stud or projecting ornament in the centre of a shield or buckler.

Bossage. (Arch.) A term applied to masonry, in which the angles of the stones are cut off obliquely, so that when they are laid side by side a space is left between them, which gives them an appearance of projecting.

Böttcher Ware. (Pot.) A kind of pottery of red unglazed clay, polished with a lathe. It was first manufactured

in 1709 by Böttcher, an alchemist who was occupied in searching for gold. Böttcher also made the first white porcelain manufactured in Germany.

Bottega. An Italian word, literally meaning " a shop," but generally applied to the place where Italian artists used to paint their pictures and expose them for sale, as well as instruct their pupils.

Botteroll. (Her.) The piece of iron with which the bottom of a scabbard is shod, used as a charge in heraldry.

Bottony. (Her.) A term applied to a cross, the extremities of which end in trefoils or buds.

Boudoir. A name given to a small room decorated in an elegant and refined manner, where a lady receives her most intimate friends.

Boulevard. Originally an earth-work fortification, but in the present day an avenue or walk planted with trees.

Bourdon. A tall staff, on which pilgrims are often represented as leaning. The scrip and purse were sometimes suspended from it.

Bourse. (Arch.) A name given to buildings containing large halls in which financial business is carried on.

Bow. (Arch.) An old term for an arch or an arched gateway. One of the gates at Lincoln is still called " Stone Bow."

As a weapon of defence the bow has been used from the remotest times and by all nations. Our illustrations represent the Egyptian bow (1), the Greek (2), the Roman (3), and the Phrygian (4), which is almost crescent-shaped. The bow was of immense importance in England from the 12th century onwards. The most fully developed form of it, the long bow, was of yew or ash, and six feet in length. It shot an arrow a yard long, and was a deadly weapon in the hands of the English yeomen. The bow was an attribute of Apollo, Artemis, and Cupid in classical art, while

6

in Christian art the bow and arrows

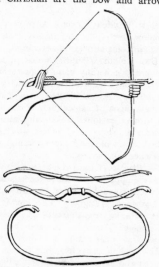

symbolise the martyrdom of St. Sebastian.

Bowed. (Her.) A term applied to serpents coiled up, with their heads coming through the folds.

Bow-drill. A tool, which consists of a shank of steel, furnished with a handle at one end. It is bent in the form of an arc by a piece of catgut. By drawing the bow backwards and forwards, a circular movement is communicated to the drill. The bow-drill is employed in all kinds of locksmith's work, but sculptors in stone, marble, and wood also find it of considerable use.

Bowl. (Pot.) A round vase, without a rim and without projecting handles. The bowls of China and Japan, which are sometimes very large in size, are often placed upon pedestals of wood or mounted upon bronze.

Bowtell, Boutell, or **Bottle.** (Arch.)

An old term denoting a round moulding or bead.

Bow Window. (Arch.) A projecting window which differs from a bay window (q.v.) in being circular or segmental.

Box, Colour. (Paint.) A box of oil-colours is generally almost square and divided into compartments, in which are placed brushes, a maulstick in three pieces, tubes of colour, and bottles of oil with screw-tops. It contains also a palette and some panels of thin wood, on which to fix drawing paper for making sketches from nature.

—, **Studio.** (Paint.) A table with drawers, the upper part of which forms a box in which colours, brushes, &c., are kept.

Boxwood. (Engrav.) The box is a tree (*Buxus sempervirens*), the wood of which is very hard and has a close and equal grain. It is of a bright yellow colour, and its stem is richly veined and in great demand for artistic purposes. In wood-engraving small blocks of box are used equal in height to printers' types. In engravings of large dimensions these small blocks are fastened together by means of sizing and are held secure by screws. They may be separated at will, if, as is the case with large wood-cuts intended for illustrated papers, it is necessary, in order to expedite the work, to distribute the small blocks among different engravers. All that is necessary when the blocks are finally joined together is to add a few touches to make the different parts of the engraving harmonise. Some box-trees are found in the Jura, but it is

from the East that we obtain most of the boxwood used by engravers.

Brace. (Arch.) A piece of timber either straight or curved, used in roofs to keep the purlins, tie-beams, &c., in their proper positions.

Bracelet. (1) (Arch.) A system of ornament employed on the shaft of columns, the purpose of which is to break the line of flutings in the ancient orders. At the Renaissance the *bracelet* came once more into use. In Gothic architecture the bracelets which serve to connect the columns with the horizontal mouldings, decorating the adjacent surfaces, are often called armlets.

Bracelet. (2) An ornament which has been worn upon the wrist in all ages and in all countries. It was generally

made of gold or silver and was often enriched with precious stones. It not unfrequently takes the form of a serpent.

Bracket. A small support of wood, iron, or other material, sometimes richly carved, projecting from a wall, and serving to hold lamps, clocks, statues and other ornaments. [Corbel.]

Brass. A very ductile alloy of copper and zinc, to which is sometimes added a small quantity of tin, lead, or iron.

Brassard. That portion of plate armour which protects the arm from the shoulder to the wrist. It consisted of

two parts which were joined at the

Brasses, Monumental. A form of sepulchral monument, consisting of a plate of engraved brass, or *latten*, as the alloy was called, representing the personage whose death it commemorates. Those found in England are always cut to the outline of the figure they represent, and are inlaid in a stone slab, while those of Flemish and French workmanship are square pieces of brass with

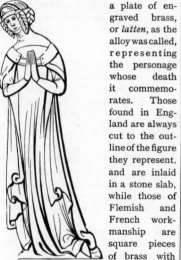

the background to the figure richly carved. Monumental brasses are of extraordinary value to the student of mediæval art, as they illustrate completely the armour, costume, and heraldry of the period to which they belong.

Brazier. A flat shallow vessel of metal, standing upon four legs, in which wood, &c., was burnt for the heating of rooms. Braziers were commonly in use

among the Greeks and Romans, and also in the Middle Ages.

Breach. An opening, generally irregular, made in a wall.

Breadth. (Paint.) In painting the quality of grandeur or largeness is termed *breadth*. This quality is not limited by the size of the picture, and is often found in the smallest canvases, nor does it depend on finish. It is to be obtained by skilful colouring and light and shade.

Breast-high. The balustrade of a window-sill, when it is of average height, is said to be *breast-high*. It may be rather less than four feet, but it is never more.

Breast-plate. A term applied among the Romans to that part of the armour which protected the breast. The high-priests of the Jews wore a breast-plate consisting of an embroidered square decorated with twelve precious stones.

Bressummer. (Arch.) A term applied to beams of wood or iron, which span wide openings, and generally support a

wall. In modern buildings bressummers of iron are commonly used. In some cases they remain apparent, in others they are concealed in plaster ceilings.

Bretess. (Arch.) A balcony of wood often attached in the 15th and 16th centuries to the façade of town halls. The term also denotes additional galleries or fortifications of carpentry frequently used in the Middle Ages.

Bretessé. (Her.) A fess bend or bend sinister is said to be *bretessé* when it is embattled on both sides, and when the projections lie opposite each other.

Bric-a-brac. A general term applied

to curiosities of all sorts, works of art, furniture, whether valuable or worthless, which the curiosity dealer exposes for sale in his shop. Here the amateur often unearths what he takes to be fine pearls and pays heavily for them, but finds them out to be nothing but vulgar paste when he gets home. Apart from their value, however, they often produce a picturesque effect.

Bricks. (Arch.) Pieces of clay dried and baked in a furnace in the shape of small rectangular parallelopipeds. Bricks have been universally used in rustic buildings, or those constructed only with a view to use and economy. At the same time in artistic buildings excellent results have been produced from judiciously mixing bricks and stone.

In the façades of chateaux of the time of Louis XIII. pilasters of stone form a framework with excellent effect to panels of brick. In the annex of the South Kensington Museum an ingenious system of decoration is furnished by the use of ornamentally stamped bricks.

—, **Common.** (Constr.) Bricks made of sandy clay mixed with argillous or calcareous marl.

—, **Perforated.** (Constr.) Bricks pierced with cylindrical holes used to lighten the construction of partitions.

—, **Floating.** (Constr.) Bricks manufactured of porous magnesia or siliceous tufa, which have the property of floating on water. They are employed on account of their infusibility in the construction of reverberating furnaces.

—, **Dutch** or **clinker.** Bricks half vitrified by constant baking.

Brickwork. (Arch.) A construction or facing of masonry composed of bricks.

Bridge. (Arch.) A construction of stone, wood, or iron, which spans a river or connects two points separated by a natural depression of the earth. A bridge may consist of several arches, or of beams or girders supported by piers, or it may be suspended on iron chains. The Romans were the first who thoroughly understood how to make bridges, and their bridges still remain among the most wonderful constructions of ancient times. In the Middle Ages chapels and dwelling houses were frequently built upon the roadway of bridges, as was the case on old London Bridge.

Brigandine Armour. A species of defence consisting of small thin plates of iron sewn on to leather. It was worn in the 13th century, and is said to have got its name from the fact that it was first worn by irregular troops called " *brigans.*" Its great advantage was its flexibility.

Brinded, or **Brindled.** (Her.) Spotted, said of animals.

Brio. (Paint.) A picture is said to be painted with *brio* or *dash* when it seems to have been done without exertion, but with spirit, and as it were at the first attempt.

Bristled. (Her.) Said of a boar when the hair on the back of the neck is of a different tincture from the body.

Bristol Board. Bristol board is a white board of a fine and satiny texture. It is frequently used as a mount to water-colour or pencil drawings. Bristol board of extraordinary whiteness is also used for pen-and-ink drawings, which have to be reduced for purposes of reproduction by one of the modern processes of engravings. Water-colour drawings and miniatures which are to be very highly finished are often executed on Bristol board, its smooth surface being well adapted for this method of work.

Broach. (Arch.) An old English term for a spire.

Brocade. A silk stuff figured in gold or silver with systems of ornament consisting of foliage, scrolls, flowers, animals, figures, &c.

Brocatel. A kind of Breccia marble, differing considerably in colour. The brocatel of Boulogne is dark, that of Spain resembles the lees of wine, that of Moulins is bluish grey, and that of Siena is yellow. The tone of these marbles is,

however, by no means uniform. They are, on the contrary, sprinkled with a variety of delicate shades. Andalusian brocatel, for instance, is reddish in colour marbled with yellow, grey, and white.

Brocatelle. An imitation brocade, lighter and less rich than the last. Gold and silver do not enter into its composition, and silk is only used in the figures worked on it.

Broché. Stuff ornamented in relief by means of a special process of weaving.

Broken Colour. [Colour, Broken.]

Bronze. An alloy of copper, tin, and zinc, combined in different proportions according to the purpose to which the bronze is to be put; also a work of art cast in bronze. A small quantity of lead is added when the bronze is to be employed in the reproduction of works of art. We frequently speak of fine bronzes, antique bronzes, meaning thereby statues or statuettes cast in bronze. Antique bronzes are works of art of the highest value. Whatever be their form or dimensions they invariably give evidence of extraordinary science and widely extended practical knowledge. After them must be mentioned bronzes of the 12th and 13th centuries, as well as those of the Florentines, such as Donatello and Ghiberti, which are absolute masterpieces. In the time of Louis XIV. immense vases, those in the garden at Versailles for instance, were cast in bronze, while the best examples of the art during the last two centuries are equestrian statuettes and Chinese and Japanese bronzes, in which the arts of founding and chiselling the metal have reached their highest limit. To-day the manufacture of ornamental bronzes is one of the most flourishing of the decorative arts.

Bronzing. An operation, the purpose of which is to give objects an appearance of bronze. There are two processes of bronzing. The one is nothing more than the application of certain chemical grounds. The other, which is chiefly concerned with metal objects, consists in the depositing of real bronze by electrotyping. This process can be repeated as often as necessary and gives to the objects thus covered an extraordinary hardness. A green or coloured coating may be given to any object according to the tone of the bronze which it is desired to imitate.

Brooch. An ornament infinitely varied in form and material, and always

provided with a long pin. It is used in women's toilets to fasten shawls, cloaks, collars, &c.

Brown. (Paint.) A colour of a reddish tone, somewhat warm and at the same time somewhat sombre, generally obtained from metallic oxides. Some browns are obtained from coal and belong to the series of aniline colours.

—, **Red.** (Paint.) A kind of brown obtained by a different degree of calcination from the same materials as the ordinary brown pigments. In painting in water-colour an opaque brown of a brick-red tone is employed. When mixed with other tints it is rapidly precipitated.

Brunswick Green. [Green, Brunswick.]

Brush. (Paint.) Painting brushes are

made of the hair or bristles of animals,

57

securely fixed either in a quill or a
ferule of tin and fastened to a stick.
They are either flat or conical in shape,
and are used to lay on and spread the
colours.

Brushwork. (Paint.)
When a picture is
painted with spirit and
without affectation, or
is freely and broadly
treated, its *brushwork*
is said to be vigorous.

Bucentaur. In clas-
sical mythology a bu-
centaur was a monster,
half ox, half man. This
name was given in later
times to the state galley
in which the Doge of
Venice and the Senate
went to sea during the
ceremony, the "Mar-
riage of the Adria-
tic."

Buckle. (Her.) A buckle furnished
with a tongue is a charge in
heraldry. It is generally cir-
cular in form, and when it is
lozenge-shaped it should be
specified in the blazoning.

Buckler. (Arch.) An ornament used in
the decoration of
friezes and trophies.
It is sometimes cir-
cular in form and
sometimes lozenge-
shaped. Bucklers of
the latter shape are
often placed obliquely and bound up
with bundles of arms.

Bucrania. (Arch.) Ornaments in
the form of ox-sculls with their horns
wreathed in flowers, which
were employed to adorn
the frieze in the ancient
orders of architecture.
Bucrania were generally
placed in the metopes or
intervals between the tri-
glyphs (q.v.). Some have and some have

not wreaths of flowers round the horns,
and their representation on ancient
temples suggested the victims offered in
sacrifice.

Buff. A clear yellow colour.

Buffet. A piece of furniture on which
dishes, plate, and glass are displayed.
The difference between a *buffet* and
dresser lies in the fact that the latter is
only fitted with shelves, while the former

has drawers and a cupboard enclosed by
doors capable of a good deal of decora-
tion.

Bugle-horn. (Her.) A figure in
blazonry in the shape
of a small hunting horn.
Thus we say a "bugle-
horn *gules*." In blazon-
ing we should specify whether it is
"*enguiché*," *i.e.* whether it has a cord
attached to it or not.

Buhl. A kind of furniture which was
invented and manufactured by Charles
André Boule or Buhl (1642-1732). It was
richly inlaid with tortoise-shell, gold,
copper, &c., and was much in vogue at
the court of Louis XIV.

Building. (Arch.) A *building* is a
general term applied to any construc-
tion whether completed or not.

Bulge. A line or surface slightly con-
vex is said to bulge.

58

Bulla. A small ornament of gold which was worn round the neck of free-born children at Rome. It was laid aside when the youth assumed the *toga virilis*. The "bullae" of poor persons were made of leather. It was regarded as a charm and as especially efficacious in keeping off the evil eye.

Bull's-eye. (Arch.) A round or oval window, placed either in the front of a

house or in a roof. From the period of the Renaissance, the 17th and 18th cen-

turies, many specimens of bull's-eyes have come down to us richly ornamented.

Bur. (Engrav.) A bur is a ridge of metal on the edge of the lines of an engraved plate, which is generally removed by an instrument termed the scraper (q.v.). Some engravers, how-

ever, have taken advantage of the *bur* to strengthen their shadows.

Burin. [Graver.]

Burnish. To burnish is to polish gold or silver and give it a brilliant surface by means of a notched agate or bloodstone. Burnished metal reflects, and seen at a certain angle, its tone seems darker than that of the dull metal, almost black in fact; hence the expression *to burnish*.

Burnisher. (Engrav.) A steel instrument not having a very sharp edge in the form of an elongated oval, used by engravers to soften a harsh line or

remove it altogether. A burnisher worked by both hands is employed to burnish a copper-plate before engraving it.

Burnishing. An operation by means of which the roughnesses of a metal plate are taken away and the whole surface reduced to the same level. When burnished the plate becomes an excellent reflector.

Burnt Sienna. (Paint.) A fine orange red pigment of a warm rich tone, which is obtained by burning raw sienna earth. It has the property of dissolving at once in water, and by means of it wonderfully clear tints may be obtained at once. It is used for topographical drawings and sketches of constructions and machines, as well as for water-colours. It is also suitable for oil-painting.

Burnt Umber. (Paint.) A russet-brown pigment produced by burning raw umber. It is semi-transparent, permanent, dries and mixes easily, but is not much used.

Buskin. A high boot made of leather and often elaborately ornamented. In classic times it was worn by hunters, horsemen, and tragic actors, and is especially characteristic of some deities,

such as Diana the Huntress, Bacchus, and Mercury. Buskins were also worn in the Middle Ages, and kings at their coronation wore them of cloth of gold and other costly materials.

Bust. The upper part of the human body; the representation, painted, drawn, engraved, or modelled, of the head, shoulders, breast, and arms cut off above the elbow. A portrait bust represents the head and upper part of the body without the hands. A sculptured bust is said to be antique in style when the neck and upper part of the breast are bare and cut off vertically. In modern busts a part of the arms is generally shown and the model is draped, sometimes in a mantle which covers the lower part of the breast. In a picture we say that the *bust* of such and such a figure is badly proportioned, or in a work of sculpture that we do not feel the *bust* under the drapery, referring in each case to some fault in the proportion or execution of this part of the body.

Bustle. (Paint.) A term signifying a restlessness and want of harmoniousness in the colouring of a picture. Sir Joshua Reynolds contrasts the "quietness and chastity of the Bolognese pencil with the *bustle* and tumult that fills every part of a Venetian picture."

Busy. (Paint.) Full of bustle (q.v.).

Buttery. (Arch.) A room near the hall and kitchen in monasteries and mediæval mansions from which beer and wine were served out.

Buttress. (Arch.) A massive piece of masonry which served as a support and added to the resistance of the vertical wall. Buttresses are universally used in Gothic architecture. They were indispensable in holding up the lofty walls of churches. Originally they consisted merely of a squared mass, the surface of which was inclined to the wall at a sharp angle so that the rain might run off; they were afterwards

polygonal and decorated with pinnacles, and in the 14th century terminated in turrets.

Buttress, Flying. (Arch.) A pier which stands at some distance from a wall surmounted by a rampant arch, which connects it with the wall. It is intended to counteract the thrust from the vaulting. It is found in Roman monuments, and was

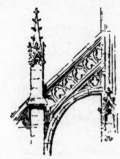

introduced early into England. In the north choir aisle of Canterbury are some flying buttresses, which belong to the transition period. In the 12th century they were very simple, and were not much decorated until the 15th century.

Byzantine Art. The art which owes its origin to Byzantium. It engrafted Christian sentiment on reminiscences of

Greek and Roman art. The Roman
arch was retained in Byzantine architec-
ture, but entablatures disappear, circu-
lar cupolas are erected, and the capitals
adorned with arabesques. The Byzan-
tine style exercised a powerful influence
on the art of the Middle Ages. Many
mosaics and paintings on a gold ground,
as well as ivory-carvings of Byzantine
origin, have come down to us, and give
us a high idea of this extraordinarily
rich and brilliant art, which imposed its
characteristic forms on the style of
many generations (328 A.D. to 1204 A.D.).

Byzantines. (Num.) Coins struck from
the time of Constantine to the fall of the
empire of the East.

C.

Cabinet. A piece of furniture fitted
with drawers, in which from the 16th
century to the present time coins and
curiosities of every kind have been
kept and classified. The term is also
applied to public or private collections
of works of art or curiosities, such as
pictures, engravings, coins, medals, &c.
Thus we speak of a cabinet of medals,
of prints, &c. In former times the term
was synonymous with collection. The
inscriptions on certain prints of the last
century call attention to the fact that
such and such a subject came from the
cabinet of Mr. X., meaning that the
original, after which the print was en-
graved, was in Mr. X.'s collection.

Cabinet-picture. A picture of small
dimensions, and generally of high finish,
such as is found in private collections.

Cable-moulding. (Arch.) A round
moulding either projecting or sunk, con-

sisting of wreathed *striae* (q.v.), resem-
bling the strands of a rope. This mould-
ing was frequently employed in the de-

coration of Byzantine capitals. The cor-
nices of buildings of the same style also
afford many examples of it.

Caboched or **Cabossed.**
(Her.) Full-faced. This
term is used to indicate
that the head of the
animal is placed looking
at the spectator and that
the neck is concealed.

Cabochon. A French term applied
to precious stones set in gold but pre-

served in their primitive form, that is,
polished but not cut.

Cadmium, Red. (Paint.) A simple
pigment containing no base but cadmium.
It is of a bright orange-red colour and is
valuable on account of its permanence.

—, Yellow. (Paint.) A pigment pre-
pared from sulphide of cadmium. It is
a rich orange and is useful in painting
sunsets. When mixed with Chinese
white it yields a brilliant series of tints.
It is permanent and not affected by the
atmosphere. White lead is the only
pigment which seriously injures it.

Caduceus. The staff carried by Mer-
cury or Hermes. Around
it two serpents were
coiled, and it was winged
at the top. It was the
symbol of peace. The
term is also applied to
the staff covered with vel-
vet and surmounted with
a fleur-de-lis, which the
king of arms and the
herald of arms carried in
grand ceremonies. It denotes also a
herald's wand, which is a rod of olive
wreathed in garlands.

Cadus. A name given to the large
jars of terra-cotta used in ancient times.

Pieces of pottery, rather more tapering in form, have also been found bearing this name. The cadus was generally used to hold wine, but also employed to contain oil, dried fruit, &c.

Cælatura. The Latin term for raised work in metal or *chasing* (q.v.).

Cage of a Building. (Arch.) The collection of outside walls which define the shape of a building.

Cairn. A heap of stones, often shaped like a pyramid and raised over a grave. The custom of building up cairns is of very ancient date, but it now only prevails in some districts of Ireland and Scotland.

Caissons. (Arch.) A French term applied to the sunk panels in a ceiling. [Coffers.]

Calantica. (Cost.) A head-dress in the form of a net or bag and fastened tightly round the head by a band. In

Egypt it was worn by both men and women, but when introduced from the East into Greece and Rome it was only adopted by women.

Calathus. A basket in which women in ancient times kept the wool, which they were going to spin. It was generally made of wicker-work, rarely of metal, and was narrow at the base, gradually expanding towards the top. Representations of calathi are frequently found on vases and other monuments of Greek art.

Calceus. (Cost.) The Roman term for a shoe or boot. It was a complete protection for the foot and so differed from the sandal. Different kinds of *calcei* designated difference of rank. The senators of Rome, for instance, wore one of a peculiar pattern, while in the time of the Empire *calcei* were frequently made of costly material and decorated with gems.

Caliga. (Cost.) The shoe worn by the rank and file of Roman soldiers. It was heavy and shod with nails.

Caligraphy. The art of writing. The greatest masterpieces of handwriting are to be found in the manuscripts of the Middle Ages and the Renaissance, and in some rare collections of the 17th and 18th centuries. The people of the far East have also produced some fine specimens of caligraphy.

Caliver. An arquebus with a wide bore. It was in use in England from the time of Elizabeth until about the middle of the 17th century.

Calix. A cup-shaped drinking vase in use among the Greeks, set on a stem and generally furnished with two small handles.

Callipers. A kind of compass, the branches of which are twisted and of unequal length. They are used by sculptors to check measurements. Their points are curved in different directions, so that it is possible to measure both inside and outside surfaces.

Callipyge. Literally *aux belle fesses.* The name of a statue of Venus in the Farnese Palace.

Calotte. The portion of a sphere, not exceeding a hemisphere in volume, cut off by an intersecting plane. The term also denotes vaults of this form.

Calotype. A method of photography invented by Mr. Fox Talbot. An iodide of silver is formed on paper by successive coatings of iodide of potassium and nitrate of silver. This is rendered sensitive to the action of light by the application of gallic acid and nitrate of silver, and only a brief exposure is necessary to obtain an image on the paper.

Calpis. (Pot.) A large earthenware vessel used by the Greeks for drawing

water. It somewhat resembled the *hydria* (q.v.), and was furnished with three handles, as in the cut.

Caltraps, Cheval-traps, or Galtraps.

Instruments of iron having four sharp projecting points, which were laid on the ground in battle to wound the feet of the enemy's horses. They are sometimes borne as a charge in heraldry.

Calvary. (Arch.) A cross of stone or iron, generally richly decorated and sometimes raised upon a platform which is reached by steps. Some calvaries, especially those of Brittany, are ambitious monuments supported by arcades and surmounted by numerous statues. The term is also applied to pictures representing the scenes of the passion.

Camaieu. (Paint. Engrav.) A painting in a single colour in imitation of a cameo. The effect of a painting in camaieu is produced by difference of tone, and objects are represented light on a dark ground or vice versâ, but only one colour is employed, such as red, blue, black, &c. Paintings in imitation of bas-reliefs, *i.e.* modelled with greys of different values, whites, or blacks, are called paintings in camaieu. These latter are also termed grisailles (q.v.). Engravings *in camaieu* are printed in colour, but with ink of a uniform tint, the gradations of tone being obtained by hatchings. The term is applied as a term of contempt to dull and monotonous paintings.

Camail. A name given to the chain-

mail which was attached to the bascinet

and covered a warrior's head and neck. Etymologically the term means *camel's hair*, and it was first applied to a garment of soft wavy texture worn by priests, to the shape of which the chain-mail bore some resemblance.

Cambered. Curved, arched. A well-cambered figure is a figure describing a graceful curve.

Cameo. Gems cut in relief are called camei or cameos. Great care was shown by the ancients in choosing stones, consisting of several variegated s rata. Cameos vary considerably in size, and as a rule the figures or objects represented stand out in white on a sombre red ground; sometimes the white and red are reversed. The term *cameo* is applied generally to all gems cut in relief, while those hollowed out or depressed are called *intaglios.*

Camera Lucida. A prism by means of which the image of any object may be thrown upon a sheet of paper. It was invented by Woollaston in 1804, and has been brought to perfection since. It is of great service to artists and others, as

by its aid natural objects, &c., can be traced with great accuracy. The only difficulty which it involves lies in the fact that the draughtsman must at the same time watch the image and follow the point of his pencil.

Camera Obscura. An apparatus by means of which a reduced tracing may be made of natural objects. There are two kinds of camerae obscurae. The one consists of a hut of wood hermetically sealed. In the roof of this hut is an opening across which a mirror is placed to collect the rays of light and throw them on a lens, so that an actual image is thrown upon the white paper in front of the artist. The outline can then be drawn with a pencil. The other

kind of camera obscura is portable and so more convenient. The optical apparatus is placed upon a tripod, round which curtains are drawn, so that the artist is placed in darkness and is able to catch the image thrown upon the white paper in front of him.

Campanes. (Her.) Bells suspended to any charges. (Sculpt.) This word is also used by the French to denote little bells carved in wood as a motive of ornamentation for bishops' thrones, altar canopies, &c.

Campanile. A tower in which bells are placed, built near a church but not actually attached to it. Campaniles are frequently met with in Italy and elsewhere. In England they are rare; there is one at Evesham, and formerly there was one at Salisbury. The term is also applied to an open construction of timber work surmounting a roof, in which as a rule either a bell or a clock is placed.

Campanulated. (Arch.) A term applied to capitals or ornaments, the profile of which suggests that of an inverted bell.

Candelabrum. A candlestick or stand to support a lamp. Candelabra generally have several branches. When placed on altars they are very

often richly ornamented, but many dating from the Gothic period are perfectly simple. The large candelabra

which are placed on the ground and only hold one candle are often of huge dimensions. Some of modern workmanship

are no less than twelve feet in height. They are infinite in shape and often designed by the most renowned architects. Sometimes they support a lamp hexagonal or circular in shape surmounting an open-work crown. Their shaft is frequently decorated with carefully executed sculptures. Finally, there are candelabra still richer in design, consisting of bronze or marble statues, which are found in the vestibules of hotels or palaces or at the foot of staircases. The candelabra in use among the Romans generally consisted of a column of a considerable height, standing upon a tripod, frequently fluted and sometimes decorated with climbing animals, upon which was placed the tray which held the lamp. Representations of candelabra are often found as ornaments on friezes. The term is also applied to the column representing a candelabrum, placed on a pier or on a square tower surmounting a cupola.

Canephorus. The *basket-bearer;* a name given to the Athenian maidens who walked in the processions of Demeter and Athena, carrying upon their heads flat baskets containing the sacred cake, &c. They are represented in the Parthenon frieze. In architecture the term denotes a decorative statue holding a vase or basket, sometimes employed as a caryatid (q.v.). Those of the Villa Albani at Rome are celebrated.

Cannets. (Her.) Ducks without feet or beaks, generally depicted in profile.

Canon. This word signifies an artistic *rule* or law based upon observation. It was applied in ancient times to statues or monuments, which were intended to serve as types or embodiments of the principles of art, and also to fix the length of the finger, the height of the face, from

which might be determined the exact proportions of the whole figure. The most celebrated *canon* in ancient times was that of Polycleitus, which he exemplified in his statue of the Doryphorus. This was in turn superseded by the *canon* of Lysippus.

Canope. A name given to Egyptian vases which contained the viscera of the dead. As inscriptions they bear various formulae of benediction. On their lid a human skull is sometimes placed, sometimes the symbolic head of a cynocephalus, a hawk, or a jackal.

Canopy. A system of decoration belonging to the Gothic period. It consists of a vaulting placed above statues fixed against a wall, or above niches made to receive a statue. Canopies of the 12th and 13th centuries suggest on a small scale the features of buildings of the period. In the 13th century they are surmounted by disengaged arcades, flanked with pinnacles, bell-turrets, and flying buttresses. In the 14th and 15th centuries canopies become still more ornate. In certain instances equestrian statues are crowned with canopies formed of two pointed arcades spreading out over a considerable area. Finally in the 16th century canopies, still ornate, frequently have the form of lanterns surrounded by volutes and scrolls, and arranged in stages receding as they mount, the whole often terminating in a graceful statuette.

Canopies formed of drapery were often employed to decorate the top of the seats of distinguished people. In the same way the word canopy is applied to the covering formed of plumes and embroidered stuffs, which was often carried over the heads of kings and important personages. In modern Europe such canopies are only used in Roman Catholic processions.

Canted. (Arch.) A term used by carpenters to denote that the angles of a square have been cut off. Thus an oriel is said to be a *canted* window.

Cantharus. A Greek two-handled vase or cup, sacred to Bacchus, varying in shape and size. On Greek vases Bacchus is frequently represented as holding it in his hand.

Cantilever. (Arch.) A projecting bracket employed to support balconies, cornices, &c.

Canting Arms. (Her.) Armorial devices which fall under the definition of a *rebus* (q.v.). They abound in early heraldry.

Canton. (Her.) May be regarded as a diminutive of the quarter (q.v.), and is one of the honourable ordinaries. It is placed in a *corner* of the shield, usually the dexter chief, and occupies a third of the chief, or a ninth of the shield. If placed on the other side of the shield it is called a *canton sinister*.

Cantoned. A cross or saltire is said to be *cantoned* when it is placed between four charges, or groups of charges. The

term is also employed to denote a single charge in the first quarter of the shield.

Canvas. (Paint.) A material upon which pictures in oil-colour are painted. The canvas is placed on a stretcher (q.v.), from which it may be removed if necessary. In the language of critics and historians of art a canvas means a picture. Thus we speak of a canvas of Raphael. Special names are given to canvases of special dimensions, such as *kit-cat* (q.v.), and *bishops' length* (q.v.).

Cap-à-pie. (Her.) Said of a knight armed head to foot.

Caparison. Armour or richly embroidered stuff with which horses were covered in the Middle Ages at the Renaissance.

Capital. An ornamental letter of a large size, beginning the first word of a chapter. In *editions de luxe* capitals are generally decorated with scrolls and figures. In ancient manuscripts they were often red or illuminated in the most brilliant colours. They sometimes encroached upon the margin and even the text of a page.

Capital. (Arch.) An ornament consisting of various projecting mouldings, placed at the summit of a column, pillar, or pilaster.

—, **Angular.** A capital placed at the

angle of a pilaster supporting an entablature.

—, **Byzantine.** The capitals in the early times of Byzantine Art were very simple in form, and were sometimes decorated with palm leaves, flowers and wreaths. The capitals of the decadence, on the other hand, were decorated with purely geometrical systems of ornament, consisting of combinations of straight lines and curves. Finally some Byzantine capitals present examples of volutes ornamented with rosettes. But as a rule the sculptured ornament is in very low relief and sometimes the abacus is bevelled.

Capital, Composite. A Corinthian capital with highly developed volutes, which closely resemble those of the Ionic capital, with this difference, however, that the four sides of the capi- tal are absolutely symmetrical. There are very varied types of this capital, which was held in high esteem by the architects of the Italian Renaissance.

—, **Corinthian.** Corinthian capitals are the richest of the pure orders, their characteristic being rows of acanthus leaves placed one upon the other with volutes above them at each corner supporting the projecting abacus. The latter is not square but hollowed out, so as to describe a concave curve. There is in existence a great variety of Corinthian capitals, the handiwork not only of Greek and

Roman artists, but also of the architects of the Renaissance and the present day, as the Corinthian order is the one which has been most frequently employed in the decoration of modern buildings. Generally speaking, Greek Corinthian capitals are more decorative than Roman, and at the same time exhibit a remarkable amplitude of line.

Capital, Doric. The Greek Doric capital, which is the simplest of the classical orders, consists of an *abacus*, an *echinus*, and *annulets*, just above the neck of the shaft. In Roman buildings the echinus is replaced by an ovolo moulding, an ogee is added to the abacus, a *cymatium* and fillet is sometimes substituted for the simple form of the abacus while 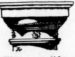 the delicate annulets which separate the echinus from the neck of the shaft are changed to *astragals*. These modifications render the Roman Doric capital far less graceful than the Greek, which should always be regarded as the true type. The total height of the Doric capital should be equal to the length of the radius of the base of the column.

—, Egyptian. The principal forms of capitals in the Egyptian style are a simple cube without mouldings, or a splayed vase or bell. They are decorated with systems of ornament, sculptured and painted in bright colours, representing lotus flowers or hieratic figures or cartouches with hieroglyphic inscriptions.

—, Indian. The system of ornament on Indian capitals is of extraordinary richness and variety. They can, however, be reduced to three types, in which groups of figures, animals, and flowers and foliage predominate respectively. The general outline is sometimes quite simple; the most frequent principle of the Indian capital being a flattened sphere surmounting consoles, which diminish the bearing of the lintel.

Capital, Ionic. This capital is characterised by spiral volutes placed underneath the abacus. The profile of the Greek Ionic capital 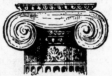 is far more delicate than that of the Roman Ionic. The latter is overcharged 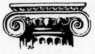 with details of ornament. The Renaissance as well as the 17th and 18th centuries produced some fine examples of the Ionic capital, especially from the point of view of profusion of sculptured ornaments. Among the theories of the origin of volutes, attention should be called 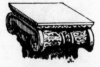 to that which compares them to the folds of a cushion interposed between the shaft of the column and the abacus, a theory which is precisely justified by the lateral appearance of the volutes.

—, Latin. The capitals of Christian basilicae from the 8th to the 10th century are generally only heavy, clumsy imitations of ancient capitals, and are often decorated with palm-leaves or 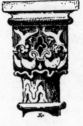 other ornaments careless in execution and barbarous in design.

—, Moorish. Capitals of the Moorish or Arabian style are generally cubic in form and are connected by rounded curves with the cylindrical shaft of the column. They are ornamented with astragals and sur-

mounted by an abacus, while their surface is decorated with systems of ornament consisting of floral and geometrical designs.

Capital, Neo-Greek. A capital of a column or pilaster conceived in a style of architecture of modern origin, which

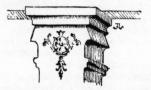

consists chiefly in cutting off the mouldings sharp and decorating the flat surface thus obtained with floral ornaments thinly incised.

—, **Persian.** The point of support in capitals of the Persian style generally takes the form of the heads of horses, unicorns, or bulls terminated in volutes and surmounting cylindrical and fluted shafts.

—, **Pointed.** The capitals which surmount the pillars in buildings of the Pointed style are rather projecting copings reaching to the spring of the arch and corresponding to the projection of the columns, than capitals properly so-called. In the 12th century they consisted of rows of buds, which developed by degrees into crockets and reached their full expansion in the 14th century. In the 14th century capitals were of so little importance as to be hardly distinguishable; in the middle of the 15th century the capital disappeared altogether, the ribs of the arch being

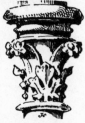

carried on to the pillars without any break in the continuity. The most marked characteristic of the capitals of the Pointed style is the execution of the foliage, which is never conventional, but as close a reproduction as possible of the object chosen for representation, and in nearly every case drawn from the flora of the locality.

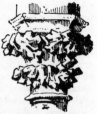

Capital, Renaissance. All the capitals used at the period of the Renaissance are borrowed from the ancient orders, but with modifications of proportion and detail which give them a special character. They are as a rule more richly decorated with sculptured ornaments than their prototypes.

Romanesque. The Romanesque

capitals of the 11th century are splayed in form and sometimes surmounted by a double abacus and embellished with ornaments. In the 12th century capitals were

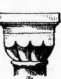

decorated with foliage and became more graceful in profile. Some capitals of

this period are simply corbels, others are decorated with grotesque and symbolic figures, generally surmounted with twisted foliage or volutes.

Capital, Tuscan. This capital is nothing more than a Doric capital stripped of a great deal of its grace. It consists of an ovolo moulding, an abacus and an astragal separating the capital from the shaft of the column. In spite of its inelegance it has been frequently used by some architects of the Renaissance.

Cap of Maintenance. (Her.) This is sometimes worn above the helmet in place of a wreath. It is made of crimson velvet ornamented with ermine,

Capitol. (Arch.) The citadel and temple of Jupiter at Rome. Later the term was applied to the principal temple in the cities of the Roman Empire.

Cappah Brown. (Paint.) A pigment obtained from a manganese peat, called cappah. It is a useful colour and almost permanent, but is adversely affected by a strong light. This danger may be obviated by mixing the pigment with a permanent colour, such as umber or Chinese black.

Caprices. A set of drawings or engravings, of which the grotesque subject and original composition belong rather to the realm of fancy and imagination than that of observation. The *caprices* of Goya are collections of engravings representing phantasmagoric scenes and hallucinations.

Carat. A special weight which is the traditional standard in goldsmiths' work and jewellery, and is also employed as the measure of pearls and diamonds. The weight of a carat is twenty-four grains. The term *carat* is also applied to small diamonds.

Caravanserai. (Arch.) A building intended in the East for the use of travellers. It is in the form of a quadrangle, enclosing an immense courtyard.

Carbine. A fire-arm which was introduced into this country in the 16th century. Whence it came is uncertain, but

in all probability we owe it to the Spaniards. It had a wheel lock and a wide bore.

Carbon Process. The fixing of photographic proofs by the carbon process, although it does not render them absolutely unalterable, makes them far more durable than those obtained with silvered paper, as the powdered carbon is fixed by means of an adhesive substance. Its unsatisfactory feature is that it gives to the proof a heavy look and destroys the transparency of the shadow.

Carbuncle. A precious stone, a variety of red garnet of extraordinary brilliance.

Carcanet. (Cost.) A necklace of pearls or other precious stones.

Carcass. (Arch). The skeleton, either of wood or iron, of buildings in general.

Carchesium. A Greek drinking vessel

furnished with two handles which ex-

tend from the rim to the bottom. In form it somewhat resembles the modern loving-cup. The term was also applied to a portion of a Greek ship, which corresponded to our top. From the *carchesium* the sails were managed and in it sailors stood to keep a look-out. It got its name from its supposed likeness to the drinking-cup.

Cardboard. A light card consisting of sheets of paper pasted together throughout their surface.

Cards. Playing cards are of great importance in the history of art. They are first heard of in Europe in the 14th century, and no doubt the first packs were simply painted by hand. At least so we may infer from the very high price paid for the pack made by Jacquemin Gringonneur for Charles VI. of France. The oldest ones still in existence are stencilled. Cards, however, are chiefly interesting to us because they influenced or even led to wood-engraving. At any rate the earliest wood-cuts that have come down to us are playing cards. The packs in use at present are copies of those made in the 16th century, and are generally produced by means of lithography.

Caricature. An extravagant representation, in which reality is so far exaggerated as to become ridiculous and grotesque. It has been practised in all times as a method of satire. Egyptian and Greek caricatures have come down to us, while at Pompeii many burlesque travesties of ancient myths were discovered. In modern times caricature has been freely used as a political weapon, and Englishmen have reason to be proud of their long line of caricaturists from Rowlandson to Furniss.

Caricaturist. An artist who draws or models caricatures.

Carmine. (Paint.) A bright rose red colour. In water-colour painting carmine, when ultramarine, Prussian blue, or indigo is added to it, produces rich violet tints. A few drops of carmine

added to a solution of Indian ink gives it a warm tone. Oil and varnish protect it, and as a rule it is permanent, being only adversely affected by a strong light. Sometimes it is obtained from the cochineal insect, sometimes from madder.

Carnation. (Paint.) Flesh tints (q.v.).

Carol. (Arch.) A small room or closet, in which one might sit and read. In monasteries *carols* were set apart for the monks to study or illuminate missals in. The recesses formed by a bay window are also termed carols.

Carpentum. A carriage with two wheels and an awning over it. It held two or three persons, and could be

shut in with the awning when desired. As a rule it was drawn by two mules, and it was chiefly used by Roman ladies.

Carpet. A woven fabric used for covering the floors of chambers. In the East carpets were employed by Oriental nations for sitting or reclining upon, or for kneeling on while in prayer. They existed in very early times in the East, in Egypt and Persia for instance, and were imported into Spain by the Moors. From Spain they reached Venice, and then spread all over Europe. The manufacture of carpets was introduced into France from Persia in the reign of Henri Quatre, while the celebrated factory at Beauvais, still in existence, was established by Colbert, the minister of Louis XIV., in 1664. A carpet factory

71

was established at Mortlake by James I., but it was unsuccessful. However the manufacture flourished later at Wilton, Kidderminster, and elsewhere in England. There are two methods of carpet-making. In the first, the materials of the pattern are knitted into the warp. This is followed in Persian, Turkey, and Indian carpets. In the second the pattern is woven up in the loom. The latter is followed in Kidderminster, Brussels, and Wilton carpets. The carpet in a room which contains much furniture should be dark in tone, as it then forms the most efficient background for the furniture.

Carrara Marble. A white marble of extraordinary beauty and brilliance obtained from the quarries of Carrara in Italy, and used by sculptors.

Cartisane. A small piece of parchment, which was worked into ancient embroideries of silk, gold, or silver thread in order to obtain relief.

Cartoons. (Paint.) A name given to the studies made by artists before they undertake the execution of a picture or fresco. As frescoes (q.v.) have to be executed on a fresh ground, which renders any retouching impossible, fresco painters are obliged to make full-sized designs which have only to be traced upon the ground. The paper used for this purpose was called in Italian *cartone.* Thence it became the custom to denote by the term cartoon all preparatory sketches of artists. Thus the designs executed by Raphael to be carried out in tapestry, and now in the South Kensington Museum, are known as cartoons.

Cartouche. An ornament with an empty space in its centre to receive an inscription, cipher, or emblem. Cartouches sometimes consist of mouldings, but more generally of scrolls trimmed with garlands, flowers, and foliage. In the Gothic period cartouches assumed the form of bannerolles with their ends rolled up. The richest and most beautiful cartouches date from the Renaissance. Those of the 17th and 18th centuries are generally too exuberantly decorated, but they always bear evidence of a fertile imagination. The name cartouche is also given to the ovals, bearing hieroglyphic instructions, which were placed in the tombs of Egyptian kings.

Cartridge Paper. A strong paper with a rough surface much used for drawing upon. It received its name from the fact that it was originally employed in the manufacture of gun cartridges.

Carving. The art of cutting wood and ivory into beautiful forms and shapes is called *carving.* Among the ancients rude figures of the gods were carved in wood. In the earliest works of sculptured stone, the influence which wood-carving had on the artist may easily be discerned. The art of carving ivory was carried to perfection by the Greeks, and was particularly employed in the production of chryselephantine statues (q.v.). Throughout the Gothic period wood-carving was cultivated with great success, and especially applied to the decoration of churches with stalls, screens, rood-lofts, and canopies. At the Renaissance the details of classical architecture were introduced into furniture and carved in wood. Numberless cabinets, chairs, and tables are in existence, both of the Gothic and the Renaissance period, which testify to the skill of wood-carvers. The most celebrated wood-carver of more modern times is perhaps Grinling Gibbons, to whom we owe the stalls of St.

Paul's Cathedral and many other master-pieces. In the present day wood-carving like all other handicrafts has fallen into decay.

Caryatides. (Arch.) Figures of women which serve as a support and take the place in classical buildings of columns or pilasters. The caryatides of the Pandroseion at Athens represent female figures holding baskets of fruit on their heads. [Atlantes.]

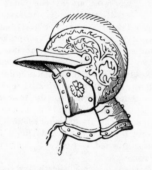

Casement. (Arch.) A frame, generally of wood, which encloses the glazing of a window and opens on a hinge.

Casino. (Arch.) A collection of buildings in watering-places and sea-side resorts on the Continent, which is used as a kind of club, and includes ball, concert, and gambling rooms.

Casque. A term applied to the headpiece which came into vogue in England in the reign of Henry VIII. It was not intended to be worn in warfare, and was

not provided with a visor. It was frequently elaborately carved and often copied in shape from the antique. In the language of poetry *casque* is a general term for all forms of headguards.

Casquet. A small coffer, either composed of or decorated with precious materials, such as sweet-scented woods, chased metals, gold, silver, enamels,

gems, &c. In the Middle Ages and at the time of the Renaissance casquets were made of iron with open panels covered with leather or variously coloured stuffs.

Casquetel. A small casque or helmet with no visor, but a projection in front.

It afforded but little protection, and was worn chiefly for display.

Cassock. This name was given to several very dissimilar articles of dress. Originally it appears to have been a loose kind of coat, and was in the 17th century worn by hackney-coachmen and others. In the 18th century it was an overcoat worn by the gentry. At the same time, from the 17th century until the time of George II., the cassock was the distinctive dress of the clergy, and during the performance of the service was worn by Protestant priests at least under the academical gown. In the present age it only survives as an ecclesiastical vestment.

Cast. (Sculp.) To *cast* is to reproduce a work of sculpture from a mould. Plaster is the material generally used in

casting. Gelatine is also employed, and is valuable on account of its elasticity. The term is also applied to a work of sculpture thus reproduced; for instance, we speak of "a cast of the Venus of Milo." The process of plaster-casting is as follows. When the clay model, which is the first step in a sculptor's work, is finished it is covered with wet plaster of Paris laid on in several pieces; the mould thus formed being called a *piece-mould*. The plaster of Paris is then removed in pieces and fitted together, so as to form a complete mould of the clay model. Water and plaster mixed is then poured over the inside of the mould, and when the mould is removed there is left a hollow cast of the figure. [Founding and Lost Wax Process.]

Castle. (Arch.) A fortified feudal dwelling, also the palace of the feudal lord. The fortified castles of the 11th and 12th centuries had a donjon surrounded by fosses. In the 13th century the circuit of the walls was extended and was flanked by towers, while an air of luxury was imparted to the portion occupied as a dwelling by the lord The castles of the 15th century were built with princely magnificence but were no longer fortresses; those of the Renaissance were palaces.

Catacombs. Underground burial places. It was in the catacombs at Rome that the Christians took refuge to celebrate their services. Catacombs also exist at Syracuse, Palermo, and Agrigentum, and in Tuscany and Etruria. The catacombs of Paris were originally stone quarries, but they contain an immense quantity of bones regularly piled up, coming from different cemeteries, such as those of the Innocents and of St. Eustace, as well as from the burying grounds which surrounded churches which have now been destroyed. Finally, in the catacombs of Paris the remains of those who fell in August, 1788, in April, 1789, and September, 1792, have been placed. In the catacombs of Rome have been found a large number of paintings, which constitute the first attempts of Christian Art. The artists who painted them are absolutely unknown to us. They are hieratic or symbolic representations, the value of which was not the actual sign itself, but the thing symbolised. Such, for instance, is the fish (ἰχθύς), the sign of Christ; the anchor, the symbol of hope; the dove, the symbol of the soul, &c. From an investigation of these signs we arrive at a mysterious writing, depending entirely on initial letters.

Catafalque. A richly decorated stage set up in churches, on which coffins are placed during funeral ceremonies.

Catalogue. A list of works of art classified either alphabetically or according to schools. The term is generally applied to a list of works in a public or private collection, or such as have been got together for the purposes of exhibition or sale.

— **Raisonné.** A catalogue which not only gives a list of works of art, but describes their subject and style, and discusses them from an historical point of view.

—, **To**. To draw up the catalogue of a collection of works of art. To catalogue works of art as completely as possible, it is not only necessary to quote the title of each object, but to give its dimensions and description, to mention its author and province, to make out its genealogy, and where possible to reproduce in facsimile the signature or mark which exists upon it.

Catenary Curve. The curve formed by a flexible body of uniform thickness, suspended by its extremities from two points in the same horizontal line. This curve inverted is frequently employed in arches, &c.

Cathedral. (Arch.) A cathedral church is a church in which the *cathedra*, or bishop's throne, is placed. Any consecrated building, therefore, may be con-

verted into a cathedral at any time by placing a bishop's throne within its walls. Considering the important office discharged by a cathedral it is natural that buildings of beauty and dignity should, where possible, be chosen as cathedral churches. But it must not be supposed that a cathedral need differ, architecturally speaking, in any respect from an ordinary parish church.

Catherine, St. According to the legend St. Catherine was an Egyptian princess, who suffered martyrdom at the hands of the Emperor Maximin or Maxentius because she would not renounce the Christian faith. She is said to have been very beautiful, as well as learned in all the science and philosophy of the heathen. The Emperor attempted on one occasion to break her to pieces on wheels armed with sharp spikes, but the wheels were destroyed with fire from heaven, and the spikes flew about and killed three thousand people. Mrs. Jameson holds that the legend of St. Catherine is based upon the story of Hypatia, who suffered martyrdom at Alexandria, not at the hands of heathen tyrants, but of Christian fanatics. St. Catherine is represented over and over again in art. Her attributes, besides the wheel, which particularly belongs to her, are a palm, a sword, a crown, and a book. Her marriage with the Infant Christ, symbolising the union of her soul with Christ, was a favourite subject with painters, especially during the 16th century. Representations of it are in existence by Perugino, Correggio, Titian, Vandyck, and others,

Cat's Eye. A stone of a yellowish or

greenish hue, furrowed with rays of a brilliant green.

Caulicoli. (Arch) Stalks which spring from between the folds of the acanthus leaves in the Corinthian

capital and curl round the volutes which support the abacus.

Causia. (Cost.) A broad-brimmed hat worn by Roman fishermen and adopted by them from the Macedonians, who invented it. Representations of it are found on vases and other works of art.

Cavaedium. (Arch.) The hollow or open part of a Roman house. The Romans in early times built their houses in the form of a small quadrangle, thus leaving an empty space in the middle, and it is this empty space which was called the cavaedium.

Cavetto. (Arch.) A concave moulding, which generally has a quarter of a circle as its profile. It is principally a cornice moulding.

Cavo-relievo. (Sculp.) A method of

carving in relief, in which the highest part is on a level with the surface of the stone, and the lowest part is depressed considerably below it. This method of sculpture was chiefly practised by the Egyptians, and our cut represents an Egyptian work.

Cecilia, St., was a Roman who lived in the reign of Alexander Severus. She was educated in the Christian faith by her parents, and being gifted with a genius for music she composed and sang hymns, and is said to have invented the organ. She suffered martyrdom in Rome soon after her husband and his brother had been put to death

for professing the Christian faith. The executioner sent to put her to death trembled so that he failed to carry out his purpose, and having wounded her left her to die. In early representations of St. Cecilia the saint appears simply holding a palm-branch; after the 15th century she is generally painted with her musical instruments, and from that time she is regarded almost exclusively as the patroness of music.

Ceiling. (Arch.) The ceiling is the covering of a roof or floor, which hides its timbers from the room below. It may be of timber or plaster. It is generally of the latter in the present day. The timber ceilings of the Middle Ages, especially those in churches, were often richly gilded and brilliant with colour. The use of plaster in ceilings came in with the revival of the classical style about the time of James I.

Celadon. (Pot.) This term was originally applied only to the sea-green colour upon old Oriental porcelain. Pieces of this colour are extremely rare and of great antiquity. The term is now applied to all porcelain in which the colour is mixed with the glaze and burnt in at the first firing.

Celebe. (Gk. κελέβη.) The name of certain Greek vases, elegant in form, with two handles and a foot. Some are quite plain while others have their surface richly decorated.

Cella. (Arch.) The sanctuary in ancient temples. Our illustration represents the plan of an ancient temple, and the part enclosed within black lines is the cella. A magazine or store room on the ground-floor of a Roman house. A name given to the separate chambers variously heated in ancient baths.

Celt. The term celt is applied to hatchets, adzes, and chisels of stone, which were once used as implements in nearly every part of the world. It was long held that the instruments called *celts* were so termed because they were made by the Celtic nations. But this derivation has been given up, and it is now generally recognised that the word is only an anglicised form of the Latin *celtis*, a chisel. The period at which they were used is so remote that for centuries a superstition has been in existence that *celts* were not fashioned by human hands, but were in reality thunderbolts, and fell from heaven. In every part of the world they have been held in reverence as of supernatural origin, and called thunderbolts or lightning stones. Medical virtues have been ascribed to them. In some countries they are said to keep off the cattle-plague, in others to purify wells. They are generally made of flint, but sometimes of quartz, porphyry, jasper, and other stones. In length they vary from two to sixteen inches. They belong to what is called the Neolithic age, which carries us back to a time when the use of bronze and iron was unknown. They, as well as the moulds in which they were made, have been found in large numbers in every part of the globe.

Cement. (Arch.) A mixture of lime and some hard substance, thoroughly crushed, or of sand, puzzolana, and lime. It is used to bind solid bodies together.

—, Roman. (Arch.) A cement obtained from the crushing of special stones. On being soaked in water it forms a soft paste, which rapidly hardens in the air.

Cenaculo. [Last Supper.]

Cendal. A silk stuff, of which banners and rich vestments were made in the Middle Ages.

Cenotaph. A monument raised to the memory of a dead person, whose mortal remains are elsewhere.

Censer. A metal vessel for burning incense. Over the cup where the incense burns is an ornamental open-work cover,

76

and the whole is supported by chains attached to the cup. In the Gothic period censers were decorated with mullioned openings. In the 17th and 18th centuries the covers were often dome-shaped, and the cups were ornamented with statuettes standing at the points where the chains were attached.

Centaur. (Myth.) A fabulous being, half man, half horse, often introduced by Egyptians, Etruscans, Greeks, and Romans into their bas-reliefs, and forming the subject of numerous works of art. The artists of the Renaissance and modern times have also given us repre-

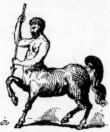

sentations of this mythological figure, the human torso placed upon the body of a horse affording an opportunity for grandeur of line. Centaurs are sometimes represented on Greek vases with their fore feet human. The female centaur was a later invention and is more rarely represented in works of art.

Centre. In geometry the centre is a point within the circumference of a circle, all lines drawn from which to the circumference are equal. The term is also applied to the central point in a picture and to the spot in a painting where the effect of light is concentrated. Thus we speak of a luminous centre, or of a composition the centre of which is not distinctly marked.

Centre. A temporary structure of wood upon which arches are built. For small arches centres consist simply of pieces of wood cut to the curve of the arch and supported under it by props. For longer arches, such as tunnels, the centres are composed of several upright curved frames or *ribs*, joined together by narrow battens nailed across them horizontally and called *laggings ;* the whole being supported by struts resting either on the ground, or, if the arch is high, on corbels introduced into the side walls. Between the top of each strut and the rib which it supports is placed a pair of small wedges of wood, which can be easily withdrawn. By this device it is possible to *ease* the centre before the masonry is quite set. The two wedges are driven slightly outwards, thus allowing the rib to sink a little. This causes the whole of the arch to settle slightly and uniformly and to take its bearing, the mortar being compressed in the joints. When the mortar has completely set, the centres are removed together.

Ceramic. The ceramic art is the art of manufacturing objects of all sorts in every kind of clay, and of decorating them by means of painting or modelling or both. The difference in the quality of clay and the variety of decorative processes have given rise to a variety of products. Under the general name of ceramics we include (1) bricks, tiles, terra-cotta, and common pottery ; (2) faïences ; (3) stone-ware ; (4) porcelain. The ceramic art occupies in consequence a very important place among the decorative arts. It is allied to architecture on the one hand, and to painting and sculpture on the other. [Pottery.]

77

Ceramography. The historical and technical study of the ceramic art.

Cerberus. The three-headed dog which guarded the entrance to Hades. He fawned on those who entered, but showed his teeth to those who went out. Representations of him are found on painted vases.

Ceres. [Demeter.]

Cerography. Painting on wax.

Ceroplastic. The art of modelling in wax. This art was practised by the ancients and by artists of the Renaissance, whose wax figures were often coloured and heightened in effect with gold tints. Among the finest specimens of ceroplastic are Michael Angelo's studies, which are to be seen in the South Kensington Museum. The art was cultivated until the end of the 18th century, and Benoit's portrait of Louis XIV. is a justly celebrated masterpiece. In spite of occasional attempts to revive it in our own century it has practically died out from an artistic point of view. It is now principally used for scientific purposes, such as the construction of anatomical figures, many of which are to be seen in museums of anatomy. Modern waxwork exhibitions have no connection whatever with art.

Cerostrotum. A method of encaustic painting on ivory, in which furrows were cut in the ivory with a heated *cestrum* or etching needle, and then filled up with wax. This is the explanation generally given of the process, but the whole subject is shrouded in obscurity.

Cerulean. (Paint.) Azure-tinted, of a fine transparent blue colour.

Ceruse. (Paint.) Pure carbonate of lead, out of which the pigment *ceruse* or white lead is manufactured.

Cervelas. Red marble veined with white.

Cestus. The *cestus* was the boxing-glove of the Romans. It consisted of a thong of leather wound round and round the hand and wrist. Sometimes the leather was studded with iron bosses, which rendered the cestus a dangerous weapon. Representations of boxers armed with the cestus are very common in Roman art.

Chair. The chair of to-day is generally a seat with a back and no arms. The chairs used in the 13th century, on the contrary, had arms and no back, and were placed against the wall with pieces of richly wrought tapestry behind them. In the 15th, 16th, and 17th centuries high-backed chairs became fashionable; these gave way in the 18th century to chairs with oval backs. Iron chairs with trellis-work seats are the invention of our own period, and have superseded rustic seats of wood or stone. For the furniture of our houses we have produced no new form of chair, but have been content to imitate with some measure of success the style of former times.

—, Curule. A seat inlaid with ivory, granted as a privilege to consuls, praetors, and curule aediles at Rome. The curule chair had bent legs in the shape of the letter X, and was made to fold up.

—, Sedan. A vehicle much used in the 17th and 18th centuries, consisting of a glass body containing a seat, and carried by two men by means of straps and two long poles. Sedan chairs were frequently ornamented with paintings and sculptured reliefs picked out with gold, and many of them are masterpieces of decorative art.

Chair-rail. The rail which runs round a room at a height of three or four feet from the floor and prevents the backs of the chairs from injuring the wall decorations.

Chalcedony. A milky white agate,

striped or veined with different colours, used by engravers of precious stones.

Chalcography. (Engrav.) The art of engraving on copper.

Chalcotype. (Engrav.) A process of engraving in relief on copper, invented by the German Heims in 1851.

Chalet. (Arch.) A rustic house with balconies and galleries of carved wood, built in imitation of Swiss houses of planks and trunks of trees and covered with a roof which projects over the façade.

Chalice. A sacramental vessel used at holy mass for the consecration of the wine. It is a deep cup mounted on a stem, and of all religious vessels is the one which has given the most opportunity to the imagination of decorative artists. Some chalices are ornamented with precious stones and enamels.

Chalk. (Paint.) A white calcareous substance, which is used in distemper painting. Chalk in the shape of a crayon is also used to draw the outlines of a composition on a canvas.

Chamber. (Arch.) A room or apartment in a house, generally a room in which a bed is placed.

Chambers. (Arch.) A term applied to a set of rooms, which can be used either as offices or as a residence for bachelors. For instance, the set of rooms in the Inns of Court are invariably called *chambers.*

Chambranle. (Arch.) A slightly projecting casing, either plain or consisting of a collection of mouldings. It follows the outline of a real or pretended rectangular opening, such as a door, window, &c.

Chamfer. (Arch.) A small surface in a wall, formed by flattening a right angle so as to get rid of a sharp corner, which

would be easily broken or damaged. A right angle is thus replaced by two obtuse angles.

Chamfron. A piece of armour generally of steel used to protect the head of a warhorse from the ears to the nose. Though apparently known to the Persians and Greeks in ancient times the chamfron did not appear in modern Europe until the 15th century.

Champagne. (Her.) A French term used to describe a charge which occupies the lower third portion of the shield. This charge is hardly known in English heraldry, but is frequently employed in German coats-of-arms.

Champ-levé. A process of enamelling in which furrows are cut in the metal plate in accordance with the design adopted, and the enamel colours inserted in these furrows. The colours are thus separated from one another by a thin band of metal with a sharp edge, and cannot mix in the firing.

Chancel. (Arch.) The chancel in a catholic church is that part of the choir near the altar where the deacons or subdeacons stand to assist the officiating priest. It is generally shut off by a rail.

Channel. (Arch.) The groove in copings or volutes, and, generally speaking, any surface obtained by cutting out the body of the

moulding. Some channels deeply hollowed out are bordered by a projecting fillet.

Chantry Chapel. A small chapel built over the grave of one who had left a chantry or endowment for the chanting of masses for his soul. The practice of bequeathing money for the building of a chantry chapel was frequent before the Reformation, and many of these chantries are to be seen in our abbey churches. There are several at St. Albans.

Chape. A tip or case of metal fixed on the scabbard of a sword or dagger to strengthen it. In the 13th and 14th centuries *chapes* were quite plain, but those which belong to the 16th century are often elaborately decorated.

Chapel. (Arch.) A religious building of small size, either isolated or annexed to, and so forming part of, a church. When, however, they belong to palaces, mansions, colleges, &c., buildings of whatever size are termed chapels. These chapels are of course often of large dimensions and exquisite architecture. Such is the Sistine Chapel belonging to the Vatican, which contains Michael Angelo's "Last Judgment," and such are the chapels which form part of the colleges of Oxford and Cambridge. Chapels annexed to a church are rare in Byzantine architecture. They appear in Romanesque churches under the name of apsidal chapels, and as time goes on increase in number and extent. In the 12th century chapels which appear square outside have often a polygonal interior. In the 13th century chapels of large dimensions, and dedicated to the Virgin, were frequently built on to the end of a church. These were termed *Lady Chapels.* Some churches have chapels attached to them not only round the choir but round the side aisles.

— of the Dead. (Arch.) A chapel built in the Middle Ages in the midst of a burying place or cemetery. It was frequently nothing but a simple canopy of stone supported by columns and sheltering an altar.

—, Sepulchral. (Arch.) A chapel annexed to a church or subterranean crypt (q.v.) in which the dead were buried.

Chapelle-de-fer. An *iron hat* used by knights in the Middle Ages as a protection for the head. Its peculiarity was its brim, which, though narrow in the 13th century, grew gradually broader. The crown was at first flat, then it followed the shape of the head, and finally assumed a conical form. When the bascinet (q.v.) was introduced, knights abandoned the *chapelle-de-fer*.

Chaperon. (Her.) A French heraldic term signifying a *hood*, such as knights used to wear under their helmets. In England the term is confined to little shields bearing death's-head and other devices that used to be placed on the foreheads of horses at ceremonious funerals.

Chapiter. (Arch.) An old term for the capital of a column.

aplet. (Arch.) A moulding decorated

with pearls or small rosettes threaded together.

Chapter-house. The meeting place of the canons of a cathedral church.

Character. By this word we denote both the originality of a work of art and its general effect. When we say that a landscape has *character* we mean that it has fine outlines. A work of art lacks *character* when it is trivial or commonplace and fails to impress the spectator.

Charcoal. Charcoal either manufactured into crayons or in its rough state is used for drawing purposes. It is prepared by burning wood, especially

box and willow, in a close furnace. The term is also applied to drawings executed in this medium. Thus we speak of a charcoal drawing.

Charge. (Her.) Any heraldic figure represented in a coat of arms. [Ordinary.]

Charge. A French term applied to a composition, or more often a portrait, in which individual peculiarities are accentuated so as to become grotesque. The *charges* of Callot are celebrated. [Caricature].

Charged. (Her.) A shield carrying some figure is said to be *charged*, and in the same way a figure may be *charged* by superposing some other figure upon it.

Chariot. An ancient carriage mounted on two wheels and entered from behind. The chariot, in the allegorical art of to-day, has a triumphal signification.

Charities. [Graces.]

Charm. [Amulet.]

Charnel-house. (Arch.) A gallery or covered place annexed to a cemetery, where the bones of the dead were placed in the Middle Ages.

Charon. In Greek mythology the ferryman appointed by the gods to take the souls of the departed across the river Styx. Representations of him are to be seen on Greek vases and stelae.

Charter-house. (Arch.) A special building or hall where charters, titles, and other manuscripts of historic interest and great value are kept.

Chasing. The art of embossing metal and then cutting or chasing it with a graver. The art of chasing was much practised by the ancients, and the names of several Greek artists who practised this branch with success have come down to us. One of these named Mys was famous for having made a chariot and horses which a fly could cover with its wings. The art of chasing was of importance in the creation of those masterpieces of art, the chryselephantine statues, the gold portion being elaborately chased. In the great period of Italian art many gold and silver

vessels were exquisitely chased. The great master of the art in this period was Benvenuto Cellini. There are some indications at the present time that this long neglected art is coming once more into favour.

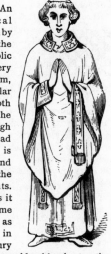

Chasuble. An ecclesiastical vestment worn by all grades of the Roman Catholic clergy. It is very simple in form, being a circular piece of cloth with a hole in the middle, through which the head is thrust. It is put on last and covers all the other vestments. In early times it was the same length before as behind, but in the 11th century the front was considerably shorter than

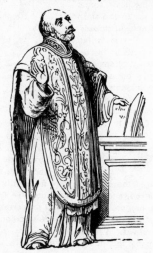

the back. Soon afterwards, however, it

regained its symmetrical form, and underwent no further change. It was frequently richly ornamented. The modern chasuble does not conform in any respect to the true model. Our second cut is from Rubens' picture of Ignatius Loyola.

Checky. (Her.) A term used to describe a shield divided into small squares. There are generally six rows of squares, and if there are less the fact should be specified in describing the shield.

Chef d'œuvre. [Masterpiece.]

Cheiron. In Greek mythology Cheiron is the kindly centaur to whom Achilles and Jason owed their education. He possessed nothing in common with the centaurs except his shape, and was skilled in all the sciences and arts.

Cheniscus. An ornament in the shape of a goose's head which was affixed sometimes to the prow, some-times to the stern of ancient vessels. It is very often met with in representations of ships on classical monuments. One is to be seen on Trajan's column.

Cherub. The head of an angel emerging from two wings employed as a painted or sculptured ornament. In the 17th and 18th centuries these figures were frequently employed, and sometimes they are found on monuments of colossal proportions.

Chesnut. A dark red brown colour.

Chest. A piece of furniture which serves the double purpose of a large coffer in which to store linen and of a bench to sit upon. It was the most im-

portant item in the household furniture of the Middle Ages. In early times it was simple in form and only decorated by ornamental iron-work. In the 14th and 15th cen-

turies its panels were richly carved and it was raised upon legs.

Chevet. [Apse.]

Chevron. 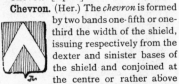 (Her.) The *chevron* is formed by two bands one-fifth or one-third the width of the shield, issuing respectively from the dexter and sinister bases of the shield and conjoined at the centre or rather above it. The point of the chevron should not touch the top of the shield as in the cut. The term *chevron* is also applied to a very simple decoration of a geometric pattern consisting of a series of lines in-

clined to one another at a certain angle. It is the most ancient ornament and is found in prehistoric and savage drawings.

Chevronel. (Her.) A diminutive of the chevron.

Chevronny. (Her.) Used to describe a shield divided by a number of lines or strips in the form of chevrons.

Chiaroscuro. (Paint.) The art of distributing light and shade in a picture, and especially of enveloping the figures or other parts of the scene represented in transparent half-tints or shadows very fine in tone. Rembrandt above all excelled in the rendering of the effects of chiaroscuro. The term is also applied, but very rarely, to drawings in *camaieu* (q.v.) In former times a drawing or

picture in *chiaroscuro* meant a drawing executed in monochrome, and depending for its effect entirely on the contrast of light and dark tints.

Chic. A word of wide application very often used in artistic slang, and generally indicating either skilful execution or an effect far removed from the conventional or commonplace.

Chicory. The water-colour painters of 1830 gave this name to a colour of a reddish yellow tone, not sold in the shops, which they obtained by evaporating what was left after four consecutive hours' boiling of a packet of common chicory burnt and diluted in a quart of water. The colour thus obtained was bituminous in tone, like sepia, and closely resembled the pigments employed in the style of oil-painting then in vogue.

Chief. (Her.) The chief is an ordinary

which occupies the upper third portion of a shield, and is considered the most honourable of ordinaries. It has one diminutive called the *fillet*, which is one-fourth of the size of the chief. When any charge is placed in the uppermost part of the shield it is said to be *in chief.*

Chilled. (Paint.) The varnish on a picture is said to have chilled when it becomes dim and cloudy. This defect is generally caused by moisture.

Chimaera. A fabulous monster, de-

scribed in Homer as having the head of

a lion, the body of a goat, and the tail of a dragon. Fantastic animals with the head of a bird, the winged body of a lion, or the figure of a man, and various other chimerical combinations were employed in the Middle Ages as subjects for decoration either painted or sculptured. The chimaeras of the Renaissance were employed as caryatids or supports in pieces of furniture, &c. Fine examples are also found on the frames of mirrors or borders of tapestry, placed in the midst of foliage and terminated in fantastic scrolls.

Chimney-back. (Arch.) The plate of metal placed at the bottom of a fire-place. The space between the hearth and the joints.

Chimney-hood. (Arch.) A mantel-piece in the shape of a pyramid. The chimneys of the Middle Ages present many examples of hoods richly decorated with arcades and sculptured ornaments. The chimney-hoods of the period of the Renaissance are vertical, but are even more extravagantly ornamented.

Chimney-piece. (Arch.) The chimney-piece was once an important element in the decoration of a room. To-day it is generally set into the wall or concealed in its thickness, and consists of nothing more than a marble frame, sometimes richly carved and surmounted by panels embellished with mirrors and paintings. The chimney-pieces of the Middle Ages were, on the contrary, monuments of art. Above the shelf, which was supported by a chambranle of large enough dimensions to allow a man to walk under it with ease,

appeared the funnel or flue, pyramidal in shape and decorated with bas-reliefs, arcades, and a thousand other deli-

cately sculptured ornaments, sometimes painted or heightened in effect with gilding. The chimney-pieces of the 12th and 13th centuries were very simple and strong in outline. In the 15th and 16th they were extraordinarily rich. In the

17th and 18th centuries they were decorated with pilasters and scrolls, while the funnel was replaced by vertical panels.

China. Pottery made of a transparent paste and originally brought to Europe from China.

Chinese Paper. A fine yellow-tinted paper, manufactured from bamboo fibre, used for taking proofs of engravings. It is generally called India paper (q.v.)

Chinese White. (Paint.) A white pigment prepared from oxide of zinc. It is not thoroughly satisfactory in oil-painting, but is the best white for use in water-colour. It is permanent under all circumstances.

Chin-piece. (Engrav.) A piece of linen or cardboard, somewhat resembling a gag, worn on the mouth by wood engravers. The object of it is to prevent the breath from spoiling the drawing ink. Lithographers also employ chin-pieces, for breath speedily condenses on the surface of the stone, dilutes the ink or crayon, and seriously interferes with the work.

Chippendale. A name applied ignorantly to almost all the furniture produced in England in the last century. Thomas Chippendale, who has given his name to so many chairs and tables to which he never put his hand, was a native of Worcestershire and a cabinetmaker. His designs are somewhat heavy and clumsy and are generally imitated with a leaning towards the classical style from the French. Chippendale furniture should be distinguished from the slender and graceful productions of Sherraton.

Chisel. (Sculp.) An instrument of iron or steel with a sharp bevelled edge, used as a cutting tool by sculptors. It may be either straight or bent. The word is also applied to the sculptor's art: thus we say that a sculptor has a delicate chisel when his work is executed with fine feeling. The chisel and the brush are used absolutely to indicate the arts of sculpture and painting. A cutting tool with a handle of wood

and a bevelled point is also called a chisel.

Chiton. (Cost.) The chiton was the garment worn next the skin by both men and women in Greece. It consisted of an oblong piece of cloth which was closed on one side, only a hole being left for the arm to be put through. On the other side it was open, though sometimes the ends below the thigh were stitched to

gether, and the upper ends were fastened together by a clasp. Round the waist it

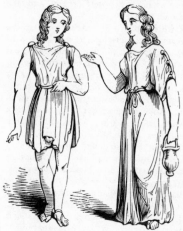

was fastened by a girdle, over which, when the chiton was long, it was drawn up so as to fall in graceful folds.

Chlamys. (Cost.) The chlamys was an oblong piece of cloth thrown over the left shoulder, and fastened by a brooch on

the right. The ends were kept in their place by small weights attached to them. It was worn by the youth of Athens

when they attained the age of an ephebus, and was the distinctive dress of traveller and soldier.

Choir. (Arch.) The part of a church reserved for the clergy. In Latin churches the choir was at the crossing. At the end of the 12th century the choir was extended and was placed in front of the sanctuary below the apse of the church. In the 13th and 14th centuries the choir was closed by a wood roof and surrounded by a cloister. Within this cloister were placed the stalls, while outside it was decorated with arcades sometimes containing painted and gilded bas-reliefs.

Chopine. A wooden clog or stilt worn under the foot. The fashion of wearing *chopines* came from Italy to England, and prevailed in the 15th and 16th century. In Venice the custom of wearing them

was universal, but they never became popular in England. Shakespeare mentions the chopine in *Hamlet*, act ii. sc. 2 : " Your ladyship is nearer heaven than when I saw you last by the altitude of a chopine."

Choragic Monument. (Arch.) A choragic monument was a small monument erected to hold the tripod which was awarded to the *choragus* who furnished the successful chorus in the theatrical representations at Athens. It was sometimes merely a pillar, at others a

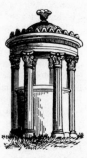

small temple. The best specimen of a choragic monument is that of Lysicrates which stood in the Street of the Tripods at Athens. It consists of a small rotunda upon a square base, and has six fluted Corinthian columns bearing a frieze representing the transformation of the Tyrrhenian pirates into dolphins.

Choragium. A room where the costumes and properties were kept in an ancient theatre.

Chord. A straight line which joins the extremities of an arc of a circle.

Chrism. The monogram of Christ painted or engraved on religious monuments. This monogram consists of a X and a P interwoven, the first letters of the word ΧΡΙΣΤΟΣ. This monogram is often complicated by the insertion of the letters Α and Ω in the lateral angles of the X. In the fifth century the P disappeared, at the same time the three letters I.H.S. began to be substituted for XP.

Chrismatory. A vessel used in the Roman Catholic Church to contain the consecrated oil, which was termed chrism.

Christ. The crucifix and image of Christ on the cross. Thus we speak of the Christ of Vandyke, of Rembrandt, meaning well-known pictures by celebrated artists.

Christina, St. Christina is a purely legendary saint, and the legend concerning her has been rejected by the Catholic Church. She is said to have been the daughter of a Roman patrician named Urbanus. She was early converted to the Christian faith and adopted the name Christina. She incurred her father's displeasure, says the legend, by breaking up his idols of gold and silver, and distributing them among the poor. He ordered her to be thrown into the lake of Bolsena with a mill-stone round her neck, but the mill-stone proved a support to her, and she was not drowned. She is said to have at last won the crown of martyrdom, being shot to death by the arrows

of Roman soldiers. Her proper attribute is the mill-stone, but she is sometimes represented bearing arrows and the crown of martyrdom.

Christopher, St. According to the legend St. Christopher was a Canaanitish giant named Offero, whose desire it was to serve the most powerful king in the world. A hermit urged him to serve Christ by dwelling on the banks of a turbid stream and helping wayfarers to cross it. At length one night he heard a child's voice calling to him, " Christopher, carry me over this night." He raised the infant on his shoulders, but soon found his burden growing heavier and heavier, and at last tottered beneath the weight. When finally he reached the opposite bank he found that he had borne Christ, and henceforth was called Christopher. He suffered martyrdom at Samos, and is represented in art with the infant Christ on his shoulders.

Chromatics. That portion of optics which treats of the diffusion, the decomposition and recomposition of light, the rays of the spectrum, the theory of colours, and the particular properties of coloured rays. The term is also applied to the method of employing and arranging colours in painting.

Chrome Green. (Paint.) A pigment obtained from oxide of chromium. It is of a dark green colour and of great permanence.

—, Yellow. (Paint.) A pigment obtained from chromate of lead. The lead is too much acted upon by oils for the colour to be permanent. In tint with white it becomes a grey.

Chromolithography. The process of lithographic printing in several colours. The drawing is executed in portions on as many different stones as there are colours required, then by means of successive printings, in the course of which the colours are superposed the one on the other and combine, reproductions of oil-paintings, water-colours, and miniatures may be obtained. It is in its

application to the last-named that chromolithography has obtained its best results.

Chromotype. The art of printing in several colours by means of typographic processes.

Chromotypography. A process of printing in colour analogous to chromolithography, with this difference that the prints are struck off typographically, that is from relief blocks.

Chryselephantine. A term applied to works of sculpture executed in ivory, gold, and other precious metals. Chryselephantine statues were much esteemed in Greece. The Athene of the Parthenon as well as the Zeus Olympius, both from the hand of Pheidias, were chryselephantine statues of colossal size. In modern times the sculptor Simart, at the instance of the Duke de Luynes, has attempted to restore the Athena of the Parthenon, and his work was exhibited at the Universal Exhibition of 1855.

Chrysographer. An illuminator who, in the Middle Ages, traced in letters of gold or silver initials, inscriptions to miniatures, and sometimes whole manuscripts.

Chrysography. The art of tracing characters by means of gold or silver ink on parchment, which was sometimes purple-tinted. Chrysography was much pursued as an art up to the 10th century. In the 11th and 12th centuries letters of gold occur with less frequency, but they came into vogue again in the 14th, 15th, and 16th centuries.

Chrysolite. A precious stone of a yellow colour.

Chrysoprase. A green agate shaded with yellow.

Church. A building consecrated for Christian worship. Churches are generally cruciform, and are either in the shape of a Greek cross, when the four branches are equal, or of a Latin cross, in which case the nave is longer than either the chancel or transepts.

—, **Collegiate.** A church which possesses a chapter of canons, but is not the seat of a bishopric. Such was the church of St. Mary the Virgin at Manchester, before it became a cathedral.

Church, Conventual. A church attached to a convent.

—, **Metropolitan.** A church which is the seat of an archbishop.

—, **Round.** A church the ground plan of which is circular. This is a very rare form. The best known examples are the Temple Church in London and St. Saviour's at Cambridge.

Church Bells. (Her.) When church bells are borne as an heraldic charge they are always represented in perspective and the clapper should be visible below the rim of the bell, while the shank should be seen at the top. The bell and the clapper need not be of the same tincture; thus, *a church bell argent with a clapper sable.*

Ciborium. A sacred vase in the shape of a covered chalice, either gold or gilt inside, in which the host was kept. The term is also applied to a baldachino

covering an altar, or to the tabernacle of the high altar. In some Christian basilicae the ciborium was of gold or silver, and was an elegant structure generally supported by four columns and with its openings veiled by curtains of rich material. Other ciboria

were made of marble or stone. Some Romanesque churches retained the use of the ciborium as late as the 13th century, but it is unknown in pointed churches.

Cincture. A term applied in furniture to certain surfaces decorated with systems of ornament. Thus, for example, the cincture of a table is the vertical portion reaching beneath the horizontal slab and forming a sort of frieze, supported by the feet.

Cincture of a Column. (Arch.) A squared moulding or a fillet bound by an apophyge (q.v.) placed at the summit and foot of a column. The term is also applied to the foliage ornament which separates the fluted portion from the plain in the truncated columns which were used in the 17th and the 18th centuries to decorate the high altar in churches.

Cinerary Urn. An urn in which in ancient times the ashes of the dead were placed. It was set up in a niche prepared for it in a mausoleum, and was sometimes of clay and sometimes of stone or marble.

Cinnabar. Native sulphide of mercury which forms a bright red pigment. It is of great service to the painter, and by mixing it with whites we obtain flesh tints. Under ordinary circumstances it is permanent, but should not be used on enamel, as when fired it is decomposed by alkalies and alkaline carbonates.

Cinquecento. Cinquecento literally means 500, but it is used as an abbreviation for *mille cinquecento, i.e.* 1500, and is applied as a general term to the art of Italy in the 16th century. During the brilliant period termed the *cinquecento* the classical revival was at its height in Italy, and classical art and classical mythology exercised a powerful influence on Italian artists, among whom we may mention Michael Angelo, Donatello, and Benvenuto Cellini.

Cinquefoil. (1) (Her.) The cinquefoil in heraldry is a conventional representation of a five-cusped leaf.

Cinquefoil. (2) (Arch.) An architectural

ornament consisting of five equal divisions or lobes, frequently used in the Gothic style, either as a pure ornament or in ecclesiastical windows.

Cipher. A mark in the form of a monogram or punning device placed by artists as a signature upon their works. We give two monograms, the one of Christopher von Sichem, the other of

Adrian Bolswert, both artists of the Netherlands. As an instance of the punning cipher we may mention the *crane* with which Mr. Walter Crane invariably signs his works.

Cipolino. A kind of marble striped with broad wavy lines of white and green. Its foliaceous structure renders it difficult for the sculptor to handle, but as it will take a fine polish it is much used as a facing. Its name is derived from an Italian word meaning a small onion, the colour and form of its markings suggesting the concentric circles of an onion cut vertically.

Cippus. (Arch.) A sepulchral column of small dimensions; a pilaster with a memorial inscription; a pedestal sometimes circular, but generally rectangular, ornamented with sculptures. It either contained the ashes of

a dead man or marked the spot where he was buried. The larger of our two

cuts represents a *cippus* in the British Museum.

Circle. In geometry a plane figure, enclosed within a curved line, called the circumference, all points in which are equidistant from a fixed point called the centre. In Christian art the circle is the emblem or symbol of heaven and eternity, and no doubt it suggested many forms of decoration to ecclesiastical architects.

Circle of Stones. (Arch.) An ancient monument formed of blocks of stone placed in a circle.

Circular. That which has the form of a circle or of a segment of a circle.

Circumscribe. To describe one geometrical figure round another so that there are points of contact between the two figures.

Circus. (Arch.) A vast enclosure where the Roman people witnessed chariot races, games, and public spectacles. The circus of the Romans was simple in construction. It was oblong in shape and terminated at one end in a semicircle, in which the spectators took their seats. At the end opposite the spectators were the *carceres* or stalls for the horses. Down the middle of the area ran a low wall called the *spina*, round which the racing chariots turned. The spina was decorated with statues, altars, and obelisks. Wherever the Romans went they established circuses, and examples exist in England at Richborough, Dorchester, and elsewhere. In modern times the term is applied to a circular building in which feats of horsemanship and athleticism are displayed.

Cire-perdue. [Lost Wax.]

Cista. The mystic chest or cist, in which the articles pertaining to the mysteries of Demeter or Bacchus were kept. The *cista* was in early times made of wicker-work, but at a later period was of bronze or even a costlier material, and was artistically decorated. The most celebrated *cista* known to us is one that was found at Praeneste, apparently of Roman workmanship, but worthy of the traditions of the Greek style. It is of bronze, and is surmounted by two figures, one a bacchante, the other a faun. Its outside is decorated with a design, the subject of which is the arrival of the Argonauts at Cyzicus.

Citadel. (Arch.) A castle or stronghold placed on a height to defend the city near which it is built.

Cithara. A musical instrument of the greatest antiquity, known to the Greeks, but no doubt borrowed by them from

the East. It resembled the guitar in shape, and was played by the finger or struck by the plectrum. Our cut represents an Egyptian playing the cithara.

City. A town, and also the special precinct or quarter of a town where the cathedral is situated.

Claire-voire. [Clerestory.]

Clamp. (Arch.) A piece of wrought iron which holds together and binds into a solid mass two walls or two pieces of timber.

Clasp. The purpose of a clasp is to

securely fasten a closed book. The

bindings of valuable MSS. are generally ornamented with rich clasps. Some are decorated with figurines executed with the utmost care, others with foliage or other ornament.

Classical. Classical in the strict sense of the term is applied to the best period of ancient Greek art, when such sculptors as Pheidias and Polycletus, and such architects as Ictinus, united in their works respect for truth, observation of nature, and worship of beautiful forms. Although *classical* literature includes the works of the Latin Augustan age, the art of the Romans is only the art of a period of decadence. By analogy the name is given to schools which take the monuments of Greek art as their models, deducing from them their canons and inspiration, and sometimes even confining themselves to a slavish reproduction of classical masterpieces without making any attempt to grasp the principles underlying them. This unintelligent imitation has at different times given rise to violent reactions and has provoked vigorous aesthetic discussions. The term *classical* is also applied to such masters as Raphael, whose work without being the result of direct imitation of Greek art, yet recalls it by the purity and perfection of its design. And finally modern work may be called *classical*, if by common consent it takes a place among the masterpieces of the world.

Classicism. A term applied to the artistic tendency towards the classic style.

Classico-Romantic. Said of works of undecided style which exhibit at the same time a classic and romantic spirit.

Claude Glass. A dark glass, in which a landscape may be observed in reverse. The effect produced in it is said to resemble a picture by Claude, and from this it derives its name.

Clay. A rich and compact earth, a kind of clayey marl with an admixture of iron, sand, and limestone, in which sculptors execute their models. It ought to be kept damp, as it is then easy to mould and yet offers sufficient resistance to the fingers. When they leave their work sculptors wrap up their clay models in soft moist linen cloths, upon which they sprinkle water from time to time from a particular kind of syringe with a rose at the end like a watering-can. Clay models if they are left to dry in the open air shrink and crack and speedily come to pieces.

Cleat. A small piece of wood nailed on to the principal rafters of a roof in order to support the purlins or horizon-

tal beams on which the common rafters rest. It is a kind of hammer beam in the shape of a wedge, and its purpose is

to prevent the beams which support the rafters from slipping. Our illustrations show the *cleat* in section as well as in perspective.

Cleave. To cut or divide diamonds and crystals in parallel layers.

Clement, St. St. Clement was one of the disciples of St. Paul and St. Peter, and he is said to have been the Bishop of Rome for many years. He was banished by a prefect who governed Rome in the Emperor Trajan's absence, but even in his banishment he did not escape from the malice of his enemies. He was

bound to an anchor and thrown into the sea, but the water receded three miles, and his followers found a small temple, and within it the body of St. Clement with an anchor round his neck. In art St. Clement is represented with a tiara and an anchor either round his neck or at his side.

Clerestory. (Arch.) The row of windows placed in the upper story of the nave in Gothic churches. It rises clear above the roof of the nave-aisles. The term, however, was once applied generally to any row of windows in a wall or building.

Cliché. A relief in metal obtained by electrotyping, from which engravings are printed. Cliché especially denotes the stereotype casts taken of woodblocks, from which the cuts in books and journals are now generally printed. By this means not only can a far larger number of impressions be struck off, but the block itself can be easily multiplied. The term is also applied to the photographic proofs on glass, which are called *negatives* or *positives*, according as the whites and blacks of the object represented are transposed or not.

Clipeus. The large round shield car-

ried by the Greeks and Romans. It was circular in form, was made either of beaten bronze or of wicker-work strengthened with ox-hides.

Cliquart. (Arch.) A coarse limestone used in the laying of foundations.

Cloisonné. Cloisonné enamel is obtained by dividing a metal surface by means of strips of wire welded on to the metal plate. Thus hollows are formed, in which the enamel in coloured powder is deposited. Cloisonné enamels have been manufactured since the 6th century. The altar given by Justinian to the church of St. Sophia was decorated with *cloisonné* enamels. These enamels were as a rule executed on plates of gold. Cloisonné work of the highest merit comes from China and Japan.

Cloister. A construction forming part

of a monastery or adjoining a church. It is generally a covered gallery surrounded by a pierced arcade, and enclosing a garden or courtyard. Cloisters were ranged round the sides of a quadrangle. The arches which looked into the quadrangle were sometimes glazed. The cloisters were set

apart for recreation and study, and carols or recesses exist in some cloisters, in which the monks sat at work. A lavatory, too, is frequently found in a cloister, and is accounted for by the fact that the cloister led to the refectory.

Closet. (Her.) A diminutive of the *bar*, which is itself a diminutive of the

fess. . The *closet* should be half the width of the *bar.*

Clothed. (Her.) A shield is said to be

clothed when a lozenge is laid upon it in such a manner as to cover the bulk of the shield, leaving only the four corners uncovered. This device is not much employed in English heraldry.

Clouded. A term applied to precious stones when their translucency is dimmed.

Club. (Her.) A charge in heraldry representing the weapon usually carried by Hercules. Clubs are sometimes furnished with spikes. Generally more than one is represented on a shield.

Clymant. (Her.) Said of a goat standing on its hind legs.

Coat. (1) (Paint.) A layer of colour of a uniform tint passed once over the surface of a canvas. A *coat* of paint is said to be *thin* when the ground or another coat can be seen underneath it.

Coat. (2) A coating of plaster in which the putty mould is wrapped after rebaking in the operation of casting.

Coat Armour. A term applied to any military garment upon which the armorial bearings of the wearer were embroidered.

Coating. (Paint.) A preparation with which walls are covered before they are painted in fresco. It consists of a mixture of chalk and sand or puzzolana. The walls must be painted while the coating is fresh, and the surface which is to be painted during the day should be coated in the morning.

Coat of Arms. (Her.) A coat bearing armorial insignia worn over the armour by mediæval warriors, so that they might be distinguished by their soldiers. The "Coat of Arms" as now understood is a complete and distinctive heraldic composition.

Cobalt-blue. (Paint.) A pigment composed of alumina and phosphate of cobalt, or of silicate of cobalt and potassium. It is a bright blue pigment and is useful in fresco and enamel as well as in oil painting. It is permanent as a rule, though it is adversely affected by light and bad air.

Cobalt-green. (Paint.) A permanent green pigment composed of zinc and oxides of cobalt. It is bright in tone, but on the whole inferior to chrome greens.

Cob-wall. A wall built of straw, lime, and earth is called a cob-wall. Cobwalls are only found in the present day in barns and outhouses of rude construction, but the houses of the Greeks and Romans in their best period are said to have been built on this rough plan.

Cochineal. (Paint.) A dried insect, soluble in water, from which a brilliant carmine lake is obtained.

Cock. The emblem of watchfulness, placed from a very early date on the summit of churches. It also symbolises St. Peter in allusion to his denial of Christ.

Cockatrice. A fabulous monster, half cock and half dragon, somewhat resembling a basilisk (q.v.). In Christian symbolic art it is the emblem of sin.

Coeur. (Her.) A term sometimes used in heraldry to denote the heart or centre of the shield.

Coffers. Compartments of which the

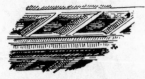

circumference is enriched with mouldings and the centre with a sculptured ornament. They are used in the decoration of ceilings and vaults. Their purpose was originally

to fill the vacant spaces which exist between the joists of the ceilings; they soon became, however, mere decorations to surfaces, which when bare did not harmonise sufficiently with their *ensemble.* Many vaults are decorated with coffers, and in Renaissance times many wooden ceilings were formed of hexagonal or octagonal coffers decorated with floral ornaments or arabesques, with pendentives often richly sculptured attached to their centre.

Cognisance. (Her.) A *cognisance* or *badge* is a device adopted by families as a distinctive mark. It is not blazoned on a shield, and it differs from a crest in being complete by itself, needing neither *wreath* or *cap of maintenance* to support it. Among notable badges may be enumerated the ostrich feathers of the Prince of Wales, the white and red roses of the Yorkists and Lancastrians, and the broom sprig of the Plantagenets.

Cognoscente. [Connoisseur.]

Coif. (Cos.) A head-dress fitting tightly and originally tied under the chin. Worn at first by hunters and knights, it gradually became distinctive of the ecclesiastical and legal professions, and in an altered form finally became exclusively a portion of the lawyer's costume.

Coilanaglyph. This barbarous and harsh-sounding word is sometimes applied to works of sculpture cut in a solid substance, in which the relief of the figures is scarcely flush with the plane surface surrounding them. This is the case with many bas-reliefs, to which the thickness of the stone forms a border, projecting beyond the most projecting of the figures. [Cavo-Relievo.]

Coin. (Arch.) A belting course placed at the angle of construction.

Coinage. The manufacture of coins.

Among the many operations in the making of coins the engraving of the dies and the execution of the matrix and coin are those which belong to the domain of art.

Coins. Pieces of metal of different value, struck with the image of the sovereign authority, sometimes represented by an allegorical figure or group of figures. Many coins, those of Greece for instance, are of the utmost importance in the study of art. For not only are they in themselves works of art of the highest merit, but they often bear upon them representations of well-known statues, and so are of great service in the illustration of the history of art.

Cointise. A general term originally applied to any scarf or other ornamental garment quaintly cut and fashioned. The wearing of cointises (from *quinteux,* fanciful) prevailed during the 13th and 14th centuries. The term especially denotes the kerchiefs worn by knights on the top of their helmets.

Coliseum. (Arch.) An amphitheatre in ancient Rome of elliptic form and colossal dimensions.

Collaboration. Participation in the conception or realisation of a work of art. There is sometimes collaboration between architects, or between architects and sculptors, especially in the execution of a statue, a fountain, &c. Artists who follow different industries frequently collaborate in the execution of one object, such as a piece of furniture on which a sculptor, a cabinetmaker, a painter on enamel, a chaser and an upholsterer may be engaged. In a case like this, however, the design is generally due to one man alone, and the collaborators would more properly be called assistants or executants.

Collar. An ornament worn round the neck, especially as the insignia of an order of knighthood. The oldest order, the knights of which are invested with a collar, is the order of the Golden Fleece,

which was established by Philip the Good, Duke of Burgundy, in 1429. The knights of the English order of the Garter, though an older body than the knights of the Golden Fleece, did not wear a collar until the reign of Henry VIII. The knights of the following English orders are invested with a collar : the orders of the Bath, St. Michael and St. George, and the Star of India.

Collar-beam. (Arch.) A horizontal beam connecting a pair of rafters above their point of support.

Collared. (Her.) This term is applied to an animal depicted on a shield with a collar about its neck, or in the case of an ape about its loins. The French term is *accolé* (q.v.), which has also another meaning.

Collarino. (Arch.) That part of the capital in the Roman Doric and Tuscan orders which is included between the fillet below the ovolo and the astragal at the top of the shaft. The collarino is not found in the ancient orders, except in a few buildings of the Ionic style.

Collection. A term given to a number of pictures, drawings, prints, and objects of art or curiosities belonging to one person, by whom they have as a rule been got together. These are private collections, but the name is also applied to the treasures amassed by public bodies and kept in public museums.

College. (Arch). A building or collection of buildings established for the education of youth. The colleges at Oxford and Cambridge are among our most interesting architectural monuments. They usually consist of one or more quadrangles, with buildings ranged round them, in which the fellows and students live, as well as a chapel, a library, and a dining-hall.

Collegiate Church. [Church, Collegiate.]

Collodion. A solution of gun-cotton in ether, a thin coating of which was spread on photographic glass plates before the invention of plates prepared with gelatino-bromide.

Cologne Earth. (Paint.) A pigment obtained from a bituminous earth resembling sepia. It is chiefly used for making sketches in which broad effects are aimed at.

Colonnade. (Arch.) A number of columns symmetrically arranged in one or more rows. The columns are surmounted by an entablature or a series of arches according to the style of the building. 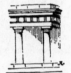 The term *colonnade* is also applied to porticos. This form of decoration was in general use in ancient architecture, and is also found in modern buildings of the classic style. The west front of St. Paul's, the work of Sir Christopher Wren, may be mentioned as a good example of a colonnade.

Colonnette. (Arch.) A column, the diameter of which is very small in proportion to its height. Colonnettes are frequently used in buildings of the Gothic style to support arcades, and when clustered form piers.

Colossal. Monuments, statues, or works of art are termed colossal when they are of extraordinarily vast dimensions.

Colossus. A statue of colossal dimensions, such as were the Egyptian figures of Osiris and the Sphinx. The statue of Apollo erected at Rhodes was a colossus. Such, too, is the enormous statue of *Independence* executed but just now by the French sculptor Bartholdi, and set up at the entrance to New York harbour in America.

Colour. (Paint.) Colour in a general sense is the impression produced upon the eye by coloured substances. In a more special sense it is the effect produced by the arrangement of colours in a picture. Thus we say, " The Venetians have the genius of colour." Colour is not only applied to drawings, in which objects

are modelled by means of different tints, but also to those in which the effect is produced only by means of contrasts of black and white. An engraving or lithograph, for instance, without any other tone but black and white, may be more full of colour than a painting, if it produces a more brilliant effect than the latter.

Colour, Bronze. A colour of a greenish or reddish tint.

—, **Flame.** A warm brilliant shade of red.

—, **Flesh.** A colour of a pale red tint, mixed with rose, white, yellow, and sometimes with bluish grey in its shaded portions.

—, **General.** A term applied to the tonality (q.v.) of a whole picture.

—, **Livid.** A leaden tint, blue, violet, or green, approaching to black.

—, **Local.** The colour which belongs to a special object. The romantic school extended this expression to mean the accurate presentment of site, costumes, and accessories. When Decamps represented for the first time the true Turks of Asia Minor instead of the conventional Turks with their garments decorated with a sun, he gave us an example of local colour.

—, **Pearly.** A colour of a very fine and harmonious grey tone.

—, **Shot.** A colour which varies according to the angle at which it is seen.

—, **Wood.** Wood colour is a yellowish brown tint. When we say that a figure is *wood colour*, we mean it is heavy and false and disagreeable in tone. Dark wood colour is frequently used in industrial art to give to common white woods the appearance of darker and more valued woods.

Coloured. When certain surfaces either in a drawing or engraving are covered with colour they are said to be *coloured*. The engraved plates in scientific works, for instance, are frequently copied from models and coloured by hand. This method of *colouring* is as a rule unsatisfactory and has a tendency to fade. In fact it is now generally replaced by chromolithography (q.v.). In cheap publications a process of colouring has been invented which is nothing more than mechanical, but it can only be applied with satisfactory results to surfaces of considerable extent. It consists in the employment of different patterns cut out in linen like vignettes equal to the number of the colours which are to be applied. The operator, by means of *leading points*, places the pattern on the engraving which he desires to colour, and passes a sponge impregnated with the necessary colour over the whole print, the colour only adhering to the vacant space where the pattern has been cut out. This operation is repeated as many times as is necessary, either before or after the drying is complete; in the former case an effect of blending can be obtained. In spite of the careful management which is essential to this process it is inexpensive.

Colouring. (Paint.) The general effect produced by the colours employed in a painting. When we say that the *colouring* of a picture is violent, bold, sad, fine, delicate, we refer to the sensation which the *colouring* produces in us.

Colourist. (Paint.) A painter is termed a colourist when he prefers to aim at grand effects of colour, and to excel in giving his works a mingled brilliance and harmony. The painters of the Venetian School are most celebrated as colourists, and among them Titian and Veronese must first be mentioned. After them come Ribera and Velasquez of the Spanish School, Rubens and Rembrandt of the Flemish and Dutch Schools, and Eugène Delacroix of the French School. The modern English School has produced several artists eminent in colour, the Pre-Raphaelites being especially entitled to mention.

Colours, Blended. The effect obtained by the passing of one colour or tone to another by means of imperceptibly graduated shades or tints.

Colours, Complementary. Colours the combination of which produces white light. According to the laws of physics the complementary colour to green is red, that to blue is orange, that to purple is yellow, and *vice versa*. In practice the combination of complementary colours does not produce pure white at all, but grey.

—, **Heraldic.** (Her.) Heraldic colours, as distinguished from the heraldic metals and furs, are five in number: azure or blue, gules or red, sable or black, vert or green, and purpure or purple. In blazoning they are thus abbreviated: az., gu., sa., vert, and purp.

—, **Light.** Colours which by the addition of white remain clear.

—, **Primary.** Primary colours, which cannot be compounded by mixture of other colours, are three in number, red, yellow, and blue. They are also termed *primitive*.

—, **Prismatic.** A term applied to the seven simple colours, purple, indigo, blue, green, yellow, orange, and red, which result from the decomposition of a ray of light by means of a prism.

—, **Relative.** (Paint.) Colours which blend easily and produce harmonious tones.

—, **Secondary,** are three in number. Each of them is formed by the mixture of two of the three primary colours: thus, orange from red and yellow, green from blue and yellow, purple from red and blue.

—, **Symbolic.** In the works of early Christian painters certain colours symbolised or were exclusively associated with certain persons or subjects. For instance, *white* was the symbol of light, purity, and faith, while *black* suggested mourning, wickedness, and death. As art freed itself from the trammels of tradition this symbolism was soon forgotten or neglected.

—, **Tertiary.** Colours, variable in number, which enter into the composition of another colour.

Colum. A strainer for wine in use among the Greeks and Romans at an

early date. It was adopted by the Christian Church for straining the sacramental wine.

Columbaria. (Arch). The recesses in ancient tombs in which the urns containing the ashes of the dead were placed. They got their name from their supposed resemblance to dove-cots. The term is also applied to holes left in a wall for the insertion of timbers.

Column. (Arch.) A cylindrical support placed vertically, consisting generally of three parts: the base, the shaft or cylindrical portion, and the capital.

—, **Attic.** (Arch.) A column decorating an attic storey above the entablature.

—; **Cantonned.** (Arch.) An engaged column placed at an angle to strengthen a pillar and to support the spring of an arch.

—, **Composite.** (Arch.) A column surmounted by a composite capital.

—, **Corinthian.** (Arch.) A lofty column with the proportions of the Corinthian order. [Corinthian.]

—, **Cylindrical.** (Arch.) A column of constant diameter, the outline of which is determined by parallel lines.

—, **Diminished.** (Arch.) A column having the diameter at its base greater than its diameter at its capital. Doric temples offer the finest examples of diminished columns. The diminished column, which forms a truncated cone, was entirely abandoned in the 17th and 18th centuries and replaced by the *swelling* column.

—, **Doric.** (Arch.) A lofty column with the proportions of the Doric order. [Doric.]

Column, Embedded. (Arch.) A column partly lost in the vertical wall against which it is placed. It is called a half column when half of it is *engaged* and the projecting portion is a semicircle.

—, **Engaged.** [Column, Embedded.]

—, **Flanked.** (Arch.) A column surrounded by pilasters.

—, **Fluted.** (Arch.) A column the shaft of which is ornamented with flutings.

—, **Gnomonic.** A column upon which a dial plate is placed.

—, **Gothic.** (Arch.) The name given to the clustered columns, forming a pier, which are used in Gothic buildings.

—, **Grouped.** (Arch.) A group of at least three columns placed upon a single pedestal.

—, **Hermetic.** (Arch.) A column covered with hieroglyphics placed in the most secret portion of an Egyptian temple.

— **in bands.** (Arch.) A column formed of drums placed one upon the other, the height of which is less than the diameter.

— **in trencheons.** A column formed of drums placed one upon the other, the height of which is greater than the diameter.

—, **Ionic.** A lofty column with the proportions of the Ionic order.

—, **Manubiary.** A column the shaft of which is decorated with trophies.

—, **Menian.** A column the capital of which is surmounted by a gallery or balcony.

—, **Miliary.** A column placed on Roman roads at regular intervals of a thousand paces.

—, **Monumental.** A column erected in memory of a great person or event.

—, **Nicked.** A column set back in a vertical wall in such a way that a clear space is left between the wall and the shaft of the column from base to capital.

Column, Oval. (Arch.) A flattened column, the section of whose shaft is an ellipse.

—, **Paestian.** A lofty column with the proportions of the Doric columns of the temple of Paestum.

—, **Pastoral.** A column the shaft of which resembles the trunk of a tree.

—, **Polygonal.** (Arch.) A column the shaft of which is polygonal.

—, **Ringed.** (Arch.) A column decorated with annulets in relief.

—, **Rostral.** (Arch.) A column with its shaft decorated by the prows of galleys.

—, **Rustic.** (Arch.) A column the shaft of which is decorated with projecting rustic work.

—, **Serpentine.** (Arch.) A column formed of interlaced serpents.

—, **Statuary.** A column surmounted by a statue.

—, **Swelling.** A column in the form of a prolonged spindle. Its diameter is the same at its base and capital, but increases considerably towards its centre. Sometimes the *swelling* is only observable in one-third of the height of the column.

—, **Triumphal.** A column erected in memory of a great victory.

—, **Tuscan.** A lofty column with the proportions of the Tuscan order.

—, **Twin.** (Arch.) A support consisting of two columns of the same diameter, placed side by side or welded together from base to capital.

—, **Twisted.** (Arch.) A column the shaft of which is made up of several spirals. According to Vignole this column should not consist of more than six spirals. There are, however, many examples of the twisted columns, the number of whose spirals exceed that laid down by Vignole. The twisted column is chiefly used in cabinet-making, the decoration of furniture, &c.

Columna Bellica. A column of the

temple of Janus at Rome before which proclamations of war were issued.

Columns, Clustered. (Arch.) A collec-

tion of columns in juxtaposition or welded together, which form a pier in Gothic architecture. The plan of some clustered columns exhibits complicated combinations of arcs of circles and squares, which serve to detach the columns from one another.

—, **Coupled.** (Arch.) Columns placed two and two, side by side, no account being taken of the rules by which the intercolumnation is fixed. The purpose of this arrangement is not only to

increase at certain points the actual resistance of the supports, but to render this resistance more evident. Sometimes the abacus (q.v.), extends without a break over the two capitals.

—, **Doubled.** Columns placed one before the other in the same plane at right angles to a façade.

—, **Median.** Columns placed in the centre of a portico, and separated from one another by an intercolumniation greater than the space between the other columns in the same range.

Comet. (Her.) A star with a fiery tail. The star may have five or more points, and the tail always streams behind it *in bend*. A comet is usually blazoned *or*, but may be equally well blazoned *proper*.

Commission. A work of art is said to be executed *on commission*, or is called

briefly *a commission*, when it is ordered by a collector, a municipality, or by the state, and has to conform to certain conditions laid down in advance.

Common-place. Said of works of art in which the figures lack distinction either in line or colour, or in the choice of subject.

Common Wall. (Arch.) A wall which serves to divide two adjoining properties, and half of which belongs to each of the proprietors.

Compass. An instrument used to measure dimensions or describe curves. Compasses, generally of metal, consist of two branches or legs, joined by a rivet at the top, and terminating at their lower end in a point. One of these points is movable and can be replaced by a

drawing-pen or pencil-case. Large compasses of wood are used to trace diagrams. Sculptors sometimes use large compasses of iron, the two branches of which move on an arc of a circle, sometimes compasses with unequal and crooked branches which allow them to take the measure of concave surfaces.

Compasses, Elliptic. Compasses the purpose of which is to trace elliptic curves.

—, **Sector.** Compasses consisting of two branches connected by a movable button, each branch terminating in a point.

—, **Spherical.** Compasses with curved branches.

—, **Trisection.** Compasses which are intended to divide angles into three equal parts.

Compasses with fixed points. Compasses both branches of which are sharpened to a point and which only serve to take the measurements of a drawing.

Compass-roof. (Arch.) A roof which extends the whole width of a building from one wall to the other. It is used in opposition to a lean-to roof, and is especially applied to open timber-roofs. [Span Roof.]

Competent. An amateur, collector, critic, or expert is *competent* when special studies added to natural taste have rendered him capable of a sound judgment and appreciation of works of art.

Complementary. Two colours are said to be complementary to one another, when their combination, according to the laws of optics, produces white. Thus, red is the complementary colour of green, while blue has orange for its complementary colour, violet yellow, and reciprocally.

Complex. A term applied to works of art comprising several distinct elements, the composition of which requires the union of qualities generally very diverse.

Complicated. A term applied to works of art or compositions which are confused and embarrassed, or encumbered with too great a mass of details or accessories, and which aim at expressing too subtle motives.

Compluvium. (Arch.) In a Roman house the compluvium was the open space in the roof of the atrium (q.v.), through which the water fell into the impluvium (q.v.).

Compony, or **Gobony**. A term applied to a border or other ordinary divided into small squares of alternate tinctures. For example, the accompanying cut would be blazoned *argent, a bend sinister, compony gules and sable.*

Compose. To *compose* is to combine the numerous elements of a work of art, so that the subject is presented in a manner which is easily intelligible, and that the arrangement of the figures, the disposition of the groups, the equilibrium of the masses, and the light and shade produce a general effect of graceful lines and harmonious colouring, which contribute to the unity of the work.

Composite. (Arch.) An order of ancient architecture, the character of which is specially determined by the capital composed of volutes and acanthus leaves, and produced by the combination of the Ionic and Corinthian capital.

Composition. (Arch.) The composition of a statue or picture is good or bad in proportion as the lines and groups are happy in arrangement, the attitudes are probable, and the scene free and unstudied. A view of a town, for instance, *composes* well when the succession of buildings exhibits a graceful and picturesque outline. A landscape is well *composed* when the trees, the distances, and the foreground represent masses well weighted and pleasant to the eye.

Concentration of Effect. An arrangement of light and shade by means of which the artist attempts to draw attention to one particular spot in preference to other portions of his picture, which are intentionally neglected or sacrificed.

Conception. The faculty of conceiving, understanding, and creating a work of art. We say, for instance, that the conception of a picture is bold, happy, or undeveloped, &c.

Conch. The shell used by the Tritons on ancient paintings and reliefs; hence in decorative art an ornament resembling the shell in shape.

Conduit. (Arch.) A small aqueduct or pipe to drain off water.

Cone. A solid figure formed by the rotation of a right-angled triangle round one of its

99

sides as axis. The term *cone of light* is applied to the divergent rays of light escaping from a very small circular opening.

Confessional. (Arch.) A kind of enclosed retreat devoted to confession, the use of which does not go farther back than the 15th century. In the 17th and 18th the confessional was an important element in the interior decoration of churches. There is no specimen of a confessional left in England which belongs to the period before the Reformation, and therefore we are unable to say what form it took in this country in early times. In those parts of the Continent where catholicism reigns, confessionals are as a rule unpretentious structures of wood resembling sentry-boxes, and fitted with a lattice. Some churches in Belgium possess confessionals of wood decorated by caryatides and covered with sculptured canopies marvellously rich in ornament.

Conical. That which has the form of a cone.

Connoisseur. A term applied to a man capable of giving a certain and well-grounded judgment on one branch or other of the fine arts.

Console. (1) A piece of furniture in the shape of a table which is supported by feet, colonnettes, balustrades, &c., according to the epoch to which it belongs.

It generally occupies a fixed place before a window or mirror. The consoles of the period of Louis XIV. and Louis XV. are masterpieces of decorative sculpture.

Console. (2) (Arch.) A projecting architectural motive, which supports still further projecting mouldings, cornices, balconies, &c.; and is generally decorated with volutes at each end, which curve in different directions.

Console, Reversed. A console sometimes employed as a support, but more often to fill a vacant space between two surfaces, one of which retreats behind the other, and so to connect two architectural members. The lower portion of the console, which is placed vertically, not horizontally, is occupied by a scroll. The reversed console is never found in classical buildings, but only in those belonging to the period of decadence.

Construction. The art of employing materials in a building according to their character and quality, so as to combine solidity and convenience.

Contour. An outline or line which defines a figure or other object, whether drawn or sculptured.

Contourné (Her.) This term is used to describe a charge which is reversed on the shield, that is to say, placed in a position the opposite to its usual one. Thus animals should always face to the dexter, so that the fish in the cut is *contourné*.

Contrast. (Paint.) An intentional opposition between several portions of a picture, by reason of which each portion has its proper value and their distinct qualities are sufficiently evident.

Contrast of Colours. When two strips of paper of the same colour but of different intensity are placed side by side that portion of the lightest strip which touches the darkest strip appears lighter than it really is, while the portion

of the darkest strip which touches the lightest strip appears darker than it is. That is, the juxtaposition of colours changes their effect. Furthermore each colour has a tendency to assume the colour complementary to the colour next to it. The discovery of this law of the simultaneous contrast of colours is due to M. Chevreul. There is one remark to add: if two bodies contain a common colour, the effect of their juxtaposition is to weaken the intensity of their common element. The laws of optics which regulate this simultaneous contrast of colours may be formulated thus: 1stly. Every colour has a tendency to tinge the colours near it with its complementary colour. 2ndly. If two objects contain the same colour, the effect of their juxtaposition is to weaken the intensity of their common element.

Contre-corbeau. (Arch.) A French architectural term used in the architecture of the 13th century, denoting a medallion replaced between the corbels supporting the springing of an arcade and serving as a point of support for two small arches inscribed with the large one.

Co-operator. An artist who assists in the execution of a work of decorative art, but takes no part in its creation.

Cop. (Arch.) [Merlon.]

Cope. An ecclesiastical vestment generally made of a stiff and costly material and ornamented with embroideries or jewels. It is semicircular in form and has a hood but no sleeves. It was originally a protection against inclement weather and was worn by officiating clergy at vespers, mass, celebration and consecration. It was fastened by a clasp and adorned with apparels (q.v.) richly embroidered and even resplendent with jewels.

Coping. (Arch.) A term given to the stones on the top of a wall, which protect it from the weather. From the stress of weather to which they were exposed, ancient copings are extremely rare, and few have come down to us earlier than

the Early English period. In buildings belonging to the Gothic period, a coping in the form of a small wall supporting a roof is placed behind a balustrade which runs along by a gutter, as is shown in the cut.

Copper. A metal which has proved of the greatest value in the arts. In the first place it was used by the ancients in the manufacture of shields, swords, vases, &c. In modern times it has been of the utmost service to engravers, and still remains from an artistic point of view the best metal both to work upon with the burin and to print from. The oxides of copper yield a number of fine pigments, such as blue verditer and Brunswick green.

Copper-plate. (Engrav.) A plate of red copper, planed and polished, with its edges bevelled and its corners slightly rounded, upon which engravers execute their work. The term is often applied to the completed work; thus we speak of a "successful copper-plate" in referring to the engraving itself.

Coptography. The art of cutting out

pieces of card so that when brilliantly lighted they throw shadows representing figures and objects of all kinds on a white surface.

Copy. A reproduction of a work of art. If a painter copies his own picture, it is dignified with the name of a *replica.*

Copy, To. To make copies of pictures or to imitate the works, subjects, and manner of an artist.

Copyist. An artist who copies or reproduces either for the purpose of personal study or with some other avowed object the work of another artist.

Copyright, Artistic. Copyright is a distinct and valuable property recognised by law, and may be defined as the sole and exclusive right of multiplying copies of an original work after it has been published. This right is by law vested in the author of an original painting, drawing, or photograph and his assigns for the term of the natural life of the author, and seven years after his death, provided that on the first sale of such painting or drawing or the negative of such photograph the copyright was expressly reserved to the vendor by agreement in writing signed by the purchaser. A register of proprietors of copyright in paintings, drawings, and photographs is kept at Stationers' Hall, and registration is compulsory. In the case of sculpture, the copyright, whether commissioned or not, belongs to the author for fourteen years, provided that before publication he inscribes his name and date on every model copy, or cast, or finished work. If at the end of fourteen years the proprietor is still living, he may, unless he has divested himself of the right, retain it for a further period of fourteen years. A registry of sculpture is kept at the Patent Office, and every copy or cast published after registration must be marked "registered." The sculptor, however, cannot protect himself against paintings, drawings, engravings, or photographs.

Coquerelles. (Her.) A French heraldic term applied to a bunch of three filberts in their husks conjoined together. Coquerelles generally appear in number on shields, for example, *three coquerelles gules.*

Coquetries. A term applied to elegant scenes, graceful figures, painted in a bright and fresh tone.

Coral. A calcareous product of the sea of a fine red colour used in making all kinds of ornaments. A fine clear red, vivid and brilliant in tone.

Corbel. (Arch.) A projecting stone, the purpose of which is to support a cornice, the springing of an arch, or the projection of a gallery. The corbels of the 10th, 11th, and 12th centuries are decorated

with figures of men and animals, representing symbolic subjects. In the 13th

century corbels disappeared from cornices, and were used only as supports to balustrades, machiolations (q.v.), the springing of transverse ribs (q.v.), or to serve as the point of support. There are numerous examples of wooden corbels in the civil architecture of the Middle Ages, and very often these corbels are placed in the upper part of the building, and uphold the projecting cornice.

Corbelling. (Arch.) Generally speaking, a projecting construction supported by the courses of a wall jutting out, one above the other, or by beams or corbels resting on a wall. The fronts of a great

number of Gothic houses present examples of *corbelling.* Each story juts out beyond the one below it, so that when the streets are narrow and the gables high the top stories of the houses ap-

proach so near to one another as to almost touch. The galleries, passages, arcades, and towers of many Gothic buildings are similarly designed, projecting beyond the surface of the wall, and resting upon corbels, consoles, or decorated mouldings.

Corbel-table. (Arch.) A series of corbels placed at regular intervals to support a parapet or any continuous projection.

Corbie (Arch.) A Scotch term applied to the *steps* in the roof of a gabled house.

Cordon. (Her.) This term is used in French heraldry to denote the cord with tassels suspended round the shield of an ecclesiastic by way of crest. It is supposed to represent the girdle worn by the religious orders.

Core. The interior of a mould employed in the founding of a statue. The metal runs between the core and the mould, and when the work is complete the core is removed through an aperture left for the purpose. [Founding.]

Corinthian. (Arch.) An antique order of great richness, the character of which is invariably determined by a capital decorated by two rows of acanthus leaves, between which small volutes are inserted. [Capital, Corinthian.]

Corium. Body armour composed of leather is called *corium.* It is frequently made to imitate scale armour, as in our cut, which is from Trajan's column. It was worn by the Romans, but its use continued far into the Middle Ages.

The Saxons wore it, and representations of it are found in the Bayeux tapestry.

Corner (Arch.) Angle or sharp edge of a block of stone or wood. The term is also used to denote an angle formed by

two walls meeting at right angles or disposed cantwise. The term *corner* cupboard is applied to a piece of furniture of triangular shape, which is placed in an angle formed by the meeting of two walls.

Corner of the Abacus. (Arch.) The projection of the entablature in capitals of the Corinthian order and in certain Ionic capitals of the Renaissance of the 17th and 18th centuries, of which the four surfaces are symmetrical.

Corner-post. (Arch) an architectural member placed at the angle or corner of a building.

Cornice. (Arch.) The upper part of an entablature which projects beyond the frieze. A large moulding, which forms the coping of a façade or portion of a façade, runs round an apartment underneath the ceiling, or surmounts a door, window, dresser, &c. The

103

term is also applied in Gothic architecture to the high moulding, sometimes

decorated with foliage, which extends

along a façade at the height of a story or the rise of a tower.

Cornice, Architrave. A cornice placed immediately upon the architrave where no frieze exists in the entablature.

—, **Broken.** A projecting cornice which is interrupted by sculptured ornaments, pilasters, &c.

—, **Centred.** A cornice which follows the outline of a circular pediment or describes a curve.

—, **Chamfered.** A cornice without a moulding formed by a simple bevel on the angle of projection.

—, **Mutilated**. A cornice which is placed upright upon a corona (q.v.).

—, **Unbroken.** A projecting cornice which runs the whole length of a façade, and is not broken by any sculptured ornament or vertical architectural member.

Cornucopia. An ornament consisting of a horn, in which are flowers, fruits, and other natural objects. It symbolises peace and pros-

perity, and in classical art was associated with those deities, which had power over the natural world.

Corona. (Arch.) A slight projection in a roof which serves to protect part of a building from the running of water. In old houses *coronae* are often found over each opening. In classical architecture the term is applied to the pro-

jecting moulding which forms a cornice. The horizontal surface of a corona is

sometimes quite simple and sometimes enriched by coffer-work, mutules, or corbels. The edge of the corona always

projects so that the water falls clear to the ground and does not wear out the

outline of the corona. In ecclesiastical decoration the term is applied to a crown, hanging from the roof, in which lighted tapers are placed at important ceremonies.

Coronet. (Her.) A coronet is an ornamented fillet of gold worn above the coats of arms of peers and peeresses. In a *duke's* coronet, here shown, the circlet of gold is chased and is surmounted by

eight strawberry leaves. The coronet of a *marquis* has four strawberry leaves separated by pearls. A *viscount's* coronet is a rim of gold surmounted by sixteen pearls, while a *baron's* has only six or four pearls, and is otherwise plain.

Coroplastae. Literally, "modellers of dolls." A name given by the Greeks to the fashioners of small images in clay or terra-cotta. The artists, for instance, to whom we owe the Tanagra figures (q.v.) were *coroplastae.*

Correct. A term which is principally applied, as regards drawing, to purity and exactness of form. A drawing may be absolutely correct and yet devoid of significance. In the work of some artists correctness is a negative quality.

Corridor. (Arch.) A long passage running round a building, which leads to the various rooms in the building; sometimes it is closed on both sides, sometimes on one only.

Corundum. A chemically pure *alumina.* A precious stone, hard and transparent.

Cosmorama. An exhibition of pictures representing views of different countries, either in body-colour, water-colour, or oil, and seen through a lens. The first *cosmorama* was set up in Paris in 1808 by the Abbé Gazzera.

Cost. [See Cotice.]

Costume. This term denotes in a general sense the clothing, arms, and accessories belonging to the epoch or place in which the artist has laid the scene of his picture. Thus we say of an artist that he "pays no attention to costume," that he "carefully studies the costume," that "his rendering of costume is admirable."

Cothurnus. (Cost.) A high boot worn by the Romans, reaching to the middle of the leg. It was particularly characteristic of the tragic actor. [Buskin.]

Cotice. (Her.) A diminutive bend. The diminutives of the bend are the *bendlet* or *garter*, which is half the width of the bend, the *cost* or *cotice*, which is half the bendlet. The *riband* is sometimes half the cotice, sometimes the same width, but does not extend to

the edge of the shield, its ends being *couped* (q.v.).

Cotised. (Her.) When an ordinary, such as a fess or a bend, is bordered on both sides by a strip of a different tincture to itself, it is said to be *cotised.* In the first of our cuts, for instance, we have a *bend sinister gules cotised sable.* But the term is not necessarily confined to the case of two strips, but may also be used to describe any border to a charge. Thus the accompanying cut would be blazoned, *Argent, a bend gules cotised with trefoils sable.*

Cotyliscus. (Pot.) A name given to a small Greek vase with one handle. It was used to hold liquids, and in its general shape resembled an amphora. The latter, however, was doublehandled, and considerably larger than the cotyliscus.

Coulisse. A groove made in the boards of a stage in which the

side scenes are moved along. The term

is also applied to the side scenes themselves, which represent a palace, a cotage, a clump of trees, &c.

Counter - changed. (Her.) When a shield bearing charges is divided by a partition line, so that part of the field is a colour and part a metal, then the charges are *counter-changed ;* that is to say, their tinctures are reversed so that metal may not fall on metal, nor colour on colour.

Counter-draw. [Tracing.]

Counterfeit. A reproduction or fraudulent imitation of a print or any other work of art.

Counterfeit, To. To counterfeit is to reproduce, copy, or imitate a work of art with intent to pass off the counterfeit as the original.

Counter-knocker. (Arch.) The plate of metal on which a door-knocker strikes.

Counter-mark. (Numis.) A sign engraved or struck upon a coin after the coin itself has been struck.

Counter-part. The empty space intended to receive the inlay in marquetry work. The term is also applied to scenes or figures, which in composition or attitude resemble scenes or figures already executed, but in the reverse direction.

Counter-passant. (Her.) Said of two beasts passing each other in opposite directions.

Counter-pilaster. (Arch.) A pilaster placed in front of another pilaster.

Counter-plate. (Engrav.) A second plate on which certain parts of a print are engraved which were left untouched on the first plate.

Counter-potent. (Her.) One of the heraldic *furs*, in which the *potents* or crutch heads are arranged head to head as in counter-vair.

Counter-profile. The outline of a moulding.

Counter-proof. (Engrav.) The proof of an engraving reproducing the original the reverse way. A counter-proof is obtained by placing over the original proof while it is still wet a sheet of blotting paper, which takes up the ink, and so produces a reversed impression. We also term any painting or engraving a counter-proof which is a reverse reproduction of the original.

 Counter-vair. (Her.) One of the heraldic *furs*. It differs from *vair* by having its bells or cups all of the same tincture, and placed base to base and point to point.

Couped. A charge is said to be *couped* when its ends are cut off so that they do not reach to the edge of the shield The term is also applied to a charge the ends of which are cut off evenly, in opposition to erased (q.v.).

Couples. (Constr.) Rafters framed together in pairs connected with a tie. This method of framing is frequently used in country houses in Scotland.

Course. (Arch.) A range of stones or bricks of uniform size running continuously in the wall ot a building.

—, **Belting.** (Arch.) A pillar of brick or stone, projecting little or not at all, used for the purpose of holding a wall together. Belting courses are always toothed that they may the more

solidly unite with the wall which is built up round them.

Couteau de Chasse. The hunting-knives in use in the 16th and 17th centuries were notable works of art. Their hilt and sheath was generally elaborately carved. The sheath contained besides the knife itself several instruments, such as a fork and bodkin, which might be of service to the hunter. These may be observed in our cut, which represents a *couteau de chasse* from the once famous Meyrick collection.

Cover a Canvas, To. (Paint.) To paint with rapidity. A term not always used in a good sense. Many artists, when they have settled upon their design and are beginning to paint their figures, often lightly *cover* their canvas with some neutral tint, which serves as a temporary ground and relieves their eye from the chalky tone of the canvas.

Coverchief. (Cost.) A complete covering for the head worn in the 11th, 12th, and 13th centuries by English women of every class.

Cowl. (Arch.) A pipe of earthenware or iron in the shape of a cone, placed on the top of a chimney-pot to regulate the draught. Sometimes cowls are furnished with weathercocks, which, by their rotatory movement, prevent the wind blowing down the chimney.

Crack. A small slit or surface chink which appears in vaults or, on panels painted in oil. In the latter case they are caused by dampness and excess of heat and cold, and increase in proportion to the bad quality of the colours or varnish employed.

Crackle. (Pot.) A kind of pottery the enamelled surface of which is covered with a network of irregular cracks. This method of decoration was only attained with considerable difficulty. Specimens of Japanese crackle are very highly valued.

The *traité* crackle, so called because it resembles the scales of a trout, bears the name of tsoni-yem. In many pieces of Chinese manufacture the crackle is filled in with a variety of colours.

Cracowes. (Cost.) Shoes with long toes, which generally turned upwards, and were often fastened to the knee by chains. They were first worn in the 14th century at Cracow, in Poland, from whence they spread all over Europe. It was thought necessary in England to pass a law limiting their length. Our cut, representing a man wearing cracowes, is from a manuscript in the British Museum.

Cradle. [Rocker.]

Cramp. (Arch.) A piece of iron sunk in masonry, which holds together two

blocks of stone placed either upon one another or side by side.

Cramponné. (Her.) A charge is said to be cramponné when it terminates in a cramp. Thus we speak of a *potence cramponné, a mascle cramponné.* It is cramponné dexter or cramponné sinister, according to the side upon which the cramp is placed.

Crancelin. (Her.) A coronet extended *in bend.* The word is of German origin and signifies a garland of flowers. It is borne in the arms of Saxony, and the Prince of Wales quarters it in his shield.

Crater. An antique vase in the shape of a truncated cone, which stands upon a hemispherical base and is double handled. It was used for mixing wine and water. The name crater is sometimes given to drinking cups. In ancient times craters were made of silver or bronze, and were very large in size.

Crayon. Small cylinders of chalk or some other material, which are used for drawing purposes. Black crayons are composed of chalk and blacklead, red crayons of ochreous clay containing red iron oxide, while white crayons are simple sticks of chalk. A drawing executed in black crayon is sometimes called a crayon or chalk drawing. In lithography an oily kind of crayon is used composed of a mixture of soap, wax, tallow, and lampblack. It is non-resisting and is very difficult to cut.

Craze. (Pot.) A term which denotes the cracking of the glaze on a piece of pottery, caused either by imperfect fusion or by the too sudden removal of the pottery from the kiln.

Credentia. A piece of furniture consisting of several shelves one above the other. The ecclesiastical credentias of the Middle Ages were sometimes circular in form, and upon them were placed

the vessels used in the services of the Church. At the time of the Renaissance

and in the 17th century they were lavishly decorated with sculptured reliefs and

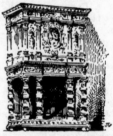

other ornaments, and made the receptacle for gold and silver plate.

Cremnitz White. (Paint.) A white pigment composed of pure white lead. It is the brightest white used in oil painting, but has less body than flake white. It is also termed Vienna white, as it is manufactured in Vienna.

Crenellated. Embattled. [Battlement.]

Crenelle. (Arch.) A term properly

applied only to the loopholes in à battle-

ment, but also used to signify the battlement itself. The adjective *crenellated* is used of a building which is furnished with a battlement as a means of defence. [Battlement.]

Créquier. (Her.) A French heraldic term applied to a chandelier of seven branches, sometimes borne as a charge. The word créquier is an old French word for a plum-tree, but it is now only employed in the sense just defined.

Crescent. (Her.) A common charge in heraldry, and also a mark of difference used to distinguish the second son. It is said to be *reversed* when its horns are

turned to the bottom of the shield; *increscent* when they look towards the dexter side; *decrescent* when they look towards the sinister.

Crest. (Her.) In heraldry the term crest denotes any addition such as a helmet or a crown placed above the shield. In the case of an ecclesiastic the crest is a

pastoral staff or else a cap. Both the cuts here given represent ecclesiastical crests.

Creste. (Arch.) A pierced leaden ornament placed vertically on the ridge of a roof. Many churches, as well as buildings erected for civil purposes, in

the Middle Ages and the period of the Renaissance have their roofs decorated with *crestes* richly ornamented and sometimes gilded.

Crevasse. (Arch.) An irregular crack in a wall running longitudinally.

Crimson Lake. (Paint.) A rich red pigment consisting of the extract of the coccus cacti insect, with oxide of iron as a base. It is more useful in water-colour than in oil-painting. It is not very permanent, and disappears under a strong light.

Criophorus. The word κριοφόρος means literally "one who carries a ram." It was the name given by the people of Tanagra to Hermes, who had saved them from a plague by carrying a ram round the walls. Examples of the *criophorus* are found not only in Greek art, but in Graeco-Roman and Christian art. Hermes especially is thus represented.

Crispin and Crispianus, SS. Two saints who left Rome with St. Denis to preach the gospel in France. During their mission they worked at their trade as shoemakers, and they are said to have been supplied with leather by angels. They are consequently the patron saints of shoemakers, and representations of them are frequently found in the shoemakers' guilds of France and Germany. They were long very popular saints in England. Their attributes are an awl and the palm.

Crispine. (Cost.) A head-dress; the mediæval form of the classical calantica (q.v.). It was fastened over the head by a clasp, and it is uncertain what its exact form was. By some writers it is described as a transparent veil, by others as a network to confine the hair.

Critic. A writer who examines, discusses, and expresses a judgment upon works of art.

Crock. (Pot.) A general term denoting any vessel made of clay. From this crockery is derived.

Crocket. (Arch.) A projecting ornament, often employed in Gothic architecture. It terminates in a curve or roll in the form of foliage or flowers. The

crockets of the 13th century have stalks of considerable length, and decorate not only roofs and gables but also cornices. In the 14th century they underwent some

change, assuming more varied forms. In the 15th century they became more florid and ornate, and were only used to decorate gables and bell-turrets, never cornices or horizontal mouldings.

Cromlech. A Celtic monument consisting of a series of menhirs (q.v.) ar-

ranged in a circle, in the midst of which stands a sun-stone (*hyrmensul*) or a druidical sphere (*feyra*).

Cross. (1) A cylinder or octagonal prism pierced by longitudinal slits, which with the help of stakes is used to trace straight or perpendicular lines upon the ground. The openings, which are opposite to each other, consist respectively of a straight slit and of a rectangle divided into two parts by a thread of silk. The visual ray passing through this slit, and the thread of silk covering a stake placed at some distance from it, are the points which determine the position of a straight line.

Cross. (2) (Arch.) In the days when England was a Catholic country, crosses, frequently of some architectural pretensions, were placed either in open spaces in towns or villages or by the roadside. Some few are still in existence, but the majority are sadly defaced. The cross of old St. Paul's was long celebrated, for it was from this that sermons were delivered. Crosses too were set up in England in commemoration of a notable event. For instance, the crosses named after Queen Eleanor were erected at every place at which her body rested between Lincoln and London, whither it was brought for interment. Market crosses built for secular purposes are still to be seen, at Salisbury and Glastonbury among other places.

Cross. (3) In Christian art the cross is the symbol of the Passion of Jesus Christ. In heraldry, the cross is an ordinary produced by a vertical band

meeting a horizontal band near the fess point, the four limbs thus formed being of the same width. When charged (q.v.) the limbs of the cross may be one-third of the width of the shield, otherwise one-fifth. No ordinary is subject to so many modifications of form as the cross. Only the principal forms of the cross are here given.

Cross, Anchored. So called because the four extremities of it resemble the flukes of an anchor. The cross anchored is much used in coats of arms, its frequency being due to the practice of crusaders, who, on returning from the Holy Land, in many cases changed their arms and replaced figures of animals by a cross.

—, **Batons.** A cross formed by the interlacing of four batons, placed slightly apart so that the field of the escutcheon is visible between. The batons are not necessarily all of the same tincture.

—, **Cablée.** A cross made of thick cords or cables interlaced.

—, **Calvary.** A Latin cross set upon three steps.

—, **Cercellée.** A cross the ends of which are divided and bent back on both sides so as to form a crook.

—, **Cléchée.** A cross *voided* so that the field of the escutcheon is visible. The limbs of this cross expand slightly from the centre towards the extremities, which latter are ornamented each with three pearls.

—, **Corded.** A cross the limbs of which are wound round with cord, yet so that the cords do not hide the cross.

Cross, Couped. (Her.) A cross is said to be couped when the limbs are cut off and do not extend to the edge of the shield.

—, **Crosslet.** In this cross each of the limbs is crossed again at a short distance from the end. It is a very common charge. It may be described as four Greek crosses joined together by a square.

—, **Eguisce.** (Her.) In this cross the four extremities are pointed by having the square corners cut off. It differs from the cross fitché, in which the limb gradually tapers to a fine point.

—, **Fimbriated.** A cross is said to be fimbriated when it is surrounded completely by a narrow band or hem of a different tincture to that of the cross or to that of the field.

—, **Fitché.** The lower limb of this cross tapers to a point from the centre downwards. The upper limbs may have any of the common forms, thus, for example, a cross-crosslet fitché. It is said that the early Christians carried fitched crosses in their pilgrimages, so that they could readily fix them in the ground and perform their devotions.

—, **Flory.** The limbs of this cross are terminated by fleurs-de-lis, and hence it is somewhat called a cross fleurdelisée. These crosses are frequently found in Spanish coats of arms.

—, **Fourchée.** This cross may best be described as a cross moline (q.v.) with the eight points cut off. It gets its name from the resemblance of its limbs to the forks or crutches (Fr. fourchette) on which soldiers used to rest their muskets.

Cross, Greek. A plain cross with four equal limbs. It is sometimes represented inscribed in a circle; for example, the robes of saints are often ornamented with a border composed of Greek crosses placed in circles. Most of the Eastern churches are built in the form of a Greek cross.

—, **Gringolée.** A cross the limbs of which are terminated each by two snakes' heads turned outwards. The term gringolée may also be applied to saltires or other charges ornamented in this way.

—, **Latin.** In this cross the lower limb is longer than the other three. Nearly all Romanesque and Gothic churches are built on the model of this cross. The nave takes the place of the long lower limb, the choir is the head of the cross, and the transepts are the two arms.

—, **Maltese.** A cross with equal limbs which widen from the centre outwards. The Knights of Malta, as heirs of the Knights Hospitallers of St. John of Jerusalem, bore this cross as the distinctive mark of their order. In heraldry this cross is more frequently represented with an indentation in the middle of the broad end of each limb, thus distinguishing it from the *cross patée,* and earning for it the second name of *cross of eight points.*

—, **Moline.** A cross the limbs of which are terminated by *fers de moulin* or *millrinds* (q.v.) It is not unlike the cross anchored, but the ends expand more, and sometimes the limbs are pierced as in the cut.

—, **Patée.** Like the Maltese cross this is composed of four equal limbs widen-

ing from the centre outwards. Sometimes the sides of the limbs are curved as in the accompanying cut, sometimes straight as in the Malta cross, but in either case the limbs in the cross patée are always terminated by a straight line.

Cross, Patriarchal. This is a Greek cross, the upper limb of which is crossed again, so that a double cross is formed. It is also called the cross of Lorraine, from the fact that it was borne by the dukes of that province.

—, **Pommée.** The limbs of this cross are terminated by a single ball. It is called by the French *cross bourdonnée* from *bourdon,* a pilgrim's staff, which was a long stick with its upper end rounded off in the form of an apple (*pomme*).

—, **Potent.** This cross has its four limbs crossed again at the ends, so that each is in the form of the letter T. The term *potent,* which is also applied to an heraldic fur, is an old English word for crutch (cf. Fr. *potence.*) The word still survives in Norfolk under the form of *pottent.*

—, **Processional.** A cross with or without the figure of Christ upon it, generally of metal, and carried at the end of a shaft or handle. As its name implies it is used in the ceremonial processions of the Roman Catholic Church. Processional crosses are often composed of precious metal adorned with gems. In the early days of the Church the large processional crosses were garlanded with flowers, each arm supporting a flaming torch, while swinging from the arms by

chains hung the letters A and Ω. Many fine examples of processional crosses are still preserved, notably at St. Denis, near Paris, where is to be seen a cross of the 12th century, of oak, covered with plates of silver and copper gilt.

Cross, Roadside. On the continent of Europe numerous roadside crosses, or calvarys, are to be found at conspicuous places, such as the meeting of four cross roads, the entrance to a village, &c. In England they were mostly destroyed by the Puritan iconoclasts.

—, **St. Andrew's.** The cross of St.

Andrew is in the form of the letter X. In heraldry it is more frequently described as a *saltire.* In woodwork a cross of this shape formed of two beams is constantly used to strengthen a rectangular structure.

—, **St. Anthony's.** The cross of St. Anthony is simply the letter T.

—, **Tau.** This is identical with the cross of St. Anthony. It takes its name from the Greek letter.

—, **Trefled.** A cross the limbs of which are ornamented at their extremities with three semicircles repre- senting the trefoil. It is sometimes called the cross of St. Lazarus, and in France the cross *fleuronée.*

Cross-bow. A weapon introduced into England in the 11th century. It dis- charged iron-shod arrows or burning

material to set fire to buildings. It was a very deadly weapon especially in the hands of the Venetians and Genoese. [Arbalest.]

Cross-cut. To cut across the edges of a piece of wood.

Crossette. (Arch.) The projection of a key-stone which is carried on above

the key-stone itself. The term is like-

wise applied to the projection of mould- ings which surround a bay.

Cross-hatch, To. To draw lines cross- ing other lines to obtain depth of shadow. [Hatchings.]

Cross-hatching. Lines or hatchings crossed by other hatchings.

Crossing. (Arch.) The part of a Gothic church west of the choir where the nave and transepts cut one another at right angles.

Crotala. Castanets of wood used in very ancient times, especially in the

mysterious worship of Cybele. They were also used by dancers to beat time with.

Crown. (1) (Her.) A crown differs from a coronet in being arched over, and being generally more elaborate. The distin- guishing feature of what is called the

imperial crown is the ball surmounted by a cross as shown in one of the accom- panying cuts. This feature is common to all countries, but other details are subject to variation. The other cut here given represents what is sometimes called the *royal* crown.

We give a few examples of various

kinds of crowns. The first cut represents the simple crown of bay leaves, worn in ancient Rome. Cut 2 is the mural crown, placed in ancient art upon the head of Cybele. Cut 3 is a radiated crown. Cut 4 represents the square crown worn by the Saxon kings. Cut 5

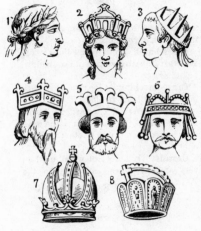

is the crown of King Edgar (A.D. 966). Cut 6 is the crown of William the Conqueror. Cut 7 represents the imperial crown of Germany, and cut 8 the crown of Charlemagne. The crown was the symbol of martyrdom as well as of kingship.

Crown. (2) (Arch.) A term applied to the highest point or vertex of an arch.

Crowning. (Arch.) A general word denoting anything that terminates a piece of architecture. For instance, cornices and pediments are *crownings*.

Crozier. The sign of office of an abbot or bishop, shaped like a crooked staff. The croziers in use in the early days of the church were of wood or ivory, and generally in the form of the T or tau. The croziers of the 13th century were of greater length, were made of either gold or silver, and were richly chased and otherwise ornamented. In the three

following centuries they were still richer in design, but in the 17th century they

assumed the bent appearance which they have ever since retained.

Crucifix. A representation of the punishment of Jesus Christ on the cross. The term is specially applied to the

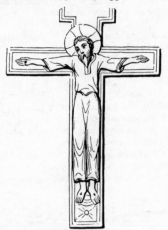

sculptured images which in Catholic churches are placed upon the altar. Before the time of Constantine the plain cross was used.

Cruciform. (Arch.) In the form of a cross. A church is said to be cruciform when the nave, choir, and presbytery form a cross with the two transepts. This is the ground plan of the majority

of Gothic churches. Churches of this plan generally assume the form of the Latin cross, but churches in the form of a Greek cross are sometimes met with.

Crude. (Paint.) a term applied to colours which owing to their unskilful distribution appear too violent and hard.

Cruets. The small vessels which contain the wine and water used in the celebration of the sacrament. It is ordered by the Roman Catholic Church that they should be of glass or some transparent substance, that the officiating priest might easily distinguish between the water and the wine. This ordinance, however, is not adhered to, and the *cruets* are frequently made of metal.

The term commonly denotes the vessels which hold condiments at table.

Crypt. (Arch.) A subterranean chapel generally vaulted, serving as a place of burial. Crypts were also built to keep alive the memory of the first Christian churches. In many English churches, such as Ripon and Rochester Cathedrals, the crypt is older than any portion of the superstructure. Among the finest speci-

mens of the crypt in England may be mentioned those of Canterbury and Gloucester. In the 13th century crypts were of a vast size, but in the 14th they disappeared. They were, however, reintroduced in the classical style, and a large crypt lies beneath St. Paul's Cathedral in London.

Cube. A regular solid body contained by six equal squares at right angles to one another. To find the cubic content of a wall is to calculate the number of cubic yards and feet which it contains.

Cuir-bouilly. Leather prepared by boiling, of which armour was made in the 13th century. It was employed principally for leg-guards and elbow-pieces.

Cul-de-Lampe. (Arch.) A French term denoting an ornament employed in ceilings or vaults. The effect of *culs-de-lampe* was sometimes heightened by painting or

gilding. In the 13th century they generally took the form of foliage; while in the 14th and 15th centuries they were frequently allegorical figures. In the 15th century they were used to support arches, and were then richly decorated.

At the period of the Renaissance *culs-de-lampe* uniformly consist of a circular capital terminated by a sculptured ornament.

Cul-de-Sac. An impassable alley. A street which has only one outlet.

Cup. A large vase of no great depth, with or without handles, mounted on

a foot. Cups are principally made of metal, but also of crystal or porcelain. Those given as prizes in certain competitions are often works of art and are richly ornamented.

Cupboard. A piece of furniture which in olden times served the purpose of a sideboard. It frequently took the form of a recess in the wall, fitted with shelves, upon which plate, &c., was set out.

Cupid. The god of love, the son of Aphrodite or Venus. Cupid (or E os as he was known to the Greeks) was a favourite subject with ancient sculptors, Praxiteles being especially famous for his statues of the god of love. He is generally represented winged and holding a bow and arrows. In works of decorative art, belonging to all ages, cupids or amorini are frequently found.

Cupola. (Arch.) A concave roof, generally circular in form. The term is applied indifferently to the dome and its interior. But for this there is no authority. Properly speaking the cupola is only the interior vaulting, and it is frequently on a different plane from the dome which surrounds it outside. Between the two

a considerable vacant space sometimes intervenes. The cupolas of St. Peter's at Rome and of the church of St. Sophia at Constantinople are built on this plan. A cupola does not necessarily presuppose a dome, while the latter is often found surmounting flat surfaces. The best example of a cupola in England is to be seen at St. Paul s Cathedral.

Curator. A functionary charged with the care of museums and of public collections of works of art.

Curiosities are ancient, rare, precious, or curious objects, which it is the delight and passion of amateurs and collectors to gather together. The term is a very comprehensive one, and includes all those objects in which the antiquary takes an interest.

Curtain. (1) (Fort.) As a military term this word denotes the parapet extending between and uniting two towers. The

word is occasionally applied in a similar sense in civil architecture to a façade terminated by two turrets.

Curtain. (2) A term applied in the language of theatrical decoration to a large hanging which separates the stage from the auditorium between the acts of a drama. Upon its large surface a piece

of mock drapery is often painted. But more ambitious designs are frequently placed upon it, and the curtain of one of the London theatres represents a scene from the *School for Scandal.*

Curvilinear. Formed of curved lines.

Cushion. A square block of wood with a slip of parchment running round its edge, so as to form a kind of saucer. It is used by goldsmiths to put gold leaf in upon a ground of wadding. An engraver's *cushion* is a flat cushion of

leather filled with sand. Upon it the line engraver rests his plate. It allows the steel or copper to be easily moved about or set at any angle, and forms a support with a certain springiness while the work is going on.

Cusp. (Arch.) The point of intersection of two similar curves having a common tangent at that point, as, for example, the points of a trefoil. In architecture the end of the cusp is frequently carved into foliage or other decorative patterns.

Cut. (Engrav.) The process of engraving a design upon wood for the purpose of reproduction is called cutting. A drawing printed from a wood-block is termed a *cut*.

Cutlass. A thick heavy sword slightly curved and with only one edge. It was originally called a coutle-axe or cuttle-axe, and was introduced into England about the 15th century.

Cyathus. A name given to a Greek drinking cup, which had one handle, and

was chiefly used to ladle out wine from the crater (q.v.) or large vessel in which the wine was mixed.

Cyclopean. A style of architecture belonging to a very remote period. Its characteristic feature is the employment of enormous blocks of stone. Cyclopean monuments are also called Pelasgic. By analogy any gigantic masonry which

gives us an idea of resistance and power

may be termed cyclopean.

Cylinder. A solid figure obtained by the revolution of a rectangle round one of its sides. Stones of this shape which serve as amulets or seals are called cylinders. Thus we speak of Assyrian or Babylonian cylinders.

Cylindrical Vault. [Barrel Vault.]

Cylix. A name given to a Greek wine-bowl of peculiar form. It was wide and very shallow; it was mounted on a foot,

and furnished with two small handles. Its large and almost flat surface provided an excellent opportunity for decoration.

Cyma. (Arch.) A moulding employed in cornices and wainscotings. It is undulating in outline, and consists of a hollow

and a round. When the upper part is hollow it is called *cyma recta*, when it is full or round it is called *cyma reversa*. The cyma resembles the ogee (q.v.).

Cymatium. (Arch.) A term used in classical architecture to signify any moulding which caps a division of the entablature and so separates it from the next.

Cyprian, St., Bishop of Carthage, suffered martyrdom at the hands of

Valerian. The story of St. Cyprian is not mere legend, but an authentic record of fact. It has, however, suggested few subjects to artists. In the few representations of St. Cyprian which exist, the saint has the palm and mitre at his feet or carries a book and the sword of martyrdom.

D.

Dabber. (Engr.) An instrument shaped something like a pestle, consisting of a mass of wool covered with leather and having a wooden handle. It is used by engravers for inking the surface of a block or plate, and by etchers for putting the etching ground on the copper.

Dado. (Arch.) A cube of stone forming the principal part of a pedestal. A stone cut in the form of a cube or of a truncated pyramid placed on the ground to receive vertical supports in iron or wood. This term is also applied to the plinth space

which runs round the wall of a room to the height of three or four feet from the bottom. It should be decorated with paper or distemper different in colour and design from the paper-hanging which covers the upper part of the wall.

Daedala. The most primitive works of sculpture known in Greece were called *Daedala*, and were said to be the works of the semi-mythical sculptor Daedalus. The majority of them were rudely carved in wood, and generally roughly decorated with colour. They represented deities, and were held in great honour. By the superstitious they were believed to have fallen from the sky.

Dag. A pistol which differed from the ordinary pistol in having a butt like that

of a musket. Frequent mention is made of dags in the literature of the 16th and 17th centuries.

Dagger. The earliest and most universal of offensive weapons. Under some name or other it has existed in almost every country, and examples are found in it dating from the stone and bronze periods. From the 14th century onward

knights invariably carried the dagger as well as civilians, who wore it stuck in their pouch. The three-edged dagger, with which the *coup de grâce* was given, was used in England and France from the 13th century, and was known as a miséricorde.

Daguerreotype. A picture produced by a process invented between 1813 and 1829 by Neipce and Daguerre. In this process the image in the camera obscura

is received on silver plates sensitised by means of iodine fumes. The plates are developed [Develop] in mercury fumes, and fixed with hyposulphite of sodium. By means of the daguerreotype the positive is obtained directly, but it is necessary to repeat the whole operation for each picture required. In delicacy this method is superior to photography, but the glistening of the metal makes it difficult to see the picture. The general effect produced by a daguerreotype can best be compared to the effect produced by the reflector of partially illuminated objects seen in a mirror.

Dais. A lofty seat for one or more persons. It was covered by a canopy, from which it got its name. The term has now been extended to include the whole of the raised platform which is usually found at the upper end of ancient or collegiate halls.

Dalmatic. A garment worn by deacons and sub-deacons in the Roman Catholic Church when assisting the officiating

priest. The garment, which is worn above the alb, is sleeveless, but covers the shoulder and the upper part of the arms.

Damask. A stuff of wool or silk,

usually decorated with bold designs covering the whole breadth of the cloth.

Damaskene. To apply decorative metallic designs to a surface of iron or steel. The design is first engraved on the steel by means of acid, a glue is then applied, and the whole is covered with sheets of gold or silver foil. When the glue has dried a sharp blade is passed over the surface, and this removes the gold-leaf except where it has sunk into the pattern. Damaskening can also be done by dulling metal surfaces so as to imitate the watering of damask, by rendering a steel surface blue except where a design has been traced with the brush, or by tracing designs in gold or silver on a ground of blue steel.

Dance of Death, or **Danse Macabre.** This subject was very popular with painters and sculptors from the 4th to the 16th century. It is frequently found in bas-relief and decorative paintings, as well as in the margins of printed books. The most celebrated Dance of Death was that painted in fresco at Basle by Holbein. The original has long since been destroyed, but etchings have survived, which give us an idea of its design. A similar fresco ran round the cloister of old St. Paul's.

Dancetté. (Her.) This is one of the fancy lines employed instead of straight line to divide a shield. The difference between *dancetté* and *indented* (q.v.) lies solely in the size of the teeth, and it is probable that the two lines were originally identical.

Dart. [Egg and Dart.]

Daub. (Paint.) A careless and unequal mixture of incongruous tones. Thus we call a picture a frightful daub when it is crude in colouring and discordant in effect.

Deambulatory. (Arch.) An old name for aisle (q.v.).

Debruised. (Her.) A term applied to charges passing one above the other.

Decadence. Art is said to be in decadence at a particular period when the works produced at that period are not equal to those of the time immediately preceding. The expression is also applied, but often incorrectly, to certain works designed and executed without sufficient regard to the laws and traditions of classical art.

Decastyle. (Arch.) In Grecian architecture a temple was termed *decastyle* when it had ten pillars in its façade.

Decentre. To remove the *centre*, or temporary structure of wood upon which arches are built, after the masonry has consolidated. [Centre.]

Decimetre. The tenth part of a metre. A metre is 39˙37 inches, and consequently a decimetre is 3˙9 inches, or very nearly equal to a hand.

Decorated Style. The culmination of the Gothic style in England is generally termed *decorated*. It was introduced in the reign of Edward I., and the crosses raised in honour of Queen Eleanor are among the earliest specimens of it. It flourished throughout the reigns of Edward II. and Edward III., and then gave way to the Perpendicular style, which marked the decline of Gothic architecture. The windows in buildings of this style are divided into lights by mullions. The largest known decorated windows have nine lights, as for instance the east window in Carlisle Cathedral, but in smaller churches two or three is the usual number. The tracery in the windows is either geometric, consisting of circles, trefoils, quatrefoils, &c., or flowing in wavy lines. Circular windows are common and the arch generally used in decorated buildings is equilateral. The doorways of this style are chiefly noticeable on account of their ornament. In form they differ but little from those of the previous style. The pillars are often diamond-shaped with shafts engaged, the capitals generally plain or ornamented with well-carved foliage. The ball-flower ornament is almost peculiar to the decorated style, while its mouldings consist of rounds and hollows separated by fillets.

Decoration. By the *decoration* of a façade we mean the system of ornament which is placed upon it. This may consist of designs either sculptured in relief or painted. One branch of the art of decoration is the adornment of rooms with tapestries, works of art, tropical plants, &c. Under the term theatrical decoration are included all the curtains, painted scenes and furniture, which help to give an air of reality and splendour to a scene on the stage.

Decorative. A work of art is said to be *decorative* when it is applied to the decoration of a particular space, and when it is designed with a view to the shape and character of the space which it fills. A painting may be said to be *decorative* when, quite apart from the subject it portrays, it produces upon the spectator the impression of a piece of decoration, either from the harmony of its colouring or the beauty of its lines. *Decorative Art* is that branch of art, which is applied to the decoration of objects of luxury or use, and to the adornment of houses and other buildings. Thus the object of decorative art is not the creation of a separate work, such as a picture or statue, but the production of sculptures, paintings, or fabrics which are intended to fulfil a definite purpose, and to decorate a room or wall space.

Decorator. An artist who devotes himself to decorative painting or sculpture, and executes his work with due regard to the space which it is intended to occupy.

Dedicated. Works offered to distinguished persons or submitted to their patronage by a written, printed, or engraved dedication are said to be *dedicated* to them.

Dedication. An inscription engraved on plates principally of the 17th and 18th centuries. The inscription sometimes

embodied armorial bearings, and described the respect of the engraver for the possessor of the picture or his gratitude towards some person of high rank.

Del. Abbreviation of the word *delineavit.* It follows the name of the original author of a drawing which has been reproduced by engraving or lithography.

Delft. (Pot.) Earthenware painted and glazed is called delft, from the town Delft, where it was first made. It is generally of rude workmanship, and more quaint than beautiful in colour and design.

Delineation. The outline of a figure or landscape.

Delta. A triangle surrounded by rays and containing inscribed within it the name of Jehovah in Hebrew characters.

Demeter. Demeter, the daughter of Cronus and Rhea, was the goddess who watched over agriculture and the production of the fruits of the earth. When her daughter Persephone was carried off by Hades, she sought for her in every land, conferring wherever she went the blessings of agricultural prosperity. She was especially revered in Attica, to an inhabitant of which, Triptolemus by name, she is said to have taught the use of the plough. Her worship is in some measure connected with the belief in a future state, and the Eleusinian mysteries held in her honour are said to have had an ennobling effect on all those who were admitted to them. Her name is generally mentioned with that of her daughter Persephone (q.v.), the goddess of the lower world, in whose charge was the seed committed to the earth. Among the known statues of Demeter, the finest is that found at Cnidus and now in the British Museum. The goddess is represented draped and with a veil, and there is much religious dignity in the figure. In representations of Demeter on vases, allusion is generally made to her sojourn in Attica and her teaching Triptolemus the use of the plough.

Demi-brassards. Half armour for the arm. [Brassards.]

Demi-column. A column so built against a vertical wall that only half of the column is seen, the rest being built into the wall. [Column.]

Demi-dolmen. When one of the vertical supports of a dolmen are non-existent so that the table of the dolmen rests with one end on the ground it is called a demi-dolmen, or an imperfect

dolmen. When such dolmens were of large dimensions they were employed for the massacre of victims, who were marched up the sloping surface and precipitated from the top. [Dolmen.]

Demi-lion Rampant. (Her.) A lion, of which the upper half only is represented on a chief or fess, the animal thus appearing at the top of the shield.

Demi-vol. (Her.) Used to describe a single wing of a bird with the features turned towards the sinister side of the shield. Several shields present three demi-vols on the same surface.

Demolition. The destruction of an edifice.

Denis, St. St. Denis of France is confounded in the legend with St. Dionysius. This connection is not supported by historical criticism, but in art they are always represented as one. Dionysius (or St. Denis as he was called when he went to Paris) was a Grecian philosopher, who was converted to Christianity by St. Paul. He became bishop of Athens

and afterwards of Paris. While at Paris he was persecuted and finally beheaded by the Roman pro-consul. St. Denis or Dionysius is represented in art as carrying a head in his hand.

Dentels. (Arch.) A system of ornament, which breaks the horizontal moulding of an entablature, and throws shadows below the projection caused by the cornice in the Ionic and Corin.hian

orders. Dentels are formed by punching out rectangular pieces from a large fillet (q.v.). Their height is generally double their breadth, and they are separated from one another by a space half as broad as the dentel itself.

Depict. [Paint.]

Depth. (Paint.) The distance measured from the bottom of a picture to the horizon. We sometimes say of a landscape that it wants depth.

Derby China. The factory of porcelain at Derby was established by Duesbury in 1750. The china made at Derby in the last century was of great beauty, and the blue and gold pieces were especially admirable. At one period china thimbles formed an important part of the industry. At the beginning of the present century the Derby factory passed into other hands, and was finally closed in 1848.

Descent from the Cross. A picture representing Joseph of Arimathea and the disciples of Christ lowering the body from the cross.

Design. (Paint.) The preliminary sketch of a picture. A collection of lines, which serves as the base of a composition and marks the more important points in it. The plans prepared by an architect for a building, or by an engineer for a machine, or by an artist for a paper or stuff, are called the *design* for the building, machine, &c. The art of design is the adaptation of forms to spaces, objects, and materials. The business of the designer is to fill space; or panels with designs which at once fit the space in which they are placed and are harmonious in themselves.

Designer. An artist who executes decorative designs for industrial purposes—wall-papers, carpets, &c., &c.—is called a *designer*.

Desk. Desks sloped at various angles are used for various purposes : (1) for painting miniatures upon ivory ; (2) for painting on porcelain ; (3) for retouching photographs ; (4) for executing tracings.

Detached. (Arch.) Isolated, standing by itself. A column is said to be detached when it stands apart from the building to which it belongs. It may be connected with the rest of the building either by a plinth or an entablature. A house is said to be detached when it does not join another house on either side, but has a free space all round it. In a painting figures are said to be detached, when they stand out naturally from the background.

Detail. This word is used to describe the secondary or accessory parts in a picture or a group. In certain kinds of work, as in easel-pictures for example, the detail should be carefully executed, because the work will be subject to close inspection. But in wall pictures on the other hand an over-scrupulous execution of the details would spoil the general effect. In architecture the detail is the smaller ornamental work. It is executed from the architect's designs, and from it the building gets much of its character.

Develop. (Photo.) After the sensitive plate has been exposed in the camera to receive the image it is removed into a

partially darkened room, where it is subject to the action of certain chemical reagents. By this means the image on the plate is *developed*.

Device. An emblem or motto, which was borne by mediæval Knights upon their shields and banners, and served to distinguish them in battle or at tourna-

ments. It was from devices that armorial bearings (q.v.) were in all probability derived. Our cut represents the device on the shield of the Prince of Condé.

Dexter. (Her.) The dexter side of a shield is the right-hand side of the shield itself, and it is thus opposite to the left hand of a person facing the shield.

Dextrochère. (Her.) A French heraldic term used to describe a charge repre-

senting a right arm, either draped or bare.

Diaconicum. (Arch.) One of the lateral absides of Christian basilicae in which the treasure was kept. It was sometimes called *secretarium*.

Diadem. A circlet worn round the heads of kings in ancient times. It was of silk or wool and was tied at the back

with strings. It was the emblem of power, and among the deities of ancient Greece Zeus and Hera are represented as wearing it.

Diadumenos. This name is given to statues which represent a youth binding a wreath or diadem round his head. The most celebrated work of art bearing this name in ancient times was a statue by Polycletus. A picture or statue representing a girl in a similar attitude is termed a *diadumene*.

Diagonal. The diagonal of a parallelogram or of any four-sided figure is the line joining two non-adjacent angles.

Diagonal Joining. (Arch.) A decoration found in Gothic houses, which con-

sists of small beams, bricks, or tiles, set obliquely and symmetrically with respect to a vertical or horizontal axis.

Diagram. A geometrical drawing representing the outline of an object, or some fact or series of facts. The diagram of a vase, for instance, gives the outline of the vase, as well as the outline of all the objects which decorate its surface. Diagrams are also used for scientific purposes. Thus by means of curves we can represent on paper the varying rates of mortality in a country, and such curves would form a *diagram* of mortality.

Diagraph. An optical instrument by means of which pictures and other objects can be traced on a scale proportional to the distance of the diagraph from the object. The instrument was invented by the architect Cigosi in the 16th century and perfected by Gavard in 1830. The apparatus consists of a glass to which is attached a contrivance for holding a pencil. The operator looking through the glass follows the lines of the picture. As he moves the glass the pencil also moves and so reproduces the picture.

Dial. The decorated disc of a clock, upon which the hours are marked. The circular form of the dial suggested to artists many ingenious methods of ornamentation. Dials vary in style according to the period to which they belong, and many of them are full of interest as works of art.

Diameter. The diameter of a circle or of any central curve is a straight line passing through the centre and terminated at each end by the curve.

Diamond. A colourless gem of the greatest brilliancy more highly esteemed by the moderns than any other precious stone. On account of its extraordinary hardness it is of great service in some of the industrial arts. A glazier's diamond is a small tool for cutting glass. It consists of a short handle, at one end of which is fixed a speck of diamond. When the diamond is drawn firmly across a sheet of glass it makes a scratch, and the glass can then be easily broken along the line of the scratch. In architecture and the decorative arts, bricks, stones, and pieces of wood or glass are said to be diamond-shaped when they assume the form of the rectangular figure known as the lozenge (q.v.).

Diamond Dust. The powdered dust of diamonds used for cutting and shaping precious stones. The value of diamond dust for this purpose was discovered by Louis de Berquem in 1476.

Diamond Fret. (Arch.) An ornamental moulding employed in Romanesque architecture.

Diamond Powder. A powder used by gem engravers. When their cutting tools are covered with a slight coating of oil the diamond powder easily adheres to them and prevents them from blunting.

Diaper. A fine linen cloth manufactured at Ypres and decorated with ornamental devices, such as geometric patterns, scroll or lattice work, &c. From this system of ornament *diaper* came to be used to denote an architectural deco-

ration. This decoration consists of the continued repetition of a small flower, carved in low relief and sunk below the level of the surface which it decorates. The sculptured diaper pattern is extensively used in buildings of the Early

English and Decorated styles. In Perpendicular buildings it is painted not sculptured, and mural paintings being perishable few examples of the diaper-pattern belonging to the Perpendicular period have come down to us. In he-raldry a shield is said to be diapered with a certain colour when it is covered with ornaments or arabesques of that colour. Sometimes the diaper takes the form of garlands of flowers. Examples are frequently found in German coats of arms.

Diaphanograph. An instrument by means of which an object can be drawn by looking at it across a sheet of glass. Also a photograph printed on glass, so that when hung against the light it presents the appearance of a monochrome. These photographs are generally prepared by first printing from the usual glass negative on a sheet of gelatine. This is afterwards covered with a special ink, and the greater or less depressions of the gelatine produce when the gelatine is pressed against a sheet of glass the effects of light and shade.

Diaphragm. A thin sheet of metal with a circular opening in it, which is placed in a camera between the object glass and the image so as to give more clearness to the image by cutting off oblique rays of light from the object.

Diastyle. (Arch.) A temple is called diastyle when the distance between the columns is equal to three times the diameter of the column.

Didactic. A work of art, whether a poem, a picture, or a sculptured group, is said to be didactic when it is obvious that the author intended to convey some moral lesson by means of his work.

Die. (Numis.) A metal block cut in intaglio from which a coin is struck.

Difference. (Her.) A *difference* or *brisure* in heraldry is the mark by which the various individuals who are entitled to wear the same arms are distinguished from one another. Thus the eldest son wears his father's arms with the addition of a charge called the *label* (q.v.), the second son adds to his father's arms a *crescent ;* the third, a *mullet ;* the fourth, a mascle, and so on. The best known case of a *difference* or mark of cadency is the *baton* which is superadded by a bastard to the arms borne by his father. The *baton* is a diminutive of the *bend-sinister*, and is *couped* at its extremities so that it does not extend to the edges of the shield. It is not uncommon to hear this mark of bastardy loosely described as the "bar-sinister," a term which is heraldically absurd, for a *bar* being a horizontal belt right across the shield cannot obviously be either *sinister* or *dexter*. The special name for a *difference* which denotes dishonour of any sort is *abatement*.

Diglyph. An ornament consisting of two grooves, as the triglyph (q.v.) does of three. It is often met with on the side faces of corbels.

Dimidiated. (Her.) A term applied to a shield which is made up of portions of two coats of arms, so arranged that each portion represents one half of the coat of arms to which it belongs. Thus we say in blazoning, "Dimidiated: first azure, second gules."

Diminutive. (Her.) A diminutive of an heraldic ordinary occupies the same position on the shield as the ordinary itself but is of smaller dimensions, and has a name of its own. Thus the diminutive of the *chief* is called the *fillet*, and that of the *pale* is called the *pallet*.

Dionysus. The son of Zeus and Semele, called also Bacchus, was the god of the vintage, and the mirth and jollity connected with it. In Greek art he is sometimes represented as a child, carried by Hermes, as in the famous statue of Praxiteles. He often assumes the

form of a youthful deity crowned with ivy or vine leaves and carrying a thyrsus and cantharus, or drinking-cup. Over his shoulder he wears the skin of a stag, and he rides in a chariot drawn by tigers or panthers. The Indian Bacchus is represented as bearded and draped, with none of the jollity which we are wont to associate with the wine god.

Diorama. This is a method of producing pictorial effects invented by Daguerre and Bouton in 1822. A picture which is not intended to be all seen at one time is painted on a large cotton sheet and additional figures and objects are painted on the back of the sheet. The spectator sits in a dark room at some distance from the painted sheet, which is illuminated from the front and also when required from the back. The lighting is so arranged that it can be varied in direction and intensity and colour at will, and thus different portions of the canvas are successively brought into view, and the same can be made to assume the appearance of daylight, dusk, or moonlight as required. By throwing a light from behind on to the back of the screen, the objects there painted are rendered visible to the spectators in front, and thus new figures can be introduced into the scene painted on the front side.

Diota. An ancient two-handled vase, a small amphora. Its body was ovoidal in shape and was surmounted by a narrow neck.

Diplois. (Cost.) The name given by the Greeks to the part of the chiton which was drawn up over the girdle

at the waist and fell in picturesque folds.

It also denoted a kind of double cloak, as in our cut.

Dipteral. A term used to describe a temple surrounded by a double row of columns.

Diptych. A painted or carved panel

folding in half by means of hinges. A beautiful ivory diptych representing the triumph of Bacchus is to be seen in the

Bibliothèque Nationale at Paris, where

it is used to protect a valuable manuscript.

Dirk. A term given to the dagger (q.v.) in Scotland.

Disciple. An artist who adopts the general method of some noted master, and is inspired by his teaching or example, is often said to be the *disciple* of that master.

Discobolus. A quoit-player. The discobolus was a favourite subject with Greek sculptors, and several admirable statues of *discoboli* have come down to us. By

far the most celebrated is that of Myron, who represented the athlete in the distorted attitude assumed just before the discus or quoit was thrown.

Discord. An inharmonious or incongruous arrangement of colours is often called a *discord*.

Discus. A quoit. As used in Greece

the discus resembled a shield without a handle. The quoit-thrower grasped it in his hand, letting it rest in his palm and fore arm. Some quoits are works of art, representations of athletes and athletic contests being engraved on them.

Dish. (Pot.) A broad flat vessel, sometimes with a rim, sometimes without, upon which food is brought on to the table.

Disk. A flat circular sheet of metal or any other substance.

Dismembered. (Her.) A term used to describe figures of birds without claws or legs. A dismembered eagle is frequently employed in German coats of arms.

Disperse. To divide and spread over the whole surface the interest of a work of art. To place in different parts of the canvas the lights of a picture. It is a term of reproach, for when the interest is dispersed the eye, attracted here and there, is unable to concentrate itself on any one point.

Displayed. (Her.) An eagle or other bird is said to be *displayed* when its wings are spread and turned towards the upper part of the shield. In this case the feathers of the wings have the appearance of rays.

Disposition. (Paint.) The arrangement of the various parts of a work of art. The disposition of a picture is eccentric when the drapery and accessories are not naturally arranged.

Disproportion. The absence of correct subordination of one part of a picture to another.

Distaff. The distaff of the ancients was of very simple construction. It was simply made out of a cane, which, when split at the top, formed a kind of basket, in which the flax was placed. A ring was then put round it so as to hold

the whole mass together. In representations of the Fates, who spin the thread of life, a distaff is always to be seen. Modern Italians make distaffs of the same material and in the same manner to the present day.

Distance. (Paint.) The furthest point of sight in a picture. The *point of distance* is in perspective the point where the visual rays meet; the middle distance is the middle portion of a picture between the foreground and the extreme distance.

Distemper. A method of colouring surfaces. In this method the colours are prepared with a solution of water and size, or for small surfaces of water and gum. The method is mostly employed for colouring walls, and the *distemper* then consists of whiting, water, size, and the colour required.

Divergent. Rays of light, or straight lines generally, are said to be divergent when they proceed from a point and are inclined at an angle to one another, so that they separate further and further from one another.

Dodecagon. A plane figure having twelve sides.

Dodecahedron. A solid figure having twelve faces.

Dodecastyle. (Arch.) In Grecian architecture a temple was termed *dodecasty.e* when it had twelve pillars in its façade.

Dog. The dog in classical as well as in mediæval art was the symbol of fidelity. In classical times it was customary to paint a dog with the inscription *cave canem* at the threshold of dwelling-houses. An example of thi device is to be seen at Pompeii. In tombs in Christian churches a dog emblematic of conjugal fidelity, is frequently to be seen at the feet of effigies of married women.

Dog-tooth Ornament. [Tooth Ornament.]

Dolabra. A cutting instrument used for various purposes, just as the modern axe or hatchet is. It was employed by husbandmen for chopping wood, &c.,

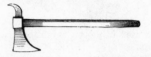

and in the columns of Trajan and Antoninus soldiers are represented as breaking through fortifications and stockades with the dolabra.

Dolium. An earthenware vessel of almost spherical form used by the Romans to hold wine and other liquids. These vessels were often of very large dimensions, sometimes large enough to contain a man. In India to the present day earthenware vessels of this shape and of various sizes are used everywhere to carry and hold water. The vessel is called a *ghurra* in India.

Dolmen. A Celtic monument consisting of unhewn stones arranged in parallel and vertical lines. Upon these

other stones are placed horizontally. Some dolmens are divided into compartments and closed at one end.

Dolphin. A conventional figure of a

large-headed cetaceous mammal. Dol-

phins are especially used to decorate fountains. They are also used in heraldry, and are then generally represented in profile with their bodies bent into a semicircle.

Dome. (Arch.) A roof formed by a series of arches springing from consecutive points on a circular or polygonal plane base and crossing one another at the summit. The solid figure thus formed may be roughly described as hemispherical, and if, for example, the plane base were a true circle, and the arches true semicircles, the dome would then be a true hemisphere.

—, **Polygonal.** Domes are sometimes built with a polygon as their base. The Louvre in Paris presents several examples of the polygonal dome, as well as of the dome erected upon a square base.

—, **Surbased**. A dome, the surface of which above the roof is less than a hemisphere.

—, **Surmounted** or **Stilted**. A dome which consists of a hemisphere standing upon a solid rectangular figure. [Arch, Stilted.]

Dominant. A term used to describe the principal colour or tone in a picture.

Donjon. A strongly fortified building

placed either in the interior of a castle or at one angle of the outer wall. Within the donjon were preserved the archives and treasure. In the case of siege, the donjon was the last resort of the besieged. In early times *donjons* were constructed, according to the Norman custom, on a square or rectangular plan. In the 11th century they assumed the form of quatrefoils and afterwards were cylindrical in shape. In the 12th century particular attention was paid to their fortifications and means of defence. But after a time splendour rather than strength was aimed at, and in the 14th and 15th centuries donjons became nothing more than magnificent dwelling-houses.

Donor. In former times the donors of pictures or windows to churches were frequently portrayed kneeling before the figure of the saint whose portrait they had presented.

Door. (Arch.) An opening or bay, which serves the purpose of entrance or exit. Gothic churches are generally provided with doors of great beauty, which vary in style according to their period. In Norman churches the archivolt is a semicircle and is supported by small columns. At a later date vertical supports deco-

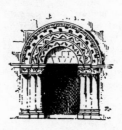

rated by niches placed one above the other replaced these columns. The space between the lintel and the arch was called the tympanum (q.v.). In Gothic buildings this tympanum was sometimes decorated with bas-reliefs, often comprising hundreds of small figures disposed in friezes one above the other. Sometimes too tympana were occupied by a repre-

sentation of the genealogy of the Virgin

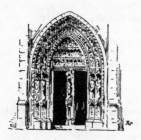

in the form of a tree, termed Jesse's tree.

Door, Folding. A door consisting of

two leaves, which close one upon the other. French windows or doors opening on to a balcony are generally constructed upon this plan. The leaves are sometimes carried up the whole length of the bay, while sometimes the upper part of the doorway is occupied by a fixed sash.

Door-frame. The fixed frame to which a door is hung. A door-frame consists of two vertical posts whose upper extremities are tenoned in a head or lintel, and whose lower extremities are fitted into a side of hard

wood or stone. The frame is either built in as the masonry progresses, or recesses are left into which it is afterwards fitted. In cases where the vertical pieces pro-

ject they are termed responds.

130

Doorway, Egyptian. (Arch.) A doorway in the form of a trapesium. Its jambs are generally inclined as in the cut, but sometimes they are vertical. Egyptian door-ways are gene-

rally ornamented with sculptured or painted hieroglyphics. A central ornament in the form of a winged globe sometimes surmounts them.

Doric. An order of ancient architecture specially characterised by sobriety of ornament. In Greece this order combines both strength and elegance, but Roman Doric is rather heavy. In Doric buildings the columns have no base. Towards the middle they show a swelling or *entasis.* Their capital is of extreme

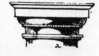

simplicity. [Capital, Doric.] The frieze was not continuous but was made up of alternate triglyphs (q.v.) and metopes (q.v.). The elements of the Doric order undoubtedly came from the East. It appeared in all the Dorian cities about the 7th century B.C., and its prevailing characteristics are those of severity and power.

Dormer. A term denoting the upper story in the roof of a house.

— **à fronton triangulaire.** In buildings of stone this form of dormer was frequently employed. Of this kind were many large dormers belonging both to the Gothic and classical style. In the latter style their summit was frequently richly decorated.

—, **Bull's Eye.** A dormer with a circu-

lar opening. Dormers of this kind are generally connected to a base of consider-

able size by ornamental scrolls, as in the cut.

Dormer, Decorated. The tympanum of a *decorated* dormer is ornamented with sculptures, and its summit is cut into arcades or terminated with pinnacles. This form of dormer is frequently to be seen in buildings of the 15th and 16th centuries. In the triangular space above the window coats of arms or bas-reliefs are frequently carved.

—, **Flemish.** A dormer constructed in stone or brick masonry, surmounted by a pediment *à redans*. These *redans* vary in number according to the height of the pediment.

—, **Gabled.** A dormer placed at the upper part of a roof and terminated by a gable.

—, **Rampant.** A dormer without a pediment set in the middle of the roof. It is sloped, but at a different angle to the inclination of the roof. The term is also applied to a dormer when its sill and lintel are not placed horizontally.

Dormer, Square. A dormer with a horizontal roof. Architecturally this dormer is quite un- ambitious. It is generally seen in private dwellings or country houses.

—, **Surbased.** A dormer the roof of which is in the form of a segment of a circle. Zinc dormers of modern construction generally assume this form. They are sometimes so ornamented as to break the lines of the concentric mouldings.

—, **Window.** (Arch.) A vertical window projecting from the slope of the roof. In the 15th and 16th centuries dormer windows played a great part in

the decoration of façades. Above the great tiled roofs of this period gigantic dormer windows of carved stone surrounded with bell-turrets and balustrades were built.

Dormitory. (Arch.) A sleeping apartment, especially the sleeping-room in monasteries and other religious houses.

Dorothea, St., virgin and martyr, was born at Cæsarea in Cappadocia. She was put to death by Fabricius, the Roman governor of the province. On her way to execution she was taunted by a youth of the city named Theophilus, who

mockingly asked her to send him of the fruits and flowers of the garden to which she said she was going. At the place of execution she was met by an angel, whom she sent with flowers and fruits to Theophilus. The latter was at once converted by this miracle and soon after suffered martyrdom himself. St. Dorothea's attributes are fruits in a basket and bunches of roses. She is more often represented by German and Flemish artists than by Italian.

Dorsal. A piece of embroidered material or a piece of tapestry hung against the wall behind a seat or to cover the back of a chair. The practice of employ-

ing drapery in this way was frequent in the Middle Ages, and in the time of the Renaissance. In some churches the stalls are ornamented with carving in imitation of dorsals.

Dosser. A term applied like dorsal to hangings of tapestry placed at the east end of a church or against the walls of a hall. The name is derived from the fact that the hangings were placed at the back of the officiating clergy or behind the chairs in a hall. The covering at the back of a seat is also called a dosser.

Double-handed Swords. These huge weapons were used in the 15th and 16th centuries in warfare, and were retained in public ceremonies until a later date. They were of great length, and wielded with both hands.

Dove. In Christian art the dove is the symbol of the Holy Ghost, as well as the emblem of love, innocence, purity, and

peace. A pyx in the form of a dove was

often hung above the altar of a church, and such a one is shown in our cut.

Dovetail. A method of joining employed both in wood and stone work. A tenon, shaped like a dove's tail, fits into

a notch similar to it in shape and size. Dovetails form a weak joint in carpentry, as wood shrinks more across the grain than along it.

Dowel. (Arch.) A dowel is a slightly tapering pin of iron fixed in a stone so as to fit into a hole made in a stone opposite to it. The joint thus formed is called a dowel-joint.

Dragon. A mythical animal with lion's claws, eagle's wings, and a serpent's tail.

In Byzantine monuments a dragon is often used to symbolise some public

calamity. Owing to its fictitious character the dragon is peculiarly adaptable to the imagination of the artist, and hence is a favourite subject for works of art. Chinese and Japanese artists, are especially fond of the dragon, and have produced some wonderful works in which the dragon is the central idea.

Dragon's Blood. A resin of a dark blood-red colour, obtained from an Indian tree, and used for colouring varnishes.

Dramatic. In painting, this word is used to characterise a scene expressing lively action or keen emotion.

Drape. To arrange the drapery on the model or on a lay-figure; and also to paint or model drapery.

Draped. Covered with drapery.

Drapery. Material or clothing of such fulness as to hang in folds. In ancient statues part of the body was always left uncovered, and the drapery over the rest modelled from very fine and flexible stuffs hung close to the body in tiny folds. In the 12th century artists adopted a uniform practice of making stiff and regular folds symmetrically placed. The draperies of the 13th and 14th centuries hang almost straight down, meeting the feet at a right angle. Later, in the 15th century, a good deal of mannerism was introduced, but at the same time the lines of the body are followed more truly. The fulness of drapery was very much increased in the 16th century, and in the 17th and 18th centuries it was much relied upon for producing artistic effects. Thus the drapery is frequently torn or flying about, and by strong shades accentuates the outline of the figure. In the present century our universally inartistic dress compels sculptors as a rule to seek their types of drapery in the fuller robes of preceding generations.

Drapery, Mock. A method of painting walls to represent drapery hanging in vertical and regular folds. These draperies generally appear as though they were fixed to the wall by round-headed nails. Though they are generally modelled with great care, they are sometimes painted quite flat, and their folds only indicated by a simple line.

Draught-board Moulding. (Arch.) A method of decorating the surface of walls adopted in the Romanesque period. It consists of black and white materials alternated, or else of projecting courses of stone intersecting at right angles so as to form squares, and by throwing shadows to break the monotony of the surface. The term draught-board is also used of pavements where tiles of different colours alternate.

Drawing. A method of representing objects by lines made with pen or pencil. In *geometrical* or architectural drawing rulers and compasses are employed to aid the hand; while in *freehand* drawing only pen or pencil may be used.

—, **Architectural**. A drawing which portrays building either in elevation or section by geometrical processes.

— **Board**. A flat board, upon which drawing paper is strained. The paper is moistened and secured to the board round its under edge by paste or glue. It becomes flat, when dry, and can be removed from the board by cutting inside the paste line.

—, **Freehand**. A drawing done without the aid of ruler or compass.

Drawing from Nature. A drawing made from the living model, from a landscape, or from natural objects.

— **from the Cast**. A drawing made from a plaster cast, either of a bas-relief or a sculpture in the round.

— **from the Flat**. A drawing copied from a subject drawn, lithographed or engraved.

—, **Machine**. A term applied to outline or washed drawing, representing machines, pieces of mechanism, &c.

— **Pin**. A short sharp-pointed steel pin with a large head. It is used for fixing sheets of paper upon drawing-boards, &c.

Dresden China. The first hard-paste

porcelain made in Europe was produced at Dresden by Böttcher. This celebrated chemist succeeded in making white porcelain in 1710. A factory was then established at Meissen, and Böttcher was appointed director. This factory is still in existence, but the pieces which are sent out from it have little artistic merit. The picturesque figures which were modelled under Kündler's management (1731—63) are of great value.

Dresser. A piece of furniture standing

or fixed against a wall. It consists generally of two front legs and an upright

back, carrying shelves on which are arranged and displayed the service of plate. About the 16th century sideboards or buffets began to take the place of dressers, and the dresser was relegated to the kitchen.

Dressings. (Arch.) A term applied to

any kind of moulding, projecting beyond

a door, window, or any other opening, and so forming a frame.

Drill. A steel tool to which a rotary motion is imparted by means of a bow. This tool is employed by sculptors to perforate holes in blocks of marble with a view to removing the superfluous portions of the block. [Bow-drill.]

Dripstone. (Arch.). A moulding over the heads of doorways and windows in Gothic architecture. It corresponds to the *corona* (q.v.) of the classical style. It got its name from an idea that it was intended for the rain to drip off, but that this idea is mistaken is shown by the fact that the moulding is used inside as well as outside a building.

Drops. (Arch.) Small cylinders attached by their upper end to a flat horizontal surface in a vertical position. They are found under the architrave in the Doric order [Guttæ].

Druidic. A term applied to the monu-

ments raised by the Druids or British

priests. Under the head of Druidic remains, which are Celtic in origin, come dolmens, cromlechs, &c., which are described under their proper headings.

Dryad. A nymph of the woods frequently represented in works of ancient art.

Dryness. A quality attributed to paintings, in which the outlines are hard and formal, the modelling stiff, and the colour harsh and inharmonious.

Dry Point. (Engrav.) A sharp steel needle with which an engraver draws directly upon a copper plate. In proportion to the pressure used, the dry point sinks more or less deeply into the metal. It does not, however, cut the plate, but as it were makes a furrow and throws up slight projections on each side. The rough edges thus caused are removed by the scraper (q.v.) if it is desired to give a grey tone to the print. If, on the other hand, the engraver aims at obtaining velvety blacks, the rough edges are not scraped away. When the plate is inked they naturally print black. A limited number of proofs only can be struck off in this case, as the process of wiping soon destroys the rough edges The dry point is used to give to a plate which has already been bitten a delicacy of tone, which it would be impossible to obtain by mere biting. It is thus of value in retouching a plate, and it was for this purpose that Rembrandt employed it. In more recent times artists have executed works of considerable size—portraits as a rule—exclusively in dry point. The beauty of these prints depends to a great extent on the skill of the printer.

Duck. (Her.) This bird sometimes appears on a shield as a common charge, but is usually shown without feet or beak, and in this case should be properly called a *cannet*.

Dungeon. (Arch.) The term *dungeon* has come to mean a place of close confinement, because in the vault below that part of the mediæval castle called the *donjon* (q.v.) prisoners were shut up. It is of course the same word as donjon, and originally conveyed no idea of imprisonment.

E.

Eagle. In ancient art the eagle is the attribute of Zeus, and it is often figured on medals and coins carrying the thunderbolt of the King of Olympus. It also symbolises victory, authority, and power, and in Christian art is the attribute of

St. John, who indeed is of en represented under the form of an eagle. The form of eagle most frequently employed in heraldry is the *eagle displayed*. The wings are shown open, and turn upwards towards the top of the shield. In the *eagle displayed* the feet are also set apart, but if the eagle is blazoned an *eagle with*

wings displayed, this implies that the bird is perched. Another less common form of eagle is the *eagle with wings abaisé;* this differs from the eagle displayed only in having the feathers drooping downwards as shown in the right-hand cut.

Eaglet. (Her.) A small eagle. In heraldry it is always represented *displayed*, and generally its beak and claws are of a different tincture to the rest of the body.

Early English. (Arch.) A term applied to the first period of Gothic architecture, as it was developed in England. It took the place of the Norman style towards the end of the 12th century, and flourished for about a century, giving way in its turn to the Decorated style (q.v.). The following are its main features. Its windows are generally long and narrow, of that form which is called *lancet* (q.v.). They sometimes occur singly, sometimes in groups of twos, threes, and fives. Round windows, and also trefoils and quatrefoils, are found in Early English buildings, especially over a group of lancets. Arches are generally lancet or equilateral, while small trefoils and cinquefoils are common. The doorways are always pointed and deeply recessed. The piers generally consist of small circular pillars ranged round a larger one. The ornaments characteristic of the Early English style are few in number; foliage is rarely used, the tooth ornament (q.v.) being the most common. The mouldings are generally plain rounds, separated by very deeply cut hollows. The most complete example of the style, which is also called First Pointed, is Salisbury Cathedral.

Earrings. Ornaments have been worn in the ear from the very earliest times. Among Eastern nations men as well as women thus adorned themselves. In Greece and Rome, however, the fashion was only adopted by women. Earrings were worn by the Saxons, but their use seems to have died out about the 10th century. They reappear in the 14th

century, and were quite common in Elizabeth's reign, the Queen herself wearing pearls in her ears. They were most popular in the 17th century, for at that period not only were they universally worn by women, but men placed either rings or pieces of silk in their ears. At different periods they have assumed an infinite variety of shapes and have generally been of a precious metal and set with jewels. Our illustrations represent the one an Egyptian, and the other a Syracusan earring.

Ears. Small protuberances on a pitcher or other earthenware vessel, which serve the purpose of handles.

Easel. (Paint.) A stand upon which a picture is placed while in course of execution. The simple easel consists of two laths connected together top and bottom by cross-pieces, and thus presents the appearance of a triangle with a narrow base. Another piece of wood is placed behind, and

this forms a tripod. By means of a screw this piece may be extended behind, and so alter the inclination of the easel. A small tablet which can be moved up and down at will is attached to the two uprights, and it is this which supports the picture. This form of easel has been in use for centuries, as our cut of an artist at work, taken from an illuminated *Romance of the Rose* of the 15th century, will show. Nowadays, another kind of easel is generally used. This consists of a vertical construction resting solidly on two cross-pieces at right angles to a third piece. The cross-pieces are furnished with casters, and the easel can thus be easily shifted from one corner of the studio to the other.

On this framework a tablet on which the picture rests moves vertically by means of an endless screw. This tablet can be raised or lowered at will by a simple

crank. The name *sketching-easel* is given to the light easels, which fold up so as to occupy as little room as possible, and can easily be carried about by the artist. Sculptors make use of an easel

in modelling bas-reliefs. In form they resemble the simpler form of painter's easel which we have described. They differ from this, however, in being more

solid and massive, as they have to support heavy weights.

Easel-picture. (Paint.) A picture of small dimensions and generally so minutely and delicately executed, that it may be placed close to the eye of the spectator.

Easing. (Arch.) When an arch is built upon a centre (q.v.) it is always necessary to provide for *easing* the centre, *i.e.* for lowering it, so that the support may gradually be withdrawn from the arch This *easing* is performed by the partial removal of two wedges placed between the strut and rib. The operation of easing is described more fully under *Centre.*

Eau-forte. This term, borrowed from the French, is frequently used as a synonym for *etching* (q.v.) or print produced by a chemical process. A metal plate is covered with wax, and the drawing is then made on the wax with a needle. The whole plate is then submerged in a solution of nitric acid and water, which eats into the plate wherever the wax has been removed. With the plate thus obtained prints can be struck in the ordinary way.

Eaves. The lower edges of the slopes of a roof, which rest upon the walls or project over them.

Eaves-course. (Arch.) A moulding running round a building and carrying the eaves.

Ebony. A wood found in the forests of Asia and in the islands of Ceylon and Madagascar. The sap-wood, which is of purest white. forms a striking contrast to the heart, which is quite black. It is this latter part of the tree which is most used, the black, hard, heavy wood forming an excellent material for artistic furniture, for picture frames, and for door panels. The word ebony is also frequently used as an adjective to denote the deep black characteristic of the wood.

Echinus. (Arch.) A projecting moulding placed under the abacus of the Doric capital. It is delicately convex

in outline, describing a slightly swelling curve. The echinus in many buildings is decorated with the egg and dart moulding (q.v.).

Eclectic. This word is used to describe a taste in art which is not confined to one particular style or one particular period, but which is able to admire the masterpieces of every school and of every time.

Écorché. A flayed figure. A statue or picture representing a body from which the skin has been removed in order better to display the muscles and veins. Michael Angelo produced two écorchés

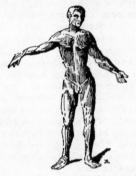

of great excellence, while the écorché of a man in repose by Houdon, and of a gladiator by Salveyre are very justly celebrated. There is also a fine écorché of a horse modelled by Géricault.

Ectypography. (Engrav.) A method of etching the reverse of the ordinary process, in which the lines intended to print dark are not bitten in but left in relief, while the lights are bitten in.

Ectypum. A cast in relief obtained from a hollow mould. Ancient inscriptions as well as coins and medals are reproduced by this method.

Edifice. A general term applied to a house or building of any kind.

Effect. The impression produced in a picture by the arrangement of light and shade.

Effigy. The head or bust of a person represented on a coin or medal; a sculptured figure on a sepulchral stone. In a more general sense *effigy* denotes any portrait of a person, especially one which is more literal than artistic.

Efflorescence. This term is used to describe extravagant and fanciful ornamentation, or the over-development of any style.

Effrayé. (Her.) A term applied to a bare-backed horse reared up on its hind legs, or salient. This attitude is supposed to suggest fright.

Egg and Dart. A decorative moulding consisting of a pointed arrow separating two eggs. Sometimes these darts are slightly ornamented, but in every case a sharp outline and straight edge are necessary to make the moulding effective. The moulding is also called egg and anchor or egg and tongue.

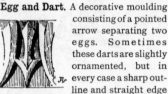

Egg-shell. A kind of porcelain which was once manufactured in China. Its characteristic is its extraordinary thinness. On account of its frangibility, as well as the difficulty which attended its manufacture—for it was ground thin on a wheel—it is very rarely met with, and consequently highly prized. The earliest specimens of it were of pure white; the later were decorated with blue flowers.

Egyptian Architecture. The architecture of the Egyptians takes us back to the very remote past. The domestic buildings of Egypt were of the most primitive description. The poorer classes had to be content with what were nothing more than huts made of bricks with no windows or means of lighting. The more ambitious houses were built round a courtyard and somewhat resembled the Roman atrium (q.v.) in form. The religious buildings of the Egyptians were on a very large scale.

Among them were the pyramids, which date from the 4th dynasty. Egyptian temples have some resemblance in style to the Doric temples of Greece. The mouldings which ornament them are very simple, and more often painted than carved.

Egyptian Brown. (Paint.) A rich brown pigment composed of white pitch, myrrh, and animal matter. In spite of its brilliance and transparency it cannot be recommended, as it is not permanent.

Elbow. (Arch.) A name given to the arms of stalls in churches. Persons seated on the *misericordiae* could rest their arms upon the elbows. The surface of the elbow was sometimes quite flat, sometimes broken by a *border*. It was supported either

by a colonnette or clusters of foliage. In many cases it consisted of a group of figurines.

Electrotype. A method of obtaining a reproduction of a bas-relief or engraved plate by placing a mould of it in a bath, in which, by means of electricity, a thick coating of metal is deposited on the mould. The mould is then removed and there remains a reproduction in metal of the bas-relief or plate. This process is of great service in art, but perhaps its widest application is in the art of engraving. Wood-cuts are seldom printed from now, electrotypes of them being generally employed. The result of this is that a far larger number of impressions may be obtained than formerly, and the wood-block may be indefinitely repeated. At the same time it cannot be denied that the practice of electrotyping has detracted very much from the beauty of wood-engraving.

Electrum. An alloy of gold and silver which was used instead of gold by the Greeks and Romans in making coins. In colour it resembled amber, to which substance the term electrum was originally applied.

Elephant Paper. A term applied to drawing paper of a large size, its dimensions being twenty-eight inches by twenty-two. The dimensions of double elephant paper for printing purposes are forty by twenty-seven. Drawing boards of similar dimensions are also termed *elephant* and *double elephant.*

Elgin Marbles. At the beginning of the present century Lord Elgin carried off from Athens a very important collection of works of sculpture. It included nearly all the monumental decorations of the Parthenon which had escaped destruction. In addition to the splendid fragments of the pedimental figures and many metopes, Lord Elgin brought to England more than two hundred feet of the beautiful frieze which ran round the cella of the temple of Athene. To this collection the name *Elgin Marbles* was given, and their value, as giving us an idea of the magnificent achievement of the great sculptors in the golden age of Greek art, cannot be over-estimated. The question whether Lord Elgin was justified in spoiling Athens cannot here be discussed.

Elizabethan. The style of architecture which prevailed in England in the reign of Elizabeth and for some years after her death has been called Elizabethan. It was Gothic in most of its main features, but the influence of the classical Renaissance is clearly discernible in it. It may therefore be said to be a sort of transition between the two great styles. The finest specimens of Elizabethan architecture are great country mansions, such as Knowle, Hatfield, and Penshurst.

Elizabethan Ware. A name incorrectly given to a kind of earthenware, of the decoration which was said to

have been copied from the chasings upon the silver plate of Queen Elizabeth's time.

Ellipse. A plane curve traced out by a point which moves so that the sum of its distances from two fixed points is constant. Each of these fixed points is called a *focus* of the ellipse. An ellipse may also be defined as the section of a right circular cone made by a plane inclined to the axis of the cone at an angle greater than the cone's semi-vertical angle.

Ellipsograph. An instrument for tracing ellipses. It consists of two grooved rods fixed at right angles and a movable rod sliding between them so that one end of it glides in each groove. A pencil is attached to the movable rod, and as this rod passes from one extreme position to the other extreme position, the pencil traces out the quadrant of an ellipse. If the pencil is attached in the *middle* of the movable rod, the curve traced out will be the quadrant of a circle.

Ellipsoid. A solid figure such that its section through each principal plane is an ellipse.

Eloy, St. The son of obscure parents, was born at Charetas. He was employed by Clotaire II. first as goldsmith and afterwards in various positions of trust. He was consecrated Bishop of Noyon in the reign of Clovis II. He was famous as much for the holiness of his life as for his skill as a worker in metal. Many are the legends that have gathered round his name. On one occasion he was shoeing a horse which was possessed by a devil. St. Eloy cut his leg off put on the shoe, and then replaced the leg by making the sign of a cross. When plagued by Satan himself, the saint is said to have seized the evil one by the nose. These two incidents of his life are generally treated in pictures of St. Eloy, who is usually represented with an anvil, on which a horse's leg lies

beside him. There are numerous statues and pictures of him in existence, one being the work of Botticelli.

Elzevir. The Elzevir family, who have given their name to a particular class of books, were printers and booksellers in Liège from 1540 to 1712. The books known as *Elzevirs* are small volumes of great beauty and rarity.

Embattled. (Her.) This term, borrowed from the battlements of a castle, is applied to one of the dividing lines of the shield. Thus the accompanying cuts represent respectively a chief embattled and a fess embattled. When the projections are shown on both sides of the ordinary so that a projection on

one side is opposite a space on the other, the ordinary is said to be *embattled counter-embattled.*

Embellishment. The decoration or ornament applied to anything; also the act of ornamenting or decorating.

Emblem. A symbolic figure or attribute serving to characterise allegorical figures. It differs from a symbol or attribute in that it conceals a moral or historical allegory. Emblems were very common throughout the Middle Ages, and were frequently introduced into church decoration. Many books of emblems were printed during the 16th century, in which types of virtues and vices were taken from the animal kingdom. The most celebrated were those by Alciati, Paradin, and Sambuco.

Embossing. The art of working patterns in relief on metal by means of a punch. It is an expensive process, and is only used at the present day in the production of delicate and costly objects.

There are in existence mechanical processes for embossing metal, wood, and even paper, but they scarcely belong to the domain of art.

Embowed. (Her.) When a charge on a shield is bent or curved it is blazoned *embowed*. The term is now usually applied to living charges such as a fish, especially a dolphin; or to the human arm, which is frequently represented in this position. It may however be employed for any other charge as a *fess* or *bend*.

Embrasure. An aperture in a wall. In modern times the apertures required in walls are chiefly those for doors and windows. But the term embrasure is better known in connection with the apertures in the walls of a mediæval castle, from whence projectiles were thrown at an attacking enemy. These embrasures had splayed sides widening outwards so as to give a wide range of fire to a musketeer standing on the inner side of the narrow slit forming the embrasure.

Embroidery. A decoration in needlework, executed by hand on a stuff already woven. The work is sometimes in relief, sometimes open. Embroideries are known to us of silk, gold, and precious stones, of every kind of thread in fact, and of every colour. The art of embroidery has been practised in all ages and by all nations. Hebrew and Egyptian women were well skilled in it. Aaron's coat and girdle, the latter of "fine turned linen, and blue, and purple, and scarlet, of needlework," is mentioned in Exodus. The Greeks especially excelled in embroidery. Homer mentions both Helen and Penelope as engaged in needlework. The web of the latter is universally famous. Coming to rather a later period we read of the vestments of the priesthood of the Anglo-Saxon Church being richly embroidered. . The so-called *Bayeux Tapestry* (q.v.) is re-

puted to have been the work of Queen Matilda, wife of William the Conqueror. The value of the embroideries in existence in England at the Reformation can scarcely be estimated. At that most disastrous period in the history of art, hundreds of pieces were wantonly destroyed. Embroidery is but little cultivated now, and belongs rather to industry than to art. The speedier methods of machinery have driven the delicate handwork of former times out of the field. Fragments of ancient embroidery, however, are still highly prized and regarded as among the most curious relics of the art of the past.

Emerald. A precious stone, semi-transparent, and of a greenish tint.

Emerald Green. (Paint.) A vivid green pigment prepared from arseniate of copper. In spite of its permanence, it should be used with caution as it contains arsenic.

Emery. A fine powder of granular adamantine spar. It is used for cutting down and polishing glass work, and for polishing fine-grained stone. Sheets of paper covered with emery powder, and known as emery paper, are used for giving a smooth surface to woodwork, and also used by draughtsmen and engravers for sharpening their pencils and steel points.

Emmanche. (Her.) An heraldic term applied to the angular division of the shield, whether placed on the dexter or sinister side. It is a figure which is very rarely employed.

Enamel. A semi-opaque vitrified material, which is melted and applied to various metals, such as gold, silver, and copper. It is capable of receiving different colours by the introduction of various oxides. Thus oxide of tin colours enamel white, oxide of cobalt blue, and copper green. The term enamel is also applied to the opaque glaze on pottery.

Enamel, Basse-taille. A process of enamelling on precious metals, which consists in chasing the metal plate and then covering it with powdered enamel of slightly different shades.

—, **Brown.** (Pot.) Brown enamel is composed of minium and manganese mixed up with brick-dust.

—, **Champlevé.** Enamel deposited in the cavities of a metal plate, hollowed out to receive it. This method of enamelling succeeded *cloisonné* enamelling in the 13th century, as it required less labour and skill. In German enamels of this class the colours green and yellow predominate, while lapis lazuli is the prevailing tint in the enamels of Limoges. [Champlevé.]

—, **Cloisonné.** [Cloisonné.]

—, **Goldsmith's.** Enamel deposited on a plate incised with a cutting tool, generally a graver.

—, **Painter's.** Paintings on plaques of metal, usually of small dimensions.

—, **Relief.** An enamel resulting from fusion, the irregular surface of which has either been left unpolished or so worn by friction as to be quite rough.

—, **White.** (Pot.) White enamel or white glazing is composed of the oxides of tin and lead mixed with sand containing quartz, and with sea salt and soda. Painters work on a ground of white enamel, which they leave untouched to obtain their lights.

Enamels, French. These enamels, consisting mainly of brooches and buckles, date from the 4th to the 8th centuries. A few specimens are to be found in the Louvre. There are also some enamelled jewels of the 9th and 10th centuries.

—, **Fusible.** Used as a ground-work in the manufacture of porcelain. It contains a large proportion of oxide of lead.

—, **Limoges.** The special characteristic of early Limoges enamels is that they have a dominant tone of blue lapis lazuli, accompanied with sea-green

and with pink for flesh tints. Hair is represented by means of incisions made with the graving tool and filled with red enamel. Such is the character of Limoges enamels before the year 1151. At the end of the 11th and in the 12th century, flesh is tinted and the metal is gilt. At the end of the 12th century the figures are partly enamelled and partly left in relief and flesh is tinted white. In the next century the outline of the figures is left in relief and the details are sunk. Both in this century and in the 14th century enamels are coloured uniformly, the tint being either a greenish blue, or a blue and yellow, or an azure. These are the prevailing characteristics of Limoges enamels, but up to the 15th century it is difficult to assign a precise date to a particular specimen because workmen were constantly influenced by the desire to imitate older work.

—, **Niello.** Sheets of metal engraved with sunk lines, which are filled with black enamel.

—, **Painted,** belong to the beginning of the 16th century. A coat of dark enamel is first laid on the metal, then a coat of white enamel through which the black undercoat appears as a grey. The design is traced on this white coating, masses being indicated by hatchings. All the white enamel beyond the outline of the figures is removed, leaving the black beneath. The vessel is then baked and the design becomes fixed.

—, **Translucent,** are small enamels on gold or silver. The tabernacle of Orvieto is said to be the finest example of a translucent enamel. At Cologne is preserved a crosier of the 14th century ornamented with translucent enamels. The same ornamentation was applied by Benvenuto Cellini to his gold work. Only six colours are found in translucent enamels, blue, green, grey, tan-colour, purple, and black. White and yellow are excluded because

they can only be obtained by means of stannic acid, which is opaque.

Enamellers. The artists to whom we owe the most celebrated enamels in the world are Elbertus of Cologne and Jean Bartholus in the 13th century; Ugolino da Siena, Franucci and Andrea d'Ardilo in the 14th century; Pierre Verrier in the 15th; Jean and Hardan Penicaud, Maso Finiguerra, and Joseph Limosin in the 17th; Dinglinger, Rode, and Bouillet in the 18th; and Augustin, de Courcy and Claudius Popelin in the 19th.

Enameller's Needle. Painters in enamel spread their tint by means of pointed needles. and also use a flat needle shaped like a spatula to deposit the masses of colour on the place where they want it. The pieces of boxwood with which they efface irregularities in their work are also called needles.

Encarpa. (Arch.) A festoon of fruit or

flowers, frequently used to decorate friezes and other flat spaces.

Encaustic. A method of painting used by the ancients especially in architectural decoration and in the painting of statues. [Polychromy.] It consists in employing colours mixed in melted wax which is kept hot during the whole process of the painting. The term encaustic is also sometimes applied to a preparation laid on marble or plaster to protect it from moisture.

Encaustic Tiles. The floors of many mediæval churches in England are decorated with encaustic tiles, some of which are of exquisite beauty of design. Their manufacture was very simple. Square blocks of red clay were stamped with a

print cut in relief. The hollows thus produced, which were not very deep, were filled up with a white clay. The whole was then glazed and fired. The encaustic tiles which are preserved

present an extraordinary variety of designs. Some represent foliage, geometrical patterns, heraldic devices, and even human heads or figures. Many are found bearing quaint inscriptions in English or Latin. Of the two cuts we

give here, the former represents an encaustic tile in a church at Malvern, as the latter a portion of an ornamental *border* from the Chapter House at Westminster.

Enceinte. (Fort.) The continuous wall with its towers and gateways surrounding

a city or fortified place is called the *enceinte.*

Enclavé. (Her.) This term is used when one part of a shield is as it were *keyed* into another by a square projecting piece. This method of dividing a shield is found mainly in German coats of arms.

Encoignure. A small table, triangular in shape, which is made to fit in to the

angle formed by two walls in the corner of a room.

Encomboma. (Cost.) A garment fastened round the waist by a large bow,

which is seen in front. It served the purpose of an apron and was worn by slaves and others to keep the tunic clean. It also formed part of the costume of the comic actor. Our cut, which represents a girl wearing an encomboma, playing the pipes, is from a bas-relief.

End-ornament. (Arch.) An ornament

sometimes plain, sometimes richly decorated, which terminates a pinnacle, pediment, or spire. End-ornaments may be spherical or pointed, and often consist of bunches of foliage.

Endromis. (Cost.) A heavy, warm kind of garment, which athletes loosely wrapt round their bodies after becoming heated

in the gymnasium. It therefore served the same purpose as the modern garment called a " sweater." Representations of athletes clothed in the *endromis* are of frequent occurrence in classical art.

Energetic. An epithet applied to a work painted with vigour, or to a drawing with a firm, solid, and strongly accentuated outline.

Engineer's Cartridge. A drawing paper of a certain size, its dimensions being thirty inches by twenty-two.

Englanté. (Her.) In blazoning a shield, this term would be used to describe a twig of oak bearing acorns of a different tincture to that of the leaves.

Engobe. (Pot.) A white paste applied to the surface of some kinds of pottery; an earthy substance used in the decoration of coloured pottery. Artificial engobe is formed of colourless earths mixed with metallic oxides, while natural engobe is a natural mixture of earthy matter with colouring oxides.

Engouled. (Her.) Said of a charge which is being swallowed by some animal; thus the cut represents a bend argent engouled by two lions' heads. The word is also applied from the other point of view to a person or animal pierced by a weapon through the mouth.

Engrailed. (Her.) A dividing line in a shield is said to be *engrailed* when it is broken up into a series of small projecting teeth having a cusp-like form. It thus differs from an *indented* line (q.v.), where the sides of the teeth are straight.

Engraver. An artist who cuts designs on wood blocks or ploughs them out on a copper plate with the graver, or in fact executes any of the processes which come under the term engraving.

Engraving. The art of engraving may be defined as the art of representing objects by incised lines on wood, metal, or stone. In the broad sense of the term engraving has been practised by all nations and in all ages. Many hundreds of years, however, passed before the method of multiplying copies by printing from one original plate was discovered. It is to this multiplication of copies that the term engraving is now generally applied, though indeed it is no essential part of engraving. Engraving as it is understood to-day dates only from the 15th century, in the early part of which the first rude wood-blocks were produced. The more important methods of engraving will be found described under their separate titles [Wood-cutting, Line-engraving, Etching, Stipple, Mezzotint, Lithography, &c.]. The term *engraving* is also applied to the art of cutting designs upon or chasing metal plates, such as sepulchral brasses, as well as to the art of cutting precious stones, either in cameo or intaglio. The print struck off from a wood block or engraved plate is called an *engraving*.

—, **Colour.** In colour engraving several plates are employed to produce one proof. Each of the plates prints a different colour, and by their superposition intermediate tones are produced. The plates are engraved as in mezzotint (q.v.), and the great difficulty is to observe the guiding points, so that in the successive printings the colours are applied exactly in the place which they ought to occupy, without over-running the outlines.

—, **Crayon.** A method of engraving popular during the last century, by means of which exact fac-similes of crayon drawings were produced. A varnished copper plate was used as in etching, but instead of working with an ordinary needle the engraver used a toothed needle, a roulette, and several other tools, which enabled him to imitate

exactly the broad strokes of the crayon or chalk. The earliest specimens of this kind of engraving were produced by François and Demarteau in France. The latter's reproductions of the drawings of Boucher and his school are justly celebrated.

Engraving en taille d'épargne. A term applied to that process of engraving, in which the part intended to be reproduced in the print is left in relief, while the rest is cut away. To this class of engraving wood-cutting belongs.

— en taille douce. In this method of engraving the lines which are to be reproduced in the print are hollowed out or depressed beneath the surface of the plate. That is, it is the reverse of engraving *en taille d'épargne.* Line-engraving and etching are among the examples of engraving *en taille douce.*

— in Camaieu. A method of engraving practised in the 16th century, the object of which was to imitate sepia drawings. As it was necessary to reproduce several distinct tones of brown as well as white, several wood blocks were used and applied to the paper one after another, a separate block being used to print each tone. Engravings in camaieu are sometimes printed all in one colour, and the differences of tone are obtained by hatchings.

— in the Dot Manner. One of the earliest methods of engraving on metal. Instead of drawing lines on the metal or scraping it away, the engraver simply covered those parts of his plate which he wished to print light with small dots or holes. Two engravings in this manner dating from the year 1406 have been recently discovered.

Enneapylae. (Arch.) A fortified enclosure surrounding the Acropolis at Athens. It was so called because it had nine gates.

Enrich. To enrich is to decorate, to adorn with various and sumptuous ornaments. Thus we say that a book is enriched with cuts when it is illustrated with vignettes.

Enrockment. (Arch.) A base formed of enormous rocks or massive blocks of stone immersed in water, and serving as the foundation of a fountain or as the piles of a bridge.

Ensemble. A term applied to the whole group of figures or all the objects in a landscape, which unite to make up a picture or artistic composition.

Ensign. A military standard, consisting of an unright staff surmounted by a device, peculiar to the nation or monarch to whom the ensign belongs. The standard of Rome, for instance, generally

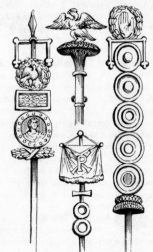

bore an eagle upon it, as will be seen in two of our cuts. Another cut represents a Roman standard subsequent to the time of Constantine, and instead of the traditional eagle an emblem of Christ is attached to it.

Entablature. (Arch.) A horizontal architectural member, which consists in the ancient orders of an architrave, a frieze, and a cornice. It is supported by

columns, and its height varies from four to five times the diameter of the shaft of the column of the order to which it belongs. When several ancient orders are placed one above the other, the entablature of the intermediate orders has no cornice. This is reserved for the top story of the building. In modern buildings columns and pilasters are generally surmounted by an entablature, the height of which varies according to the space at the disposal of the architect, due regard being kept of course to harmony of proportion. Sometimes too a false entablature is placed at the summit of a façade, although there are no pilasters to justify its existence. Entablatures surmounted by projecting cornices are sometimes mere opportunities for decoration, and are taken advantage of to hide the slope of a roof, gutters, &c. The mouldings which cap pieces of furniture are also termed entablatures.

Entasis. (Arch.) The swelling in the middle of a shaft of a column. It is one of the characteristics of the Doric order, in which the swelling of the columns gives an effect of lightness to a structure which otherwise might appear too heavy.

Enté. (Her.) This is a French term applied to parts of the shield which are fitted into one another by means of curved indentations which may take

various forms. The first cut here given would be described as *enté en rond*, or *indented round;* the second *enté en pointe;* and the third *enté-ondé.*

Entre-coupe. (Arch.) The vacant space

between two vaults which spring from the same point.

Entre-deux. A French term applied to a piece of furniture, often richly deco-

rated, in the shape of a console or small cupboard, which stands against a panel between two doors or other openings.

Entre-sol. (Arch.) An intermediate story in a house, in which the rooms are of a low pitch. It is generally situated between the ground floor and the first floor, but sometimes it is found between some other two floors.

Epaulets. Shoulder-pieces of metal, which were introduced about the 14th century to serve as a protection to the upper part of the arm. With this the *epaulet* worn by officers has nothing to do. The latter, which is a kind of shoulder knot, was first worn in the latter half of the 18th century by men of fashion.

Epaulment. (Arch.) A wall built to uphold earth.

Épi. (Arch.) An ornament of glazed earth or lead surmounting pointed roofs. *Epis* of earthenware were employed from the 13th to the 14th century, at which time they were replaced by *épis* of enamelled faïence. The finest specimens of this class consist of a small square pedestal, sometimes decorated with human masks. Above this pedestal is placed a fir cone, a basket of flowers, foliage of varied hue, or a bird poised on a small globe. Leaden *épis* are either cast or beaten with a hammer. To-

wards the end of the 15th century excellent results were obtained by combining these two kinds of *epis*. The Renaissance produced some admirable specimens, consisting of capitals decorated with foliage and surmounted by vases of graceful form. In the 17th century they assumed the form of colonnettes, vases, or chimæras.

Some are made to-day in lead and after the best designs, but for the sake of economy zinc is too often used instead of lead, and this material robs them of all chance of durability.

Epichysis. (Pot.) A jug from which wine was poured into a cup. It was a form of the Greek oenochoe (q.v.), and had a lip, through which the liquid ran, and a light delicately-shaped handle. In our cut an epichysis is represented with a drinking-cup placed over its mouth.

Epigraph. An inscription placed upon a building to preserve the memory of its construction.

Episode. A scene or group of figures represented in some part of a picture, bearing little relation to the principal subject. The term is also applied to subjects which represent one particular incident in a long chain of events. Thus we speak of a picture representing an "*Episode* in the Crimean War."

Epistyle. (Arch.) An architrave or horizontal beam placed on the capitals of columns, so as to hold them together and to act as a support to the upper part of a building.

Epitaph. (Arch.) A tablet of marble, stone, or metal upon which a funeral inscription is engraved. The term is also applied to the inscription itself.

Équerre. (Her.) French heralds use this term to describe a small square piece cut out of the corner of a shield by means of an elbow of a different tincture. This device is common in German coats of arms. The term *escarre* is also sometimes used.

Equestrian. A term applied to statues which represent a personage mounted upon a horse. There were many celebrated equestrian statues executed by Greek and Roman sculptors. Lysippus, for instance, was the author of equestrian statues of Alexander and his generals. In modern times too the equestrian statue has been a favourite form of portraiture.

Equilibrium. A term applied to a figure in its natural and stable position and also to the arrangement of a composition, in which the groups, masses, and blacks and whites are well distributed and balanced.

Équipollé. (Her.) A French heraldic term used to describe a shield divided into nine small squares so as to form a chequer board. The usual arrangement is to have the four corner squares and the centre one of the same tincture, and the remaining four of some other tincture.

Erased. (Her.) Used to describe a head or limb torn off roughly so as to leave a ragged edge. It is opposed to *couped*, which means cut off clean.

Erechtheon. (Arch.) One of the buildings at Athens due to the genius of Pheidias and his contemporaries. It stood on the north side of the Acropolis, and was dedicated to Erechtheus. Above all it was celebrated for the caryatides (q.v.) which supported the

entablature in that portion of it called the Pandroseum.

Ermine. (1) (Her.) This is one of the heraldic *furs.* It consists of a white ground decorated with black *spots,* or in technical language a field argent, powdered with spots sable.

Ermine. (2) (Cost.) The winter skin of a species of pole cat, which is white with black spots. It was valued very highly in the Middle Ages, and in the 13th century it was enacted that only royal personages and those of the nobility who had more than £1,000 a year should wear it.

Ermines. (Her.) This fur, called in French *contre-hermine*, is the opposite of Ermine, the field being black and the spots white.

Erminois. (Her.) In this fur the field is gold and the spots sable. Its reverse is *peau* (q.v.).

Eros. [Cupid.]

Escallop. (Her.) A shell which is often found in coats of arms and is a very honourable bearing. It was assumed by the pilgrims on their return from the Holy Land, and the two kinds of escallops shown on shields are dignified by the names of saints. The one with ears is called the escallop of St. James, and the one without ears the escallop of St. Michael. The escallop was particularly the emblem of St. James, and representations of it are frequently to be met with in churches dedicated to this saint.

Escarpment. An abrupt, precipitous slope. [Scarp.]

Esclatté. (Her.) This term is employed when the dividing line in a shield, instead of being straight, is rough and jagged as if it had been violently broken.

Esconison. (Arch.) A triangular space formed by two straight lines and curve, often found in a window jamb or arch. It is enclosed by the curve of an arch or rose window and the two sides of the rectangle, in which the curve, be it circle or ellipse, is inscribed. Esconisons are sometimes decorated with foliage and other ornaments, at other times the triangular

spaces are filled with decorative paintings representing allegorical figures. In buildings of the Gothic style we find pierced esconisons in the angles of round windows.

Escutcheon. A cartouche or tablet upon which coats of arms are emblazoned or inscriptions and ornaments set forth. The name is also given to metal plates which assume this form, such as those used for key-holes upon doors.

Espagnolette. (Arch.) A French term denoting an arrangement for closing a window, which consists of a rod of iron with a hook at each end. It is moved by a handle from the inside of a room. When the window is closed these hooks are held fast in staples, and when, by turning the handle, the window is opened, the hooks are released from the staples.

Essorant. (Her.) A French term applied to a bird standing on the ground and holding its wings up so as to dry

itself. The cut represents a *goose, collared and crowned, essorant.*

Esteté. (Her.) A term used in heraldry to denote animals represented without heads. For example, the cut represents an *eagle esteté sable.*

Instances of headless animals are frequently found in Polish and Silesian coats of arms.

Estimate. A detailed description of any work or undertaking, including a minute account of the expense necessary to construct a building or execute a work.

Estrade. (Arch.) A raised portion of the floor of a room, on which a bed or seat may be placed.

Etalon. (Arch.) The tracing of the plan of a building on the very spot where it is to be constructed and on the exact scale on which it is to be built.

Etching. (Engrav.) The word etching is derived from the Dutch word *etsen*, to eat, and denotes a process of engraving in which the incised lines are obtained not laboriously by working with the graver but by the action of acid. The plate to be etched upon is covered with an etching ground (q.v.), great care being taken to lay this ground equally all over the plate. The drawing or picture to be reproduced is then traced with an etching needle, which removes the ground wherever it is applied, and so exposes the plate. The plate is then put in acid and the exposed parts are bitten in. The acid used is diluted nitric acid. If a plate is to be re-bitten it is covered with a ground once more, but this time the ground is only passed lightly over the plate with a roller (q.v.), so as to cover the portions upon which the ground was formerly, but to leave the lines exposed. The ground is then removed altogether, and the plate may at once be inked and impressions struck from it.

Etching Ball. The etching-ground when formed into a compact mass and enclosed in a piece of silk is called an etching-ball. It is in this form that it is laid upon the plate. It is generally spherical in form as in the cut, but sometimes the ground is obtained in small sticks, resembling sticks of Indian ink.

— **Ground.** The ground used in etching is the substance which covers the plate and resists the action of the acid. One ground frequently used is composed of white wax, gum mastic, and bitumen. It is formed into balls and enclosed in a piece of silk; it is

then laid on the plate and made level with a dabber (q.v.). When the ground is to be laid, the plate must be heated to a proper temperature, so that the substance composing the ground may melt through the silk. Another method of laying the ground is to mix it with oil of lavender and lay it directly with a roller.

— **Needle.** The sharp-pointed instrument which etchers use for drawing upon the copper plate. It is not intended to cut into the plate itself, but only to scrape away the ground and so expose it to the action of the acid.

Etchings. The impressions struck off on to paper from an etched plate. The early impressions or proof-etchings are printed on Japanese paper (q.v.), and are often very costly.

Ethnographic. A term applied to all that relates to our knowledge of various races from the point of view of their distinctive characteristics.

Hence artistic works which reproduce the types of foreign races are termed ethnographic. Scenes of the East and Algeria, such as those of Decamps and Gerôme, may be called ethnographic paintings.

Etoile. (Her.) A synonym for star. The heraldic star consists of five rays issuing from a centre.

Etruscan Vases. 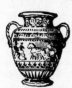 The first painted Greek vases which were brought to light in modern times were discovered in Etruria about the end of the 17th century. The learned men of that time at once concluded that they were the work of Etruscan potters, and they were long known as *Etruscan vases.* This appellation was proved to be erroneous by Winckelmann and others, and has now been discarded. The majority of the so-called Etruscan vases were indeed of Greek workmanship, and were imported into Italy in very early times. At the same time many vases were dug up in Italy which had no doubt been made in Etruria in imitation of the productions of the Greek potters.

Étui. A case of gold or silver, richly chased, which was worn by ladies at their girdles in the 16th and 17th centuries. It was the forerunner of the modern chatelaine.

Eurythmia. In architecture *eurythmia* refers to beauty of proportion, in painting and sculpture to grace of composition and to the harmonious balancing of the lines in a figure or of the groups in a large composition.

Eustace, St. A legendary saint, frequently represented in Christian art. He was a Roman soldier, and before he assumed the name of Eustace, which he did on his conversion, he was called Placidus. Like St. Hubert (q.v.) he became a Christian on seeing a white stag with a cross between its horns. He endured many tribulations, losing for a while his wife and children, and finally being burnt alive in a brazen bull, but he remained steadfast in the faith. In pictures he appears in the costume of a Roman soldier and holds a palm branch; near him stands the white stag to which he owed his conversion.

Eustyle. (Arch.) A eustyle temple is one in which the intercolumniation or distance between the columns surrounding it is equal to two and a quarter diameters of the column measured near the base.

Evangelists, The Four. The earliest representations of the four evangelists are purely symbolic. They are figured as four scrolls or books in the angles of a Greek cross, then as four rivers flowing from a rock, upon which stands a lamb, the symbol of Christ. They then appear as the four beasts mentioned in Ezekiel

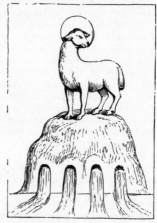

as supporting the throne—a cherub, a lion, a bull, and eagle. They were next represented as monsters, half men and half beasts, holding books or scrolls. St. Matthew alone had a human face, the others had the head and feet of a lion, bull, and eagle respectively. For their individual attributes, see under their separate headings.

Ewer. (Pot.) A vase of graceful shape, with a handle and gullet and mounted on a foot. The purpose to which the ewer was originally put was to contain water at table. Benvenuto Cellini produced ewers which were masterpieces of art, and one, in which is represented the combat between the Centaurs and Lapiths, is particularly celebrated. In modern times ewers have been made of gold and silver and even more precious materials, while gems have been lavishly employed in their decoration. The ewer is above all a decorative vase, and lends itself admirably to richness both of material and design.

Excavation. Excavation denotes the hollowing out of the ground to make space for foundations, which precedes the construction of every building. The term is also applied to the digging up and bringing to light of long-hidden and forgotten works of art. It is to the work of industrious excavators that almost all our knowledge of the monuments of ancient art is due. Of the great results of which scientific excavation is capable, the best evidence is afforded by the important discoveries made in the plain of Olympia by the German Government. This enterprise was undertaken with a full knowledge of what might be found there, and the expectations of the *savants* who carried it out were accurately fulfilled.

Excudit. We often find upon prints an inscription such as the following: *Marc Antonio sculpsit, Antonio Salamanca excudit.* This means that the impression before us was printed from a plate engraved by Marc Antonio and published by Antonio Salamanca. The part played by the publisher was of some importance, for he frequently retouched the plates which he issued.

Execution. The technical part of an art, including skill of hand and profound knowledge of technique. A badly composed picture may show immense skill in execution. The qualities of execution differ absolutely from those of composition, and many artists who have never displayed any fertility in the choice of subjects or knowledge of composition are sometimes in the very front rank as far as execution is concerned. Mr. Ruskin's definition of execution is "the right mechanical use of the means of art to produce a given end."

Exedra. (Arch.) A semicircular bench, resembling in form those on which the philosophers and rhetoricians sat in ancient times. In Christian basilicae an exedra is placed on each side of the

episcopal throne in the centre of the apse and raised some steps above the general level of the floor. Some authors term these exedrae *subsellia*. It was upon them that the priests took their seats at official meetings.

Exercise. A model given to a pupil to copy to familiarise him with certain difficulties. A composition on a given subject set for the purpose of accustoming students to compose pictures and arrange groups.

Exergue. The space on the field of a coin or medal outside the main design, upon which an inscription, device, or date is inscribed. The term is also applied to the inscription itself. Some medals have a different exergue

on each face. Sometimes there are two exergues on the same face of a medal or coin, arranged symmetrically with regard to its diameter.

Exhibition. A temporary collection of works of art got together sometimes for the purpose of sale, sometimes for the illustration of the work of some particular artist or period. The first public exhibition of English art was held in April, 1760, since which year an exhibition has been held annually. From the time of the establishment of the Royal Academy in 1768 this exhibition has been under the auspices of that body. During the last ten years many exhibitions have been established in rivalry with those held by the Academy.

Exomis. (Cost.) A short sleeveless tunic, which left the right arm and shoulder quite free and unimpeded. It

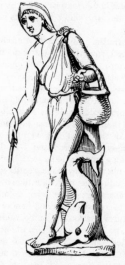

was worn by both Greeks and Romans, especially by those who were engaged in active physical toil.

Expert. A term applied to those who are, or believe themselves to be, connoisseurs in works of art and make a profession of their real or supposed knowledge. The catalogues of public auction sales afford us proofs of the frequent ignorance of experts even of modern pictures. In certain legal cases, experts generally chosen from the body of artists of repute, are called upon to give evidence.

Expression. A figure is said to have expression when in its interpretation the character of the subject is well represented. It is in the treatment of the face and especially of the eye that artists display their power of setting forth expression.

Exterior. The outside of a building, as opposed to the interior or inside.

Extrados. (Arch.) The upper convex surface of a vault or arch; the curve

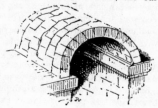

formed by the upper side of the voussoirs (q.v.).

Extradossed. (Arch.) A term applied to arches, the extrados of which is formed of stones regularly squared and not left in their natural condition.

Extremities. A term used in artistic language for the arms and legs and more especially for the hands and feet of the human figure. Thus we speak of "extremities badly drawn," or of "extremities painted with consummate knowledge and skill."

Ex-voto. A tablet of marble bearing an inscription, or an inscription upon the walls of a religious edifice setting forth the accomplishment of a vow, or intended to keep green the memory of some favour obtained. In Catholic countries, in chapels in the neighbourhood of the sea, we often find pictures of ships in distress with the Virgin appearing through the clouds. The connections of

these rude paintings with art is, however, very slight.

Eye. (Arch.) A term used to denote the centre of an Ionic capital, as well as the circular opening in the summit of a dome and the small circle in the centre of a rose window. From within the eye of a volute, following the sides and diagonals of a square inscribed within a

circle we can determine with a compass the contour of a volute, as is shown in our second cut. In symbolic art the eye has always been the emblem of watchfulness and so of the divine power. Among the Egyptians Osiris was typified by an eye, and in early Christian art the eye stands for the Providence which sees all things.

Eye-shade. A piece of green card which engravers wear on their foreheads. It projects like a visor, shields the eyes from the rays of light, and so renders the sight more distinct.

F.

Façade. (Arch.) The outside surface of a building; especially the principal front, which is the most exposed to view and is more richly decorated than the rest of the edifice. The chief entrance to a building is generally to be found in the façade.

—, **Composite.** A façade ornamented with entablatures of different orders. The west front of St. Paul's is an example of a composite façade.

Face. (Paint.) The front part of the head from the forehead to the chin. Expression and individuality are to be looked for in the face, and the importance attached to the proper representation of the face in portrait-painting may be gauged by the fact that in the 16th and 17th centuries portrait-painters were called face-painters. In architecture a flat moulding or a broad smooth surface is termed a *face*. Thus we speak of the *face* of an architrave.

Face-painter. An old term which was applied in the 15th and 16th centuries to a portrait painter, the accurate representation of the features being regarded then as the end of and aim of portrait-painting.

Facet. A small smooth surface, especially that surface between the angles of diamonds or crystals which is sometimes natural, sometimes obtained artificially by cutting.

Facing. (Arch.) When a rough wall of brick or stone is covered with a thin coat of a better material, such as marble or plaster, this outer coating is called a facing.

Facsimile. An exact reproduction, obtained sometimes by artistic means, but more often by purely mechanical processes, such as photography, heliogravure, &c. In the last century facsimiles of the drawings of the old masters were produced by means of line engraving. In these facsimiles not only the touch of the artist but even the tone of old paper was reproduced. To-day the processes of engraving which depend upon photography have rendered easy the production of extraordinarily accurate facsimiles. The term is also applied to reproductions of hand-writing, signatures, marks, and monograms, with which books are sometimes illustrated.

Faded. A term applied to colours which have lost their freshness or brilliance. Some shades of colours when faded produce an excellent effect.

Faenza Ware. A name given to majolica from. the little town near Bologna where majolica was once made.

Faïence. (Pot.) Just as faenza became

in Italy the general name for majolica, so faïence, said by some to be derived from faenza, became in France a general name for a kind of pottery composed of glazed or enamelled earth. The secret of making it was known in very early times to the Chinese, Arabians, Persians, and Assyrians. There are some very fine specimens of Moorish faïence dating from the 12th and 13th centuries at the Alhambra at Grenada. But many pieces are known of far greater antiquity than this. In the museum at Sèvres, for instance, there are examples dating from the 9th century. In a convent at Leipzig, built in 1207, were found some enamelled bricks, while the tomb of one of the Dukes of Silesia, who died in 1290, consists entirely of enamelled terra-cotta. The potteries of Nuremberg are celebrated. In the 15th century German potters imported faïence to Delft, and in 1650 there were in existence no less than fifty factories of faïence in England, France, Sweden, and Denmark. Their prosperity, however, declined in the 18th century, but a revival of the art has taken place in our own days.

—, **Common**. A faïence generally porous, of a red or yellow tint, with an opaque white or varnish coloured glaze.

—, **Fine**. A faïence consisting of silica, alumina, and sometimes lime. Its paste is porous, white, absorbent, and opaque, and its glaze is transparent and has protoxide of lead as its base.

— **of Henri II**. A very rare faïence of the Renaissance period, composed of plastic, clay, and flint, or quartz ground very fine. Lead enters in the composition of its glaze. There are only fifty-six specimens of it in existence, twenty-eight in France, twenty-six in England, and a solitary one in Russia. All these pieces were found either in the Vendée or Touraine. They are cups, ewers, &c., emblazoned with the arms of Francis I., Diana of Poicters, and Henri II. They were manufactured at Oiron by the potters F. Charpentier and Jean Ber-

nard, from about the year 1525 to the end of the reign of Henri II.

Failli. (Her.) This term is used by French heralds to denote a failure or break in an ordinary. It is specially applied to a chevron divided into several pieces as shown in the accompanying cut.

Falchion. A sword of uncertain form used in the Middle Ages. In all probability it resembled the German *sabre*, and was used as being lighter than the broadsword.

Falcon. (Her.) The bird of prey used by sovereigns and nobles for hawking is a frequent charge in heraldry. It is sometimes represented on a perch. In some coats of arms the falcon wears a mantle embroidered with fleur-de-lis attached to its neck by a ribbon. In symbolic art the *falcon* is the emblem of royalty or nobility, for the sport of hawking was restricted by law to kings and nobles.

False. (Arch.) A term applied to pretended mouldings or openings, produced either in relief or by means of painting, which decorate a façade or contribute to its symmetry.

Fan. Fans were known to the Greeks as well as to Eastern nations, and representations of them occur in monuments of classic art. Our first cut represents Cupid fanning his mother, and is taken from an ancient sculpture. During the Middle Ages fans do not seem to have been used in Europe, but they reappeared about the fifteenth century. The fans made to fold up, which are generally used in the present day, were introduced in the 17th century. The artistic portion of them generally consists of a

painting, drawing, or engraving on parchment, vellum, or silk. The majority of fans, it is true, are vulgar in design, and owe their commercial value simply to their mounting. Some few, however, are thought worthy to be placed in col-

lections and kept under glass without ever being mounted at all. Many modern artists have made designs for fans of the highest merit. Perhaps the finest specimens have been produced by the Japanese, who excel in this branch of decorative art.

Fancy. A work of pure imagination may be said to be full of fancy. The word is also used in a bad sense. Thus we may term a work not sufficiently studied from nature but painted out of the artist's head a " mere fancy."

Fanfreluche. A French term denoting brilliant and excessive ornaments. In some of Boucher's portraits of ladies, for instance, the *fanfreluches* are rendered with much skill.

Fantastic. A work is said to be fantastic when it is fanciful and extravagant, displaying curious effects of light and representing supernatural scenes, phantoms, and apparitions.

Fan-tracery. (Arch.) This term is applied to a kind of vaulting found in late Perpendicular buildings. All the ribs, of which the vaulting is composed, rise from the springing of the vault and diverge as they go upwards, so as to produce the effect of a fan spread out. The best examples of fan-tracery are to be seen in Henry VII.'s Chapel, Westminster, and King's College Chapel, Cambridge.

Farnese Bull. A celebrated sculptured group, the work of Apollonius and Tauriscus, sculptors of the school of

Tralles. Fragments of it were discovered in Rome in the 16th century, and it was restored with more courage than knowledge by Giovan-Battista della Porta. As it exists now only the torsos of the two male figures and a portion of the female figure are original. The group represented the punishment inflicted on Dirce by Zethus and Amphion, in consequence of Dirce's treatment of their mother Antiope.

Farthingale. A kind of cage worn by women in the 16th century under their dress. It was not at all unlike the hoop or crinoline, and served the same purpose of spreading out the dress, till it had the appearance of a bell.

Fasces. A bundle of twigs or rods, with an axe in their midst, which was in ancient times carried before Roman magistrates. Soon after the expulsion

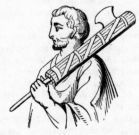

of the kings, however, the axe was removed, and was only carried in front of a dictator or a quaestor in time of active service. Our cut represents the fasces with the axe.

Fascia. (Arch.) A flat moulding, like a fillet, used in classical architecture. In architraves of the Ionic or Corinthian orders two or even three *fasciae* are found, each one receding from the one above it.

Fates, The. Three sisters, the daughters of Night, who spun the thread of human life. They were named Clotho, Lachesis, and Atropus, and it is said that Clotho put the wool on the spindle, Lachesis spun it, while Atropus cut it.

The Fates are frequently represented in art, mediæval as well as classical, as three maidens of sober aspect. The marvellous group in the eastern pediment of the Parthenon, now among the Elgin marbles, is held by some critics to represent the Fates.

Faun. The *fauns* were silvan deities frequently represented in Greek and Graeco-Roman art. They should more properly be called Satyrs. In ancient times a faun from the hand of Praxiteles was particularly famous. In art fauns generally assume the form of youths, with shaggy hair and horns sprouted from their forehead. There is a well-known statue of a laughing faun in the British Museum dating from the Graeco-Roman period.

Feathering. (Arch.) A series of foils or small arcs with cusps between them, which decorates the inner surface of a Gothic arch. Feathering is also termed foliation. [Foils.]

Feeling. The feeling of a picture may be defined as that quality by which expression is given to the emotions actuating the painter in the conception and execution of his design. This " feeling" is only possible in the work of a painter who has attained a perfect mastery over his material; for where the technique is imperfect, expression of emotion or feeling is out of the question.

Felicitas, St. A Roman widow who suffered martyrdom in the time of Marcus Aurelius. Her seven sons were put to death before her eyes because they would not renounce the Christian faith, and she herself was afterwards cruelly slain, according to one account, by being put in a cauldron of boiling oil. She is represented in art as amply draped and holding a palm branch. Sometimes she appears standing in a cauldron, as in Raphael's " Martyrdom of St. Felicitas," which is the most celebrated rendering of this subject. The date of her martyrdom was November 23rd, A.D. 173.

Feminalia. Short breeches worn by the Romans, which fitted closely and reached to the knee, resembling our knickerbockers. They did not come into

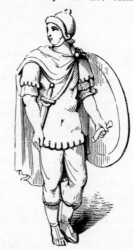

general use in Rome until after the *toga* had gone out of fashion, and then they were principally worn by soldiers on service in cold climates.

Fenestella. (Arch.) In ecclesiastical architecture the fenestella is the niche in which the piscina (q.v.) is placed.

Fenestration. The general arrangement of windows in a building.

Feretory. A shrine resembling a

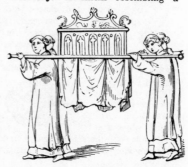

small coffin in form, in which the relics

of saints were carried in ecclesiastical processions. The feretory was frequently richly decorated with chasing and enamel, if of metal, and with carvings in relief, if of wood or ivory. Our cut, representing four monks bearing a feretory, is take from a MS. by Matthew Paris.

Fess. (Her.) The *fess* is one of the principal ordinaries in heraldry. It crosses the shield horizontally and occupies one third of its width. The *bar* is a diminutive of the fess, occupying only one-fifth of the shield. The *closet* or *barrulet* are diminutives of the bar.

Fess-point. (Her.) The centre point in a shield.

Festoon. (Arch.) An architectural ornament of great beauty and variety. It generally consists of foliage, flowers, or branches intertwined or bound together. It is peculiarly appropriate for the adornment of friezes. In the pointed style of architecture festoons consist of a series of lobes or indents. Festoons were employed with excellent effect by the architects of the Renaissance style. A representation of a festoon will be found under the heading Encarpa.

Fibula. A kind of brooch or clasp. Ancient *fibulae*, as well as those of the Middle Ages, were made of gold, silver, or ivory, and sometimes ornamented with precious stones and chased with care. In museums and art collections many ancient fibulae of beautiful workmanship are to be seen. In ancient times the term fibula was applied to girdle-clasps, which very closely resemble the buckles which are used to-day for the same purpose, and were provided with a movable tongue. [Brooch.]

Ficelles. A slang term applied in Paris to the thousand and one tricks of the artist's trade—to the painter's happy thoughts, due sometimes to chance, sometimes to patient research. At first sight, for instance, the foreground of a picture may appear to be executed by impossible methods. A closer inspection shows us that, thanks to a "ficelle," it is quite simply painted. It is a "ficelle" again when a sculptor sprinkles a mixture of acidulated water on the folds of his draperies, and by means of this colour accentuates the relief. Nor are "ficelles" unknown in the engraver's art. The highest form of art, it is true, knows not "ficelles," but it cannot be denied that these dodges play an important part in the art of modern times.

Fictile. (Pot.) The term *fictile* was applied by the Romans to pottery of every kind. Architectural ornaments and pottery of the highest artistic merit were known as fictile, as well as the earthenware pots and pans in everyday use. The moulds and stamps employed in the potter's art were placed in the same category. Of our cuts the upper one represents a stamp used by the ancient potter to make the pattern which ran round the neck of a vessel, and the lower cut shows the pattern thus produced. [Pottery and Vases.]

Field. (Her.) In heraldry the *field* of a shield is the groundwork or basis upon which the different charges are laid. The tincture of the field must always be specified first in blazoning a shield.

Figure. A representation of a man, woman, or animal, drawn, painted, or sculptured. A life-size figure is a representation of a man or woman of natural size; a half-figure represents a person as far as the waist only; a figure half life-size represents a man or woman half

the ordinary height. An academy figure is a figure of which the dimensions are those of the studies generally painted or modelled in schools of art, *i.e.* a little less than half-life size. The following proportions are generally observed in the drawing of figures. They have been arrived at from the observation of centuries and the careful examination of the human structure. The height of a male figure ought to be eight times the height of the head, of a female figure seven times the height of the head, ŏf the figure of a child six times the height of the head.

Figure, Colossal. A painted or sculptured figure, the proportions of which are far beyond life-size. A monumental figure may be from eight to eighteen feet high or more according to the space which it is to occupy in a building or the size of the square in which it is to stand. The largest figure of this kind in the world is Bartholdi's statue of Liberty, which measures upwards of 150 feet from the base to the summit of the torch.

Figurine. A small figure or statuette, generally in terra-cotta or some material less durable than marble. Greek figurines, though exquisitely graceful and artistic, often lack the restraint observable in classical statues of larger dimensions. This in reality adds to their interest, for it shows us of what Greek art was capable when not devoted to civic or religious purposes. The finest figurines known to us are those found at Tanagra. [Tanagra figures.]

Filigree. Goldsmith's work consisting of threads of metal intertwined and soldered. The ornaments of the 11th, 12th, and 13th centuries are decorated with filigree of exquisite workmanship. Filigree lent itself especially to the representation of the crockets and festoons which decorate those architectural monuments in miniature, the mediæval reliquaries. [Reliquary.] Eastern nations have always been famed for their

skill in filigree. The Italians introduced the art into Europe.

Fillet. (1) (Arch.) A square moulding which is also termed a list or listel. Fillets serve to separate convex or concave mouldings, and their number and

proportions vary in the case of classical buildings according to the order to which they belong, in the case of Gothic buildings according to their style or period.

Fillet. (2) (Her.) The *fillet* is the diminutive of the *chief*, and is generally represented as one-fourth the size of this ordinary.

Fillet. (3) (Cost.) A band worn upon the head by the Greeks, both men and women, and tied at the back with a bow.

It was not, as was the case of the diadem, a sign of distinction or dignity, but simply a personal adornment.

Filomena, St. A purely legendary saint, whose worship has become popular in the present century in Italy. In 1802 a skeleton of a girl was discovered, the sepulchre bearing a fragmentary inscription, which was elaborated by a zealous priest into a memorial inscription in honour of an imaginary saint called Filomena. She was said to have suffered martyrdom in the reign of Diocletian or Maximian; and though there is absolutely no reason to believe that such a person ever existed, she was

at once honoured as a saint. There are, as is naturally to be expected, few artistic representations of St. Filomena, but images of her are to be seen in various Italian churches.

Fimbria. [Fringe.]

Fimbriated. (Her.) When a charge, as for example a cross, is surrounded by a narrow border of a different tincture to itself, it is said to be *fimbriated.*

Fine-grinding. An operation by which the materials used in certain arts, such as potter's clay and painter's colours, are reduced to a fine powder.

Finial. (Arch.) In all styles of architecture a *finial* denotes a sculptured ornament, which represents a leaf or a flower, and which is employed (especially

in Gothic buildings) as a termination to gables, pinnacles, and canopies. Finials first made their appearance in the 12th century. At the beginning of the 13th century their section is square, and they consist of four bunches of leaves with

a bud above. In the middle of the 13th century they are composed of two rows of leaves, and at the end of the century they are still more elaborate. In the

14th century they are extraordinarily bold in design, but in the 15th they begin to lose their character. They are

stripped of their leaves, and finally in the 16th century they are replaced by a stem which springs from between the crockets on the slope of a roof.

Finish. (Paint.) The term *finish* is applied to the final touches in the execution of a picture. In a highly finished picture no detail is carelessly carried out. As a fine example of finish Gerard Dow's "Water Doctor" may be quoted. In pictures of small size *finish* is necessary to success. In large pictures, on the other hand, *finish*, if carried too far, produces only an impression of dryness.

Fire. (Her.) A natural figure in heraldry. It is represented on coats of arms by a flame, a torch, a brand, or burning coals. In early Christian art *fire* is the attribute of many saints and martyrs who suffered death at the stake.

Firebrick. (Constr.) An inflammable brick which contains neither iron, or oxide of iron. Firebricks are used in the construction of furnaces in which porcelain, faïence, and enamels are baked.

Firedog. An andiron (q.v.) of large dimensions. Firedogs were often magnificent specimens of ironwork. Those placed in halls and

dwelling rooms were richly decorated, while those placed in kitchens were stronger and plainer in design, and generally terminated in a kind of tray, upon which dishes were placed. In collections there are still to be seen many exquisite firedogs of wrought iron decorated with coats of arms.

Firelock. A kind of firearm discharged by means of flint and steel. It was invented in the early part of the 17th century.

Fireplace. In early times, in the 12th century for instance, fireplaces were deeply recessed and surmounted by a chimney-hood (q.v.) In the Early English period the fireplace was very plain and but little recessed. It was not until the 15th century that much decoration was lavished on fireplaces. At that time the hearth was set far back, and it was no longer necessary to use a hood.

Firing. The operation of fixing the colour in glass or enamel, by submitting the painted objects to the action of fire.

First Proof. (Engrav.) A proof printed from a plate before the inscription and author's name has been cut on it.

First State. (Engrav.) An engraving is said to be a first state when it is struck from a plate which has only been bitten once and has not received its final touches. The term is also applied to a print, either finished or not, which differs from the proof of the second printing.

Fish. A curious symbol frequently found on early Christian monuments and tiles. It is the emblem of our Lord, and the usual explanation of it is, that it is taken from ΙΧΘΥΣ, the Greek for fish, the letters of which are the initials of the words Ἰησοῦς Χριστὸς Θεοῦ Υἱὸς Σωτήρ, *i.e.* Jesus Christ, the Son of God, the Saviour. Another explanation is that it contains a reference to the text, " I will make you fishers of men," but the one first stated is the more probable.

Fish-tail. (Engrav.) A term applied to a broad flat brush, which is used to

lay the ground upon plates, which are to be bitten by acid.

Fitché. (Her.) An heraldic term which means tapering or pointed. For instance, a cross fitché (q.v.) is a cross the lower limb of which tapers downwards to a point.

Flabellum. A large circular fan formed of peacock's feathers. It was used as a brush in Asia, in Roman houses, and in the churches of the East. It was employed in the Latin Church until the 14th century, and it is still retained in certain ceremonies in which the Pope takes part. [Fan.]

Flag. A stone used in the making of pavements.

Flagellation. A term applied to pictures or bas-reliefs representing the scourging of Christ.

Flagon. A long-necked vessel with a spout and a lid, used for holding liquids. At the time of the Reformation the flagon was ordered to be used instead of the cruet in the services of the Church. It has now been replaced by a vessel of a different shape.

Flail. A weapon made on the model of the agricultural implement of the same name. It was made of wood, and its arm was sheathed in iron and often rendered more dangerous with spikes.

Flake White. (Paint.) A pigment composed of oxidised carbonate of lead. It owes its name to the fact that it is sold in flakes or plates. It has a good body, and under certain conditions is permanent. Oil and varnish dissolve it, and it is apt to turn grey in an impure atmosphere, while it, in its turn, is destructive to lakes and orange leads when mixed with these pigments.

Flamboyant. (Arch.) A name given to the French Gothic architecture of the 15th and 16th centuries, which corresponded in point of time with the Per-

pendicular (q.v.) style in England. The flamboyant style is characterised by

balustrades and traceries, resembling flames in their contours.

Flammeum. (Cost.) A long thick veil of a brilliant yellow or *flame* colour, which was worn by Roman women on

their wedding day. During the ceremony it covered the head of the bride, who was unveiled by her husband on reaching home.

Flanches. (Her.) A *flanch* consists of a segment of a circle cut out as it were from the side or flank of the field. Flanches are always borne in pairs and are reckoned as a *subordinary* (q.v.). They are rather rare in English heraldry, but a good example is to be found in the arms of Sir Bartle Frere: *Gules, between two flanches or, two leopards' faces in pale or.*

162

Flanks. (Arch.) The flanks of an arch are those portions of an arch between the spring-line and the vertex.

Flask. A vessel to contain liquids, used in Italy and elsewhere. It is a kind of flagon, long and narrow, and generally of a graceful form. Flasks were carried by pilgrims, and so we often find a flask suspended to a pilgrim's staff in works of art.

Flasques. (Her.) A diminutive of flanches, a smaller piece being cut out of the field of the shield.

Flemish Bond. (Arch.) That method of laying bricks in a wall so that in each course headers (q.v.) and stretchers (q.v.) appear alternately.

Flemish White. [White Lead.]

Flesh-tints. (Paint.) A term applied to those tints or colours observed in the nude human body. The representation of the nude is one of the most important branches of painting, and therefore too much stress can scarcely be laid upon the study of flesh-tints. The best colours with which to represent flesh are pink madder, brown madder (for the darkest touches), Indian red (as a shadow colour), Venetian red and vermilion for the carnations of flesh. In painting flesh the colours should be laid on thickly, as a good effect cannot be obtained by thin layers of colour over a large surface. The term "flesh-tints" in a general sense denotes the power displayed by a particular artist in the rendering of the nude; thus we speak of the flesh-tints of Rubens, of Titian, &c.

Fleur-de-lis. A flower which is found in many coats of arms as the symbol of nobility or sovereignty. It is pre-eminently the royal insignia of France. It assumes different forms at different epochs. The two most strongly marked types are those of the reigns of St. Louis and Louis XIV. The former was slender

and graceful in design; the latter squat and heavy. In early times the banner of France was covered with fleur-de-lis, as in our cut, but from the time of Charles VI. it showed only three fleur-

de-lis on a blue ground. For many centuries the fleur-de-lis were quartered on the royal arms of England in assertion of the claim of the English royal family to the throne of France. They were expunged from the shield by George IV.

Fleur-de-lis flory. A fleur-de-lis

 adorned with buds between the flowers or enriched with foliage and scrolls, so as to be transformed into an elaborate floral decoration. Fleur-de-lis flory are frequently found as a system of ornament on hangings. They are also worked into the design of mosaic pavements.

Fleuron. (Arch.) A name given to the small rose-like flower, surrounded by leaves, which is employed as an ornament in the classical style of architecture. It is most frequently found in the centre of the abacus of Corinthian capitals. It was the same ornament as that generally known as the honeysuckle pattern.

Flint-ware. (Pot.) A kind of fine faïence, which takes its name from the flint which enters into its composition.

Floral. Floral ornament is the system of ornament borrowed from the vegetable kingdom. The floral ornament of the Greeks is almost confined to the acanthus; that of the Gothic style, however, is of considerable variety. At the beginning of the 13th century the leaves generally sculptured were those of the ivy, vine, holly, marsh-mallow, and eglantine, By the end of the 13th century the leaves of the oak, wild plum, fig, and pear had been added to those already mentioned. In the 14th century the leaves of the black hellebore, chrysanthemum, sage, pomegranate, geranium and fern were the favourites, while in the decorative art of the 15th century we most often meet with the thistle, thorn, and mugwort.

Flooring. (Arch.) An arrangement of

thin planks of wood placed upon timbers called bridging joists. Floorings

receive different names according to the arrangement of the planks and the

method of joining employed, such as *plain jointed, rebated, fillistered,* &c. These technicalities, however, scarcely belong to the domain of art. Some floors are composed of marquetry, and have different coloured woods inlaid in them, which sometimes produce an admirable decorative effect.

Florentine Fresco. A method of fresco-painting differing from the ordinary method in that the lime may be kept wet and fit for painting on for a considerable time. By this means the greatest difficulty of fresco-painting is obviated. [Fresco.]

Florentine Mosaic. The inlaying of tables and other small surfaces with precious stones, such as lapis lazuli and chalcedony, is termed Florentine mosaic. By this process very beautiful effects may be obtained.

Florid. (Arch.) A term applied to the Gothic architecture of the latest period just before the Renaissance, when the ornamentation was wonderfully exuberant, and crockets developed from simple leaves into large bunches of foliage.

Flourishes. Embellishments or scrolls disposed round a system of ornament or adding richness to a cartouche, vignette, or initial letter.

Flower-painting. The representation of flowers is the object of special and exclusive study on the part of certain artists. Flowers have always been prized in the Netherlands, and it is there that the finest pictures of flowers have been produced. The flower-paintings of Daniel Seghers of Antwerp (1590—1660), David de Heem, Van Huysum, and J. B. Monnoyer are justly celebrated.

Flowers. In classical art flowers are the attribute of Aphrodite and the Hours; in Christian art of many legendary saints, such as St. Dorothea and St. Elizabeth of Hungary.

Flowers of Sulphur. Flowers of sulphur are used by engravers to slightly

bite in an engraved plate. Sometimes a mixture of flowers of sulphur and oil is used. This affects the surface of the plate and produces the impression of a washed drawing, which varies in energy according to the length of the exposure of the plate to the biting in.

Flush. (Arch.) Two walls are said to be flush when their facings are on the same level. One surface is said to be flush with another when they are on the same level.

Flutings. (Arch.) Hollow mouldings of uniform depth and equi-distant, introduced in the shaft of a column or the front of a pilaster.

—, **Cabled.** Flutings of which the indent is filled with a cable (q.v.).

—, **Decorated.** Flutings in which ornaments consisting of flowers and foliage are introduced. Buildings of the 12th century present many examples of decorated flutings, while on the columns of porticos of the Renaissance style flutings are found decorated with laurel leaves and foliage of great richness.

— **en gaine.** Flutings the edges of which, instead of being parallel, converge towards a base narrower than their summit. Flutings of this character are used to decorate pedestals in order to make the light play on their surface and so to give them an appearance of greater height.

—, **Ribbed.** Flutings which are sepa-
rated by listels (q.v.).

Flutings, Sharp. Flutings the curves

of which terminate at their point of contact in an acute angle.

—, **Twisted.** Flutings encircling a column in spirals.

 — **with Astragals.** Flutings filled with flat or convex astragals. These astragals are sometimes simple, sometimes cut in the form of a cord or cane, round which foliage is turned in spirals.

 —, **Zigzag.** Flutings drawn in a zigzag line.

Flux. A substance used in painting in enamel. It consists of glass, as clear and transparent as possible. It is spread over the plate which is to be enamelled and serves as a ground, importing to the plate a brilliant surface and serving to fix the colours. During the process of enamelling every colour is mixed with a certain quantity of flux. The term is also applied to a colourless enamel, employed by potters, which is blended with colours and serves as their vehicle.

Focus. (Photo.) To put an object in focus is to make either it or the glass to retire or advance until the image on the glass is absolutely clear.

Foils. (Arch). The divisions or compartments of an arch or spandril formed by arcs of circles in Moorish and Gothic architecture. Arabian arches are divided into foils, which are always of an uneven number. Sometimes in arches inscribed in rectangular openings the

division and outline of the foils are carried on to the extrados of the vault. In the pointed style many examples of windows are found divided vertically by ribs or mullions, which cross and interlace at

the spring of the arch, leaving foils between them in the form of convex or concave portions of arcs of circles, their intersections being formed by projecting crockets often ornamented by foliage.

Foil Arch. (Arch.) A foil arch is an arch made of our several smaller arches or foils.

Fold. A term applied to the angles and broken masses formed by draperies which fall loose. The proper treatment of the folds of draperies is an important part of the work of both sculptor and painter.

Folding Doors. [Doors, Folding.]

Foldingstool, or **Faldstool.** A movable chair or stool, which folds up in very much the same manner as the modern campstool. It was made of wood or metal, and sometimes covered with some rich material, such as silk. In olden times bishops carried foldingstools

about with them, and used them if they had to officiate in any but their own church, and so an ecclesiastical significance was attached to foldingstools, the term sometimes even denoting the *cathedra* or bishop's throne itself. Our two cuts are taken from MSS. of the Saxon period.

Foliage. The reproduction and arrangement of leaves, either real or fantastic, is one of the most frequent systems of ornament employed in architecture. In the ancient styles of architecture foliage is as a rule borrowed from the flora of the country. Thus on the monuments of Egypt we find the

palm-leaf and lotus, while on the buildings of Greece and Rome the leaves of the acanthus, bay, and olive predominate. In Romano-Byzantine monuments the foliage is generally nothing more than a barbarous and clumsy imitation of the antique. The sculptors of the Gothic period, however, took as their models the plants which grew in the neighbour-

hood of the church they were decorating. In the 12th century the foliage, though of considerable variety, is still somewhat fantastic. In the 13th century it is modelled from nature with conscientious accuracy and arranged with consummate grace. The leaves most generally used at this period are those of the ivy, vine, oak, strawberry-plant, apple-tree, chestnut,

fig-tree, parsley, marsh-mallow, liverwort, celery, chicory, cabbage, holly, and thistle. At the Renaissance garlands of flowers and fruit were employed for decorating purposes as well as foliage. In the 17th and 18th centuries garlands of leaves, either of the oak or olive, occur as ornaments and sometimes completely cover considerable portions of a façade. The acanthus of classical tradition, which was restored to favour in the 16th century, is held in honour by the architects of to-day. But at the present time new forms are rarely introduced. The reproduction of the foliage of classical antiquity is more popular than ever.

Foliated. (Arch.) Decorated with foliations or featherings (q.v.).

Foliation. (Arch.) A term applied to the cusps or foils which separate the small *arcs* within a larger arch or spandril in Gothic architecture. Trefoil or cinquefoil arches afford us examples of foliation.

Font, Baptismal. A basin in which the holy water used in the ceremony of baptism is kept. The fonts of the

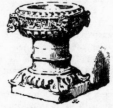

Romano-Byzantine and Gothic periods were of stone, copper, or lead. The majority of them were covered with a

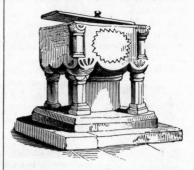

lid. In early times this lid was flat and unornamented, as in our second cut, which represents a font of Norman

workmanship in Hunstanton Church. At a later period, however, the lids were elaborately carved and architectural in design, representing spires, pinnacles, &c. Among fonts which are interesting from an artistic point of view we may mention those in the cathedrals of Hildesheim (13th century) and Strasbourg.

Foot. A term applied to the lower part of a vase which serves as a support and generally consists of a moulding resting on a small square plinth.

Foot-board. (Arch.) The base of Gothic stalls resembling a step raised some height from the ground.

Footing. (Arch.) A continuous projection forming the base of a wall. The base of a column is also called a footing, as is the base of a pedestal or pilaster.

Foot-lights. (Arch.) Rows of gas jets or lamps placed on a level with the stage, which serve to throw a strong light on the actors.

Foot-pace. (Arch.) A term which denotes the daïs of a hall, or that part of it in which the floor is raised above the general level.

Foot-stall. (Arch.) A now obsolete term for pedestal, to which word it bears an etymological resemblance.

Forced. A painted or sculptured figure is said to be forced when it presents a distorted attitude or exaggerated movement, which the artist has been unable to render efficiently.

Foreground. (Paint.) That portion of a picture on which the objects nearest to the spectator's eye are represented. In a portrait the foreground is the space, which is so rendered as to appear in front of the figure. The objects depicted in the foreground, being those most clearly seen, should be painted with some care and minuteness.

Foreshortening. A method of drawing or colouring used to produce a certain effect in the representation of objects and figures, the perspective of which makes them appear smaller to the eye than they really are. All objects which project perpendicularly to the plane of the picture must be foreshortened. The arms of a figure, for instance, are seen foreshortened if they are extended directly towards the spectator. Foreshortening is one of the difficulties of draughtsmanship, and many artists, such as Michael Angelo and Rubens, have been properly celebrated for their skilful management of it. Foreshortening, which is difficult to comprehend or is disagreeable to the eye should be rigorously avoided. Sculptors, as well as painters, have foreshortening to reckon with, not only in the execution of bas-reliefs, but in the composition of any statue which is intended to occupy a particular place. In this case the sculptor has to take into account the effect which his work will have in the position which it is to occupy.

Forge. To forge metals is to work them by exposing them to the action of the fire and by striking them with a hammer. There are in existence pieces of forged iron, which take a high rank among the masterpieces of decorative art. [Bickern.]

Form. A term used in painting and sculpture to denote the qualities of *line* as opposed to colour. An artist who devotes himself especially to line may be said to prefer form to colour.

Format. The dimensions of volumes.

167

Books are generally made of a certain format, such as quarto, octavo, &c.

Formative Arts, The. The formative arts are those arts, called by the Germans *die bildenden künste*, which deal with the forms and materials, of the external world. They are three in number, architecture, sculpture, and painting, and are at the opposite pole from the arts of music and poetry.

Formeret. (Arch.) An arch which adheres to the wall in a groined compartment. The term *wall-rib* is also applied to it. An example of a formeret will be found in the cut to transverse rib [Rib, Transverse], where the arches marked A A are formerets.

Fortification. (Arch.) Fortification may be defined as the science of protecting any place against hostile attack. The principles of construction enter largely into it, but its connection with art is of the slightest.

Fortress. (Arch.) A name given to any artificially strengthened building or to a building the natural strength of which has been taken advantage of by human ingenuity. The Tower of London is an admirable example of a fortress.

Fortuna. A goddess worshipped by the Greeks and Romans, and called by the former Tyche. In art she is represented as a draped female figure, holding a horn of plenty in one hand and a rudder in the other. Sometimes a ball lies beside her, emblematic of the sudden revolutions of fortune.

Forum. (Arch.) An open space in ancient Rome, in which the assemblies of the people, elections, and other public business took place. It occupied a piece of ground between the Capitol and the Palatine Hill. It was surrounded by temples and filled with interesting monuments. It has long been covered by the strata of successive civilisations, but of late years an extensive excavation has been carried on on its site and many valuable monuments brought to light. The term was extended in the time of the Empire to public places in all towns brought under the sway of Rome.

Foundations. A term which denotes the trench dug out to receive the walls which support a building from below as well as the subterranean portion of the walls of an edifice. Foundations vary according to the nature of the soil on which they are constructed.

Founding. (Sculp.) The following is, briefly stated, the method employed in the founding of a statue. A pit is dug in a dry place, and sometimes lined with brick. A rude model of the work to be cast in the foundry is then made. This, which is called the core, only reproduces the attitude and outlines of the statue, but is by no means an exact facsimile of it. It is generally composed of a mixture of plaster of Paris and brickdust, and is raised on bars of iron, which serve to support it. The core, when complete, is covered with wax of the intended thickness of the metal, which accurately represented the statue and is obtained from a piece-mould (q.v.), and finished by the sculptor. The wax is then thickly coated with a porous clay. When the clay is dry the whole mass is baked, and during this operation the outer coating of clay which forms the *mould* is hardened, while the wax melts and is allowed to run off through tubes or vent-holes inserted for this purpose. These holes also allow a free passage to the air, which would otherwise play havoc when the metal was poured in. The molten metal is run in through another hole left for the purpose, and as soon as the mould is filled the metal is allowed to cool slowly. The clay coating which forms the mould is then removed, and finally the core taken out, a hole being left in the statue for this purpose and soldered up afterwards.

The founding of the statue is then complete.

Foundry. An establishment where the operation of founding or casting statues in bronze is carried on.

Fountain. (Arch.) A construction from which an assemblage of jets of water issues. In the Gothic period fountains were constructed which resembled small pyramidal buildings. At the time of the Renaissance and in the centuries which followed it fountains were placed in the midst of a portico and were surmounted by a frame-work or cartouche of large

dimensions. They sometimes consist of a large flat cup of circular form or of several such cups placed one above the other. The Italians and French have produced the finest specimens of fountains, and in both Rome and Paris the masterpieces of this kind of art are to be seen. English people have as yet produced nothing in this direction worthy of note.

Foyer. (Arch.) A large saloon in a theatre, which serves as a promenade and place of meeting between the acts. It is only lately that the foyer has become a prominent feature in English theatres.

Fraise. (Cost.) A large pleated collarette, such as was introduced into France by Catherine de Médicis and was worn until the reign of Louis XIII.

Fraises. (Her.) The heraldic name for strawberry leaves.

Frame. (Arch.) A projecting border, either square or circular, which surrounds a plain panel or a painted or

sculptured mural decoration. The term is especially applied to the ornamental mouldings of wood, sometimes gilded, sometimes painted, which surround pictures, drawings, or engravings. Picture-frames have varied considerably at different periods. In early times they were carved out of solid blocks of wood and then belonged entirely to the domain of art. Each frame was designed to suit the picture which was to be placed in it, that it might add to rather than detract from its effect. But nowadays, when pictures or prints form a part of the decoration of every room, frames are manufactured by the dozen, and nothing is required of them but that they should fit the picture. They are produced by purely mechanical means, and generally consist of a flat moulding of wood, to which flutings, foliage, garlands, and other plastic ornaments are applied. The whole is then gilt or coloured by the ordinary processes. The rules of the Royal Academy, which forbid any but gilt frames to be hung on their walls, has checked variety in the manufacture of frames in England. However, a tendency is now observable to employ bronze, stamped leather, plush, and even sacking in frame-making. The frames

which surround drawings and engravings under glass generally consist of flat slips of wood, a margin being left between the frame and the print or drawing to heighten its tone. For water-colour drawing a white mount is best, while for drawings in monochrome a mount of a bluish tint is to be preferred. In this kind of framing there is considerable scope for taste, which is particularly shown in choosing a mount best suited in colour and dimensions to set off the drawing it surrounds.

Frame-wall. A wall which consists of beams, arranged as in the cut, with the spaces between filled with bricks, plaster, or blocks of terra-cotta. The brick or plaster is always of the same thickness as the frame-work made by the beams.

François Vase. One of the most celebrated of the ancient Greek vases which have come down to us. It is archaic in style and dates from the sixth century, being the work of the potter Ergotimus. Its ground is red, and it is decorated with black figures in zones. Among the subjects represented are the procession of the deities at the marriage of Thetis and Peleus, the battle between the Lapithæ and Centaurs, several incidents in the life of Achilles, &c.

Frankfurt Black. (Paint.) A bluish-black pigment of great service in oil painting, as it dries well and is permanent. It is prepared from calcined vine twigs or cocoa-nut shells.

Freestone. (Arch.) Stone which is cut in square blocks and worked with a chisel.

French Blue. (Paint.) An artificial blue pigment chemically obtained. It is injured by heat but is otherwise permanent.

French White. (Paint.) A pure white

pigment obtained from lead, possessing the qualities, good and bad, of white lead. On account of its destructive influence on other pigments its use cannot be recommended.

Fresco. A mural painting executed on a fresh ground—in Italian *al fresco*—of lime and gypsum. The brushes used are long and pointed or square and flat, but in either case have very long hairs. The colours are diluted in earthenware vessels. The colours, when applied to the surface, lose their strength and brightness, as they combine with the lime; in order therefore to double or treble the value of the tints each piece must be gone over two or three times, but care must be taken to do this immediately. The ground soon becomes unfit to paint on, and therefore in fresco painting retouching is impossible. This is its chief difficulty. On the other hand, as the colour combines with the lime in the ground it is of great durability. Fresco painting is chiefly used for the decoration of walls and ceilings. A good example of it is to be seen at South Kensington Museum, one room in which is decorated by two designs illustrating the arts of War and Peace and painted in fresco by Sir Frederick Leighton. The art was known to the ancients, but not revived until the 16th century, when it began to be successfully practised by the Italians. It should be remembered that the term *fresco* refers exclusively to the *process* by means of which this class of wall-paintings are carried out, and must not be applied loosely to any mural decoration.

Fret. (Arch.) A flat or semicircular

moulding applied to a flat surface and consisting of broken lines or interlace-

ments. The meander pattern, for instance, is an example of the fret, as is

also the ornament known as the *broken batoon* shown in our second cut. There

are also crenelated, triangular, and undulating frets.

Fret. (Her.) A *fret* is a *subordinary* formed by interlacing two narrow bands, crossing one another in *saltire*, with a *mascle;* or to use less technical terms, it may be described as a thin St. Andrew's cross interlaced with a hollow lozenge.

Fretty. (Her.) This is the name of a *varied field*, formed by the alternation and interlacing of narrow bands crossing the shield in directions of the *bend* and of the *bend-sinister*, as shown in the accompanying cut.

Frieze. (Arch.) The part of the entablature situated between the architrave and cornice in the ancient orders. In the Doric order the frieze is decorated with metopes and triglyphs; in the Ionic and Corinthian orders it is ornamented with bas-reliefs forming a continuous design. The finest example of an ancient frieze in existence is the frieze of the Parthe-

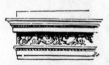

non to be seen among the Elgin marbles at the British Museum. The term *frieze* is applied to the broad border which sometimes runs round a room between the top of the wall paper and the cornice. By an analogy frieze may also denote a drawing, painting, or sculptured bas-relief, the length of which is considerably greater than its height.

Fringe. Fringes have been employed to decorate the borders of garments and cloths in every age and in every country. They are frequently mentioned in the Bible, and many representations of them occur in Assyrian monuments. The Egyptians, too, added rich heavy fringes to their garments, and we are told that

Julius Cæsar wore them on the sleeves of his tunic. They may be obtained by leaving the threads of the warp in the cloth after it is woven; these threads are then knotted and so prevent the cloth from unravelling. On the other hand the richest and costliest fringes are made separately and sewn on to the cloth which they adorn.

Frisquet. (Engrav.) A name given to the piece of paper laid by wood-engravers on that portion of the block which they have not yet cut when they take a proof of their work. A proof is

171

thus obtained of only those lines already cut by the engraver.

Frithstool. (Arch.) The meaning of this curious old term is *the stool of peace*, and the chair denoted by it was in ancient times the last resting-place of those who sought sanctuary within the walls of a sacred building. The frithstool was made of stone and stood close to the altar in minster churches. A specimen is still to be seen at Beverley.

Frontal. The cloth, frequently of embroidered silk, which was hung over the front of an altar.

Frontispiece. A term applied to a reproduction of a drawing or painting obtained either by engraving or some mechanical process, and placed as an illustration facing the first page of a book or magazine.

Fruit. (Her.) Fruits are occasionally employed in heraldry as charges. Those of most frequent occurrence are *acorns, nuts, apples,* and *grapes.*

Fruits. Representations of fruits combined with foliage often appear as forms of sculptured ornaments. [Garland.]

Fulham Pottery. In the 17th century John Dwight established a manufactory of porcelain and earthenware at Fulham. He took out a patent for the manufacture of porcelain, but not satisfied with his progress he burned his moulds and receipts and devoted himself to the making of earthenware. Some interesting figures and statuettes made at the Fulham potteries are to be seen in the British Museum.

Funeral Banquet. A funeral banquet very often forms the subject of Greek stelae or sculptured tomb-stones. The dead man is represented as reclining on a couch and receiving from his relatives the food necessary, according to the Greek idea of death, to support his life in the tomb.

Funeral Chariot. A carriage of no definite form, but built after the special design of a painter or architect, on which the body of a hero is carried to

his last resting-place. Such is the chariot now in the crypt of St. Paul's upon which the great Duke of Wellington was borne to his last resting-place.

Funicular Ornament. (Arch.) A round convex moulding in the form of a small cable.

Fur. (Her.) Eight furs are employed in heraldry: Ermine, Ermines; Erminois, Pean; Vair, Counter-vair; Potent, Counter-potent. Descriptions of these different furs will be found under the name of each of them.

Furies. The daughters of earth and darkness, whose duty it was to pursue the guilty who had left their sins unatoned. Their proper abode was in Hades, but, as in the story of Orestes, they were sometimes sent to persecute the guilty on earth. In the Greek tragedy which bears their name they appear as women of hideous mien, clothed in black, with snakes for hair. The sculptor Calamis is said to have fashioned some statues of the furies and to have invested them with none of the hideous features which were ascribed to them by Aeschylus. In later times they were regarded as maidens of a dignified beauty.

Furnace, Enameller's. A furnace of fire-proof earthenware covered with a lid and placed on a tripod or solid block

three or four feet high. Into this furnace the plates covered with powdered enamel are placed, until they become of a white heat.

Furniture. The furniture of a room includes all that contributes to its decoration. Considerations of expediency as well as the varying taste and fashion of the time assign to furniture a very important place among the decorative arts.

Furrings. (Arch.) A small piece of wood placed on a roof at the base of the rafters and projecting some distance: its purpose is to carry the rain water off from the vertical wall.

Fusil. (Her.) The *fusil* is an elongated form of the *lozenge*, and like the lozenge is reckoned as a *subordinary*. It is usual for several *fusils* to be borne together on a shield.

Fusilly. (Her.) This is the name given to the *varied field* formed by covering the surface of the shield with alternating *fusils*.

Fylfot. A mystic cross of very ancient origin, which is said to have been introduced into Europe from India. It occurs as a decoration in Celtic pottery and also on early monumental brasses.

G.

Gabardine. (Cost.) A cloak of uncertain shape, in all probability reaching to the feet and fastened round the waist by a girdle. It was worn by shepherds, and from the passage in Shakspere's *Merchant of Venice*, "He spat upon my Jewish gabardine," it has been thought to have been the dress affected by the Jews.

Gable. (Arch.) A kind of triangular pediment, always very high in proportion to its width, frequently employed in Romanesque and Gothic architecture. In buildings of the Romanesque period gables serve to mask roofs and then only present a flat surface terminated by a cross. In Gothic architecture, gables surmounted by crockets and finials, not only mask the slope of a roof but also terminate the pointed arches above doorways. Sometimes several gables rise on different planes, the one above the other, each one projecting beyond the one beneath it. This method of decoration was particularly

adopted in domestic buildings of the Gothic period. In modern times gables are rarely seen. There is one peculiar kind of gable, the sides of which, instead of being straight lines, present a series of projections, which resemble the steps of a staircase. These projections are called corbiesteps (q.v.) in Scotland.

Many old houses in Belgium as well as in Scotland are found with gables built upon this plan. Properly speaking a gable only denotes the pediment we have described, whereas a gable-end denotes the gable and the whole wall which it surmounts.

Gablet. (Arch.) A small gable used in Gothic buildings to surmount a niche in which a statue was placed, or to terminate small pointed arches.

Gabriel, St. The angel who under-

took the duty of a messenger. He it was who announced the birth of Christ, and it is in relation to his event that he is generally represented in art. He always appears as fully draped and carries a sceptre or lily. Sometimes he is in a kneeling posture, sometimes he floats through the air, his arms folded on his breast.

Gadlyngs. Small spikes placed upon the knuckles of gauntlets in the fourteenth century. They were more for

ornament than use, but they suggest the bosses of metal which made the ἴμας ὀξύς, the boxing-glove of the Greeks, such a formidable weapon.

Gaku. A Japanese term denoting a picture stretched and held in a metal or wooden frame. It is thus quite distinct in character from the kakémono (q.v.).

Galea. A Latin term denoting any kind of helmet. Of the two *galeae* engraved here, the one has a ridge and a

plume and somewhat resembles that worn by centurions. The other, which is smaller in size and less pretentious in style, is of the pattern worn by the ordinary Roman soldier.

Galeated. A word used of an ancient statue of deity or hero when it wears upon its head a galea or helmet.

Galgal. Celtic monuments which present the appearance of artificial hillocks of conical or pyramidal form. Their Latin name is *tumulus* (q.v.).

Galilee. (Arch.) The name Galilee was given to a large porch or small chapel placed at the entrance of a church. It seems to have been the part of a church which women were allowed to enter. The following is said to be the origin of the term. A woman having applied to see a monk, was told, " He goeth before thee into Galilee, there thou shalt see him," the western porch at the same time being pointed out to her. At Ely and Durham the Galilee is at the west of the nave, and that at the latter cathedral is perhaps the most beautiful specimen of late or transitional Norman in existence.

Gall. A bitter fluid secreted in the gall-bladder of animals. Ox-gall after being clarified is mixed with the pigments used in water-colour painting and makes them flow readily on the paper. Ox-gall is also used to *set* or render ineffaceable pencil and crayon drawings.

Gallery. (Arch.) A hall of large dimensions, the length of which is always at

least twice its width. The term was originally only applied to the long corri-

dors which united two portions of a building. Such corridors in large houses were often decorated with pictures, and so any room in which pictures were hung came to be termed a gallery. Hence public buildings which are devoted entirely to the display of works of art are called galleries. In theatrical architecture the balconies which run round the top of the auditorium are called galleries. In Gothic architecture the term gallery has a special signification. It denotes the division into stories of the interior or exterior façade of a church. These divisions are marked by balustrades or arcades. Some Gothic galleries are as wide as the aisles. In the 13th, 14th, and 15th centuries they are sometimes nothing more than passages in the interior of the walls.

Gallery, Whispering. (Arch.) A vaulted gallery which is so contrived acoustically that the faintest whisper can be heard from one end of it to the other, being at the same time imperceptible in the middle.

Galley. A long ship with a single

deck, propelled either with oars or sails. The *galley* was the form of ship universally used in ancient times, and representations of it are often found on bas-reliefs, &c. The *galley* survived in Southern Europe until the eighteenth century, but is obsolete now. It occurs as a charge in heraldry under the name *lymphad*.

Gallo-Roman. A term applied in archaeology to objects belonging to that period of history, during which the Gauls were placed under the Roman yoke.

Galoon. (Arch.) A system of ornament consisting of a row of pearls

applied to a band, or of a band pierced and covered with *striae*. In either case, as a rule, it projects but little.

Galvanography. Under the term galvanography or galvanoplastic art are included all those processes by which statues, bas-reliefs, and engraved blocks or plates may be exactly reproduced. A hollow mould in wax is taken of the object to be copied; the wax mould is then placed in a bath, and an electric current passing through it, a metal deposit is formed upon the wax. Thus a facsimile is obtained, the thickness and solidity of which are proportional to the length of time the object is permitted to remain in the bath. The process of covering metal objects with a thin coat of another metal is an important branch of galvanography. It is thus that copper-plates, from which an engraving is to be printed, are covered with a film of steel. On the art of engraving indeed galvanography has exerted a most powerful influence. [Electrotype.]

Gambeson. A tight-fitting body-garment worn in the 13th and 14th century either underneath the hauberk (q.v.) or without it. It was of considerable thickness, being padded and quilted as shown in our cut, which is taken from a picture by Memling.

Gamboge. (Paint.) A solid resinous green pro-

duced from the tree known to botanists as the *Hebradendron cambgoides*. It readily dissolves in water and forms a beautiful gold yellow pigment. It is very useful in water-colour, especially in obtaining greens, which vary in tone according as the gamboge is mixed with Indian ink, Prussian blue, or indigo. Mixed with carmine, gamboge yields an orange green.

Ganymede. In Greek mythology Ganymede was the son of King Tros and Callirrhoë. He was carried off by Zeus and appointed his cup-bearer in Olympus. He is generally represented in works of art as a handsome youth, while an eagle, the bird of Zeus, stands at his side, as a symbol that he holds office in Olympus. In modern and popular pictures it has become the fashion to represent Ganymede as carried off to Olympus by an eagle, but this is a late development of the myth, and is justified neither by the art nor poetry of the ancients.

Garden. The proper arrangement and disposition of gardens is closely allied to architecture, and therefore a few words must be said with regard to it here. One of two contrary methods may be followed in this art. In the one method rigid symmetry and dignified regularity are aimed at. All inequalities of surface are either rigorously levelled or advantage is taken of them to form terraces, while avenues, labyrinths, and flower beds are formed of combinations of straight lines and portions of circles. Moreover trees are cut into artificial shapes, such as cones, pyramids, or even grotesque animal forms. This kind of garden was popular in the 17th and 18th centuries and many of its characteristics may be observed at Hampton Court Palace. In the other method of garden architecture an attempt is made to conceal design by giving a studied air of naturalness to the whole, so that it may resemble a landscape as much as possible.

176

Gargoyle. (Arch.) A term applied to the spouts placed at the base of roofs in Gothic buildings for the purpose of carrying the rain water far from the walls. Gargoyles came into use about the end of the 12th century. They then consisted of two layers, one of which formed the gutter or trench, the other the lid. Even at this early period they were decorated with ornaments and grotesque sculptures. They most frequently represented animals or fantastic creatures, from the throat of which the rain water was discharged. Some-

times they assumed the form of stooping figures projecting beyond the roof and holding a horn, from which the water flowed out. In the 15th and 16th centuries gargoyles were made of beaten lead, and represented chimæras, sirens, and other mythical animals, not only on the façades of castles but even on gables overlooking the street. Gargoyles are primarily a necessity, but they serve a distinct purpose from an artistic point of view, for by their horizontal projection they add distinction to the great vertical line of buildings.

Garland. (Arch.) A kind of architec-

tural ornament representing foliage, flowers, and fruits plaited and tied together with ribbons. Garlands generally appear in the form of a long cylindrical band,

which is flexible and swells slightly in the middle. They are sculptured on certain projecting surfaces, placed round the shafts of columns and employed in decorating panels, pediments, &c.

Garnet. A gem generally of a red colour, useful for decorative purposes, but little esteemed on account of the abundance in which it is found. It is of little service to the gem engraver, as it easily splinters.

Garret. (Arch.) The top story of a house, generally formed within the roof. It is thus of necessity low-pitched and has a sloping ceiling.

— **Window.** (Arch.) A window which admits daylight into a garret. It fits into the roof and moves up and down, being fixed on one side like a hinge.

Garter. (Cost.) A strap or tie, the purpose of which is to hold up the stocking. In Saxon and Norman times it was fastened transversely across the leg and was then called a " cross-garter." That this fashion was revived in Shakspere's time we gather from *Twelfth Night*, in which play it will be remembered Malvolio wears "cross-garters." Generally speaking, however, the garter was a simple tie just below the knee, sometimes with a bow, sometimes without. The celebrated " Order of the Garter " was established by Edward III. in 1350. Its badge is a garter and its motto " Honi soit qui mal y pense."

Gateway. (Arch.) A covered opening, large enough to admit carriages. A smaller opening through which foot passengers may pass is generally found by the side of it. In the Middle Ages gateways were important structures, and a house, called a gatehouse, is frequently found above them. There the porter or gate-keeper dwelt. In the 17th and 18th centuries they were very lofty, their height being often equal to two stories. In this case the upper part which formed the impost, was decorated with a pediment, richly ornamented. Gateways and gatehouses are still to be seen in large numbers on the Continent, but they are rarely found in England. St. John's Gate in Clerkenwell, for so many years the meeting place of the Urban Club, is the best and most easily accessible example.

Gauntlets. Gauntlets of leather, sometimes covered with metal plates, sometimes studded with nails called *gadiyngs* (q.v.), became a part of the

ornament of the knight towards the end of the 13th century, and were worn in some form or other, until armour was finally relinquished in the 17th century.

Gelatine. A colourless substance extracted from bones and membranous tissues, insoluble in water but liquefying under the action of heat. Gelatine plays a most important part in the modern processes, by means of which a photograph is transformed to a plate or *cliché*, from which engravings may be printed. Gelatine is also used by sculptors to obtain a large number of proofs from the same model or to obtain the imprint of a bust, bas-relief, or other object. Gelatine mouldings possess the advantage of being easily detachable, on account of the elasticity of the material.

Gelatino-bromide. (Phot.) A process by means of which sensitive glass plates may be prepared in advance and kept in the dark for an indefinite period,

177

both before and after being exposed in the camera. Plates prepared by the gelatino-bromide process are more sensitive than collodion plates; they are more rapidly affected by the light, and, more than this, they do not require, as collodion plates do, to be developed immediately in order to bring to light the image obtained.

Gem. A generic term for all kinds of precious stones. It is especially used in the sense of an engraved gem.

Gem Engraving. [Glyptics.]

Genealogical Tree. (Her.) This is a

conventional tree carrying at the intersection of its branches shields on which are blazoned the arms of the various members of a family, starting from the trunk and working upwards with the branches.

Geneviève, St. St. Geneviève was a peasant girl who was born at Nanterre in 421, and from her early childhood dedicated herself to Christ. Many fabulous stories are related of her. Her vigils were frequently disturbed by demons, who extinguished the tapers which she piously kept burning, and which were immediately relit at her prayer. When Attila, the Hun, lay siege to Paris, Geneviève entreated the people not to flee and so saved the city. Henceforth she was held in great honour, and when she died at an advanced age she was buried by the side of Clovis and Clotilde. She is most frequently represented as the peasant girl of Nanterre, with her flock of sheep round her, but sometimes she appears as the patroness of Paris, wearing a veil and holding a book and a taper, while a demon with the bellows looks impishly over her shoulder. Representations of her are only found in French art.

Genius. A kind of guardian angel or good spirit called a *genius* was supposed by the Romans to be called into being at the birth of every mortal. In artistic representations the genius appears as a winged boy wearing a chlamys. Not only mortals but places too had their guardian angel. This was called a *genius loci*, and was represented by a serpent, as in our cut.

Genouillères. Knee-pieces of leather or metal, first worn in the 13th century. They formed a sort of connection between the thigh-piece and the greave.

Genre-painting. Under this term may be classed all those pictures, the subjects of which are taken from real life, domestic history, or the field of fanciful anecdote, in opposition to grand historical and religious scenes. Genre always implies a faithful imitation of nature and the reproductions of actual types. At the same time it does not exclude either poetry or imagination. Genre-painting has been practised from the very earliest times. The finest genre pictures in existence are those painted by the artists of Holland and the Netherlands. This branch of painting, however, has been cultivated by artists of every school, and British painters have shown a distinct preference for it ever since the time of Hogarth.

Genre-sculpture. Genre-sculpture is far more rare than genre-painting. Bronze and marble do not easily lend themselves to the treatment of familiar subjects. There are, it is true, some specimens in existence of Greek sculpture which may be said to belong to the branch of art called *genre*. Such are the group of boys playing the knuckle-bones called the *Astragalizontes* [Astragolus], and the figure of a boy holding a goose, which we so often see in museums. But for the most part works of genre-sculpture are of small dimensions and in a less durable material than marble or

bronze, such as terra-cotta. The genre-sculpture of modern times is for the most part vulgar and devoid of interest.

Geometrical Drawing. The science of drawing geometrical figures with the help of certain instruments, such as compasses, squares, and protractors. A course of geometrical drawing is a preliminary step in the education of the artist.

— **Tracery.** (Arch.) A term applied by Rickman to tracery belonging to the decorated period, in which the figures composing it—circles, trefoils, quatrefoils, &c.—do not regularly join each other but touch only at points. It is opposed to flowing tracery (q.v.).

George, St. The story of St. George, the patron saint of England, is purely mythical. He is generally represented on horseback bending over a dragon, whom he has pierced with a sword. Sometimes a maiden appears at his side

in accordance with the legend that he rescued the daughter of the king of Egypt from a dragon. It is thus the subject of St. George is treated in a well-known picture by Raphael. The banner of St. George, a red cross on a silver ground, is the banner of England.

Gesture. A term applied to the attitude of a painted or sculptured figure, to the pose of the body, or the set of the limbs. When we say that the gesture of a figure is bad, we mean that the figure is clumsily drawn, that the limbs are not properly proportioned, that the prevailing lines are unpleasing to the eye, or that the attitude does not sufficiently suggest the action, which the artist proposed to himself to represent.

Giallolino. (Paint.) A name given by the Italians to what is generally known as Naples yellow (q.v.). It is an opaque pigment of good body, and is composed of antimony and oxide of lead.

Giants, The. In Greek mythology the giants were a race of monsters who sprang from the blood of Uranus. They made war upon the gods for a long time with success. Athene and Zeus were unable to destroy them until they called in the aid of Heracles. [Gigantomachia.]

Gigantomachia. The war of the gods with the giants was a favourite subject with Greek sculptors. It was represented on many famous reliefs. It formed the subject of the metopes on the eastern façade of the Parthenon, as well as of the great frieze which decorated the altar dedicated to Zeus at Pergamum.

Gilding. The art of applying gold either in leaf or dust to surfaces of metal, stone, or wood. The gold thus applied is itself termed *gilding*. The art is one of great antiquity, but it is only in modern times that the method of applying a thin coating of gold has been discovered.

—, **Electro.** In this process the objects which are to be gilded are plunged into spcially prepared baths of chloride of gold and submitted to the action of an electric current. A fine film of gold is thus deposited upon the objects.

—, **Glass.** A process which consists in applying to glass a layer of chloride of platinum mixed with essence of terebinth and plunging the object in a gold bath after it has been fired.

Gilding, Matt. A process in which gilt objects are dulled by means of mercury, or have a similar aspect given to them by means of acids or are covered with a coating of silver and copper before being plunged in the gold bath.

—, **Japanner's.** In this process the pattern to be gilded is drawn upon a flat surface and covered with glue or some adhesive varnish. Powdered gold dust is then sprinkled upon it.

—, **Leaf.** A process which consists in covering the surface to be gilded with glue or size, and then laying on thin gold leaf.

—, **Oil.** In this process the objects to be gilded are covered with a preparation of thick oil before the gold colour is laid on. Then leaves of gold are applied and finally a coating of varnish, which preserves the gold from the action of the air.

—, **Water.** In *water gilding* the gold is reduced to a fluid state by solution in mercury and then laid on.

Giles, St. St. Giles the hermit was by birth an Athenian, but having discovered in himself early in life the gift of working miracles he left Greece and became a hermit. He lived for many years in a cave near Nîmes, and here happened the event with which he is always associated in art. One day the King of France was out hunting, and the stag, which he had wounded with an arrow took refuge in the cave of St. Giles. The King on tracking the stag was astonished to find the wounded animal crouching at the foot of the holy man, and at once implored his forgiveness. St. Giles, then, is always represented as an aged hermit, with a stag pierced by an arrow at his side. He is a popular saint in England and Scotland.

Gillotage. Under the term *gillotage*, which is derived from the name of its inventor, Gillot, are included all those processes which consist in producing upon zinc by means of acids the relief of a drawing traced upon it in printer's ink. A plate thus results, from which proofs may be struck by the ordinary processes of typography.

Gimp. A trimming of thread or silk with large meshes. The word is used, as is dentel, to denote a kind of ornament employed in Gothic architecture.

Gipciere. (Cost.) A bag suspended at the waist and worn as a purse by men and women in the Middle Ages. Its etymological meaning is a game bag, but it soon lost this signification, and generally denotes, as we have said, a purse or pouch.

Girandole. A chandelier with several branches, sometimes constructed to resemble a bunch of flowers. It is used to illuminate large halls.

Girder. (Arch.) A piece of timber or iron placed horizontally either on a continuous wall or on pillars set at a distance from one another, and serving as

the base of a roof, floor, &c. Girders, as they often have to support considerable weights, should not be left without support along their whole length.

Girouette. (Arch.) A movable sheet of metal placed on the summit of a roof and fixed to a vertical shank. It indicates the direction of the wind. In the Middle Ages square girouettes were only placed on the castles of knights banneret; simple knights had only the right to set up a pointed girouette. There are still in existence some curious girouettes decorated with armorial bearings, such as fleur-de-lis, &c.

Glacis of the Cornice. (Arch.) A

term denoting an inclined surface above a project- ing moulding or cornice. The object of it is to prevent the rain from staying upon the projecting portion of a building.

Gladiators. Among the Romans, men called gladiators were trained to fight to the death for the amusement of the pub-

lic assembled in the amphitheatre. These displays were enormously popular under the Empire, and it is not surprising that

they suggested subjects to many Roman artists. We give here two cuts, each of which represents a vanquished gladiator appealing for mercy. The one is from a Pompeian bas-relief, the other from a vase. The well-known statue called the "Dying Gladiator" has long since been proved to be not a gladiator at all, but the statue of a dying Gaul. It is the work of a Pergamene artist, and belonged to a group presented by King Attalus to Athens and afterwards removed to Rome.

Gladius. The weapon of the ancients, which corresponded to our sword, and assumed various forms and shapes. It had no guard, and the hand was only

protected by a cross bar. The sword of the Greeks was leaf-shaped, that of the Romans straight and only tapering at the point. A specimen of each is here represented.

Glaive. A broad-bladed sword fixed on a long staff like a guisarine (q.v.) or partisan (q.v.). It was used through- out the Middle Ages, and until the end

of the 15th century was the national weapon of the Welsh.

Glass. A solid and transparent body obtained by the fusion of siliceous sand with certain alkaline earths or salts and metallic oxides. Small vases and drinking vessels were made out of this material in the earliest times. The manufacture of glass was understood by the Egyptians nearly two thousand years before Christ. It was practised by the Greeks and Romans, and many specimens of ancient glass have been dug up in tombs. To what a point of excellence glass-making was carried by the ancients, the Portland vase (q.v.), now in the British Museum, will testify. In the Middle Ages the art of glass-making seems to have been neglected, and cups were then made of horn or wood instead of glass. About the 15th century, however, the art was revived by the Venetians, who were long without rivals in the making of glass. Cups, bowls, and bottles of Venetian manufacture are to-day of the greatest value. The finest modern glass comes from Venice or Germany.

— **Case.** A small glass cupboard in which works of art are placed, either in private collections or in exhibitions and museums. Glass cases are sometimes vertical and rise to a considerable height, shelves being placed one above the other so as to render it possible to exhibit a large number of objects in one case. Sometimes they are horizontal, in the form of a table covered with glass, and about breast high.

—, **Cut.** A term applied to objects made of glass, the facets of which are cut on a grindstone.

—, **Filigree.** Glass vessels decorated with fillets variously coloured and interlaced.

— **Painting.** There are two prin-cipal systems of glass-painting. The more ancient is termed *mosaic glass-painting*, in which every colour was on a separate piece of glass, and the pictorial effect was produced by combining variously coloured pieces. This method disappeared from use about the 16th century. The later system, which took the place of mosaic glass-painting in the 16th century, may be termed the enamel method. Colours are laid on to the glass with a brush and fixed by the processes ordinarily employed in enamel-painting. This system of glass-painting has survived until modern times.

Glass Window. Churches of the Gothic style have in every period been decorated with windows, consisting of painted glass, held together by strips of lead and kept in their place by bars of iron fixed to the mullions of the windows. The glass windows of the 12th century had a ground of colourless glass for the picture they represented, and a border of coloured glass. In the 13th century glass windows were of a brightness, which was positively dazzling. In the 14th century the drawing was more correct, and an attempt was made to introduce picturesque effects, light and shade, &c., into stained glass. In the 15th and 16th centuries, the tendency to regard glass windows as pictures became still more marked. Much of the coloured glass which decorates the churches and palaces of the 17th century is of great splendour. Among the finest specimens of the glass of this period are the windows of Gouda in Holland and Liège in Belgium, and in King's College Chapel, Cambridge. In the 18th century little fine-coloured glass was manufactured, and the present century has been able to do little more than make an ingenious pastiche on the productions of all preceding centuries.

Glaze. (Pot.) A vitreous coating, with which pieces of pottery are covered, and

182

which renders them impermeable. In addition to serving this useful end, the glaze gives a brilliance to the pottery, on which it is placed. The glaze may be applied in several ways, either as powder or in a volatile state; in any case it is vitrified in the baking.

Glazing. (1.) (Arch.) The covering of any surface, vertical or horizontal, oblique or curved, with panes of glass. The pieces of glass used for glazing in old houses were dark green in colour, and presented a wrinkled projecting disk in their centre. The panes of glass used to-day are colourless.

Glazing. (2.) In oil-painting *glazing* consists in the application of a thin layer of colour over a solid pigment. The thin layer of colour is always darker than the pigment over which it is laid. The tints used in glazing are generally transparent, but opaque pigments mixed with a large proportion of colourless oil are sometimes employed. By this means an effect of transparency is produced, the tonality of a picture is softened, and the modelling is rendered more harmonious.

Globe. A sphere, a spherical body. In heraldry the term is applied to a figure which represents the world in the form of a ball. A golden globe surmounted by a cross is regarded as part of the insignia of royalty.

Glory. An allegorical figure, a woman draped and winged, holding in her hand a trumpet, a branch of laurel, or the tablets of immortality. The rays of light placed round the heads of saints. [Aureole.] The term is also applied to rays of gilded wood surrounding a triangle or delta, in which the word God is inscribed in Hebrew characters, and which decorates the altar in some churches belonging to the 17th and 18th centuries.

Glyph. (Arch.) Channels or flutings which break level surfaces. Such are the channels which ornament the frieze in Doric temples. When there are three glyphs or two glyphs and two half-glyphs this ornament is termed a triglyph (q.v.), when there are two glyphs a diglyph (q.v.).

Glyptics. The art of cutting designs upon precious stones, either incised or in relief. The masterpieces of this art were produced by the Greeks, and fine specimens of gem-engraving are among the most valuable relics of ancient art that have come down to us. The art was revived by the Italians of the 16th century, but it can scarcely be said to be practised with any measure of success at the present time.

Glyptotheca. The gallery in which a collection of works of sculpture is placed; also the collection itself. The most celebrated collection which in modern times goes by this name is the *Glyptothek* at Munich.

Gobelins. The great national factory of tapestries established in Paris in the reign of Louis XIV., and the tapestries manufactured there. Formerly both high-warp and low-warp tapestries were made at the Gobelins, but since 1825 the low-warp process has been almost entirely abandoned. The reproductions in tapestry which we owe to the Gobelins have won for themselves a world-wide celebrity. The productions of this famous factory are distinguished by the perfection of the process employed, the beauty and finish of the work, and the excellence of colouring. Every shade and tone necessary for the interpretation of picture or painted designs can be accurately rendered in hanging or carpet.

Gobony. (Her.) [Compony.]

Godroon. A system of ornament in form of oval mouldings or flutings in relief, which is employed to decorate

the round body of a vase or any convex surface. The name is also applied to

certain projecting ornaments which are generally found in the decoration of roofs.

Goffering. The impressing by means of hot irons systems of ornament either sunk or in relief upon stuff, leather, paper, cardboard, &c.

Gold. A precious metal used in the plastic and decorative arts. The costliest ornaments and vessels have been made of gold in all ages and in all nations; and gold has been especially used as the material for ecclesiastical chalices and decorations. In symbolic art gold signifies purity, dignity, and glory, and in Christian paintings the *nimbi* on the heads of saints are always represented as of gold.

Gombron Ware. (Pot.) The first Oriental ware brought to England in the 17th century was shipped at Gombron, and hence was called Gombron or Gombroon ware. When the importation of pottery from Persia came to an end on the opening up of communication between China and England, the term Gombron ware disappeared from use.

Gonfannon. A special kind of banner or flag borne at the head of a lance and ending in one or more points. Such banners are now frequently carried in processions of the Roman Catholic church.

Goniometer. An instrument employed to measure angles.

Gore. (Her.) This is an *abatement* or *difference* sometimes borne on shields. It consists of two curved pieces cut out of the sinister side of the field so as to form a cusp pointing towards the dexter.

Gorge. (Arch.) The upper part of a column below the echinus in the Doric order. The term is also applied to a moulding of concave outline as well as to a kind of ogee (q.v.) of

strongly-marked profile, which is employed in buildings of the Gothic style.

Gorget. A piece of armour used in the 15th and 16th centuries to protect the junction of the helmet and cuirass.

Gorgoneion. An ornament representing the head of a woman seen in full face, with serpents coiled round it and lips parted, which resembled the head of

Medusa which Pallas carried on her shield. On account of its adaptability for filling up a certain space on a wall or shield it was very widely used for decorative purposes.

Gothic. A term applied to mediæval paintings and sculptures, distinguished by lank figures, the attitudes and movements of which display a certain stiffness. This deficiency, however, is fully atoned for by an extraordinary skill in execution and perfection of detail. Works of sculpture belonging to the Gothic period, being executed with the place they were to occupy in view, always fit into a moulding or niche, without exceeding their proper limit.

Under the term Gothic are included all buildings of the pointed style which succeeded the Romanesque. The most beautiful and refined buildings of this

style belong to the 13th century. The development and periods of the Gothic style may be stated in a few words. From the 4th to the 11th century the Latin style of architecture prevailed.

This was succeeded in the 11th century by what we call the Norman, but which on the continent is termed the Romanesque style. Out of this grew Gothic architecture. In the 13th cen-

tury the Early English or Lancet style was cultivated; of this the best example is Salisbury Cathedral. This was followed in the 14th century by the Decorated style, which gave way in the 15th and 16th centuries to the Perpendicular style, or Gothic of the Decadence. These are the three main periods of Gothic architecture. The names we have given them are those

generally adopted in England, but they are by no means universal. The three styles are sometimes termed Primary, Secondary, Tertiary, and the style which we have called Perpendicular is frequently known as Flamboyant. Gothic mouldings and ornament vary according to the style to which they belong, and information on these points are to be found under the headings *Decorated*, *Early English*, &c. We give some cuts of Gothic bases, belonging to the 10th, 12th, 13th, and 14th centuries respectively.

The term Gothic is also applied to characters of angular form, which were in general use in the Middle Ages, and are still retained in Germany. Mediæ-

Canticu:

val manuscripts are executed in Gothic characters of extraordinary beauty, and their splendour is enhanced by initial letters sometimes painted and sometimes

Ações ceuls que ces

even worked in gold. Manuscripts are generally executed in characters of a graceful outline and absolute regularity.

In legal documents and accounts, on the other hand, a kind of cursive was adopted which could be rapidly written. Gothic characters differed in different periods, those of the 16th century resembling but little those of the 13th century.

Gouache. (Paint.) A method of water-colour painting, in which opaque colours, diluted in a mixture of water, gum, and honey are used. The effect of gouache is an opacity of tone. In this method of painting the white of the paper plays no part. The paper is covered just as thickly as the canvas is in oil-painting; the lights are laid on afterwards and not left blank on the paper. The miniatures in mediæval missals were painted in gouache, and nowadays the method is employed in the execution of fans and hand-screens. The disadvantage of gouache is that it cracks and scales and speedily loses its brilliance when exposed to the air.

Gouge. A tool used by engravers of precious stones to pierce holes and to

hollow out large surfaces. The term is also applied to a kind of chisel hollowed out in the form of a demi-cylinder, with a very sharp bevelled edge. It is used by

sculptors in wood. Gouges differ very much in size and shape.

Grace Cup. (Pot.) A loving-cup handed round the table in the Middle Ages after grace was said. The name is said to have originated in a device adopted by Margaret, wife of Malcolm Canmore, in the 11th century, to prevent the Scottish nobles leaving the table before grace was said. To every man who remained at the table a draught of wine from a gold cup was given, and this cup was henceforth called the Grace-cup.

Graces, The. The Graces, which were three in number, were regarded by the Greeks as the goddesses of beauty, innocent jollity, and amusement. They have been a favourite subject with the painters and sculptors of all ages. They are generally represented as youthful maidens, dancing and singing, and crowned with roses. Sometimes they are draped, sometimes they are quite nude. Their attributes are the rose, the myrtle, and dice.

Gradation. In decorative art gradation consists in placing next to one system of ornament another which most closely resembles it both in form and colour, following a certain ascending or descending scale.

Gradine. (Sculp.) A toothed chisel used by sculptors. With the *gradine* large pieces are removed from the marble, or certain parts, such as the beard and hair, are modelled, the teeth producing a series of ridges, which serve as the basis of the work.

Graduate. To divide in degree. To split up into divisions, the measure of which increase or decrease according to a fixed proportion.

Graeco-Pelasgic. The earliest period of Greek art is generally termed Graeco-Pelasgic. It carries us back to an almost mythical age. To it belong the colossal structures known as Pelasgic walls, which are composed of huge polygonal blocks of stone fitted together with the utmost regularity. An example of the Graeco-Pelasgic style is to be found in the walls of Mycenae; in fact the famous Lion Gate at Mycenae is its most finished production. The sculptured bas-relief over this gate represents two lions facing each other with a column between them. The heads were of brass, but are now lost. Much that Dr. Schleimann excavated at Mycenae may be termed Graeco-Pelasgic, and gives us an excellent idea of the condition of art at this remote period.

Graeco-Roman. A term applied to buildings constructed by the Romans in accordance with the principles of the Greek orders of architecture, with certain modifications of detail.

Graffiti. Drawings executed by hand and cut with a scraper in stone or plaster. The term is only used in this sense in archæology. It also denotes a method of decoration which consists of black drawings on a white ground, or *vice versa*, obtained by outlines accentuated by hatchings. By this method pictures or arabesques are executed in stucco, and employed to decorate pilasters, archivolts, or friezes.

Grain. (Paint.) A term applied to the more or less wrinkled surface of a canvas, a panel, or a piece of board or paper. Paper of fine or coarse grain is used in water-colour according to the subject. In engraving the *grain* is the effect produced by lines which cross one another.

Granite. A hard stone composed of mica, quartz, and felspar. The Egyptians executed colossal statues in red granite. In Brittany calvaries are frequently to be seen of grey granite. Granite is used for sculptured monuments and even for statues. For the latter purpose it is totally unfitted.

Granitel. A term applied to a kind of grey granite which the Romans employed in building, and also to marble which presents the appearance of granite.

Granular. A canvas or panel used in oil-painting is said to be granular when it is covered with wrinkles or roughnesses.

Granulation. A kind of decoration employed in jewellery, which consists in covering the surface of gold leaf with minute and almost invisible bosses of gold. It is found in Etrusco-Greek jewels, but hitherto modern artists have failed to reproduce it.

Graphite. A very fine plumbago. From the graphite of Siberia mixed with sulphur of antimony and gum or size are manufactured crayons in the form of small cylinders, which are placed in a shank of cedar, juniper, or cypress wood.

Graphometer. A mathematical instrument used to measure angles or distances. It consists of a semi-circle of copper divided into degrees and a fixed and a movable alidade, through which the operator can observe all directions included within the same horizontal plane.

Grating. A kind of fence formed of bars of iron or wood, sometimes richly ornamented. In the 12th century iron gratings were most elaborate. The ornament consisted chiefly of foliage, the twigs of which were soldered to the base and fastened to the uprights with clasps. In the 14th century ornaments cut out of sheet iron and twisted were added to the foliage. At the end of the 15th century riveted sheet iron was generally used and gratings became of considerable importance from a decorative point of view, and were surmounted with ornaments of great splendour.

Graver. (Engrav.) A steel instrument with a sharp point at one end. Some

gravers have a square, others a lozenge-shaped, point. The furrows cut with the

square-pointed graver are broad and not very deep, and they print grey, because they do not take much of the ink. The handle of the graver is cut off flat on one side so that it can be held close to the copper-plate.

Greaves. Greaves, or armour for the front of the legs, were worn both by the ancients and in the Middle Ages. They

were generally made of metal, often richly chased, or (in the Middle Ages at least) of cuir-bouilli (q.v.). Our cut represents a fine specimen from Pompeii.

Greek. A name given to a system of ornament consisting of broken lines at

right angles to one another, describing portions of squares or rectangles.

Greek Architecture. Of Greek architecture before the development of the

orders little is known. The three purely Greek orders are the Doric, Ionic, and Corinthian. The first named appeared in the 7th century B.C., the second a hundred years later, and the last in the fifth century B.C. [Corinthian; Doric; Ionic.]

Green. Green is a colour formed by a mixture of yellow and blue. Green pigments are, generally speaking, oxides of copper. Malachite or mountain green is a hydrated bicarbonate of copper. Scheele's green is a cupric arsenite. Sap green, or verde vessie, on the contrary, is obtained from the juice of buckthorn berries; but this is not a useful pigment, being fugitive, and it is only employed in water-colour.

— **Bice.** A pigment composed of a carbonate of copper mixed with oxide of iron. It is generally permanent, being only destroyed by acids.

—, **Brunswick.** (Paint.) A pigment used in oil-painting, obtained from sulphate of copper, white oxide of arsenic, potash, and acetous acid. Ordinary Brunswick green is nothing more than a mixture of chromate of lead and Prussian blue, and is by no means permanent.

—, **Chrome.** [Chrome Green.]

Grees. Steps rising gradually one above the other. The term is generally

applied to stories, galleries, or constructions of any kind which retreat one behind the other.

Gregory, St. St. Gregory was born at Rome in 540; in 590 he was made Pope, and fourteen years later he died. He is the last of the Popes who was canon-

ised. Artistic representations of him are frequently met with. He appears as a tall, dignified man, with little or no beard; he wears the tiara and carries a crosier, and his attribute is the dove, in allusion to the legend that the Holy Ghost in the form of a dove inspired him while he was writing his homilies. Many legends have gathered round the name of St. Gregory and have suggested subjects to religious painters, but space does not allow us to refer to them in detail here.

Grès Cérame. [Stoneware.]

Grey. A term applied to the shades obtained by the mixture of white with black or some other dark colour. Thus, when we speak of a grey brown, a grey blue, or a grey green we refer to greys of a different tone, their dominant tint being brown, blue, or green respectively.

Grey-beard. (Pot.) A term applied to the brown stone pots, with a bearded head or mask on the neck, which were imported in large numbers from the Low Countries to England during the 16th and 17th centuries.

Griffe. (Arch.) A decorative leaf slightly

curled at the edges, which connects the convex circular moulding at the base of Romanesque columns and the clus-

tered columns of the Gothic style to the

square pedestal beneath it. Sometimes the *griffe* starts from the torus (q.v.) and fills the small triangle formed by the angle of the plinth. This is the position most frequently occupied by it. In buildings belonging to the 13th century we find *griffes* cut out of the solid plinth and presenting no point of contact with the torus.

Griffin. (Arch. and Her.) An imaginary animal with the head and wings of an eagle, and the body and feet of a lion. In the heraldic griffin the front feet as

well as the head and wings are often those of an eagle, only the back half of the creature being in the form of a lion.

Grillage. A grating of iron or wood, with which openings may be closed without shutting out the light.

Grisaille. (Paint.) A painting in imitation of bas-reliefs, in which only black and white and the greys obtained by mixing them are employed.

Groin. (Arch.) A curved line formed by the meeting of the surfaces of two intersecting vaults or portions of vaults.

Groined Vault. (Arch.) A vault formed by the intersection of two demi-cylinders.

Two barrel vaults (q.v.) laced perpendicularly to one another will form a groined vault.

Grolier Scroll. A system of ornament

189

consisting of curves and angles combined. It obtained its name from the Chevalier Grolier, who in the 15th century adopted this scroll for the decoration of the bindings of books.

Groove. (Arch.) A hollow cut lengthways in a plank or block of stone and

intended to receive a projection of precisely the same dimensions.

Grotesques. Systems of ornament painted, drawn, or sculptured, representing fantastic subjects or forming arabesques, in which extravagant figures and fanciful animals are interlaced. Mediæval sculptors executed grotesques with extraordinary skill. The taste for this method of decoration continued during the period of the Renaissance. There are in existence grotesque figures designed by Leonardo da Vinci and Raphael. In the 17th century Teniers and Callot painted fantastic scenes in which grotesque figures play an important part.

Grotto. An artificial cavern made of rocks and often adorned with statues. Grottoes were much employed during the 18th century in the decoration of gardens.

Ground. In the language of art the word ground has several significations. Laying a ground in engraving is an operation the object of which is to cover with a uniform grain a plate of metal, which is to be engraved in mezzotint. To perform this operation a rocker (q.v.) is employed, an instrument said to have been invented by Abraham Blooteling (1634-1695). The rocker is run up and down over the plate, first in one direction and then in the other. A proof of the plate is then struck off, that a judgment may be arrived at as to the grain. This, if the plate is to be a success, should yield a velvety black,

uniform in tone in every part of the plate. For the meaning of the term in etching see Etching-ground. In painting, the ground is the first layer of colour which is applied to the canvas before the artist begins to paint his picture.

Ground Floor. (Arch.) That part of a house which is on a level with the

ground or is raised above it only by a few steps.

Group. A collection of several figures or objects forming one whole. The groups in a picture should present well-balanced masses. In sculpture a group is a collection of several figures, each of which is necessary to the action of the whole. The outline and arrangement of such a group should present an harmonious effect.

Grouping. A term applied to the fashion in which figures are arranged in a painting, drawing, or piece of sculpture.

Guard. The part of a sword, poniard, or sabre the object of which is to cover and protect the hand. It is richly decorated with niello, damascene, sculpture, or chasing in the more splendid weapons of every age. The guards of Japanese sabres are above all marvellous examples of decorative invention. They consist generally of iron or steel inlaid with precious metals.

Gubbio Ware. (Pot.) A factory of majolica was established at Gubbio in 1498 by Giorgio Andreoli, of Pavia. The pieces of this ware now extant are distinguished by vigorous modelling and admirable colour. They are not commonly met with, and are of great value.

Giorgio carried on his work for upwards of thirty years, and pieces dated 1531 bear his name.

Gueridon. A French term applied to a decorative stand, designed in imitation of an ancient candelabrum, used either to hold flowers or as a stand for a lamp.

Guilloche, Guillochis. A system of ornament formed of symmetrical lines, undulating and crossed, yet parallel

to one another, as shown in the cut given above.

Guisarme. A destructive weapon con-

sisting of a scythe and bill, which was

fixed on a long pole and was employed by infantry against cavalry. It is of great antiquity, a weapon closely resembling it being spoken of in the 6th century, while from the 11th until the 16th century it was in constant use.

Gules. (Her.) The heraldic name for red. It is shown on a shield by parallel vertical lines, as in the accompanying cut, in which the white half of the shield represents *argent* or silver. This shield would be blazoned *party per bend gules and argent.*

Gum Arabic. A gum obtained from acacias in Africa and Australia. When dissolved in water it yields a size, which is a valuable vehicle in water-colour. A little honey or white sugar-candy is generally added to it, to prevent its scaling when dry. A light coating of gum arabic laid over water-colours produces the effect of a brilliant varnish, but has the disadvantage of too often scaling or cracking when the paint is dry.

Gurgoyle. (Arch.) A term having the same meaning as gargoyle and denoting

a spout or gutter, generally carved in a grotesque form, which carries off rain water from a roof. [Gargoyle.]

Gusset. (Her.) This name is sometimes given to a nondescript charge such as that shown in the cut. From its meaningless irregularity such a charge would not be considered honourable, and would be assigned as a mark of abatement to a man who had in some way disgraced himself.

Guttae. (Arch). An architectural ornament consisting of a series of small truncated cones, placed underneath the corona of a cornice or at the base of the triglyphs in the Doric order.

Gutter. (Arch.) A reservoir at the base of a roof which receives rain-water and directs it to a waste pipe. In ancient buildings we find gutters hollowed out of blocks of marble or stone. In some mediæval churches the gutter projects beyond the façade and is surmounted by an arcade. From the

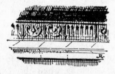

end of the 13th century gutters are provided with projecting gargoyles (q.v.), and some carry off the water in conduits made in flying buttresses. In ambitious buildings of the 13th and 14th centuries grooves, which serve as gutters, are sometimes cut in solid blocks of stone. At a later period gutters were made of terracotta or of wood covered

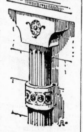

with lead or bronze. The surface of the gutter is often enriched with ornament. In some modern buildings there are gutters of some pretensions, formed of tubes, decorated with flutings, rosettes, &c.

Gutts, or **Gouttes**. (Her.) This is the heraldic name given to *drops* of water or other liquid when represented on a shield. The liquid of which the drop is supposed to be composed is suggested by the tincture of the *gouttes*. Thus *gouttes de sang* are blazoned *gules, gouttes de larmes azure.*

Guze. (Her.) A small round disc or *roundel* (q.v.) of *sanguine* or blood colour is called by English heralds a *guze.*

Gymnasium. A collection of buildings and porticoes in which the youth of antiquity indulged in exercises and games. The training of the physical powers was a very important element in Greek education, and the gymnasia of Greece were very elaborate institutions, including colonnades, shady walks, baths, &c. The influence of the gymnasium and the physical types developed there upon art was considerable. [Athletes.] The gymnasium of modern times is generally a simple unpretentious building, in which physical exercises may be practised. It possesses, it need scarcely be said, none of the importance, civic or artistic, which belonged to the gymnasia of ancient times.

Gypsum. A sulphate of lime, the commonest form of which is plaster of Paris. Owing to its plasticity it is useful in taking casts of works of sculpture or other objects. It has been used for this purpose from the very earliest times and in this connection is mentioned by Pliny.

Gyron. (Her.) This subordinary is a device in the form of a right-angled triangle cut off from one corner of the shield— the *dexter chief*—by lines drawn *bar-wise* and *band-wise* intersecting at the *fesspoint*. A gyron is, however,

seldom borne alone, but the device is utilised to form the varied field called *gyronny.*

Gyronny. (Her.) This is the name given to the *varied field* found by an alternation of *gyrons*. The usual number is eight, but the number should always be specified

in blazoning. Thus the accompanying cut would be blazoned *Gyronny of eight argent and gules.*

H.

Hair-pencils. (Paint.) Hair-pencils are generally made of the hairs of the martin or badger. The hairs are mounted

in a quill if the pencil or brush is to be used for painting in water-colour, and in a tube of tin or copper if it is to be used in oil-painting.

Halbert, or Halbard. A weapon much used in England during the Tudor and early Stuart period. It consisted of a long wooden handle with an axe and a spike at the end. It was frequently ornamented with gilding and perforated in various shapes. Of the two cuts given below one represents a halbert of the time of Henry VII., the other a halbert of the time of Henri II. of France. The halbert subsequently

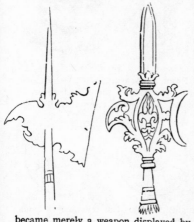

became merely a weapon displayed by royal body-guards. Several of these weapons may be seen in the armoury at the Tower of London. The *halbert* was introduced into France in the 15th century by the Swiss and German mercenaries. As a charge in heraldry it is always represented in pale.

Half-binding. A description of book-binding in which only the back and corners of the book are covered by leather, the sides being in paper or cloth.

Half-life size. This term is used to describe figures in painting or sculpture standing about two feet nine inches high, or about half the height of a man of average stature.

Half-primed. (Paint.) A term applied to a canvas which is only covered with a thin ground or priming (q.v.).

Half-timbered. A term applied to the houses built during the reign of Queen Elizabeth, the front of which consisted of a wooden frame, filled in with white plaster. The beams were frequently elaborately and quaintly carved, and the plaster

which filled the frame was sometimes moulded. Half-timbered houses are to be found in many towns of England, and are among the most picturesque specimens of domestic architecture to be found in our country. An admirable example is afforded in London by Staple Inn.

Half-tone. (Paint.) A tone intermediate between two sharply-marked tones of different values.

Hall. (Arch.) A salon of large dimensions, generally lighted by a glass roof, which serves as a waiting-room or a place of meeting for public or private bodies. In palaces and castles the hall is a very large saloon in which receptions take place. In this case it is of the height of several stories and richly decorated.

Hamades. (Her.) A French heraldic term applied to a design consisting of three *barrulets*, *couped*, that is to say, three diminutive *bars* which are cut off short so as not to reach to the edge of the shield.

Hammer. A tool used in several branches of art for striking or beating. The hammer used by sculptors in marble consists of a block of iron almost cubical in shape, mounted on a very short

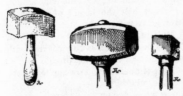

handle. The surfaces of this hammer, which is of considerable weight, soon get worn into hollows by constantly striking the chisel. The hollows thus formed are sometimes filled up with melted lead,

which in its turn is replaced when it is worn out. Chasers of metal use a hammer with a large round head. It is by gently striking the graver and moving it after each blow that the flat spaces

are obtained which accentuate the modelling of objects in metal. A small hammer is used by engravers to beat out the metal at those places where it has been effaced, so as to keep the surface perfectly horizontal. The plate is struck

with the point and not the head of the hammer.

Hammer-beam. A transverse beam which projects some distance from the wall and serves as a support to a rafter. The hammer-beam itself rests upon a concave rib springing from the wall. Hammer-beams are always constructed in pairs, and their ends are often ornamented with grotesque heads and other curious devices.

Hammer-work. A method of making ornaments out of metal by striking it when cold with a hammer. A plaque of metal is cut into the shape required, and the relief and modelling are beaten out with a hammer. The term is applied especially to silversmith's work, which is beaten with a hammer, and the surface of which is covered with innumerable facets resulting from the operation.

Hanap. A drinking cup of large size which stands upon a foot. Some *hanaps* have richly chased lids, which are masterpieces of decorative art. In the Middle Ages hanaps were made of precious metals, assumed various forms,

and were richly ornamented.

Hand. In the symbolism of early Christian art a hand in the attitude of benediction frequently represents the Almighty Father. Our cuts show a hand in the act of benediction, as it was con-

ceived in the mystic symbolism of the Latin and Greek Churches respectively.

Handle. The projection placed on the

neck or body of a vase that it may the more easily be taken hold of. The handles of decorative vases are often of considerable size, and, in addition to their practical object, they serve the purpose of breaking the outline and of affording an opportunity for decoration.

Handrail. (Arch.) A moulding of wood or iron convex in outline, some-

times with a sharp edge slightly projecting, which is placed upon stair-rails or balconies to form a support. Handrails are made of variously-coloured woods and are varnished and sometimes inlaid.

Hand-screen. A small light screen provided with a handle.
Hand-screens generally consist of a light frame of wood or iron-thread, on which is stretched a piece of satin, decorated with paintings in gouache (q.v.). The

Japanese manufacture hand-screens in large quantities, using for the purpose bamboo canes, which they split and stretch out in the shape of a fan and then cover with drawings admirable in colour and decorative in effect.

Hanging Committee. In the arrangement of public exhibitions a committee of artists, which goes by the name of the "hanging committee," is charged with the duty of hanging the pictures selected on the wall space at their disposal. The hanging committee at the Royal Academy consists of eight academicians—six painters, one sculptor, and an architect. The latest elected academician is always one of the committee as a matter of course, and the others are chosen from the council of the Academy in turn. The duties of a hanging committee are extremely delicate, and it is not surprising that complaints on the part of disappointed artists are frequently and loudly expressed.

Hangings. Strips of painted paper or stuff placed side by side and so arranged as to cover the surface of a wall. In the Middle Ages and up to the 17th century tapestries and strips of leather were used as hangings.

Hard. This term, applied to a picture, denotes stiffness of drawing and harshness of outline. *Hardness* is characteristic of the earliest masters as well as of modern painters who adhere slavishly to the teaching of academies and draw without feeling.

Harp. A musical instrument, which

was known in the most remote ages of

antiquity. It is the attribute of David and St. Cecilia. Our first cut gives a representation of an Egyptian harp, and is taken from a painting in a tomb at

Thebes. The heraldic harp generally follows closely in design the ordinary musical instrument of this name, but sometimes it approximates to the lyre. It is often represented with two heads at the extremities, one human, the other of an animal, as in our second cut. The arms of Ireland, which occupy the third quarter of the Royal Arms, are *azure, a harp or, stringed argent*.

Harpy. (Her.) A harpy is an imaginary being having the head and breasts of a woman, and the wings, body, legs, and claws of a vulture or eagle. A good illustration of the employment of harpies in heraldry is to be seen in the arms of the city of Nuremberg.

Hart. (Her.) A full-grown stag is by heralds generally called a *hart;* the female, shown without horns, is called a *hind.* In Christian art the hart is the attribute of St. Hubert, St. Julian, and St. Eustace.

Hat. (Her.) A cardinal's hat is a red broad-brimmed hat with tassels hanging from it on either side. In heraldry it is

employed as the crest to a shield as shown in the cut. For archbishops and bishops the hat is green and for abbots

black, and a difference is sometimes made in the number of tassels.

Hatchet. (Her.) This is a not unfrequent charge in early heraldry. Hatchets of all shapes are to be found in different coats of arms, including both battle-axes and axes for cutting trees. When the handle of the axe is shown, the axe is said to be *helved.*

Hatchings. Lines either parallel or crossed, by means of which the modelling of objects is indicated in engraving. These lines according to their size and closeness enable the engraver to suggest tones, to render the effect of vibrating lights, and to distinctly mark the form and even the texture of each object. For instance, it is by means of fine and delicate hatchings that flesh is indicated, while vigorous hatchings represent the folds of drapery, &c. Sometimes the

small spaces between cross-hatchings are stippled, in order to tone down the too strongly marked whites and to give depth to the modelling. In maps and topographical plans hatchings represent the slope of mountains, and they vary in number and length according to the height and declivity of the mountain. The length of the hatchings is in inverse ratio to the suddenness of the declivity, and represents the distance existing between two consecutive curves.

Hauberk. A kind of cuirass or coat of mail in use in the Middle Ages. It had wide sleeves and reached to a little

below the knee as shown in our cut. It

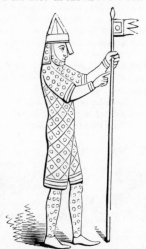

is said to have been introduced about the 12th century.

Haunch. (1.) An anatomical term denoting that part of the *os iliacum* which is articulated in the thigh bone, and generally in popular language the exterior projection of this bone.

Haunch. (2.) (Arch.) The haunch of an arch is the part which lies between the vertex of the arch and its springing.

Hauriant. (Her.) This term is used to describe a fish depicted upright on a shield, or, in heraldic language, a fish *in pale* with the head *in chief*. The word is derived from the supposition that the fish assumes this attitude when rising to the surface to *draw in* air.

Hawk. (Her.) In coats of arms the hawk is represented perched on both feet upon a horizontal beam. It may be with or without a hood, but like the falcon it has as a rule jesses or ties attached to its feet.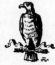

Hawk Bell. (Her.) This is a little bell of spherical form that used to be attached to the legs of hawks. In heraldry these bells are sometimes borne as separate charges on a shield, but more often appear in connection with the hawk, which is then blazoned *a hawk belled.*

Head. The dimension or height of the human head is employed as a measure in painting and sculpture. Thus we speak of a figure measuring seven heads and a half, by which we mean its height is equal to seven and a half times the height of the face and 'skull together measured vertically.

Header. A stone or brick so placed in a wall that its longer side is in the thickness of the wall. [Bonder.]

Heart. In Christian symbolism the *heart* occupies an important place. It is the symbol of the greatest of the three Christian virtues, Charity ; the symbols of Faith and Hope being the Cross and Anchor respectively. It is the attribute of St. Theresa and other saints. A figure of a heart surmounted by a flame, and known as the *flaming heart,* frequently occurs in religious decorative art. When the flaming heart is placed in the hands of painted or sculptured figures representing saints, it symbolises the Love of God. In the sacred art of the Jesuits the flaming heart is the image of the heart of Jesus, who is often represented as parting his garments and showing in the midst of his breast a flaming heart. In architectual decoration an ornament frequently occurs which presents some resemblance to a human heart. It consists of a combination of four curves or portions of a circle.

Heavy. This term is applied in painting to opaque tones, to over-accentuated outlines, and to figures without elegance ; in architecture, to proportions and details which lack grace and lightness.

Heighten. To heighten a colour is to

increase its intensity; to heighten the tone of an engraving is to add to the intensity of the blacks, and so to make the whites stand out as strongly as possible.

Heliochrome. (Phot.) A process of coloured photography which has as yet been but imperfectly developed. Its object is to obtain, after taking the plate from the camera, a cliché or proof exactly reproducing the image formed on the polished glass. Unfortunately the colours which have hitherto been obtained have been so fugitive that it has only been possible to look at them under cover of luminous rays. The heliochrome proofs which we see to-day are nothing more than photographs taken by the ordinary method and coloured by some ingenious process.

Heliography. The art of obtaining by means of light ordinary photographic proofs. The term is especially applied to a process of preparing steel plates by photography, so that proofs may be struck from them just as though the plates had been engraved or etched in the ordinary way.

Heliogravure. (Engr.) Heliographic engraving. Among the most celebrated processes of heliogravure that of Dujardin must be mentioned. By this process, with the aid of skilful touches, facsimiles of drawings or engravings may be obtained and transferred to metal plates. When the plates have been subjected to acierage, thousands of proofs may be struck from them.

Helix. A curve described on the 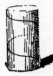 surface of a cylinder by a point revolving round the cylinder in an upward direction. This curve is applied in the construction of spiral staircases within a circular or cylindrical space. The term also denotes the volutes of Corinthian capitals.

Hellenistic. The term Hellenistic is applied to that period of Greek art from about the year 290 B.C. onwards, during which the Macedonian kings were supreme and art flourished no longer in Greece itself, but under the auspices of Greek artists in Alexandria and the cities of Asia Minor.

Helmet. A defensive covering for the head, of leather or metal. It varied in successive centuries in form, shape, and size. Sometimes it was nothing more than a sort of iron skull-cap [Chapelle-de-Fer], at other times it had a high ridge

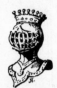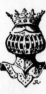

surmounted with plumes. The crest or badge of the wearer was frequently displayed above the helmet. In heraldic devices this very important piece of armour is of frequent occurrence. It may either be employed as an addition

to the shield or as a common charge. In the latter case it is always represented as an esquire's helmet, that is, as a closed helmet, seen in profile. When employed as an addition to the shield, helmets are placed over the coat of arms and take different forms and positions according to the rank of the wearers. The royal helmet is of burnished gold and stands on the shield *affronte*, showing six bars to protect the face. The helmet of princes and peers of every degree is of silver, ornamented with gold, while that of knights, esquires and gentlemen is of polished steel. The

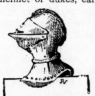

helmet of dukes, earls, and marquises ought to appear in profile on a shield and to have ten protecting bars. From the cuts which are given here a general idea of the various forms of the helmet may be gathered. The helmet of an esquire or gentleman has already been described. It appears in profile with the visor down. Knights and baronets have the same helmet with the visor up and without bars. An example of this is given in one of the accompanying cuts, surmounted by an imperial crown.

Hemicycle. (Arch.) A term applied to a hall, chapel, or apse built upon a semi-

circular plan; to a mural surface of this form; or to steps placed one above the other in concentric circles.

Hemisphere. The half of a sphere. Cupolas frequently assume the form of a hemisphere, at the summit of which a circular opening is sometimes to be seen.

Hephaestus. In Greek mythology the son of Hera and Zeus. He was deformed at his birth, and according to the legend was hurled from Olympus by his mother, for whom in revenge he made a chair, which held her in its grasp till he released her. He was the god of fire and of the arts of the smith and potter, which depended on fire. He was besides the artificer of the gods and fashioned the aegis of Zeus and the armour of Achilles. In art Hephaestus is represented as a bearded man, wearing the *chiton* and *pilos*, the costume of an

artisan, and working an anvil. The principal scenes in which he figures on painted vases are the fastening of Prometheus to the rock, the making of the armour of Achilles, and the splitting open of the head of Zeus at the birth of Athene.

Heptagon. A polygon of seven sides.

Hera. In Greek mythology Hera is the queen of the heavens and the consort of Zeus; the deity who personified the fertilising properties of the atmosphere. She was worshipped chiefly in the spring, and the peacock and cuckoo were sacred to her. The earliest images set up in her honour are said to have been simple pillars with no resemblance to a human form, and for many centuries this holy tradition prevailed. In the gold and ivory statue of Polycleitus she was seated on a throne and held in one hand a pomegranate, the symbol of marriage, in the other a sceptre surmounted by a cuckoo. She is generally represented as veiled, and thus she appears on the Parthenon frieze.

Heracles. The son of Zeus and Alcmena. He was regarded by the Greeks as the personification of strength and athleticism, and a statue of him was set up in Gymnasia as an ideal to which the athlete might attain. He is generally represented in art with a club and a lion-skin, and the incidents of his life and the arduous labours which he performed are favourite subjects with vase painters.

Heraldic Art. The art of blazoning, *i.e.* the art of explaining, describing, and representing the armorial bearings of a noble house or province by means of special terms, conventional figures, and in conformity with rules generally adopted. This art took its rise about the time of William the Conqueror, and originated in the customs of the knights of the Middle Ages adopting a distinctive badge or colour when they were engaged in jousts or warfare. After the Crusades the knights who had distin-

guished themselves by their prowess adopted the badge which they had worn during the war. Thus in the coat of arms of the Russell family, as it was before the Crusades (first cut), the chief has no charge upon it, but after the

Crusades three escallops, the symbols of pilgrimage, were emblazoned in the chief. In the 14th and 15th centuries the art of heraldry was finally developed and formulated, and after this period it began to decline.

Heraldic Beasts. [Beasts, Heraldic.]

Hermæ. A name given to a particular kind of statue, which consisted of a head or bust carefully modelled, set upon a quadrangular pil-

lar, which as a rule tapered towards the base. Sometimes a single, sometimes a double head was set on the pillar. The term is derived from the fact that in early times the god Hermes was frequently represented in this guise, but in later times terminal figures representing bearded gods or even philosophers were called Hermæ. On account no doubt of the great antiquity of this form of statue, the Hermæ were held in great honour, and to desecrate them was regarded as a serious crime. They were placed at the corners of streets and served as landmarks or boundaries. By the Romans they were employed in the decoration of gardens or as pillars to break the monotony of balustrades or walls.

Hermathene. A terminal figure, consisting of a pillar surmounted by the head of Athene.

Hermes. In Greek mythology was the son of Zeus and Maia, who, first honoured as the god of the animal kingdom, came to be regarded as the protector of commerce. He was the messenger of the gods and watched over the welfare of human travellers. Hence it was that the pillars placed at cross roads were surmounted by his head and were called Hermæ. His attributes are a caduceus (q.v.) and a petasos (q.v.), or winged cap, and he is represented as wearing wings on his heels. In ancient works of sculpture Hermes is represented as bearded and carrying a kid on his shoulders and is then known as Hermes Criophorus. [Criophorus.] In works of the best period he appears sometimes as a youth, sometimes as a child.

Herring-bone. (Arch.) In some walls the bricks or stones are arranged in what is called a herring-bone pattern, *i.e.* the courses are sloped alternately from left to right and from right to left.

Hexagon. A polygon having six sides. Terra-cotta tiles are frequently hexagonal in form. Mosaic pavements are often composed of hexagonal tiles of

the same size, set simply one against the other without the intervention of other tiles of different shape or smaller size.

Hexahedron. A solid figure having six sides. The cube and playing dice are examples of the hexahedron.

Hexastyle. (Arch.) A temple is termed hexastyle when it has six columns in its façade.

Hieroglyphic. Painted or engraved letters used among the Egyptians. They consist of typical representations of figures, animals, stars, plants, &c., and

form a distinct pictorial language. As a general term hieroglyphic is used to denote any kind of writing which bears a symbolic meaning.

High Altar. (Arch.) The principal altar in a church which contains more than one altar is termed the high altar, in contradistinction to the *low* or *lesser* altars.

High-light. (Paint.) The high-light in a picture is that spot which appears to the eye to be of the greatest brilliance. It is always a reflected light and is consequently only found on such surfaces as reflect and do not absorb the light. A high-light, for instance, may be upon a burnished metal plaque or in the eye, but it is never seen upon dull, heavy textures.

Highly-coloured. (Paint.) Over-coloured; painted in bright, crude colours.

High-relief. (Sculp.) A piece of sculpture executed upon the flat surface of a block, from which it projects so far as to resemble a sculpture in the round. Sometimes indeed a high-relief has only a few points of contact with the surface of the block from which it is cut, and for the rest is entirely detached. The finest high-reliefs in existence are the

metopes of the Parthenon, some of

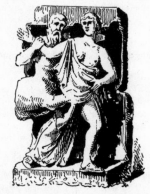

which are among the Elgin marbles at the British Museum.

High-warp. That kind of tapestry in which the warp is arranged vertically. Technically speaking high-warp tapestry is superior to low-warp (q.v.). The tapestry manufactured at the Gobelins is high-warp.

Himation. A garment worn by the

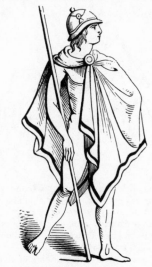

Greeks, consisting of a square mantle

which was thrown over the left shoulder and fastened by a brooch, leaving the right arm free. To wear the himation with grace and ease was a mark of gentle birth and refinement.

Hinge. Two pieces of metal, or movable wings, about a common axis, which allows them to describe a rotatory movement. Our first cut represents a sample of the commonest pattern. Sometimes, however, hinges are more decorative. On cupboards and other pieces of furniture belonging to the last century they are found with their shank terminated by a small vase or button or even by a more elaborate ornament. Our second cut gives an example of this.

Hip-knob. An end ornament or finial placed on the point of a gable or on the top of a hip.

Hippocentaur. A monster half horse, half man. The hippocentaur does not

differ from the centaur (q.v.), and the term is used in contradistinction to ichthyocentaur, or fish-centaur.

Hippodrome. Among the Greeks a circus of large dimensions and oblong form, terminated at one end by a circle arranged for chariot and horse races. In some respects it resembled the Roman circus (q.v.), a raised wall being constructed down the middle, round which the horses or chariots had to turn.

Hippogriff. A fabulous animal; a winged monster, half horse and half griffin.

Hippopod. A fabulous monster. The figure of a man with the legs of a horse used in the composition of arabesques on friezes.

Hip-roof. (Arch.) A roof the sides of which slope in different directions and meet at the ridge is called a hip-roof.

The external angle formed by the two sides of the roof is termed the *hip*, and the timbers in the hip are termed the hip-rafters.

Historic Painting. The painting of historic scenes, or scenes in which historical personages are introduced. The first historical painter was Polygnotus, who decorated the Lesché at Athens with scenes from the Trojan War. In all probability, however, these paintings were decorative and symbolic rather than graphic, and if they were now in existence they would scarcely rank high as historic paintings. It is in modern times that this branch of art has been cultivated with the greatest measure of success.

Honeysuckle Pattern. (Arch.) A pattern frequently used in Greek decorative art and termed *honeysuckle* as resembling the plant of that name.

Honourable. (Her.) This term is applied to certain *ordinaries* to distinguish them from the *sub-ordinaries* and from other charges. There are nine *honourable ordinaries*, the Chief, Pale, Bend, Bend Sinister, Fess, Bar, Cross, Saltire, Chevron.

Hood-moulding. A projecting mould-ing carried over an arch or other open-ing which serves the same purpose as the dripstone (q.v.).

Horizon. The horizon in perspective is always situated at the height of the eye of the observer, and is represented by a straight line parallel to the line of the earth.

Horizontal. A line or plane is said to be horizontal when it is parallel to the horizon.

Hors Concours. A term applied to artists exhibiting in the Salon at Paris who have received all the highest awards, and so can only compete for the *grandes médailles d'honneur.*

Horse-brey. (Her.) This is an instru-ment sometimes used to compress the nose of a res-tive horse. It is jointed at the middle and has pointed teeth. It occasionally appears as an heraldic bearing, and is then often described as a *pair of breys or barnacles.*

Hospital. (Arch.) A collection of buildings intended for the shelter and cure of the sick.

Hotel. (Arch.) A building in which travellers are housed and fed on payment of money. Hotels are often, from an architectural point of view, of great splendour, and the decoration of their interior frequently displays admirable taste.

Hôtel de Ville. A building in which the municipal authority has its seat. Many *hôtels de ville* are distinguished by the richness of their architecture. The term is employed in France, Bel-gium, and Holland.

Hourd. (Arch.) Timber galleries placed on the summit of towers and parapets in the fortified castles of the Middle Ages. Some *hourds* were constructed of ma-sonry and so were permanent, whereas the timber *hourds* were movable. In the *hourds* of the 13th century the timber-work was at once solid and simple, and

rested on supports of stone. In the 14th century *hourds* were in most countries replaced by machicolations (q.v.); but

in Germany and Switzerland they re-mained in use during the 15th and 16th centuries. The term is French and has no equivalent in English.

Hour-glass. A double glass, the two swelling portions of which are connected with a narrow tube, through which a certain quantity of sand can run in a certain time. The use of the hour-glass to measure time was once universal.

Hour-glass Stand. An iron bracket attached to pulpits, especially about the time of the Commonwealth, in which the hour-glass was placed. Hour-glass stands are still to be seen in some Eng-lish churches, and are often excellent specimens of ironwork.

Hours, Book of. A prayer-book. There are in existence books of hours in manuscript, the illuminations of which are masterpieces by Memling and Jean Foucquet. Among the early printed books of hours are some, the pages of which are bordered with wood-cuts of extraordinary delicacy. These are keenly sought after by collectors, and the most highly prized were printed by Simon Vostre, Hardouin, Kerver, &c.

Housing. (Arch.) A small niche or recess in a wall, in which a statue was placed.

Hubert, St. A noble of Aquitaine, who was converted by seeing a milk-white stag with a crucifix between its horns, when he was hunting on a holy day.

203

For many years he was a hermit in the Ardennes, and afterwards became Bishop of Liège. He died in 727. Representations of him by Flemish and German artists are not infrequent. The St. Hubert engraved by Dürer is perhaps the best known. He generally appears in episcopal vestments and carries a hunting horn and book. The stag always appears close to him or upon the book.

Hue. Properly speaking the term *hue* denotes a colour which results from the mixture of a primary with a secondary colour. It is, however, carelessly applied to any colour, and is very often used where the term tint would be more correct.

Humetty. (Her.) Another term for *couped*. [Cross, Couped.]

Humorist. An artist who executes grotesque scenes and fanciful sketches, and who appeals to the sense of the ridiculous in those who look at his pictures.

Hunting-horn or **Bugle.** (Her.) This

is a very well-known armorial bearing. The horn itself takes the form shown in the cut, but it is generally represented with strings attached and with a band round the middle, and is then blazoned *stringed and garnished*.

Hyaline. Transparent and diaphanous like glass. Rock crystal, for instance, is hyaline.

Hyalograph. An instrument by means of which perspective can be mechanically drawn.

Hyalography. The art of engraving upon glass either with a diamond, emery, or hydrofluoric acid. The term is also applied to a mechanical process of drawing by means of which objects are reproduced as they are seen in perspective.

Hydra. (Her.) This is a fabulous animal represented as a dragon with seven heads. A celebrated classical

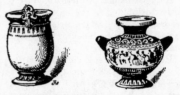

myth tells of the manner in which Hercules slew the hydra near Argos, in Greece.

Hydria. (Pot.) An ancient vase of

variable form used to contain water.

The hydria when made of terra-cotta was

often of elegant form and covered with

ornament. It was generally provided with three handles, two large and one small one. Sometimes a small handle was placed immediately underneath a larger one, in order to add to its strength, as is shown in our third cut. The term hydria was sometimes applied to a water-can of bronze or silver, resembling in shape the modern water-pail, and provided with a semicircular handle reaching from one side of it to the other. A hydria of this kind is represented in our fourth cut.

Hydroceramic. (Pot.) A term applied to vases of porous earth, which allow drops of liquid to form beads on their surface and keep water cool by evaporation.

Hydro-metalloplastic. A term applied to all those processes of gilding, silvering, and coppering which consist in immersing objects in a bath until they are covered with a metallic deposit produced by chemical affinity.

Hypaethral. (Arch.) An uncovered roofless building is said to be hypaethral, which, literally translated, merely means under the sky. Ancient temples were frequently hypaethral, for by adopting this form of building the difficulty of roofing over a large structure was avoided.

Hypaethrum. (Arch.) A term given to the latticed window which surmounted the grand entrance of some ancient

temples. The hypaethrum not only admitted air and light into the temple but added considerable dignity to the exterior effect of the door.

Hypocaustum. A subterranean fur-

nace with flues, which heated the caldarium or hot bath of the Romans.

Hypogeum. (Arch.) A part of a building lying below the level of the ground. It is particularly applied to the subterranean chambers in which the ancients placed their dead.

Hyposcenium. (Arch.) The orchestra in ancient theatres.

Hypothenuse. The side of a right-angled triangle opposite the right angle.

Hypotrachelium. (Arch.) The upper part of the shaft of a column, immediately beneath the last moulding or *neck* of the capital.

Hyrmensul. [Cromlech.]

I.

Icebreaker. A projecting angle placed on the piers of a bridge, facing up stream, to catch the blocks of ice which flow down when the frost breaks up.

Ichnographic. A term applied to a drawing, sketch or plan executed by the processes of ichnography.

Ichnography. The art of drawing by means of compass and rule. The term is also applied to the art of tracing plans and figures.

Iconoclasts. Breakers of images. At various periods in the history of art Iconoclasts have wreaked their fury upon images. The name was first given to the Byzantine emperors of the 8th century who destroyed the images of the Christian Church. One of the greatest Iconoclasts whose name is known to history was Savonarola, who in two years gave to the flame many hundred masterpieces of Florentine art. Those who carried out the Reformation in our own country in the reign of Henry VIII. well earned the title of Iconoclasts, for they wantonly destroyed or carried off the marvellous collections of works of

art which had grown up at the shrines of the saints. Whatever escaped their fury was reserved only for the Puritans, the Iconoclasts of the 17th century. In this age of tolerance and artistic appreciation the spirit of Iconoclasm is happily almost extinct.

Iconographic. That which relates to iconography.

Iconography. That science which includes the study and description of the paintings, sculptures, and engravings of antiquity and the Middle Ages, and especially the knowledge of portraits, images, busts, or statues. The *iconography* of a celebrated person is a description of all existing portraits of him.

Iconology. A knowledge of the attributes of mythological personages; a study of emblematic figures, as well as the interpretation and description of works of art. Sacred iconology deals with the attributes and artistic representation of persons mentioned in the holy Scriptures, the lives of the saints, &c.

Icosahedron. A solid figure presenting twenty equal plane sides. The surface of a regular icosahedron consists of twenty equilateral triangles. A large number of crystals are cut in the form of an icosahedron.

Ideal. The *Ideal* in art is the supreme or typical perfection, which only exists in the imagination of the artist. The ideal is individual. Each artist pursues his search for the ideal in his own way. But the ideal implies for the artist the perfection of the type set before him, whatever it may be. To attain the ideal is to approach as closely as possible to perfection, relying all the time upon the study of nature and interpreting it in an individual manner. The ideal of Michael Angelo is very different from that of Rembrandt and Velasquez, yet all three have left behind them masterpieces of very strongly marked character. The ideal of a human figure cannot represent literally one individual. It must

be, as it were, an epitome of the good points in many individuals. Lucian in his description of Panthea gives us an excellent illustration of what an ideal figure should be. For he imagines this paragon of beauty to combine all the graces which the greatest sculptors of Greece had expressed in their work. In the familiar language of every day the word *ideal* has a slightly different meaning. Thus when we speak of a portrait being ideal, we mean that the elements of coarseness and commonplaceness which may exist in the sitter's face are eliminated.

Idealise. To render a scene ideal or poetical; to interpret it with a refined sentiment; to give a figure a noble attitude and outlines of the utmost purity; to draw a portrait and at the same time to ennoble the features of the model.

Idealist. An artist whose works testify to his search after the ideal.

Ideography. A method of expressing ideas by signs representing the objects spoken of. Egyptian hieroglyphics are a kind of ideographic writing.

Idol. A statue, often painted or gilded, representing a deity. Some Indian idols are works of art of extraordinary beauty and admirable workmanship.

Illegitimacy. (Her.) The proper *brisure* or difference (q.v.) charged upon the arms of illegitimate children is the *baton* which is a diminutive of the bend sinister. This mark of difference is popularly but incorrectly known as the bar sinister.

Illuminated. Adorned or decorated with illuminations. Brightly coloured; clothed in a brilliant and striking colour.

Illumination. The art of illuminating, *i.e.* of embellishing manuscripts with drawings in body colours and gold. The earliest illuminations were executed in red lead, and later in cinnabar. The art was practised from the 3rd century until the 17th, and monks

were especially skilled in illumination. Many specimens of illumination are still in existence dating from the Middle Ages, and some have been reproduced by chromolithography.

Illuminator. An artist who executes illuminations. The most skilful illuminators flourished in the 15th, 16th, and 17th centuries. There were also illuminators among the Greeks and Romans. A manuscript of Vergil dating from the 4th century is preserved in the Vatican. We are told that the manuscripts executed by the Byzantine illuminators were marvels of art. The gospel of Charlemagne (8th century) is to be seen at the Louvre. The art of the illuminator decayed in the 10th century, but in the 13th it increased in variety and richness. Among the most celebrated illuminators we must mention Jehan Foucquet (1416—1485), author of "*Les Heures d'Anne de Bretagne,*" and later in the 17th century, Robert, who executed in 1641 the garlands of flowers which formed a border for a text written by Jarry, entitled "Guirlande de Julie," presented by the Duke de Montausier to Julie de Rambouillet.

Illustrate, To. To execute drawings or engravings intended for the illustration of a book. To illustrate a volume is to furnish representations of the principal scenes in the work and at the same time to execute designs for borders, head-pieces, tail-pieces, and initial letters.

Illustration. A term applied to the coloured ornaments of ancient manuscripts as well as to the engravings printed apart or the cuts inserted in the text which embellish modern books, and are suggested by the subject of the work in which they are placed. From the "Books of Hours," the "Nuremberg Chronicle" (15th century), and the "Dance of Death," down to the modern *éditions de luxe,* an immense number of illustrated books have appeared. Varying with the taste of each epoch,

illustrations have been executed on copper, stone, or wood. In addition to illustrations in black and white we sometimes find illustrations executed in colour by the processes of chromolithography and chromotype. A decided tendency may be observed in the illustrations of to-day to facsimile the sketch or drawing of the artist by the various mechanical processes based upon photography.

Illustrator. An artist who executes drawings or vignettes intended to illustrate books or journals. From the time of Holbein to the present time, the list of talented illustrators would be a very long one. Very many of our great artists, among whom we may mention Fred. Walker, Millais, and Holl, first won distinction in this popular branch of art.

Image. A statuette or small representation of a living person. The classical nations made images of their ancestors, which they regarded with a kind of reverential awe and carried in solemn processions, such as funerals and triumphs. These *images* held the same place in the estimation of the ancients as is held to-day by genealogical trees, and many a Roman aristocrat was as proud of having a large array of images in his house as Englishmen often are of having "come over with the Conqueror." Small images of various materials, representing the Virgin or some other holy person, and generally placed in a small niche, are frequently found in the churches or even in the homes of devout Catholics.

Image-maker. A term applied in the Middle Ages to artists who carved and illuminated images. The thousands of statues which decorate Gothic churches are the work of image-makers. From the 13th to the 16th century image-

makers generally followed their own inspiration. We can therefore institute no comparison between the mediæval image-makers and the decorative sculptors of to-day. For the latter only work to carry out a given design set them by the architect or the chief of the works. It is this independence of the image-maker from control which explains the originality, the audacity even of much of the decorative work of the Gothic period. In the 16th and 17th centuries there were indeed sculptors but no image-makers, and after this time the term is only applied to those who make childish images or carry out valueless designs. And so it has come about that the word, which in the Middle Ages designated a true artist, whose works, in being naïve, were none the less meritorious, is nowadays only used in a bad sense.

Image-making. The art of making images, which was practised with much success in the Middle Ages, but which did not until long after rank among the arts. The term is especially applied to the manufacture of painted or gilded statuettes generally placed on small brackets and covered with a canopy. Sometimes images of this kind are arranged in the form of a diptych or triptych. They generally represent Christ, the Virgin, and the saints. In the 14th and 15th centuries images were made which opened and shut as reliquaries. In the 16th century figures painted in enamel and elsewhere took the place of representations of holy personages in relief.

Imaginary Beings. (Her.) There is a whole class of heraldic charges consisting of imaginary beings, formed by piecing together various parts of different animals, as for example a cock with the head and feet of a goat. The most common for heraldic purposes of these imaginary beings are the *dragon* and the *griffin*, but the *wyvern* and *cockatrice* are often met with, and occasionally but more rarely the classical *centaur, nereid, pegasus,* and *chimera.*

Imagines à Vestir. Wooden images of the Virgin and the saints set up in Italian churches. Their heads, feet, and hands are finished with some care, while the rest of them is only roughly blocked out and covered with vestments of costly material and richly embroidered. These imagines present a curious parallel to the rough images of deities which were treasured in some Greek temples and richly draped, as the image of Athene in the Erectheum.

Imbricated. (Arch.) A term applied to surfaces decorated with imbrications.

Imbrication. (Arch.) A method of decoration consisting of thin plates placed one upon the other, either in the form of fish-scales or of small pointed jaggings, which partly overlap, like the tiles on a roof.

Imitate, To. To copy; to reproduce by imitation; to produce works in the manner of a master or the style of a school.

Imitation. Works of painting or sculpture are said to be executed in imitation when, although they are really composed of a worthless material, they pretend to be precious substances. Thus we speak of an imitation of marble, an imitation of bronze.

Imitative Arts. This term is applied collectively to painting, sculpture, and engraving to distinguish them from architecture on the one hand and from music and dancing on the other.

Impale. (Her.) To impale is to conjoin two coats of arms side by side on one shield. This is frequently done in the case of husband and wife, while a bishop's coat of arms is often impaled with that of his diocese.

Impasto. (Paint.) An abundant appli-

cation of very thick oil-colour to the surface of a canvas. The object of impasto is to give relief, force, and solidity to the objects represented. We speak of vigorous impasto, solid impasto, &c. It is to be noticed that impasto always strengthens the luminous portions of a picture. The shades ought to be ligh̆tly treated, or there is a danger of their losing their transparency. By the use of special impastos, applied to the canvas by particular processes, some artists have succeeded in representing rocky country, rugged walls, &c.

Imperial. (Arch.) A dome is said to be imperial when its curves unite so as to form an acute angle.

Impluvium. (Arch.) A square tank or cistern sunk in the middle of the floor of the atrium in a Roman house. The rain-water which fell through the compluvium (q.v.) was collected in the impluvium.

Impost. (Arch.) Projecting stones terminating a pillar upon which the first voussoirs of an arch rest. A fixed

slab placed above a door or window and forming part of the frame of a bay. The term is also applied to the mouldings which decorate an arch or bay.

Impression. (Engr.) A print struck off from an engraved plate is called an impression. ·Thus we speak of an early impression, a brilliant impression, a poor impression, &c. The term *impression* is applied in painting to a vivid sketch which represents a scene in nature as it impressed the artist who drew it. [Impressionist.]

Impressionism. The doctrine affected by impressionists (q.v.).

Impressionist. The impressionist school is a contemporary school of painting, the adherents of which set themselves to render, not reality in its minuteness, but a rapid aspect of nature, reproducing as nearly as possible the impression made upon their own mind by any particular scene. It is quite clear that nature, looked at rapidly, especially landscape, can be rendered by means of a few vigorous and forcible touches, and further, that the value of this general and summary impression may be spoilt by excessive toil in the elaboration of details. Among the sketches of impressionists are to be found many charming studies extraordinarily truthful in tone ; but hitherto this school has not been able to convince the public, whose aesthetic education leads them to expect something more in a picture than is revealed to them in a rapid impression, and to look with suspicion or contempt on any drawing which does not exhibit what they regard as " finish."

Imprint. A reproduction, either depressed or in relief, obtained directly from an object. The imprint of a medal for instance is the hollow mould of this medal. The imprint of an incised tombstone or of an intaglio is on the contrary in relief. It is obtained with wax or plaster, sometimes with clay.

Improvisations. A rapid sketch drawn under the impulse of a sudden idea. Many etchings may be called *improvisations on copper*, when they are drawn with a free point and are boldly bitten in.

Inalterable. A term applied to painted decorations on porcelain, faïence, or enamel, the colours of which, after being passed through the fire, remain unaffected by the action of the air. Photographic proofs are said to be inalterable when they are struck off with the aid of thick ink, which does not turn yellow or fade.

In Antis. (Arch.) A temple *in antis*, in the language of ancient architects, was a temple the façade of which is

decorated by two columns of the same thickness as the pilasters or prolongations of the side walls of the *cella* which support the roof of the temple. [Antae.]

Incense-burner. A kind of metal vase

in which perfumes are burnt on live coals. In India, China, and Japan the most beautiful incense-burners are made. They assume a multitude of shapes. Some of them are in the form of chimæras, dragons, and other fantastic animals, which exhale odoriferous vapours through their mouths, while others are simple vases, pierced with openings arranged in geometrical patterns.

Incise. To cut lines in metal or wood. An engraver *incises* lines in the plate upon which he works. One method of decorating metal plates is to incise lines upon them.

Incisura. A term used by the Roman painters to denote the hatchings or lines which were drawn with a brush upon flat tints to deepen the tone. *Incisura* was chiefly employed in fresco-painting. In modern oil-painting it has no place, as the effect is now got by other means.

Incitega. A stand upon which am-

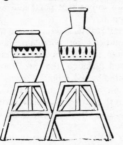

phorae and other jars rounded at the bottom were placed. They were made of various materials, earthenware, wood, metal, &c. The one figured in our cut bears a curious resemblance to the wicker-stands now used to hold soda-water bottles.

Incline, To. To set obliquely or at an acute or obtuse angle.

Incrust, To. To decorate a surface with incrustations; to cut hollows in the surface of a stone wall, for instance, and let in slabs of marble; to embellish panels of wood with ornaments of metal or ivory in such a way that the incrustations do not project from the plane of the surrounding surface. When wood of one colour is let in upon another it is said to be veneered (q.v.), not incrusted.

Incrustation. A method of ornament which consists in making incisions with a graver upon a smooth surface, and filling the hollows thus obtained with a material different from that upon which the incisions are made. Thus incrustations of marble are made upon blocks of stone or marble of a different colour, while panels of wood are sometimes covered with incrustations of copper, brass, or even of precious metals.

Incunabula. A term applied to the volumes printed before the first years of the 16th century. Xylographic incunabula were printed from engraved blocks of wood, while typographic incunabula were printed by means of movable type.

Incuse. (Numis.) An incuse coin is a coin which bears on its obverse the same subject in relief as appears incuse on the reverse. Such are the archaic coins of Magna Graecia.

— **Square.** The earliest Greek coins were irregular pieces of metal shaped like ingots. The convex surface bore an emblem, while on the reverse is nothing but a square indentation called an *incuse square*, the impression of the square head which held the metal when it was struck.

Indelible. That which cannot be effaced. Ordinary photographic proofs undergo changes on exposure to the light, get covered with spots, and end by disappearing, but when a certain kind of thick ink is used in their printing they are indelible.

Indented. (Her.) This is one of the

ornamental forms taken by the dividing lines of a shield. The difference between *indented* and engrailed (q.v.) is this, that in the former case each little tooth is a triangle, in the latter it is a cusp.

Index. An analytical or alphabetical table of names, which is placed at the end of artistic catalogues and other works.

India Paper. A paper of a yellowish colour manufactured in India and China of vegetable fibre, of great value in taking proofs of engravings. It is an absorbent paper, and receives a clear impression of even the most delicate lines.

— Rubber. An elastic gum of great service in art, being used to efface pencil lines traced upon paper. It is the sap of a South American tree, and solidifies on being exposed to the air. Its value was only discovered in the last century, but it is now universally used.

Indian Blue. [Indigo.]

— Ink. [Ink, Indian.]

— Lake. (Paint.) A red pigment obtained from the resinous secretion of the *coccus ficus*. It is a good colour, though not so brilliant as madder lake, and is fairly permanent.

— Ochre. (Paint.) A useful red, composed of sulphur, oxygen, and iron. It is permanent and a pleasing colour.

— Red. (Paint.) This pigment is a red hæmatite which is found in the Persian Gulf and also in the Forest of Dean in Gloucestershire. It is of great use to the painter, as it is a rich colour and quite permanent. It has been used as a pigment from ancient times.

Indian Yellow. (Paint.) A pigment used by water-colour painters with much effect, as it has greater body than gamboge, and is transparent. In water-colour it is permanent even in a strong light, but it speedily disappears in oil.

Indicate. When in a sketch a form is suggested by an outline, but not drawn with precision, that form is said to be indicated. For instance, the contour of a figure, the execution of which is not completed, may be said to be indicated. In a picture, all that is not finished is indicated, that is to say, is expressed by indefinite lines or vague tonalities, which, did they occupy an important place in the composition, would need to be treated more seriously. We say that an artist is content with indications when by means of refined lines and simple and true colours he indicates exactly and without dryness that which he wishes to represent. In primitive art another method of indication is adopted. A part suggests the whole ; thus a tree is employed to indicate a forest, a ship a fleet, &c.

Indigo. (Paint.) A blue pigment used in water-colour painting, which yields a tone less close to green than Prussian blue. Indigo is brighter than the latter, and slightly tinged with violet. Under ordinary conditions it is permanent, but it is adversely affected by white lead and impure atmosphere.

Individuality. A term which denotes the originality of an artist and the personal character which he communicates to his works. Thus we speak of a strongly marked individuality, a scene the rendering of which lacks individuality, and so is commonplace.

Inescutcheon. (Her.) [Shield of Pretence.]

Infringement. An infringement of the law of artistic copyright (q.v.) is an imitation or fraudulent reproduction of a work of art the copyright of which is reserved.

Infulae. A portion of the ecclesiastical

costume, consisting of small pendants hanging from the mitre and falling over the shoulders of the wearer. Our cut is from a brass of the 15th century in East Horsley Church.

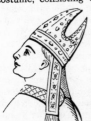

Ingriste. A French slang term which denotes a pupil of the school of Ingres. It is not to be found in dictionaries, but is dignified by having been used by many authors and critics of repute.

Initial. A letter which begins a chapter. The initial letters of manuscripts were often enriched with paintings, while some formed the subjects of beautiful miniatures and small pictures of wonderful perfection of workmanship. In some printed works the initials form exquisite vignettes composed with taste and engraved with care. [Capital.]

Ink. A black liquid more or less intense, which consists of a mixture of gall-nut, sulphate of indigo, green copperas, and gum arabic, used both for writing and printing.

—, **Coloured.** Mixtures of powdered colours and varnishes of various kinds, used in typographic and lithographic printing.

—, **Indian.** An ink consisting of a mixture of lamp-black, gelatine, and odoriferous substances. The odour peculiar to Indian ink arises from the addition of camphor of Borneo and powdered musk. Lamp-black is used for the fine ink and burnt cork or grapeskins for the commoner sort. Indian ink is the most solid colour known to us. It is the only true indelible ink, for it has a base of carbon. It was once used exclusively in architectural sketches, which are now executed in water-colour. The imitations of real Indian ink are numerous. The dragons and chimeras, accompanied with gilt characters on a blue ground, are no longer a guarantee of the authenticity of the manufacture of the tablets, which are everywhere on sale. Some Indian inks have a reddish tone and present a brilliant effect when they are used as thick as possible. Others on the contrary are greyish in tint and approach a purple blue, yielding tones of much delicacy. The latter tints remain dull on paper whatever be their degree of intensity, and the inks from which they are obtained are far preferable to the inks yielding reddish tones. They are besides the nearest approach to the ink made in China, as a comparison of the tints they yield with Chinese and Japanese paintings will readily convince us. The Chinese have always manufactured the best Indian ink, which is sometimes termed Chinese ink, and hitherto have successfully kept the secret of their manufacture.

Ink, Lithographic. Ink composed of a mixture of soap, tallow, and lamp-black, diluted with pure water. It should be used at once, as it rapidly thickens and decomposes.

—, **To.** (Engrav.) To smear ink by means of a pad over a copper-plate ; to pass a roller impregnated with ink over the surface of an engraving in relief or over a lithographic stone upon which a drawing has been executed with pen and ink or lithographic crayon.

—, **Vignette.** A mixture of lamp-black and oil containing resin in solution used in printing vignettes engraved on wood.

Inlaid Pavement. (Arch.) Pavement

which consists of variously coloured tiles inlaid to form geometrical patterns.

Inlay. A term applied to the piece of wood, metal, or ivory which is inserted in panels of wood in the process of *inlaying.*

Inlaying. A method of decorating furniture, which consists in incising patterns on the surface of wood and filling the spaces thus formed with pieces of variously coloured wood, ivory, metal, &c.

Inscribe. To draw a geometrical figure within another geometrical figure, so that there are some points of contact between them.

Inscription. (Arch.) Words engraved on a tablet of marble or on a surface reserved for the purpose on an entablature, indicating the purpose of a building, perpetuating the memory of an event, or fixing a date.

Instantaneous Photography. [Photography, Instantaneous.]

Instruments. A general term applied to boxes of compasses, squares, rules, &c., which are used by artists and architects, as well as to graphometers, levels, &c., employed in surveying.

Intaglio. A precious stone, decorated with figures, &c., depressed below the surface. The stones used for seals are instances of intaglios. The intaglio is the reverse of the cameo (q.v.).

Intercolumniation. The space between two columns. The intercolumniation is measured from the axis of one column to the axis of the next, and varies in the different orders, the unit of measurement, or module as it is

called, being half the diameter of the column. The intercolumniation is less in Doric buildings, where an effect of strength and dignity is aimed at, than in buildings of the Ionic or Corinthian style. [Aræostyle ; Eustyle ; Pycnostyle.]

Interior. A term applied to *genre* pictures (q.v.) representing the inside of churches or palaces or more generally scenes of cottage life. The term also denotes those pictures in which per-

spective plays an all-important part, such as Panini's Interior of St. Peter's at Rome. The painters of the Dutch and Flemish schools have particularly excelled in the painting of interiors ; and among the most celebrated of them may be mentioned Van der Poel, Kalf, Neef, and Van der Meer.

Inter-joist. (Arch.) The space between two joists.

Interleave. To place leaves of white paper between the pages of a volume, or between the engravings in an album, before having them sewn or bound.

Inter-modillion. (Arch.) A vacant space between two modillions (q.v.).

Interpretation. The manner in which an artist renders or expresses nature according to his personal sentiment ; for nature can never be interpreted with rigorous accuracy. Art is necessarily and on all occasions an interpretation of nature, but an interpretation which aims at being happy rather than literal.

Interpreted. A term used of the manner in which a figure, subject, scene, or group is executed, painted, or sculptured. Thus we say of an artist that he has interpreted a scene well, of a landscape or effect of light that it is badly interpreted.

Intersection. The point common to two lines which cut one another ; a line common to two surfaces which meet one another. In architecture the term intersection is particularly applied to that part of a church where the nave and transepts cut one another at right angles. [Crossing.]

Interstice. An interval of small dimensions.

Inter-tie. (Arch.) A piece of wood or iron which holds together crosswise two other pieces of wood or iron.

Intrados. (Arch.) The concave surface formed by the

voussoirs of an arch from the springing line to the keystones.

Intransigeant. A name given in Paris to certain artists of the extreme impressionist school, who under this title have organised exhibitions of their own.

Invected. (Her.) This name is given to one of the dividing or partition lines on a shield. It consists of a series of curves terminating in cusps. They may be small and numerous, or few and large, as here shown.

Invention. A term applied to the manner in which an artist composes a scene or imagines a subject. A picture, the subject of which is feebly composed and badly realised, is said to lack invention. When we speak of a charming invention, we mean an excellent idea, a scene which is *spirituelle* and happily treated.

Iodine, Scarlet. (Paint.) A pigment obtained from iodide of mercury. It is opaque and of good body, and is the most brilliant of all the scarlets. It is, however, useless to the painter, as it is not permanent even under the most favourable conditions. Other pigments decompose it, and air and light speedily destroy it. Under no circumstances can its use be recommended.

Ionic. One of the ancient orders of 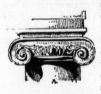 architecture. The distinguishing feature of the style is that its capital is ornamented with volutes. The Ionic columns of Greece and Asia Minor possess unrivalled grace and delicacy of outline; the Roman Ionic style, however, is heavy and graceless. In the 17th and 18th centuries architects frequently used columns of the Ionic style in their façades. As a general rule, it may be laid down that when Ionic pillars are used to decorate a neo-classical façade, it is in the sub-basement or first story, and they are almost always surmounted by a Corinthian entablature.

Iron Brown. (Paint.) A rich brown pigment obtained from calcined Prussian blue. It possesses many advantages; if pure it is quite permanent, it dries well, and is transparent.

Iron-work. A general term which includes all objects made of iron. In the Middle Ages many fine examples of artistic iron-work were produced. At the period of the Renaissance, in the 17th and 18th centuries, the iron-work

produced was of great richness. Many specimens belonging to these different epochs are preserved in museums, and in the iron gates and railings of many great houses we may still see of what the old workers in iron were capable. The iron gates and railings from Hampton Court, now in the South Kensington Museum, are masterpieces of art. Bands of iron fixed to doors and windows, and bars and bolts with which doors are fastened, are often fine examples of iron-work. The artistic iron-work of to-day, though it has at its disposal many elaborate mechanical processes, can do nothing more than imitate inefficiently the masterpieces of previous centuries.

Iron Yellow. (Paint.) An iron ochre bright in colour and transparent. It is a useful pigment and is permanent.

Isabel. A colour intermediate between white and yellow, in which yellow predominates.

Isinglass. Gelatine extracted from the sturgeon, employed to size canvases and in certain kinds of size-painting.

Isodomus. (Arch.) A term applied by Greek architects to that style of masonry in which the courses of brick or stone were of equal height.

Isography. The art of reproducing or making exact facsimiles of writings, manuscripts, and autographs.

Isokephaleia. A principle in Greek sculpture, according to which the heads of the figures in a bas-relief were the same distance from the base of the relief, whether they were riding, standing, or sitting.

Isolated. (Arch.) A building or portion

of a building is said to be isolated when it is wholly detached from the main body of the building. A pillar set against a wall is said to be isolated when it is not in the same plane as the wall, with which it is only connected by its base and capital.

Isometrical Perspective. [Perspective, Isometrical.]

Issuant. (Her.) This term is most frequently applied to demi-lions, and implies that the lion is *issuing* from the bottom of a chief, so that only the upper part of the lion is seen. The term *naissant* (q.v.) has a slightly different meaning.

Italian Pink. (Paint.) A vegetable yellow pigment, the best of which is obtained from quercitron bark. It is sometimes called yellow lake. It is bright and transparent, but its use is not to be recommended, as its permanency cannot be guaranteed.

Italian Varnish. A varnish which consists of white wax and linseed oil, used in oil-painting for glazing (q.v.).

Italic. A term applied to the characters invented by Aldus Manutius, the printer. Instead of being vertical, they incline slightly to the right. Italic characters inclined at the angle at which we generally write are employed in modern books to attract the attention of the reader, and discharge the function of words written and underlined.

Ivory. An osseous substance, forming the teeth and tusks of the elephant, out of which works of art of all sorts are made. When we speak of *ivories* we generally mean objects carved in ivory. The ancients executed statues of ivory of immense size, and had discovered a method of softening the material. [Chryselephantine.] Byzantine ivories consist entirely of bas-reliefs, diptychs, reliquaries, crosiers, &c. In the Middle Ages and as late as the 15th century altar-pieces were carved in ivory, while there are many crucifixes of ivory belonging to the 16th and 17th centuries. Ancient ivories of fine workmanship are very highly prized by collectors. The grotesque ivory carvings of the Japanese are well known and of great value. They generally take the form of *netsukés*, or attachments for securing medicine boxes or tobacco pouches under the girdle.

Ivory Black. A pigment obtained from calcined ivory, of great value to the painter.

Ivy. A foliage of a particular kind employed in garlands and other systems of decoration. It is one of the attributes of Bacchus, and garlands of ivy are frequently employed in the decoration of rustic buildings.

J.

Jack. (1.) (Arch.) A machine with which weights may be lifted. It is also used to hold up, with the aid of stays, a portion of a building while the work of restoration or consolidation is in progress.

Jack. (2.) A term applied to the leather cups and bottles, sometimes rimmed with silver, which were used as drinking vessels in the 16th century.

Jackfield Pottery. (Pot.) A manufactory was established at Jackfield, near Broseley, in 1713. Stoneware, both

black and white, was produced there. The industry ceased at the beginning of the present century, and specimens of Jackfield ware are now hard to come by.

Jack-rafter. (Arch.) A short rafter used in the construction of hip-roofs. It is joined at the top with the hip-rafter (q.v.), at the bottom with the wall plate.

Jade. A mineral varying in colour from green to yellow and yellowish white. It is a species of nephrite, and may be described as a native silicate of calcium and magnesium. It is found in China, America, and some islands in the South Pacific. By the Chinese it is held in high estimation, and in spite of its toughness carved into all sorts of forms. It is never found in a natural state in Europe, yet curiously enough jade celts (q.v.) have been found in Switzerland and by Schliemann at Hissarlik. Their presence in these localities is difficult to explain.

Jamb. (Arch.) The vertical uprights which frame an opening, whether it be a window or door. The term is also applied to the uprights which support a chimney-piece. The jambs of some mediaeval chimney-pieces consist of clustered colonettes.

Jambe. (Her.) This is the name usually given by heralds to the leg or part of the leg of an animal when shown alone on the shield. If, however, the foot alone appears, being cut or torn off below the second joint, it is called a paw (q.v.).

Jambs. Pieces of armour which protected the leg. In the 14th century they were composed of cuir bouilly (q.v.), but after the 15th century they were always made of metal. They ceased to

be worn altogether in the reign of James I.

James, St., the Greater. Of James the Greater, the kinsman of Christ, we know little, except that he followed our Lord, and that after the crucifixion he was put to death with the sword. In art he is generally represented with the attributes of a pilgrim, the staff, gourd, and scallop shell. Sometimes he bears a sword, the emblem of his decapitation. In Spain, where he is particularly revered, an extraordinary mass of legends has gathered round his name. In the year 939 he is said to have appeared on a milk-white charger to lead on the troops of King Ramirez to achieve a brilliant victory over the Moors. So strong was the belief in the appearance of St. James on this occasion that ever since " Santiago " has been the battle-cry of the Spaniards, and in the pictures of the Spanish school St. James is commonly represented as mounted on a white charger.

James, St., the Less. Like St. James the Greater, St. James the Less was a kinsman of Christ, whom he is said to have closely resembled. He is said to have been the first bishop of Jerusalem. He suffered martyrdom by being thrown down the steps of the temple and having his brains beaten out with a fuller's club. In art accordingly he is generally represented as leaning upon a fuller's club, and he is often to be recognised on account of the striking resemblance which his features bear to the accepted features of Jesus.

Janus. A god much honoured by the Romans, in whose estimation indeed he rivalled Jupiter himself. He was particularly associated with the beginning and ending of enterprises. In art he is represented as Bifrons, *i.e.* two-faced, and he generally holds a key as a symbol of the opening and closing of undertakings. The worship of Janus was an ancient one at Rome, and it was the custom to open his

temple in time of war and to close it in time of peace.

Japanese Paper. Japanese paper, which is used in expensive printing, is made from the bark of the tree called by botanists *morus papifera sativa.* White Japanese paper is the best and thickest. It is used for printing proofs of etchings and engravings upon. It is transparent and of a satiny texture, and the velvet tones which result from the deep biting-in of a plate come out admirably upon it. But it too quickly absorbs the ink, and when it is to be printed upon the plate must be more thoroughly inked than when ordinary laid paper is used.

Japanning. A process of painting and varnishing, by means of which a smooth and brilliant surface is given to such articles as trays, boxes, &c. It is practised especially by the Japanese, and is of service in decoration as it dries very hard and is unaffected by damp.

Japonaiseries. A French term which includes all objects of art and curiosity which come from Japan.

Jar. (Pot.) A full-bellied vase of glazed earthenware, sometimes with handles, sometimes without. In ancient times earthenware jars were, and in the East still are, hung by their handles or necks on long poles and thus carried upon the shoulders.

Jardinière. A vase of porcelain or metal, sometimes richly decorated, made to hold plants or flowers.

Jasper. A species of hard and opaque quartz, out of which decorative vases, columns, and many other ornaments are carved.

Jaune. [Yellow.]

Javelin. A short spear, used as a missile. It has been employed by all nations, both savage and civilised, and in all ages, and wherever it is found it is of the same general form. In the Middle Ages it was a weapon of war, but gradually disappeared after the introduction of firearms. Its use now is chiefly ceremonial.

Jazerine. A material used for armour in the Middle Ages. It consisted of plates of steel fastened on canvas and overlapping. Its great advantage was its lightness.

Jerome, St. St. Jerome was one of the Fathers of the Church, who died in 420 A.D. In order to quell his fervid spirit he spent some time in absolute seclusion in the wilderness. By some he is regarded as one of the founders of monasticism, and he is represented in art more frequently than almost any other saint. He generally appears as an aged man, with a cardinal's hat (though this of course is an anachronism), and a lion by his side. The lion no doubt originally symbolised the strong fiery spirit of St. Jerome, and having been accepted as a symbol a story was required to explain it. This story, which resembles the old fable of Androcles and the lion, ran that one day St. Jerome was sitting in his cell when a lion approached with a thorn in his foot. This thorn St. Jerome removed, and henceforth the lion was his constant companion. One of the most celebrated representations of St. Jerome is a print by Durer.

Jesse, Tree of. A tree representing the genealogy of Christ as it is given in the Gospel of St. Matthew. The various personages who form links in the chain of descent are placed on branches stretching out from the tree. At the bottom Jesse is shown in a recumbent position, and at the top the Virgin and our Saviour in an aureole. Representations of the tree of Jesse are frequently found, sculptured, painted, or embroidered, in the ecclesiastical ornaments of the Middle Ages. This is not to be wondered at as the subject is peculiarly adapted to decorative treatment. Candlesticks also sometimes assumed the form of a tree with branches, and hence were called Jesses. A very

fine specimen of a Jesse window is

to be seen at Dorchester in Oxfordshire (1320).

Jesses. (Her.) These are the little straps, generally of leather, by which the bells worn by falcons and hawks were attached to the birds' legs.

Jet. A species of lignite of a brilliant black, of which all kinds of personal ornaments are made. Artificial jet is manufactured in large quantities out of black glass.

Jettie, or Jutty. (Arch.) A portion of a building which projects beyond the

rest. The best example of a jettie is to be found in half-timbered houses (q.v.).

in which each storey projects beyond the one below. The effect of this in some Gothic houses is that where the streets are narrow and the houses high the gable-ends almost touch across the street.

Jewel. A term applied to gems set in one or other of the precious metals, and by a figure of speech to objects of art admirable in execution and of considerable worth.

Jeweller. An artisan, sometimes an artist, who sets precious stones in gold or silver.

Jewellery. The art of mounting precious stones in gold or silver. The precious stones thus mounted and their setting. Personal adornment being one of the primary instincts of mankind, it is not surprising that in all ages and amongst all nations the making of jewellery has been one of the earliest manifestations of art. The jewellery of the Assyrians and Egyptians was of great beauty, while the jewels found at Hissarlik by Schliemann and at Cyprus by Cesnola were many of them masterpieces of art. Throughout history we find fine specimens of the jeweller's art produced, following the style of each epoch. The jewels of the Middle Ages were simple but massive, but at the Renaissance they became singularly beautiful and elaborate. The handicraft was introduced into England in all probability after the Revocation of the Edict of Nantes, when some foreign goldsmiths settled in Clerkenwell. It was first practised at Birmingham, its present centre, about the middle of last century. Manifold processes enter into the production of jewellery—gem-cutting and engraving, enamelling, repoussé work, chasing and casting. Of these something is said under their separate headings.

Joggle. (Constr.) In masonry any

joint is called a joggle, in which both the stones which are to be fitted together are indented. A joggle in masonry resembles what in carpentry would be termed a rebate (q.v.).

John, St. In the earliest examples of Christian art St. John with the other evangelists was symbolised by a scroll, or by a river flowing from a rock. [Evangelists.] Somewhat later he was represented by an eagle. Later on he generally appears as a handsome beardless youth, with brown or golden hair. An eagle stands by his side, and in his hand he holds a chalice, from which a serpent crawls, in allusion to his having driven poison from a cup. Thus he is represented by Raphael. As the exile of Patmos and the writer of the Revelations he is represented as an old and bearded man writing upon a tablet. He generally wears a blue or green tunic and a red robe.

Joint. (Arch.) A small space left between the stones or bricks of a wall or other construction, which is filled with mortar or cement, so as to bind the

masonry solidly together. The thickness of joints is determined, when the bricks or stones are laid, by small blocks of wood, which allow the mortar or cement

to be put in. The term angle-joint is applied to a joint formed by placing side by side two pieces of stone or wood, which are cut at a certain angle and not square. There are many other kinds of joints both in stonework and timber-work. Some of these are to be found under their separate headings, such as dovetail, mortise, &c.

Joist. (Arch.) A piece of timber placed horizontally to support a plank. In the Middle Ages and during the period of the Renaissance the joists of

ceilings remained in view and were sometimes carved. In some Gothic buildings we find joists with the end

engaged in the wall roughly fashioned into the head of some monster, while the horizontal part is cut level, so that

nothing may lessen the solidity of the joist, by seeming to take off from its thickness.

Joist, Binding. Binding joists are so contrived that an empty space is left between them, through which a chimney may pass. Their diameter is generally greater than that of an ordinary joist.

Jube. (Arch.) A term applied to the rood-loft (q.v.) or gallery of a church. It is derived from the fact that the words *jube domine benedicere* were pronounced from the jube by the officiating priest before the reading of the lessons in the Catholic service.

Judas Iscariot. Throughout the

Middle Ages the apostle who betrayed Christ was regarded with execration, as the type of infamy and brutality, and countless legends were invented to illustrate the infamy of his nature. He is never represented alone in art, but when he occurs in such scenes as the last supper or the betrayal he is a person with a scowling expression of face. He never wears the aureole like the other apostles, and he is habited in a robe of yellow, which colour has in consequence been regarded in some Catholic countries with disgust.

Jug. (Pot.) An earthenware vessel of simple form, with one handle and a beak from which liquids are poured. It is a noticeable fact that the jug has retained a uniform shape in all countries

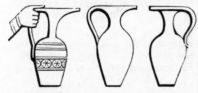

and all ages, this shape no doubt being suggested by considerations of practical convenience. The first three illustrations we give represent Egyptian jugs, which as far as their form is concerned

might be modern English. Of the other two cuts the one is a metal jug of oriental workmanship, the second an earthenware jug of strong outline, such as is in common use. .

Julian St. St. Julian is a legendary saint, who is said to have lived in the 3rd century A.D. One day when he was out hunting, a stag which he was following prophesied that he would kill his father and mother. This destiny, in spite of his endeavour to avoid it, he ultimately fufilled, and to do penance he retired to the bank of a river and ferried travellers across it. He is therefore represented with a stag or as ferrying wayfarers across a river. He is the patron saint of travellers.

Juno. [Hera.]

Jupiter. [Zeus.]

Jupon. A kind of surcoat worn by knights in the Middle Ages, and reaching down over the hips. Sometimes it was embroidered with the coat of arms of the wearer, sometimes it was plain, but as a rule it had an ornamental border round its lower edge. The jupon of Edward the Black Prince is still to be seen hanging over his tomb at Canterbury. Our cut, which is from a sepulchral brass in Walton Church,

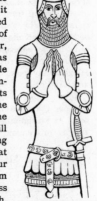

Hertfordshire, represents a knight wearing the jupon.

Jury. An artistic jury is a committee of artists appointed to select from the pictures sent in to an exhibition those they think worthy to be hung. The jury appointed every year in the Paris Salon is elected by the exhibitors themselves. But the elective principle has not hitherto found favour in England. One small society has adopted it, it is true, but in the more important English galleries the pictures are selected and hung not by a jury elected by the exhibitors, but by a hanging committee of older artists, who hold office in rotation.

K.

Kakémono. A Japanese term denoting a "hanging picture," provided at its lower end with a roller on which it may be rolled up. The picture itself is surrounded with an ornamental border designed in accordance with certain decorative principles. The Japanese ornament their houses with *Kakemonos*, but never leave one permanently on the wall, varying them with the season, for they consider some appropriate to summer, others to winter.

Kaleidoscope. An apparatus invented in 1817 by Sir David Brewster, which consists of mirrors arranged in a tube. In this tube movable fragments of coloured glass, irregular in shape, are placed, and from their chance combinations, as reflected in the mirrors, symmetrical figures are obtained, which are often used as patterns in industrial art, especially in the manufacture of coloured stuffs.

Kaoline. (Pot.) A silicate of aluminium, produced from the decomposition of felspar in the form of a white earthy matter. From it a fine faïence is manufactured, which bears the name of porcelain. This plastic clay has been known for countless centuries in China and Japan, but its discovery in Europe is due to the English potters of the middle of the 18th century.

Keep. (Arch.) The principal tower in a mediæval castle, also termed Donjon (q.v.).

Keepsake. A name which was given to a certain class of album or illustrated volume which was published in England in the early decades of the present century. Thence it has been applied to sentimental figures or female heads possessing a charm and beauty tinged with melancholy, such as were frequently met with in the volumes known as "keepsakes."

Kept down. (Paint.) A portion of a picture is said to be *kept down*, when it is painted in a lower tone than the rest, so as not to divert the spectator's attention from the important part of the composition.

Key. In the Middle Ages keys were designed with much care and taste, and were frequently masterpieces of decorative art. Many of them indeed are such fine examples of metalwork as to be worth preserving in museums. Key-holes too of copper or beaten iron were often

noticeable from an artistic point of view, being richly ornamented. In ancient art the key was the symbol of Janus, and in Christian art St. Peter is always represented with two keys, which are also borne by religious houses under the patronage of St. Peter, and are the insignia of the papacy.

Keystone. (Arch.) The central stone of an arch. It is inserted last and serves to hold together or consolidate the arch. It is sometimes ornamented in buildings of the Renaissance school, and in vaulted ceilings is frequently termed a *boss*.

Khásí. A term applied to a method of mural decoration in vogue in India and Persia. It consists in covering the walls with glazed and painted tiles or with blocks of mortar, which are formed of several pieces of mortar of different

221

colours, cut into shapes and pieced together, so as to form decorative designs.

Khmer. A name given to the architectural monuments of ancient Cambodia, which in their profusion of decoration and their striking originality have an obvious connection with Hindoo art.

Kiln. (Pot.) A cylindrical oven, placed vertically, in which faience and porcelain are baked. Pieces of great value are baked separately in cases of terra-cotta, called seggars, so as to be isolated from one another. In baking china three processes are necessary: the first that of firing, which changes the clay into *biscuit;* the second that of glazing; the third that of fixing the colours. Great care must be exercised that the pieces of china are not exposed to too great heat. The degree of heat which any piece can stand depends on the colours employed in its decoration, some colours volatilising at a lower temperature than others.

King-post. (Arch.) A vertical piece of timber placed in the middle of a truss (q.v.), resting at its lower end on the cross-beam, so as to support the ridge, where the principal rafters meet. King-posts may be seen in gable-ends as well as in open-timber roofs.

Kiosque. (Arch.) An ornamental pavilion placed in a picturesque situation. A small circular or polygonal construction surmounted by a small dome, such as the pavilions frequently met with in Turkey.

Kit-cat. A term denoting a canvas of a particular size, used for painting portraits not quite three-quarter length. A series of portraits of the members of the Kit-cat Club were painted by Kneller of this size to fit the walls of Tonson's villa at Barn Elms, and canvases and portraits of these dimensions have been called Kit-cat ever since. The Kit-cat Club was an association of politicians and litterateurs who favoured the Protestant succession, and was established in 1703. Its meetings took place at the "Cat and the Fiddle," in Fleet Street, kept by Christopher Kit, from whom it took its name.

Knee-rafter. (Constr.) A rafter the lower end of which is bent or curved, so that it may fit in more securely with the wall below it.

Knocker. (Arch.) A piece of metal fixed on to the door. Ancient knockers vary considerably, according to the period to which they belong. In the Gothic period they frequently represent a fantastic animal. After the Renaissance they were very elaborate both in design and execution. In the 17th and 18th centuries a purely decorative form

of knocker became universal, whereas in the previous century knockers had represented capricious, and fantastic, scenes, in which the figures of both men and animals were treated with extraordinary skill. Several celebrated artists have at various epochs produced knockers, which are to-day considered as works of art and treasured in museums.

Knot, or **Knob.** (Arch.) A term applied to any architectural ornament which is round in shape, whether it

consist of foliage, flowers or even a

sculptured head. [Cul-de-Lampe.]

Knotted. (Her.) This epithet is applied in heraldry to rough branches or trunks of trees shown on shields, For example, the cut would be blazoned *gules, a knotted staff in bend argent.*

Kylin. An animal somewhat resembling a dragon and covered with scales, frequently depicted on or forming the subject of pieces of Chinese porcelain. It is of good omen.

L.

Labarum. A Roman standard bearing upon it the sacred seal of Christ. [Chrism.] Before the time of Constantine the *labarum* was decorated

with an eagle, but after the conversion of that emperor the chrism was adopted. The labarum, which was the banner carried in war before the Roman emperors, was purple in colour, bordered with gold and ornamented with a fringe and precious stones.

Label. (Her.) This is a mark of difference or cadency borne by an eldest son to distinguish his arms from those of his father. It consists of a bar with three pendants or points, and is placed across the shield in chief. On the death of the father the son of course removes the label from his arms. The arms borne by the present Prince of Wales as heir to the throne are : *the Arms of England differenced with a Label of three points argent ; over all, on a shield of pretence, Saxony.*

Labyrinth. (Arch.) An Egyptian palace, consisting of a number of buildings and courtyards surrounded by walls, so arranged as to be impenetrable and to mislead the uninitiated who ventured within. Subterranean labyrinths were used by the early Christians as places of worship on account of their safety. A garden labyrinth consists of winding walks, bordered on each side with a close hedge, all of which communicate with the centre, but go off in different directions, so that it is not easy to keep the correct path.

A system of decoration called labyrinth, consisting of variously coloured marbles forming inter-crossed lines at right angles to one another, is sometimes used in the pavements of French cathedrals. The *labyrinth* on the pavement at Chartres is particularly famous.

Lac. A very solid varnish, frequently employed in China and Japan for the decoration of furniture and other objects. It is a resin obtained from certain trees, the *Angia simensis* and *Thus vernix*, and is applied in a liquid state and in several layers to the trays, boxes, or furniture which are to be lacquered. [Lacquer.]

Lace. An open-work textile fabric, consisting of very fine meshes, which are arranged in systems of ornament. The ancient lace of Malines and Alençon as well as Venetian and English pointlace is much sought after, and may be classed among artistic objects of the greatest value and rarity.

Lacerna. A loose garment worn by

the Romans over the toga. It was open in front and fastened under the neck by a brooch. It fell behind in ample folds and had a hood, which could be used to

conceal the face. It was probably borrowed from the Gauls, and only came into use in the later days of the Republic. In the period of the Empire it was a common garment both for civil and military personages.

Lachrymatory. A name given to certain vases, elongated in form and of small dimensions, used by the Romans to hold the sweet-smelling oils with which they perfumed the funeral pyre. Their name was given to them because it was erroneously thought that they were intended to hold tears.

Lacinia. A term applied to the

excrescences in the neck or throat of

a she-goat. In the works of Roman sculptors fauns are frequently represented with *lacinia* and the pointed ears of a goat, as in the cut engraved here.

Laconicum. A semicircular chamber in the baths of the Greeks and Romans, which was heated by flues, and resembled a modern Turkish bath.

Lacquer. A coloured and opaque varnish applied to the smooth surface of boxes, articles of furniture, &c. It is so called because its base is a resinous substance called lac. Lacquer work of the highest excellence has been produced in China and Japan, some pieces of relief-lacquer taking many years to finish. The process of lacquering is as follows. The wood to be lacquered is planed smooth and then covered with a mixture of powdered red sandstone and ox-gall. This coating is dried and polished and then covered with a layer of lacquer. The lacquer is dried slowly in a damp-room and then polished with slate. A second coating of lacquer is then laid on and the drying process repeated, and so on with the third and fourth coating. A piece of lacquer work always has more than three coatings, and some are known to have received eighteen. When a perfectly hard and polished surface is obtained, the lacquer is painted and finally mounted.

—, **Aventurine.** Aventurine lacquer-work is of a reddish brown colour and is spangled all over with particles of gold, which glitter the more the nearer they are to the surface. It is used for large cabinets &c.

—, **Black.** This is the lacquer most commonly in use, and is seen in pieces of furniture as well as in small boxes of exquisite workmanship. Its value of course depends on the number of its coatings and the polish imparted to its surface.

— **on Gold Ground.** The most costly lacquer work is on a gold ground. Pieces of this class are always small and generally in high relief. The effect is some-

times added to by projecting bosses of gold and silver.

Lacquer, Red. Red lacquer is peculiar to Japan and is now very rarely met with. It was never applied to any but small ·objects, such as cups.

Lacunar. (Arch.) A term denoting a ceiling and also the sunk panels or compartments of a ceiling.

Lacustrine Dwellings. [Lake Dwellings.]

Lady Chapel. (Arch.) A chapel dedicated to the Virgin Mary, called by Roman Catholics "Our Lady." Lady chapels were generally placed at the extreme east end of churches, and were in fact a prolongation of the chancel or choir. They were sometimes termed "retrochoirs." It was in the 12th century that the majority of lady chapels were built, at that period the Virgin being held in especial honour. We have said that the lady chapel was generally placed at the east end of church or cathedral. But this was not the invariable custom. For instance, the lady chapel at Ely is a separate chapel placed at the north-east corner of the north transept, while at Durham the "Galilee" (q.v.), or western porch, is the lady chapel.

Lagena. (Pot.) An ancient vase in which wine was kept. Vases bearing this name are generally of a slightly elongated spherical form. Sometimes they have a swelling belly and a short neck, and stand upon a foot.

Laggings. A term applied to narrow battens joining centres (q.v.) horizontally, the centres being constructed underneath long arches such as tunnels. [Centre.]

Lake. (Paint.) A term applied to certain pigments which consist of vegetable or animal matters with a base of alumina or oxide of iron, such as carmine lake, yellow lake, &c.

—, **Carmine.** A lake obtained from the cochineal insect. It is generally permanent, as it contains less base and more colouring matter than most lakes. It is, however, affected by white lead and strong light. In water-colour it yields tones of less value than pure carmine. In oil painting it possesses great power, and is easi y laid on.

Lake, Mineral. A violet colour which enters into the composition of a pink used in colouring porcelain.

—, **Venetian.** A red pigment obtained from a mixture of alumina and a solution of gelatine and alum, in a decoction of a Brazilian wood.

—, **Yellow.** A pigment obtained from the decoction of berries with a base of alumina. It is not a very useful colour, as it does not dry easily, and under certain circumstances c. anges to orange or red.

Lake Dwellings. Dwellings constructed not on dry land but on piles driven into the bottom of lakes or creeks seem to have been universal among savage races. The custom of living at some distance from the shore, no doubt adopted in the first instance for purposes of safety, still prevails in the creeks of the Amazon and Orinoco, in New Guinea, and in Central Africa. Herodotus describes the Paeonians as dwellers in cities built on lakes. The Celtic races in mediæval times had their lake cities, and even as late as the 16th century Irish chieftains are known to have taken refuge in fortresses built on lochs. Dr. Keller has established the fact that in prehistoric times lake dwellings existed in all the shallow lakes of Switzerland. Those who inhabited these curious huts knew the use of bronze or iron, but had not altogether discarded implements of stone; they practised spinning and weaving, made canoes and fished. They were acquainted with agriculture, and lived in the security which comes of social organisation.

Lamb. In very early times Christ was represented in art as a *lamb*, in allusion to many texts in the Old and New Testa-

ments. This representation was of course symbolic, and it varied consider-

ably. It no doubt arose in the first instance from a pious hesitation on the part of the Latin artists in attempting a

realistic representation of Jesus Christ, Sometimes the lamb appears on an eminence from which four rivers flow.

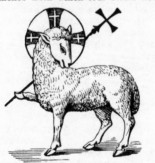

[Evangelists.] A passage in the Apocalypse, which speaks of the lamb with seven horns and seven eyes, has sug- gested the curious symbol of Christ given in our first cut. In a Latin relief of the 4th century engraved here, we see the lamb raising Lazarus from the dead. The *Agnus Dei*, or Lamb of God, is represented with a nimbus on his head and holding a staff surmounted by a Greek cross.

Lambeth Ware. (Pot.) Lambeth was one of the earliest sites of the manufactories of stoneware and Delft in England. As early as 1640 some Dutch potters settled in the village of Lambeth and became famous for their glazed pottery and tiles. The manufactory flourished until the end of the 18th century, when the rise of the Staffordshire potteries killed the Lambeth industry. However, it soon revived, and is still in existence.

Lamboys. A skirt, consisting of hoops of steel, worn by warriors in the reigns of Henry VII. and Henry VIII. It belonged rather to German armour than English and was never in great vogue

in this country. A fine example of the lamboys is to be seen in the suit of armour given to Henry VIII. by the Emperor Maximilian, and now in the Tower of London.

Lambrequin. A French term which

is primarily applied to the point of a

label or the mantling of a helmet. In architecture, however, and decorative art it bears several other meanings. For instance, it denotes the broad

borders of stuff trimmed with fringes and tassels, which are employed either to hide the joining of draperies or as a mere ornament. In the 17th and 18th centuries lambrequins, cut in the solid stone, are frequently found on the bases

of pilasters. The name is also given to points of lead-work placed on each side of the ridge of a roof. For the heraldic sense of the word, see Mantling.

Lamp. In ancient times the lamp generally assumed the form of a flat vessel of terra-cotta or metal, with a small handle. It was filled with oil, and had several small apertures, in which wicks were placed. Such were the ancient lamps

of simplest form. Some, however, were marvellously beautiful works of art, and were richly ornamented with chasings or figures in relief. The modern lamp is sometimes of bronze, sometimes of marble or stone. An attempt is always made to give it an elegant shape, and it may be decorated with chains and other ornaments. It stands upon a foot and supports a vessel, which contains the

oil, or it is suspended by chains from the ceiling. In Christian art the lamp is the sign of watchfulness and piety,

and particularly symbolises the wise virgins of the parable.

Lampblack. A black pigment obtained from burning turpentine, resins, or resinous woods. It is a solid but somewhat heavy colour, and on this account should only be used in small quantities. It is permanent, but dries slowly.

Lance. (1.) A weapon borne in all ages and by soldiers of all nations. Among the Greeks and Romans the lance was sometimes placed in a rest and sometimes thrown as a javelin. In the latter case it was provided with a strap to give it a rotatory motion. In the Middle Ages the lance was pre-eminently the weapon of the knights of chivalry, and it was used both in jousts and in war. It consisted of a shaft about fourteen feet long, tipped with a spear-head and a handle protected by a small round plate.

Lance. (2.) (Her.) A charge representing the lance used in jousts and tournaments. On coats of arms it is sometimes shown with a pennon, sometimes without. Several lances

are generally blazoned, and they may be in pile, en saltire, accosted, &c. In the hand of Pallas the lance signifies strength and foresight. In Christian art it is the symbol of St. Matthew and of St. Thomas, as well as of many lesser and later saints.

Lance. (3.) (Arch.) As a system of ornament the *lance* is widely used. It most frequently forms the head of the iron bars, which make up a railing. The finest specimens of *lances* are to be found in the iron work of the 17th and 18th centuries.

Lanceolate. Any ornament, architectural or otherwise, which is shaped like a lance, is termed lanceolate.

Lance-rest. A contrivance of iron fixed on the breastplate to support the lance. In early times it was nothing

more than a hook, but by the 16th century it had been elaborated into the queue-shaped rest seen in our cut.

Lancet. (Arch.) A long narrow pointed arch used in the architecture of the 13th and 14th centuries. It is particularly characteristic of what is called the Early English style (q.v.). The lancet arch consists of two arcs of circles the centres of which are at a great distance

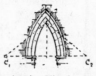

from one another. The Early English style is sometimes termed the Lancet style.

Landscape. (Paint.) A picture representing a view of natural scenery, in which the interpretation of nature is the predominant feature, and in which figures of men or animals are only introduced as accessories, to give a tone of reality to the scene or to furnish a scale of dimensions.

—, **Historic.** A landscape, the subject of which is not copied exactly from nature, but is composed in accordance with the taste of the artist. Into historic landscapes, ruined temples, statues, and vases are frequently introduced as well as figures, which give the scene an air of fable or ancient history. To this class belong the majority of Claude's landscape as well as several of Turner's.

— **Painter.** An artist who devotes himself to the interpretation of nature. Among the great landscape painters of the world we may mention Ruysdael, Hobbema, Rembrandt, Poussin, and Claude, and belonging to a later date, Constable and Turner of the English school, and Corot, Rousseau, Daubigny, and Courbet of the French school.

Langue-de-bœuf. A weapon the broad blade of which was supposed to resemble an ox's tongue. It was fixed in a long staff and was carried by bodyguards. It was rather a sign of dignity than an implement of war.

Langued. (Her.) This term is used to blazon the tongue of an animal when this member is shown projecting and is of a different tincture to the rest of the animal's head.

Lantern. (Arch.) A lantern is a small cage, consisting of a metal frame filled

in with panes of glass, which protect from currents of air the flame burning

within them. Many of the lanterns of forged iron belonging to the 17th and 18th centuries are masterpieces of decorative art. As an architectural ornament a lantern is a kind of finial, in the form of a glass dome, a pierced campanile, or a belvedere rising above the top of a building. The term is also applied to the interior of Gothic towers, at the intersection of the nave and transepts, when the tower is not concealed by a vault. The upper portion of Gothic spires which are pierced by windows on all sides are called *lanterns.* The spire of Rouen Cathedral, for instance, is surmounted by a lantern. There is yet another sense in which the term lantern is used. It denotes the small towers which surmount a staircase or serve as an end ornament to a massive buttress. Such lanterns are generally met with in buildings of the Renaissance style.

Lanterne des Morts. A small building generally in the form of a hollow column, terminated by a pierced turret. *Lanternes des Morts* were generally shrines in honour of the dead, or served

as landmarks to point the way to religious houses. In the 14th century they ceased to assume the form of solitary columns, and were replaced by chapels, in which a lamp was always burning.

Laocoon. In Greek mythology Laocoon was a Trojan priest of Apollo, who when the famous wooden horse was received within the walls of Troy, warned his countrymen not to accept the gift of the Greeks. It being the will of the gods that Troy should be taken, serpents were sent to devour Laocoon and his two sons while they were sacrificing. The judgment of heaven on the presumption of Laocoon was the subject of a celebrated group, sculptured by Athenodorus, Agesandrus, and Polydorus, three artists of the Rhodian school. It was discovered in 1506 in Rome, and was perhaps first estimated at its proper value by Winckelmann. It is now at the Vatican. In the realistic expression of physical anguish it reaches the utmost limit attainable by sculpture. Lessing made the Laocoon group the text for his famous essay on the limits of sculpture and painting.

Laordose. This curious term, which is in all probability a corruption of La Reredos, is applied in the Durham manuscript to the altar-screen. [Reredos.]

Lapidary. An artisan who cuts and engraves precious stones, or who places them in a setting of gold or silver. In another sense an inscription engraved upon a stone may be termed a lapidary inscription; hence the concise and solemn style of memorial inscriptions engraved on public monuments has been termed the lapidary style.

Lapis-lazuli. An opaque blue stone, veined with white, used in the decorative arts, especially in the adornment of some kinds of expensive furniture.

Lapithae. The Lapithae were a mythical race of Thessaly, the most celebrated among them being Ixion and Peirithous. Ixion, for presuming to harbour a passion for the goddess Hera, was punished by being bound to an ever-revolving wheel. The most famous incident in the life of Peirithous was his marriage with Deidamia. His kinsmen, the Centaurs, were invited to the marriage feast, and after the banquet attempted to carry off the bride. Then followed the battle between the Lapithae and Centaurs, which was one of the favourite subjects of Greek sculpture. We find it represented on the metopes of the Parthenon, the frieze of the Theseum at Athens, and on the western pediment of the temple of Zeus at Olympia. It also forms the subject of countless Greek vases.

Lararium. A shrine or chapel in which the Romans placed images of the Lares and Penates, or household gods.

Lares. In the religion of Rome Lares were guardian angels supposed to be the spirits of deceased persons, one of which protected every Roman house. An image of a Lar, in the form of a youth crowned with laurel, and holding a horn of plenty and sometimes a patera, was reverently kept in the lararium (q.v.), where sacrifices were offered in its honour.

Large. (Paint.) A term used of the free, ample treatment of a subject in painting, in opposition to paltry, timid, thin. Thus we say of an artist that he has a *large* touch; of draperies, that they are *largely* treated.

Larmier. [Corona.]

Larvae. As the Lares (q.v.) were supposed to be the souls of the good departed, so the *Larvae* in the religious system of the Romans were regarded as the spirits of those whose crimes on earth had entitled them to no rest after death. They were invested with no material form and so are not represented in art.

Last Judgment, The. The subject of Christ come to judge the world was frequently treated by Italian painters. For some reason or other it was never attempted in early Christian art. Among the most celebrated representations of the Last Judgment we may mention those of Luca Signorelli at Orvieto and Michael Angelo's great design in the Sistine Chapel.

Last Supper, The. The Last Supper, or Christ supping with his apostles the evening before the passion, is a favourite subject with artists of all schools, and is constantly represented in frescoes, pictures, and bas-reliefs. The *Last Supper* by Leonardo da Vinci is perhaps the most celebrated work with this incident for its subject. In the majority of pictures representing the Last Supper Christ wears a nimbus, as do all the apostles except Judas, who is never represented nimbed.

Latch. (1.) (Arch.) A small shank of metal on a door, which by its own weight falls into a socket placed on the door-post to receive it, and forms an efficient means of keeping a door closed.

Latch. (2.) A name given to the cross-bow (q.v.) in the 16th century.

Lateral. (Arch.) A term applied to anything situated on the *side* of a building; thus we speak of lateral openings— meaning openings on the side of a principal opening—lateral chapels &c.

Lath. (Arch.) Long thin slips of oak or fir used in roofs, wainscoting, &c.

Latten. A metal resembling brass, which was much used in the Middle Ages for making monumental brasses, crosses, candlesticks, &c. Its exact composition is uncertain and the ancient authorities are contradictory. Modern latten resembles the orichalcum of the ancients, being a mixture of copper and calamine.

Lattice. (Arch.) An open space, crossed by thin slips of wood or bars of metal, meeting each other diagonally.

Laurel. (Arch.) Foliage of a certain kind arranged in garlands and frequently used as a decorative motive. In heraldry the laurel is represented as a shrub with long pointed leaves and a smooth trunk without knots. The laurel is the symbol of success, victory, and triumph. In classical art the laurel was sacred to Apollo, and the victors in the Pythian games were crowned with laurel. It is figured as an emblem of peace on Christian sarcophagi. In decorative panels bunches of laurel are often represented, the leaves of which are dark green and the flowers of a beautiful rose tint.

Laurence. St. St. Laurence was deacon to Sixtus II., Bishop of Rome, and was by him appointed keeper of the treasures of the Church. Sixtus having been persecuted and put to death by the prefect of Rome, Laurence was arrested and suffered martyrdom by being roasted alive on a kind of gridiron. Representations of St. Laurence are frequently met with in art. He is represented as a youth in the dress of a deacon, carrying the palm of martyrdom. The attribute by which he is most easily recognisable is the gridiron, but sometimes instead of this he bears a censer or the treasures of the Church in a bowl.

Lavabo, or **Lavatory.** (Arch.) A special room in mediæval buildings in which piscinae and small reservoirs were arranged under richly ornamented arcades. In religious houses the monks washed their hands in the lavatories before and after dinner, and they were

therefore situated near the refectory. The lavabo in some abbeys consists of a basin placed round a central column which supports the springing of the vault.

Lavatorium. (Arch.) A kind of lavabo consisting of a large basin, in which the bodies of the religious dead were washed before burial.

Lay-figure. An artificial figure, the frame of which is of wood or metal. Its joints are articulated by means of spherical pieces set side by side, so that its limbs are movable. There are lay

figures of animals, principally horses, as well as of men. In size they vary from life-size to a few inches in height. They may best be described as articulated dolls, constructed in accordance with

the laws of anatomy and bearing the structure of the human skeleton. The articulated joints allow them to assume every attitude. The lay-figure is chiefly used for hanging draperies upon, for thus the artist is enabled to study the folds at greater leisure than he could from the living model. At the same time it is dangerous to copy too slavishly the attitudes of the lay-figure, for its outlines must always be harder and cruder than those of the living model.

Lay the Ground, To (Engrav.) To cover a copper plate with a grain or file-like ground by the use of the cradle or rocker (q.v.). This instrument is held firmly in the hand and then rocked to and fro, by which process an indented furrow is made across the plate. This is repeated until the plate is covered with parallel paths or ways and a grain of the proper texture is obtained.

Lazurline, or **Lazurstein.** A brilliant blue pigment obtained from *lapis lazuli,* generally known as ultramarine (q.v.).

Lead. A heavy malleable metal which has been employed for a variety of architectural and artistic purposes. It has been especially used in roofing buildings and in making épis (q.v.) and girouettes (q.v.). Statues intended to serve as garden decorations have been successfully cast in it. Some pigments, such as white lead and chrome yellow, have lead as a base. They are, however, of little service to the painter, for not only do they easily tarnish themselves, but they adversely affect other pigments with which they come in contact.

Leading. (Arch.) Thin strips of lead

inclosing small panes of glass. The

most simple leading assumes the lozenge pattern. Sometimes leadings present patterns consisting of complicated polygonal combinations.

Lead-pencils. Ordinary lead pencils, used for drawing or jotting down hasty sketches, consist of a small rod of plumbago enclosed within a piece of cedarwood. They are cut sharp with a knife, and the lead may have a fine point put to it by rubbing it on emery paper. Lead pencils of a very fine grain are made from the graphite of Siberia.

Lead-plate. A thin plate of lead is often placed in the joints of a wall or at the base of statues set on pedestals, in order to fill up the inequalities of the stone and so to render the adherence and therefore the stability more complete.

Leaf. (1.) (Arch.) The leaves of a table are the separate pieces of timber of which its surface is composed. A table may be increased or decreased in length by the addition or removal of a leaf. The rectangular piece of timber which forms a door is termed a leaf. The leaves of a folding door are the two portions which meet together when the door is closed.

Leaf. (2.) A system of ornament representing a leaf, treated sometimes realistically, sometimes in a conventional spirit. It may be applied to a moulding and repeated along its whole length, or may decorate the bell of a capital. Decorative leaves sometimes project considerably from the ground upon which they are worked, sometimes they are only sketched in outline. [Foliage.]

—, **Acanthus.** The leaf of the acanthus is constantly used in decorative sculpture. It is generally represented turned back, so as to form a kind of

volute, and it is especially characteristic of the Corinthian and Composite orders of architecture. [Acanthus.]

Leaf, Angle. A leaf placed at the angle formed by two mouldings, such as the angle of a ceiling cornice. The centre nerve of the leaf generally coincides with the angle of the moulding, and the two portions of the leaf are arranged symmetrically one on each face of the moulding.

—, **Cabbage.** This leaf was employed as an architectural ornament in the 15th and 16th centuries. The crockets which decorate gable-ends are often formed of cabbage leaves, in the execution of which with the chisel the artists of the Middle Ages displayed extraordinary skill.

—, **Fig.** The leaf usually employed to cover the nudity of statues. Where this has to be done it is far better that the sculptor should do it himself with flying draperies or other accessories, if indeed he can do it without making his purpose painfully evident. The use of the fig-leaf is in all cases a clumsy expedient, dictated by a spirit of ignorant prudery.

—, **Laurel.** An ornament consisting of the leaves of the laurel, generally arranged three together.

— of a Fan. A piece of paper, parchment, or satin, cut in the form of two portions of concentric circles and bounded by two radii. Upon the leaves of fans water-colour drawings or *gouaches* are often executed.

 — of an Entablature. A term applied to rows of leaves which decorate an entablature or separate two mouldings. In

Gothic architecture their tips curve over so as to form crockets, as in our cut.

Leaf, Olive. An ornament consisting of the leaves of the olive-tree, usually arranged in bunches of five leaves.

—, **Parsley.** Small thin leaves, which, like the acanthus leaf, enter into the decoration of the Corinthian capital.

—, **Thistle.** An ornament sometimes found on capitals of the 15th century.

—, **Water.** A leaf of undulating form and unbroken border, which is employed to decorate mouldings or surfaces of a considerable size. It is also frequently employed in iron-work, especially to en-

rich the front of balconies, in which case, however, leaves of a more strongly marked outline are used to relieve the dryness of the usual spirals and scrolls.

Leaning-place. (Arch.) The portion of a wall included be- tween the ground and the window-sill, together with the sill which surmounts it. In buildings of the Gothic style leaning-places are called *allèges* (q.v.).

Lean-to. (Arch.) A shed or roof with

a single slope fixed to the wall of a building by its upper edge. The term

is also applied to buildings which have a roof arranged on this plan.

Leather. The skins of animals tanned and hardened have been used extensively for decorative purposes. In the Middle Ages a specially prepared leather under the name of cuir - bouilly (q.v.) was used in making portions of armour, caskets, &c. This was stamped when in a soft state and richly ornamented. In the 16th century leather was used as hangings for rooms. These hangings were stamped with ornament and their beauty enhanced by gold and silver leaf. Leather cut and twisted into volutes was used from the 16th century onwards as a frame for cartouches, &c. Stamping is not the only process by which leather is ornamented. Figures in relief were sometimes chased upon it, and pieces of leather thus decorated are often very beautiful and costly.

—, **Cordova.** Strips of leather ornamented with figures cut in low relief and either painted or gilt. In modern times many imitations of Cordova leather are produced by stamping, and used, as were the genuine materials, as hangings or chair-covers.

Lebes. A large vessel of swelling form

generally made of bronze. It was used either to catch the water which was poured from a jug over the feet and hands after meals, or as a caldron, in

which to boil meat. The cuts we give here represent specimens of the *lebes* used for the latter purpose.

Lectern. A portion of church furniture placed in the choir and forming a single or double reading-desk. It gene-

rally revolves on a pivot and very frequently assumes the form of an eagle with outspread wings. The gospel was

originally chaunted from the lectern and the books of the clergy were placed upon it. Now only the lessons are read from the lectern and nothing but the Bible rests upon it. There are many beautiful lecterns in existence of sculptured wood, while others are made of stone, marble, beaten iron, or copper.

Lecythus. (Pot.) A Greek vase in the form of a cylin-

drical cruet, with a narrow neck and a lip which widens out considerably. From this lip a handle reaches to the body of the vase. The lecythus was intended to contain oils or perfumes. Athenian lecythi were often of exquisite beauty of workmanship, and were adorned with painted figures of great beauty.

Leeds. (Pot.) The first potteries were established at Leeds in the 18th century. Dresden china was accepted as a model, and perforated or reticulated pieces were made in considerable numbers. Leeds china was of a dullish white, and was distinguished by its glaze, one of the ingredients in which was arsenic. Artistic pottery has long ceased to be made at Leeds.

Legend. The title or explanation of a picture or engraving; the inscription on a coin or medal. The term also denotes the inscriptions placed in certain parts of pictures or frescoes.

Lemniscus. A fillet worn by the Greeks. It consisted of ribbons of various colours, and was suspended to crowns at the back of the head or, as

was more usually the case, attached to

wreaths or fillets.

Lemon Yellow. (Paint.) A pigment composed of chromic acid and barium. It is said to be entirely permanent and unaffected by damp, foul air, light, or admixture with white lead and other dangerous pigments.

Leonard, St. St. Leonard, who died in 559, was a native of France, and until he retired to live the life of a hermit was in high favour at the French court. He devoted himself to ministering to prisoners and captives, and hence has always been regarded as the patron saint of prisoners. He is generally represented with chains hanging round his waist, and wears the tunic of the Benedictines. The principal events of his life are set forth in mosaic in St. Mark's, at Venice.

Leopard. (Her.) In heraldry the leopard is always repre-

sented walking, and with his head turned so as to be full face towards the spectator; in other words a leopard is always *passant guardant*. Hence it is supposed that in early heraldry the term leopard was merely used as an abbreviation for *lion passant guardant*, and that it did not imply a distinct animal; at any rate we find that the arms of England were formerly always blazoned *gules, three leopards or.*

Lesche. (Arch.) A building among the Greeks consisting of covered courts with porticoes. The walls were generally covered with paintings, often by the greatest artists, as was the case at

Delphi, where the *lesche* was decorated with pictures representing the sacking of Troy and the visit of Odysseus to the Shades by the great Polygnotus himself.

Letter, Before. [Proof before letter.]

Letter, Ornamental. A decorated or illuminated letter. Ornamental letters, most frequently used as initials to chapters, are often painted in mediæval manuscripts. In printed books ornamental letters are used, and are either drawn and engraved on wood or reproduced by some chemical process. These afford great scope to the talent of the artist. In their simplest form they are only initials of a large size surrounded by ornaments. The more elaborate among them, however, are vignettes, in which the letter is ingeniously woven out of the attributes or figures in the design.

Lettered. [Proof, lettered.]

Level. A right-angled triangle of wood or iron, two sides of which are accurately adjusted. A plummet is suspended from the apex of the triangle, and if the ine which is to be verified is perfectly horizontal, the thread ought to divide the cross-bar which forms the hypotenuse of the triangle into two equal parts. The level is used by workmen of every class —masons, carpenters, and cabinet-makers. It is the symbol of equality, and is thus figured in emblematic trophies.

—, **Spirit.** A level consisting of a tube filled with spirit and slightly curved. A bubble of air is left in it, which occupies the exact centre of the tube when the level is placed on a perfectly horizontal surface.

 —, **Water.** A tube of iron the extremities of which are bent so as to be at right angles to the main body of the tube. A small

glass bottle filled with coloured water is placed at each end. A line drawn from the eye of the observer over the surface of the water in the bottles, serves to determine a horizontal line.

Library. (Arch.) A term applied to a room in which books are arranged in shelves, or to a public building which serves the purpose of a storehouse for books and provides accommodation for readers.

Lichaven. A dolmen which has only two supporting stones. The name of trilith is also given to these dolmens because they are formed of three stones, two being placed vertically and buried in the ground, the third forming a table and being placed horizontally.

Lich-gate. (Arch.) This term, which is derived from the Anglo-Saxon lic, *a body*, denotes a shed or roof placed over a churchyard gate. The bearers of a coffin sometimes deposited it here on their way to the interment. It is also called *corpse-gate*.

Licked up. (Paint.) In studio slang, a picture is said to be *licked up* when it is precisely and minutely painted, and when the artist has set himself to conceal the marks of the brush as well as the effect of the colour freshly laid on. In fact, the surface of a picture thus licked up is actually polished with a flat brush. The term is only used in a bad sense; at the same time licked-up pictures constantly delude the public by their apparent finish.

Lierne. (Arch.) A *lierne* in a vaulted compartment is the rib running along the apex of the vault from boss to boss. Liernes are found in pointed vaults, and were used principally about the middle of the 15th century.

Life-size. A term applied to any work of imitative art which represents its subject in its actual dimensions.

Light. (Paint.) The quality which is possessed by the most luminous part of a picture, drawing, or engraving in contradistinction to those parts which are relatively obscure and so said to be in shade (q.v.). The term is also applied to the way in which the luminous portions of a picture are rendered. Thus we say of a picture that it lacks light or that its light is well distributed. Light also denotes the way in which pictures themselves should be *lighted* in a studio or exhibition gallery, so as to appear to best advantage. Thus we may describe a picture as being in a good or bad light. As a general rule a top light is best for pictures, as this produces the smallest number of reflections on the surface of the canvas. For seeing sculpture, the angle formed with the horizon by the luminous rays ought not to be more than forty-five degrees.

—, **Red.** (Paint) A pigment produced from sulphate of iron or from yellow oxides of iron burnt. It is permanent but should not be mixed with colours, which are adversely affected by iron.

—, **Secondary.** (Paint.) A term applied to a glimmer of light which is only accessory in the lighting of a painted scene. Thus if in a moonlit pasture a shepherd is seen advancing lantern in hand, this lantern, which throws a light over a part of the canvas, bears the name of a secondary light, as opposed to the rays of the moon, which is the principal light of the picture.

Lighthouse. (Arch.) A tower, turret, or other lofty construction, built upon the sea-coast or on the bank of a large river, and carrying a powerful lamp at the top, which serves as a guide to sailors. At the entrance of the harbours constructed by the Romans a lighthouse was generally built in imitation of the great lighthouse of Alexandria. This

resembled a huge funeral pyre, and consisted of several truncated pyramids placed in retreat one above the other. Colossal figures have sometimes taken the place of a lighthouse. Such was the famous Colossus of Rhodes, and such is the great statue of *Independence*, executed by Bartholdi, which stands at the entrance to New York Harbour. In such

cases as these a lantern or beacon must surmount the figure.

Lights. (1.) (Paint.) The lights in a picture are those parts where the light falls with the most brilliance. A strong effect is obtained by making those parts to which it is desired to give prominence the lights of the picture.

Lights. (2.) (Arch.) The architectural term for the divisions of a window between the mullions. Thus a window may consist of three, five, seven, or more lights.

Lily. The symbol of purity and innocence. In representations of the Annunciation (q.v.) it is always to be seen, either in the hand of the angel Gabriel or placed in a vase.

Limbus. A border worn on the garments of both men and women among the Greeks and in a less degree the

Romans. It assumed a variety of patterns, many of which resembled architectural mouldings. Representa-

tions of the *limbus* are frequently found on Greek vases, from which our cuts have been taken.

Limestone. A hard finely-grained stone used in building.

Limoges Enamels. [Enamels, Limoges.]

— Faïence. The manufactory of faïence at Limoges was founded in the year 1773 by Massié. Early pieces of this ware are rarely met with and are consequently very valuable. After passing through many hands the manufacture languished, until in the present century it received fresh impetus from American enterprise.

Line. (1.) (Paint.) The great ambition

of an exhibitor at the Royal Academy is to have his picture hung *on the line*, that is at about the height of the eye, where it can best be seen. Thus we say of an artist that he is on the line, or that he is hung above it. It is the privilege of Academicians to have a certain number of pictures on the line every year.

Line. (2.) The contour of a figure. Thus we speak of a figure which possesses great purity of line. If we say of an artist that he has sacrificed line to colour, we mean that he has allowed his colour to predominate over his design.

—, Dotted. A line formed of a series of round points or small strokes regularly spaced, which are used on a plan to indicate axes, invisible lines, or directions.

—, Horizontal. The line of intersection between a horizontal and a vertical plane. In perspective the term is applied to all lines parallel to the horizon.

— Engraving. That branch of engraving in which the design to be copied is reproduced on copper by incised lines. The process is as follows. The drawing to be reproduced is traced and trans-

ferred to a copper plate; it is then cut in with a sharp tool called the dry-point. The lines thus slightly cut in are emphasised with the graver (q.v.), and when the work of the graver is finished the plate may be printed from. The resources at the disposal of the line engraver are few. He has only lines of different lengths and at different distances from one another, aided by dots and cross-hatching, with which to reproduce the tones and values of his original. Many line engravers to lessen their work have used etching (q.v.), not only to get the first sketch of the original on their plate, but also in the later stages of their work. The labour involved in the process is very considerable, and it is not surprising that in modern times the art has considerably declined. Samuel Cousins, the last great line engraver of England, is recently dead, and has scarcely left any one to take his place.

— of Beauty. A term applied, in accordance with a certain artistic theory, to a graceful, curved, or undulating line —sometimes quite mannered—outside which, it is said, there is no line really beautiful and worthy of admiration.

Hogarth was the first to formulate the theory of the serpentine line or line of beauty, which he did in two large volumes. He placed his line of beauty on a palette underneath his own portrait and it is here engraved.

— of Level. The line which determines the horizontal position of two points at some distance from one another.

Line of Shadow. The line which in a lighted body separates the luminous part from the part in shadow.

— of Slope. The line which determines the difference in level between two points.

—, Plumb. A line perpendicular to the surface of smooth water. This line indicates the direction of the plummet.

Lineal. That which relates to the lines of a drawing or painting. Thus we speak of the lineal harmony of a painting.

Linear. A term applied to plans executed by means of regular lines, geometrical curves, and to drawings made with the rule and compass.

Linen Scroll. A decorative pattern found in panels of carved wood and so called from its resemblance to a linen napkin folded up. It is characteristic of the ornamental woodwork of the 15th and 16th centuries.

Linstock. A pike with two branches which terminated in a snake's head, as is shown in the cut. It was carried by cannoniers in the 16th century, and a

lighted fuse being placed in one of the branches, it enabled him to fire the cannon and at the same time to have a weapon with which he could defend himself.

Lintel. (Arch.) The horizontal beam, sometimes plain, sometimes ornamental, which unites the uprights of a door or window. The lintel may be of timber, iron, or stone. In the latter case, if it is a monolith, it is generally of little width. More often, how-

ever, it is composed of stones, narrowed towards their base, which form a secure plat-band. Lintels of iron can hardly be treated in a decorative spirit, yet they have the advantage of rendering a very wide bearing possible.

Lion. (Her.) The lion is the most common of heraldic charges, having been always highly esteemed by heralds. The several positions in which lions are represented are each denoted by special words of French origin, to which it is customary, however, to give an Anglicised pronunciation. Lions are said to be *armed* when their claws are of a different tincture, *langued* when their tongue shows, and *disarmed* when they have neither claws nor tongue. Unless otherwise specified, lions, like other heraldic charges, are always represented looking towards the dexter side of the shield.

— Couchant. The lion couchant is represented as lying down, its front paws stretched out straight on the ground and its head raised up.

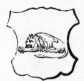

Lion Dormant. A lion dormant is represented in heraldry as lying down in an attitude of sleep, with its head laid upon its front paws.

— Passant. A lion in this attitude is shewn walking with the right fore paw raised, as represented in the accompanying cut.

— Passant Gardant. In this position the lion differs from the *lion passant* in that his head is turned towards the spectator instead of being seen in profile. An illustration of this is given under the word *Leopard* (q.v.) The arms of England are : *Gules, three lions passant gardant in pale or.*

— Passant Regardant. Here the lion resembles the lion passant except that he is looking backwards towards his tail, that is to the sinister side of the shield.

— Rampant. In this well-known position the lion is reared up on his hind legs, with his weight on the left ; the two fore legs are elevated, the right above the left. The arms of Scotland are : *Or, within a tressure fleury counter-fleury, a lion rampant gules.*

— Salient. The lion salient is reared up as the lion *rampant,* but with this difference, that both the hind paws and the fore paws are placed together as they would be for a leap.

— Sejant. A lion sejant is represented sitting down on the haunches with its fore legs firmly planted on the ground and looking toward the dexter side of the shield.

Lion, Statant. A lion in this position is shown in profile, his feet planted firmly on the ground and his face turned towards the spectator.

Lioncel. (Her.) A *lioncel* is a lion's whelp. In heraldry a lion is represented alone on a shield, but lioncels appear two together. Our cut represents two lioncels addorsed.

L-iron. (Arch.) A bent piece of metal used to strengthen angles formed by pieces of wood or iron placed perpendicularly to one another.

Listel. (Arch.) A plane moulding, semi-rectangular in profile, which separates a concave or convex moulding [Fillet.] The term is also applied to that part of the shaft of a column which occupies the interval between the flutings.

Lithochrome. A process the object of which is to produce imitations of pictures. To attain this end lithographic proofs are struck off on paper rendered transparent by thick varnish ; oil-colour is then applied in thick coatings to the wrong side of these proofs, which are finally sized down upon canvas and varnished in the ordinary way.

Lithochromography. A term applied to colour-printing on stone. It is generally called chromolithography (q.v.).

Lithochrysography. The art of printing in gold and colour on stone.

Lithocolla. A cement by means of which lapidaries fix down the gems which they are cutting to the grindstone.

Lithoglyph. An engraved gem.

Lithoglyphy. The art of engraving upon precious stones.

Lithograph. A print struck off from a lithographic stone.

Lithographic Stone. The stone used by lithographers comes for the most part from Solenhofen in Bavaria and from various places on the Danube. It is of a yellowish grey colour, and it is essential that it should have a uniform surface and be entirely free from veins and spots.

Lithography. A branch of the art of engraving in which the drawing to be reproduced is traced upon a stone in an oily ink or crayon. The stone is damped, and the printer's ink only adheres to those portions of the stone where the design is drawn. Prints are then struck off in the usual manner. The process was invented in 1796 by a German named Senefelder. In the present day it must chiefly be regarded as a branch of industrial art, for it is used principally in the production of cheap illustrations. But it has been adopted by many brilliant artists. The French draughtsmen, Prudhon, Géricault, Delacroix, Vernet, and Gavarni, all executed lithographs, which can really be regarded as proofs of orignal drawings. Unfortunately only a limited number of copies can be printed from the stone without destroying the delicacy of the drawing. Some engravings have been executed on stone in the ordinary way, *i.e.* the graver has been employed to incise lines on stone. This process, however, cannot be recommended, as it entails considerable labour and is inferior in its results to ordinary line engraving.

Lithophany. A process by means of which designs are modelling on plaques of porcelain or biscuit, which are transparent, and when held up to the light display lights and shades. Difference of tone is obtained by increasing or decreasing the thickness of the porcelain or biscuit. The porcelain is cast in moulds which are produced mechanically or by hand, and the whole skill of the artist in making these moulds consists in properly graduating the thickness of the plaque. The thick portions give the blacks, while the whites, which are also transparent, are yielded by the thin portions.

Lithophotography. A process of lithographic printing in which the drawing on the stone is not executed by the artist himself, but is obtained from a photographic cliché, which leaves a proof upon the stone similar to a proof taken on sensitised paper. Lithophotographic proofs have the appearance of photographs, and sometimes are a little blurred, but they have the advantage of being permanent if they are printed in a certain kind of ink.

Lithostereotype. A chemical process of engraving upon stone, invented by Tissier in 1841, which also goes by the barbarous name of Tissierography. It consists in hollowing out by means of azotic acid those portions of the stone which are not covered with ink or crayon. The part in relief then stands out just like printer's type. The cliché thus obtained can be printed from by the ordinary typographic process.

Lithostrotum. A mosaic pavement, composed of small pieces of coloured marble.

Lithotypography. A process by which facsimiles of printed pages are traced upon stone either by moistening the pages of the old volume with a special chemical compound and pressing it upon the stone or by tracing proofs freshly struck from printers' types. The stone is then eaten with acid as in the lithostereotype process and printed from. The advantage of lithotypography is that by it old printed books can be exactly facsimiled.

Little Masters. A term applied to a group of artists who executed small designs either on wood or copper for illustrative and other purposes. They flourished in the 16th and 17th centuries, and included Jost Amman, Aldegrever, Hans Schaüfling, Baldung Grün, Hans

Sebald Beham, Burgmair, and Altdorfer. The majority of them worked under Dürer's influence, and their prints, though small in size, are admirable in execution.

Litre. (Arch.) A French term which denotes the band which ran round some c urches of the Middle Ages and Renaissance period, upon which the coats

of arms of the pious founders were painted. It is also applied to the large ornamental bands painted upon the flat surface of a wall, and especially to the vertical bands which separate panels

Lituus. The ancient counterpart of the bishop's crosier. It was a twisted wand carried by augurs, and was used for purposes of divination. When represented in works of art it is generally in the form of a spiral.

Liverpool. In the 17th and 18th centuries Liverpool was an important centre of the ceramic art. Many potteries were established there, in the majority of which Delft ware was taken as a model.

Loaded. (Paint.) A canvas is said to be *loaded* when the paint is laid thickly upon it. By loading a canvas in certain parts strong shadows may be obtained, which add to the effect of the picture. [Impasto.]

Lobe. [Foils.]

Local Colour. [Colour, Local.]

Lock. A contrivance for making fast a door. It consists of a metal bolt turned by a key. The works of the lock are generally hidden in the thickness of the wall and only a plate shows, which is frequently ornamented.

Locker. [Credentia.]

Loft. (Arch.) A term applied to a garret or small room in the roof of a building or to a gallery in a church or hall, such as a rood-loft, a music-loft, &c.

Loge. (Arch.) A French term which denotes in theatrical architecture what is called in English a *box*—a small room closed on three sides and open only in the direction of the stage.

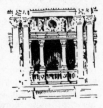

Loggia. (Arch.) A gallery or portico projecting from a building and sometimes decorated with paintings. The term is also applied to the paintings themselves. Thus we speak of the loggias of Raphael at the Vatican.

Lombard Style. (Arch.) A term applied by some writers to the Romanesque style of architecture, from the fact that many examples of it are to be seen in the north of Italy.

Longinus, St. The name given in the legends of the early Church, upon no authority, to the centurion who pierced the side of our Lord and who spoke tl e words, "Truly this man is the Son of God." He is frequently represented in pictures of the crucifixion wearing the dress of a Roman soldier and carrying a spear in his hand.

Loophole. (Arch.) A long narrow opening in the walls of fortified castles, through which archers discharged their arrows. When they were cruciform, so that missiles could be discharged from them in every direction, they were called ballistraria (q.v.).

Lost Wax Process. A process of bronze founding in which the core is covered with an accurate representation of the object to be cast in wax, the wax being of the intended thickness of the metal. The wax is then coated with a porous clay and the whole mass is put in a pit and baked. During the process of baking the wax melts and runs off through apertures left for the purpose. The space left after the wax is melted is occupied by the metal. This, the oldest method of bronze founding, is probably the best, and in the present day it is being pretty generally adopted. In the method, which for some time has been in vogue, the core was made of the exact size of the object to be cast and afterwards pared down, so as to leave space for the metal to run in between the core and the mould. [Founding.]

Lottinoplastic. A method of moulding invented in 1833 by the littérateur and traveller, Lottin de Laval. It consists in taking an impression of an object by means of damp sheets of paper placed one over the other upon the object and successively plugged with a brush. When the sheets of paper have acquired the consistency of cardboard they can be withdrawn, and when they are dry may be rolled up. Lottinoplastic is of service in the reproduction of statues of bas-reliefs, and it has the great advantage, for travellers at least, of furnishing moulds easy to carry and of trifling weight.

Lotus. The leaves and flowers of the lotus plant are frequently employed for decorative purposes in the buildings of India and Egypt, and are considered

as the symbol of fecundity and life. The open flower of the lotus, as well as the buds and the leaves shaped like a

bell, have frequently been reproduced by the Egyptians. In fact the greater number of Egyptian capitals are in the form of a lotus-flower with the upper

 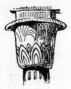

part cut off, swelling at the base and contracted towards the top, or of a calix, the circumference of which is decorated with convex lobes representing the petals of the lotus.

Louvre. (1.) A name given to the palace of the Louvre in Paris, and more especially to the collection of works of art made in the reign of Francis I. and considerably increased by Louis XIV. and Napoleon I. The galleries of the Louvre include collections of pictures, drawings, objects of art belonging to the Middle Age and Renaissance, ancient and modern sculpture, as well as examples of Assyrian, Egyptian, and Etruscan art. To these we must add the print-room and the galleries, in which special bequests of pictures and other artistic objects are placed.

Louvre. (2.) (Arch.) A small lantern or turret placed on the roof of halls in ancient houses, in order to carry away the smoke which rose from the open hearth.

Louvre or **Luffer Boarding.** [Abatson.]

Lovers' Knots. (Her.) A cord intertwined and terminated in a knot at each end.

Lowestoft Ware. From a fine clay found near Lowestoft some excellent pottery has been made. The manufacture dates from the middle of the 18th century. The earliest pieces were blue and white, the later were generally decorated with variously-coloured floral designs of great excellence.

243

Low-relief. An expression synonomous with bas-relief, denoting sculptured ornaments which have but a slight projection. [Bas-relief.]

Low-side Window. (Arch.) A small window which is frequently to be seen at the west end of the chancel in Gothic churches. It was low down in the wall near the ground and had no glass in it, being closed either with bars or shutters. It is said to have served some ecclesiastical purpose in the time before the Reformation, but if it did so this purpose has long been forgotten.

Low-warp. A process of weaving tapestries in wool or silk, in which the warp is horizontal, the warp being vertical only in high-warp tapestries. The principal advantage in the process consists in the relative speed in the work and consequently in its cheapness compared with the high-warp process. On the other hand, low-warp is inferior to high-warp tapestry from the point of view of style. But this inferiority does not strike the untrained eye, and it is only by minute details that it is possible to distinguish the two methods of manufacture. The low-warp process is exclusively employed at Beauvais and Aubusson, while the high-warp has always been regarded as the privileged process of the Gobelins.

Lozenge. (1.) A geometrical figure having four equal sides. Its opposite angles are equal, two being obtuse and two acute.

Lozenge. (2.) (Arch.) A name given to certain sculptured mouldings which

consist of lozenges placed side by side. Lozenge mouldings are most frequently met with in the Romanesque style. The term is also applied to plates of metal cut out in lozenge patterns, which cover the roofs of spires, domes, cupolas, &c.

Lozenge. (3.) (Her.) The lozenge is a diamond-shaped quadrilateral figure, and is one of the heraldic *subordinaries*. It must be distinguished from the *fusil*, which is much more tapering in form, and also from the *mascle* and *rustre*, which are always pierced. When the whole field of an escutcheon is covered with lozenges, as in the cut, it is said to be *lozengy*.

Lucarne. [Arch.] A window which projects vertically from the slope of a roof. It assumes different forms, which are described under the varieties of Dormer (q.v.).

Lucia, St. A Syracusan saint who suffered martyrdom in A.D. 303. She determined at an early age to dedicate herself to the Lord, and suffered terrible persecution at the hands of the Roman governor, being stabbed to death with a poniard. The commonest legend concerning her is, that, not wishing to marry the youth to whom she was betrothed, she plucked out her eyes and sent them to him on a salver. Whereon he is said to have been at once converted to Christianity and she to have recovered her sight. Most representations of St. Lucia are suggested by this legend, for in pictorial art she generally holds her eyes on a salver. Her other attributes are the palm of martyrdom and a poniard, with which she was put to death. She is the patron saint of the blind.

Luke, St. The disciple and companion of St. Paul. Tradition says that he was a physician and also a painter. In very early times portraits of the Virgin were ascribed to him. He has therefore always been regarded as the patron saint of artists. In pictorial art he is

represented either as an evangelist holding his gospel and with an ox at his side, or as a youthful painter with a portrait of the Virgin in his hand. In pictures of the Byzantine school and the schools derived from it he assumes the latter character.

Luke, St., Academy of. St Luke being regarded as a painter himself and a patron of painters, the earliest guilds of artists were established under his name. A guild of St. Luke was established at Florence in 1345, in Paris in 1391, and at Rome in 1593. That at Rome is still in existence.

Luminous. A term applied to brilliant and striking tones, bright canvases, and pictures in which the lights predominate over the shades.

Lunette. (Arch.) A small vault constructed in a barrel vault of larger dimensions than itself, its purpose being to admit light to a dark place, or to

throw a part of the weight of a construction upon other points of support. The term *lunette* also denotes a window or space (often semicircular) about a square-headed window or door. This

space is frequently filled with decorative paintings, which are themselves called lunettes.

Lustre. (1) (Pot.) The glazing, varnish, or enamel which applied to porcelain in a very thin layer gives it a smooth and glistening surface.

Lustre. (2) An arrangement of lights hanging from a ceiling, a vault, or the nave of a church. Ecclesiastical lustres are frequently in the form of crowns and are hung from the roof by chains. [Corona.] The lustres which light the auditorium of a theatre are of immense size. The fittings and decorative portions are generally of gilded bronze and are enriched with crystal balls and drops arranged in festoons.

Luxembourg. A gallery of pictures in Paris, inaugurated in 1818, including a large number of works by living artists. In accordance with a law, which, however, is very little respected, works ought not to receive a definite place in the Louvre until the artists who painted them have been dead at least five years.

Lyceum. A building among the ancients in which learned men met to discuss and the youths of Athens received instruction.

Lyre. A stringed musical instrument frequently represented in ancient works of art. In form it resembled the cithara. It was the attribute of Apollo and St. Cecilia.

M.

Macabre. A term applied to subjects, either painted, sculptured, or engraved, in which figures a representation of Death, either under the form of a skeleton or of an *écorché*.

Mace. The mace was originally a spiked metal club for use in actual fighting, but it is now confined entirely to ornamental purposes. Many corporate bodies, especially the universities, have maces of their own, which are carried before the chief officers of the university on important occasions. The most

noted mace is that belonging to the House of Commons. It always rests on the table of the House when the Speaker is present, and when the Speaker leaves the chair and the House resolves itself into committee the mace is placed under the table.

Machiolation. (Arch.) A projecting and continuous gallery built into the fortified castles of the Middle Ages at the summit of the curtains and the towers, with openings whence the foot of the buildings might be seen from above. *Machiolations* in stone replaced timber *hourds*, the deteriora-

tion of which was necessarily rapid. *Machiolations* were substituted for *hourds* from about the 12th century. In the 14th century they were so constructed that projectiles might ricochet, or describe curves, or strike the besiegers even when at a certain distance from the walls. In the 15th century *machiolations* were sometimes

ornamented with trefoils; but they disappeared finally when artillery came into general use. In certain Gothic houses timber *machiolations* were occasionally erected on the upper stories to sustain the cornice angles, but without being of any utility, and simply for the purposes of decoration.

Madder. (Paint.) From the root of the *rubia tinctorum* a series of pigments are obtained called madder lakes. They vary in colour from a light pink to a dark purple. They are useful both in oil and water-colour painting, and when free from adulteration are permanent.

Madonna. A painted or sculptured representation of the Virgin. A statuette of the Virgin generally placed in a niche upon the public way, often at the angle of a building.

Maenades. [Bacchantes.]

Magdalene, Mary. From the 13th century onwards' Mary Magdalene was perhaps more eagerly worshipped than any saint in the calendar. To the scanty facts that can be gathered with regard to her from the New Testament, the Middle Ages added many interesting legends. It was said that after the death of Christ Mary with Martha and Lazarus, whose sister she is assumed to be, came to France and landed near Marseilles. Here Mary lived the retired life of a penitent, spending years in complete solitude in a cave. It is this legend which has suggested the subject we so often meet with in picture galleries of the repentant Magdalene. Of these the best known is that by Correggio at Dresden. In other artistic representations Mary Magdalene appears thin and haggard with a wealth of golden hair. Her invariable attribute is the box or cup of ointment with which she anointed Christ.

Magot. Chinese or Japanese grotesque figures, painted, designed, sculptured, and sometimes illuminated, in which the dimensions of the head are considerably exaggerated. There are *magots* in porcelain, in faïence, in bronze, in wood, or in ivory, which are sometimes miracles of clever execution. The term *magot* was contemptuously applied by Louis XIV. to the subjects painted by Teniers, and hence it has generally been employed to mean genre pictures, such as were painted by the Flemish master.

Maître. (Her.) This is the French name for a peculiar charge that is more often met with in Germany than elsewhere. It is a sort of wedge with curved outline rising from the base of the shield and occupying a large portion of the field. Thus the annexed cut would be blazoned : *Argent, a maître gules.*

Mail. A general term applied to all armour which consists of chains, rings, or scales. It is opposed to plate armour, (q.v.). It was worn by the ancients and was universal in the Middle Ages until the reign of Edward I., when it began to be superseded by plate.

Majesty. (Paint.) A term denoting pictures of our Lord seated upon a throne and surrounded by angels, with the symbols of the Evangelists (q.v.) and the A and Ω.

Majolica. (Ceramics.) A term applied to certain Italian faïences of the Renaissance as well as to faïences of modern manufacture, made in the style of

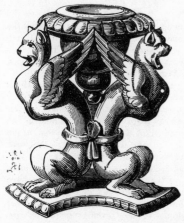

the pottery introduced into Italy by the Arabs or the Spaniards of the Balearic Isles. The first specimens of majolica were made at Faenza and at Gubbio (1425—1480). They consist chiefly of large plates painted in various colours and sometimes having a metallic lustre. At the end of 1520 we find

pieces of majolica ornamented with yellow or red arabesques of very delicate workmanship, but they attained their zenith in 1530; their decadence dates from 1560.

Malachite. A green carbonate of copper used in jeweller's work and in decorating furniture. A green pigment is obtained from it, to which the name " mountain green " is also given.

Mallet. (Sculp.) The mallet generally used by sculptors consists of a cylindrical

block of wood slightly curved so as to form the arc of a circle, and fitted on to a wooden handle that passes through it. In heraldry the mallet sometimes appears as a common charge.

Mameliere. A round plate or boss fastened to the breastplate, as indicated in our cut, which is from a brass in

Minster Church, Isle of Sheppy. A chain attached to it held the helmet or sword in its place.

Manche. (Her.) A long hanging sleeve which is used as a charge in heraldry.

Manduchus. A grotesquely ugly mask with open gaping mouth which was worn by the actors in Roman rustic plays. Our cut is taken from an engraved gem, and beside the *manduchus* there is another attribute of the pastoral player, the *pedum* or shepherd's crook.

Maned. (Her.) When the manes of horses, unicorns, &c., are of a different tincture from their bodies they are said to be *maned*.

Manganese, Brown. (Paint.) A native brown pigment of considerable value in painting. Its advantages are that it dries very rapidly and is permanent.

Manica. The term *manica* is used in several senses. First of all, it denotes the long sleeve reaching to the wrist worn by Eastern nations, and regarded

with contempt by the Romans of the republican ages (cut 1); secondly, it denotes a protection for the arm worn

by gladiators (cut 2); and thirdly, a covering reaching from the elbow to the wrist worn by Roman archers (cut 3).

Maniple. A piece of linen, frequently richly embroidered, which was worn by priests across their left hand or arm. In its origin it was no doubt a handkerchief, but it soon became a mere orna-

ment. One of our cuts represents the maniple held in the hand of Stigand, Archbishop of Canterbury, in the Bayeux tapestry. It was also borne as a charge in heraldry.

Manner. The method of composition and the process of execution adopted by a particular artist. For instance, when we say that a picture is painted in the manner of Corot, we mean that, at the first glance, it reminds us of the work of that artist. We may say too that an artist has several "manners," meaning that his style or technique have undergone distinct changes. In fact few painters have lived whose pictures do not display several "manners," corresponding to the growth, development, and decadence of their talent.

Mannered. The style (or work) of an artist is said to be *mannered* when.

instead of being fresh and suggestive of nature, it exhibits certain stereotyped tricks or dodges of execution. The term is applied indifferently whether these tricks are caught by the artist from his own previous work or copied by a pupil from his master.

Mannerism. Mannerism may be defined as *manner* in a bad sense. Qualities of treatment which when moderately displayed mark individuality of style, when carried to excess and too often repeated degenerate into mannerism.

Mansard. (Arch.) A window placed in the slope of a roof. Mansard brought this kind of window (to which he gave his name) into fashion in 1650. Pierre Lescot, however, had used it much earlier in the Louvre. Rooms with mansards are often low-pitched, and have as a rule insufficient light, but from a decorative point of view the external effect of a mansard is admirable, and helps to soften the hard outline of a roof.

Mantelpiece. (Arch.) A slab of marble placed horizontally, rather higher than breast-high, upon the two vertical uprights of a modern chimney.

Mantle. (Her.) The mantle is a ong flowing cloak worn in former times by knights over their armour, and still worn by peers when in their robes of state.

The decoration and fulness of the mantle varies with the dignity of the wearer, and each order of knighthood has its own appropriate mantle. In blazonry it is often shown as covering a shield.

Mantling. (Her.) The *mantling* of a helmet is an accessory formed of cloth or other material hanging in ornamental folds. It was probably intended originally to protect the helmet from the effects of the weather. The mantling of a peer's arms ought to be of crimson velvet, in other cases its colour should follow the tincture of the field of the escutcheon.

Manuscript. Books written by hand and sometimes enriched by miniatures. Some manuscripts of the 12th and 13th centuries were decorated on each page by painted illustrations, or with initial letters in gold. The manuscripts of the 14th and 15th centuries are adorned with equal richness. And even as late as the 17th and 18th centuries we find splendid examples of the art, both as regards colouring and design.

Marble. A carbonated limestone rock of great hardness and of various colouring. After being cut, trimmed, and polished this stone offers very strong resistance to the attacks of time and weather. Architects have very frequently employed coloured marble for pavements and the like, as also for decorating façades. Statuaries generally use white, not veined marble. The finest antique works have been sculptured in marble from Carrara or Paros.

Marble, Artificial. Imitation of marble executed in stucco.

—, **Parian.** The marble most highly prized among the Greeks was that which was quarried in the Island of Paros. It was not of a brilliant white, but of a soft tone.

—, **Pentelic.** Marble from Mount Pentelicus used by Greek artists for their statues and sometimes for buildings.

—, **Statuary.** White, not veined marble.

Marbled. A description of paper imitating the colours or patterns of marble, used for ornamenting the outsides of volumes, cardboard, &c.

Marbling. A description of painting in imitation of marble ; a chance medley of colours, reproducing the spots and veins of marble, with which the sides of bound books are sometimes covered.

Margaret, St. According to the legend St. Margaret was born in Antioch, and on her refusal to marry the governor of that city she was subjected to the cruellest tortures. She was confined in a dungeon, where Satan, in the form of a dragon of hideous mien, tried to break her spirit, but she triumphed over all her persecutions and gained many converts to the Christian faith. She was finally beheaded. She has always been regarded as the type of purity, and she is the patron saint of women in childbirth. Artistic representations of her are frequent. She is generally standing over the prostrate dragon, which she overcomes with the cross.

Marine Painter. A painter who devotes himself to the representation of sea subjects, and to the various effects observable on the sea-shore or on the open sea under the varying circumstances of atmosphere and weather.

Mark. The works of artists, whether painters, engravers, potters, or goldsmiths, are frequently signed with a conventional mark, which takes the form sometimes of a punning device, sometimes of a monogram. The marks on the bottom of pieces of porcelain frequently tell us the date as well as the locale of its manufacture. Goldsmiths' work may also be identified by the mark or cypher placed upon it. We give here

the mark adopted by the *communautés d'orfèvres* at Bar-le-Duc. But it is the engravers who have made the most frequent use of *marks.* Some engravers indeed are only known to us by a rebus

or cypher. Such are the "Master of the Die" and the "Master of the Rat," whose mark we give. Lucas Cranach signed his works with a dragon holding a ring in his mouth, Hufnagel with a

nail surrounded by an E, while Hans Schaufelin employed cross shovels. The marks of these three artists are given in the cut.

Marked. (Paint.) Indicated too distinctly, accentuated. In a landscape, for instance, the distances are too marked when instead of being suggested with a light touch, they are painfully and laboriously insisted upon.

Mark of Cadency. (Her.) This is another name for *difference* (q.v.) or *brisure.* It is a mark added to a shield to distinguish the individual wearer from other members of the family who are also entitled to the same coat of arms.

Marks, Guiding. Fixed points or marks, the object of which is the guid-

ance of artist or workman while his work is in progress. Thus it is by means of guiding marks that several colours may be printed by successive printings on one sheet of paper.

Mark, St. The evangelist and friend of St. Peter is said to have suffered martyrdom in the year 68 A.D. In the 9th century his bones were taken from Alexandria to Venice, and from that time he became the patron saint of Venice. In art he is represented as one of the evangelists holding a book and accompanied by a lion [Evangelists], or mitred as the Bishop of Alexandria.

Marli. (Pot.) A French term, denoting the inside border of a plate or dish. Filets of gold or colour are frequently drawn upon this border. Dishes of Rouen ware often exhibit *marlis*, decorated with delicate arabesques and other patterns.

Marmoset. (Arch.) Small figures, found principally in buildings of the Gothic style, placed in a squat or grotesque attitude on the profile of mouldings at regular intervals. These small figures frequently hold a phylactery in front of them partially concealing their bodies.

Marquetry. A method of decoration by placing in juxtaposition pieces of wood, metal, or other materials variously coloured. The taste for marquetry was introduced in France in the 16th century, and the furniture of Boule (1642-1732) is decorated in

this style, with great richness of composition and exquisite workmanship.

Marquise. (Arch.) The term *marquise* is applied to a light roof which projects from the façade of a building. It is generally placed over a flight of steps. On the outside of theatres *marquises* of considerable length are not infrequently to be seen. Almost invariably they have a glass roof.

Mars. (1.) [Ares.]

Mars. (2) (Paint.) This term is used to describe a series of artificially prepared pigments coloured by oxide of iron. They are called Mars Brown, Mars Orange, Mars Red, and Mars Yellow. They are all useful pigments and generally permanent.

Martel-de-fer. A weapon, which was the development of the hammer. It had a hammer one side and a pick the other,

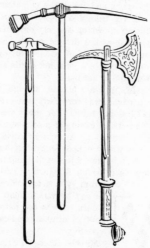

and no doubt was a very efficient destroyer of armour. Our three cuts represent specimens belonging to the

periods of Edward IV., Henry VIII., and Elizabeth respectively.

Martello Tower. (Arch.) A round tower armed with guns, such as Charles V. built in Sardinia and Corsica, as a protection against pirates. Similar towers were built in England, especially on the South Coast, where specimens are still to be seen, as a defence against the invasion of Napoleon I., which was so long expected.

Martlet. (Her.) This is the name for the conventional swallow employed in heraldry. It is always shown without legs and beak and in profile with the wings closed. The *martlet* is the special *mark of cadency* assigned to a fourth son.

Martha, St. St. Martha, the sister of Mary, who "troubled herself about many things," is regarded not inappropriately as the patron saint of housewives. According to the legend, she came to France with Mary Magdalene and Lazarus, and freed the neighbourhood of Aix from a loathsome dragon; in allusion to which she is sometimes represented with a dragon at her feet. As the patron saint of housewives she carries a bunch of keys at her girdle and holds a ladle in her hand.

Martin, St. St. Martin, though by birth a pagan, was very early converted to the Christian faith. For many years he followed the calling of a soldier, and while quartered at Amiens he divided his cloak with a naked beggar, an incident which is the subject of the majority of pictures in which St. Martin figures. From 371 A.D. to his death in 397 he was bishop of Tours. He is the patron saint of drinking and conviviality.

Mascle. (Her.) The mascle is diamond-shaped like the lozenge, but is *voided* or pierced so that the field of the escutcheon is seen through. In the case of the *mascle* the part thus voided or cut out is itself diamond-shaped, whereas in the *rustre* the hollow part is circular.

Mascled Armour. A kind of mail worn by the Norman soldiers, consisting of small lozenge-shaped pieces of

metal, which were sown on a leather tunic. Our cut is from the Bayeux tapestry.

Mask. (1.) (Arch.) A system of decoration taking the form of a head, usually carved whimsically and surrounded with a garland. It is sometimes placed in the centre of a *cartouche*, serving as an ornament for a key stone, for the central portion of a lintel, of a panel, or the like. The term is also applied to theatrical masks, of which the two common types are the tragic and the comic masks, both inspired by antique models. They are generally used in decorating the façades of theatres, or are placed on monuments erected to the memory of dramatic or lyric authors or actors.

Mask. (2) (Sculpt.) A mould taken

from the face of a corpse. These masks have often been used as models in instruction.

Masoned. (Her.) Towers and other buildings used as heraldic charges are said to be *masoned* when the joints of the masonry are clearly shown. As a rule *sable* would be the colour used to designate the joints.

Masonry. (Arch.) A term which denotes the preparation and piecing together of stones in walls or buildings. When we say that the masonry of a building is defective, we mean that the combination of stones in courses and the superposition of the joints do not give a sufficient guarantee for its durability. The two main classes into which masonry may be divided are: (1) that in which the stones are squared and laid in even courses, to which the name *ashlar* (q.v.) is given; (2) that in which the stones are put together without being squared or cut into any regular shape; this is called rubble. From earliest times walls have been composed of blocks of stone. Cyclopean masonry [Cyclopean] is referred to by Homer and must necessarily be of great antiquity. The Greeks and Romans had several kinds of masonry, of which an account is given below. The masonry of the Norman period was of considerable variety, the *opus reticulatum* of the Romans and herring-bone masonry both being employed. After the 12th century it is difficult to distinguish between the masonry of different periods, except in those buildings in which flints are used. In the Early English style flints are left

rough, in the Decorated and Perpendicular styles they have a smooth surface.

Masonry, Clyclopean. [Cyclopean.]

—, **Herring-bone.** Masonry which consists of stones laid in courses inclined alternately from right to left and from left to right. When the stones are squared, as in the cut, this form of masonry is termed herring-bone ashlar. It was used by Roman architects and by them termed *opus spicatum*.

—, **Greek.** The following are the different kinds of masonry employed by Greek architects : (1) opus isodomum, in which the stones are ashlar and laid in courses of equal height; (2) opus pseudisodomum, in which the stones are ashlar but laid in courses of unequal height; (3) opus emplectum (ἐμπλεκτὸν), in which the faces of the wall are ashlar and held together by girders called *diatoni*, while the space between the faces is filled with rubble. In Greek masonry the stones were laid in mortar.

—, **Oblique.** Masonry in which the stones are lozenge - shaped and arranged in regular courses.

—, **Reticulated.** Masonry formed of stones cut square or lozenge-shaped and so arranged that the joints give the wall

the appearance of a draughtboard. This

form of masonry under the name of *opus reticulatum* was employed by the Romans.

Masonry, Roman. The kinds of masonry in use among the Romans were the following : (1.) opus incertum, in which the stones used were not squared ; this corresponds to the modern rubble; (2.) opus reticulatum, in which the stones formed a draughtboard pattern ; (3.) opus spicatum, in which the stones are so placed as to form a herring-bone pattern.

—, **Romanesque.** In the Romanesque period the walls were formed of stones laid in regular courses of unequal height, or else herring-bone or reticulated masonry was employed.

—, **Rustic.** Masonry in which the surface of each stone instead of being flat was cut away so as to come to a point. When the stones thus prepared are set side by side, their projecting surface causes a space to be left between them.

Massicot. A yellow or reddish pigment consisting of protoxide of lead. Like all lead pigments it is affected by damp and bad air, and on account of its non-permanence should be banished from the palette.

Master. A term applied to a painter, sculptor, engraver, or architect who founds a school, and whose works are generally admitted to possess high merits. [Little Masters.]

Mastic. (Paint.) A resin which when dissolved in alcohol or turpentine forms the varnish generally used by painters upon their pictures. It is obtained from a tree which grows in the Levant.

Masterpiece. A work of art which is great both in intention and accomplishment ; or in another sense the most masterly and finished work of a particular artist.

Mater Dolorosa. The mother of sorrows, a name given to the Virgin,

when sorrowing for her crucified Son. In art, the Mater Dolorosa is generally represented alone, sometimes with one sword in her breast, sometimes with seven, in allusion to the seven sorrows she endured. When she holds the body of the dead Christ on her lap, the picture is called a *pieta*.

Matrix. A steel die, from which impressions in relief are obtained upon coins and medals by striking. Matrices are obtained in the first instance from punches (q.v.) cut in relief. The common method now is to make one punch from a steel matrix, and then to obtain from this punch as many matrices as are required. Engravers fix the matrix in a metal case, of cylin-

drical form, with a screw, and place the whole upon a cushion, as shown in our second cut.

Matt. Dull, lustreless, applying to a surface having neither brilliancy nor polish. Used also in reference to unvarnished colours in distemper and to unburnished gold.

Matter. (Engrav.) A kind of punch, used by engravers in mezzotint, consisting of a shaft of metal with a kind of round die on the end. This die is covered with small projecting points placed at irregular intervals. It is used to lay a light ground or to *matt, i.e.* to render darker the parts of the work that are too transparent or clear. Some matters are

made with a wooden handle and are used like roulettes (q.v.).

Matthew, St. St. Matthew, the apostle and evangelist, is seldom represented in art. In the few pictures of him in existence he appears as a bearded man writing his gospel, while an angel stands at his side. Sometimes he holds a bag, in allusion to the calling of tax-gatherer, which he followed before his conversion. [Evangelists.]

Matthias, St. The attribute of St. Matthias, the successor of Judas among the apostles, is the lance or axe, with which he is said to have been put to death.

Maulstick. (Paint.) A light wand of wood, generally rather more than a yard in length. On the top of it is placed a small sphere of wood, which is covered with a piece of cloth or skin. The painter holds the maulstick in his left hand with his palette and brushes, and lets it rest gently on the edge of the picture or on the canvas itself, if it is of large size. The maulstick thus serves as a support for the wrist of the painter's right hand.

Maurice, St. St. Maurice, one of the great military saints and the patron saint of foot soldiers, is generally represented in armour, holding the palm of martyrdom in one hand and the standard in the other.

Mausoleum. (Arch.) A term first applied to the tomb erected in 351 B.C. in honour of Mausolus, King of Caria, by Artemisia, his wife. A large portion of the sculptures which decorated this tomb were discovered in 1855 by Sir Charles (then Mr.) Newton, and are now in the British Museum. They were the work of Scopas, Leochares, and other distinguished sculptors of the 4th century B.C. The term mausoleum is now applied to any funeral monument of large proportions and ambitious design.

Mediæval. [Middle Ages.]

Meander. A system of ornament consisting of fragments of lines broken up

in different directions, or twisted, or crossed. Some authors also give this title to interlaced straight lines cutting each other at right angles. The latter decoration, however, is generally termed *Greek* or *Guillochis* (q.v.).

Medal. (Numis.) A disk of metal with the effigy of a person struck upon it, or engraved with a figure, scene, or allegorical group.

Medium. (Paint.) The liquid vehicle in which pigments are ground. The usual medium is linseed oil, and though generations of painters have attempted to find a new medium which should give the mellow tone of age to their pictures, they have not hitherto been able to improve on the old-fashioned linseed oil.

Medallion. A medal of large dimensions. The term is applied to subjects painted, drawn, engraved, or sculptured, and set in a circular or elliptic frame.

Architectural ornaments inscribed in a circular cartouche or decorating an entablature or façade are termed medallions.

Medusa. The youngest of the mythical beings called Gorgons. Her hair was turned into snakes by Athene and her face rendered so terrible, that all who looked upon it became stone. She was destroyed by Perseus, and her head worn henceforth upon the aegis of Athene. Medusa was frequently represented in Greek art. One of the metopes of the temple of Selinus in Sicily, which dates from the 7th century B.C., has for its subject Perseus cutting off Medusa's head. Small representations of her

255

head were used as charms, and many such have been found. [Gorgoneion.]

Meissen. [Dresden China.]

Mellow. (Paint.) An old picture is said to be mellow when its tones have been softened down by time, the influence to which the old masters are said to owe so much. A modern picture may be called mellow when its tones, so far from being harsh and crude, have something of the softness and quietness of an old master.

Members. (Her.) This term is applied by heralds to the legs and feet of birds

so far as they are free from feathers. When the *members* of a bird are of a different tincture to the rest of the body, this fact is expressed by the use of the word *membered* followed by the name of the tincture.

Menhir. A Celtic monument consisting of an enormous stone driven into the ground and standing vertically,

Mentoniere. A piece of armour which was worn as a protection for the chin

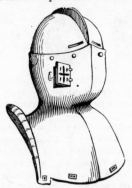

and throat. It was generally provided with an aperture to breathe through, as is shown in our cut.

Mercury. [Hermes.]

Merlon. (Arch:) The part of a parapet between the intervals formed by the loopholes or crenelles (q.v.). Merlons

assume different forms according to their style and period. Sometimes they are

terminated by small pyramids, sometimes they are pierced with long vertical loopholes.

Mermaid. (Her.) A mermaid is one of the mythical beings whose existence is due to the fertile imagination of the ancients. This being is half woman and half fish, and is generally represented combing her hair while she holds a mirror in the other hand. The *mermaid* has always been extremely popular with heralds either as a charge or as a supporter of a shield.

Metal. (Her.) There are two metals employed in heraldry, gold and silver, which are always described by their French names, *or* and *argent*. See *Tincture.*

Metal-work. The arts of beating and casting not only iron and bronze, but also the more precious metals, have

been practised from the earliest ages and among all nations. Among the

specimens of the most ancient Greek art found by Dr. Schliemann at Mycenae are many interesting objects in gold and silver. Throughout the supremacy of Greece and Rome cups and other objects of great beauty were made of metal. We engrave here two cups of classical work-

manship. In the Middle Ages the most noticeable examples of metal - work were the monumental brasses (q.v.) iron railings, locks, hinges, and other architectural decorations. [Iron-work] Of late years the art of working in metal has been revived with considerable success.

Metoche. (Arch.) In Greek architecture a *metoche* is the space existing between two dentels.

Metope. (Arch.) The space between the triglyphs in the frieze of the Doric order (q.v.). Metopes were decorated either with paintings or bas-reliefs.

The term is also applied to the bas-reliefs found on metopes. For instance, when we speak of the metopes of the Parthenon, we mean the series of reliefs representing the combat between the Lapiths and Centaurs, some of which are now among the Elgin marbles.

Mezza-majolica. (Pot.) A kind of glazed pottery made in Tuscany before the stanniferous glaze was known. It

is easily recognisable by the following strongly-marked characteristics: the outlines of the figures drawn upon it are traced in blue or black, the flesh is white, while the draperies are tinted blue.

Mezzanine. (Arch.) A small story placed midway between two larger stories. A mezzanine floor is generally found between the first and second story of a building. The term is also

applied to the small windows, generally of greater length than height, which

light an entresol or intermediate story.

Mezzo-relievo. A term applied to sculptured works in relief, which project half their proper proportion from the ground on which they are carved.

Mezzotint. A process of engraving which may be de cribed as the reverse of line engraving and etching. In these two processes the engraver sets to work on a polished plate, whereas in mezzotint he has first of all to give his plate a roughened surface, which if inked would print a deep uniform black. Technically speaking, the process is as follows. The preliminary operation of laying the ground is performed with an instrument called the rocker (q.v.) or cradle. This somewhat resembles a cheese-cutter in shape, its edge being deeply notched or serrated. It is rocked to and fro and so driven across the plate, leaving behind it an indented path or way. A close series of parallel ways is thus made across the plate.

Other ways are then made at a certain angle over the previous ones, until a sufficiently close velvety texture is obtained. The ground being laid, the whole plate would, as we have said, print *black*. The lights of the picture which is being engraved in mezzotint are obtained by scraping away the ground, the high lights being got by the use of the burnisher. The advantages of mezzotint are manifold. It does not involve the labour entailed by line engraving, in which the lines have to be ploughed into the copper, and it is therefore capable of greater freedom than some methods. Then again by its range of tone it is admirably adapted for the representation of the various textures in a portrait or the planes of a landscape. Its invention has generally been ascribed to Prince Rupert, who is said to have hit upon it from seeing a soldier scraping the rust off his musket. This story has, however, been proved to be false. The real inventor of mezzotint was Lieutenant-Colonel Ludvig von Siegen, who in 1642 published a print of Princess Amelia Elizabeth of Hesse. Some ten years later he explained his invention to Prince Rupert, who introduced it into England. It is in England that mezzotint has been practised with the greatest success; in fact, nearly all the engravers who have attained celebrity in this branch of their art have been Englishmen.

Michaelangelesque. A term applied to works of art in which the method of Michael Angelo is imitated. Figures, for instance, are said to be *Michaelangelesque* when their pose is bold, their movement rapid, or their anatomy strongly accentuated.

Michael, St. The archangel Michael when represented in pictorial art is young and of a smooth countenance. His face wears an expression of severity, indicative of his perpetual contest with the powers of evil. Sometimes he is robed in white, sometimes in armour with sword and shield in his hand. He is always winged, and often poises his spear before killing the dragon. In pictures of the Judgment St. Michael is clothed in armour and is winged, and holds in his hand the balance in which souls are weighed.

Middle Ages, The. All works of art are said to belong to the Middle Ages which were produced between the 12th and 16th centuries. This, however, is by no means the historical meaning of the term *Middle Ages*, which extend from the fall of the Roman Empire in 475 A.D. to the taking of Constantinople by Mahomet II. in 1453.

Middle Distance. (Paint.) That part of a picture which lies between the background and foreground.

Middle-tint. (Paint.) A colour intermediate between the brightly lighted part of a picture and the part placed in shadow. Middle-tints help to give harmony to a picture, and to render the transition from light to shade less abrupt.

Milky. A term applied in painting to slightly opaque tones of white. Precious stones are said to be milky when they are sprinkled with spots or covered with a light tint of white.

Millefiori. (Pot.) A kind of mosaic glass, consisting of several rods of glass, of various tints, melted together. It was made in Venice centuries ago, and its manufacture has been revived within the last sixty years.

Milling. A term applied to the regular notches incised on the edge of a coin.

Mill-rine. (Her.) The mill-rine or mill-rind is the iron clamp fixed to the centre of a millstone. It appears in heraldry as an armorial bearing, either alone or shown on the millstone, but more often alone. The same instrument gives also the idea for a special kind of cross, the cross moline (q.v.).

French heralds make a distinction between different kinds of mill-rines. Thus in the accompanying cuts they would call the first a *fer de moulin* or mill-rine, and the second an *anile.*

Minaret. (Arch.) A lofty tower set by the side of a mosque, with a projecting balcony at its summit and a roof in the shape of a bulb. 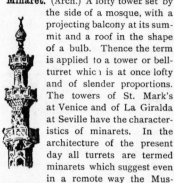 Thence the term is applied to a tower or bell-turret whic 1 is at once lofty and of slender proportions. The towers of St. Mark's at Venice and of La Giralda at Seville have the characteristics of minarets. In the architecture of the present day all turrets are termed minarets which suggest even in a remote way the Mussulman style.

Mineral Blue. (Paint.) This pigment is described as a ferro-prussiate of alumina. It is a good colour, but its permanence cannot be relied upon.

— **Grey.** (Paint.) A neutral tint obtained from lapis lazuli, of great service in oil-painting, as it admirably represents effects of cloud and mist.

— **Yellow.** (Paint.) A pigment obtained from proto-chloride of lead. Like all lead pigments it is destroyed by time and exposure.

Minerva. [Athene.]

Miniature. (Paint.) The term *miniature*, derived from minium (q.v.), was first applied to the small water-colour drawings which adorn manuscripts. It was afterwards extended to all works of art, whether paintings, drawings, or engravings, of small dimensions and delicate workmanship. Small portraits on ivory or vellum, executed with such care and minuteness that the smallest detail will bear inspection, are more particularly known as miniatures. The art of miniature-painting in this sense was brought to great perfection in England during the last two centuries, but has had to encounter a serious rival in photography.

Minium. (Paint.) Minium, which is also known as red lead, is a peroxide of lead. It is a brilliant red pigment, with just a suspicion of yellow in it. It was used extensively by the illuminators of manuscripts and in earlier times by painters in oil. However, as it contains lead, it proves destructive to other pigments, and its use cannot be recommended. In architecture it is of considerable service, being employed to cover iron rails and planks of wood, the former of which it preserves from rust, the latter from damp.

Minster. (Arch.) A church which belongs to a monastery or religious house. Several of the English cathedrals are termed minsters, but this is to be accounted for by the fact that they were originally the houses of prayer attached to a monastery, and became cathedral churches after they were built.

Mirror. An ornament consisting of a looking-glass placed in a frame, generally gilded and sometimes enriched with carvings. The most esteemed mirrors at the present day are those which have a convex surface and present a diminished image of whatever they reflect. The mirrors of the ancients consisted of a circular piece of metal with a highly polished surface. The metal employed was either a mixture of copper and tin or silver. The back of the mirror was often decorated with designs of great beauty and interest, incised upon the metal, which fact places Greek and Roman mirrors among the most valuable relics of ancient art.

Misere-corde. A small dagger, which was used by the warriors of the Middle Ages for giving the death stroke to a wounded antagonist. It was generally damascened, engraved, or otherwise richly decorated. The three specimens

in our cut belong respectively to the

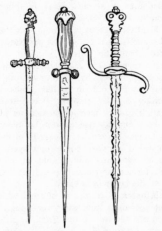

reigns of Henry VI., Edward IV., and Henry VIII.

Miserere. (Arch.) A small seat placed within the stalls in Gothic churches. In that part of the service during which the occupants of the stalls were supposed to stand, these seats were turned back and afforded a considerable amount

of support to the person who to all appearance was standing upright in his stall. *Misereres* generally assumed the form of brackets, and were ornamented with bas-reliefs and symbolic or grotesque figures.

Missal. A term applied to the manuscripts or printed volumes of large dimensions which are used in the services of the Catholic Church and contain the prayers of the mass. They are generally enriched with colour, and their ornamental letters are designed in imitation of those found in mediæval manuscripts.

Mitis Green. [Emerald Green.]

Mitre. (1.) A term applied to the joining of planks or mouldings at an angle, generally at an angle of forty-five degrees. Frames and parels are formed by

mouldings cut in mitre and joined by means of a mortise or tenon or simple nailed.

Mitre. (2.) The head-covering worn by bishops. In the 11th and 12th centuries it was a simple round bonnet with two strings at the side, as in our second cut. It assumed the pointed shape, which it still retains, in the 15th century. In coats of arms of ecclesiastical dignitaries the

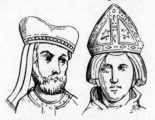

mitre takes the place of coat and helmet and rests upon the top of the shield.

Mitred. (Arch.) A term applied to towers and bell-turrets, the crowning of which has the form of a mitre.

Mixtion. A term applied to the mordant which is used in fixing gold leaf upon wood in the operation of gilding.

Model. Any object which an artist

undertakes to reproduce is called a model. Thus we speak of a drawing model. In the language of sculptors the term *model* is applied to the first representation of his subject modelled in clay, as well as to the plaster cast taken from the clay. These two stages on the way towards a statue in marble or bronze are called the clay model and plaster model respectively. *Model* is used absolutely to denote the living model. [Model, Living.]

Model, Living. One whose profession it is to pose to an artist. Many female models, possessed of great beauty of face and form, have gained considerable celebrity from sitting to distinguished artists. Male models are of various nationalities, frequently Italians. Young children and white-bearded old men, with strongly marked features, were in great request when religious painting was still fashionable, and artists wanted models for the infant Christ, the saints, and the prophets. Nowadays, however, the artist devotes himself to the reproduction of less conventional types, to modern or even realistic portraiture, and so the classical type of the model is fast disappearing. The living models of tradition—the men with slouched hats and torn and patched cloaks, the women with curious costumes, so very much the worse for wear—only pose now in academies or schools of art. In these institutions the model stands upon a pedestal or table in the midst of a semicircle. The students sit round in tiers, the draughtsmen in the front row, the painters in the second, and the sculptors behind. A good deal of nonsense has been talked of late years by ignorant but well-meaning persons about the temptations to which models are exposed. They are as a rule a hardworking and deserving class, who devote themselves with intelligence and energy to the profession, to which, in most cases, they have been brought up from their earliest childhood. The business of a model, like so many of the liberal professions, runs in families.

Modelling. (Sculp.) That part of the sculptor's art which consists in constructing in clay or wax the model, which is to be reproduced in plaster, terracotta, bronze, marble, stone, or wood. The term has another meaning. In a painted portrait we say that the modelling is good, when the painter has succeeded in indicating the various planes of the figure which he has represented. The term is also applied to painting. The modelling of a figure is admirable, when its projection is so strongly and withal so subtly indicated that you can see all round.

Modelling Tools. The tools used by the sculptor for modelling clay are made of wood, ivory, or metal, and vary considerably in shape and size. Our first cut represents that one generally used; the second and third tools have serrated

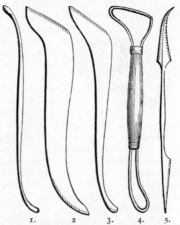

1. 2 3. 4. 5.

ends for removing masses of clay, which purpose is also served by that represented in Fig. 4, which, it will be noticed, has a loop. The last, Fig. 5, is a metal tool used for cutting plaster.

Modelling Wax. (Sculp.) A yellow wax, with which black resin, terebinth, and oil are mixed. It is used by sculptors for modelling works of small dimensions, and especially for making preliminary sketches for statues which are

afterwards modelled in clay. It is slightly tinted with vermilion or red brown. The facility with which modelling wax is moulded varies according to the quantity of oil which enters into its composition, and it is harder in summer than in winter.

Modillion. (Arch.) A term applied to brackets placed at regular intervals under a pro-

jecting cornice or balcony. The name is also g.ven to small b r a c k e t s placed against a wall and supporting vases or busts. The **v**olutes of modillions are placed horizontally or ver-

tically according to the purpose which they serve, and the height and projection of the cornice they support.

Modulus. A measure by which the intercolumniation (q.v.) and other proportions of Greek buildings are measured. The modulus generally taken as the standard by architects is the diameter of the column near its base.

Moerae. [Fates, The.]

Mole. (Arch.) A kind of stone jetty running out into the sea at the entrance of a harbour, the purpose of which is

to break the force of the waves.

Monde. (Her.) An heraldic term, denoting the globe encircled with band, and surmounted by a cross, which is among the insignia of royalty.

Monochrome. A painting executed in one colour.

Monogram. A cypher used as a signature to works of art. It con ists of initial letters, interlaced or juxtaposed, or sometimes of an emblem, which serves to denote the artist, such as the master of the die, the master of the bird. [Mark.] Potters as well as painters used monograms, and pieces of porcelain may often be identified by the monograms found upon them. The name of Christ and the Virgin written as monograms are frequently found as ecclesiastical decorations. Monarchs and potentates too have had their monograms, and our third cut, in which the letters K A R O L V S are juxtaposed, represents the signature of Charlemagne.

Monograph. A biographical study or a collection of documents bearing upon the life of one artist is termed a monograph, as is also an essay on a special branch of art, such as enamels, faïences, bronz**e**s, &c.

Monopteral. (Arch.) An antique temple, circular in form, which was surrounded by a single row of pillars. The choragic monument (q.v.) of Lysicrates at Athens was a fine specimen of a monopteral building of the Corinthian order. Our second cut shows a monopteral

temple represented on a coin of the Tullia gens at Rome. It will be seen that a statue is placed in it, as

a receptacle for which the monopteral temple was frequently employed.

Monopyle. (Arch.) A term applied to a building which has only one door. An enclosure with a portico, which surrounds a temple, and has only one entrance, is sometimes termed a peribolus.

Monostyle. (Arch.) In ancient architecture a temple is said to be monostyle when it is surrounded by only one row of columns. The term is also applied to a single column complete in itself, such as the column of Trajan.

Monotriglyph. (Arch.) A term applied to a method of intercolumniation, which only allows a single triglyph (q.v.) to be placed in a frieze.

Monstrance. A monstrance is a transparent pyx used in the services of the

Catholic Church, to expose the host to the eyes of the worshippers. [Ostensoir.]

Monument. (Arch.) A term applied to an architectural construction, or more especially to a statue placed upon a pedestal to perpetuate the memory of a celebrated man or an important event.

This purpose is fulfilled sometimes by a single statue, sometimes by a symbolic group, or elaborate construction such as the Albert Memorial in Hyde Park.

Monument, Choragic. [Choragic Monument.]

—, **Celtic.** A term applied to the monoliths or collections of unhewn stones, set up in those parts of Gaul or Great Britain which were once inhabited by Celtic tribes. [Cromlech, Dolmen, Menhir, &c.]

—, **Expiatory.** A monument erected in expiation of crime.

—, **Funeral.** A monument in the form of a chapel, stele (q.v.), or tombstone erected over a grave or in a cemetery in memory of the dead.

—, **Historic.** A term applied to all those ancient buildings which on account of their artistic value, their historic importance, or their distinguished associations are of public interest. It is the duty of a community to see that its historic monuments are not tampered with. They should indeed only be restored with the utmost caution, for when once they are robbed of their antiquity their interest and sentiment are gone.

Moorish. (Arch.) A style which was introduced into Spain after the invasion of that country by the Arabs. The mosque at Cordova and the Alhambra (13th century) may be instanced amongst the most noteworthy of Moorish buildings. The term *Moorish* is also applied to a system of ornament consisting of fantastic foliage which is frequently employed in damascening.

Morbidezza. (Paint.) An Italian term, which denotes the delicate, subtle, and vivid rendering of the flesh in painting, sculpture, or engraving.

Mordant. A mixture of Jew's pitch, thick oil, and plumbago, to which some drops of essence are added, used in mat gilding. The term is also applied to a substance obtained from metallic oxides, and used to fix the colours in dyeing and calico-printing.

Morion. A helmet of a curious shape, with a sharp peak in front and behind,

which was adopted by the Spaniards from the Moors, and reached England in the 16th century.

Morse. A brooch or clasp used by priests to fasten their cape. It afforded an opportunity for a good deal of decoration, often of a mystic or symbolic character, and was generally of gold or silver.

Mortar. In architecture the term mortar is applied to a mixture of sand, cement, and lime, tempered in water, which is employed to bind together the materials used in a building. In another sense a mortar is a small vessel in which certain substances are reduced to powder or colours ground. [Pestle.]

Mortier. (Her.) A charge in French heraldry representing the head-dress of the chancellors of France and of the

presidents of parliament. The chancellor's *mortier* was of gold cloth, embroidered and turned up with ermine. The president's *mortier* was of black velvet or plush, ornamented with large galoons (q.v.) of gold.

Mortise. (Arch.) A notch cut in a piece of wood to receive a projecting piece called a *tenon* (q.v.).

There are several methods of carrying out this method of joining. The mortise, for instance, may be straight or oblique, and more than one tenon may fit into it.

Mortise Chisel. A tool consisting of a quadrangular piece of metal with a bevelled edge. The cutting edge forms the greater part of it. It is used for making mortises (q.v.).

Mosaic. Under *mosaic* may be classed all works which consist of pieces of hard coloured substances, such as glass, marble, &c., put together and combined to form various patterns. Florentine mosaic (q.v.), for instance, consists of small squares of polished marble and precious stones applied to pieces of furniture and ornaments. Pavements and facings, which consist of plaques of coloured marble, are another form of mosaic, perhaps the most ancient of all. [Pavimentum.] The term is

also applied to the designs incised in ancient buildings. [Graffiti.] There yet remains the enamel *mosaic* which is employed by the goldsmiths and jewellers of Rome. Finally a few words must be said of the decorative *mosaic*, which consists of small cubes of coloured enamel applied by means of cement to a hard surface. This last occupies an important place in the history of decorative art. Some fine specimens of it are to be seen at the mosque of San Sophia in Constantinople and at St. Mark's in Venice. A part of the South Kensington Museum is thus decorated, and had Wren's design been carried out the dome of St. Paul's would have been brilliant with mosaic.

Mother-of-pearl. A substance with which the inside of certain shells is coated. It is white, hard, and iridescent, takes a high polish, and is accordingly of considerable value in the decorative arts.

Motive. In painting the motive is the subject of a picture; in sculpture it is the pose of a figure or the arrangement of a group; in architecture it is the general effect of the painted or sculptured decoration.

Motto. (Her.) A word or sentence written below an escutcheon. It is frequently a punning device suggested by the name of the bearer of the coat of arms. The motto of the Cavendish family, for instance, is *Cavendo tutus.*

Moucharaby. (Arch.) A projecting balcony on the outside of a building covered with a lattice of wood. It is frequently found in buildings of the oriental style, and produces a picturesque effect.

Mould. (Sculp.) A mould is an imprint of an object in relief, by means of which a reproduction of this object may be obtained. The mould *à creux perdu* can only furnish one copy of an original,

for it must be broken to be detached from the cast. From the mould *à bon creux*, however, which consists of movable pieces, an indefinite number of copies may be obtained.

Moulding. (Arch.) A projection, square, convex or concave in profile, ornamenting a wall. Examples of *flat* mouldings will be found under the headings *Fillet, Listel, Dripstone, Fascine,* and *Plinth;* of *convex* mouldings under the headings *Baguette, Quarter-round,* and

Torus; and of *concave* mouldings under the headings *Cavetto, Gorge,* and *Scotia.* Some mouldings, such as the *cyma* and *ogee,* are half convex, half concave. Mouldings are frequently decorated with foliage. Not only are they used in architecture but they serve to ornament numerous surfaces upon which their projection and

shadows produce effects of light and shade. In the Greek and Roman orders the mouldings, to which we have already referred, are employed. In buildings of the Romanesque style these mouldings are retained, but their outline is heavy, and very often plat-bands (q.v.) decorated with *frets* or *chevrons* receive the name of moulding. In the Gothic period fresh mouldings were introduced such as the *chamfer,* and a whole series of small mouldings, the purpose of which was to set off the profile of the curved mouldings. At the Renaissance the antique mouldings

were revived, with some slight modifications, but without the loss of their original grace.

Moustiers Faïence. (Pot.) A very fine faïence was made at Moustiers in the 17th and 18th centuries. The earlier specimens were blue and white in colour, and the decorative designs upon them were suggested no doubt by the antique. On the later examples of Moustiers polychrome decorations were introduced.

Muffle. A hollow demi-cylinder of fire-proof earth, closed at one end

and open at the other. It is used by painters in enamel and in porcelain for firing and vitrifying their colours.

Muller. (Paint.) A small pestle of crystal, porcelain, or marble, which is used by painters to grind their colours either on a piece of polished glass or in a porcelain saucer. The muller is generally in the form of a truncated cone, the upper part of which is slightly convex, so that it can be held in the palm of the hand.

Mullet. (Her.) The rowel of a spur borne as a charge in heraldry. Unless otherwise stated it has five points.

Mullion. (Arch.) A term applied to the stone compartments which divide the surface of windows in buildings of

XIII. XIV. XV. XVI.

the Gothic and Renaissance styles. Throughout the Middle Ages mullions had a distinct outline in every century. In the greater part of the window

mullions are vertical, but in the upper part they inter-crossed and form complicated curves. During the period of the Renaissance windows were divided by

mullions cutting one another at right angles. The space between the mullions was filled with panels of glass held up by iron bars.

Multifoil. (Arch.) A term applied to an arch, which consists of more than five foils or segments of circles.

Mummy Brown. (Paint.) A term denoting a rich brown pigment, which is composed of white pitch, myrrh, and the flesh taken from ancient mummies. For a long time, however, mummy brown extracted from real Egyptian mummies has been very rare, as the variety which the druggists of the Levant palm off upon Western Europe is not genuine, but is obtained from the bodies embalmed by both Jews and Christians in the Levant in bitumen and some aromatic substances. But whether genuine or not, it cannot be recommended to the painter, as, although it is a rich colour, it dries with difficulty, is not permanent, and may contain ammonia and particles of fat.

Muntin. A vertical piece of wood or iron, which forms part of the framework of a door or bay.

Mural Decoration. Nearly all the arts have been called into requisition for the purpose of decorating wall surfaces. The ancient Egyptians and Assyrians employed low reliefs in marble for this purpose, and many specimens of their work are still extant. Walls have been covered with thin slabs of marble, brilliantly enamelled tiles, stucco, mosaic, stamped leather, and paper. Then they have been painted in every age and in every country. It is from the painted walls of Pompeii that we gain our scanty knowledge of Greek painting, and this method of mural

decoration continued through the Middle Ages, and indeed still survives. There are, however, very few pre-Reformation mural paintings in existence For at the triumph of Protestantism these interesting examples of art were ordered to be destroyed, and replaced by texts and allegories. The usual method at the present time of decorating walls is to cover them with wallpapers. This practice seems to have been generally adopted in the 18th century, though it was not unknown before. The design is printed on the paper from wooden blocks, cut in relief, a separate block being used for each colour. The best kind of papers are printed by hand, but the cheaper kind are printed in machines.

Murex. The murex is, strictly speaking, a shell-fish, but in art it generally denotes a twisted shell-shaped trumpet, which was one of the attributes of the Tritons. Our illustration is taken from an antique gem.

Murrey. (Her.) A term used in old heraldry books for sanguine (q.v.)

Murrhine Vases. Murrhine vases were first brought to Rome in the time of Pompey. They were highly valued by the Romans, who paid fabulous sums for them. Pliny describes them as brilliant, iridescent, and of various colours. Many opinions have been set forth as to the material of which they were composed. Some say they were of jade, others of opal, while others again hold that they were Chinese porcelain.

Muses. The daughters of Zeus and Mnemosyne, and the patronesses of music and the fine arts. They were nine in number, and each had one branch of art under her control. In early Greek works of art the Muses are represented together as nine maidens similarly attired, and each holding a musical instrument or a roll of manuscript as their attribute. They are led by Apollo, who is hence called Musagetes. In later art they have each their separate attributes, suggested by the branch of art, such as history, tragedy, comedy, &c., which is regarded as their own.

Museum. A public building in which a collection of works of art, belonging especially to ancient times, is gathered together and classified for the purpose of intelligent study. The British Museum and the South Kensington Museum are the most celebrated institutions of the kind in England.

—, British. The British Museum was established in 1754, on the site which it occupies at present. A nucleus was formed by the collection of Sir Hans Sloane, the Cottonian library, and the Harleian manuscripts. The collection of Sir William Hamilton, acquired by purchase in 1772, was the foundation of the Department of Antiquities. In 1802 a large collection of Egyptian antiquities were acquired, and some years later were purchased the Townley Marbles. The magnificent sculptures from the Parthenon, known as the Elgin Marbles, were obtained in 1816, and seven years later the library of George III. became public property. The enlargement of the building was then inevitable, and the Museum, as we know it to-day, was designed by Sir Robert Smirke. In 1857 Mr. Sidney Smirke built the Reading-room, the plan of which was suggested by Sir Anthony Panizzi. Important additions have been made every year to the British Museum, which, besides a vast library, includes a collection of artistic objects from all countries, and belonging to all ages; nor must the admirable department of prints and drawings be forgotten. Between the years 1880 and 1883, the Natural History Collections were removed from Bloomsbury, and placed in a separate building in Cromwell Road, now known as the Natural History Museum.

Museum, South Kensington. The South Kensington Museum was one of the results of the Exhibition of 1851. It was intended primarily to include examples of art applied to industry, as well as a collection of such works as should have an interest and value for art students. But it has gone far beyond these limits, and is, in addition, the refuge of many miscellaneous objects, such as the Dyce and Forster collections of books, drawings, &c., and a large number of pictures, the majority of which belong to the British School. The majority of the pictures acquired under the terms of the Chantrey Bequest find a home at South Kensington.

Muzzle. (Arch.) An architectural

decoration representing the muzzle of an animal, whether real or fabulous. The muzzles of lions are frequently employed in the decoration of fountains or gutters, jets of water issuing from the openings thus formed.

Mutule. (Arch.) A kind of modillion, of considerable size, peculiar to the

Doric order. It is sometimes quite plain and sometimes covered with rows of guttae (q.v.).

Myology. That branch of anatomy which includes the study of muscles. The living model does not always give the artist sufficient guidance. As the model gets tired the muscles relax, and after a while no longer display the tension which they should have in action. The artist must then fall back on his knowledge of anatomy, and by this means imagine what his model can no longer represent to him.

Mythology. The greater number of subjects affected by ancient sculptors and painters were suggested by their mythology, *i.e.*, by the fabulous history of their gods, goddesses, and heroes. An account of the chief among these deities, with the attributes by which they may be recognised, will be found under separate headings. Mediaeval and modern artists too have often sought their inspiration in classical mythology, especially in times like the present, when there has been a sort of classical revival.

N.

Naga. Among the Dyaks of Borneo a certain kind of jar, to which the name of naga (a dragon) is given, is very highly prized. It is uncertain when and by whom these jars were made, but all have a figure of a dragon traced upon their surface.

Naiant. (Her.) This terms mean *swimming*, and is used in heraldry of a fish represented on a shield in a vertical position. When a fish is shown in a horizontal position, it is said to be *hauriant* (q.v.).

Nail. The heads of nails form one of the simplest methods of ornament in the world. They are frequently employed to decorate the panels of doors or of small pieces of furniture such as coffers, cabinets, &c. In this case brass-headed nails are generally used.

Nail Ornament. (Arch.) A system of ornament frequently used in the Romanesque style. The "nails" often present

the appearance of diamond points and are set side by side. Sometimes, how

ever, they are spaced out and the heads of monsters are incised upon them. In this case they are commonly known under the name of corbels or modillions.

Naissant. (Her.) This term is applied to demi-lions, or other charges rising out from the *middle* of a fess or some other ordinary. It differs from *issuant*, which implies that the charge rises from the *lower edge* of the ordinary, which in this case is always a chief.

Naked. (Arch.) A term applied to the surface of a wall, to which projecting 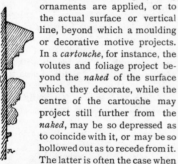 ornaments are applied, or to the actual surface or vertical line, beyond which a moulding or decorative motive projects. In a *cartouche*, for instance, the volutes and foliage project beyond the *naked* of the surface which they decorate, while the centre of the cartouche may project still further from the *naked*, may be so depressed as to coincide with it, or may be so hollowed out as to recede from it. The latter is often the case when the cartouche is incrusted with marble.

Naos. (Arch.) The central portion of a Greek temple, in which stood the statue of the deity to whom the temple was dedicated. In the modern Greek church the *naos* is the nave reserved for the faithful.

Napkin Pattern. (Arch.) A name

given to a decorative pattern frequently

carved upon panels of wood in the Gothic period. It suggests a square piece of cloth folded sometimes double with the two ends curved inwards, sometimes in many close folds. The commoner name for this ornament is linen scroll (q.v.)

Naples Yellow. (Paint.) A pigment which was originally composed of the oxides of lead and antimony, but is now generally manufactured from zinc. It derives its name from the fact that it was once prepared at Naples. It is a useful pigment, and, though it is affected by bad air and by pigments, such as the ochres, which contain iron, it may be regarded as permanent.

Narthex. (Arch.) The interior vestibule of a Christian basilica railed off from the rest of the building, where the catechumens and penitents were admitted.

Nasal. That portion of a helmet which protected the nose. Our cut represents the head of a warrior from the Bayeux tapestry.

National Gallery. The National Gallery, which is situated in Trafalgar Square, in London, contains about 1,300 examples by English and foreign masters. Compared with many foreign picture galleries it is a very young institution. It dates its foundation from 1824, in which year a small collection of 38 pictures was purchased from Mr. Angerstein. This formed the nucleus of the unrivalled collection now at Trafalgar Square. The Angerstein Collection was speedily augmented by gifts and bequests, and in 1853 the nation possessed 236 pictures. Shortly before this time the pictures thus acquired had been removed from Pall

Mall, where they had been exhibited at Mr. Angerstein's house ever since their purchase, to the building now known as the National Gallery. Annual grants from Government, largely supplemented by private munificence, have enabled us within the short space of rather more than sixty years to get together a collection of pictures which in some respects is unsurpassed in Europe. We may particularly congratulate ourselves that our gallery, small though it be, contains for the most part picked examples of the great masters and is singularly free from rubbish. Of late years the pictures have been carefully rehung according to schools, and their value from an educational point of view has thus been much enhanced.

National Portrait Gallery. [Portrait Gallery, National.]

Native Green. (Paint.) A pigment artificially prepared from oxide of chromium or chrome ochre. It is a deep opaque sage green, and is very useful, as it is quite permanent.

Nativity. The " nativity " or birth of Christ was one of the favourite subjects of the old masters. It is represented as taking place in a stable. The child, wrapped in swaddling clothes, lies in the manger, its mother and Joseph keeping watch over it. The ox and the ass are never omitted from the scene. This may be called the realistic representation of the scene. Sometimes, however, it is treated symbolically, the infant lying on the ground and the mother kneeling over it, while attendant angels keep guard.

Nature. An artist is said to execute his work from nature when he paints, draws, or models from the living model, or places his easel before the landscape he wishes to represent and paints in the open air.

Naturalism. An æsthetic tendency displayed by a certain school of artists to keep as close as possible to nature in the representation of her various phases. The naturalism of the present age too often lacks loftiness of aim, and is sometimes little better than brutality. However, such artists as Albert Dürer and Lucas Cranach have shown that it is possible to be a naturalist without losing nobility of sentiment.

Naumachia. (Arch.) This term, which literally means a sea-fight, was applied to amphitheatres or circuses in Rome, in which sham sea-fights took place. The first was built by Julius Cæsar, and the *naumachia* of the later emperors were vast structures. Representations of them are frequently met with on coins or medals.

Nave. (Arch.) That part of a Gothic church which extends from the choir to the western door. The word *nave* means a ship, and it was applied to the body of the church, in accordance with the simile which compared the church to a ship.

Nebris. A fawnskin, frequently found in representations of Bacchantes and Thyades.

Nebulé. (Her.) This is one of the varieties of the dividing lines of a shield. *Nebulé* take slightly different forms on different shields, but they all resemble pretty closely the specimen here shown, consisting of well-marked double indentations and projections.

Necklace. An ornament worn round the neck. It has been made of glass

beads and the seeds of plants as well as of jewels and richly chased gold. There is no race, either barbarous or civilised,

among whom necklaces have not been worn. Our cuts represent two necklaces

discovered in Etruscan tombs, the upper one being now in the British Museum.

Neck-moulding. (Arch.) A broad fillet or astragal, which separates the shaft of a column from the capital.

Necropolis. A term applied in ancient times to that portion of a city, sometimes a subterranean vault, in which the dead were buried. In modern times it denotes a large cemetery.

Needle. (Arch.) A name given in Gothic architecture to the pinnacles or bell-turrets, which are sometimes termed *spires*, as well as to steeples in the form of a tapering pyramid. Egyptian monoliths or obelisks of pyramidal form and of great height in proportion to their breadth are also called *needles*. Such is Cleopatra's Needle, which now stands upon the Thames Embankment.

Negative. A term applied to a photographic proof, in which the light parts are represented by black and the parts in shadow by white spots.

Neo-Greek. A style of painting adopted by some artists who attempt to infuse modern sentiment in the style and subjects of ancient Greek art. In architecture the term *neo-Greek* is applied to a style inspired by the Greek orders with these modifications: the ornamentation projects but little, foliage for instance, being only incised, while uniform surfaces of considerable size and mouldings with a long narrow outline predominate.

Neptune. [Poseidon.]

Nereids. In Greek mythology the Nereids were the daughters of Nereus and were regarded as the spirits of the sea. They are represented as attending Aphródite, when she was born of the sea. The Greeks with the anthropomorphism which was characteristic of them, imagined the Nereids as maidens of great beauty and thus they appear on painted vases and other works of art, swimming in the sea or riding on dolphins. They suggest an obvious parallel with the mermaids of Teutonic mythology. Four figures representing Nereids are among the marbles discovered by Mr. Fellows at Xanthus, and are now in the British Museum.

Nereus. One of the sea-gods of Greece, the father of the Nereids. He is represented in works of art as an aged man, with a long beard and a Jove-like head.

Nero Antico. A marble sometimes used by the ancient sculptors of Egypt and Greece. It is of a very deep black in colour and is unknown in its natural state in the present day.

Nerve. (Arch.) A term applied to the mouldings which surmount the surface of a vault. It is synonymous with rib (q.v.), which is the term more commonly employed.

Nervous. A painting is said to be *nervous* when the colours are firm and the drawing is vigorous. The term is applied to a piece of sculpture, the modelling of which is solid without being heavy, while the various planes are strongly and clearly marked.

Net. (Her.) Nets are sometimes borne as charges on coats of armour, and may cover either the whole or part of a shield. Or a net may be supercharged on some other charge; thus, for example, we might have a fess or a bend charged with a net of a different tincture.

Netsukés. A Japanese word denoting a small toggle or button, carved in ivory or wood and attached by the Japanese to the fasteners of their medicine boxes

or pipe-cases. In spite of their small size they are often exquisitely carved, as a rule into grotesque forms, and as they have been made continuously from the 15th century they constitute an important branch of Japanese art.

Neutral. A term applied to a vague colour, which does not present any predominant tone. It particularly denotes a grey of a bluish violet tint used in water colours. Neutral tints form excellent grounds for pictures, for they increase the value of striking colours and make them stand out with peculiar brilliance.

Nevers. (Pot.) From the beginning of the 17th century Nevers was the centre of a very important ceramic industry. The earliest pieces of *Nivernais* pottery were made under the auspices of a family named Conrad, and were copied from oriental models. In the 18th century Italian faïence was imitated at Nevers. About 1760 the manufacture lost its artistic interest and became entirely commercial.

Newel. (Arch.) A term applied to the central part of a spiral staircase.

Niche. (Arch.) A recess either in the façade or in the interior wall of a

building, sometimes enclosed by pilasters and intended to contain a statue, bust, or decorative vase. Examples of niches are found in every style of architecture. In the Arabian style the term *niche* is

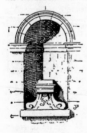

applied to the series of *alveoli*, which support ceilings. In buildings of the

Gothic periods we meet with niches formed by colonnettes supporting a small pediment and sheltering a statue. In the 16th century niches are generally covered with a canopy. In the architecture of

the 17th and 18th centuries niches play an important part in the external decoration of buildings.

Nicholas, St. St. Nicholas, one of the most popular saints in the calendar, was born at Panthera, in Asia Minor, was for many years bishop of Myra, and died in 326 A. D. On one occasion he threw three purses or balls of gold into the house of a nobleman, whose three daughters were penniless and undowered. On another he restored to life three boys who had been killed and put in a brine-tub by an innkeeper. These two episodes in his life have suggested subjects to many artists. His attributes are three balls of gold, an anchor, and a ship, for he is the protector of seafaring men and commerce. He is also the patron saint of Russia, and in an especial degree the friend of young children.

Nickelled. A term applied to metal ornaments, whether of iron, copper, or bronze, upon which is deposited by an electro-metallic process a coating of nickel. This protects the metal from rust and from the alterations caused by rust and damp, and at the same time gives it a brilliant appearance.

Niellatori. The artists who practised that branch of engraving metal plates called niello. (q.v.)

Niello. A process of decorating metal plates brought to perfection by the goldsmiths of Italy in the 15th century. A design was incised upon a plate of silver or of gold and silver mixed. A black compound consisting of copper, lead, borax, sulphur, and sal ammoniac was then introduced at a high temperature into the incised lines, and when cool formed an incrustation, leaving the rest of the metal plate bare. The plate was then polished and presented the appearance of black incrustation on a

light ground. This method of engraving metal plates was practised with success by Byzantine and German artists, and many of their works are executed with wonderful delicacy. The Italians, however, were the most distinguished *niella-tori*, and among them Tomaso or Maso Finiguerra is justly the most celebrated. He was in the habit of testing his half-finished work, by taking a proof of it in earth or sulphur or even on paper. There is in the print-room of the Paris Library a proof on paper of a *Pax* partially engraved in niello by Finiguerra in 1452. This proof is of the greatest importance in the history of engraving, for there is no doubt that intaglio engraving, the art of multiplying copies of a design incised on a metal plate, took its rise from the rough proof taken by the goldsmiths of the 15th century from their nielli.

Niggling. (Paint.) When such details as the leaves on a tree are treated separately, and without any regard to their mass, they are said to be *niggled*, and their method of treatment is called *niggling*. The works of the Pre-Raphaelites afford many complete instances of niggling, and will illustrate the confusion and want of dignity insured by this false realism.

Night. The Greeks with their characteristic anthropomorphism, regarded Night as the daughter of Chaos, the wife of Erebos, and the mother of Sleep and Death. Artistic representations of her are by no means unknown. A statue of Night by the sculptor Rhoecus is said to have existed in Ephesus in the 7th century B.C. On painted vases she appears as heavily draped and wearing a veil covered with stars. She bears two children, Death and Sleep, in her arms.

Nike. The goddess of victory among the Greeks. She was particularly associated with Athene and Zeus, and the golden and ivory statues of Athene at Athens and of Zeus at Olympia each held a winged Nike in its hand. Nike was generally represented as a draped maiden with wings. She holds a palm-branch and wreath in her hand, and sometimes stands upon a globe. Coins struck in commemoration of a victory frequently have a figure of Nike struck upon them. One of the most celebrated statues of Nike in existence is from the hands of Paeonius. It was ordered by the Messenians to commemorate the victory of Sphacteria, and a cast of it is to be seen at the British Museum. As we have said, Nike is generally a winged goddess, but in early art she is represented without wings, and a temple in honour of Nike Apterus, or Wingless Victory, existed at Athens.

Nimbed. A saint is said to be *nimbed* when his head is surrounded with a nimbus.

Nimbus. The luminous circle placed by painters and sculptors on the heads of saints. Some nimbi are cruciform,

others triangular. They assume indeed a variety of forms, according to the saint whose head they surround. [Aureole.]

Niobe. In Greek mythology Niobe was

the wife of Amphion, and as a punishment for her boast that she might rival Leto as the mother of beautiful children, her children were all slain by the arrows of Apollo and Artemis. The tragic fate of Niobe and her children has from early times been a favourite subject with artists. The most celebrated rendering of it in ancient times was a group by Scopas.

Nocturne. (Paint.) A group of modern painters have borrowed the terminology of music for the description of their works, and for some time it has been the fashion to call impressions of night nocturnes.

Norman Architecture. Norman architecture is the style which prevailed in England from the Conquest until about the end of the twelfth century. The doorways and windows are round-headed, and are often recessed and enriched with several bands of ornaments. The arches are always round. The piers are generally massive, and are either circular or multangular. The mouldings principally used are the zigzag, beakhead, and square abacus. The capitals are heavy and large, and sometimes rudely carved with grotesque heads or foliage. The general effect of a Norman building is massive and sombre. The majority of Norman churches were found wanting by the succeeding ages and modified or destroyed. The nave at Rochester and St. Bartholomew's Church in Smithfield are good examples of the style.

Note. (Paint.) A term applied in painting to the tonality of a work or to some special quality in its composition. Thus we speak of a good note of colour. By an easy transition a picture itself in which a certain note of colour is evident may be called a *note*. Thus in the catalogues of pictures belonging to the advanced school we frequently meet with such titles as a *note in red*.

Nowed. (Her.) An heraldic term which means knotted or twisted. It is applied to serpents or wyverns or other animals which are represented with their tails twisted or tied in a knot.

Nude. A term applied to studies of the figure made from the naked living model. For instance we speak of a drawing of the nude and at the same time we term the drawing itself a nude.

Numismatics. The science which treats of the coins and medals of all ages and their artistic and historical significance. From an artistic point of view the study of ancient Greek coins is of the utmost importance, for not only are they in themselves of great beauty, but they preserve for us the representation of many Greek statues in miniature, and so supply links in the chain of art-history which otherwise would be missing.

Numismatist. A term denoting those who collect and study coins and medals.

Nuremberg Pottery. (Pot.) Nuremberg has been a centre of ceramic industry from early times. Many beautiful plaques, tiles, and dishes were made there in the 16th century, which in their decoration display the influence of the Renaissance. The Nuremberg potteries were in a flourishing condition in the 18th century.

O.

Obelisk. (Arch.) An Egyptian monu-

ment in the form of a monolith of

pyramidal form. By analogy the term is applied to any small pyramid which is high in comparison with its breadth. Egyptian obelisks were generally monoliths of colossal proportions, such as the so-called Cleopatra's Needle, which stands on the Embankment in London. In some modern buildings obelisks—which, however, are not monolithic—are employed either as finials or as lamps.

Oblatorium. (Arch.) A lateral apse in a Christian basilica in which the bread and wine were blessed. It is also known under the name *Prothesis*.

Oblique. A term applied to any direction which is neither vertical nor horizontal.

Obliterate. To efface a copper plate from which engravings have been struck by covering it with deep and irregular incisions, which completely destroy the value of the work. The purpose of obliterating plates is to prevent any further prints being struck from them, as a large number of prints diminishes the value of the earlier impressions. A purely fictitious value is thus frequently given to engravings. In a recent instance only fifty impressions were struck from a plate, which was then broken up into fifty pieces and distributed among the fifty subscribers, although it was in a perfectly good state and might still have furnished many hundreds of proofs.

Oblong. A term applied to any object the length of which is greater than its breadth.

Observe. To study a model closely and so to reproduce it with accuracy. Thus in criticising a picture we say that the figures are well observed, or that the effect of light and shade is the result of careful observation.

Obtuse. An angle greater than a right angle.

Obverse. (Numis.) That side of a coin or medal upon which the face or the main device is struck. It is opposed to reverse (q.v.), which is especially reserved for the inscription.

Oceanides. The daughters of the Greek sea-god Oceanus. In Greek art they are represented, like the mermaids of Teutonic mythology, as being half human, half fish. They wear seaweed wreathed in their hair and ride on dolphins.

Oceanus. In Greek mythology Oceanus is said to be the son of Uranus and Gaia, and the god of the sea. In artistic representations he appears as an aged man with a bull's horn. He rides upon a dolphin or in a chariot drawn by seamonsters, and in his hand he holds a sceptre, symbolic of the power he exercises over the sea.

Ochre. (Paint.) An argillaceous substance coloured by oxide of iron.

—, **Brown.** A pigment obtained from a clay containing oxide of iron and oxide of manganese.

—, **Red.** A red pigment obtained from sulphate of iron or by calcining yellow ochre. It is of a good colour and permanent as a rule, the only objection to its free use being that it contains iron, and so is likely to adversely affect some pigments with which it is mixed.

—, **Yellow.** A yellow pigment which is nothing more or less than a peroxide or hydrate of iron. It is useful both in oil and water-colour, as it is permanent. It is somewhat opaque, and should be avoided when transparency is aimed at. What has been said about red ochre applies equally to yellow. The iron it contains renders it dangerous to some other pigments, and this danger is greater in chemically prepared than in native yellow ochre.

Octohedron. A solid body with eight faces.

Octostyle. (Arch.) A term applied to ancient temples, the façade of which was decorated with eight columns. The Parthenon, the famous temple of Athene at Athens, was octostyle.

Oculus. (Arch.) A small opening or window of circular form which admits light and air. The term is especially applied to the circular openings made

at the top of the pediment in Latin basilicae. The oculus is also found in buildings of the Romanesque and Gothic styles. When it plays an important part in the decorative scheme of a façade it is called a rose window (q.v.).

Odeon. (Arch.) A Greek building, differing in its roof and internal architecture from a theatre. It was used principally for concerts. The most celebrated Odeon at Athens was built in the time of Pericles, and stood not far from the theatre of Dionysus.

Oenochoe. (Pot.) A vase or jug which was used in ancient Greece for pouring the wine from the *crater* to the drinking cup. The majority of these vases, which are often richly decorated, are graceful and tapering in form. Sometimes, however, the *oenochoe* is ovoidal in

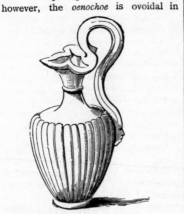

shape, has a very thin neck and a

light handle gracefully curved in the shape of an S. Such is the one represented in our second cut, which is taken from a bronze oenochoe found at Volterra.

Offskip. (Paint.) That portion of a landscape which recedes into distance is called the *offskip*.

Ogee. (Arch.) A moulding formed of two segments of a circle, the concave segment occupying the upper part of the mould-ing and the convex the lower. The ogee, which is of a gracefully undulat-ing form, is a moulding frequently employed in the entablature and projecting crowning of a building.

—, **Reverse.** An ogee moulding, the upper part of which is occupied by the convex segment of a circle. It is employed as a moulding in pedestals and sub-basements.

Ogive. (Arch.) A term applied by French architects to the Pointed or Gothic style which flourished in Western Europe from the 12th to the 16th century. In England we call this *Pointed* (q.v.).

Oil. (Paint.) The oils used in oil-painting are linseed oil, nut oil, poppy oil, spike or lavender oil, and drying oil for colours, such as lake, ultramarine, and blacks, which do not dry easily. For grinding colours a mixture of linseed oil and mastic is used. Up to the last century artists ground their colours themselves, and each had his own receipt for mixing the oil, of which he was very proud and which he jealously guarded. Some used linseed oil with a little copperas, while others added a certain quantity of litharge to nut oil.

—, **Drying.** Drying oil is obtained by adding to warm linseed oil a mixture of litharge, white lead, and black ochre.

—, **Linseed.** The best linseed oil formerly came from Holland. The painters of the last century, in order to make it as white as poppy oil, exposed it in leaden jars to the sun, adding white lead and

calcined talc to it. Linseed oil is an excellent siccative,

Oil, Nut. Nut oil, though not so good a siccative as linseed oil, is much whiter. It is accordingly used in diluting whites and greys, which would be easily tarnished by the colour of linseed oil.

—, **Poppy.** This oil is clearer than linseed oil, has neither taste nor smell, and is used for diluting white lead, the brilliance of which it does not in the slightest degree tarnish.

—, **Spike.** Spike oil is an essential oil of lavender and is used by painters for oiling out and for cleaning parts of the canvas. It is also found useful by painters in enamel.

Oiling-out. (Paint). When a picture is to be retouched, it has first to undergo the process of *oiling-out*. For this purpose a drying oil is used, which was prepared in the last century by artists themselves according to various recipes. As a rule it consisted of poppy oil, with certain substances added.

Oilettes. (Arch.) Long narrow slits in the walls of a fortified building through which archers discharged their arrows. Sometimes they were straight, sometimes cruciform; in the latter case they enabled the besieged to aim their arrows in several directions. [Loophole.]

Oiron Faïence. [Faïence of Henri II.]

Okimono. A Japanese word, which literally means " a thing to be placed." Hence it is applied to ornaments and objects which serve a decorative rather than a practical purpose.

Oleograph. A reproduction of a picture obtained by a process of printing in which a kind of oil-colour is used instead of the ordinary printer's ink. The term is especially applied to the proof obtained by the processes of chromolithography. The oleographic process has the advantage of cheapness, but its results are seldom, if ever, artistic.

Olive. The foliage of the olive-tree, which is a native of Asia, is frequently

used in decorative art. The leaf is oval in shape, its upper surface being of a dark green, while underneath it is of a lightish hue. The wood of the olive-tree is of a fine yellow tone, delicately veined with brown. It takes a beautiful polish, and is sometimes used in cabinet-making. In symbolic art the olive is the emblem of peace, and as this it figures in Byzantine art.

Olive Moulding. (Arch.) A decoration consisting of oblong pearls, which is employed to enrich baguettes and other mouldings which are convex in profile.

Olla. A common jar, generally made of baked clay, used by the ancients for cooking and other domestic purposes. It generally had a wide mouth and was covered by a lid, as is shown in our cut.

Olpe. (Pot.) An ancient vase of variable size, which resembles a leather flask in shape. It has a circular handle and a wide flat rim.

Onuphrius, St. St. Onuphrius, according to the legend was a monk of Thebes, who spent sixty years of his life alone in a bleak desert. After enduring without a murmur the pangs of hunger, he was found dying in the wilderness by another monk, who buried him. In art he is represented as an aged man, scantily clad and with a lean and hungry look.

Onyx. A variety of agate or chalcedony of remarkable beauty and marked by parallel and concentric rays variously coloured. It was much used by the ancients for cameo-engraving.

Opal. A blueish white variety of quartz, which is semi-transparent and iridescent.

Opalescent. A body is said to be *opalescent* when it is semi-transparent and iridescent like an opal. The scientific explanation of the phenomenon of opalescence is that particles of gas or solid matter are uniformly intermixed in a transparent body.

Opaque. (Paint.) A term applied to pigments which lack transparency. Chrome green is a good example of an opaque pigment. Some pigments undergo a curious change when laid on the canvas; they lose their *opacity* and so allow any colour which has been laid on beneath them to be distinctly seen. This is especially the case with pigments containing lead, the use of which can never be recommended.

Open Air. (Paint.) [Plein Air.]

Opening. (Arch.) A general term applied to the bays, windows, doors, and other spaces which break a façade, the nave of a church, &c.

Opisthodomus (Arch.) That part of the Greek temple behind the cella (q.v.) in which the treasures of the deity and other relics are kept. It was at the western end of the building, the Greek temple differing from the Christian church in having its principal entrance in its eastern façade.

Opus Alexandrinum. (Arch.) A simple kind of mosaic pavement much used in Rome. Its distinguishing feature is that its patterns, which are always geometrical, are composed entirely of two colours.

Opus Antiquum. (Arch.) A form of masonry employed by Roman architects in which the stones were not squared. This kind of stone-work is also called *opus incertuum.* Both the *opus antiquum* and the *opus spicatum,* or herring-bone masonry, were used in buildings of the Latin and Romanesque styles.

— **Reticulatum.** (Arch.) A term applied by Roman architects to that kind of brickwork or masonry which we term diamond pattern.

— **Spicatum.** (Arch.) In Roman architecture the masonry which we call herring-bone was called opus spicatum. [Masonry, Herring-bone]

Or. (Her.) The heraldic name for gold. It is indicated on a shield by tiny dots powdered over a plain field. The shield in our cut would be described thus: Or, a bend gules.

Orange. A secondary colour produced by the mixture of two primary colours, red and yellow.

— **Chrome.** This pigment, which is a rich opaque orange, is a chromate of lead. Like all lead pigments it has a deleterious effect on the pigments with which it is mixed, but in pure air and unmixed it is fairly permanent.

— **Vermilion.** A pigment somewhat resembling red lead. It is more brilliant and less opaque than vermilion. It is also pure and permanent and dries well.

Oratory. (Arch.) A small private chapel or a room arranged and decorated as a chapel.

Orb. The orb surmounted by a cross is the symbol of sovereign power. It is

frequently represented as held in the left hand in portraits of royal personages, who hold the sceptre in the right. Queen Elizabeth, for instance, in the well-known portrait of her in the National Portrait Gallery, holds an orb in her hand.

Orchestra. (Arch). In the theatre of the Greeks and Romans the *orchestra* was the central portion of the building, and corresponded to the pit of an English theatre. The Greek orchestra was set apart for the evolutions of the chorus, but in the Roman theatre the orchestra was filled with the seats assigned to senators and other important personages. The orchestra in the modern theatre is a narrow space in front of the footlights, in which the musicians sit. It is sometimes sunk below the level of the stage, and concealed from the sight of the audience.

Order. (Arch.) The term order was applied to the three main styles of Greek architecture, which were distinguished the one from the other by various details and especially by their proportions and

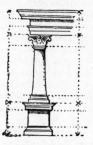

by the character of their columns and entablatures. They were entitled the *Doric, Ionic,* and *Corinthian,* and under these heads they are discussed. In Roman times another order entitled the *Tuscan* was developed. Two orders may be combined in the same building, each retaining its main features. At the Renaissance the classical orders were revived with certain modifications.

Ordinary. (Her.) The simple forms which were originally used as heraldic distinctions were called ordinaries. The honourable *ordinaries* are nine in number, the chief, pale, bend, bend sinister, fess, bar, chevron, cross, and cross saltier. In addition to these there are thirteen subordinate ordinaries. A description of each of the ordinaries, honourable and subordinate, is to be found under its separate heading.

Oreillettes.
Round bosses of metal, sometimes with a projecting spike, which were worn in the helmets of the 15th century to protect the ear.

Orfrays. An embroidered border now only employed in sacerdotal vestments, executed in threads of gold, silver, or silk.

Organ Case. A timber construction enclosing the mechanism and pipes of an organ. The organ cases of the 15th and 16th centuries were frequently ornamented with paintings. In the 17th and 18th centuries they assumed a decorative character of imposing fulness. They projected beyond the statues or columns which formed their support and were decorated with an extraordinary wealth of sculptured ornament.

Oriel. The term *oriel* is applied to the small rooms sometimes found at the end of halls in country houses or colleges, with a bay window projecting some distance from the wall. This window is called an oriel window, and by analogy any window resembling its shape is known by the same name.

Orientation. (Arch.) The arrangement always followed in the building of Christian churches, which enables the worshippers to face the east.

Orient Yellow. (Paint.) A rich but somewhat opaque yellow of a beautiful golden tint. It is a very serviceable pigment both in oil and water-colour, as it dries well and is permanent.

Oriflamme. The oriflamme, which was the standard of the ancient kings of France, was once the banner of the *abbés* of St. Denis. In former times it had three points terminated by tufts and was hoisted at the end of a lance. Nowadays oriflammes are hung like banners and are frequently carried in processions.

Original. A term applied to the personal method of conceiving and interpreting a work of art which is suggested by nature or by the artist's own imagination. In another sense the word denotes a picture, drawing, or statue, from which copies or reproductions have been made.

Originality. Originality includes all the distinctly personal or individual qualities which characterise an artist's work. To lack originality is to remain in the old bonds. But originality is something different from eccentricity. Indeed, it is the virtue to which eccentricity is the corresponding vice.

Orle. (Her.) The *orle* is a narrow band extending round the shield at a slight

distance inside the edge, so as to form another shield hollowed out. It thus might properly be described as an *escutcheon voided*, and was in fact so blazoned by early heralds.

Ornament. A painted or sculptured motive enclosed by regular or irregular lines and contributing to the richness and effect of a work of art. Ornament consists of a succession of purely conventional patterns or of a free rendering of foliage and figures. In any case they consist of an arbitrary series of lines or curves which vary according to the fancy of the artist. The question as to the origin of conventional or geometrical ornament is wrapt in obscurity. Similar patterns are found in the decoration of all ages and all countries. The most probable theory is that they are developments or degradations of natural objects. It is easily conceivable, for instance, that a human head drawn over and over again, without reference to the original, might finally be so conventionalised as to become a mere pattern or arbitrary arrangement of lines. Architectural ornament includes mouldings of every kind as well as the cartouches, metopes, brackets, &c., which decorate façades, friezes, or vaults. [Foliage, Moulding, &c.]

Ornament, Arabian. Arabian ornament is based upon geometrical combinations of circles, polygons, trapeziums, triangles, lozenges, and other figures variously coloured and harmonised with the utmost ingenuity.

—, **Egyptian.** The principal systems of ornament employed in the Egyptian style consist of hieroglyphics, winged globes, scarabs, symbolic animals, and foliage, especially that of the lotus and palm.

—, **Gothic.** The Gothic ornament of the 12th and 13th centuries consisted of a scrupulously exact reproduction of the flora of the country or district in which a particular building was situated, together with representations of chimerical animals. In the 14th century the taste for ornament decreased. The architects of the 15th century, however, were very lavish in their use of ornament, which soon lost its purity of line and became meaningless and extravagant.

—, **Greek.** Greek ornament for the most part consists of foliage applied symmetrically to the various portions of the entablature (q.v.). Such are the leaves which adorn the curve of capitals and the roses which are placed on friezes. The classical architecture of the Renaissance adopted Greek ornament with some slight modifications,

—, **Polychrome.** Ornament in several colours. [Polychromy.]

—, **Roman.** The ornament applied to Roman architecture differs but little from

that applied to Greek architecture. However, in the decoration of wall surfaces and pavements the Romans employed mosaics and fresco-paintings on variously coloured grounds. In these works the design generally consisted of a central motive surrounded by foliage, garlands, and arabesques. The fragments of paintings found at Pompeii present many examples of wall surfaces thus decorated with arabesques, figurines, fanciful buildings, and labyrinths.

Ornament, Romanesque. During the Romanesque period architectural ornament, which in the Byzantine age had been of the utmost richness, was confined to the faulty reproduction of classical motives. The ornament which added so much grace to the Greek orders is scarcely recognisable in the heavy clumsy decoration of Romanesque architecture.

Orpiment. (Paint.) A pigment compounded of sulphide and oxide of arsenic. It is a rich colour varying from yellow to orange. It is found in a natural state and is also manufactured. It was much used by the ancients, and by them called *auripigmentum*, but modern science has proved that it is not permanent, and that it is adversely affected by other pigments; its use therefore cannot be recommended.

Orthography. A term applied to geometrical elevations and geometrical drawings representing a building with its dimensions reduced to scale, without any attempt at perspective.

Ostensoir. A transparent vase or pyx (q.v.), in which the host is placed, and so exposed to the sight of the worshippers. Many of the *ostensoirs* made by goldsmiths in Catholic countries during the last century were of great beauty. They are generally in the form of a *gloria* and are sometimes enriched with heads of

cherubims, ears of corn, and bunches of grapes. One of the finest in existence is that in Notre Dame, at Paris. It is in the form of a sun and is of solid silver. It was presented to the church by the Canon of La Porte and was executed by Ballin, goldsmith to the king, after the design of the architect de Cotte. It measures no less than five feet in height, and is supported by the figure of an ange' holding the book of Revelations in hi⋮ hand.

Osteology. The important branch of anatomy which includes the study of bones, the osseous system, and the skeleton. It is a study of the utmost importance to artists.

Outremer. [Ultramarine.]

Outline. (Paint.) The imaginary line which surrounds an object, when represented in drawing or painting, is termed an *outline.* How much can be achieved by a single outline is proved by the exquisite drawings of Holbein. In painting, an emphatic definition of outline should be avoided, as it is not essential to good draughtmanship, and it produces an effect of harshness, which is not seen in nature.

Oval. An oblong curve. In principle

the oval is a curve which in form approaches as nearly as possible to half an egg cut lengthwise. But the term has a wider application. Thus an ellipse is called an oval. Oblong

curves are often formed by several arcs

of circles meeting one another, and having their several centres placed symmetrically. The human face seen in front may be inscribed in an oblong curve of this kind. The *oval* of a face is a common expression.

Over-all. (Her.) When a figure is

borne over another figure, so as to hide part of it, it is said to be over-all.

Ovolo. (Arch.) A continuous ornament in the form of an egg, which generally decorates the moulding called a *quarter-round*. The eggs are generally separated from one another by pointed darts. The *ovolo* is very widely employed to decorate the mould-

ings of the ancient Greek orders as well as Roman and Renaissance mouldings. Some writers on architecture have fallen into the error of using the term *ovolo* to denote the quarter-round mould, instead of the ornament which decorates it.

Owl. In ancient times the owl was the bird sacred to Athene, and Athenian coins bore an owl as their type. From this circumstance arose the famous proverb, "Owls of Athens," of which the modern form is "Coals to Newcastle."

Oxgall. [Gall.]

Oxybaphon. An ancient vase of con-

siderable dimensions and of the shape shown in our cut. It somewhat resembled the crater both in shape and use, and was sometimes provided with lateral handles placed not far below its rim.

P.

Pad. (Engr.) A kind of dabber slightly flattened and covered

with silk, by means of which the varnish, while still warm, is spread over copper plates which are to be etched.

Padding. (Paint.) Under this term is included every figure in a painting which does not add to the value of the composition, each accessory which, being superfluous, detracts from the merit of the work.

Pagoda. (Arch.) A term applied to the religious buildings of India, China, and the kingdom of Siam.

Paint. The pigments used by artists are generally known as *paints*.

Painting. Painting may be defined as that one of the formative arts, the end of which is to represent upon a flat surface by means of lines and colours the phenomena of the natural world, so that an illusion of reality in outline, modelling, and colour may be obtained. The means by which this end is arrived at may be summed up in *colour, perspective, light,* and *shade.* Painting may be roughly divided into (1) drawing, including water-colour, pastel, pencil, and chalk drawing, &c. In this class the work is executed upon paper, parchment, and similar materials; (2) oil-painting, in which pictures are executed in oil-colours upon canvas or panel; (3) mural painting, in which pictures are executed on wall-surfaces in dry colours or in water, tempera, or wax colours. To these divisions must be added vase-painting, glass-painting, and painting on porcelain and enamel. Painting may

be subdivided according to the objects represented, as follows : (1) historical painting, under which may be included religious and mythological works; (2) portraiture; (3) genre, the representation of domestic life and humorous scenes; (4) animal painting; (5) still-life; (6) landscape and seascape. Painting in some form or another has been practised in almost every age. The Greeks were the first to attain any proficiency in the art, and though they knew little of perspective, yet if we may judge from the vase-paintings and mural decorations that have come down to us, their work was always distinguished. In the Byzantine period painting was entirely conventionalised, and in the dark ages the art seems to have died out, but it had a new birth in Italy in the 13th century through the genius of Cimabue. [Schools of Painting.]

Palace. (Arch.) A collection of buildings, richly adorned and on a large scale, which serves as a dwelling for sovereigns and princes, or as a place of meeting for state bodies.

Palaestra. (Arch.) A Greek word denoting the place where athletes were trained. Structurally speaking, the palaestra differed but little from the gymnasium (q.v.). The Greeks valued physical grace and beauty very highly. The palaestra, therefore, occupied a very important place in the life of the ancient Greeks, and as it afforded the best opportunity for the study of the nude, its influence upon art, especially the art of sculpture, was considerable.

Pale. (Her.) The pale is one of the

honourable ordinaries. It consists of two perpendicular lines drawn from the base to the chief of the shield, which enclose a space equal to one-third of the shield.

Palette. (Paint.) The palette, one of the principal requirements of the painter, consists of a thin piece of wood, generally walnut or pear, hollowed out at one end . with a hole through which the thumb is passed. Palettes are either oval or square. To begin with the palette is set, that is to say, it is covered with colours arranged in a certain

order. On its edge a small saucer is sometimes hung to hold the oil. In water-colour painting palettes of porcelain are used, while the palette used in distemper may be described as a large piece of wood surrounded by holes, in which the colours are ground in water and mixed with size. The palette is often regarded as the symbol of painting. The gilder's palette is an instrument of wood

which the gilder uses to spread his gold leaf upon. The term palette is also applied to the tablet used by workers in stucco, as well as to the iron instrument with which binders stamp ornaments on the back of books.

Palette Knife. (Paint.) The palette knife is a strip of horn or flexible metal, which is used by painters to mix their colours on the palette before laying them on their canvas with a brush. In former times this was the only purpose to which the palette knife was put, but in the present generation its importance has considerably increased. Some painters of the modern school use the palette knife only and

never the brush in the execution of their works. Others lay in their skies and foregrounds with the palette knife. The palette knife has changed its traditional form, and often assumes a triangular or other shape, according to the method of work of the artist who uses it.

Palettes. Small disks or plates of metal which, when plate armour was worn, were fixed

at the shoulder, as represented in our cuts.

Palimpsest. A term applied to ancient manuscripts upon parchment which has already been written upon once and then erased or otherwise washed clean. In modern times certain chemical reagents have been discovered which render the original writing more or less legible, and by this means many valuable fragments of ancient literature have been discovered in palimpsest.

Palissy Ware. (Pot.) Palissy ware is the pottery made by the distinguished French potter, Bernard Palissy (1506—1596?). This indefatigable artist set about making enamels, and for nearly twenty years met with no success. At length, however, he triumphed, and made the figures in high relief for which he is still famous. His most characteristic works were the *rustiques figulines*, which were dishes or vases with a rough ground, upon which frogs, snakes,

fish, lizards, and other creatures were figured.

Pall. (Her.) A pall is an ecclesiastical vestment worn over the shoulders. The part of it shown on a shield takes the form of the letter Y. The pall is only worn by archbishops, and is the distinctive mark in heraldry of these dignitaries of the Church.

Palla. A robe worn by Greek women and reaching from the neck to the feet. It consisted of a rectangular piece of cloth, a portion of which was folded over

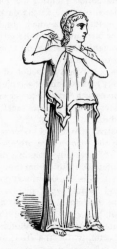

before it was put on, so that the upper portion fell double over the wearer. It was secured at the shoulders with a brooch.

Palladian. A name given to the classical style of architecture, as it was revived in the 16th century by the celebrated architect Andrea Palladio. At a time when architecture was losing its grace and simplicity, Palladio insisted on an observance of proportion and restraint. The buildings which give

us the best idea of the Palladian style are to be seen at Vicenza and Venice.

Pallas Athene. [Athene.]

Pallet. (Her.) A diminutive of the *pale* (q.v.).

Pallium. A garment which may best be described as a large cloak. It completely enveloped the wearer, and was much worn by the Greeks, among whom it took the place occupied at Rome by the

toga. It could be worn in an infinite variety of ways according to the taste of the wearer.

Palm. The leaf of the palm-tree forms a frequent motive in decorative art. It

is particularly appropriate in the construction of trophies, as it is the symbol of victory. In Indian fabrics the name

palm-leaf is given to a different ornament. This is a leaf curved at the end and covered with foliage and arabesques, often very complicated in design and rich in colour. A system of ornament consisting of small palm-leaves is used in various styles of architecture. Sometimes the leaf is inscribed in a curve, or it consists of several stems, five in number or even more, held together by a kind of clasp. Their lower portion

often ends in a scroll. In classical art the palm is the emblem of Victory, and figures of Victory frequently hold a palm-branch in their hand, as in our cut, which is a copy of a Roman gem. In Christian art the palm

is the emblem of martyrdom, and in mediæval pictures martyrs are invariably represented holding a palm.

Palstave. A curious weapon, consisting of a piece of metal, such as is represented in our cut, which could be

fixed upon a staff and used with considerable effect. It is pre-eminently a

Scandinavian weapon, but it was used as well by all the Celtic nations.

Paludamentum. A cloak generally of fine texture and rich colour, which was worn by Roman officers over their

armour. It was fastened on the shoulder by a brooch, and in shape, though not in size—for it was considerably larger— it resembled the Greek chlamys.

Paly. (Her.) In heraldry a field is said to be *paly* when it is divided into several equal parts by perpendicular lines. These equal parts are alter-

nately metal and tincture. The shield in our cut is described thus: Paly of four, argent and gules.

Pan. Pan was regarded by the Greeks as the god of flocks and herds, hunting and fishing. He was said to have been the inventor of the shepherd's pipe, which after him was called Pan's pipe. He is represented in art as a short-bearded man, with the ears, horns, and legs of a goat, and his attributes are a pipe and a crook.

Panathenaic Amphorae. (Pot.) These vases were given as prizes to the victors in the Panathenaic festival, which took place every year at Athens in honour of Athene. The vases are in the form of amphorae with lids. On the body of the vases is a representation of Athene in her panoply. On each side of the goddess stands a column surmounted by an owl, cock, or human figure. The inscription Τῶν ᾿Αθήνηθεν ῎Αθλων runs down the side of the vases, which are always purposely archaic in style. On the Parthenon frieze, now among the Elgin marbles in the British Museum may be seen a representation of the Panathenaic procession.

Pandroseum. (Arch.) A name given to a portion of the Erechtheum, which stood on the Acropolis at Athens, consisting of a porch, the entablature of which was supported by caryatides (q.v.).

Pane. (Arch.) A sheet of glass placed within the frame of a window.

Panel. In architecture a panel is a flat or convex surface surrounded with a frame or decorated with mouldings. Sunk compartments in walls, for instance, are panels. The term panel also denotes a piece of wood which is used instead of canvas for painting pictures on. English panels are to be preferred to any others, as they do not spoil under the influence of atmospheric changes.

Panel-picture. A name given to a picture painted not upon canvas but a piece of wood or panel. Panel-

pictures were painted by the earliest artists, and many specimens are to be seen in every picture gallery. The cut we give here is from a manuscript of the 14th century, and represents an artist painting a panel-portrait of herself, scanning her own features in a mirror.

Pannel. (Her.) A common charge of occasional occurrence in heraldry, representing a poplar-leaf. Pannels generally appear in number on a shield. Thus, for example, we might have the following charge: *Ten pannels argent placed three, three, three, and one.*

Panorama. A picture painted on canvas without any break in its continuity and fixed against a circular wall. The spectators stand in the centre of the panorama upon a platform considerably raised and in half darkness. A strong light falling on the foreground, whether it is painted or real, adds to the depth and greatly increases the illusion. The panorama was invented by Richard Barker, an artist of Edinburgh, who in the year 1788 exhibited a panorama of that city. The exhibition was continued in London, where views of London and pictures representing the wars of Napoleon were shown. The first panorama was seen in France in 1799, and since that time exhibitions of this kind have enjoyed unbroken popularity in Paris. One of the most recent was a picture of the battle of Champigny, and was the work of Detaille and de Neuville.

Pantheon. (Arch.) An ancient temple consecrated to the worship of all the gods. Athens and Rome, for instance, had each its Pantheon. The name Pantheon has also been given to buildings raised in honour of the illustrious men of a nation.

Pantile. (Arch.) A curved tile used in roofing.

Pantograph. An instrument by means

of which drawings may be either enlarged

or reduced in exact mathematical proportion. Pantographs are worked on different systems. The one in most general use is based on the principle of similar triangles and enables us to obtain reproductions of an original, larger, smaller, or of the same size, according to the position of the pivot, on which the apparatus moves, of the point which follows the outline of the drawing, and the pencil with which the image is traced upon the paper.

Pantometer. An instrument with which angles are measured and perpendiculars dropped ; and also an instrument invented in 1752 by the Abbé Louvrier, with which portraits of persons in profile are executed mechanically.

Papelonné. (Her.) This term is applied to a shield covered with semicircular scales ranged in rows like tiles on the roof of a house. The body of the scale represents the field of the escutcheon and the edge of the scale is shown of a different tincture.

Paper. A material manufactured from vegetable substances reduced to a paste and pressed into thin leaves, available for drawing, writing, painting, or printing. It is made in certain sizes, each of which has its technical name, and these are given below :

WRITING AND DRAWING PAPERS.

	Dimensions.	
	in.	in.
Emperor	66	by 47
Antiquarian	53	,, 31
Double Elephant	40	,, 26¾
Atlas	34	,, 26
Colombier	34½	,, 23½
Imperial	30	,, 22
Elephant	28	,, 23
Super Royal	27	,, 19
Royal	24	,, 19
Medium	22	,, 17½
Demy	20	,, 15½

	Dimensions.	
	in.	in.
Large Post	20¾	by 16½
Post	18¾	,, 15¼
Foolscap	17	,, 13½
Pott	15	,, 12½
Copy	20	,, 16

PRINTING PAPERS.

	Dimensions.	
	in.	in.
Demy	22½	by 17¾
Royal	25	,, 20
Super Royal (about)	28	,, 20
Imperial	30	,, 22
Double Foolscap	27	,, 17
Double Crown	30	,, 20
Double Demy	35½	,, 22½

CARTRIDGE PAPERS.

	Dimensions.	
	in.	in.
Copy	20	by 16½
Demy	22½	,, 17¾
Royal	25	,, 20
Cartridge	26	,, 21½
Elephant	28	,, 23
Double Crown	30	,, 20
Double Demy	35½	,, 22½
Imperial	30	,, 22

Paper, Creswick. A particular kind of paper used for water-colour drawings.

—, **Chinese.** A paper of a yellowish tint, manufactured from the bark of the bamboo, upon which proofs of woodcuts or line engravings are printed. Some Chinese papers are clear in tint, while the tint of others is almost bistred. Chinese paper furnishes excellent proofs of woodcuts and fairly good proofs of line engravings. Proofs of the latter, however, on Chinese paper are somewhat too dry and spiritless, and are not to be compared for a moment with the magnificent proofs taken on parchment or Japanese paper. Chinese paper is also called India paper.

—, **Glass.** Canvas or paper upon which glass reduced to a very fine powder is sized. In the execution of picturesque etchings it is used to dull the surface of the copper, so that the plate, when inked, may yield a series of irregular

spots which help to mark the planes and give strength to the rendering of certain passages. Glass paper or emery paper is used to sharpen the point of gravers.

Paper, Emery. Paper covered with emery powder is used by artists to sharpen pencils or steel points, and by cabinet-makers to give a smooth surface to wood.

—, **India.** [India Paper.]

—, **Japanese.** [Japanese Paper.]

—, **Laid.** A term applied to paper in which the wiremarks, watermarks, or imprint of metal threads, which rested on the damp paste during the process of manufacture, are still to be seen. Laid paper is solid, of great resisting power; it lends itself admirably to the printing of line engravings, but its use in taking proofs of vignettes in relief should be discountenanced.

—, **Parchment.** Paper immersed in a solution of sulphuric acid, which gives it the appearance of parchment. This kind of paper is used as a covering for books.

—, **Tissue.** A transparent paper which is used for laying over engravings for tracing and other purposes. It is generally made from the refuse of flax-mills.

—, **Tracing.** Tracing paper, such as is used by artists, is obtained by soaking ordinary tissue paper in turpentine or varnish. The process gives it a glazed surface, and enables it to be drawn on without tearing or cracking.

—, **Transfer.** A paper coated with a special preparation from which tracings may be obtained on a lithographic stone or a plate of zinc. A drawing is made upon the paper, which is then slightly damped, laid upon the stone or plate, and submitted to pressure. A perfectly accurate tracing is the result.

—, **Vellum.** Vellum paper is a strong paper without any grain, as uniform and satiny as possible. When of a good quality it is excellent for taking proofs of engravings in relief, as it reproduces the most delicate qualities of the cut. Unfortunately vellum paper is far less solid than laid paper, and it easily gets spotted with damp.

Paper, Whatman. A very solid kind of paper, the grain of which varies from fine to coarse. Whatman paper of a coarse grain is used by water colourists. That with a fine grain is used in printing *editions de luxe*, after having been submitted to a heavy pressure, so as to soften the asperities of its grain. A thick kind of Whatman forms an excellent mount for prints or drawings.

Paper Hangings. From the 18th century paper printed with variously coloured designs has entirely taken the place of tapestry, leather, and other costly materials which were previously used as hangings. The earliest wall-papers were obtained by a process of stencilling, the later have been printed from wooden blocks upon which the design has been cut. A separate block is used for each colour, and the more costly papers are printed by hand, the cheaper ones being printed rapidly in a machine.

Papier Maché. A material composed of paper pulp sometimes mixed with size, which is reduced to a plastic mass and then pressed in moulds into various shapes. It is then dried, varnished, and painted, and various small ornaments may be made from it. It seems to have been first made in Paris about 1740.

Parabola. A parabola is a curve which results from the section of a cone by a plane parallel to one of its sides.

Paraboloid. A surface produced by the revolution of a parabola.

Parallel. Two lines in the same plane are said to be parallel if, when produced ever so far both ways, they never meet. The term is also applied to similar things placed symmetrically, to subjects of

similar outline which form *pendants* to one another, or to parts of a building of the same proportion.

Parallelipiped. A solid figure bounded by six rectangles or six squares. In the latter case it is termed a *right* parallelipiped. The cube is a parallelipiped.

Parallelogram. A four-sided figure, the opposite sides of which are equal and parallel. The *lozenge* (q.v.) is a parallelogram, the four sides of which are equal.

Parapet. A wall or barrier about breast high, which runs along the edge of a balcony, a platform, or bridge, or protects the top of a house or church.

Parallel-ruler. A contrivance consisting of two rulers, connected by metal hinges, which enable the rulers to be

placed at various distances from one another. By the use of the parallel-ruler parallel lines may be drawn without the aid of the square.

Parastate. (Arch.) A term applied indifferently to pilasters, pillars, and pied-droits (q.v.).

Parcae. [Fates, The.]

Parchment. The skin of a sheep or goat, which is prepared and polished with pumice stone and used for several artistic purposes. Old manuscripts, for instance, were executed on parchment, as well as gouaches and miniatures. Expensive works are sometimes printed on it, while it is admirably adapted for taking proofs of line engravings. A painting is said to have a parchment tone when it is a yellowish white, suggesting new parchment, or a yellowish grey, suggesting old parchment.

Parclose. (Arch.) The circumference of a church stall.

Pargetting. A term applied to the decorative figures, foliage, and garlands of plaster, which are found both inside and outside houses of the 16th and 17th centuries. In many English towns fine specimens of pargetting are to be found, often in very high relief.

Parian Marble. [Marble, Parian.]

Parody. A burlesque imitation or reproduction. To parody the manner of an artist is to reproduce sketches of his works, in which his style and touch are so exaggerated as to produce a grotesque and ridiculous effect.

Parthenon. The great temple built in honour of Pallas Athene, which stood on the Acropolis at Athens. It was built in the 5th century B.C. by Ictinus; in its *cella* or shrine stood the famous gold and ivory statue of the goddess, while its exterior was adorned by the magnificent sculptures designed by Pheidias himself, some of which are now to be seen among the Elgin marbles in the British Museum.

Parti pris. A French term for which there is no exact equivalent in English. It denotes the method in which an artist has chosen to distribute the light of a picture, to conceive a scene, to compose or treat a subject. Thus we may say of a picture that it lacks *parti pris*.

Partizan. A long staff surmounted by a broad blade, somewhat resembling a spear-head, but with an ornamental pro-

jection on each side of it. It was in its origin a weapon of war, but like the

halberd and some other weapons, it early degenerated into a mere mark of dignity.

Party per. (Her.) These words are used to denote that the shield is divided, and are followed by a word explaining how the division is made. Thus the

three cuts here given represent respectively divisions denoted by the phrases, *party per fess, party per bend sinister,* and *party per pale.*

Party per Fess. (Her.) When a hori-

zontal line is drawn through the centre of a shield, the shield is termed *party per fess,* because the line passes through the fess point. The proper description of our cut is party per fess, engrailed, argent and gules.

Party per Pale. (Her.) When a per-

pendicular line is drawn down the centre of a shield from chief to base, the shield is termed *party per pale.* We give an example of a shield, party per pale, gules and argent.

Party per Saltire. (Her.) When a shield is divided by partition lines in the

direction of the *bend* and the *bend sinister,* it is said to be *party per sal-tire,* for the two partition lines crossing one another make that form of cross known as a *saltire.*

Parvise. (Arch.) An enclosed piece of ground situated in front of a Christian basilica or church. In early times the parvise was called the *atrium,* and was set apart for catechumens and penitents. In the Middle Ages the term parvise was reserved for a space shut in with low walls or railings in front of the

principal door of a church. Thus we speak of the parvise of a church or of a cathedral.

Passage. (1.) (Arch.) A corridor which serves as an exit or adit from one wing of a building to another. The term is also applied to a vast covered gallery and to a narrow street reserved for foot-passengers.

Passage. (2.) (Paint.) The method of transition from one tone to another, or from light to shade. When the transition from the luminous part of a picture to the portion plunged in shade is not gradual, the passage is said to be abrupt. In the language of art criticism we are frequently told that a "picture contains charming passages." This is of course a metaphor taken from literature or music.

Passe-partout. (Engrav.) A passe-partout is an engraving either in relief or line, formed of two movable parts. The term may be applied, for instance, to ornamental letters engraved on wood, the frame of which always remains the same, while the centre is movable. Some etchings too, used to illustrate books in the last century, may be called passe-partout. These consisted of a richly decorated border, in the midst of which vignettes with various legends were placed; these vignettes could be changed from time to time, the frame meanwhile remaining the same. A double mount in which a drawing or engraving may be easily slipped is also called a passe-partout.

Paste. (Pot.) A mixture of various substances ground and blended from which porcelain is made. The term *paste* is also applied to glass, coloured by rock crystal, so as to imitate gems. From this paste facsimiles of ancient engraved gems have been obtained both in ancient and modern times, and the copies are often so accurate that they even deceive connoisseurs, From an artistic point of view they are often not a whit inferior to the originals from which they are copied.

Pasteboard. A material composed of several sheets of paper pasted together and compressed, so as to form a close, compact body. It is used for several artistic purposes, such as drawing up and mounting prints or water-colours.

Pastel. (Paint.) A process of drawing in colour, in which variously coloured crayons are used. The pastel is drawn upon paper with a rough surface or upon a canvas covered with a kind of dis-temper. The colours are laid on with hard crayons, while the lights, masses, and planes are indicated with soft crayons, which can be crushed and spread with the finger or stump. Draw-ings in pastel are easily effaced. Their whole surface may be destroyed with one stroke of the brush. They there-fore should be set with a special fixative and be carefully shielded from air or damp, and even placed under glass, if it is desired to preserve them. The crayons used in pastel drawing have a basis of pipeclay or gum arabic, accord-ing as the colours to be mixed are soft or dry. A box of pastels generally includes thirty crayons, hard, medium, and soft, giving for each colour the gradation of tints from white to the natural tone.

Pastiche, Pasticcio. The imitation of a work of art, in which the reproduction either of the work of a particular master is aimed at or of the details and char-acteristics of a school. Many modern pictures may best be described as pleasant *pastiches* of the ancient masters.

Pastoral. The term *pastoral* is applied to pictures in which conventional shep-herds and shepherdesses play a part. The works of Watteau and Boucher are among the most celebrated *pastoral* pic-tures.

— Staff. (Her.) This term is applied to the staff which priors and abbots often employed as a crest to their shields. In earlier times it was surmounted with a cross-piece, so as to form a *Tau;* later on a globe was substituted for the cross-piece. In processions the pastoral staff was carried behind the shield of the prior of the convent.

Paten. A vessel used in the services of the Catholic Church. It is on the paten that the host is laid before the communion. Considering the purpose which it serves, it is not surprising that

the paten was in olden times frequently engraved or enamelled, and sometimes brilliant with jewels. Our cut repre-sents a paten, now in Cliffe Church, Kent.

Patenôtre. (Arch.) A system of orna-ment consisting of rows of chaplets or

garlands made up of small round or oval seeds.

Patera. An open shallow dish or saucer, which was used by the Romans

for holding liquids. The special purpose to which the patera was put was to contain the wine which was to be

poured over the head of a victim in a sacrifice.

In architecture the term patera is applied to an ornament which consists

of a circular rosette, the outline of which suggests the form of the ancient patera.

Patina. (1.) A green crust, formed of carbonate of copper, or verdigris, which appears on the surface of bronzes exposed to the air. On ancient works in bronze we find a green blue patina or rust, which allows the masses of brown metal, as well as the brilliant spots which reflect the light, to be seen through it. This patina is obtained artificially by the forgers of ancient works of art, by plunging metal objects in a bath of acetic acid, chloride of sodium, and hydrosulphate of ammonia. The term is applied in painting to the tone assumed by the varnish which covers a picture after several years' exposure to the light. Time gives to some pictures a *patina* of an exquisitely delicate tone. By an extension of meaning, the soft, mellow appearance which works of art gain under the influence of various atmospheric conditions or under the influence of particles of dust is called *patina*. For instance, marble statues or buildings may be covered with a patina, which gives them a harmonious appearance.

Patina. (2) A vessel, generally of earthenware, considerably deeper than

the patera (q.v.). It was used by the Romans for a variety of domestic purposes.

Patte. (Paint.) In the slang of the French studio *avoir la patte* is to combine a ready skill of hand with spirit and energy. An artist is said to have *une patte de diable*, when he paints pictures with an astonishing cleverness, which is great enough to cover a thousand faults of drawing or composition.

Paul, St. St. Paul is frequently represented in art. His invariable attribute is the sword, and he appears as a man of short stature and bearded. Among the incidents in his career which have suggested subjects to painters may be mentioned his persecution of St. Stephen, his conversion, and his martyrdom. His conversion has been treated by Raphael,

Michael Angelo, and Rubens. St. Paul too, is often represented in conjunction with St. Peter.

Pavilion. (Arch.) A term applied to small shelters of picturesque design, to little houses standing apart in gardens, or to large spaces covered and glazed, and symmetrical in form, which protect a square or market.

Pavimentum Sectile. (Arch.) A name given by archaeologists to mosaic pavements, composed of fragments of coloured marbles of various shapes, but always arranged so as to form geometrical combinations.

— **Sculpturatum.** A pavement covered with designs, the outlines of which are obtained by engraving and by filling the hollows made by the graver with black mastic. This method of ornamenting floors was practised by the Romans, and carried to perfection by the Italians. A fine specimen of the *pavimentum sculpturatum* is to be seen in the Duomo of Siena.

— **Tesselatum.** A mosaic floor composed of uniform and regular cubes of variously coloured marble, arranged in geometrical patterns.

— **Vermiculatum.** A mosaic flooring, in which subjects drawn from the natural world are represented by means of small pieces of coloured marble of different shapes and sizes, so arranged as to follow the outline of the figures or ornaments represented.

Paving. (Arch.) The covering of the horizontal surface of the ground with slabs of stone or marble, squares of terra-cotta, or cubes of wood laid in a bed of asphalte.

Paw. (Her.) The lower part of the leg of the lion or any other animal is called a *paw.* In the language of her-

aldry the word is confined to the case when the limb is cut off below the middle joint, and if more of the leg than this is shown it is called a *jambe* (q.v.).

Pax. A plaque of metal, sometimes circular in form, sometimes square, which in the services of the Church was first kissed by the officiating priest and then carried round for the worshippers to kiss. It was damascened, engraved, or ornamented with *nielli*, and the subjects generally repre- sented on the *pax* were the crucifixion, the head of Christ, or the Lamb. From the pax of Maso Finiguerra were struck the first line engravings known to us [Niello.]

Payne's Grey. (Paint.) A compound colour of a lilac grey tint.

Peacock. In classical art the peacock is the attribute of Hera (q.v.) or Juno. In the Christian art of the Byzantine period it symbolizes the resurrection.

Peau. (Her.) This fur differs only from ermine in the tinctures of its field and spots, which are sable and or respectively. It is thus the reverse of *erminois* (q.v.).

P e d e s t a l. (Arch.) A support, upon which a statue is placed. It is generally 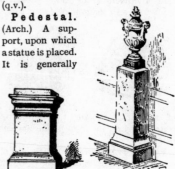 square, and is provided with mouldings,

a base, and a cornice. The square part is termed the dado. Pedestals upon which statues stand in gardens are sometimes cylindrical or cut cantwise.

Pedicule. (Arch.) An isolated pillar serving as a support; for instance, the *pedicule* of a baptismal font; also the crowning of a pointed arch upon which a statuette is placed.

Pediment. (Arch.) A crowning of a building formed of two portions of oblique cornices or a circular portion which meets the cornice of the entablature at its ends. The façade of ancient temples was always terminated by a pediment, the two sides of the pediment marking the slope of the roof. Mediæval buildings, too, were frequently surmounted by a pediment,

which, however, was generally known as a gable (q.v.). The pediments of the Renaissance period are as a rule circular or broken. The pediments of ancient temples were generally filled with groups of statues, which together represented some subject drawn from classical mythology. For instance, on one of the pediments of the Parthenon was represented the birth of Athene from the head of Zeus. Pediments were surmounted with Acroteria (q.v.).

—, **Angular.** A pediment, the outline

of which is formed by two oblique cornices and a horizontal cornice. Pediments of this form are generally decorated with finials placed on their summit.

—, **Broken.** A pediment, the lateral

cornices of which terminate in volutes or are cut off from the centre of the pediment, so as to leave an empty space, in which a pedestal is placed supporting a bust or statue.

Pediment, Circular. A pediment, the cornice of which describes an arc of a circle. In the 17th and 18th centuries

this form of pediment was in frequent use.

—, **Couped.** A pediment is said to be couped when its summit is broken, so as to give room for a vase, statue, bust, or other ornament.

—, **Double.** When one pediment is inscribed in another, the two are said to form a double pediment. The greater serves to crown the

entablature, the lesser to crown an opening or ornament set within the greater.

—, **Open.** A pediment pierced by an opening in which is a

moulding encircling a bull's-eye.

—, **Surbased.** A flat pediment, the angle of which is larger than a right angle. The majority of ancient temples, the façades of which were of considerable breadth, had *surbased* pediments.

—, **Surmounted.** A pediment, the angle of which is less than a right angle.

—, **Triangular.** A pediment in the form of an equilateral triangle. This kind of pediment as well as the surmounted pediment were frequently employed by the architects of the Renaissance. Many

chateaux of this period have dormers

with triangular or surmounted pediments.

Pelasgic. (Arch.) The term Pelasgic is applied to the earliest remains of architecture known in Greece, to which the name Cyclopean (q.v.) is also given.

Pelice. (Pot.) A form of Greek vase, more tapering than the amphora, which

it resembles in other respects. It has two handles connecting the neck with the body of the vase.

Pelta. A light shield of wicker or wood, covered with leather, but never

strengthened with metal. It was either round or semicircular, in which latter case it was termed *lunata.* It was carried by Asiatics, and Amazons are frequently represented *peltatae,* or bearing the *pelta.*

Pen and Ink Drawing. The universal adoption of the various processes of engraving has done much to encourage pen and ink drawing, simple drawings in black and white being easily reproduced. Steel pens, the fineness of which varies with the kind of drawing which is to be executed, have now generally replaced the old-fashioned quill. Some artists use reeds sharpened to a point, goosequills, or even hair brushes charged with ink, to add a few vigorous touches to pen and ink drawings.

Penates. The household gods of the Romans were called Penates. With the Lares (q.v.) they resembled the patron saints of Catholic times. They were kept in the *lararium,* and sacrifices were offered in their honour. They are represented in art sometimes as old men fully draped, sometimes as youths holding a patera and a horn of plenty.

Pencil. A pencil consists of a thin strip of graphite or plumbago inserted in a cylinder of cedar-wood. The best are manufactured from Cumberland lead. They are used by artists for making rapid sketches upon paper. The term pencil is sometimes applied to the small hair-brushes, set in metal ferrules, which are used by water-colourists.

Pendant. In Gothic architecture the term *pendant* is applied to a boss or other ornament which hangs downwards from a ceiling or roof. Pendants are most frequently found at the intersection of vaults. In another sense a picture or piece of sculpture may be said to be a pendant to another, when

it is similar in size and subject and designed to fill a similar space.

Pendant, Post. In Gothic architecture a pendant post is a post set against the wall, its upper end being connected with the tie-beam while a corbel or capital supports its under side.

Pennon. A small narrow flag either in the shape of a tapering triangle or of a

 swallow's tail. In the Middle Ages it was usually fastened to the end of a lance, and if arms were blazoned on it they were so depicted as to be upright, when the lance was carried horizontally.

Pentacle. A mystical figure consisting

of two triangles, the one superposed on the other as in our cut.

Pentadecagon. A geometrical figure which has fifteen sides, and therefore fifteen angles.

Pentagon. A polygon with fifteen sides and fifteen angles.

Pentaptych. A painted or sculptured panel, which consists of five leaves folded one over the other. Some authors give the name of pentaptych to a triptych, when the two leaves which fold over the centre leaf are each formed of two panels.

Pentathlon. The *pentathlon* was the most highly esteemed of all the athletic contests of the Greeks. As its name implies, it consisted of five "events"—running, jumping, discus and spear throwing, and wrestling. Whether the prize was given to the man who won the " odd event," or was reserved for the victor in them all, is a matter of doubt. The

competitors in the pentathlon are frequently represented on painted vases.

Penthouse. (Arch.) A shed or roof with a single slope fixed to the wall of a

building by its upper edge. The term pent-roof is applied to any roof arranged on this plan.

Penumbra. The penumbra is that part of a shade in which there is a spot of light due to divergent rays. At the point at which the light blends with the shade the lines become less hard and less dry.

Peperino. A conglomerate of ashes and small stones, of volcanic origin, much used under the name of *lapis albanus* by the Romans for building purposes. It is grey in colour, somewhat tinged with green, and it is quarried at the present day at Marino.

Peplum. (Cost.) A long robe worn by

Greek women, very similar in construction and arrangement to the palla (q.v.)

of the Romans, which has already been described.

Peribole. (Arch.) The exterior circumference of a building, also the space surrounding an ancient temple, which was decorated with statues, altars, and votive offerings.

Peridrome. (Arch.) A covered gallery running round a building.

Peripteral. (Arch.) An ancient temple is said to be peripteral when it is surrounded on all sides by free columns. The colonnade thus formed is termed the peripteros.

Peristyle. (Arch.) A colonnade running round the interior of a courtyard. An ancient temple is called peristyle when its interior is adorned with a row of columns. In Roman domestic architecture the peristyle was the central courtyard, surrounded with a colonnade, through which entrance was gained to the private apartments.

Perpendicular. (1) The perpendicular direction is that given by the force of gravity. A figure is said to be out of the perpendicular when the vertical line which marks the centre of gravity falls outside the middle of the base of this figure. Such is the case with certain antique statues, the Venus of Milo for instance. A monument is said to be out of the perpendicular when its vertical lines do not coincide with those given by the plumb-line. The most celebrated example of this is the Leaning Tower of Pisa.

Perpendicular. (2.) (Arch.) This term denotes the style of Gothic architecture which was in vogue in England from the end of the 14th century until the middle of the 16th. The following are some of its main characteristics. Its arches are depressed and belong to the varieties of arches known as *obtuse pointed* and four-centred. Mouldings are angular, and windows are crossed by transomes. A square label is generally found over arched doorways, and the spandrils thus

formed present an opportunity for decoration. The roofs are generally somewhat flat, and the general impression given by a building of this style is one of horizontal and perpendicular lines.

Perpent. (Arch.) A course of stones, the thickness of which is equal to the thickness of the wall; thus the two

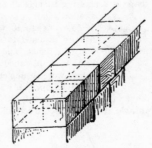

opposite faces of the stones form the two vertical sides of the wall.

Perron. (Arch.) An outside staircase, a series of steps projecting from a façade or connecting the terraces of a garden,

which are situated on different levels.

Persienne. (Arch.) A shutter which lets in the daylight. A kind of pierced frame, made up of slips of wood inclined at an angle like louvre-boarding.

Persephone. Persephone, the daughter of Zeus and Demeter, was carried off to the lower world by Hades, whose bride she became. Her mother, Demeter (q.v.), sought for her over the whole earth, but found her not. At last Hermes went to the lower world to look for her, but she had then eaten half the pomegranate which Hades had given her, and so she could only return to the

upper world for half of each year. She is represented in Art as somewhat resembling Demeter, but younger. Her attributes are a pomegranate and ears of corn and poppies.

Perseus. Perseus, the slayer of the Gorgon, Medusa, and the rescuer of Andromeda from a sea-monster, has suggested many subjects to artists both ancient and modern. The earliest known representation of Perseus is on one of the metopes of a temple at Selinus, which belongs to the 7th century B.C. He is there shown as cutting off Medusa's head. Among the latest works of art which deal with Perseus are a series of designs by Mr. Burne-Jones. Perseus is easily recognisable in artistic representations as he carries the Gorgon's head and a curved sword, and wears wings on his heels and head,

Perspective. Perspective is the art of representing upon a plane surface objects as they appear to the eye of the spectator from one fixed point.

—, **Ærial.** The art of indicating the relative distances of objects by means of a gradation of tone. Thus due diminution should be given to the strength of the light, shade, and colour of objects according to their distances, the quantity of light received by them, and the medium through which they are seen.

—, **Isometrical.** A perspective drawing, the purpose of which is to indicate in the representation the relation which the dimension of the actual object bears to the dimension of the object as represented.

—, **Linear.** A branch of science which enables us to represent upon a plane surface, by means of a geometrical drawing only, solid bodies as they appear to the eye, their proportions and dimensions being determined by their relative distance from the spectator and the position in which they stand with regard to him.

— **of Shadows.** A branch of perspective by the aid of which after putting the objects represented in perspective, the position and outline of the shadows is represented.

Perspective, Parallel. When an object presents a face or side towards the spectator, its representation is determined by the rules of parallel perspective.

—, **Visual.** When we speak of *visual perspective* in a picture, we mean that the artist has got very near to an appearance of reality, without having recourse to any theoretical rules, and without the strict application of the laws of geometry.

Pestle. (Paint.) A piece of crystal, marble, or porphyry, which resembles a truncated cone in form. It has a plane surface, with which colours placed on

a block of marble are ground. Pestles are made in all sorts of shapes. Some are large enough to be held in both hands; these are used for grinding colour to be used in oil-painting. On the other hand the pestles used by

painters in enamel and on porcelain are very small; they are provided with a handle, and grind the colours in small saucers of marble or agate.

Pétard. (Paint.) In the language of the studios of Paris, *tirer in pétard* is to produce a work which is purposely eccentric and is designed to attract the attention of the public to its author. Similarly a picture is said to be too

pétard when it is painted in extravagantly brilliant tones, which take it out of the realm of truth.

Petasus. A low-crowned, broad-brimmed hat, worn in Greece by travellers. It was an attribute of Hermes, and Greek artists when they wished to make it clear that a personage represented by them was on a journey, adopted the simple expedient of slinging a petasus over his back.

Peter, St. The attributes of St. Peter are the keys, the cross, and the book. As this apostle was regarded as the first bishop, he is often represented as wearing a mitre. Representations of the following incidents in his career are frequently found: His call with St. Andrew; his attempt to walk on the sea; the striking off of Malchus's ear; the denial of Christ; the delivery of the keys of the Church to Peter by Christ; and his death by crucifixion head downwards. The legend of Simon Magus, his attempt to bribe Peter and his subsequent fall, have also suggested many subjects.

Petite Nature. A French term applied to figures in painting or sculpture, the dimensions of which are intermediate between life size and half life size.

Petimtse. (Pot.) A Chinese word denoting a kind of felspar, which is mixed with kaolin (q.v.) used in the manufacture of porcelain. It vitrifies while the kaolin remains infusible.

Pew. (Arch.) This term is applied to the parallel rows of seats placed in the nave and aisles of churches. The pews which belong to an early period are often exquisite specimens of wood carving, and add to the dignity and beauty of the churches in which they are found. In the first half of the present century pews were constructed in the shape of square wooden boxes, which were disfigurements to the church, and possessed the sole advantage of concealing their occupants from the gaze of their neighbours.

Phaleræ. Round bosses of metal, to which pendants were sometimes attached, worn at Rome by those who had distinguished themselves in military

service or elsewhere. They corresponded to modern medals. Our cut represents M. Caelius (from whose cenotaph it is taken) decorated with phaleræ.

Phantoscope. An optical instrument which is used to throw images upon a screen or upon vaporous clouds.

Pharos. (Arch.) A term applied by the Greeks and Romans to a lighthouse (q.v.). It was derived from the structure on the island of Pharos, near Alexandria, which was regarded as typical.

Phelloplastic. The art of reproducing celebrated buildings or bird's-eye views of towns in cork. By employing a reduced scale the exact dimensions of a building or city may be given. This process, which was invented by Agostino Rosa in 1780, has been found useful in making models of harbours, docks, &c.

Pheon. (Her.) This heraldic charge represents a broad arrow head, such as was discharged from a crossbow. It was a mark of royalty, and as such still survives in the well-known broad arrow.

Phigaleian Marbles. (Sculp.) The sculptured frieze from the temple of Apollo Epicurius, at Phigaleia, is now at the British Museum, and is generally described as the Phigaleian Marbles. It represents the battle between the Centaurs and Amazons, and belongs to the best period of Greek Art. But it is restless and violent in composition, and lacks the restraint characteristic of the style of Phidias.

Philatory. A reliquary containing the bones or relics of a saint. That

represented in our cut is at Aix-la-Chapelle, and is said to contain the arm of St. Simon the Just.

Philip, St. The first of the Apostles who was called upon to follow Christ. In art he is represented as wearing a short beard and carrying in his hand a staff surmounted by a small cross. The principal scenes in his life which have suggested subjects to painters are his exorcising a dragon at Hieropolis and his martyrdom. In some pictures of his martyrdom he is represented as crucified with his head downwards,

Phocas, St. In the Greek Church St. Phocas is the patron saint of gardens and gardeners. The legend runs that he lived near the city of Sinope, where he cultivated his garden and distributed gifts among the poor. One night some strangers came to his door, and after they had supped they told him they had been commanded to seek out Phocas

and to put him to death. Phocas dug a grave in his garden and then revealed himself. He was put to death and buried among his flowers. In Byzantine pictures and mosaics representations of St. Phocas, spade in hand, are common, but they do not occur in later art.

Photocalque. A kind of camera obscura, in which by a combination of mirrors an image may be obtained upon a piece of polished glass, placed horizontally, and a tracing taken of it without difficulty.

Photochromatic. A term applied to all those processes the object of which is to reproduce colours by photographic methods.

Photogalvanography. A process of heliographic engraving, by means of which drawings either in relief or incised may be obtained and clichés made from them.

Photogenic. A term applied to colours which act upon sensitised photographic plates.

Photoglyptic. A process of engraving in which photographic clichés are used. A cliché in gelatine is obtained from a cliché on glass. The gelatine cliché having been covered with a special kind of ink, prints white or black, according as it represents the light or shadowed portions of the picture reproduced.

Photographic Camera. A rectangular case, the sides of which are of leather and allow the distance between the two vertical faces to be increased or dimin-

ished at will. The object glass is placed on one vertical face, while the other is covered by a piece of dull glass. By expanding the camera and regulating its

distance from the object which is to be reproduced, an image of extraordinary clearness may be obtained. It is thus that the proper "focus" of an object is found. To obtain a photographic image, a frame containing a sensitive plate is placed at the back of the camera.

Photograph. A faithful representation of an object obtained by the action of the sun's rays upon a chemically prepared plate.

Photography. A process of obtaining images of natural objects by means of chemical agents and special apparatus.

—, Instantaneous. The process of obtaining photographic proofs instantaneously, or in a scarcely appreciable space of time, by opening and shutting the object glass as rapidly as possible. Instantaneous photography has yielded valuable information on the movements of horses and other questions, which without its aid were well-nigh insoluble.

— on Enamel. Photographic proofs transferred to enamel and rendered inalterable by baking.

—, Polychrome. A term including all the processes by which photographic proofs in colour are obtained.

Photogravure. A process by which photographic clichés are transformed to plates in relief, from which prints may be obtained. The term is also applied to the prints thus obtained.

Photolithography. A process which consists in transforming a photographic cliché to a drawing upon stone.

Photosculpture. A process which consists in photographing a model from several points of view, and making a rough sketch in clay by following with a pantograph the outline of the photographs, each of which gives a different aspect of the model. A rough sketch of a figure is thus obtained, and only a few touches are necessary to get rid of the edges and impart individuality to the subject.

Phototypography. A process by means of which photographic clichés may be transformed to engravings in relief, which may be printed from in a typographic press.

Phylactery. A phylactery is a band which was worn by the ancients, the Jews especially. In artistic representations of the Gothic period figures often hold phylacteries, the ends of which are curled up in their hands. Legends, mottoes, verses of the Psalms, &c., are frequently inscribed on these phylacteries. In manuscripts of the same period phylacteries are employed as borders to pages and are wound round bunches of flowers and foliage.

Picture. A representation of any object in the natural world painted upon canvas or panel is termed a picture. In ancient times the majority of pictures were painted on mural surfaces, but

pictures hung upon a wall as decorations were known to the Greeks and Romans, as may be seen by our cut, which is taken from a wall-painting at Pompeii.

Picture Frame. The object of a picture frame is to isolate a picture from the surrounding wall-surface. Every

frame should be designed to suit the picture which it is intended to fit, if the picture is to have its proper effect, but unfortunately the general practice is to make all picture frames uniform in substance and design. The picture frames of the Renaissance and the periods of

Louis XIV., XV., and XVI. were of carved wood and of considerable artistic merit. Modern frames are usually made of wood or pasteboard, sometimes gilded and decorated with mouldings. The majority of them, however, are manufactured wholesale, and lack character. During the last few years a new system of framing has been introduced, in which plush, velvet, satin, sackcloth, Japanese stamped leathers,

and other materials, have played an important part. In France frames covered with these materials have long been popular. The hard and fast rule which the Royal Academy imposes on exhibitors of framing their pictures in gilt frames has checked the ingenuity and taste of English artists in this direction.

Picture, To make a. A scene or group which composes well and hangs together is said to make a picture. A composition fails to make a picture when it is unhappily conceived and badly arranged.

Picturesque. All manifestations of nature which have effect, relief, and colour, or indeed are worthy to inspire a work of art, are said to be picturesque. "Design, relief, and colour make up the picturesque Trinity," says a famous art critic. All that charms us by its aspect and arrangement, as well as by

the absence of the commonplace, may be called *picturesque.* Thus there is picturesqueness in a limited sense of the word in ruins, cottages, &c. In the broadest application of the term it may be said that everything that is paintable is picturesque.

Piece-mould. In taking a cast of a statue or model in plaster of Paris, the wet plaster of Paris is put on and removed in pieces. The mould thus formed is called a piece-mould, the pieces being fitted together before the mould is used for obtaining a cast.

Pied-droit. (Arch.) A term applied to the vertical part of a wall supporting an arch; also to the vertical sides of an opening of a bay. In this sense the term does not differ from *jamb.* In the Romanesque style jamb-stones are sometimes found in the form of pilasters or square

or prismatic pillars without any colonnette at their angles.

Piedouche. (Arch.) A pedestal of small dimensions and of a peculiar shape used for supporting a bust. Piedouches generally consist of a large hollow moulding, enriched above and below with projecting mouldings. Of late years, how-

ever, many sculptors have adopted the fashion of cutting off busts abruptly and setting them upon a square piedouche without any moulding or decoration, save a cartouche bearing an inscription.

Pier. (Arch.) The term *pier* may be

applied to any vertical support, such as a pillar or column, or the wall between two windows. In architecture the term is now seldom used, but in the language of construction it is frequently and widely employed.

Pieta. A term applied to pictures representing the Dead Christ. The Virgin and sorrowing women stand near, and sometimes the Virgin holds the head of Christ in her lap.

Pilaster. (Arch.) A square support terminated by a base and a capital. In

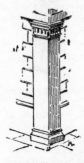

Greek architecture the capital of a pilaster always differed from that of a column. In build-

ings of the Roman and Renaissance periods, on the other hand, the capitals of pilasters were actual capitals of columns drawn upon a square plane.

Pile. (Her.) The pile, which is classified in heraldry as a *subordinary*, is a long pointed stake extending from the top of the shield to the base. It is supposed to represent the stakes of wood driven

into the ground to form foundations for castles. When charges are so arranged on a shield as to suggest the shape of a pile, they are described as borne *in-pile.*

The proper description of the second cut is Argent, three swords in pile, their points towards the base.

Piles. (Arch.) A series of stakes driven into the ground and held together at the top by a frame work of timber. They serve as a foundation for masonry when the ground is damp or un-

stable. Works constructed in water are also built upon piles.

Pileus. A round felt cap, generally brimless, which was worn by the ancients. The Phrygian cap which Paris is represented as

wearing in the Aeginetan marbles is a form of the pileus.

Pillar. (Arch.) Vertical supports with or without decoration. They are espe-

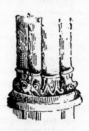

cially used in Gothic architecture, sometimes singly, sometimes in clusters. Pil-

lars are frequently square and sometimes surrounded with columns. In the Early English period they are round or cruciform. In the 14th century they are supported on pedestals equal in number to the colonnettes which cluster round them. In the 15th century they lose their capitals.

Pily. (Her.) A term applied to a shield covered with piles.

Pinacotheca. A name given at Athens to the hall of the Propylæa, in which pictures were displayed. In the time of the Roman empire, when Greek art had influenced the Romans, picture galleries in private houses were called *pinacothecæ*. The term has survived in modern times to denote a museum of paintings, such, for instance, as the Pinakothek at Munich.

Pinchbeck. An alloy of copper, zinc, and tin, of a fine yellow colour which readily adapts itself to gilding processes, and is much used in the manufacture of cheap jewellery. This alloy got its name from Christopher Pinchbeck, a musical-clock maker, who plied his trade in Fleet Street in the last century. He invented the cheap imitation of gold by which he will always be remembered.

Pink. A pale rose colour. The term is also applied to a series of pigments of a greenish yellow colour, obtained by precipitating upon a base of chalk or alumina the juice of a plant known to botanists as *rhamnus frangula*. [Italian Pink.]

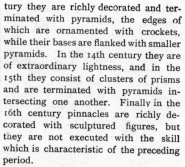

Pinnacle. (Arch.) A small bell turret in the form of a pyramid upon a polygonal base. In buildings of the Romanesque style instead of pinnacles we find very simple finials. The pinnacles of the 11th and 12th centuries are sometimes terminated with a sort of cone. In the 13th century they are richly decorated and terminated with pyramids, the edges of which are ornamented with crockets, while their bases are flanked with smaller pyramids. In the 14th century they are of extraordinary lightness, and in the 15th they consist of clusters of prisms and are terminated with pyramids intersecting one another. Finally in the 16th century pinnacles are richly decorated with sculptured figures, but they are not executed with the skill which is characteristic of the preceding period.

Pinx. An abbreviation of the Latin word *pinxit*. It often follows the name of the painter of a picture which is reproduced by the process of engraving, lithography, or photogravure.

Piscina. (Arch.) A reservoir or cistern placed in the open air, and used by the Romans as a swimming bath. In Gothic churches the piscina was a basin in which the priest washed the chalice

after administering the sacrament. It was either set against a pillar or placed under an arcade, in which case it was generally richly ornamented.

Pitch. (Arch.) The pitch of a roof is its slope or inclination to the horizon.

Pitcher. A vessel for holding liquids similar in shape and size to a jug.

Pithos. A large earthenware jar somewhat resembling an amphora in form, but deeper and rounder. Sometimes it had a narrow neck. Sometimes it was wide-mouthed. The *pithos* was frequently of such huge dimensions that it could easily hold a man. The tub in which Diogenes was said to have dwelt, was

perhaps a broken, useless *pithos;* at any rate, it is represented as such in our illustration, which is from a bas-relief in the Villa Albani.

Pix. A box or casket in which the consecrated wafer was kept in the Catholic Church. It is generally of metal, and often richly decorated and enamelled.

Plan. (Arch.) A term which includes geometrical drawings in general, and in particular drawings which represent the projection of the walls of a building upon a horizontal plane or the outline of the walls upon the ground.

Planchette. A tablet mounted upon a

tripod used by surveyors. [Alidade.]

Plane. (Paint.) A term applied in art to the different vertical surfaces parallel to the surface of a canvas, which, with the aid of perspective, represents the distances existing between a series of objects and the eye of the spectator. If a figure, for instance, is represented as too near or too far, it is said to be out of its proper plane. Of an ill-constructed picture we say that its planes are not sufficiently indicated.

—, **Ground.** The ground plane may be defined as the *floor* of a drawing or picture. It extends from the lower edge of the picture to the horizon.

—, **Horizontal.** In a picture or drawing a plane is said to be horizontal when it is parallel to the lower edge of the picture.

—, **Picture.** The vertical plane upon which a picture or drawing is made. It is parallel to the spectators, and is represented by the whole paper or canvas upon which the drawing is executed.

—, **Vertical.** In a picture or drawing a plane is said to be vertical when it is at right angles to the ground plane of the picture.

Planisher. A workman whose business it is to prepare copper plates for engravers. He also aids the engraver in effacing, if necessary, any part of the plate after it has been engraved. He lowers the tone of those portions of the plate which have been too deeply bitten in by striking it with a wooden hammer so as to beat down the metal and lessen the breadth of the hatchings. He may also efface parts of a copper plate, sparing the rest of the work, and then beat out the plate wherever the engraver wishes to engrave it afresh. When this

has to be done the plate is held in a vice and beaten on the reverse side to that which has been effaced.

Plaque. A flat piece of metal, terra-cotta, or china, upon which designs are executed by processes peculiar to the material. Plaques of various kinds are and have been from earliest times a popular form of decoration.

Plaster-cast. A copy of a work of sculpture, produced in plaster by mechanical processes. Thus we speak of a plaster-cast of the antique. [Cast.]

Plastic Art. Plastic art is the art of reproducing the relief or form of an object; the art of modelling figures. In plastic art such malleable materials as terra-cotta, clay, wax, and plaster are used, while the creations of the plastic artist may be afterwards translated into marble or bronze. The term plastic art is used in opposition to graphic or pictorial art. Bas-reliefs may be said to occupy an intermediate position between plastic and graphic art.

Platband. The upper part of a rectangular opening or bay constructed of ashlared stones.

Plate. (Engrav.) A piece of copper upon which an engraver works is called a plate. Hence the impression obtained from an engraved plate is itself termed a plate. Thus we describe an engraving as an excellent plate, or we speak of a book illustrated with plates. The term is only applicable to impressions struck from steel or copper, and should never be used of wood-cuts. A plate is said to be *worn* when so many impressions have been taken from it that it prints pale and indistinct. When a wood block is worn out a precisely opposite effect is produced, for it prints black. The pieces of glass upon which photographic proofs are obtained are also called plates.

Plate Armour. Plate armour, which consisted of solid plates of metal, came into use in the 14th century. It was extremely heavy and unwieldy, but in some form or other it continued in fashion until its uselessness was generally recognised, and it was finally abandoned in the 17th century.

Platinotype. (Phot) A process of printing photographic proofs by means of the salts of platinum. The proofs thus obtained are generally of a cold black or sepia tone. Prints obtained by this process have many advantages. They have not the glossy surface of the ordinary photograph, and they are quite permanent.

Plein Air. (Paint.) The *plein air* school is a school of modern French painters, whose creed it is to paint their pictures in the open air. In a studio lighted by a single light, which falls at a given angle, strongly-marked arrangements of light and shade are always obtained; when, however, the model poses in the open air, the modelling of the planes is less positive on account of the wealth of light, reflections, and luminous rays which envelop it on all sides. Under these conditions, the modelling is only obtained by accurately observing the value of the tones, and a projection, which, in the studio, would throw a decided shadow, is only indicated in a *plein-air* picture, by a tone-value helping to detach it. Lastly, it must be added that the expression of *plein-air* is not always used in a good sense. Some impressionists wishing to simplify things as far as possible, abuse the effects of *plein-air:* they dispense altogether with modelling, which, in this case — as many contemporary works show — demands a skilful rendering, and an extensive knowledge of the value of tones.

Plinth. In architecture a plinth is a square block at the base of a column, the purpose of which is to set off the circular mouldings above it. In all the ancient orders except the Doric the bases of columns are provided with a plinth. In

sculpture the plinth is the rectangular or circular base upon which a statue is placed. The titles of statues or other inscriptions are frequently placed upon plinths.

Their chief purpose is to set the statue at a proper elevation, so that the lower limbs of the figure are not concealed, and that the foreshortening does not alter its proportions.

Plumb. The direction of the plumb-line is found by letting a weight attached to a string fall freely to the ground. A figure is said to be out of plumb when the vertical line indicating the centre of gravity falls outside the middle of the base of this figure. Many ancient statues are out of plumb—the Venus of Milo, for instance. A building is said to be out of plumb when its vertical lines do not coincide with the direction given by the plumb-line. The most celebrated instance of such a building is the Tower of Pisa.

Plumbago. A substance also known as black lead, which is in reality a sulphuret of iron. It is used in the manufacture of lead pencils.

Pochade. A rough sketch, which may be easily and rapidly rubbed out.

Podium. (Arch.) A low projecting wall, which was placed in Roman buildings both outside and inside. A podium running round the interior of a building was often used as a shelf for wine casks, &c.

Point. (1) (Engrav.) Steel instruments with a sharp tip are used by engravers and called *points*. In past times engravers used simple sewing needles as points, but nowadays

small steel vergettes fitted into a handle of wood are frequently employed. In crayon engraving double and even triple points are used, so as to make

two or three dots or points at once. These points are fixed in wooden handles and are frequently blunted, in order that the marks they make on the plate may be the bigger. Engravers on

wood use a point which consists of a thin blade of steel. This is inserted into a haft of wood, cut in two, and bound together again with a twisted cord. The wood engraver uses the point as a kind

of knife for cutting away the block, so as to increase the white, which in a wood engraving ought to be deep enough not to be touched by the roller, with which the parts in relief are inked.

Point. (2) (Her.) The name sometimes given to a charge in the form of a wedge with broad end downwards, occupying about a third of the whole field. It is not essential that the *point* should rise to the top of the shield.

Point. (3) (Arch.) To point is to mark the joints and courses of the bricks or stones of a wall by means cf lines drawn upon the wall. Sometimes the pointings are painted in several colours and a flower is placed in the centre of each stone.

Pointed. The style of architecture generally called Gothic is also known as *Pointed* or *Christian Pointed.* As one of its characteristics is the pointed arch and window, this designation is a correct and convenient one. The Pointed style may be divided into three

great periods: (1) the primitive period, in which the pointed arch assumed the

lancet shape; (2) the secondary period, which lasted through the 13th and 14th centuries, and coincides in point of time with what we generally term the Decorated style; (3) the tertiary period, which occupied the 15th and part of the 16th centuries, when what we call the Perpendicular style

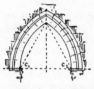

flourished. The following are the principal varieties of the pointed arch: (*a*) the lancet, or acute, which was in vogue in the 12th and 13th centuries. This form of pointed arch was frequently employed in the military architecture of the Middle Ages, but its chief interest

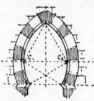

for us is that it is the distinguishing characteristic of the Early English style, of which Salisbury Cathedral is the most convenient example; (*b*) the equilateral, which consists of two arcs of circles, the radius of which is equal to the breadth of the arch at its springing line. This

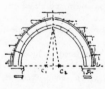

form of pointed arch was frequently employed in the 14th century; (*c*) the lanceolated, which consists of two arcs of circles, which are continued below the line, in which the centres lie. The Moorish and Saracenic arch sometimes assumes this form; (*d*) the obtuse, which consists of two arcs of circles, the radius of which is less than the breadth of the arch. This form of arch is characteristic of the buildings of the 15th century.

Pointing. (Sculp.) An operation, the aim of which is to reproduce a plaster cast in a block of stone or marble. The model and the block of marble are set side by side. Above each of them a square of wood is placed, the sides of which are marked off into equal spaces, and from which a plumb-line is suspended. This plumb-line may be moved and describes an imaginary parallelopiped, within which are enclosed the roughed-in block and the model of the statue. The distance between the plumb-line and one of the most projecting points of the model is then measured, and this

distance is marked on the block. The block is then cut away with a chisel as far as the point marked, so as to obtain the necessary depth. By repeating this operation for all the projecting points taken in one plane a silhouette of the model is obtained, the exactitude of which depends upon the nearness of the points taken to one another. Continuing the process for the other planes, an exact mathematical reproduction of the lines of the original is obtained. There is then nothing left for the sculptor but to give the marble its finishing touches before handing it over to the polisher.

Point of Sight. If a line is drawn from the spectator's eye at right angles to it, it will meet the horizontal line of a picture in a point called the *point of sight* or

centre of vision. This is the vanishing point of horizontal lines which are at right angles to the spectator.

Point, Station. The position selected by the painter in front of the object which he wishes to represent. If his picture is to be a consistent whole, the station point must not be changed.

Point, Vanishing. [Vanishing Point.]

Points of the Shield. (Her.) In order to determine accurately the position of a charge or a shield, heralds have assigned names to certain points, and by mentioning these points the position of a charge can be described with sufficient accuracy. There are altogether nine points thus distinguished by special names. We must first explain that the upper part of the shield is called the *chief*, the middle the *fess*, and the lower the *base*. Again the side of the shield which would be on the right hand of any

A, the dexter chief.

B, the precise middle chief.

C, the sinister chief.

D, the honour point.

E, the fess point.

F, the nombril point.

G, the dexter base.

H, the precise middle base.

I, the sinister base.

one standing behind it is called the *dexter* side, and the other side is called the *sinister*. We have then the following three points specified in the upper portion of the shield: *dexter chief, chief, sinister chief.* Similarly in the lower portion we have *dexter base, base, sinister base.* The central point of the shield is called the *fess point*, and the points immediately above and immediately below are called respectively the *honour point*

and the *nombril point*, making in all nine specified points.

Polishing. The polishing of marble statues is generally entrusted to workmen, but the sculptor should watch the process with care. Fine touches may easily disappear under the action of pumice-stone. The sculptors of antiquity sometimes polished their works with wax. Statues which are required to keep their polish are often covered with a light coat of varnish. Copper plates which are to be engraved are polished first with the scraper, then with sandstone, pumice-stone, and powdered chalk.

Polychrome. That which is of several colours. Greek sculpture was polychrome, that is to say, was painted in a variety of tints. This was of course done in a conventional spirit and without any attempt at realistic colouring. In modern times polychrome sculpture has not been held in honour, yet several attempts have been made to resuscitate this branch of art, especially by French sculptors, not only by colouring white marble statues as in former times, but also by employing materials of various colours. In ancient Egypt and Greece buildings too were polychrome, and no doubt richness of colour added much to the effect of temples such as the Parthenon. Some portions of Byzantine and Gothic buildings were painted, and their mouldings and other details heightened with colour and gilding. Nowadays there is a distinct prejudice against the polychrome decoration of churches and houses, and the effect formerly got by colour is now obtained by the use of variously coloured materials, such as bronze, marble, tiles, pottery, &c.

Polychromy. This term includes all the processes of printing, decoration, and colouring in which several colours are used.

Polygon. A geometrical figure which has several sides and several angle

Polygonal. That which has the form of a polygon.

Polyhedron. A solid figure presenting many plane sides.

Polyptych. Under this term were included, particularly in the Middle Ages and during the period of the Renaissance, altar-pieces and panels

closed by means of several leaves folded one over the other. In ancient times the term was applied to writing tablets of more than two leaves or sheets.

Poppy, Poppy-head. (Arch.) This term is applied to ornaments, sometimes consisting of fleurs-de-lis, sometimes of other flowers or foliage, which terminate the ends of seats and benches in churches. They are most frequently found in buildings of the Perpendicular style.

Porcelain. A hard, compact, and impermeable kind of pottery, formed from a fine and translucent paste, the principal base of which is kaoline.

—, **Hybrid.** A term applied to a kind of Italian porcelain in which the kaoline of Vicenza plays but a small part, the base being formed of quartz and vitreous grit, and glazed with a mixture of lead, quartz, and flux.

—, **Opaque.** A name incorrectly given to fine faïences, which are sometimes known as demi-porcelain.

Porch. (Arch.) The vestibule outside a Christian church, corresponding to that portion of an ancient temple which was called the pronaos. Some mediæval churches possess porches of extra-

ordinary magnificence. From the period of the Renaissance there have come down to us many beautiful specimens of porches of carved wood, while the entrance to many country churches is covered with a rustic porch of a picturesque appearance.

Porphyry. A hard stone, red or green in colour, covered with small white spots and capable of receiving a very high polish.

Portcullis. (1.) (Arch.) An iron grating hung on chains and placed in a vertical groove. When it was let down it served to close the entrance to the castles and strongholds of the Middle Ages. Under the name of *cataracta* the portcullis was in use among the Romans.

Portcullis. (2.) (Her.) A portculllis

with nail heads visible upon its trans-

verse bars frequently occurs as a charge in heraldry. It was one of the badges of the house of Tudor, and is frequently found as an architectural decoration in churches which were built under the auspices of the Tudors.

Porte-cartons. A small piece of furni-

ture which gene-rally resembles the letter X or Y in shape. It stands about breast-high, and is used to hold mounted draw-ings or portfolios, which can be thus more easily turned over.

Porte-Cochère. (Arch.) A gateway through which a carriage and horses may pass. [Gateway.]

Porte-crayon. An instrument of copper or brass, which consists of two branches soldered together. Its ends open out wide, so that in each of them a crayon or piece of chalk may be inserted, which is held tightly in its

place by a ring pressing together the branches of metal. It is chiefly used for holding a black crayon, which is thus prevented from soiling the fingers, and may be used when it is too short to be held by itself.

Portfolio. A term applied to a case in which drawings and engravings are preserved. It consists of two leaves of cardboard bound at the back in linen or canvas; it is sometimes provided with pieces of linen at the sides to keep the dust out and is fastened together with ribands. Portfolios are made of every shape and size.

Portico. (Arch.) A covered gallery or colonnade open to the air on one side, the vault or ceiling of which is supported by columns, pillars, or arches. The Greeks built porticoes of extraordinary

magnificence, which served as meeting-places or lounges, and were frequently

decorated with paintings and statues. The Romans adopted the portico from

the Greeks, and in the time of the Empire it was an invariable adjunct to the villa.

Portière. A curtain fixed on the lintel of a bay, draped and caught up or al-

lowed to fall ver-tically. Its purpose is the decoration or concealment of an opening. Tapes-tries and costly textures are some times used as por-tières.

Portland Vase. A vase now in the British Museum, so-called because it was brought to England by a Duke of Portland. Its body is of dark blue glass; this is covered with a thick layer of glass of a lighter colour, which is then cut away, and the result is a design of great beauty.

Portrait. A representation of a person, feature for feature; the image of a living model, drawn, painted, or sculp-tured, in which the artist endeavours to reproduce with accuracy the appearance,

attitude, and expression characteristic of his model.

Portrait, Bust. A representation, painted or sculptured, of the head and upper part of the body of the sitter.

—, Full-length. A portrait representing the whole figure of the sitter from head to foot.

—, Medallion. A portrait, in the form of a medallion, representing only the head of the sitter, and this generally in profile.

Portrait Gallery, National. A gallery founded in 1857, for the preservation of the portraits of distinguished English men and women. The collection includes painted and sculptured portraits, as well as drawings, and provides a valuable commentary upon history. It has not been treated with the respect it deserves: it was for long housed in a series of wooden sheds at South Kensington, and then banished to Bethnal Green, but the generosity of an anonymous donor has provided money for a new building, and the collection is to be worthily placed in Trafalgar Square.

Pose. The attitude assumed by a painted or sculptured figure is termed the *pose*. Gracefulness of pose is one of the necessary conditions of artistic success.

Poseidon. Poseidon was worshipped by the Greeks as the god who controlled the element of water. He is represented in art as a god closely resembling Zeus, except that his long hair is matted with the salt sea. The horse is sacred to him and his attributes are the dolphin and trident. His contest with Athene for the sovereignty of Attica, on which occasion Poseidon called forth a spring of water while Athene made an olive-tree to grow, was a favourite subject with Greek artists, and was represented in one of the great pedimental groups of the Parthenon. The god of the Romans which corresponds to Poseidon is Neptune.

Post. (Arch.) A piece of timber, set vertically, which answers the same purpose in a wooden house or building as a pillar does in a stone construction.

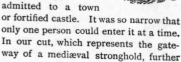

Post-scenium. (Arch.) That portion of an ancient theatre that is situated behind the scenes.

Postern. (Arch.) A small gate by which foot-passengers were admitted to a town or fortified castle. It was so narrow that only one person could enter it at a time. In our cut, which represents the gateway of a mediæval stronghold, further

strengthened by a drawbridge, the postern is the small opening on the left-hand side. When a building had but one gate a small wicket which opened by itself took the place of the postern.

Potboiler. A so-called work of art, produced, not because there is any artistic fitness about it, but merely because it answers a popular demand, and so serves to keep its author's pot boiling, is not inappropriately termed a *potboiler*. How great is the excess of potboilers over works of art among the thousands of pictures annually exhibited, a visit to any modern exhibition will convince the most optimistic visitor.

Potent. (Her.) This is one of the eight furs employed in heraldry. It consists of a series of crutch-heads, upright and inverted, and arranged in the same way as the upright and inverted bells in *Vair* (q.v.). The term is derived from an old English word, *pottent*, meaning a crutch. For an illustration of an heraldic crutch-head see Cross Potent.

Potiche. (Pot.) A Chinese or Japanese vase, generally of porcelain, with narrow neck and slightly swelling body. Potiches were made of every possible size, and were covered with rich ornamentation. The Chinese use large full-bellied potiches with lids, which suggest the roofs of temples, to hold their crops of tea.

Pottery. The term pottery, strictly speaking, only denotes that branch of the ceramic art which is devoted to the production of opaque ware, the term *porcelain* being reserved for translucent objects. However, in a general sense we speak of all manifestations of the ceramic art as *pottery*, and in the historic summaries which follow porcelain is treated of as well as pottery proper. Further information on particular wares may be looked for under separate headings. The potter's art is perhaps the oldest and simplest of all arts. It needs but few materials and no elaborate machinery besides the potter's wheel, which has retained very much the same form in all ages and in all countries.

—, **Arabian.** Pottery was manufactured by the Arabians from the 8th to the 14th centuries. It included tiles, with which walls and floors were covered, mosaics and vases, and other vessels of a blue or green glaze picked out with black. The patterns mostly in vogue among the Arabians are geometrical, but on decorative vases figures of animals are sometimes found.

Pottery, Assyrian. The principal specimens of Assyrian pottery known to us are bricks and tiles found among the ruins of Babylonian temples. They are richly coloured and covered with a glass glaze. Some curious coffins of baked clay, with a green glaze, and figures of warriors embossed upon them, were found at Warka in Mesopotamia, and remain our most interesting evidence of the skill of the Assyrian potter.

—, **Celtic.** Celtic pottery generally consists of grey or blackish earthenware vases, very roughly made, and decorated with ornaments incised with a stiletto, which was used upon the paste while it was still soft.

—, **Chinese.** Chinese pottery takes us very far back into the past. In very early times the Chinese made both stoneware and porcelain, and to them belongs the credit of having invented crackle. The most ancient decoration employed by the Chinese was blue upon a white ground. Their polychrome pottery is distinguished by a profusion of ornament and by the introduction of dragons and grotesque animals. It has been classed

by some authors in several families. Although this classification is purely conventional and has been upset by recent discoveries, it presents the advantage from a decorative point of view of setting before us the colours and patterns adopted by the Chinese. It may therefore be useful to give the classification here : (1.) *Chrysanthemo-Paeonian family:* vases decorated with chrysanthemums and

peacocks. (2.) *Green family :* vases of a copper green colour covered with historical subjects, rustic decorations, rocks, daisies, butterflies, insects, &c., all of which have a hieratic signification. (3.) *Rose family :* vases of a pale carmine red decorated with arabesques, bunches of flowers and figures of a familiar character. These are the principal classes of Chinese pottery and porcelain. There still exist one or two which should be mentioned, such as "reticulated" ware, in which the outer side is cut out in lace-like patterns and superposed on an inner vase, and the very delicate transparent China known as egg-shell.

Pottery, Dutch. The earliest Dutch pottery was made at the Hague, but it was at Delft that the finest specimens were produced. At the latter town the manufactory was established about the middle of the 17th century " at the sign of the Metal Pot." The majority of the pieces were inspired by oriental models. The colours are bright and clean, and the outline of the figures does not mix with the glaze. Blue decorations on a white ground are common, while many pieces are brilliant with blue, white, and gold.

—, **Egyptian.** The Egyptians manufactured pottery in very early times.

For the most part it was of a soft paste and decorated with black zigzag orna-

ments and dull blue enamel. The

decoration employed was for the most part geometrical, supplemented sometimes with such rude devices as animals' heads and hieratic symbols. Besides cups, lamps, &c., statuettes of the gods were made of earthenware by the Egyptians. Our two cuts, which will give an idea of the decoration employed by the Egyptians, are taken from wall-paintings at Thebes.

Pottery, English. The earliest pottery made in England was Staffordshire stoneware. In the middle of the 17th century the art of making pottery which resembled that made at Delft was introduced into England. Drug pots, tiles decorated with blue landscapes were made at Fulham and Lambeth, as well as jugs, cups, and other vessels. Factories were established at Derby in 1750, and at Worcester a little later, while in 1769 the celebrated Josiah Wedgwood opened his works, where he made vases, cameos, and medallions in the Greek style. Among his most finished productions was a copy of the ancient vase known as the Portland vase (q.v.), which was decorated with white figures on a green ground. He also imitated Egyptian pottery in black biscuit, with red and white bas-reliefs upon it, while his bas-reliefs and cameos of a bluish grey ground decorated with designs by Flaxman in white are justly celebrated.

—, **Etruscan.** A great many vases

have been found in Etruria and hence

designated Etruscan. It has, however, been established beyond doubt that these vases were not the work of Etruscan potters but were manufactured in Greece and exported thence into Etruria. The term Etruscan pottery cannot therefore be applied to them with propriety.

—, **French.** The earliest French pottery was derived from the Italy of the Renaissance. The first productions of French potters were of simple earthenware with a lead glaze. Then came the products of Beauvais, which were of

earthenware, with a pale green glaze and a uniform tint; the pottery of Saintes and la Chapelle-des-Pots was green in colour and marbled. Green pottery was also made at Sadirac in the 16th century, while the early factories of Paris produced a bluish grey enamel brilliantly marbled. To the same century belongs Bernard Palissy, whose rustic pottery is so celebrated. It included mythological subjects, popular figures, dishes decorated with fishes, lizards, snakes, and foliage in relief modelled from nature and coloured with warm tints, browns, whites, blues, greens, and yellows. The *épis* (q.v.) placed on gable roofs in Normandy were made by the methods invented by Palissy. A little later in point of date are the fine faïences of Henri II. (q.v.), which were made at Oison.

They were of a fine hard paste, decorated with designs of brown and black upon an ivory ground. Their ornamentation consisted of figures in relief or in the round, masks, and heraldic devices; the pieces were small and slight, and assumed the forms of cups, ewers, &c. Pottery has also been made at Nevers, Rouen, Moustiers, Marseilles, Paris, and Sceaux, among other places, while the chief centres of the manufacture of porcelain in France are St. Cloud, Sèvres, Chantilly, and Vincennes. Our cut represents a tea-cup ornamented with *bleu-de-roi* manufactured at St. Cloud.

Pottery, Gallo-Roman. The vases made in the Gallo-Roman period are more careful in execution than those of the Celtic period; their outline is more graceful and they are decorated with ornaments in relief.

—, **German.** The following are the most important centres of the manufacture of pottery in Germany: (1.) Nuremberg;

the pottery made here was antique in style and of very finished workmanship. The decoration was generally borrowed from the animals of the country, which sometimes suggested the shape of a vase or cups. Drinking cups, too, assumed

316

various curious forms, jack-boots or reversed helmets, as in our cut, being frequently taken as patterns. (2.) Bayreuth, where pottery was made of a bluish enamel, decorated with delicate designs in a dull blue grey. It was fine in substance and well-worked. (3.) Saxony where the famous Dresden china (q.v.) was made. From the time that Böttcher discovered his white clay very fine por-

celain has been made in Saxony, while Böttcher's workmen established factories both at Berlin and Vienna. We engrave here a coffee-cup, richly ornamented, which was made at Berlin by workmen carried off from Dresden, and which is an excellent specimen of the polychrome pottery at Prussia.

Pottery. Greek. Greek vases are as a rule simple and graceful in form, and are decorated with palm-leaves, meanders, inscriptions, and subjects taken from the mythology of the Greeks. They are our best evidence as to the style of the Greek painters. A very fine clay was used in their manufacture. The vase was made on the wheel, and the neck and handles were attached afterwards. The vase was then baked, and after the baking the vase-painter drew his design upon the

still soft clay. In black-figured vases the *red* of the clay served as a ground, the figures being filled in with black.

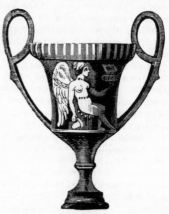

In red-figured vases the figures were first drawn in outline; the whole body of the vase was then coloured black, and finally the details of the figures which stood at red on a black ground were drawn with

a pencil. Black-figured vases were made from 540 B.C. to 460 B.C., and are some-

what archaic in style; after 460 B.C. vases were generally red-figured and less conventional in style and execution. The various forms assumed by Greek vases are given under their separate headings.

Pottery, Hispano-Moorish. This pottery is characterised by its grace of form and the metallic lustre of its tones. That made at Malaga is distinguished by its blue ornament and copper lustre; that of Valencia by its still more brilliant metallic lustre, heightened with yellow and reddish gold. The faïence of Majorca gave its name to Italian majolica.

—, **Indian.** The art of making pottery was derived by the Indians from Persia. Among specimens of Indian pottery may be enumerated large pieces of enamel, monumental in size, and executed in brilliant and varied tones; blue porcelain, decorated with arabesques, flowers, and birds; and polychrome porcelain, which resembles the choicest cloisonné enamels, incrusted with gold and precious stones.

—, **Italian.** From the 11th to the 13th

century Italian pottery was covered with

enamel. In the next century it was characterised by metallic lustres. This was succeeded by the pottery of Lucca della Robbia, which was modelled in terra-cotta and ornamented with religious subjects in blue and white. Then came the enamelled ware known by the name of majolica, with its wonderful colours and lustres. The most celebrated centres of the industry were Siena, in Tuscany, Faenza, Forli, Rimini, Ravenna, Bologna, Castel-Durante, Gubbio, Ferrara, &c.

Pottery, Japanese. There are three distinct kinds of Japanese pottery: faïence, soft paste stoneware, and porcelain. The most highly prized faïence is Satsuma, which is decorated with figures, flowers, birds in gold and silver, on a creamy white ground, covered with a very fine crackle stoneware, sometimes glazed and sometimes not. We find cups, teapots, statuettes, grotesque figures, and pieces of a violet brown incrusted with designs executed in white. Japanese porcelain is of the same character as Chinese, but is easily distinguished from the latter by the character of its decoration, which is never absolutely symmetrical, but which is remarkable for the excellence of its design and the brilliance of its colour.

—, **Persian.** Persian pottery consists for the most part of enamelled faïence, of a white, yellow, green, or pale blue ground, covered with designs of turquoise or cobalt blue. Its ornamentation includes geometrical figures, flowers, birds, butterflies, hares, gazelles, antelopes, and cavaliers with falcon on wrist. Persian faïence is characterised by unrivalled harmony of tones.

—, **Roman.** The domestic pottery of

the Romans was red in colour, about the

tint of sealing wax. It had a brilliant lustre and was of a very fine grain. Many specimens of it have come down to us in an admirable state of preservation. Architectural ornaments, such as

antefixes, metopes, bas-reliefs, &c., were made of earthenware by the Romans, and may be classed among the products of the potter.

Pounced Pattern. A well-defined outline of a design executed on a sheet of paper of sufficient resisting power. The process is as follows: the paper is pierced with a series of punctures placed as close together as possible. To obtain a tracing of this outline, a pad in the shape of a small bag containing a coloured powder is passed over the sheet of paper, and the powder settling in the small apertures indicates the outline which it is desired to reproduce. This process is used to transfer to canvas sketches made upon paper, or to obtain an exact repetition of a system of ornament.

Poussinesque. (Paint.) A term used in French art criticism to describe a landscape painted in the manner of Poussin, that is with the dignity of the classic convention.

Précieux. A work of art may be said to be *précieux* which unites a searching execution with delicate handling and a touch of exquisite fineness.

Prefericulum. A shallow open vase, in the form of a basin, generally of metal, in which the utensils used in

some religious rites of the ancients were carried.

Predella. The *predella* is the step which projects beneath an altar-piece. On it were generally represented either three or five scenes from the life of the saint who figured in the large canvas above it.

Premier Coup. [Alla Prima.]

Preparation. The method in which a picture is sketched on or a new canvas got ready by being covered with tones, which are intended to give a value to the complete work.

Pre-Raphaelites. The name *Pre-Raphaelites* was given to a small band of English artists who attempted a revival of the aims and practice of the pre-Raphaelite school about the year 1850. They formed themselves into a band, which they termed the pre-Raphaelite brotherhood, and pictures exhibited by them at the Academy were catalogued under the name of the artist followed by the letters P.R.B. Their aims no doubt were sincere, and their attempt at *realism* as falsely interpreted by the early Italians was earnest. Though the sum of their own achievement is not great, yet in bringing about a reaction against the ignorance and vulgarity of the English school in the fifties they did good work. Among their number were Rossetti, Millais, Holman

Hunt, F. G. Stephens, J. Collinson, and Woolner.

Presbytery. (Arch.) That portion of a church in which the high altar is placed and where the officiating clergy stand. Properly speaking it is east of the choir, and is raised slightly above it.

Presentoir. An ornament in vogue in the 16th century, which consisted of a

dish set upon a tall slender stem, as represented in the accompanying cut.

Press. A machine by means of which the leaves of a book are printed or impressions struck from an engraved plate. Special presses are used for typographic and lithographic printing, as well as for the printing of line engravings, &c.

Press View. Before an exhibition is thrown open to the public the gallery in which it is held is given up for one day to newspaper critics. This opportunity of seeing the pictures undisturbed by the public is called the press view.

Primary Colours. [Colours, Primary.]

Priming. (Paint.) A uniform layer of colour with which a canvas, panel, or other painting surface is covered, so as to form a ground. In the last century painters generally primed their canvas with a layer of brown red, mixed with a little white and nut oil. In the present day some painters prefer to work on a canvas covered with a grey priming, consisting of a mixture of white lead and black, with a little linseed or nut oil added, while others leave the grain of the canvas visible in some places. Oil priming has the disadvantage of robbing the colouring of the picture of its vivacity, but on the other hand it prevents the canvas from cracking when taken off the stretcher. At the same time it should be remembered that Titian and Veronese executed many of their oil paintings without any priming at all. Panels which are to be painted upon are first of all sized and then covered with several layers of white, so as to fill up the pores of the wood. If pictures are painted upon copper plates, the copper is covered with a priming similar to that used in preparing canvas, but a kind of grain, to hold the colours, must then be made upon it, either with the palm of the hand or with a dabber covered with taffetas.

Mural surfaces are primed for oil-painting by being impregnated with boiling oil and siccative colours, with linseed oil and varnish added. Sometimes a coating of lime and powdered marble is laid on first. Plaster walls before being painted upon are covered with a mixture of pounded brick and resin.

Print. (Engrav.) A general term for any proof printed from an engraved plate or lithographic stone.

Printing. (Engrav.) The process of striking off copies from an engraved block or plate. Proofs are printed from a wood block or from a metal plate in relief by the ordinary methods of typography. Line engravings, however, on steel or copper are printed in presses made especially for the purpose.

—, Lithographic. In striking off proofs of a drawing executed on a lithographic stone, the printing ink only adheres to those portions of the stone which have

been touched by the lithographic crayon or thick ink. A pressure being exerted on a sheet of damp paper, the printer's ink leaves the stone and adheres to the paper.

Printing of Line Engravings. To obtain proofs of a plate engraved in line, the plate is slightly warmed and thoroughly inked with a dabber. The surface of the plate is then wiped so that the ink only remains in the hollows. The plate thus prepared is placed in a press between two cylinders, a sheet of damp paper and a thick flannel being laid upon it. In passing between the two cylinders under considerable pressure the paper takes up all the ink, and thus a proof of the engraving is obtained.

— of Mezzotints. The printing of mezzotints presents considerable difficulties. As the portions of the plate which print white are more hollow than those which print black, before printing the hollows must be wiped perfectly dry by hand or with a small dabber covered with linen and fixed on a little stick. Mezzotint plates only yield a small number of proofs, and are easily worn out.

— of Woodcuts. Proofs are printed from woodcuts, from clichés of woodcuts, or from any relief engravings obtained by mechanical processes, in the ordinary method employed in printing books. The blocks are carefully adjusted, placed on the marble, and inked with a roller. In order to produce strong differences of tone, small pieces of paper cut out are put in the places where decided blacks are wanted. The object of these pieces of paper is to increase the pressure, while the delicate parts, being only covered by a single sheet of paper, only yield light grey tones.

Priory. (Arch.) A monastery which is presided over by a prior.

Prism. A solid geometrical figure, the bases of which are equal and parallel and the sides formed of parallelograms. A prism is said to be triangular, hexa-

gonal, &c., according as its base is a triangle or a hexagon. A prism is said to be a *right* prism when its sides are perpendicular to the plane of the base and its lateral faces are rectangles. In optical experiments a prism of glass or crystal is used, which refracts a beam of white light falling upon it and decomposes it into the seven colours which form the spectrum.

Prismatic. That which has the form of a prism.

Private View. It is customary for the directors of exhibitions to ask the exhibitors and their friends to a private view of the pictures, before the public are admitted. Of late years invitations have been sent out so indiscriminately that the day on which it is impossible to look at works of art is that on which the private view is held. Private views have, indeed, degenerated into crushes, in which women are stared at and costumes chattered about.

Proboscis. (Her.) The trunk of an elephant generally represented as twisted in the shape of an S and placed in pale. This heraldic charge is very rarely met with, and only in German coats of arms.

Process. A mechanical method by which something is produced or executed. The innumerable methods of producing plates, from which impressions may be struck, by the use of photography, are termed processes. The cheap reproductions of pictures which illustrate so many modern books and journals are often produced by mechanical processes, and are called process blocks.

Prochous. (Pot.) A Greek vase somewhat resembling the oenochoe (q.v.) in shape. It had a very graceful handle rising considerably above

the neck, while the lip if looked at from above formed a trefoil. These characteristics will at once be recognised in our cut. The prochous was used to hold wine, and was frequently enriched with paintings.

Profile. A term which in general denotes the representation of an object seen from one of its sides. In drawing and painting a profile is a portrait of a person looked at sideways. In architecture a profile is a section so made as to show clearly the projections of a moulding or system of ornament, the drawing of which in face does not enable us to appreciate its relief. The design of profiles in buildings of the Gothic style

was always subordinated to the line of the masonry and the mouldings were always combined, so that the joints were hidden and did not break the convex or concave surface of these mouldings. The section of Gothic piers display profiles of extraordinarily learned design. In the 13th century the piers

consisted of clustered columns, but in the 14th their profile or horizontal sec-

tion was made up of a very large number

of mouldings. Finally when mouldings are executed in plaster, the term counter-

profile is applied to the pattern cut out so as to show the profile.

Profile, Back. A term applied to a portrait representing a person seen sideways, so that the back of the head is in the foreground, and the features are partially hidden by the projection of the forehead and cheek.

Progression. A system of ornament in which the details assume greater importance according to the extent of the surface to be covered. In the decoration of a pediment, for instance, the ornament should be conceived in progression, since a larger surface has to be filled in the middle than at the extremities, which terminate in a point.

Projection. The representations of bodies upon a plane surface, vertical or horizontal; also the figure obtained by joining the foot of perpendiculars drawn from every point of an object on to the plane. The drawing of projections belongs to the sphere of geometrical drawing and presumes an extensive knowledge of geometry. The architect, however,

must be familiarised with this branch of drawing, for it enables him to

judge of the effect of the details of a building, and also to indicate the outline of the shadows projected by an imaginary focus of light conventionally placed above and in the left hand of the drawings, and directing its rays at an angle of 45 degrees. Anything which stands out from the line of a wall or other flat surface is said to be a projection. The body of mouldings, entablatures, and balconies, for in-

stance, *project* from a façade. In a washed drawing showing the elevation of a building, lit by an imaginary ray of light directed at an angle of 45 degrees, the dimension of the shadow cast by a moulding is determined by the projection of this moulding. In painting, the relief given to the objects represented is called the projection. Of a badly modelled figure, for instance, it may be said that it lacks projection.

Pronaos. (Arch.) A term applied in ancient temples to the porticoes or porches placed in front of the cella.

Proof. (Engrav.) A tentative impression taken from an engraved plate or a lithographic stone, which enables the artist to judge how far his work is complete and what retouches are necessary. It must be observed, in passing, that after a lithographic stone has been prepared for printing, any alteration in it is a matter of extreme difficulty. The term proof is also applied to an engraving printed from a plate, block, or stone. The proofs of engravers of medals, which serve the same purpose as proofs of engravings, are obtained in wax or plaster.

Proof, Artist's. A proof of a line engraving pulled with or without the signature of the artist. Sometimes artists' proofs are further distinguished either by an irregular margin, the engraving not being exactly in the centre of the plate, or by square lines surrounding the subject, but drawn somewhat irregularly, or by sketches or tentative strokes in the margin.

— **before Letter.** A proof of a line engraving or lithograph before its title together with the names of the painter and engraver have been cut or written in lithographic ink in the place reserved for that purpose.

—, **Lettered.** A proof of an engraving which bears engraved upon its margin either in printer's type or in regular handwriting the title of the engraving, together with names of designer, engraver, and printer of the plate.

—, **Natural.** A proof which reproduces the actual *lines* of an engraving without any "dodges" or *retroussage.* Such a proof is obtained by carefully wiping the whole surface of a plate after having inked the furrows.

—, **Negative.** (Photo.) A cliché obtained by exposing sensitive plates in a dark room. In a negative the lights and darks of the object reproduced are transposed.

—, **Positive.** (Photo.) A proof obtained from a cliché, either upon paper or upon glass, in which the whites and blacks correspond to the lights and shades of the original.

—, **Remarque.** A proof of a line engraving which represents a particular state of the plate. The *remarque* proof is distinguished by a sketch drawn by the engraver on the margin or on the white portion of the proof, or by the absence of certain lines in various parts of the plate. Thus the proof of a plate bitten by aqua fortis, before it has been retouched with the dry point or rebitten,

is a *remarque proof*. These remarque proofs give us the various states of a plate from first to last.

Proof, Wax. A tentative proof obtained by the engraver to give him an indication of what retouching is necessary. It is obtained by filling in the lines with lampblack, and applying to it a sheet of paper coated with white wax and exerting upon it a gentle pressure with a burnisher.

— **with Grey Letter.** A term applied

to proofs in which the characters of the legend are grilled with hatchings.

— **with White Letter.** A proof in which the characters of the legend or inscription are only indicated by outlines.

Proper. (Her.) When charges on a shield are represented in their own natural colours they are usually blazoned *proper*.

Properties. In the language of the theatre this term denotes all objects accessory to the *mise en scène*.

Proportion. A term applied to the dimensions of a painted or sculptured figure, and also to the relation which exists between the dimensions of the various parts of the body. In painting and sculpture the proportion of the human body is indicated by the head, a well-proportioned human body being equal to seven or eight times the height of the head. In architecture the proportion of the entablature is furnished by the radius of the shaft of the column at its base.

Proportioned. A figure is said to be well-proportioned when its proportions are accurately observed and when the dimensions of its various parts are properly harmonised,

Propylaea. (Arch.) This term denotes in ancient architecture the vestibule of a temple decorated with columns, and

particularly the building which was placed at the entrance of the Acropolis at Athens and formed a magnificent approach to the Parthenon.

Proscenium. (Arch.) In modern theatres the proscenium is that portion of the stage which extends in front of

the curtain as far as the footlights. In an ancient theatre it was that part which was situated in front of the scene.

Prostyle. (Arch.) An ancient temple was said to be prostyle when its front alone, was adorned with a row of columns.

Prothesis. [Oblatorium.]

Protractor. A semicircle of horn or metal, divided into 180 degrees, which is used to measure angles or to draw them upon paper. The commonest form of protractor is a pierced demi-disk, as shown in our cut.

Prow. The prow of an ancient galley, pointed with iron or steel, is frequently employed as a system of ornament. The prow has sometimes only one metal point, sometimes several. [Rostrum.]

Prussian Blue. [Blue, Prussian.]

Prussian Brown. (Paint.) A useful and permanent brown pigment, obtained by calcining Prussian blue. It is a good transparent colour, dries quickly, and is suited generally to oil and water colour.

Pseudisodomos. (Arch.) A kind of masonry employed by ancient architects in which two courses of small and

large stones alternated with regularity. Masonry which consisted of stones all of the same height was called by the Greeks ἰσόδομος. [Masonry, Greek.]

Pseudodipteral. (Arch.) A temple is said to be pseudo-dipteral when it is apparently built upon the dipteral (q.v.) plan, but is in reality only surrounded by one free row of columns, another row of columns being attached to the walls of the cella.

Psyche. The story of Psyche, who was beloved of Eros or Cupid, has always been a favourite one with artists. Eros and Psyche are generally represented together, and Psyche frequently has the wings of a butterfly.

Pteroma. (Arch.) In classical architecture *pteroma* signifies the portico which surrounds the *cella* of a temple.

Pulpit. A tribune with a seat, raised at a considerable height above the ground, from which sermons were delivered. In Italian churches many pulpits are to be seen of marble or bronze, supported by colonnettes. In mediaeval churches the pulpits were nearly always of wood and perfectly simple in construction. In the 15th

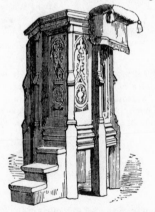

century pulpits were set against the pillars of the church or against the wall, and were fixed. At a little later period they were surmounted by sounding boards in the form of a canopy or tapering pyramid. In the 16th, 17th, and 18th centuries pulpits were designed in accordance with the architectural style of each epoch and some were marvels of allegorical and theatrical fancy. Belgian pulpits particularly exhibit a quaintness of execution and design. The pulpits of the present day are generally nothing but an ingenious pastiche on the productions of former times. Our cut represents the pulpit of carved wood in the church at Wenden, in Essex.

Punch. (Engrav.) A steel instrument called a punch, which generally has two large blunt points, is used in crayon engraving to add masses of black when the work has already been bitten. The punch is held perpendicular to the plate and subjected to a series of sharp taps, being moved a little at each tap. A hollow of considerable width and depth is thus obtained, which is represented in printing by a mass of intense black. Many plates were executed by this method in the last century and were printed in red. In die-engraving a punch is a steel instrument upon which a figure is engraved, and from which imprints may be obtained by striking the punch at the end the farthest removed from the figure. Engravers often keep a collection of punches, upon which the commonest charges in heraldry are engraved. The term punch is also applied to the imprint of an initial, device, sign, or symbol placed upon goldsmith's work, or on gold and silver ornaments. In the present day the application of these symbols to gold and silver plate is under the

permanent control of the State and is regulated by especial laws.

Puncheon. (Arch.) A piece of wood which serves as a vertical support.

Punching Compass. A compass, the branches of which curve inwards, the one being armed with a blunt point, the

other with a sharp. It is used to mark exactly where a copper plate which has been planed down is to be beaten out.

Pupil. An artist who adopts the traditions and produces works in the style of a painter or sculptor is said to be a pupil of such a master. Thus we speak of a pupil of Raphael or of Rubens.

Purity. A term which denotes correctness and precision of drawing. For instance we speak of the purity of outline in the figures of Raphael or in the *Source* of Ingres.

Purlin. (Arch.) A piece of wood placed horizontally and forming part of a roof, its purpose being to support the rafters.

Purple. A secondary colour obtained from the mixture of the two primary colours red and blue.

Purpure. (Her.) The heraldic *colour* purple shown on a shield by diagonal lines from sinister to dexter.

Purree. (Paint.) A name given to the pigment more generally known as Indian yellow (q.v.).

Put in. In a painting or drawing, when a figure is set upon the canvas or paper with a few strokes so as to vividly suggest its movement and attitude, it is said to be well *put in*.

Puzzolana. A reddish earth which is mixed with lime to form a cement used by builders.

Pycnostyle. (Arch.) An ancient temple was said to be pycnostyle when its intercolumniation measures one and a half times the diameter of the shaft of the column at the base.

Pylon. In Egyptian architecture a *pylon* is a mass of masonry in the form of a truncated pyramid with a door in the middle, terminated in a platform as is shown in the cut. Sometimes poles with waving banneroles were set against the pylon. The pylons at

Thebes were approached by an avenue of sphinxes and obelisks.

Pyramid. A solid figure with a triangular or polygonal base, the lateral faces of which meet in a point at the summit. Under this name are generally designated the three Egyptian monuments of the IVth dynasty, the loftiest of which, the pyramid of Cheops, is 146 metres high, and is built upon a square base. It consists of a solid block

of calcareous stone faced with solid flags, accurately set in their places.

Pyramidion. (Arch.) A term applied to pyramids the height of which is very small in proportion to their base. The

summit of an obelisk is often in the form of a pyramidion. Many sepulchral monuments designed in the Neo-Greek style are thus terminated.

326

Q.

Quadrangle. A quadrangle is a figure which has four sides, and consequently four angles. Colleges and similar institutions are frequently arranged in the form of a series of quadrangles or square open spaces surrounded with buildings.

Quadrilateral. A quadrilateral figure is a figure which is bounded by four sides.

Quarrel. (Arch.) A small pane of glass, either diamond-shaped or square, set diagonally.

Quarter. (Her.) Each of the equal parts into which a shield may be divided by a cross is termed a quarter. The quarter which occupies the dexter chief is termed the *first quarter*, that which occupies the sinister chief the *second quarter*, while those occupying the dexter and sinister base are known as the *third* and *fourth quarter* respectively. A shield divided into four quarters is said to be *quartered*.

Quartered per Saltier. (Her.) A shield is said to be quartered per saltier when it is divided by diagonal lines, which cross in the centre of the shield.

Quarter-foil. (Her.) A flower with four leaves, which occurs as a charge in heraldry. The term double quarterfoil is applied to a flower with eight leaves.

Quarterings. (Her.) When a shield is divided up into a number of squares, in each of which is a coat-of-arms, these squares are known as quarterings. Our cut, which represents the shield of the Seymour family, clearly illustrates the meaning of quar-

terings, but it must be understood that more than four quarterings may appear on one shield.

Quarterly. (Her.) A shield divided by a horizontal line and a vertical line crossing one another in the middle is said to be parted *quarterly*. If divided into eight parts by a horizontal cutting three vertical lines it would be blazoned *quarterly of eight*.

Quarternary. The quaternary hues are compounds of the primaries, with two primaries or one secondary predominating. Such as *auburn*, where orange predominates, *puce*, where violet predominates, *olive*, where green predominates.

Quarter-round. (Arch.) A quarter-round is a convex moulding consisting

of a quarter of a circle. It is frequently decorated with the egg and dart ornament, as is shown in our cut.

Quatrefoil. (Arch.) A system of ornament employed in Gothic architecture, which consists of four arcs of a circle drawn from the angles of a square taken

as centres. Sometimes the four arcs of

circles are tangents or secants. At some periods their extremities are separated by angles, as in our second and smaller cut. In the 12th century the inner surface of the curve is decorated by a *torus*.

In the 14th century each foil, instead of consisting of a portion of a circle, consists of a portion of a pointed arc.

Quattro-cento. (Paint.) A name applied to the style of the painters who practised their art in Italy during the 15th century. The *quattro-centisti* may be said to include all the artists who are more generally known as Pre-Raphaelites.

Quattro-Coronati. According to the legend of the Church the "four crowned brothers" were architects, who refused to build a pagan temple in the reign of Diocletian. For this refusal they suffered martyrdom. In art they are represented crowned and with palms in their hands, while mallets and other tools lie at their feet. There is a church in their honour at Rome.

Quartz. A siliceous stone, the commonest of the minerals ; it is generally transparent and crystalline. It is found in nearly every part of the world. The most beautiful varieties of quartz are used for cameos, intaglios, while the commoner kinds are employed in the manufacture of glass and porcelain.

Queen-post. (Arch.) A post which springs from a tie-beam and helps to support a timber roof. It is not placed like the king-post in the centre of the tie-beam, but between the centre of the tie-beam and its extremity, and, therefore, queen-posts are always found in

couples, and are connected at their upper end by a beam called a collar beam.

Quincunx. An arrangement in squares like a chess-board. The most frequent instance of the quincunx is a plantation of trees, so laid out as to present straight lines, from what-ever point of view it is looked at. To obtain this result the ground is divided into a certain number of equal squares

and the centre of the square is ascertained by drawing diagonals. Trees are then planted at the four corners and at the centre of each square.

Quirk. (Arch.) A channel or groove separating a convex moulding from the fillet which surmounts it.

Quoif. [Coif.]

Quoin. (Arch.) The external corner of a building. It is generally decorated, sometimes with pilasters, sometimes with a belting-course [Course, belting] of projecting stones, which gives a decorative character to the building, if the rest of it is of brick.

R.

Radegund, St. St. Radegund was the wife of Clothaire, King of France, and lived towards the end of the 6th century. She became a Christian, and, in consequence, was obliged to retire from the court. She was early canonized as a saint, and in artistic representations she appears wearing a crown or with a crown at her feet. Sometimes wolves are at her side and the legend tells us that she had power over wild beasts.

Radiated. A term applied to decorative motives, which consist of rays.

Radiation. A method of decorating a circular surface by means of radii diverging from its centre. The term is

also applied to a system of ornament, which consists in the arrangement upon a surface of any form whatsoever of radii of a circle.

Radient. (Her.) In heraldry a charge is said to be *radient* which has rays round it. Our cut, for instance, is described as azure, a pale, or, radient.

Radius. A constant distance between the centre and any point on the circumference of a circle or on the surface of a sphere is termed a radius.

Raffaelle-ware. (Pot.) A kind of majolica, upon which mythological and other scenes were painted. It was made at Urbino in the 16th century under the patronage of the Dukes of Urbino. There is no reason to believe that Raphael ever designed any specimens of this ware, though it is quite possible that some of his school furnished the Urbino potters with design. Perhaps the fact that Raphael was born at Urbino is sufficient to account for the name which this pottery received.

Rafter. (Arch.) A piece of timber, supporting the laths or battens, upon

which a roof of tiles, slates, or zinc rests.

—, **Principal.** (Arch.) A piece of wood or iron, which plays an important part in the frame of a roof.

The principal rafters give the angle of

the roof and support the purlins (q.v.) on which the rafters are laid.

Ragged. (Paint.) A painting is said to be *ragged* in style when the objects or figures represented, instead of being evenly joined to the background, terminate in rough edges.

Ragstone. (Arch.) Stones of small size, sometimes squared, sometimes just as they came from the quarry, used in building.

Raguly. (Her.) A charge is said to be *raguly*, when it i ragged or rough like the trunk of a tree. Our cut, which represents a *cross raguly* will render the term quite plain.

Rail. (Arch.) The upper part of a balustrade about breast high, upon which the hand may be rested. In domestic staircases the rail is generally of wood, but in stone balustrades it is frequently of marble. The term rail is also applied to the horizontal pieces of wood separating the panels in doors or wainscoting.

Rais de Cœur. (Arch.) A system of ornament in the form of a heart. It consists of fleurons and water-leaves placed alternately, and decorates the surface of some

mouldings which have a convex profile.

Rampant. (Her.) An animal rearing up on its hind legs in a fighting attitude is said to be rampant. [Lion Rampant.]

Rampart. (Arch.) A fortified wall which forms a defensive enclosure for a

town or castle. In the Middle Ages

ramparts connected fortified gates, and were bordered by fosses.

Ranieri, St. St. Ranieri is the patron saint of Pisa, and representations of him are not found outside that town. He was born in 1100, and after a youth spent in dissipation he was converted, travelled to Palestine, and lived for many years in a desert. On his return to Pisa, his native city, he was much reverenced, and when he died he was buried in the Duomo.

Ranseur. A ranseur is a weapon, consisting of a long, cutting blade, from the base of which two smaller blades project. It underwent several modifications of form; that shewn in our cut being its earliest.

Rapier. A light, narrow sword, worn by gentlemen from the 16th century onwards. It was a weapon of personal adornment rather than of warfare.

Raphaelesque. A picture is said to be Raphaelesque when it suggests the work of Raphael, or is in the style of that master. We speak of a Raphaelesque drawing, Raphaelesque beauty, &c.

Raphael, St. St Raphael is one of the archangels. His special mission is to guard mankind, and especially to protect travellers. His attributes are a casket or wallet and a pilgrim's staff, and he is generally represented winged and wearing sandals. The legend of Tobit and the Archangel Raphael has suggested subjects to many painters, and it is in allusion to this legend that Raphael sometimes carries a fish.

Rapin. A word of constant occurrence in French artistic slang, of which many etymologies have been suggested, all of them unfortunately inadmissible. For instance it has been derived from *râpé*, " shabby," a derivation which is not altogether unlikely, for the *rapins* of old were not generally millionaires. Then, again, some say it comes from *rapiner*, " to steal," a purely gratuitous calumny. Other etymologists see in the word the pun, *rat qui peint*, but this is too far-fetched to be entertained for a moment. Whatever is the derivation of the word the *rapin* of fifty years ago was a jovial student of art, always on the watch to play tricks and practical jokes on the terrified "Philistines." For this engaging pursuit he too often neglected the study of his art. In the present day the race of *rapins* of the ancient school has entirely disappeared. It has gone the way of the old-fashioned students and of the school of Bohemians, who advertised their ideas and affected eccentric costumes. The modern student of art is too often a Philistine himself and avoids any suspicion of eccentricity. His costumes and manners are conventional, and whatever else he may be he is seldom a *rapin*.

Rasp. (Sculp.) An iron tool used by sculptors in working on their marble.

Our cuts will give an idea of its shape and character.

Ray. (Her.) A ray or beam of light is sometimes found as a charge in heraldry. The following is a description of our cut; Azure, a ray of the sun issuing out of the dexter corner of the escutcheon.

Rayère. (Arch.) A French term denoting a long, narrow opening in the thickness of a wall of a mediæval castle, through which light was admitted.

Re-acierage. The process of *acierage* may be described as the covering of a copper-plate with a thin film of steel. When this steel film is worn the plate may be re-covered; this second process is termed re-acierage.

Reagent. Chemical substances which are used to develop photographs and to fix the images obtained on a photographic plate are termed reagents.

Realgar. [Red Orpiment.]

Realism. This word is susceptible of two meanings. In its strict sense realism is the representation of real objects, such as actually exist, as opposed to *idealism*, which may be defined as the construction of the perfect type of these same things, as the mind attempts to conceive it. In historical painting the realistic school devotes itself to representing events, persons, costumes, and places as accurately as possible, and will have nothing to do with conventional types and draperies. There is, however, another school of realists. These, pushing to its extreme limit the doctrine of reality in the representations of scenes and objects, forbid the reproduction of aught that requires interpretation or the exercise of the intelligence. They limit themselves strictly to the reproduction of that which is seen and do not always concern themselves with seeing the beautiful side of things. And so it happens that as often as not they incline by choice to what is ugly.

Rear-vault. (Arch.) A vault placed

behind a bay, which terminates in a round or pointed arch or in a straight lintel. The purpose of the rear-vault is to strengthen the building or to increase its effect. Gothic architecture presents many examples of rear-vaults richly decorated.

Rebaking. An operation, the purpose of which is to fix the colours of painted pieces of glass or enamel by submitting them to the action of the fire.

Rebate. (Arch.) A notch or recess cut in a piece of timber so as to fit another piece of timber. The commonest instance of a rebate is the notch cut in a door-post to receive the door.

Rebiting. (Engrav.) When some of the lines on an etched plate are not sufficiently accentuated, or if the plate has been worn from too many copies having been struck from it, it undergoes the operation of rebiting. This requires the utmost care, as the etching ground has to be laid so as not to cover any of the lines which are to be rebitten and must not be dabbed all over, as at the first biting. When a worn plate has been rebitten it can scarcely deceive the practised eye, as the proper relations of its tones is lost and the lighter lines become weaker.

Rebus. (Her.) A rebus is a charge in heraldry, which has a punning allusion to the bearer's name. A popular definition of it is "a word represented by a picture." Such devices were very common in the Middle Ages. In West-

minster Abbey there is a very good example of a rebus in Bishop Islip's chapel. The device consists of a human *eye*, and a *slip* of a tree. Many other examples might be quoted. We will content ourselves with two, of which we give cuts. The first is the rebus of

Thomas Compton, Abbot of Cirencester. It is taken from a window in the Lady Chapel in Gloucester Cathedral and its

significance will be plain to all. Our second cut is the coat of arms of a Devonshire family named Arches.

Re-canvassing. An operation which consists in replacing a worn-out canvas or worm-eaten panel upon which paintings have been executed by new and sound materials.

Rectangle. A rectangle is a figure enclosed by four straight lines, in which the opposite sides are equal and all the angles right angles.

Rectangled. A term applied to geometrical figures which contain a right angle. Thus we speak of a rectangled triangle, a rectangled parallelogram

Rectangular. A figure or solid body in which the angles are right angles is termed rectangular.

Recuse (Numis.) A term applied to coins struck with two different types, the one superposed upon the other.

Red. Red pigments are formed of ochre or clay coloured by oxides of iron, which have been calcined and pulverised. These pigments, when they have a base of iron, are always deep in colour. Reds obtained from oxide of lead or from mercury are bright and intense. Among the latter may be mentioned red lead (protoxide of lead), cinnabar, and vermilion.

Red Lead. (Paint.) This pigment is an oxide of lead. As, when mixed with most other pigments, it decomposes it is of little use to the artist. It is of a scarlet colour, and when it is pure and unmixed it is not affected by light.

— **Ochre.** (Paint.) There are several kinds of red ochre, such as Indian red, scarlet ochre, and Indian ochre. This pigment is generally a sulphate of iron. In colour it is less strident than vermilion, and when pure it is permanent.

— **Orpiment.** (Paint.) This pigment, which is a compound of arsenic and sulphur and is of an orange colour, should never be employed by the painter, as it destroys other pigments and absorbs the colour of the ground. It is also known as realgar.

Redan. (Arch.) A pierced or indented system of ornament used in Gothic

architecture. The form of redan in vogue in the 13th century consisted of three arcs of circles intersecting one another two and two. The term is also applied to the *ressaults* of a wall, the upper surface of which, instead of being horizontal, is cut off so as to resemble the steps of a staircase.

Redorte. (Her.) This name is applied

by heralds to a figure formed by inter-. twining the branches of a tree, with or

without their leaves on, so as to make a succession of loops.

Reduct. (Arch.) A term applied in military architecture to fortified works, the purpose of which is to prolong the defence of a castle.

Reduction. A term applied in art to a copy of a sketch or picture on a smaller scale than the original; and also to engraved reproductions obtained by mechanical processes, and designed on a smaller scale than the drawings from which they are made. It also denotes small copies of a statue; we speak of a reduction, for instance, of the Venus of Milo. There is a special method of reducing statues, which is based upon the application of the pantograph, or by which mathematically exact copies may be obtained. This method goes by the name of Collas, its inventor.

Re-enter. (Engrav) When a line on an engraved plate, which has been worn in printing or is not bitten deeply enough, is cut with a graver to its proper depth, it is said to be *re-entered.*

Refectory. (Arch.) The dining room in a monastery or convent.

Reflection. A term applied to the portions of a body illuminated not by rays of direct light but by reflected rays. In an illuminated body there are three distinct parts, the light, the shade, and the reflection. The last is the part of an object plunged in a penumbra lighted by the rays proceeding from other bodies at some distance from the object and receiving the light directly.

Refraction. A change of direction taken by luminous rays in certain transparent bodies. It is in consequence of this phenomenon that a rod half plunged in water appears broken, that the disc of the sun on the horizon appears larger than at its zenith.

Regals. A music instrument used in the Middle Ages, which combined the characteristics of an organ and accordion.

In mediæval pictures saints are frequently represented as playing upon

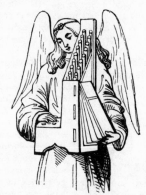

regals. The cut given here is from a picture by Memling.

Regardant. (Her.) A term applied in heraldry to animals which have their head turned towards the sinister side of the shield.

Reglet. (Arch.) A small flat moulding, which is also known by the names of *fillet* and *listel.* When it is very large it becomes a plat- band, and some writers then describe it as a *taenia.*

Regrating. (Arch.) An operation which consists in cutting away the ornaments and projecting mouldings from the surface of a building, so as to render the whole surface uniform. By this process of levelling many ancient buildings have been destroyed or restored, as the modern iconoclast prefers to style it.

Regular. (Arch.) A plan or façade is said to be regular when it is arranged symmetrically.

Relief. In painting the relief is the apparent projection of objects obtained by modelling or a gradation of tints. Thus the reliefs of a picture may be well rendered, or a portrait may be said to lack relief. In sculpture a relief is a figure or series of figures executed on

a flat ground, from which it projects in a greater or less degree, according as it is a high or low relief. In architecture the mouldings and systems of ornament which project from the surface of a wall or of a façade are termed reliefs.

Relieving Arch. [Arch, Relieving.]

Reliquary. A coffer or box, of very variable form, in which relics are kept. In the Middle Ages there were reliquaries large enough to be reverenced as shrines, while some were small enough to be carried in the hand. Sometimes they assumed the form of an arm or a skull, according as the relic

within was a bone of the arm or a fragment of the skull. As a general rule they

were very richly decorated, especially those made from the 13th to the 15th century, some of which were formed of blocks of rock crystal supported upon

pierced columns. Others were vases of jasper or porphyry with enamelled

mouldings, and many were resplendent with precious stones.

Remark. [Proof, Remark.]

Rembrandtesque. (Paint.) In the manner of Rembrandt. A painting is said to be Rembrandtesque when the combination of effects, especially of light and shade, recall those adopted by Rembrandt. Thus the effect of light in a picture may be said to be Rembrandtesque or the picture itself may be so termed.

Renaissance. The period during which there was a general revival of art throughout Europe. This movement began in Italy in the 15th century, and continued with little abatement of vigour throughout the 16th. It reached England and Germany somewhat late. The architecture of the Renaissance was characterised by a return to the ancient orders, which were interpreted, however, with a certain amount of freedom.

Render. To render is to represent, express, or interpret by the means proper to any particular art.

Rendering. A term denoting the manner in which a work of art or figure is painted, drawn, or executed. Thus we speak of an inadequate rendering, or say that the rendering of a certain subject is admirable.

Repaint. Those portions of a picture upon which fresh colour has been laid after the completion of the picture are said to be repainted. Of all the processes of restoration repainting is the most dangerous, and the most hopelessly prejudicial to the value of a picture.

Reparata, St. St. Reparata was from the 7th to the 13th century the patron saint of Florence and representations of her are to be found in early Florentine pictures. The tradition was that she suffered martyrdom in Cesarea at the age of twelve.

Repetition. A method of ornament, which consists in decorating a surface by representing the same motive a large

number of times in a geometrical arrangement.

Replica. An original work of art of the same dimensions as an earlier production by the same artist, and representing identically the same subject as that treated in a former work.

Repose. A work of art is said to have repose when its parts are balanced and harmonious, when no spots within it unduly attract the eye, and when there is a quietness and dignity over the whole composition.

Repoussé. A term applied to the art of fashioning ornamental objects in metal by beating it behind with a hammer, as well as to the ornaments executed by means of this process. The forms of the decoration are only roughly indicated by the hammer, and the work has to be finished by chasing (q.v.).

Reproduction. A term applied to the copying of works of art and especially to the interpretation of pictures by means of engraving, photogravure, and photography. The right of reproducing a work of art belongs to the artist and is distinct from the possession of the work, if the artist takes care at the time of sale to reserve this right to himself. If he neglects to take this precaution the right of reproduction ceases to belong exclusively to any one. [Copyright, Artistic.]

Reredos. (Arch.) The screen at the back of an altar, which is frequently richly carved, is called the reredos, The term also denotes an open fire-hearth.

Respond. (Arch.) A term applied to the two vertical parts of a bay or open-

ing, which are united by the horizontal part or lintel. The surface of the respond

either is plane or varies according to the style, epoch, or character of the building to which it belongs.

Ressault. (Arch.) The projection of a moulding or entablature, which is

advanced beyond the surface of a building. The term is also applied to the projection of one part of a building beyond another. For instance, pilasters may be said to form a ressault.

Ressenti. An Italian term denoting the forcible expression of a form in a drawing. For instance, Michael Angelo's manner may be called *ressenti*.

Restoration. The restoration of pictures is a task which necessitates the utmost prudence. If pictures are " repainted," *i.e.*, retouched on a considerable scale, they at once lose their value. Even if the portions repainted are of the smallest importance, and if the restorer takes the greatest care in laying on tones exactly similar to the earlier ones, the retouches are enough to clash violently with the old portion of the picture, as the desiccation of the oil leads infallibly to a modification of tone. When paintings on canvas scale off, the gaps should be stopped with a mastic composed of whiting and strong size. The joins may be hidden with the utmost care by means of a brush, and the picture may then be covered with a layer of siccative varnish.

The restoration of sculpture, especially of ancient statues in marble, presents still greater difficulties than the restoration of pictures, and it should be carried out with still greater reserve. The less important parts of a figure, if missing, may be restored or replaced easily enough, either by means of plaster coloured so as to closely reproduce the tone of the original, or by pieces of marble fixed in their place by

tenons or attached by copper. But, as a general rule, the restoration of statues should be restricted to carrying out whatever is necessary to hold them together. It will never occur again to any sculptor to attempt to restore the arms of the Venus of Milo. During the last two centuries, and even in the early part of the present century, ancient statues were restored with the most surprising boldness. An absent head was too often replaced by another differing from it both in period and province. The Glyptothek at Munich, for instance, is a monument to the misplaced energy of restorers. It is now found necessary to catalogue those portions of each work exhibited in that gallery which have been added by later hands.

In architecture the object of restoration is the reproduction of a building, wholly ruined or partially destroyed, in accordance with the original plans and designs. There can be no doubt that of late years the work of restoring churches has been carried a good deal further in England than it should be. Architects have been too ready to destroy buildings which were perfectly safe, in order to provide themselves with an opportunity of putting something of an earlier style in their place. Lord Beaconsfield once said, that no church would be properly restored until we had hung an architect. We are not likely to take this extreme measure, and perhaps the safest maxim to follow is: " Restoration should not be reconstruction but only the arrest of decay."

Restore. To restore is to repair works of painting or sculpture, buildings and historic monuments, with a view of bringing them back as nearly as possible to the condition in which they were when they left the hand of the artist, and before they had suffered the defacement of time.

Retable. [Altar-piece.]

Retaining Wall. (Arch.) A support, stay, or mass of masonry, which serves to strengthen a building. The object of a retaining wall is to counteract the

thrust of earth or to sustain an embankment.

Reticulated. (Pot.) A name given to certain pieces of porcelain which are bounded by a double surface, the inner surface being solid, the outer being in the form of a pierced network. In some pieces of reticulated porcelain of Chinese manufacture the outer surface is pierced with arabesques, and is placed over a vase of the same form or

merely cylindrical, but of a different colour. Vases which are only apparently reticulated are contrived by making an impression with a hollow stamp upon the porcelain.

Retouch. A modification or correction carried out in a picture, drawing, or engraving; an alteration made in a photographic cliché to soften the modelling or, in too many cases, to render it insipid. In line-engraving the object of *retouching* is to strengthen or weaken the tone obtained by hatchings already drawn. In wood-engraving *retouching* is limited to weakening or lessening the lines and contours, which appear too hard or too strongly marked. The process of retouching in wood-engraving only allows the work to be modified by the suppression, not by the addition of lines, whereas in line engraving a second series of hatchings may be laid over a previous one, and even skies may be added if necessary. This kind of re-

touching is absolutely impossible in wood-cutting, where the surface of the block is cut away and a fresh surface, fit to engrave upon, can only be obtained by fitting fresh pieces of wood to the original block.

Retrait. (Her.) This is a French term used to describe a charge which is disconnected in the middle so that one part is in retreat as compared with the other.

Retreat. (Arch.) A term applied in the Middle Ages to small vaulted rooms or private chambers lighted by arcades.

Retreat, In. (Arch.) That part of a building which lies behind the line of

the principal façade is said to be in retreat. Niches, pavilions, for instance, may be in retreat.

Return. (Arch.) A term applied to a corner, the angle of a building, the angle of an entablature, a cornice or a projecting moulding. A moulding itself, too, may be said to *return.* The term may also denote a building,

which forms a right angle with another building.

Revarnishing. (Engrav.) There are two methods of revarnishing an etched plate. The one is by heating the plate and using a dabber, the other is by laying on a mixture of varnish and smoke-black with a hair brush. The object of both these methods is to allow the engraver to retouch the plate, which has already been bitten and to make such alter-

ations upon it, as necessitate a re-biting.

Reveal. (Arch.) A term applied to the interior surface formed by the opening

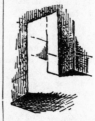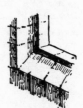

of a bay. Reveals may be either rectangular or oblique.

Reverse. (Numis.) The side of a coin or medal opposite to the face or obverse.

Reversed. In the process of engraving pictures are sometimes reversed, that is to say, they are reproduced in the opposite way to the original. A head, for instance, which looked towards the right, looks towards the left when reversed.

Revolution. A term applied in geometry to the rotatory movement by means of which a solid may be deduced from a plane figure.

Rez-de-Chaussée. [Ground-floor.]

Rhyparography. A term applied in ancient times to that branch of art which was concerned with the representation of common every-day subjects. The name *rhyparographus* was given by Pliny to a painter named Piræicus, whose "subjects were barbers' shops, cobblers' stalls, jackasses, eatables, and the like." Pliny adds that, in spite of the meanness of their subjects, these pictures were very pleasing and sold at higher prices than the works of many masters. From the above extract from the Roman critic it will be seen at once that *rhyparography* includes both *genre* and *still life*, and that Piræicus, as far as subject is concerned, differed little from the Dutch school.

Rhyton. An ancient vase in the shape

337

of a horn used for drinking. It was curved in shape and provided with a

handle and suggested the hollow horns which, no doubt, in the early stages of Greek civilisation were used as drinking-vessels. The sharp end frequently assumed the form of the head of an animal, while the wide portion was decorated with paintings.

Rib. (Arch.) The side or projecting edge of a pointed arch or vault. In the

early times of Gothic architecture ribs are very simple in profile, being generally in the form of a torus. At a later period their profile assumed delicate curves, and in the 15th century they were sometimes ornamented with bosses and garlands.

—, **Diagonal.** A diagonal rib is a rib which, in a groined compartment, passes from angle to angle and so intersects another diagonal rib in the centre.

—, **Transverse.** (Arch.) In a groined compartment the transverse rib is the main rib stretching from wall to wall. Transverse ribs were very slightly or-

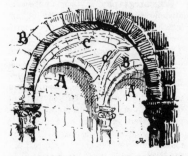

namented in the 11th century, but their decoration became more and more rich and complicated the nearer they came in date to the 14th century.

—, **Wall.** The ribs which, in a groined compartment, adhere to the wall are termed wall-ribs. An example of the wall-rib may be seen in the cut given to transverse rib.

Riband. (Her.) One of the diminutives of *bend.* The *riband* is generally one-fourth the width of the bend, but is *couped* or cut short so that its ends do not reach to the edge of the shield.

Ridge. (Arch.) A term applied in buildings of the Ro-

manesque or Gothic style to a moulding at the intersection of surfaces, especially on spires and clock towers. The word is also used in building to denote the bands of metal, generally zinc or lead, placed at the

angle of roofs, and also to the semicircular tiles, covering the top of a roof.

Ridge-piece. (Arch.) A piece of timber forming the upper part of a roof.

Ridge-plate. (Arch.) Plates of lead or zinc covering the top of a roof. Ridge plates are sometimes surmounted by pierced crests (q.v.) and by vanes. In some Gothic buildings there are fine specimens of ridge-plates, the lower edges of which are cut in the form of flames, while the roofs of buildings of the Renaissance period present magnificent examples of this method of decoration.

Ridge-tile. (Arch.) A semi-cylindrical

tile used to cover the ridge or line of

junction of the two slopes of a roof. It

sometimes projects beyond the edge of the roof, as is seen in our first cut.

Rifler. An instrument used by engravers of coins. It consists of a rounded piece of metal, the end of which is covered with interlacing striæ, like a file.

Right of Reproduction. The right of reproducing a work of art, whether drawn, painted, or sculptured by engraving or photographing, or of publishing a copy of a statue in plaster, marble, terra cotta, or bronze, can be assigned by the artist. The acquisition of a work of art only confers upon the purchaser the right of reproduction when it is a portrait or when at the time of sale the artist has made no restrictions. Apart from these circumstances the artist may sell the right of reproducing his work to one and the work itself to another. [Copyright, Artistic.]

Rinceau. A French term denoting an ornament consisting of sprigs of foliage arranged in scrolls. Rinceaux are employed as a decorative motive in all styles of architecture. The borders of

mural paintings sometimes consist of rinceaux with palm leaves and other foliage. In the neo-Greek style cartouches and other decorations in relief are surrounded with incised rinceaux.

In the Romanesque style examples of this form of decoration are also found, but it is in Roman architecture, espe-

cially in the friezes of buildings of the Corinthian order, that the finest specimens are to be seen, formed generally of acanthus leaves. At the time of the Renaissance rinceaux were treated with

peculiar delicacy, and so arranged that the portions on each side of a vertical line drawn down the centre, corresponded with one another, as far as

their main outlines were concerned, but differed considerably in their details and accessories. Vases, mascarons, and small figures frequently break the lines of the rinceaux.

Rissolé. A term used in French art-criticism to describe a picture of a golden tint. Some painters of the Ro-

mantic school have attempted to reproduce the tones *rissolés* of Rembrandt, but have too often merely succeeded in getting red, heavy tones.

Rivet. (Constr.) A nail with a round head, the extremity of which has been flattened so as to form a second head. Iron plates are often joined with rivets, made red hot and hammered. In small works riveting is done without heating the rivets.

Rocaille. A term applied to the art in vogue at the time of Louis XV. Scrolls and foliage, which are a feature of this style, are characteristic, both in form and outline.

Roche, St. St. Roche is the patron saint of those afflicted with plague or disease. He was born at Montpellier at the end of the 13th century, and devoted his life to ministering to the sick and plague-stricken, and he is said to have died in prison in his native town in 1327. His worship began in the 15th century, and he has been particularly reverenced at Venice. He is generally represented in the guise of a pilgrim, with staff and shell, and he shows the plague spot on his left thigh. Representations of him are frequently met with in art galleries, especially in the pictures of Italian masters.

Rocker. (Engrav.) A tool used by the engraver in mezzotint. It is a kind of chisel with a sharp bevelled edge, which is set on the surface of the copper and rocked too and fro so as to obtain a series of points forming a rough grain. This grain retains the ink and enables the engraver to get a proof of a velvety black, which, if the rocker has been handled evenly, is of an equal tint. After this operation, which, after all, is only mechanical and may be simplified, the engraver cuts away

the lights with a cutting tool, just as he would were he working with bread crumbs on paper covered with black chalk.

Rockwork. A decoration in the rustic style generally made up of masses of natural or artificial rock. It is used principally to ornament fountains and to form grottoes.

Rococo. A decorative style which was an exaggerated development of the *rocaille* style (q.v.). It was characterised by a profusion of meaningless ornament, consisting of scrolls, foliage, and animal forms hopelessly confused and intermingled. As a general term *rococo* denotes anything that is heavy, ugly, and tasteless.

Roller. (Engrav.) A wooden cylinder furnished with handles and covered with leather, upon which a peculiar varnish is smeared. When the roller is skilfully passed over a plate, which has already been bitten, the varnish does not touch the furrows, but only covers the plane surface, so that the plate may be rebitten.

Roll-moulding. (Arch.) A term applied to many mouldings, varying a good deal from one another, but all presenting some resemblance to a roll.

Romain, St. St. Romain was bishop of Rouen in the 7th century. The exploit for which he is famous was the destruction of a noisome dragon, which in representations of him is generally shown at his feet.

Romanesque. (Arch.) The Romanesque style of architecture grew up in northern Italy and is the link between Classical and Gothic architecture. It is called by some writers round-headed Gothic. Its distinguishing characteristics are an extraordinary severity and simplicity of style. Its arches are generally semicircular, and its vaults barrel vaults. Its walls are thick and massive; in it the classical ideas of proportion with regard to columns, &c., are renounced; and the classical mouldings and ornaments, though they still occur, are much modified.

Romanticism. A movement in art which took place in 1830, parallel to the literary movement initiated by Victor Hugo and others. It was characterised by an emancipation from the so-called classical conventions and traditions. The Romantic school has left behind it works that are remarkable for their colour, their movement, their expression of the passions, and their interpretation of great poetical sentiments. It produced both great painters and skilful decorators and flourished particularly in Paris, where Eugène Delacroix may be regarded as its earliest apostle.

Ronde-bosse. A French term denoting a sculpture work in the round, in contradistinction to works in high or low relief.

Rond-point. (Arch.) A French term denoting the semicircular or apsidal

termination of a church. It is also applied to any circular space at the end of a walk, or the intersection of avenues, in the centre of which a monument, statue, or fountain is set up.

Rood. A representation of the Trinity,

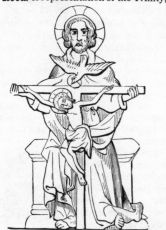

which in Catholic churches is placed over the altar screen, is termed a *rood*. The accompanying cut, which is from a drawing in Queen Mary's Psalter, will give the reader an idea of the orthodox form of the rood. The screen which supported it was called the rood-screen, and when it rested on a simple beam this beam was known as the rood-beam.

Rood-loft. (Arch.) A screen separating the choir from the nave of a church; originally a tribune or gallery, which served as a pulpit. There are many rood-lofts to be seen in churches of both the Gothic and Renaissance periods.

Roof. (Arch.) The coping or upper

part of a building, which serves as a covering and protection against wind and weather. The height of roofs varies considerably; sometimes, indeed, they are quite flat. The average height of a roof is between a third and fourth of the breadth of the building, but in the Gothic style it sometimes exceeds the

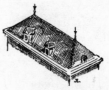

height of the façade. It is surrounded by gutters, which carry off the damp, and so preserve the walls of the building from damp. Above

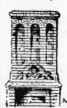

it rise chimneys, which afford the archi-

tect plenty of scope for design. In mediæval and renaissance houses beautiful specimens of chimneys are found ; some of them entirely of brick, with or without mouldings, others of stone, enriched with pilasters and varied ornaments. In later times they were of larger dimensions, and even more richly decorated.

Roof, Broken. A roof with two slopes, conducting the water to the same pipe.

—, **Mansard.** A roof, in which are

placed vertical windows or lucarnes, known as *mansards.*

—, **Pectiné.** A conical roof with a toothed edge, somewhat resembling the

teeth of a comb. In Gothic buildings the roof of turrets, when they are of small diameter, are covered with small tiles, cut into semi-circles, and edged with sharp teeth. Were square tiles applied to a convex surface, the right angles would not only project in clumsy fashion, but would be very fragile.

—, **Philibert Delorme.** A roof without ribs.

—, **Pointed.** A roof, such as was in vogue in the 15th and 16th centuries, of considerable height and very abrupt slopes.

—, **Pyramidal.** A roof in the shape of a pyramid.

—, **Span.** A term applied to roofs which consist of two oblique surfaces, inclined one to the other like a pack

saddle. Some Romanesque churches present examples of clock-towers, with roof in this form, the gable ends being pierced with. openings.

Roof, Truncated. A roof which has scarcely any slope, its surface being as nearly as possible horizontal.

Roofing. (Arch.) The covering of a. building ; the materials used in making this covering.

Rook. (Her.) The *rook* or *castle* of the game of chess is sometimes used as an heraldic device, and then takes the conventional form here shown.

Rose. (Arch.) In the Romanesque and Gothic styles church windows of circular form are called rose windows. The small rosettes which decorate Corinthian capitals are known as roses, while the same term is applied to the circular ornaments

placed in the centre of a pavement, made up of various coloured substances.

Rose Madder. (Paint.) This pigment is a lake obtained from the root of the " Rubia Tinctorum." It yields exquisite tints, and although it dries slowly is a useful pigment.

Rose Rubiate. (Paint.) A useful and transparent pigment of a rose colour. It may be used with advantage both in water colour and oil.

Rosette. (Arch.) A painted or sculptured ornament of circular form. Ceilings and coffers are sometimes decorated with rosettes, consisting of several rows of

leaves arranged in a circle round a bud.

Rosso Antico. A deep red marble with white spots and veins. It was used by the sculptors of Egypt as well as by those of Greece and Rome.

Rostrata. (Arch.) An epithet applied to columns at Rome, which were decorated with *rostra* or beaks of ships.

Rostrum. (Arch.) An ornament consisting of the prow of an ancient ship.

The name, *rostrum*, was also given in ancient times to the tribune set up in the Forum Romanum, because this tribune was decorated with the beaks of ships.

Rotunda. (Arch.) A building of circular form, generally surmounted by a cupola.

Roucou. A red paste, dry and of a disagreeable odour, which is obtained by the maceration of the berries of the arnotto-tree, and is used in gilding to obtain vermilions.

Rough-cast. To rough-cast a wall is to cover its suface with a coating of plaster.

Rough in, To. (Sculp.) To remove, by means of the chisel and hammer, and in the case of large surfaces with a saw, those parts of a block of stone or

marble which protrude beyond the outline of a figure or the profile of a moulding, these outlines or profiles being approximately traced upon the stone or marble.

Roulette. (Engrav.) A small disc of tempered steel, furnished with sharp teeth. Some roulettes are fixed perpendicularly, others parallel to the handle. The roulette is passed several times over the plate, covered with the etching ground, so as to trace upon it

a series of points which may be crossed at will in every direction. The grain thus obtained varies in strength according to the size of the teeth of the instrument and the force with which it is driven over the etching-ground.

Roundels. (Her.) These are small circular discs which are frequently met with in coats-of-arms. It is usual that not fewer than three together should appear on a shield, and the round-els may themselves be charged, that is to say, they may have another charge placed upon them. They are distinguished by special names according to their tinctures; thus the *roundel or* is called a *bezant*, probably from a gold coin of Byzantium; the *roundel vert* a *pomme*, and so on.

Rowel. (Her.) The little spiked wheel that forms the penetrating part of a spur. It has five or six projecting points or rays like a star, and is not an unfrequent charge in heraldry.

Royal Academy. [Academy, Royal.]
Royal Blue. (Paint.) A blue pigment composed of glass, which has been made blue by fusion and then powdered. It is of much service in fresco and porcelain painting, and was first used at

Sèvres. In oil and water-colour it is to be avoided.

Rubble-work. (Arch.) A coarse kind of masonry, which consists of plaster and stones mixed.

Rubens Brown. (Paint.) This pigment is a native earth, richer and warmer than Vandyke brown. It is faintly permanent, but is adversely affected by strong light.

Rubens Madder. (Paint.) This pigment is of a rich purple colour, with just a suggestion of yellow. Although it does not dry easily, it is useful to the painter, as it is quite permanent and is not affected by light or other pigments.

Rubric. A term applied to mediæval manuscripts, in which the initial letters were illuminated in red. The drawing of these letters was the work of an artist, called a *rubricator*, who devoted himself exclusively to this small branch of art.

Rub out. Useless strokes in a crayon drawing are rubbed out either with indiarubber or bread crumbs.

Ruby. A precious stone, of a rich transparent red. It is second in value only to the diamond.

Rudder. In ancient symbolic art the rudder suggested good fortune, and is

frequently associated with a cornucopia, as it is in the accompanying cut, which is copied from a gem.

Ruelle. (Arch.) A term applied to the bedrooms which certain ladies of quality and *précieuses* of the time of Louis XIV. transformed into reception rooms. The full form of the expression was *ruelle de lit*.

Ruins. A term applied to the *débris* of a building and to pictures, which represent such *débris* laid out in a conventional landscape.

Rule. A flat piece of wood, metal, or glass, with which straight lines are drawn.

— **Lesbian.** An instrument used by ancient architects, and consisting of a plate of lead, by means of which convex surfaces might be measured.

Rundle. A small disc of leather or metal pierced with a circular opening.

Rustic. (Arch.) A style of ornament in which surfaces are decorated with vermiculations and stones are left with their faces unhewn.

Rustic-work. (Arch.) A kind of masonry in which the surface of the stones is purposely left rough, or cut in quaint shapes, so as to suggest that they have not been hewn or squared. This rough surface is covered with many different sorts of ornament.

—, **Cavetto.** Masonry in which the projecting surface of the stones is terminated by a moulding of concave outline, like that known as cavetto (q.v.).

—, **Chamfered.** Rustic-work masonry, in which the projecting portions of the stones are cut at an angle of 45 degrees.

—, **Continuous.** Rustic-work continued round the façade of a building.

—, **Diamond.** Rustic-work masonry, in which the stones are cut into faces, so that only one sharp point projects. The stones thus terminating in a diamond point may be either squares or rectangles.

—, **Vermiculated.** Rustic-work,

the surface of which is cut into irregular figures resembling stalactites,

or covered with threads depressed below the surface, not unlike twisted worms.

Rustre. (Her.) The *rustre* is a small diamond or lozenge pierced or voided

with a *circular* opening, thus distinguishing it from the *mascle*, which is pierced with a diamond-shaped opening. Rustres are generally borne in number.

Rutilant. That which shines with a vivid brilliance. Stuffs, for instance, may be said to be of a rutilant tone.

S.

Sable. (Her.) In heraldry black is always blazoned *sable*. It is shown on a shield by means of vertical and horizontal lines crossing one another so as to make a dark shading.

Sablière. (Arch.) A piece of timber placed horizontally, the purpose of which is to support other pieces of timber.

Sacellum. (Arch.) A name given, in ancient architecture, to small temples or shrines, roofless and open to the air.

Sacrarium. (Arch.) That part of the ancient temple in which were kept the sacred utensils and vases.

Sacrifice. (Paint.) To sacrifice is to neglect certain details in a picture so as to increase the *value* of the principal motive. To sacrifice artistically is to know exactly what parts to neglect in order to make the other parts stand out with due effect.

Sacristy. A building attached to a church, or a small room arranged for the purpose, in which the sacred vessels and the sacerdotal vestments are kept. The treasures of the church are also kept in the sacristy. Sometimes sacris-

ties are vaulted chambers and are attached to the exterior of the church like lateral chapels. On the other hand, sacristies often consist of one or two bays, which are lost in the general arrangement of the building.

Saddle-back. (Arch.) A term applied to two surfaces inclined at an angle so as to form an inverted V, thus, Λ, especially when the surfaces are slightly convex.

Saffron. (Gild.) A powder obtained from saffron flowers and used to produce vermilions.

Sagum. (Cost.) A garment, consisting of a rectangular piece of rough cloth, which was fastened by a brooch upon the left shoulder. It was worn in ancient Rome by lictors and soldiers. The word is Celtic in origin and means cloth of coarse wool. It is connected etymological with our word *shaggy*.

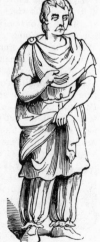

345

Salade. A helmet worn by infantry

in the 15th century. It was sometimes made with a movable visor, sometimes

it covered the head and upper part of the face.

Salient. (Her.) An animal is termed salient when it is represented as leaping forward. [Lion Salient.]

Salle des pas perdus. (Arch.) A French term applied to a long public gallery, such as the large hall in front of the audience chamber of a palace, or the waiting-room in a railway station.

Salon. The exhibition of the works of living artists which takes place every year in Paris, at the Palais des Champs Elysées, remaining open from the 1st May to the 20th June. The exhibition obtained the name of *Salon* from the Salon Carrée of the Louvre, where an exhibition of the "Salon des Arts" took place as early as 1737. *Faire le Salon* is to write a critical account of it in a public journal. Similarly we say in England, "to do the Academy," "to do the Grosvenor."

Saltire. (Her.) The *saltire* is really

only a special form of the cross, formed by combining the *bend* and the *bend sinister*, and is often described as a St. Andrew's Cross. There is no diminutive of the saltire.

Samian Ware. (Pot.) There is a red kind of pottery to which the name *Samian Ware* has been given, because there is a tradition that it was first made at Samos. It was manufactured in all parts of the civilised world, everywhere, at least, that the Roman legionaries penetrated, and much Samian ware (of a kind) has been discovered in England.

Sancte-bell. A bell, generally of silver, carried in the services of the Roman Catholic Church and rung to call attention to certain solemn parts of the service. In England before the Reformation a sancte-bell was sometimes hung in a small bell-turret.

Sandal. (Cost.) The simplest kind of footgear, consisting only of a sole and leather-thongs. Among the Greeks and Romans sandals were sometimes richly decorated and their thongs ornamented with jewels.

Sandbag. (Engrav.) A bag covered with leather and stuffed with sand is used by engravers to rest their block or

plate upon. It enables them to get their work at whatever angle they like. [Cushion.]

Sandvent. An earthy matter, which covers the surface of blocks of stone when they come out of the quarry. This sandvent must be removed before the stones are cut and laid in courses or decorated, as it would not offer sufficient resistance to time and weather.

Sanguine. A deep red resembling blood colour. The term also denotes a blood-coloured crayon and a drawing executed with this crayon. For instance, we speak of a portrait in sanguine; a sanguine by Watteau.

Santiago. [James, St., the Greater.]

Sap green. (Paint.) A pigment obtained from buckthorn berries or the

flowers of the blue iris. It is useful and permanent in water-colour.

Sapphire. A brilliant and transparent precious stone of a rich blue colour.

Saracenic. (Arch.) A term applied to the Moorish style of architecture, such as was employed at the Alhambra Palace at Granada. Richness of colour and elaboration of design are its distinguishing characteristics. All animal forms are excluded from its decorative scheme, and flowers and plants are treated in an emphatically conventional manner.

Sarcophagus. (Arch.) A tomb, in which in ancient times bodies were placed without being burnt. Sarcophagi were made of a special stone which was believed to have the curious property of

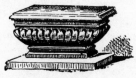

eating away flesh. This stone was a kind of pumice stone, found in Troas, and it was said to complete the destruction of a whole body, except the teeth, in the brief space of forty days. Ancient sarcophagi are often decorated with reliefs, and may be ranked among the

most interesting relics of ancient art. In the Middle Ages, the term sarcophagus was applied to tombs in the form of altars, decorated with flutings and sometimes surmounted with statues, either lying or kneeling.

Sard. An agate of a reddish colour.

Sardonyx. A hard siliceous stone, which was of a dark tint, such as black or purple, or was made up of strata of white and red. The last-named variety was highly prized by ancient gem-engravers, as it could be so cut that its strata produced the effect of a white cameo on a red ground.

Sash frame. (Arch.) A window frame which opens or shuts by being moved up or down in vertical grooves. Windows in English houses have long been constructed upon this principle.

Satiny. That which has the brilliance or lustre of satin. Thus we may say of a proof of a woodcut, that it is of a satiny texture, or of a picture that the rendering of its flesh tints is satiny.

Satiric. A term applied to the draughtsmen of caricatures and humorous sketches. The artists on the staff of *Punch,* for instance, would doubtless describe themselves as satiric.

Satsuma. (Pot.) A fine stoneware produced in Japan in factories belonging to the princes of Satsuma. It was decorated with flowers, arabesques, &c., worked in gold as well as in enamels. The older the pieces of Satsuma ware are, the more refined and simple is their style of ornament.

Saturnus. A deity worshipped at Rome. He was believed at a very remote period to have reigned over the city, and the age of Saturn (like the age of Cronos in Greece, to which deity Saturn presents some resemblance) was remembered as a golden age. Saturn is said to have instructed his people in agriculture and gardening, and he is represented holding a sickle in his hand. A festival was held in his honour at Rome in December, and the Saturnalia always afforded an opportunity for merriment and riot.

Satyr. A mythological figure. A demi-god of the Greeks and Romans,

347

whose characteristics were a brutal, sensual face, the feet of a goat and a hairy body. His head was covered with unkempt hair, from underneath which horns sprouted. Statues and masks of satyrs were frequently used as a decoration.

Saucer. (Paint.) Small vessels of zinc, fixed to a plate of metal folded over so

as to fit on the edge of a palette, are used by painters in oil to hold either oil or varnish. Painters in water-colour

used small concave disks of porcelain of a spherical shape. They also use rectangular saucers, which are set side by side upon porcelain. In these

colours can be mixed, and several colours used at the same time. Some saucers, hollowed out of a block of crystal, intended particularly for Indian ink, may be co-

vered with a piece of glass, so as to preserve the tints from dust or evaporation.

Saunders Blue. (Paint.) A corruption of *cendres bleues;* the name is sometimes given to ultramarine (q.v.).

Savonnerie. A term applied to the carpets made at the royal factory which was established in Paris in the 17th century, and merged in 1728 in the Gobelins manufactory.

Saxon architecture. [Anglo-Saxon architecture.]

Saxony. (1) (Pot.) Dresden or Meissen china is frequently described as Saxony. [Dresden.]

Saxony. (2) (Her.) The arms of Saxony, borne on a shield of pretence by the Prince of Wales in virtue of his title of Duke of Saxony, are *Barry of ten, or and sable, a coronet extended in bend, vert.* This *coronet extended in bend* is by French heralds called a *cancerlin.*

Scabbard. The sheath of a sword, which was generally decorated with much elaboration. Many artists have provided the goldsmiths with designs for scabbards, and at the British Museum may be seen some exquisite designs for scabbards by Holbein.

Scabellum. (Arch.) In the ancient languages the term *scabellum* denoted a kind of square footstool, with a pedestal of a considerable size, and about the height of a step, as well as a movable footstool which was placed under the feet of statues, representing a god seated on his throne. In modern architecture the term is applied to square pedestals with or without a capital, of no great height, the purpose of which is to support a bust. In this case it is placed over a grave or behind a sarcophagus, or simply set up as a kind of commemorative monument.

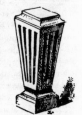

Scaffold. (Arch.) When a building is

in course of construction, or a large mural surface is being painted, the upper part of the wall or building is reached by means of a scaffold, which is a temporary construction, made up of poles and planks.

Scagliola. A spurious marble, composed of gypsum and glue. A variegated surface is obtained by sprinkling finely powdered spar, marble, &c., over it. It was first made in the 17th century by Guido del Conte, but its use cannot be recommended as it is not durable.

Scale. (1) (Paint.) Pictures, whether on canvas or panel, are said to *scale*, when their surface cracks and the paint comes off in flakes. The scaling of pictures is due to the varnish used, to bad mixtures of colour, and also to want of care in the rolling of the canvas.

Scale. (2) (Arch.) A system of ornament consisting of tiles cut obliquely, or notched so as to form arcs of circles. Scales are used to cover the surface of inclined walls, so that they may resemble a roof. They were first used in the 12th century,

when they were either square or semicircular. In the 13th century they varied very much in form, and in buildings of the Renaissance fine specimens the found pierced with all kinds of patterns.

Scale. (3) A proportion adopted in executing a reduction or enlargement of any work. A scale is a graduated line,

upon which are marked the multiples of the unit of length. This unit is greater

or less, according as the objects to be reproduced are to be reduced or enlarged.

Scale, Dotted. (Arch.) An indication of the length, altitude, and dimensions of

a building written in figures on a sketch or plan drawn to a known scale.

Scale-stone. (Sculp.) When a clay model is to be reproduced in marble, the marble block which is to be carved and the clay model are set upon similar blocks, called *scale-stones*. Before the work of pointing (q.v.) begins, the scale blocks are covered, each with a series of similar marks.

Scantlings. (Sculp.) The pieces of stone or marble removed from a block by means of a hammer and chisel in the process of roughing in (q.v.) are called scantlings.

Scapulary. (Cost.) A narrow band of stuff which reaches from the shoulders to the feet. It forms part of the costume of some monastic orders.

Scarab. A carved stone representing a beetle. Scarabs were prized among the Egyptians as amulets, and large collections of them have been made in modern times accurately dated by means of the hieroglyphics engraved upon them.

Scarf. A piece of wood placed diagonally across a series of planks, which it serves to strengthen and hold together.

Scarlet. (Paint.) A bright red colour of great brilliance obtained from the action of chloride of zinc and cream of tartar upon cochineal.

349

Scarp (Arch.) The exterior surface of a wall inclined in talus (q.v.). In fortification the scarp is the back of the fosse

placed at the side of the rampart facing the besieging party.

Scarpe. (Her.) A scarpe in heraldry is a diminutive of the bend sinister (q.v.). The shield in our cut may be blazoned, *Argent, a scarpe, gu es.*

Scarpellino. An Italian word denoting a workman employed by a sculptor to carve his work in marble. The work of the *scarpellino* is checked by the use of a pointing machine, but the scarpellino, who puts the finishing touches to the marble, must possess skill both of eye and hand.

Scauper. (Engrav.) A tool used by

woodcutters to cut away the spaces between the lines of a block. In line engraving an instrument of the same name is used to draw broad strong lines.

Scene-painting. Scene-painting was hardly practised at all in England until after the Restoration. As everyone knows in Shakespeare's time the scenic arrangements were of the simplest kind, and the drama seems to have flourished very well without elaborate mounting. The first attempt at stage adornment was made by Inigo Jones, who, however, relied upon machinery and heavy sets rather than upon painted scenes. His experiment does not seem to have met with encouragement, and no more trials were made in this direction until the time of Betterton. Even then heavy sets were for some time popular, but better taste intervened at last, and during Garrick's management de Loutherbourg did much to advance the scenic art. Among the artists who have also been scene-painters we may mention Nasymth, David Roberts, and Stanfield, while the name of Beverley is indissolubly connected with the theatre. In the present age the legitimate art of scene-painting is less encouraged than that (if art it may be called) of stage-carpentry, and the machinist is a more dignified person than the artist.

Scheele's Green. (Paint.) Scheele's green is a compound of copper and arsenic. It is a pigment of useful colour and more permanent than other greens obtained from copper.

School of Painting. In the most rigid application of the term, *school of painting* denotes the painters or pupils who worked in the bottega or studio of one master. Hence it was extended to include the painters of a city or province, who learnt their art from one master. A picture is said to belong to the school of a master when it is executed in the style of that master. We may also speak of the English school, the French school, meaning thereby the painters of England or France, of every date and every style.

—, **Bolognese** The Bolognese School flourished in the 16th and 17th centuries. It was characterised by learning and a sense of decorative effect, but was marred by academical precision. Its chief masters were the Caracci, Guido, Albano, Domenichino and Guercino. Of the earlier Bolognese School of the 15th century Francia was the best representative.

—, **Brescian.** The greatest artists of

the Brescian School (16th century) are Moretto and Moroni, both distinguished painters of portraits. Moroni's masterpiece, *Il Taglioni*, is to be seen in the National Gallery.

School of Painting, Dutch. The Dutch School is distinguished for the realism of its portraits and genre pictures, and for the excellence of its landscape. The greatest master of the school in the 16th century was Lucas van Leyden. In the 17th century flourished Rembrandt, the greatest master of light and shade the world had seen, Gerard Dow, de Hooghe, Terburg, Metzu, Van Ostade, Teniers, and Wouverman, all of whom were distinguished by the careful finish and accurate drawing of their works, Ruysdael, Cuyp, Van der Velde, Hobbema, and Van der Meer, painters of landscape and sea-pieces, and Paul Potter, famous as a painter of animals.

—, **English.** The English painters of the 16th and 17th centuries were, with the exception of Dobson, an excellent portrait painter and pupil of Vandyck, chiefly miniaturists. Vandyck, Sir Peter Lely and Kneller, all spent many years in England, but can hardly be said to belong to the English school. In the 18th century the English School first became of real importance. Hogarth, the caricaturist, is by some regarded as the father of English painting. To the same period belong Reynolds, Gainsborough, Romney, Richard Wilson, and Morland. In the early part of the 19th century the landscape painters of England were justly celebrated. Among them are Constable, Crome, Cotman, Turner, Bonington, De Wint, and Copley Fielding. In portraiture and *genre* the most distinguished painters of this period were the Scotchmen Raeburn and Wilkie. The Englishmen Lawrence, West, Barry, Northcote, Mulready, Maclise, and the rest are as a rule feeble in drawing and colour, and too often trivial in sentiment. About the middle of the present century a revolution was brought about in English art by the efforts of the Pre-Raphaelites (q.v.), of whom the most striking representative is perhaps D. G. Rossetti. The last ten or twenty years have been distinguished by a great outburst of artistic energy, a good deal of the best work being produced under the direct influence of the French School. The English School in one branch, that of water-colour, has always claimed to take precedence of all other schools. From the 18th century onwards the list of English water-colour draughtsmen is a long one, including Girtin, de Wint, David Cox, Prout, William Hunt, Turner, &c. But it should be remembered that their methods are not those of the painter, and in spite of our oft-repeated boast, we have none who can handle water-colour with the skill and artistic feeling of the modern French and Dutch aquarellistes.

School of Painting, Ferrarese. The school of Ferrara, which flourished in the 15th and 16th centuries, was closely connected with that of Bologna (q.v.). Like the Bolognese, the Ferrarese painters were for the most part academic and uninspired. Among the artists of Ferrara the chief were Lorenzo Costa and Dosso Dossi.

—, **Flemish.** The peculiar glory of the Flemish School is the richness of colour affected by its masters. For three centuries this School held an unrivalled position in European art. In the 15th century flourished the Van Eycks. The portrait of Arnolfini and his wife by Jan van Eyck, which is now in the National Gallery, is one of the finest pictures ever painted. The Van Eycks were followed by their pupils Van der Weyden and Memling. In the 16th century the Flemish School fell under the influence of Raphael and suffered considerably from the " Italianisers." Among the Flemish painters of this century may be mentioned Van Orley, Mabuse, Pourbus, and Antonio Moro. In the 17th century there was a distinct

revival of the glory of Flemish art, brought about by the genius of Rubens, Vandyck, Snyders, and others.

School of Painting, Florentine. Florence was the cradle of the Renaissance of art, and the Florentine School occupies the most important position of all the Italian schools of painting. To the 13th century belongs Cimabue; to the 14th Giotto, the father of modern painting, and Orcagna; to the 15th Masaccio, Filippo Lippi, Sandro Botticelli, Ghirlandaio, Pollaiuolo and Verrocchio; to the 16th Luca Signorelli, Leonarda da Vinci, Lorenzo di Credi, Michael Angelo, Andrea del Sarto, Sodoma and Bronzino.

—, **French.** The French School took its rise in the 15th century. Its earliest manifestations were the miniatures of Jean Foucquet, and in the portraits in oil by Clouet. These early works were produced under the influence of da Vinci, del Sarto, and Cellini, and were mere pastiches of the Italian style. Then came Jean Cousin, who was painter, sculptor, and architect; he was followed by Quentin Varin (the master of Poussin), Vouet, Callot, Le Nain, Lesueur, N. Poussin, Claude Lorrain, Lebrun, Jouvenet and Monnoyer. These artists conferred distinction on the 17th century. In the 18th century lived Le Moyne, Vanloo, Oudry, Watteau, Lancret, Boucher, Fragonard, Greuze, Chardin, and Vernet. Towards the end of the 18th century Louis David attempted a revival of classicism with some success. The school of the early 19th century included Prud'hon, Gros, C. Vernet, Géricault, Ingres, Delaroche, Ary Scheffer, Delacroix, Charlet and H. Vernet. The great revolt against classicism took place about 1830, and Géricault and Delacroix prepared the way for the Romantic movement, out of which came Corot, Diaz, Th. Rousseau, Troyon, Couture, Courbet, Fromentin, J.-F. Millet. The French school of to-day undoubtedly takes the lead in Europe

as far as technical skill is concerned, and the schools of Paris afford the most efficient education. At the same time it must be acknowledged that much of the most modern French art suffers somewhat from a love of morbid sensationalism.

School of Painting, German. The German School of painting dates from the 14th century, William of Cologne, whose St. Veronica is in the National Gallery, being its earliest master. In the 15th century the most important German painters were Martin Schongauer, Lucas Cranach, and Albert Dürer, all of them perhaps more famous as wood engravers than as painters. The greatest German master of the 16th century was Holbein. Since his period the German School has produced very few great painters, although at the present day the schools in Munich and some German towns are admirably conducted and much frequented.

—, **Lombard.** The Lombard School of painting includes the schools of Mantua, Modena, Parma, Cremona, and Milan. The period of its highest development was in the 15th and 16th centuries. It numbers among its members Andrea Solario, Bernardino Luini, Correggio, Caravaggio, &c.

—, **Luccan.** It was at Lucca that the earliest painters of Italy worked. In the 12th and 13th centuries a kind of rude traditional art was practised by Giunta, Pisano, and others at Lucca. This was before the re-discovery of the art of painting by Cimabue and Giotto, and the examples of the Luccan School have little else than an archæological interest.

—, **Milanese.** In the 16th century the chief master of the School of Milan was Vincenzo Foppa. In the 16th century the school was dominated by the influence of da Vinci, and during this period it numbered among its masters Luini, Beltraffio, Gundenzio, Ferrari, and Andrea Solario.

—, **Modenese.** The School of Modena

is a subdivision of the Lombard School. In the 16th century Correggio and Parmigiano were its most distinguished masters.

School of Painting, Neapolitan. The Neapolitan School has no distinct character of its own, and only consisted of foreign painters up to the 17th century. In the 15th century works by Van Eyck influenced the painters of Naples. Antonello da Messina, who was then at Naples, learnt the method of the Flemish master, but he soon returned to Messina and finally settled at Venice. In the 17th century Aniello Falcona, Salvator Rosa, Luca Giordano, and the Spaniard Ribera all worked at Naples.

—, **Paduan.** The one great figure of the Paduan School is Andrea Mantegna, who flourished in the 15th century. He was influenced by and in turn influenced the Venetian School, in which he is generally given a place.

—, **Roman.** An offshoot from the Umbrian School. Nearly all the members of the school came from other cities and worked under the influence or carried. on the tradition of Raphael. As we should expect from this fact, the Roman School is distinguished by a knowledge of composition and perfection of draughtsmanship. Raphael and Giulio Romano were the chiefs of the school in the 16th century, while Sassoferrato and Maratti represent it in the 17th.

—, **Sienese.** The School of Siena is one of the earliest of the Italian schools. In the 13th century its masters were Guido da Siena and Duccio; in the 14th century Lippo Memmi and Ambrogio Lorenzotti, in the 15th Sano di Pietro and Matteo di Giovanni.

—, **Spanish.** The most strongly marked characteristics of the painters of the Spanish School are a love of realism and the lavish use of brilliant colour. In the 15th century Spanish artists merely copied Italian masters. In the 16th, in which century they achieved their national style, the most celebrated masters of the Spanish School were Alonso Berruguete, Luis de Morales, Alonzo Sanchez Coello, Jose Ribera, and Ribalta. Then came F. de Herrera, Diego Velasquez, Alonzo Cano, Francisco Zurbaran and Murillo. In the 18th century the Spanish School is represented by Goya, while in the present century the greatest Spanish painter has been Fortuny.

School of Painting, Umbrian. In the 15th century the chief painters of the Umbrian School were Allegretto Nuzi, Gentile da Fabiano, Piero della Francesca and Fiorenzo di Lorenzo. Then followed Timoteo Viti and Perugino, and the latter's pupils Raphael, Lo Spagna, and Pinturrichio.

—, **Venetian.** The characteristic of the art of the Venetian painters is brilliant colour. In the 15th century flourished Crivelli, Gian and Gentile Bellini and Carpaccio, in the 16th century lived Giorgione, Palma Vecchio, Titian, Tintoretto, Lorenzo Lotto and Paul Veronese. The Venetian School of the 17th and 18th centuries is represented by Tiepolo, Canaletti and Guardi.

—, **Veronese.** The Veronese School attained its height in the 16th century, when Domenico Moroni, Bonsignori and Cavazzola flourished. Pisanello, the most distinguished member of the school, belongs to a slightly earlier date.

Schweinfurt Green. (Paint.) A green obtained from copper and arsenic. It is a permanent and serviceable pigment, and is considerably lighter in colour than Scheele's green.

Scie d'atelier. This is a piece of French artistic slang, denoting a mystic saying, a song, the refrain of which is purposely monotonous and is endlessly repeated. The object of this repetition

353

is to annoy and torment all those who hear it. For a *scie* to be successful it must not only attain this end, but must even go beyond it. In some *ateliers* the *scie* takes the form of a traditional practical joke, unpleasant and even dangerous. Such, for instance, is the bucket of water, suspended over the entrance of the studio, which empties its contents on the head of the novice or even the master himself. But there are also *scies* which are spontaneous and improvised, full of allusion to passing events, in which that class of students, already described under the term *rapin* (q.v.), finds material upon which to exercise its wit.

Sciography. A term applied by the ancients to the art of representing objects, due regard being paid to their light and shade. It also denotes a geometrical drawing, showing the section and the interior of a building.

Sconce. An ornamental candlestick fixed to the wall by means of a bracket. Sconces have assumed various forms, and have afforded plenty of scope for

the decorative artist. Many of them have plates of brass behind them, which are sometimes incised, sometimes embossed, with admirable designs, and serve as reflectors.

Scotia. (Arch.) A moulding of convex outline, consisting of two portions of a curve. It is also known by the name of "hollow round," while sometimes it is termed a *trochilus.* It derives its name from the strongly marked shadow which it takes (σκότιος, dark.)

Scraper. (1) (Engrav.) There are several tools-used by engravers which differ slightly from one another, but are all known as *scrapers.* The mezzotint engraver uses the *scraper* to remove the grain from those portions of his plate which he desires to print white, his method of work being to leave the grain to obtain his *shades* and to scrape the plate to obtain his *lights.* He works in the same way as a draughtsman in crayon, who gets his light portions by rubbing the surface with breadcrumbs. Another kind of *scraper* consists of a quadrangular blade, the edges of which are very carefully sharpened. It is used to remove the roughnesses produced upon transparent paper in making a tracing and also to get rid of the *burs* or ridges, which result from the use of the dry point upon a copperplate. The latter is the more important use of this square scraper, and its management by the engraver is a matter of considerable delicacy. If it is not handled properly there is a danger of its scratching the plate as well as removing the bur. Then again by scraping away hatchings different effects of modelling may be obtained, and the strength of the tones may be increased or diminished. Wood engravers use a scraper to polish their

wood-block before putting in the distances and the luminous parts, as well as another kind of scraper, the angles of which are almost rounded. In water-colour drawing a *scraper* is used to put in the lights and considerable skill may be displayed in its handling. Many of Turner's water-colour drawings were made on paper stained grey; he was thus enabled to wash or scrape out his lights.

Scraper. (2) (Constr.) In rough-casting buildings an instrument, called a scraper, is used. As will be·seen from

our cuts it assumes various forms. The triangular scraper is especially useful to painters, as it enables them to reach the ground of hollow mouldings.

Scraper. (3) A tool of very variable form, used to scrape a surface. Stone cutters use a scraper to efface the marks of a toothed hammer. Sculptors, on the other hand, use

scrapers of a particular form to cover certain portions of their work with irregular *striæ*.

Screen. (1) (Arch.) A pierced enclosure, which separates the nave of a church from the choir, or shuts off side-chapels from the nave.

Screen. (2.) A piece of furniture, gene-

rally consisting of a panel of stuff embroidered or decorated with paintings, which is stretched on a frame and serves to ward off the light and heat of a fire. Some tapestry screens are of great

beauty. Screens from China or Japan, either lacquered or incrusted, are of great value and are eagerly sought for by collectors. They sometimes consist of several leaves, placed vertically and connected with one another by hinges. Screens of this kind also are decorated with paintings or richly embroidered stuffs.

Screw Clamp. A contrivance of wood or iron, in the shape of a rectangle open on one of its sides. It is provided with a screw, as shown in the cut. Cabinet makers use a screw-clamp to hold fast the materials which they are joining. It is also employed by photographers to fix their camera to the table.

Scriber. (Engrav.) An instrument used by wood engravers to hollow out the lines surrounding a vignette or to serve as a guide in the drawing of horizontal or perpendicular lines. The point of the scriber, which indicates the guiding marks, ought to be slightly blunted so as not to leave any marks on the wood.

Scrinium. A case or box, generally

circular in form, which was used by the

ancients for holding books, rolls of parchment, &c. Its form will be readily understood from our cut.

Scroll. (Arch.) A system of ornament consisting of spiral volutes. Ionic and Corinthian capitals, as well as consoles at all epochs, are decorated with scrolls.

The rococo style is nothing but the result of carrying to its utmost limits the application of scrolls to decoration. The supports of old signboards and various kinds of ancient iron work present admirable examples of scrolls.

Sculp. (Engrav.) An abbreviation of the word *sculpsit*, which often follows the name of the engraver on engraved plates ; *e.g.*, Marc Antonio sculp.

Sculpture. The art of reproducing objects in relief or in the round, in a hard material which can be cut with a chisel. To execute a model in clay is the process of modelling, but to translate the model into bronze or marble is, properly speaking, the aim of sculpture. However, as the artistic skill of the sculptor is almost entirely displayed in the execution of the clay model, the art of modelling in clay is generally described as sculpture.

Sculpture, English. The English sculpture belonging to Saxon and Norman times was very rude and primitive. An idea of its style may be obtained from a bas-relief of the 11th century, now preserved in Chichester Cathedral. To the 13th century belong the admirable statues, which decorate the western façade of Wells Cathedral, and which are among the finest specimens of mediæval sculpture. In the 14th or 15th centuries many excellent effigies were produced in England. In the 16th

century Torrigiano came to England from Florence and modelled the figures on Henry VII.'s tomb. Nicholas Stone and Grinling Gibbons are the most notable English sculptors of the 17th century, but the latter was better known as a carver of wood than of marble. The English sculptors of the 18th century had little merit, they cultivated a pseudo-classic style and not unfrequently clothed their models in togas and wigs. The best of them were Nollekens, Bacon, and Flaxman. In the earlier half of the present century no advance was made in English sculpture. Little praise can be given to Baily, Chantrey, Westmacott, or Wyatt. During the last thirty years, however, an immense improvement has taken place. Alfred Stevens, the author of the Wellington Monument, was a sculptor of genius, while there are still among us, besides Sir Frederick Leighton, whose " Athlete struggling with a Python " is a work of conspicuous merit, such distinguished sculptors as Hamo Thornycroft, Alfred Gilbert, and Onslow Ford.

Sculpture, French. The mediæval sculpture to be seen on the façades of French churches is of the greatest interest and in it perhaps Gothic sculpture reached its highest point of excellence. At the Renaissance, French art fell under Italian influence, and the most celebrated French sculptor of the 16th century was Jean Goujon, who got his inspiration from Cellini. The 17th century seems to have produced no great sculptor in France. In the 18th century the most conspicuous French sculptor was J.-A. Houdon, while Chaudet and Bosio were his younger contemporaries. In the early part of the present century flourished Rude, Duret, Stuart, and Carpeaux. Technically speaking the French sculptors of to-day are unsurpassed, some modern works of sculpture, such as those by Rodin, show a knowledge and power which have rarely been equalled.

—. German. In the Middle Ages sculp-

ture was not practised with the success with which it was pursued in France. In the 14th century, however, many fine works were produced. The 15th century was the golden age of sculpture in Germany. Many admirable specimens of wood-carving were then produced, some of which may be ascribed to Wohlgemuth and his great pupil, Albert Dürer. But the most brilliant name in the history of German sculpture is undoubtedly Vischer. The family of Vischer were at work in the 15th and 16th centuries and produced many masterpieces. Their best work is to be seen at Nuremberg, Augsburg, and Lübeck. Since the 16th century German sculpture has declined. During the last hundred years many large works have been executed, in all of which the influence of the classic style is obvious, but which are for the most part without merit. Schadow, Kiss, and Schwanthaler are perhaps the best known of the modern German sculptors, but they have no great claim to consideration.

Sculpture, Greek. Sculpture is the peculiar glory of Greece. It flourished as an art among the Greeks for many centuries, and at Athens it was carried to its highest point of excellence. The earliest sculpture of the Greeks, such as the so-called Niobe at Sipylus. and the Lion Gates at Mycenae, was produced under oriental influence, but in very early time the Greek sculptors developed a characteristic style. To the 7th and 6th centuries belong the Apollo of Tenea, and the well-known metopes of Selinus, but it is not until we approach the beginning of the 5th century that we leave the age of experiment behind. Then flourished Callon and Onatas, the authors of the Aegina pediment, Myron, whose *Discobolus* is familiar to all, Ageladas, the Master of Phidias, and others. The great Athenian School was at its zenith in the 5th century, for then flourished Phidias, the greatest sculptor of all time, some of whose

works may be seen at the British Museum. He it was who decorated the Temple of Athene, on the Acropolis at Athens, and made the gold and ivory statue of the goddess, which stood in the *cella*. He also worked at Olympia, where the gold and ivory Zeus was from his hand. The most celebrated of his followers were Pæonius and Alcamenes, while Polycletus, the chief of the Argive School, was his contemporary and rival. In the following century there was a second outburst of artistic energy, which was in some measure due to the encouragement of Alexander the Great. The New Attic School lacked the severity and grandeur which were the noblest characteristics of its predecessor, yet Scopas and Praxiteles both produced works of great beauty and elegance. The head of the Peloponnesian School at this period was Lysippus, who is chiefly remembered as the Court sculptor of Alexander. Then came the period of ruin and decay, and at Rhodes and Pergamum Greek sculpture made its last effort before Rome won her supremacy.

Sculpture, Italian. Before the 13th century, Italy seems to have had no school of sculpture. In that and the following century, however, much excellent work was done in Italy, chiefly in the decoration of churches and shrines. It is the 15th century that is the golden age of Italian sculpture and Florence is the city in which the best work was produced. There flourished Donatello, Luca della Robbia, Vittore Pisanello, Verrocchio (the sculptor of the magnificent Colleoni) and Ghiberti, to whom we owe the great baptistery gates. In the 18th century flourished Michael Angelo, the greatest sculptor of modern times, whose David, whose Moses, are yet the wonder of the world. Then there was Cellini, who was more renowned as a goldsmith than as a sculptor, Giovanni da Bologna and Antonio Begarelli. Bernini is the greatest Italian sculptor of the 17th, Canova

represents the decadence of the 18th century. The Italian sculpture of the present time is for the most part worthless. Vulgarity and realism of an offensive kind are carried to excess by men who have ever before them such models as Donatello and Michael Angelo.

Sculpture, Roman. The Romans developed no school of sculpture of their own. Until, after the Conquest of Greece, *Graeculi esurientes* thronged the streets of Rome, the art of sculpture was not known in Latium. And when it became popular, it was only practised by Greeks, who brought the noble traditions of their country's art into the strange land. Some of them contented themselves with copying well-known masterpieces, and it is to their copies that we owe much of our knowledge of Greek sculpture ; others produced original works, in which the Greek convention was piously observed. They were not distinguished men, and the names of most of them are forgotten. Apollonius, Kleomenes, Agasias, and Pasiteles are the best known of the Greeks who formed a school of sculpture in Rome.

Sculpturesque. Figures, attitudes, or scenes which, from their style and the beauty of their lines, lend themselves easily to reproduction in sculpture, are said to be sculpturesque.

Scumbling. (Paint.) When the tints in a picture are too brilliant, they may be softened by blending them with a neutral tint, this neutral tint being laid on with a nearly dry brush. This process is called scumbling. In black and white drawing the hard outlines may be

scumbled by being rubbed with the blunt end of the chalk or the stump.

Scutcheon. (Her.) This is a name sometimes given to a cartouche or tablet prepared for the re-

ception of coats-of-arms or of some decorative design.

Scutum. An oblong shield carried by Roman foot-soldiers. It was made of pieces of board covered with hide and then with cloth. The soldiers of each

legion had shields of a distinctive colour and ornamented with their own device. Our cut is taken from Trajan's column and the shield which it represents is decorated with the thunderbolt.

Scymitar. A sword with a curved

blade, used by eastern nations.

Scyphus. (Pot.) A vase used by the Greeks as a drinking-vessel. It

was two-handled and had no foot, while its diameter decreased towards the base.

Scythe. (Her.) A scythe, with or without a handle, is sometimes borne as a common charge in heraldry. If the handle appears the scythe is then said to be *helved;* for example, *a scythe gules, helved sable.* This charge is often found in German coats-of-arms.

Seal. A piece of metal or stone, circular, square, or oval, in which

a design is hollowed out, and from which an impression in relief can be taken upon melted wax. These impressions also bear the name of seal. Sometimes seals are fixed to wooden handles, as shown in one of our cuts, or they are mounted in gold and hung from a chain.

Searched. (Paint.) An outline, silhouette or effect, which is not commonplace or vulgar, but is the result of accurate observation, and at the same time displays a strongly marked character or style, is said to be *searched.*

Seascape. Pictures or drawings representing maritime scenes or views of the sea. Thus we speak of a seascape by Turner, Van de Velde, or Henry Moore.

Sebastian, St. St. Sebastian, whose martyrdom has proved a favourite subject with artists of all schools, was a soldier in the Roman army. He was tied to a tree and shot at with arrows, and in art he is generally represented undergoing this torture. This method of destruction, however, seems to have failed, and he was finally put to death with clubs.

Séchiste. (Engrav.) A barbarous word employed by some French art critics to designate engravers who execute plates entirely with the dry point (*la pointe sèch?*), without using any of the materials employed by etchers.

Secondary Colours. [Colours, Secondary.]

Secrétaire. A piece of furniture, in which deeds and papers are kept, and a panel of which draws out horizontally, so as to form a table to write upon.

Section. A drawing representing the interior of a building, which is supposed to be cut through in a vertical plane, so as to show its length and breadth. The

thickness of the walls, the roof and the interior arrangements may thus be seen. The term *section* is also applied to a line so drawn as to show the outline of a moulding.

Sector. A portion of a circle, included between two radii and an arc of the circle. The term spherical sector is given to the solid figure produced by the rotation of a sector round a diameter as its axis. The different portions of a fortified enclosure are known as sectors.

Sedan Chair. [Chair, Sedan.]

Sedilia. (Arch.) A term applied to the stone seats, set like niches in the south wall of the choir of churches. They were used in Catholic times by

the officiating clergy. They are gener-

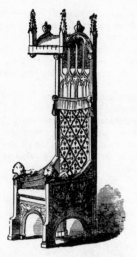

ally surmounted by arches, which vary in form according to the style and epoch to which they belong.

Seggar. (Pot.) A kind of sheath or box of terra-cotta, in which pieces of

porcelain are placed, to be submitted to the action of the fire.

Segment. A portion of a circle included between an arc and chord of a circle. A spherical segment is a portion of a sphere included between a curved surface and a plane cutting it.

Sémé. (Her.) In heraldry a shield is said to be sémé when it is covered with small objects, such as hearts, fleurs-de-lis, &c.

Semi-transparent. A term used to describe the incomplete transparency of certain precious stones and fine pottery.

Sendal. A kind of silk from which banners and rich vestments were made in the Middle Ages.

Sénestrochère. (Her.) A French term applied to a left hand and arm shown on a shield. In blazoning it should always be specified whether the arm is clothed or bare, and whether the hand is open or shut.

Sentiment. The sentiment of a work of art is the general effect by which the artist has expressed his own feeling and sought to inspire the same feeling in the spectator. Sentiment is a subtle quality, and may depend upon colour, drawing, or any of the means upon which an artist relies to express himself.

Sepia. (Paint.) The sepia used by water-colour draughtsmen is obtained from the bladder of a small mollusc. Its tone varies in warmth according as it is natural or coloured. Natural sepia yields a reddish-brown tint; artificially coloured sepia gives the same tint, of a somewhat vinous shade. Many sepia drawings—as the monochrome sketches, in which sepia is used, are called—were produced about the year 1830. These sketches, however, which were always somewhat cold in aspect, have had their day. The majority of them, indeed, are of a most distressing dryness; yet many celebrated artists, such as the Frenchmen Charlet and Delacroix, have produced admirable sepias. Some painters of the present day use sepia or bistre, which is of nearly the same tone, in the execution of washed drawings, rapidly thrown off, in which, by laying on the sepia in broad masses, effects of light may be easily obtained. Then, again, the warm tone of bistre or sepia is used

in taking proofs of engravings, which, if printed in black, would have too violent an effect. Such, for instance, are the proofs of Turner's celebrated *Liber Studiorum.* In a similar colour are printed the facsimiles of ancient works and the reproduction of pen-and-ink drawings, or of old texts, which have become mellow with age, and the yellowish tone of which is rendered exactly with sepia or bistre.

Serapeum. (Arch.) A name given by the ancient Romans to temples of Serapis as well as to the Egyptian monuments in Memphis and Alexandria.

Serpent. (Her.) The *serpent* not unfrequently appears as a charge on shields, and is represented *erect*, as in the accompanying cut, or *nowed*, that is, tied into a knot, or else curved into a circle, when it is said to be *involved.*

Set-off. (Arch.) When a moulding is terminated with an oblique section, plain or curved, it is called a set-off. Gothic buildings offer frequent examples of such mouldings. The term is also applied to the diminishing of the thickness of a piece of wood or pilaster.

Setting. (1.) The process of placing a precious stone in a bezel and holding it fixed there with small clamps of metal. All the decorative metal-work in a ring or necklace is known as the *setting.*

Setting. (2.) Drawings in pastels, crayon and lead pencil having a tendency to rub out, a liquid is generally laid over them with a brush, to *set* or *fix* them, and so render them permanent. Ox-gall has been used for this purpose, as well as a solution of gum or size in alcohol. The liquid is either applied directly to the surface of the drawing, or if the paper used is sufficiently porous, it is put on at the back of the pastel or crayon.

Severe. A work of art is said to be severe when it displays a rigid adherence to the rules and traditions which govern it, when fancy and originality are excluded from it. Greek statues, executed in accordance with the archaic tradition, are conspicuous examples of severity of treatment.

Sfregazzi. (Paint.) An Italian word, which denotes a method of shading adopted by Titian and the Venetians. Instead of the brush the finger was used, and by this means the colour was laid on more thinly and uniformly than by the brush.

Sfumato. An Italian term, which may be applied to pictures which are soft and vaporous in execution, and to drawings the outlines of which are vague and put in with the stump.

Sgraffito. An Italian method of decoration, a kind of fresco painting, which consists in applying a white coat upon a ground of black stucco, or a coat of a light colour upon a dark ground, but picked out with hatchings, so as to give it the effect of a drawing. This process can properly only be called *sgraffito,* but it is often called *graffiti.* The latter term, however, should, strictly speaking, only be applied to drawings upon ancient walls.

Shade. That part of a picture, drawing, or engraving representing objects which, not being struck with luminous rays, are relatively obscure. The term also denotes the result of the mixture of several colours.

Shaded. (Paint.) A term applied to tones or colours, the tints of which are delicately graduated.

Shade Lines. Shade lines are employed in architectural and topographical drawings, to indicate the outline of the shadow. They are put in with firm broad strokes, as is shown in our cut.

Shadow. If rays of light fall on an

opaque body, the outline of the illuminated portion of this body is projected on the nearest surface. This outline is called a shadow.

Shadow Cast. A shadow projected upon a surface by a lighted body. The lines which bound cast shadows diverge the more the smaller the luminous bodies are, and the nearer the lighted objects approach to one

another. The more brilliantly lighted are the bodies, the more vigorous are the shadows. The cast shadow is always darker than the shadow, properly so called, if the body casting the shadow and the surface receiving it are of the same tonality.

Shaft. (Arch.) That portion of a column, cylindrical or prismatic in form, which lies between the base and the capital. The suface of the shaft is sometimes smooth, some-

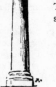

times decorated with flutings or foliage arranged in spirals. Half the diameter of a shaft at its base is called a *module*, and serves as the scale, by which the other parts of the column and the entablature are measured.

Shanks. (Arch.) A term denoting the plain spaces which separate the channels of a triglyph in a Doric frieze.

Shears. (Her.) This pastoral implement occasionally appears on the coat-of-arms of knight or gentleman. In blazoning the herald specifies the position in which the shears are placed, but they are generally represented vertical with the blades uppermost.

Sheathed. (Sculpt.) A term applied to statues, the lower extremity of which is enclosed in a sheath, which generally begins at the hips and continues to the base. Many caryatides are thus *sheathed*. The advantage of this treatment of the figure is, that the beauty of the torso is not sacrificed, while the lower portion, being conventional in its arrangement, harmonizes admirably with the architectural forms beneath it.

Sheep. In Byzantine art twelve sheep represented the Twelve Apostles, while Christ was pictured as the Good Shepherd. [Apostles.]

Shell. (Arch.) A vault in the shape of a quarter of a sphere, sometimes de-

corated with flutings, and forming the upper part of a semicircular niche.

Shellac. A solid varnish obtained from certain trees. When it is in a pounded form, it is called seed-lac; when it is in cakes with a smooth uniform surface, it is called shell-lac. [Lac.]

Shelving Ridge. A surface which

presents two sloping planes, which

join at their upper end, and meet a

horizontal plane at their lower end.

Sherraton. A cabinet-maker who flourished in the 18th century. Everything that left his hand was light and graceful in form, and far more refined in taste than the heavy, over-elaborate productions of Chippendale. His name is now prefixed as an adjective to the chairs and tables which he fashioned as well as to those which are constructed in accord with his style. Thus we speak of a Sherraton table, a Sherraton sideboard.

Shield. (1.) As a portion of defensive armour the shield has been used in all

countries and in all ages. Its material and form have of course changed from time to time. It has been made of wood covered with hide as well as of metal. Shields have been round, semicircular, and oblong. Our first two cuts represent the shield in use in the time of William the Conquerer; our third cut shows a

shield ornamented with the escutcheon

of the bearer. [Scutum.]

Shield. (2.) (Her.) The heraldic shield has taken different forms at different periods, and seems to have been influenced by the style of architecture prevailing at the time. The form of an inverted Gothic arch was the model for shields from the 13th to the 15th centuries. During the succeeding two centuries heralds adopted a much squarer form, as shown in the accompanying cut, probably for the sake of its convenience in inserting quarterings. The lozenge-shaped shield has been employed since the 14th century for the arms of ladies of noble family. A lozenge is also frequently employed by the Flemish, whilst the Italians make use of an oval shield. The Germans, on the other hand, affect shields of a fantastic outline. An example of such a shield, called a *targe*, is given in the accompanying cut.

Shield of Pretence. This is a small shield borne within another shield. It

is also called an *inescutcheon*, and is said to be *pretended* upon the main shield. By means of this device the husband of an heiress blazons his claim to his wife's lands, and in the same way George III. bore the arms of Hanover on a shield of pretence over the arms of England.

Shingles. (Arch.) Small squares of

pine, chestnut, or oak cut like tiles, which were used to protect the beams of a building against the dripping of water. The houses of the middle ages were generally covered with shingles, which were sometimes painted or cut into patterns, so as to form geometrical combinations. Small houses in the country are still to be seen the façades of which are decorated with shingles.

Shore. (Arch.) A transverse stay

placed in the trenches dug at the foundation of a building; a piece of timber employed to strengthen empty spaces during the underpinning of a part already built. Windows and other openings are frequently *shored*.

Shrine. A box or coffer of a precious metal and richly carved, in which the relics of saints are kept; the term is also applied to a structure such as a tomb, in which relics and bones may be deposited; the shrine of St. Thomas at Canterbury for instance. Moveable shrines, before the

13th century, consisted of simple boxes of wood, covered with plates of

metal. They were often large enough to hold the whole body of a saint. Towards the end of the 13th century shrines were made of gold, silver, or enamelled copper, and took the form of miniature churches and chapels. In the 15th century they were surmounted with pierced

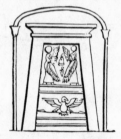

spires and enriched with statuettes, and in the 17th and 18th century they were characterised by volutes and are of a swelling outline. Some ancient shrines are of sculptured and gilded wood; these are often placed under a canopy and above the altar.

Shrinkage. A diminution in the volume of ceramic paste or terra-cotta, which results from drying or baking. The same phenomenon, though less sensible than in terra-cotta, may be observed in bronze founding.

Shutter. (Arch.) Pieces of wood or iron fitted together and serving to close a window or bay. Some shutters consist of a single leaf, though this single leaf may consist of two leaves held together

with iron hinges as shown in our first

cut; other shutters are composed of planks of wood, which fit into grooves. In old-fashioned shops these moveable shutters, fitting into grooves, were invariably used. The most modern kind of shutter is a mechanical arrangement of slips of wood or a sheet of iron, turn-

ing round a horizontal cylinder, placed above the opening or window, and put into its place by means of a wheel.

Sibyls. In ecclesiastical art, especially in the stained glass of the middle ages, we find figures called Sibyls, who are associated with the prophets. They are mythical creatures, and it is impossible to explain their origin. In number they are twelve, each having her own emblems and attributes. In modern times Mr. Burne-Jones has made many designs of the Sibyls and introduced many of them into his glass windows.

Siccative. (Paint.) Siccative or drying oils are those which form a permanent coat on the surface to which they are applied, and prevent it undergoing chemical change. They are used in the preparation of painters' varnishes and colours. They are obtained by adding litharge, white lead, black umber, and talc to linseed oil.

Sickle. (Her.) This well-known implement for cutting corn sometimes appears in coats-of-arms. The handle need not

necessarily be of the same tincture as the blade of the sickle. The cut shows a sickle with a jagged edge.

Side Aisle. (Arch.) The lateral nave of a church, the vault of which is not so high as that of the principal nave. It is only at the end of the 11th century that the choirs of churches were surrounded by side aisles. Some churches consist of a nave and four side aisles; but these are the exception, the general rule being that churches should have two side aisles. Their breadth is variable.

Siderography. The art of engraving on iron or steel, which was much practised in the 15th and 16th centuries, and was restored to honour early in the present century by American artists.

Sienite. (Sculp.) A coloured marble, which was originally quarried at Syene in Egypt. It was used by the ancients, both in sculpture and architecture.

Sigillography. The study, description and interpretation of historic seals.

Signature. In old books, and indeed in many modern books, too, certain marks, called signatures, are put at the bottom of the first page of each sheet to facilitate their arrangement.

Sign-board. The sign-board of the middle ages and renaissance generally consisted of a bracket of iron supporting a sheet-iron panel. Some were decorated with scrolls of extraordinary profusion; of these many specimens are preserved in museums. In addition to signboards of sheet-iron there are in existence curious bas-reliefs and interesting paintings which served the purpose of signboards in the 17th and 18th centuries. These sometimes represent quite complicated scenes, such as the interior of shops thronged with a crowd of people, and are of the utmost importance in the history of costume, arts and trades. Some distinguished artists, too, have not deemed it derogatory to paint signboards. Watteau, for instance, painted

a sign-board for the picture-dealer Gersaint, Géricault a " White Horse," &c.

Silhouette. A term applied to drawings or portraits, which may be described as solid masses of black upon a light ground, their outlines only being indicated. The term also denotes the outline of the shadows cast by illuminated bodies.

Sill. (Arch.) The surface formed by a course of stones out-

side a window. Sometimes the stones forming the sill are covered with one long, flat stone, running the whole length of the window, the purpose of which is to prevent the rain from penetrating the joints of the lower course.

Silver-plating. A process consisting of covering metal objects with a coating of white lead and then with silver leaf. The objects are afterwards burnished and covered with a spirit varnish.

Simon Zelotes, St. One of the Apostles. He is generally represented with a saw as his attribute, in allusion to the tradition that he was sawn asunder. According to one legend St. Simon was a brother of Jesus, and hence he is sometimes, though rarely, represented in pictures of the Trinity.

Simplicity. When the effect of a work of art is produced by unity of line and largeness of mass, when the attention of the spectator is not diverted by restless detail, it is said to possess simplicity. The magnificent figures from the Parthenon, the finest products of the sculptor's art, owe much of their grandeur to their monumental simplicity.

Simpulum. A sort of vase with a long handle, somewhat resembling a modern ladle which was used for taking wine out of a crater.

Sinister. (Her.) That side of the shield which would be to the left of a man standing behind it is called the *sinister.* Thus the *sinister* side of a shield comes to the *right* hand of a person looking at the shield.

Sinking. (Arch.) A sudden depression of the ground, which causes the destruction of the superincumbent masonry.

Sinople. (Her.) [Vert.]

S-iron. (Arch.) A piece of iron, generally in the shape of an S, sometimes in the shape of a geometric pattern or of foliage, which is attached vertically to a wall, and is connected by a holdfast to horizontal pieces of timberwork.

Sistrum. An instrument used by the Egyptians in the festivals of Isis just as the bull-roarer still is among some tribes of savages to warn off the uninitiated. In structure it was very

simple, consisting only of some metal rods inserted (as our cut shows) in a

metal frame. It was rattled violently to produce a noise.

Sitting. (Paint.) A term applied to the space of time during which an artist

works, either from nature or from a model. Thus an artist may be said to finish a sketch at a sitting. If the matter be looked at from the point of view of the model who sits to the artist, it has a slightly different meaning. A portrait, for instance, may want one or two more sittings (of the model) to be finished.

Sizing. (Paint.) The purpose of sizing is to render drawing-paper fit to receive a wash of any colour whatsoever. The paper is smeared with a sponge soaked in a mixture of white soap and Flanders size, to which powdered alum and a few drops of alcohol have been added.

Skeleton. (1.) The osseous frame of a man. Many artists keep skeletons in their studios, which are artificially jointed with brass wire. Skeletons thus arranged will assume almost any position at will, and so are of the utmost service to the artist, for they enable him in his drawings to set the limb properly on the trunk, and to verify the projection of the bones.

Skeleton. (2.) (Sculp.) A series of

bars of iron, round which a clay model or plaster cast is built up, its purpose being to strengthen the weak parts of the cast or model.

Sketch. A rapid design executed from nature, or the record of a picturesque idea. If it is made from nature, it should be in as few strokes as possible, and should be sober in detail, so as not to have the effect of a finished work. The first suggestion of a composition is generally set forth in the form of a sketch, and it often happens that the transcription of an idea is more brilliant and charming than the finished work. Sometimes painters sketch their works on the canvas, putting in the general outlines of the drawing before they begin to paint. The lights are not sketched in the same way as the shades. Account must be taken of the effects which the tones applied to the canvas will produce as the artist advances in his work, and in putting in the sketch the artist must take care not to cover those portions of the picture which must remain transparent, and should allow the grain of the canvas to be seen. The slighter the sketch the more likelihood is there of producing a good result. A sculptor's sketch is the first suggestion of a statue or basrelief, in which the artist does nothing more than hint at the attitude and lines of the figures. Sometimes the sculptor works up his sketch into a finished work, carrying out all the details with accuracy and precision, but more often he leaves the first sketch as it is, and starts another on a different scale. When we say that a work is a mere sketch, we mean that it is unfinished, nothing but its main outlines being suggested.

367

Sketch-book. A note-book of white or tinted paper, plainly and simply bound. In his sketch-book the artist jots down rapid sketches, which he works up afterwards in his studio. These memoranda in line, filled out sometimes with a written description, are a valuable aid to the artist. In fact sketches taken from nature furnish the painter with the most precious documents in composing and making his pictures.

Sky. (Paint.) That portion of a picture in which clouds and the expanse of the heavens are represented. When we say that a sky is fine, we mean that it is painted in delicate and refined tones, and is modelled with subtlety and firmness. In another sense a picture is said to be *skied* when it is hung in an exhibition high up above the line.

Slate. (Arch). A common schist of a blueish, black grey or violet tone, which is cut into rectangular plates, generally with two of its corners broken. Slates are used for covering the roofs of buildings.

Slit and Tongue. (Constr.) A method

used by joiners to unite two pieces of wood, cut out so as to fit one in the other, as shown in the accompanying cut.

Slope. (Arch.) A term applied to anything that is inclined or set at an

angle. For instance, we speak of the slope of a pediment or the slope of a roof. In the ancient orders of architecture the cornice of the entablature serves as the base of the pediment, while the upper part of this cornice is repeated in the slopes of the pediment. A piece of ground the plane of which is inclined

is termed a slope, and advantage is

often taken of it to construct a flight of steps.

Sloppy. (Paint.) A picture which is loosely composed, and roughly painted, is said to be *sloppy*.

Smoke. (Engrav.) When the coloured varnish which has been smeared over an engraved plate does not allow the lines to stand out with sufficient force, the copper is smoked or blackened. To do this while the varnish is still warm, the plate must be exposed to the flame of a resinous torch, the black smoke of which incrusts itself in the varnish and

gives the plate when it is cold a beautiful black tint. In order that the smoking should be successful it is necessary that the layer of black should be very thin, and that there should be no trace of the passage of the smoke. Furthermore, the operation must be rapidly performed, so that the varnish is not burnt and deprived of all power of resistance to the biting.

Smoke-proof. (Engrav.) A proof of a relief engraving taken upon unsized India paper. To obtain smoke-proofs, the wood or cliché is inked with smoke black, and a pressure is exerted upon the damp paper with a burnisher. To prevent tearing the paper, a piece of card is placed between the paper and the tool. Smoke-proofs are the most trustworthy impressions of wood-cuts.

The block is most carefully inked as a rule with the roller or finger. The distances can thus be carefully brought out, and the foreground may be strongly marked by vigorous inking. As engravers take these proofs themselves as a guide in the completion of their work, or for their private collections, they are always very limited in number, and eagerly sought after by amateurs.

Smoky. Proofs of an engraving are said to be *smoky* when the dust and smoke of many years have given them a dirty yellow, almost black tone. The term is also applied to pictures which have been exposed to smoke so as to give them the appearance of old canvases, the varnish of which has turned black with dust and age.

Sober. (Paint.) A term applied to a refined scheme of colour, which produces a calm, tranquil impression upon the spectator.

Soccus. (Cost.) A loose kind of

slipper which in Greece was worn both by men and women. In Rome, however, it belonged only to the costume of women and comic actors.

Socle. (Arch.) The term *socle* is applied to the square sub-basement of a

building or column, and also to the small pedestal, with or without a moulding, which serves to support a bust or vase. In the sense of pedestal, the use of the term is not strictly accurate. What should properly be understood by socle is the moulding or projection of the base of a pedestal. In

buildings of the Gothic style we find examples of socles cut in facets.

Soffit. (Arch.) The portion of a ceiling below the cornice. Soffits are often

decorated with rosettes of extraordinary richness. The term is also applied to the under surface of a cornice, the round portion of an arch.

The terms flat soffit and curved soffit are applied by builders to the stones with which they construct the flat part or the concave surface of an arch.

Soften. (Paint.) When the outlines in a picture are too strongly indicated and drawn with too much dryness, they should be softened down until they blend with the tonality of the ground and no longer strike the spectator disagreeably.

Softener. (Paint.) A large soft flat hair brush, either cylindrical or of a special shape, with which two colours freshly laid on the canvas are blended.

Solarium. (Arch.) In a Roman home the *solarium* was the terrace built over a porch or upon the flat roof of a house. It was surrounded by a parapet, but open, as its name implies, to the sun's rays.

Solid. In geometry bodies are said to be solid when they are bounded by surfaces. In architecture full heavy masses are known as solid, while in painting the term is applied to strong, robust workmanship, and to figures which project violently from the canvas.

Sombre. Dark. A term applied to schemes of colour in which black predominates.

Sopra Bianco. (Pot.) A name given to a kind of Italian faïence, which is decorated with designs of a clear milky white standing out on a delicate white ground.

Sounding-board. (Arch.) [Abatvoix.]

Space. In a picture a figure is said to lack space when it is placed in a frame of too narrow dimensions, so that it appears cramped and confined.

Span. (Arch). The span of an arch is the width between the imposts.

Spandrel. (Arch). The triangular space included between the convex or outer surface of an arch and the rect angular moulding which surmounts the arch. The spandrels of doorways in Gothic buildings are frequently richly decorated with carvings.

Spangle. A small leaf of thin metal, circular in shape, and with a hole pierced through its centre, so that it can be fixed on to a stiff material with thread or silk. Spangles scintillate brilliantly in the light. The court dresses of the 18th century were decorated with garlands and other designs formed of spangles of gold and silver.

Spar, Fluor. A mineral, which in fusion dissolves metallic oxides, and thus produces a kind of crystal, the colour of which varies with the nature of the metal dissolved. With this spar candelabra, vases, and other decorative objects are made.

Spatula. The spatula used by painters

in enamel is the instrument with which the powdered enamel is taken hold of

and spread over the surface of the plate. The spatula used in sculpture is a trowel-shaped tool,

with which moulders take the plaster from the bowl and spread it in the mould.

Spectrum. The image produced by a ray of light crossing a crystal prism, the colours of which, joining one another by imperceptible shades, are violet, indigo, blue, green, yellow, orange, and red.

Speculum. The mirror of the ancients was made either of a white metal, (a mixture of copper and tin),or else of silver. In order that it might give a bright reflection its surface was highly polished. Its back was often decorated with incised designs of great beauty, and mirrors form an important class of ancient works of art.

Sphere. A solid figure produced by a semicircle turning on its diameter as its axis. The term is also commonly applied to globes representing the surface of the earth. By the term armillary sphere we denote a celestial globe formed of circles representing the movement of the stars.

Spheroid. A solid figure having the form of a flattened sphere. It is produced by half an ellipse turning about on one of its axes. The terrestrial globe may be described as an oblate spheroid.

Sphinx. A monster having the head and breasts of a woman, the body of a lion and the wings of an eagle. The term is also applied to colossi of granite found in ancient Egypt. Near the pyramid of Cheops there still exists a huge sphinx cut in rock, which measures twenty metres in height and forty

metres in length. Some authorities

hold that the Great Sphinx is nothing more than a solitary rock, to which the Egyptians gave its present form by means of blocks of stone skilfully arranged,

the head alone having been sculptured. This Sphinx was the image of the

Egyptian god Hoz-en-Kohn.

Sphyrelata. A name given in Greek to all kinds of hammered metal-work. The metal was beaten when cold, and this simple process is the most ancient that is recorded. Many *sphyrelata* belong to a time before soldering was invented.

and their pieces were joined together by nails. The surface of these primitive

works of art was often enriched by incised ornaments. Of our two illustrauons the

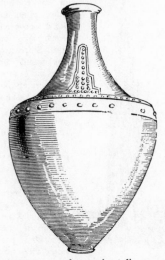

one represents a bronze bust discovered

at Vulci, which is almost childish in its simplicity, the other a vase, in which grace and proportion are by no means lacking.

Spikes. (Arch.) Ornamental pieces of iron curved into all sorts of shapes and

always armed with sharp points, which are put on the summit of walls to prevent them being scaled. They afford an excellent opportunity for artistic treatment, and they are sometimes admirable specimens of decorative iron-work.

Spiral. A plane curve describing several revolutions round a fixed point, its distance from this point becoming greater at each revolution.

Spire. (Arch.) A pointed pyramidal bell turret, sometimes of stone, but more often of wood covered with lead or tiles. Spires are not found in England before the Norman period, and then they are neither lofty nor tapering. In the Early English period they were carried to a great elevation, and were generally octagonal. The spires of the Decorated period did not differ much from the spires of the

preceding period. They were, however, ornamented with crockets, &c. In the Perpendicular period spires retained the same form, and almost invariably had a gutter and parapet at their base. This was not the case in earlier times, when *broach* spires, or spires springing straight from the tower, without a parapet, were common.

Splay. (Arch.) The term *splay* is applied to any sloping surface, but especially to doorways or windows, the width of which is increased by their sides sloping inwards.

Springing. (Arch.) The springing of an arch or vault is the point from which it rises.

Springing-stone. (Arch.) The stone which supports the haunch of an arch or vault is called the springing-stone, and the lowest line of the arch is similarly known as the springing-line.

Spur-post. (Arch.) A piece of twisted iron, set against the wall at the entrance of a *porte-cochère*, at about the height of a step. The purpose of it is to keep off the wheels of carriages from the corner, as well as to protect the doors when they are open.

Square. (1.) A plane four-sided figure, the four sides of which are equal, and all the angles of which are right angles.

Square. (2.) The square used in drawing is a thin plate of wood, in the shape of a right-angled triangle, pierced with a circular opening or eye, so that it may slip easily on the paper. With the square and ruler perpendiculars

may be drawn, while parallelograms may be traced with two squares. A square, such as the one represented in our cut, is used by masons to test whether they have cut their blocks of stone evenly.

Square, Double. A square formed of two flat rules placed at right angles to one another.

—, Graphometric. A surveyor's square, which serves the double purpose

of a square and graphometer. It consists of a cylinder, the lower portion of which is movable, and works on a screw. Slits made in the cylinder take the place of the pinnules of the graphometer, and allow the operator to look in all directions perpendicular to, or at an oblique angle to, any given line.

—, Octagonal. A surveyor's square in the form of an octagonal prism.

—, of 45 degrees. A drawing square, having one right angle and two angles of 45 degrees. It is often used with the T-

square and planchette, and with its aid are traced architectural designs, the projections of mouldings, &c., while in shaded drawings it is used

to trace the direction of luminous rays, which, by a convention generally adopted in projections, are directed at an angle of 45 degrees from left to right.

—, Set. A square in the form of a

right-angled triangle, resembling in form half the pediment of an ancient temple, and hence called in French *équerre à fronton.*

—, Sliding. A flat piece of metal, with divisions measured upon it, to which two other pieces of metal are perpen-

dicular. One of these two pieces is fixed, the other can be moved to and fro, so as to measure the diameter of cylindrical bodies.

Square, T. [T-square.]

—, -touch. (Paint.) When a painter lays his colour on the canvas in square patches, he is said to employ a *square-touch.* This point of style may be best observed in the works of the group of painters, who call themselves the Newlyn School.

Squaring. An operation, the purpose of which is to enlarge a sketch, to execute a composition on a large scale after a given model. It will be readily seen that by the process of squaring a sketch may also be reduced. The method is as follows: The model is divided up into a certain number of equal squares, and the surface, upon which the model is to be reproduced, is also marked out in the same number of equal squares, less or greater than the

squares on the model, according as it is the artist's purpose to reduce or enlarge the original sketch. Large mural paintings, as well as important easel pictures, are designed in this way. The advantage of the process is considerable, as the sketch, which enables the artist to see the general effect of his work, can be accurately reproduced. In the squaring, which is a tedious job, and must be carried out with the most scrupulous exactitude, painters are often assisted by their pupils, deeming it enough if they themselves correct errors of transcription.

Squinch. (Arch.) A truncated vault of considerable projection. A number of stones arranged so as to form a shell.

In outline it may either be a quarter round or the arc of a circle. In the 17th and 18th century overhanging squinches were a favourite architectural decoration. Many large doorways and

corners of public buildings present examples of squinches decorated with rustic-work and sculptured ornaments.

In classical architecture the term squinch is applied to the spherical triangles formed in a hemispherical vault by the penetration of two demi-cylindrical barrel vaults, and also to the curved triangular surfaces obtained by the intersection of vaults of different form. Other architectural combinations of a similar kind, but not identical, give rise to squinches of various polygonal forms.

Stadium. In ancient times this term was applied to a course laid out for foot-racing. The name was derived from the celebrated course at Olympia, which measured precisely one σταδιον.

Stage. (Arch.) That part of a theatre which is set apart for the actors who perform in view of the public.

Stage-box. (Arch.) A term applied to the boxes in a theatre which are situated on each side of the stage between the curtain and the orchestra. Stage-boxes generally give the theatrical architect an opportunity for decoration, and they

are frequently enriched with caryatides

and sculptured ornament.

Stag's head. (Her.) A stag's head *attired* with antlers and *tyres* sometimes appears as a common charge in heraldry. When placed *affronté*, which is the usual position, it is said to be *cabossed*, and the antlers are by heralds frequently termed *attires*.

Stained Glass. [Glass Painting: Glass Window.]

Staircase. (Arch.) A series of steps, serving to connect the storeys of a building which are on a different level. The staircases with which the summit of the religious buildings of the Middle Ages was reached were often in turrets pierced with openings to admit the light. Sometimes they were set in the thickness of a wall. Many staircases in castles of the Renaissance period are marvellous from the point of view both of art and construction. In the 17th and 18th centuries staircases were built extraordinarily light and strong. The staircases of many public buildings of the present day are no less remarkable for their width and proportion than for the beauty and richness of the materials employed in their construction.

—, **Circular.** A staircase with a cir-

cular string-course. A staircase the

steps of which do not follow a straight line but a curve.

Examples of the latter are very frequent in staircases on the outside of a building, which lead to a doorway at some height above the level of the ground.

Staircase, Spiral. A staircase turn-

ing round a core, which is generally cylindrical, or in the midst of which a vacant space is left. This form of staircase is also termed a winding staircase or a helicoïdal staircase, and it also resembles a vyse (q.v.).

Stair-rail. A balustrade of wood or iron, which is arranged along the edge of

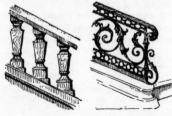

a staircase, and serves as a support.

Stake. A piece of wood or iron driven into the earth. At the top of the stake, as employed by surveyors, a

slit is generally made, in which a piece of card of a bright colour is placed, so that it may be seen at a distance. Small stakes are sometimes set on blocks of wood accurately squared. Stakes are used by surveyors to fix points, to measure ground, as well as in making plans and

drawing foundations. In some cases, especially in the cutting of new roads, stakes, consisting of long poles with a flag attached to them, are set up on the top of houses to serve as guiding points.

Stalactites. (Arch.) A kind of architectural decoration, consisting of projecting rustic-work. It suggests the appearance of the petrified concretions formed in caves and grottoes which are known by the name of Stalactites.

Stall. A wooden seat with a high back. Rows of stalls are placed round the choir in churches. In Christian basilicæ the stalls were of stone or marble. From the 13th to the 16th century stalls were generally of wood and decorated with a marvellous profusion of carvings. These carvings were frequently grotesque and

375

free, not only in style but in subject. There are few of the English cathedrals

that do not display in their stalls magnificent monuments of wood-carving.

Stamnos. A Greek vase with an ovoidal body, with two handles attached to it above its shoulders, and closed by a

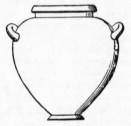

slightly arched lid. It was used for holding liquids, and was frequently richly decorated with paintings.

Stancheon. (Arch.) A stay, generally of iron, and of great strength ; especially the iron bar between the mullions of a window.

Standard. The ensign of war, a flag of a rich, heavy material, which is displayed as a decoration.

Star. (Arch.) An architectural ornament, painted, sculptured, or incised, consisting of painted rays which vary in number. In Romanesque architecture fleurons (q.v.), to which the term star is applied, are arranged on surfaces in various geometrical patterns, or are set side by side so as to form a continuous system of ornament.

Starling. (Arch.) An angular projection on the piles of a stone bridge, so situated as to divide the current

of water, and in winter time to break blocks of ice.

State. (Engrav.) The condition of an engraved or etched plate before it is entirely finished. In the case of some engravings we have proofs of the first state, the second state, the third state and so on as the plate nears completion. When the state is completely finished and ready to be printed from it is said to be in its final state.

Station Point. The point from which a building or any object should be looked at, so that the whole can be seen by the spectator at one glance.

Stations. The term station is applied to the various stages of Christ's Passion, representations of which are frequently hung in the nave of Catholic churches.

Statuary. An artist who models statues or figures. In this sense the word is seldom used. It is more often employed to denote a collection of statues, and we sometimes hear people speak of the " statuary art."

Statue. A work of sculpture in the round representing the human figure. A statue in marble, bronze, or wood. A colossal statue.

—, **Equestrian.** A statue representing a person mounted on horseback.

—, **Monumental.** A term applied in the Middle Ages to statues representing recumbent figures and covering a tomb,

above which they are only raised by a slab, which is often of inconsiderable thickness.

—. **Persian.** A term which is sometimes, though rarely, applied to architectural figures, which serve as caryatids.

Statuette. A statue, the dimensions of which are very much less than those of the human figure. A statuette half life-size ; a statuette in bronze, or terracotta.

Stay. (Arch.) A piece of timber introduced into a building to form a support.

Steeple. (Arch.) A tower, in which church bells are hung. In the 11th century steeples were built on a quadrangular base. They consisted of several storeys, slightly retreated the one behind the other; they were pierced by openings, strengthened at their angles by buttresses, and were terminated with a pyramid on a square base. In the 12th and 13th centuries steeples were quadrangular in base alone ; as they got higher they became octagonal and were terminated with a tower, and sometimes, though rarely, surrounded with a balustrade and had bell-turrets at their corners. In the 14th, 15th, and 16th centuries the same principles were followed ; the spires or pyramids terminating steeples became lighter and were pierced. Steeples are sometimes included within the general plan of the building, sometimes they are built without reference to it. This depends on the period to which the steeple belongs and the vicissitudes which the church has undergone. Some churches have two towers or steeples, generally at the west end. The full complement of towers in a cathedral church is three, two at the west end and one over the crossing.

Stele. By this term we denote ancient monuments in the form of monoliths placed vertically, the inscriptions upon which serve to commemorate an historic event or to preserve the memory of the dead. Some of the most interesting relics of Greek and Roman art are *stelæ*, upon which is sculptured the likeness of a departed man. In the British Museum is to be seen a most interesting collection. In modern times the term is loosely applied to broken columns, *cippi* or square stones which serve as funeral monuments, and even to the small colonnettes supporting a decorative object, such as a statuette or vase.

Stencilling. A method of executing decorative paintings, which was once very popular, but is now seldom resorted to. Patterns are cut out of a piece of card, which is laid upon paper. Colour is then laid on, and only reaches the paper, where the card has been cut out. The advantage of this process is its extreme simplicity.

33

Step. (Arch.) The steps in a stair-

case are the horizontal parts upon which the foot is placed. The steps of

a staircase in the interior of a building, whether they are of wood or stone, are generally bordered with a projecting

moulding, called an astragal, the profile of which is either a quarter round or an apophyge.

—, **Corner.** Corner steps are steps situated at the turn of a staircase. They are broader than the steps immediately above them.

—, **Moulded.** A step is said to be moulded when it is bordered by a moulding.

—, **Straight.** A step which is of the

same width throughout. The steps which led up to ancient temples were *nearly always straight* and very rarely had an astragal or moulding on their edge.

—, **Weathered.** A step, the upper surface of which is inclined at an angle, instead of being horizontal.

—, **Winder.** Steps arranged like the

radii of a circle. Modern staircases, built either in circular cages or in rectangular cages with rounded corners, present many examples of *winder steps*.

Stephen, St. St. Stephen, the first of the Christian martyrs, persecuted by Paul is frequently represented in religious pictures. The Stoning of St. Stephen was a very favourite subject with painters of all schools. When represented alone, St. Stephen always appears as a youth, wearing the vestments of a deacon. He holds a palm in one hand and the scriptures in the other, and as a rule stones lie at his feet.

Stereobate. (Arch.) A continuous base with neither moulding, base, or

cornice (στερεός, solid). By the term stylobate we designate pedestals which have mouldings.

Stereography. The art of drawing solid bodies upon a plane surface and indicating the relief by shading.

Stereometry. The art of measuring bodies in relief.

Stereotype. To stereotype is to reproduce by the process described under the term cliché (q.v.) printed pages set in moveable type, together with the woodcuts with which they are illustrated. After a page has been stereotyped, the type may be distributed. The invention of stereotyping has had a most important effect not only on the art of printing but also on the art of engraving.

Sticciato. (Sculp.) An Italian term denoting a work in relief, which hardly projects from the surface of the marb.e or plaster upon which it is carved or modelled.

Stil de grain. (Paint.) A term applied to certain greenish-yellow pigments obtained like lakes by precipitating the decoction of buckthorn berries or French berries.

Still life. (Paint.) A term which

includes all pictures having for their subjects fruit, flowers, vases, and other inanimate objects which generally form the accessories and not the main interest of a picture. The Dutch have chiefly excelled in the painting of *still life*. A picture of an inanimate object is itself called a *still life*.

Stilus. A pointed instrument with which the ancients traced letters upon a tablet covered with wax.

Stippled. A painting, drawing or engraving is said to be stippled when it is executed by means of a series of points and not by flat tints or hatchings.

Stockade. (Arch.) A barrier formed of stakes, the purpose of which is to strengthen the base of the piles of a bridge or to defend the entrance of a harbour, river or canal.

Stola. (Cost.) A garment worn by Roman women. It was long and reached to the feet, being girt round the waist by a girdle. It had sleeves and was some-

times fastened at the shoulder by a brooch. It was as characteristic of the Roman matron as was the *toga* of the Roman citizen.

Stone. (Arch.) A piece of siliceous or calcareous rock or quartz used in

building. Stones are sometimes put into walls in the rough state in which they leave the quarry ; sometimes they are carefully squared on all their surfaces before being used.

Stone, Druidic. A Celtic monument, consisting of a stone, considerably higher than its breadth, planted vertically in the earth. These stones are called Peulvans or menhirs, and in Celtic remains are found variously combined. [Dolmen.]

—, **Engraved.** A precious stone engraved in cameo or intaglio, i.e., either in relief or incised.

—, **Gall.** (Paint.) Gall stone yields a tone approaching that of natural earth of Sienna. It is used by painters of miniatures and fans, who, by means of a solution of gall stone, render the vellum upon which they work less rebellious to the tints applied to it.

—, **Precious.** A hard stone employed in jewellery and works of art.

—, **Rocking.** A Celtic monument consisting of two blocks of stone placed one upon another in a position of equilibrium,

so that the very slightest movement is enough to make the upper block oscillate.

—, **Tomb.** A stone, generally incised, which covers a grave. It is placed either on a level with the ground or set in a vertical wall. There are many tombstones of the Gothic period and the Renaissance, which represent historic personages and are valuable documents in the history of costume. Some tombstones, too, are very richly ornamented. The figures traced upon them, though quite hastily drawn, are often remarkable for their grandeur and vigour.

379

Stone, Toothing. A projecting stone left in the alternate courses of a wall, so that if the wall is carried on in the same line the courses of the new construction may be easily united with the old.

Stoneware. A kind of pottery which is opaque, hard and impermeable.

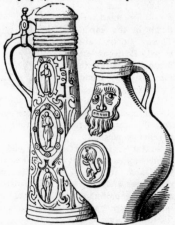

Common stoneware is made of a paste which consists of clay, sand and silicates.

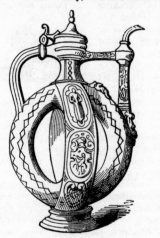

The paste of fine stoneware does not differ perceptibly from the paste of fine

faïence. The vases and statuettes of stoneware made by the Chinese and Japanese are very much sought after by collectors. In Germany stoneware has been made from the 8th century, while English stoneware is admirable in quality.

Stool. A support of considerable height, terminated by a circular or square plat-

form, which may be moved up and down on a kind of pivot. A stool of this sort is used by modellers in clay to place their clay upon, while when the clay is to be translated into marble, it is the stool upon which the block of marble is placed. The term also denotes a seat of wood, frequently used in the Middle Ages. It had the form of a short bench without arms or back.

Stopping out. (Engrav.) When an etcher desires one portion of his plate to be more deeply bitten than another, he removes the plate from the acid, after it has been for some time exposed to its action. He then covers those portions of the plate which he deems sufficiently bitten, with lampblack, and replaces the plate in the bath. This process is termed stopping out.

Story. (Arch.) A term applied to the horizontal divisions made in a building by means of planks.

Stoup. A vase or basin placed at the entrance of a church ; a small shell, which holds holy water. In the 9th and 10th centuries stoups took the place of

piscinæ, which had been placed in churches for the ablutions of the worshippers. In the 12th century stoups took the form of simple octagonal vessels; in the 13th century they were set against the wall, and so gave an opportunity for a good deal of decoration. In the 14th and 15th centuries they were either circular or polygonal, and were supported by a colonette, while during the Renaissance they consisted of a large basin, which had a tapering ba-

luster to support it. Finally there are some stoups in existence in the shape of immense shells, which are made fast to a pillar or placed upon pedestals of various forms.

Strainer. A kind of double frame of wood. Round its circumference run

grooves, in which the edges of a strip of damp paper may be fixed. As it dries the paper stretches, and so gets a per-

fectly smooth surface. Strainers are used to stretch paper on which water-colour drawings or sketches are to be made.

Strapassé. A piece of French artistic slang, an epithet which may be applied to painted or sculptured figures the attitude of which is twisted or exaggerated.

Strap-work. A form of ornament, consisting of bands or fillets interlaced and

intertwined as in our cut. It is found in some buildings of the 11th century, but it did not come into common use until the end of the Renaissance period.

Strawberry Leaf. A leaf somewhat resembling the trefoil, which occurs in heraldry on the coronets of dukes, earls, &c.; it is also used as an architectural ornament in buildings of the Gothic style.

Stretch. To stretch an engraving or drawing is to stick it down fast with gum to a white or tinted mount, the purpose of which is to increase its effect. The term is more strictly applied to the process of mounting an engraving or drawing by stretching it on a frame. Neither method of stretching is to be recommended as each is very likely to destroy the value and beauty of drawing or engraving.

Stretcher. (1.) (Arch.) A stone or brick so placed in a wall that only its narrow side is apparent, its longer sides being lost in the thickness of the wall.

Stretcher. (2.) (Paint.) A wooden square or rectangle, upon which a painter's canvas is *stretched* and held fast by small nails. When the picture is framed, the thickness of the stretcher is concealed in the frame. In the kind of stretcher represented in our first cut, which by the way is not used in England, the pieces of wood of which the stretcher is composed are held in their places by small transverse slips, one at each angle. The advantage of the stretcher with keys, represented in our second cut, is that by driving in the keys the tension of the canvas may be increased.

Striæ. (Arch.) A term applied to the narrow fillets which come between the flutings upon the shaft of a column.

Striated. Any surface is said to be striated when it is covered with a series of parallel fillets, either in straight or zigzag lines.

Strigil. A bronze instrument, with which the ancients scraped their limbs after bathing, and with which the ancient athletes removed the oil after anointing themselves.

String. (Arch.) A slightly projecting moulding, which runs round a room on

the façade of a building. A horizontal band, marking on the outside of a building the divisions between the stories.

String-boards. The point of support of a staircase on the side farthest from the wall. String- boards may be of wood or stone, they may be grooved or twisted, plain or decorated with mould-

ings, and they generally spring from the first steps.

String-course. (Arch.) A narrow moulding, which runs horizontally along the wall. It projects but little from the surface.

Strip. (Arch.) A small piece of timber strengthening a rafter or ridge or sup-

porting a beam of wide bearing. Strips

are nothing more than a kind of strut beam (q.v.).

Struck. Any object which has received an impression from a die, such as a coin or medal, is said to be struck.

Structure. The manner in which a building is constructed, also the building itself. Metaphorically the term is used to denote the way in which the human figure, either in painting or sculpture, is rendered from the anatomical point of view. The *structure* of a figure may be said to be perfect or faulty, as the case may be.

Strut beam. (Arch.) A piece of wood used to strengthen timber-work, by

diminishing the bearing of a beam or upholding a wall which needs to be consolidated. The strut beam is almost always placed obliquely, and is sometimes held in its place by wedges driven in with a hammer.

Stucco. (Arch.) A coating with which walls are covered, and which takes the polish of marble. Stucco consists of a mixture of slaked lime and pulverised marble or sometimes alabarium or plaster. But stucco formed of this last mixture is less capable of resisting damp. The stucco with which the outside of buildings is coated is sometimes composed of puzzolana and pieces of tiles reduced to powder. It is the *opus albarium* of the Romans.

Studied. A painting or piece of sculpture is said to be *studied* when it displays profound knowledge and research

on the part of its author. Thus we say of a picture, "The draperies are closely studied," or of a landscape that "its foreground is well studied."

Studio. The place in which a painter or sculptor works. All studios should face north, for then an artist can work as long as daylight lasts without being inconvenienced by the rays of the sun ; moreover, light coming from this quarter is more equable and fresher than from any other.

Studio-box. (Paint.) A table with drawers, the upper part of which forms

a box, in which colours, brushes, &c.. are kept.

Study. A sketch, the execution of which is precise and searched ; a drawing or painting from nature or the living model. It is from studies that a painter builds up and composes his pictures.

Stump. A piece of leather or paper rolled in a cylindrical form, and bound round with thread. At each end it has a blunted point. The stump is used for blending together the hatchings

of a crayon drawing, and also for laying the black or grey tones of the crayon directly on the paper. Its use cannot be recommended, as it gives a drawing a soft cottony appearance. The dis-

383

advantages of the stump have recently been set forth in the following terms:— "The stump does not teach drawing, as it cannot teach painting; in point of fact the use of the stump is likely to injure the painter's art, as it may engage his sympathies for darkness rather than light, for shadow more than for colour. Nor does the stump help drawing, because the use of it is antipathetic to a line. This feeble invention is neither a severe enough instrument for the draughtsman, nor is it pliable enough for the painter. It is a kind of middleman whom we with all our hearts desire to be rid of."

Stumped. A term applied to drawings shaded with the stump. The laborious drawings from the antique produced in schools of art are generally *stumped*.

Style. The word style denotes in artistic phraseology the manner peculiar to an artist or epoch. For instance, the style of Raphael, the Gothic style, the Italian style. The word is also used in connection with works of a noble character, in which the figures are drawn or modelled in a key of lofty sentiment. Thus we speak of a work of the grand style, of figures which lack style.

Stylobate. (Arch.) A pedestal with moulding, base and cornice running round a building;

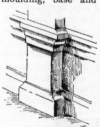

a projecting sub-basement decorated with moulding, following the ressaults of a façade. The word is synonymous with *plinth*, at least when the plinth is decorated with mouldings. Plain, undecorated sub-basements are called stereobates (q.v.).

Sub-basement. (Arch.) The lower part of a construction. A continuous socle (q.v.) running round the base of a

façade or a row of columns. In build-

ings of the Renaissance period of the centuries which followed it, sub-base-

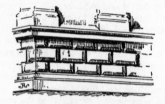

ments are generally found running round entrances and are decorated with rustic work. In Gothic buildings subbasements are generally found running round entrances, and are decorated with a profusion of sculptured ornament, representing rich draperies, blind arcades or symbolic and grotesque bas-reliefs inscribed in trefoils, quatrefoils, &c.

Subject. A term applied to the motive, historical or conventional, real or ideal, which an artist chooses for interpretation in his work. For instance, a happy subject, an ill-chosen subject. Some subjects do not lend themselves easily to artistic treatment: others, on the other hand, are an inexhaustible mine of wealth. It is not too much to say, however, that subject of itself can never make a picture interesting. A great subject, if not greatly

treated, is of no avail. Pictorial art is not a debased species of literature, and it is nobility of line and colour, treatment, in fact, which alone can make a picture great.

Sub-ordinaries. (Her.) The *sub-ordinaries*, though of less dignity than the *honourable ordinaries*, are of frequent occurrence in heraldry. They are sixteen in number :—the *Canton, Gyron, Inescutcheon, Orle, Tressure, Lozenge, Fusil, Fret, Flanch, Flasque, Mascle, Rustre, Label, Billet, Bordure, Pile.* Descriptions of these sub-ordinaries will be found under the different headings.

Sudarium. A term applied to the handkerchief upon which S. Veronica took an image of the face of Christ.

Suite. A term applied to a collection of pictures, the subjects of which are taken in a certain order of ideas or events. For instance, the suite of pictures painted by Rubens for the gallery of the Medici.

Sulphur. A sulphur is an impression taken from an engraved plate upon a thin layer of sulphur, which was laid upon the plate in a melted state. Some " sulphurs " of goldsmiths' work are still preserved, and they have an artistic importance, because they form a curious link in the history of engraving.

Summer. [Bressummer.]

Summit. The upper extremity. The summit of a building. The point at which the sides of an angle or the faces of a solid meet. The summit of a triangle ; the summit of a pyramid.

Sun-blind. (Arch.) A long strip of

stuff, which may be rolled up on a small

cylinder, to which one of its ends is attached. It is used to protect a window from the heat of the sun and the brilliance of the light. Sun-blinds may be placed either inside or outside a window. In museums and picture galleries they are indispensable to diminish the glaring effect of the sunlight. They are generally of some soft texture, but they may be made of very thin bamboo canes, as indeed they generally are in China and Japan.

Sun-dial. A plaque set either vertically or horizontally, on which the hours are marked.

The time of day may be told from the depth of the shadow cast on the face of the dial by the Gnomon. According to Viollet-le-Duc sun-dials were set up on the highways as early as the 13th century. In the 14th and 15th centuries they were placed against the walls of churches and other buildings.

Sunk-in. (Paint.) When colours, after they have dried on the canvas, lose their brilliance, they are said to have sunk in.

Sunset. (Paint.) It is a common practice among artists and art critics to describe a picture by the effect which the painter wished to produce. Thus we speak of a sunset by Claude Lorraine or by Crome.

Support. A piece of bent iron, which is driven obliquely into an opening made for the purpose, and holds a piece of wood on a bench. Wood carvers fix the block

on which they are working with a chisel by means of a support of this kind.

Supporters. (Her.) The figures which stand upon each side of a shield. Only persons of noble rank are entitled to supporters.

Surbased. (Arch.) An arch or vault is said to be surbased when its height is less than half the length of its springing line.

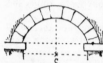

Surcoat. (Cost.) A garment worn in the Middle Ages over armour. The coat-of-arms of knights was frequently emblazoned on their surcoat.

Surface rib. (Arch.) A sharp rib placed at the angle of a Gothic vault.

Surmounted. (Arch.) An arch or vault is said to be surmounted when its height is more than half the length of its springing line.

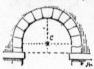

Sustained. (Paint.) A scheme of colour, which is at once free and energetic, or solid tones which enhance the effect of the modelling, are said to be sustained.

Sword. A sword is a common charge in heraldry. In religious pictures angels and archangels are frequently armed with a sword of undulating blade, called a flaming sword. At all periods of history, and in all centuries, the sword, which is pre-eminently the weapon of valiance and noblesse, has been ornamented and enriched with all the resources of decorative art.

Sycamore. (Her.) An heraldic *sycamore* is a piece of armour in the shape of a barrel hoop. The binding that fastens the hoop and keeps it in a circular

form should be distinctly marked. This charge is, however, of very rare occurrence.

Sylvester, St. St. Sylvester was the Bishop of Rome who is said to have been instrumental in converting Constantine to Christianity. In order to convince the Empress Helena of the truth of the Christian faith he restored to life a bull which had been slain by a magician. Hence a bull is his attribute in artistic representations, in which he himself always appears in episcopal vestments.

Symbol. A conventional representation of figures or objects, which are the sign of an idea ; a figure is said to be symbolic when it embodies certain attributes and characterises an abstract idea. For instance, we speak of a figure symbolic of victory, the soul, thought, &c. The attributes of music, painting, sculpture, &c., have a symbolic value.

Symbolism. The principle applied in Gothic architecture, by which, in painting or sculpture, the virtues and vices are represented under the form of persons or fantastic animals. By the term " symbolism of art " we understand the conceptions peculiar to each epoch, to each architectural style, in which the beliefs of the people are expressed.

Symmetry. A system of ornament, in which the motives are reproduced exactly on each side of an axis real or imaginary passing throught the centre of the composition. In the Gothic style absolute symmetry can scarcely be said to exist. At one end of the building, for instance, there may be a belfry, at the other a simple gable. Many church doors are flanked by towers or bell turrets of different styles, epochs, and

proportions. During the period of the Renaissance, and from that period down to the present day, the principles of symmetry have, as a rule, been rigorously

applied to the façades of buildings.

Systyle. (Arch.) In ancient architecture a temple is said to be systyle when the distance between any two of its columns is one and a half times the diameter of the columns.

T.

Tabernacle. (Arch.) A kind of small compartment occupying the centre of an

altar and resembling a diminutive chapel or temple. In it is placed the chalice with the consecrated Host, and it is terminated by a small platform, on which stands a cross or ostensoir.

Table. In architecture the term *table* is applied to a horizontal moulding, which marks the division between the stories of the building. Tables receive different names according to their position, *e.g.*, bench table, corbel table, &c.

—, **Altar.** (Arch.) The horizontal part of an altar, upon which are placed the holy vessels and books, with which the priest officiates.

—, **Devil's.** A popular name for dolmens (q.v.) and other so-called Druidical remains.

—, **Engraver's.** A table used by ancient engravers as well as the woodcutters of modern times. Its peculiarity is that it is hollowed out, as shown in our cut. The engraver stands in the

hollow, placing his elbows on the projecting portions, which serve as supports. This table is sometimes furnished with a

projecting rim, which prevents the engraver's tools from slipping off.

—, **Model's.** A kind of platform or support, set upon short legs. It presents a considerable horizontal surface raised above the ground and upon it living models pose, especially for the benefit of art students, who make studies from the life.

Tables. (Paint.) In Latin the term *tabula* was applied to an easel picture,

and in the Middle Ages painted panels were often known as *tables*. Our cut is from a fresco at Pompeii.

Tablet. A term applied to the square oblong pigments, of varying thickness, used in water-colour drawing. It also denotes the small wax plates, which the ancients used for writing upon with a stilus.

—, **Memorial.** A tablet of stone, marble or other material, upon which a commemorative inscription is placed. Houses in which illustrious men were born or lived are sometimes, though

far too seldom in London, marked with a memorial tablet.

Tablinum. (Arch.) A small room in a Roman house situated near the *atrium*, in which the family archives were kept.

Tachiste. A term used in French art criticism to denote those impressionists who see no charm in a picture beyond *taches* or strong touches of varying colour and intensity, which are not blended with the ground.

Taenia. In the costume of the ancients *taeniæ* were the ribands which were twisted round the fillet worn by priests and others. It was the *taenia* which served to fasten the fillet. As an architectural term *taenia* denotes the fillet which, in the Doric order, separates the architrave from the frieze.

Tailpiece. (Engrav.) An engraving on

copper or on wood, or a cliché of a wood block, used to illustrate a book. Tailpieces are as a rule merely ornamental, and are placed at the ends of chapters.

Talaria. A sort of sandal, orna-

mented with wings fastened with thongs to the feet of Mercury, Perseus and some other mythological figures represented as flying through the air.

Talon. (Arch.) A moulding formed of two arcs of circles, one convex, the

other concave: the first is placed at the upper part of the moulding, the second at the lower part. If the convex and concave parts are reversed, it is called a reversed talon.

Talus. A sudden slope or inclination in the ground; an obliquity in the surface of walls. The *talus* of 45 degrees offers the most resistance, and it is this which is most frequently employed in military architecture.

Tan. A reddish brown colour, tinged slightly with yellow.

Tanagra figures. Terra-cotta figures made in ancient times at Tanagra in Bæotia. Tanagra figures are very delicate in execution and of inexpressible charm. Some are gilded, others painted, and they are highly prized by collectors. The finest of them date from the 5th century B.C., and are thus contemporary with the Elgin marbles. The interest they

possess, as showing us of what the more homely side of Greek sculpture was capable at this period, can hardly be overrated.

Tangent. A term applied in geometry to a straight line, which has only a point in common with a single curve.

Tapestry. Tapestry may be defined as painting in textile fabrics. In tapestry designs are obtained by interlacing threads on lines stretched vertically or horizontally so as to form arrangements of lines and tints. It should be remembered that in tapestry there is no canvas or other material to form a groundwork. The groundwork is formed by the coloured threads themselves. The purpose of tapestry is to cover wall-spaces, and it should always be hung loosely and not stretched as though held in a frame. [High Warp; Low Warp.]

Targe. (Her.) [Shield].

Tarsia. An Italian word, which denotes a curious art practised in Venice and some other Italian cities in the 15th century. It was a kind of wood mosaic. Landscapes and other scenes were represented by inlaying woods of various colours upon a foundation of walnut wood.

Tassel. An ornament which consists of a hemispherical head or knob surrounded by a pendent fringe. The cords with which curtains are held back are generally terminated in tassels, and architectural ornaments sometimes resemble a tassel in shape.

Tassets. A name given to the plates of metal which, in a suit of armour, were

fixed on to leather and hung from the waist. They protected the hips and thighs and scarcely hampered the movements of the wearer.

Taste. In the artist taste is the quality which leads to the selection of material best fitted for artistic expression and to the refined and delicate treatment of the material selected. In the amateur taste is the faculty of distinguishing between true and false art.

Tau. A sacred instrument used by the Egyptians in the shape of the Greek T. The term is also applied to an heraldic charge in the form of a T, which is really a cross potent, or, as it is more usually called, St. Anthony's cross.

Tazza. (Pot.) A cup of the shape

indicated in our illustration. It had a slender foot and two handles.

Technique. In painting and sculpture the term *technique* denotes manipulative skill, mastery of material and all those qualities of hand and eye which contribute to the executive excellence of a work of art. It has been the fashion of late years to decry *technique* and to attach too great a value to certain gifts of literary invention. But as it is an artist's business to be articulate in his own medium, whether it be paint or clay, it is quite certain that *technique* is of far greater importance, and is dependent on far higher qualities of mind than any knack of finding subjects or portraying sentiment.

Telamones. (Arch.) Figures of men

used to support cornices or entablatures.

They are also called *Atlantes* (q.v.), and served the same purpose as the more delicate and graceful caryatids.

Teleiconography. A method of reproducing drawings at a distance by means of a series of currents transmitted by telegraphic wires.

Tempera. (Paint.) Tempera is a method of painting, in which dry colours are diluted in glue or size.

Template. (Arch.) A piece of sheet iron cut out to reproduce a moulding reversed. When drawn along damp plaster it gives a moulding in relief.

The term is also applied to the outlines of sheet iron or wood, with the help of which portions of stones are cut away, so as to leave a moulding projecting.

Temple. (Arch.) A building consecrated to the worship of the gods among the Greeks and Romans. Ancient temples, independently of their dimensions and the purposes to which they were put, may be subdivided according to the number of columns which decorated their façade. The temple was called *tetrastyle*, when it had four columns in its façade, *hexastyle* when it had six, *octastyle* when it had eight, *decastyle* when it had ten, and *dodecastyle* when it had twelve. A temple is said to be *in antis* when the two ends of its façade are terminated with pilasters. When its façade is the same rear and front it is termed *amphiprostyle*. A *peripteral* temple has a colonnade running all round its cella, while a *dipteral* temple is characterised by a double colonnade. Yet another classification of ancient temples is possible. They may be classified according to the distance which exists between their columns. When the distance between the columns is one and a half times the diameter of the column, the temple is called *pycnostyle;* when the distance is two diameters it is called *systyle;* when the distance is two and a quarter diameters the temple is called *eustyle;* when the distance is three diameters, *diastyle;* and *araeostyle* when the distance is more than three diameters, Finally, it should be mentioned that as a rule ancient temples were hypaethral, that is, open to the sky.

Tender. Light, delicate. Bright, fresh colours are called tender.

Tendril. The tendril of the vine affords a charming motive for decoration. It is used in architecture and frequently found as an ornament on vases and other works

of art. Our cut will give some idea of the free treatment of the tendril. It is taken from a painted vase in the museum at Naples.

Tenebrosi. (Paint.) A school of painters who worked principally at Venice, and recognised Carravaggio as their leader. Their effects were produced by strong lights and shadows, and to this they owe their name.

Tenières. A name given to pieces of tapestry, which were made in Brussels in the 17th century, and the subjects of which were suggested by the peasant scenes of Teniers.

Tenon. (1) (Arch.) A piece of iron, used to bind courses of stone or blocks of masonry which have to be held securely

together. Also a piece of iron or wood, cut so as to make a solid joint.

Tenon. (2.) (Sculp.) A piece of stone or marble which is not detached from a statue, while it is being carved. It consolidates weak places, which the blows

of the hammer upon the chisel might break. Tenons are generally removed by a saw, when the statue is finally placed upon its pedestal. But if violent movement is expressed in a statue it is more prudent to retain the tenons for the support of the legs or arms.

Terebinth. A liquid resinous substance. Essence of terebinth is a hydrocarbonate and is used to dissolve thick matters, to clean paint brushes, and to remove the varnish from plates, which have been etched.

Terminal figures. Terminal figures are busts placed upon stone pillars.

Sometimes the stone pillars are terminated by figures down to the waist with or without arms. Sometimes, though rarely, two terminal figures are juxtaposèd, the lower limits of the two being replaced by a single pillar. Terminal figures are frequently employed in the decoration of parks and gardens, while pillars surmounted by the upper parts of tritons and naiads ornament grottos and fountains.

Terra-cotta. (Sculp.) This material, which is a baked clay, has always been used by sculptors for their less important works. Casts of statuettes are made in clay, which is then baked. The process has the advantage of being simple and inexpensive, and it is well adapted for the reproduction of small works. The most celebrated terra-cottas known are the Tanagra figures (q.v.).

Terra di Sienna. (Paint.) A kind of earth used both in oil and water-colour painting. It is of a cold yellowish tone, when in its natural state, but when *burnt* it acquires a warm useful tone. [Burnt Sienna.]

Terra Verde. (Paint.) A useful and permanent green pigment, which is found in the form of an earth in Cyprus and in Italy. Among its ingredients are silica and oxide of iron.

Terrace. (Arch.) In the architecture of gardens a terrace is an elevated walk, rising by steps above the ground in front of it, or a plot of ground laid out in front of a building, and raised upon a slope above the general level.

The term also denotes a horizontal roof, which forms a raised platform above a building. The upper storey of Roman houses, which was called the *solarium*, presents a good example of a terrace of this sort. A wide space with a railing running round it is also called a

terrace, and sometimes the term is applied to a row of uniform villas. In this last instance the word appears to have lost its true meaning.

Terre Plen. (Arch.) A French term applied to a solid mass situated be-

tween the two arches of a bridge. Our

cut will sufficiently explain its purpose and construction.

Tertiary colours. (Paint.) Colours are called *tertiary* when they are produced by the mixture of a primary and secondary colour, one of the colours being in excess of the others. They are olive, citrine, and russet.

Tesselated pavements. (Arch.) In Rome pavements were frequently decorated with elaborate mosaics. Patterns and pictures were made by an artistic arrangement of variously coloured stones. These pavements are called tesselated, and are to be found wherever the Romans pitched their camp. Fine specimens exist in England and have from time to time been unearthed with the villas of which they formed part. The designs are frequently decorative, but are sometimes pictorial. At Pompeii was found an admirable representation of the battle of Issus, a copy of a celebrated picture by a lady artist named Helena. This, perhaps the most famous tesselated pavement, is now in the Naples Museum. The best known examples in England are at Brading, in the Isle of Wight, and Bury, in Sussex.

Tessera. (Arch.) A small pebble, or piece of glass or earthenware, used in the making of tesselated pavements.

Testoon. (Numis.) A French coin in circulation in the reign of Louis XII. The term is derived from *tête*, a head, and was applied to the coin in question because it bore the king's head upon it. From this was derived the English word *tester*, meaning a sixpence.

Tetragram. A term denoting the

mystic letters, placed in a triangle, which stand for the name of God.

Tetrahedron. A geometrical term, denoting a solid figure, bounded by four plane sides.

Tetrastyle. (Arch.) A temple is said to be *tetrastyle* when its façade is ornamented with four columns.

Texture. (Paint.) A term applied to the arrangement of neighbouring tones, or different shades of the same colour in alternation or juxtaposition. The secret of the vibration of the greens in Constable's landscapes results from the fact that he gets his effect by a texture of greens of different intensity. In another sense texture denotes the quality of the surface of draperies, &c. Thus we say that an artist is skilled in rendering *textures*, when he clearly marks in his pictures the varying qualities of the surfaces which he represents.

Thanatos. In Greek art of the best period, and later, Thanatos, or Death, is personified by a winged youth or man. He was regarded as the brother of Hypnos, or Sleep, and was shorn of all his terrors. He was usually represented as a boy, but sometimes (as, for instance, on a *lecythus* in the British Museum) he is bearded.

Theatre. (Arch.) A large building, in which plays are presented. It is divided into two portions, the auditorium, reserved for the spectators, and the stage, reserved for the actors. Ancient theatres were open to the sky. Modern theatres

are covered buildings, lighted by gas or electricity. The construction of the theatre has undergone very slight modifications. The auditorium is with

us as it was with the ancients a semi-circular series of seats, and the stage of to-day, though of course its mechanical appliances are far more elaborate than

of old, keeps quite close to the ancient type. At the close of a scene or at the end of a play a curtain is let down, which shuts off the stage from the auditorium. The background of a scene consists of a curtain, as shown in our second cut, upon which the distances are depicted ; the middle distance and foreground being indicated by wings. The framework within which the scene

is set may be increased or diminished in size by drawing up or letting down a curtain fixed at the front of the stage. The effect thus produced may be estimated from our third cut.

Theatrical. Painted or sculptured figures are termed theatrical when their attitude is unnatural or exaggerated. For instance, a statue may be theatrical in pose ; the rendering of a scene is said to be theatrical when it lacks simplicity.

Thecla, St. St. Thecla was a maiden of Anconium, and she became a Christian at hearing the preaching of St. Paul, whom she is said to have followed on some of his journeys. She was cruelly persecuted on espousing the new faith, but the lions, sent to devour her, spared her life She spent many years in a desert

in Seleucia, and she finally disappeared in a rock, which opened behind her, when she was being pursued by some " sons of Belial." In art she is represented as holding a palm ; sometimes lions crouch at her feet.

Thermæ. (Arch.) The word *thermæ* originally meant *hot springs ;* then it denoted *hot baths ;* and finally it became a general word among the Romans for a collection of baths included within one building. The *thermæ* comprised numerous rooms, baths, and sweating rooms, and frequently covered a large tract of ground. [Baths.]

Thin. (Paint.) A term applied to a too superficial treament, to a modelling which lacks consistence, to the rendering of a body in a relief by tones which lack solidity, or to the application of colour in too fine layers.

Thistle. (Her.) The thistle has always been the emblem of Scotland. The order of the Thistle, which is supposed to be of very ancient origin, was revived by James V. of Scotland, and its statutes have been since several times modified by different sovereigns of the United Kingdom.

Thole. (Arch.) The keystone of a cupola ; the cupola or dome itself.

Thomas, St. St. Thomas was that one of the disciples of Jesus who, when Jesus reappeared after the Crucifixion, demanded some proof that he was the Lord. This doubting on the part of Thomas has been the subject of many pictures. When St. Thomas is represented alone, his attribute is commonly a builder's square. This square alludes to a curious legend, according to which Thomas was sent to Gondofures, king of the Indies, who wanted an architect to build him a palace. Thomas, while the king was away, did not build his palace, but gave his money away in alms. On his return, the king threw Thomas in prison, but on being told in a vision that Thomas by giving away his alms had

built him a palace in heaven, he at once released him. And in allusion to this quaint tradition St. Thomas is represented as carrying a square.

Three-quarter. (Paint.) A portrait is said to be three-quarter length when it only shows the sitter as far as the hips. Technically the term is applied to portraits which measure thirty inches by twenty-five.

Through-stone. (Arch.) A stone which goes right *through* a wall, so that its ends can be seen on either side.

Throwing. (Pot.) The most primitive method of fashioning pots is what is known as *throwing*, that is by shaping the lump of wet clay with the hands as it revolves on the wheel before the potter.

Thrust. (Arch.) The force exerted by an arch or vault upon a pier. The pur-

pose of the flying buttress in Gothic architecture is to counteract the thrust of the vaults of the nave, and the skill of the French architects of the 12th and 13th centuries consisted in giving a feeling of decoration to the masses of masonry indispensable to the stability of a building.

Thunder-bolt. The attribute of Zeus. It assumes the form of a long kind of spindle, from which proceed zigzag rays,

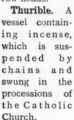

pointed like arrow-heads.

Thurible. A vessel containing incense, which is suspended by chains and swung in the processions of the Catholic Church.

Thyrsus. A kind of staff or javelin, surrounded

with vine-branches or ivy and terminated by a pine-cone. It was the attribute of Bacchus and his followers, whether priests or priestesses. According to some authorities the *thyrsus* ending in a javelin point represented the deceit of a combatant, who sought to hide his arms under flowing ribbons, while the *thyrsus* surmounted by a pine-cone symbolised peaceful life. The Egyptians, Phœnicians, Greeks, and even the Jews carried *thyrsi* in their religious ceremonies.

Tiara. A headdress worn by the kings of Persia and also by the Jews. Our cut shows a royal *tiara* as it is still worn in Persia. The term *tiara* is also applied to the triple crown worn by the Pope.

Tibia. A wind instrument made of reed, wood, or the shin-bone of an animal. There were in use among the ancients several kinds of tibiæ, but they

all had points of similarity, and were provided with holes for the fingers.

Tibicen. A Roman word denoting a player on the flute.

Tie-beam. (Arch.) A term applied to the horizontal piece of wood in a roof. In Gothic buildings, in which the timber-

work of the roof is apparent, the tie-

beams are decorated, at the ends set into the walls, with carvings, which generally take the forms of the heads of fantastic animals.

Tierce-point. (Arch.) The point of intersection of two pointed arches.

Tige. (Arch.) In some systems of ornament the term *tige* is applied to cylindrical branches, from which foliage emerges. Sometimes the *tige*, slightly swelling at the end or spreading out into a bud, is decorated with flutings or striæ; sometimes its surface is unbroken.

Tight. (Paint.) A painting is said to be tight, when it is handled without breadth or freedom, when the outlines are harshly defined and abruptly cut off from the background.

Tile. (Arch.) A square of burnt earth used in roofing houses. Tiles of convex form are placed at the ridge of a roof and known as ridge-tiles (q.v.). Some tiles are varnished and coloured, and by means of these roofs may be decorated

with geometrical designs. Roman temples were sometimes covered with bronze tiles laid side by side, while the roofs of Chinese temples generally consist of tiles of coarse porcelain painted green or yellow. The term *tile* is also applied to plaques of marble, stone,

or earthenware, sometimes decorated, sometimes with a uniform surface, which are used to cover walls or pavements. As a rule they are either square or rectangular. Sometimes, however,

they are triangular or in the shape of a lozenge, hexagon, or octagon; they are then capable of very varied combinations.

Tile, Gutter. A hollow tile placed at the angle formed by the intersection of two roofs inclined in opposite directions, and serving to carry off rain water. Sometimes plates of lead or zinc are used instead of tiles.

—, Hanging. (Arch.) A tile rounded or cut to a sharp point, principally used to cover turrets or circular roofs. In the Middle Ages ridge tiles were largely used to protect the beams of timber-built houses from the effects of rain water. They are still sometimes put to this use.

Tilting lance. A lance with a broad, blunt point, which was used in tourna-

ments, not to inflict mortal injuries, but simply to dislodge an opponent from the saddle.

Tincture. (Her.) In heraldry the term *tincture* is used as a general expression for the colouring of a shield and includes all the three terms, *colour*, *metal*, and *fur*. There are five colours, *azure* or blue, shown by lines drawn horizontally across the shield; *gules* or red, shown by verti-

cal lines; *vert* or green, shown by diagonal lines downwards from dexter to sinister; *purpure* or purple, shown by diagonal lines downwards from sinister to dexter; *sable* or black, shown by horizontal vertical lines crossing each other. There are two metals, *or* and *argent*, or gold and silver. *Argent* is represented by a perfectly plain shield; *or* by a plain field powdered with dots. There are eight furs, descriptions of which will be found under their respective names: ermine, eimines, erminois; peau; vair, counter-vair; potent, counter-potent. The accompanying cut shows a *sable* on an *argent* on an *azure* shield.

Tint. (Paint.) A light shade; also the colour which results from the mixture of several colours; the application of a particular colour with varying intensity.

Tinted. (Paint.) Covered with a tint, uniformly covered with a light shade.

Tinting Tool. (Engrav.) A tool used by engravers on copper as well as on wood to cut lines of different

breadths. They vary in size according to the purpose for which they are required.

Tissierography. A process of relief engraving invented by Louis Tissier between 1831 and 1839, by means of which drawings with pen or pencil, or tracings on autographic paper, may be printed typographically.

To-fall. (Arch.) (Lean-to.)

Toga. (Cost.) The characteristic dress of the Roman citizen. It underwent many changes of form, and, not being a rigid garment, was capable of an infinite variety of folds. But generally it was an oblong piece of cloth, which enveloped the body. One end of it was then brought from behind under the right arm, passed

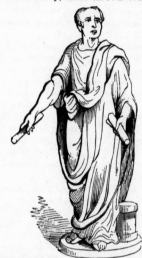

across the body, then thrown over the left shoulder, until it reached the ground behind.

Tomb. (Arch.) A monument erected over the spot where the remains of a dead man lie. Tombs vary in form according to their style and epoch. Egyptian and Roman tombs sometimes cover a large extent of ground. In the Middle Ages tombs often assumed the form of small buildings; they were then either attached to the outside wall of a church or placed in a chapel in the interior. During the Renaissance, tombs were decorated with pilasters, columns or entablatures and equestrian statues, and were sometimes important constructions. In the 17th and 18th centuries the tombs of illustrious men were conceived in an exquisite spirit of decorative art. In the beginning of the present century, the neo-Greek style prevailed. Tombs were then often pyramidal in shape, and were decorated with bas-reliefs. They were generally inartistic and almost always ridiculous. The revival of sculpture in the present day will no doubt have the effect of im-

proving the public taste in monuments in honour of the dead.

Tombstone. A term applied to blocks

of stone, which cover or stand at the end of tombs. Tombstones in the Middle Ages were sometimes decorated with incised designs of much rich- ness, and when they represented persons of rank or distinction, the faces, hands, and armorial bearings were incrusted with marble.

Tonality. (Paint.) A collection of tones subordinated to one dominant tone. A vigorous tonality. A picture painted in a violet tonality.

Tone. (Paint.) Tone is defined by some writers as the variations of a colour or tint, which are produced by its ad- mixture with white and black. It keeps the same hue and becomes lighter and darker. The term is also applied to the brilliance, the intensity of tint, the domi- nant effect, observable in the colours of a picture. Thus we speak of warm tones, cold tones, energetic tones, &c.

—, **Local.** A term applied to the general tone covering a surface, the modelling which is obtained by means of dark touches, representing the shades, and light touches, indicating the light.

—, **Neutral.** A term applied to a scale of broken tones, which, precisely on account of their neutrality, give an ad ditional value to other brighter tones or colours.

Toned down. (Paint.) Colours are said to have toned down when with age they have become lower in tone and more sombre than they were when freshly laid on.

Toothing. (Arch.) The demolition of a piece of masonry so as to bind more

solidly together a portion already con- structed with a

portion still in course of con- struction. The term *Toothing stone* is applied to the stones left uneven or toothed in or- der to facilitate the binding of two portions of a wall built at different dates.

Tooth Ornament. (Arch.) A system of ornament in the

form of a series of pointed teeth. It is peculiar to the Ro- manesque and early Pointed style.

Topaz. A precious stone of a yellow tone. The burnt topaz is somewhat darker.

Topia. (Paint.) A term applied by Vitruvius to a landscape of a purely decorative and conventional character, many florid specimens of which have been discovered at Pompeii.

Topographic. A map or plan repre- senting the form of a country with all its details is termed topographic.

Toque. The headdress worn in former times by

the Doge of Venice. The ducal toque was richly ornamented and had ear pieces. In France the term was applied to the black velvet cap, surmounted by eagles' feathers, which the imperial noblesse wore before 1815.

Torchère. An allegorical figure holding a torch, lamp, or candle. The name is

given to vases of metal which have a handle and in the interior of which some inflammable substance is put, which on combustion produces an intense flame. Also to the

supports of delicate shape, upon which candelabra are placed.

Toreuma. The name given by the ancients to bas-reliefs executed in metal and chased.

Toreutic. (Sculp.) Among the Greeks and Romans the term toreutic was applied to the chasing, carving, and boring of hard substances, such as ivory, stone or silver.

Torsade. A French term denoting a system of ornament in imitation of a

twisted cable; also a twisted fringe, used as a border for curtains, draperies, &c.

Torso. That portion of a human figure which includes the shoulders, veins, and

breast. The term is generally applied to a statue deprived of head and arms. The " torso of the Belvedere " which was discovered at Rome at the end of the 15th century, and is now preserved in the Museum of the Vatican, and the "torso Farnese," now at Naples, are two admirable fragments of ancient sculpture.

Torus. (Arch.) A moulding of convex profile. This profile is generally a

semicircle. In buildings of the Gothic style, however, we sometimes find tori

which have an elliptic profile or a profile made up of two arcs of a circle, cutting one another at a right angle. In mediæval buildings archivolts often consist of one or more *tori* separated from each other by small angular mouldings.

Touch. (Paint.) The method in which the colours are laid on the surface of the canvas by the painter. We speak of a light touch, a want of touch, or a square touch; it may be said that the modelling is indicated by a few skilful touches.

Tourelle. (Arch.) A tower of small diameter runing up the height of a building, in which a circular staircase is generally placed. [Turret.]

Tourmaline. A hard stone formed of a silicate with a base of limestone or magnesia, and containing boric acid and fluor. It is sometimes colourless, sometimes of a dark green or brown red, coming very near to black.

Tournure. The characteristic aspect of a drawing; grace or grandeur of line.

Tower. (Arch.) A building of great height in proportion to its breadth with a circular, polygonal, or square base. The towers of castles serve as a donjon, to connect curtains and to protect the angle

of a fortified enclosure. In the 12th century towers were square; in the 13th they were circular; from the 14th to the 16th century they nearly approached the square, especially when they were donjons. The clock towers of churches are

called towers, when their base is square,

their upper stories polygonal, and

when they do not terminate in a pyramid.

Tower, Clock. (Arch.) The tower of a castle or church in which a clock is placed. Its face generally serves as an opportunity for decoration.

Tracer. An instrument consisting of two flat pieces of metal, the ends of 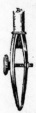 which are made to approach one another by means of a screw. The tracer is dipped in ink and is used to draw lines of uniform thickness. Some tracers are used to draw straight lines; they are then provided with a handle, which can be unscrewed; or the tracers may be adapted to a compass, in which case they draw curved lines and arcs of circles.

Tracery. (Arch.) A term applied to a kind of ornament found in the upper part of Gothic windows. It is geometric in pattern, and it has been applied to

many objects of domestic use. The clock case in our cut is a somewhat florid

instance of tracery applied to wood carving.

Tracing. A mechanical reproduction of a drawing. Tracings are indispensable to an engraver if he wishes his print to be an exact reproduction of the original work. Sometimes also an artist will trace a first sketch when he finds in it certain qualities which he can only reproduce by this mechanical means. There are several methods of obtaining tracings. A simple method is to place the drawing, assuming it to be on paper,

against a window pane, and to set over it a sheet of thin paper. The lines of the drawing will then appear through and if they are followed with a pencil an exact reproduction will be obtained. A similar, but more convenient method is by the use of transparent paper, called tracing paper. The original drawing can then be laid on the table or on a drawing-board, and the lines followed with pen or pencil on the tracing paper. Another method is by the use of blackened paper, which is laid with its black-ened face downwards on a sheet of white paper, the drawing being placed above the blackened paper. By lightly pressing with a blunted steel or ivory style on the lines of the drawing, the black is transferred to the white paper below, and the drawing is reproduced. This method, though extremely easy, has the disadvan-tage of spoiling the original drawing. The method generally employed by en-gravers is as follows: A sheet of gelatine paper is laid upon the drawing which can be seen through the gelatine; the en-graver follows the lines of the drawing with a sharp point which cuts into the gelatine, so that the lines of the drawing are represented by little canals in the gelatine paper. The whole sheet of gelatine is then dusted over with black powder which remains in the depressions when the plane surface is wiped. The tracing thus prepared is laid face downwards on the wood to be engraved, and either the hand or a burnisher passed over it, so as to transfer the lines of black powder to the block. The engraver thus has on his block an inverse of the ori-ginal drawing, so that consequently the print will face the same way as the original.

Tracing of Shadows. A tracing the purpose of which is to determine the precise form of cast shadows and the luminous parts of a body having

given the luminous point in relation

to this body.

Trajan's Column. (Arch.) A column set up in the Forum by the Emperor Tra-jan to celebrate his victory over the Dacians. Æsthetically it is not a su-premely beautiful object, but it is very valuable as a record of costume and weapons, being decorated with reliefs representing the military life of the Romans. A cast of it may be seen at the South Kensington Museum.

Tranquil. A work, which is executed in a quiet, harmonious tonality, may be termed tranquil. To produce a tran-quil effect all striking notes in a picture must be softened, and its brilliant lights must be extinguished.

Transemaux. This barbarous term was proposed by M. Salvetat, to denote transparent faïence enamels, while he suggested *opemaux* to mean opaque enamels.

Transept. (Arch.) The smaller arms

in the crossing of a Gothic church are

called transepts, one of them being towards the south, the other towards the north. Some churches have a double set of transepts.

Transition. (Arch.) The term *transition* is applied to an architectural style which possesses the characteristics of two styles, one of which is gradually giving way to the other. In English architecture, for instance, there is a period of transition, when the Norman style is giving way to the Early English, another when the Decorated style is taking the place of the Early English, and a third when the Perpendicular is supplanting the Decorated.

Transom. (Arch.) A horizontal bar or mullion in a window. Transoms are sometimes quite plain, sometimes decorated with simple mouldings.

Trap. (Arch.) An opening in a floor or ceiling, which is closed either by a grating or by a shutter.

Trapezium. A quadrilateral figure, in which two sides are parallel and all the sides unequal. A solid figure is called a trapezohedron, when each of its faces is a trapezium. A particular form of this solid figure has twenty-four faces presenting the appearance of symmetrical quadrilateral figures.

Travertino. (Arch.) A kind of limestone, which was used by the Romans for building purposes and highly prized by them. It is a very hard stone, is white when freshly cut, and tones down to a yellow with age and exposure. It was quarried by the ancient Romans at Tibur, whence it was called *Lapis Tiburtinus,* Travertino being its modern name.

Tread. (Arch.) The horizontal part of a step, upon which the foot rests.

Treasury. (Arch.) A small isolated building, chapel, or sacristy, belonging to a Gothic church, in which relics and sacred vessels made of the precious metals were kept.

Treat. (Paint.) To *treat,* in painting, is to express or represent in a certain way. For instance, we speak of a subject treated with spirit, a figure badly treated, a group happily treated.

Trefoil. (Arch.) A system of ornament in vogue in the Gothic style, which consisted of three foils or portions of a circle. Some trefoils are simple, some are composite, that is to say,

other trefoils are inscribed within them. It also occurs as a charge in heraldry; in this case it may be described as the three-leaved grass, having a small stalk. Our cut may be thus described: Argent, three trefoils, gules, one over two.

Trellis. (Arch.) A garden decoration consisting of vines or creepers, trailing over walls or vaults. In the 12th and

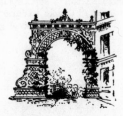

following centuries vaults were built in gardens and covered with trellis-work. From the 16th century onwards the principle of *trellis* was applied to architecture, and at that period porticoes,

covered with richly decorated lattice-work, to which the term trellis was applied, were quite common.

Tresse. (Arch.) A system of ornament, either flat or convex. It consists of

bandelettes (q.v.) intertwined. In the romanesque style *tori* (q.v.) are frequently decorated with *tresses*.

Tressure. (Her.) A French heraldic term, denoting a narrow *orle* (q.v.). The *tressure* is frequently met with in coats-of-arms, and may be either simple or double, fleuronnée or fleurdelisée.

Triangle. A geometrical figure having three sides and three angles. A right-angled triangle is a triangle which has a right angle; in an equilateral triangle

the three sides and the three angles are equal; an isosceles triangle has two equal sides; and a scalene triangle has three unequal sides.

Triangular. That which has three sides or is in the form of a triangle.

Tribune. (Arch.) A semicircular seat always found in Roman basilicæ; in all styles of architecture, a raised gallery,

supported by columns or arches; a passage made in the thickness of the wall

in Gothic buildings and bounded by pierced balustrades. The term is also applied sometimes to the platform in a rood-loft, from which discourses were delivered. Some authors give the name *tribune*

to the galleries running round the lantern, which terminates a dome. Generally any raised place or rostrum, from which speeches are made, may be described as a tribune.

Tricky. A work of art is said to be *tricky* when its effect is produced not by the means proper to the art itself, but by *ficelle* (q.v.) or sleight of hand.

Triclinium. (Arch.) The dining-room of a Roman house. It was so-called from the fact that it contained three seats arranged round a table, there being room on each seat for three persons to recline.

Trident. A three-pronged fork. Neptune is always represented armed with a trident. It is also the attribute of the gods of the sea, such as Tritons, Nereids, &c., who are represented in mythological scenes or as decorative groups on fountains, &c.

Triforium. (Arch.) A gallery immediately above the nave in a basilica or church. Sometimes the triforium occupies the whole breadth of the aisles; sometimes it is only a narrow gallery, set against the roof of the nave. The purpose of this vaulted gallery is to serve as a flying buttress to counterbalance the thrust of the central vault.

Triglyph. (Arch.) A system of ornament, found in the frieze of the Doric order. It consists of a projecting piece pierced by three narrow flutings or *glyphs*. The frieze of the Doric style is made up of alternate metopes and

triglyphs, and in Greek temples the angle of the entablature is strengthened by two triglyphs, one on each face. In Roman Doric buildings, however, the angles are formed by two demi-metopes, and the triglyphs are always placed at the axis of the column.

Trilith. [Lichaven.]

Trilobe. (Arch.) A system of ornament consisting of three cusps or lobes It is also called trefoil. It was constantly employed in buildings of the Gothic style from

the 12th to the 16th century. Examples of mullions and arcades in the form of trilobes are very common.

Trimmer. (Arch.) A piece of wood, in which the joists of a plank are held fast.

Tripod. That which has three feet. A term applied to table lamps or incense-burners, which stood upon three feet. The most famous tripod in

ancient times was the seat with three legs, upon which the priestess of Apollo sat to declare the oracle at Delphi. In consequence of this the tripod was the attribute of Apollo.

Triptych. A picture painted on a panel and covered by two leaves, which turn on hinges. Some triptychs are painted with bas-reliefs painted and gilded. Some of the finest triptychs in existence we owe to Rubens, while the early masters of Italian and German

schools painted a very large number of

triptychs. The doors or leaves were generally painted on both sides, as well as the central panel.

Triquetra. A mystical ornament, sometimes found as a motive in architectural decoration.

Triumphal Arch. [Arch, Triumphal.]

Trochilus. (Arch.) A moulding with a concave outline, which generally separates two *tori* or convex mouldings. The trochilus is a special variety of the scotia (q.v.).

Trophy. A decoration consisting of a group of arms, bound together with ribands and hung from a wall. Mural surfaces are frequently decorated with painted or sculptured trophies. The term

trophy is also applied to a group of attributes of the chase, thus we speak

of a trophy of the chase. The practice of setting up a trophy in commemoration of a victory dates from very early times. After a battle the ancients set up trophies, which consisted of the arms and spoils taken from the vanquished. In modern times trophies, consisting of flags, &c., are put up in churches.

Trowel. A trowel consists of a triangle with a rounded end fitted on to a handle. It is used by masons to spread the plaster between the courses. A small trowel is used to mark the joints between the stones or bricks in a piece of masonry. Painters use a palette knife shaped like a trowel to spread the ground over a canvas, and to put in those parts of a picture, which by their rough execution are intended to present a contrast to the more carefully finished parts.

Truc. This piece of French artistic slang is almost synonomous with *ficelle* (q.v.), but it refers rather to the method than to the means of execution. It does not differ greatly from the English word, " knack." An artist is said to have the " truc," when he possesses a special knowledge of the details of his art, and can grasp at once the method in which a thing is to be done.

Truculent. Brutal and lively at the same time. Thus bright fresh colours, which do not lack harmony, but are laid on with a vigorous hand, are termed truculent.

Truité. (Pot.) A term used by Jacquemart and other French writers on the Ceramic art to denote a fine crackle which is found on some pieces of Chinese porcelain. The name is given to these pieces of porcelain because their surface resembles the scales of a trout.

Truncated. Any solid figure is said to be truncated when its upper part is cut off parallel to its *base.* Our cut gives an example of a truncated pyramid.

Pedestals are frequently cut into the shape of truncated pyramids, their upper part presenting a smooth horizontal surface.

Trunk-light. (Arch.) [Abat-jour.]

Truqueur. A *truqueur* is an artist who fraudulently manufactures pictures, drawings, or the autographs of famous men, and attempts to entrap amateurs into buying his forgeries as if they were genuine. The art of *trucage* has made immense strides in our own days. The *truqueur* visits Greece to collect scraps of Parian marble, which he converts into bas-reliefs of the 5th century, and studies the arts of all nations and ages with an intelligence worthy of better things than his fraudulent employment.

Truss. (Arch.) A term applied to the pieces of timber or iron which support the ridge of a roof, through the intermediation of longitudinal pieces called purlins, placed parallel to one another. The truss of a mansard roof assumes a particular form. It may best be described as a truss of the usual shape, inscribed in a triangle, as low as possible,

the whole of which would be raised by means of strut beams.

T-square. A T-square consists of a flat rule placed at right angles to a piece of wood which is grooved, so that it may be applied to the edge of a drawing board. If this part of the square be moved along with the left hand, the flat rule allows the draughtsman to draw horizontal lines, which are absolutely

parallel, provided that the edge of the drawing-board is perfectly straight. The branches of some T-squares are moveable, so that oblique parallels may be drawn. Perpendicular lines may be

obtained by placing a set square on the horizontal rule. When once the management of the T-square is mastered the execution of architectural and geometrical drawings is much facilitated.

Tube. (Paint.) A small cylinder of tin, one of the ends of which is closed by a screw top of the same metal. The other end is folded over when the tube has been filled with pounded colour, reduced to the state of a soft paste. By unscrewing the top and squeezing the tube, the amount of colour which the artist needs may be obtained.

Tubes of a considerable size are made to hold colours used in oil-painting. In former times oil colours were kept in small pigs' bladders folded in the shape of a purse. The colour was pressed from the bladder on the palette by pricking the bladder with a pin.

Tufa. A kind of red sandstone which is soft as a rule, and not very durable. It was used by the early builders of Rome, because it could be split off into square blocks without any cutting, a wedge only being used.

Tumulus. A term applied to a mass of earth or stones in the form of a small cone or hillock. In the remotest ages of antiquity, tumuli were raised as tombs

or commemcrative monuments. There are still in existence many Celtic tumuli. Etruscan tombs generally consist of a sub-basement of masonry, with a cone of earth built on the top of it, which is sometimes of large dimensions, and planted with trees.

Tunic. (Cost.) A garment, in shape something like a blouse, worn by the ancients under the toga. In Greece travellers, artisans, and the like wore a tunic without any garment to cover it.

Turitulum. A moveable censer into which incense was thrown by the hand. Sometimes it was an open grate, as shown in our cut, sometimes it more closely resembled the modern thurible.

Turret. (Arch.) A small tower, circular or polygonal in form, found in Gothic

and Renaissance buildings, in which is a

405

staircase or small retreat, often elabo-rately decorated. Sometimes they spring from the surface of the ground, sometimes they are corbelled out and project beyond the wall of a building.

Tuscan. (Arch.) An order of architecture of the Etruscan style, called also the Rustic order. It was employed on the ground floor of some Roman build-

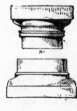

ings, such as the theatre of Marcellus. This order, which is described by Vitruvius, is nothing but a degenerate reproduction of the Greek Doric order. The Tuscan order, according to Vignole, differs only from the Doric order in being less elegant, as far as its proportions are concerned.

Tusses. (Arch.) Stones placed one above the other, so as to form alternate

projections and hollows. Their purpose is to bind together the old and new portions of a wall which has been extended. The term is also applied to the projecting stones in a belting-course, placed at the inside angle of two walls, in order to increase their cohesion.

Tympanum. (Arch.) The triangular space included between the cornice and the sloping sides of a pediment. The term is also applied to the triangle or kind of es-

coinson circumscribed by an archivolt, an entablature and a pilaster. These

tympana of arches are sometimes decorated with bas-reliefs, paintings, or

mosaics. It also denotes the field bounded by the haunches of the arch and the springing-line of the arch above the doorways of Gothic churches.

Tynes. (Her.) The name given by heralds to the small branches that project from the antlers of a stag. It is not gene-rally necessary to specify the number of *tynes*. The full antlers attached to a small portion of the

skull, as here shown, are sometimes borne as a separate charge.

Type. A term applied in art to a figure of a precise and strongly marked character. Thus we speak of a type of a beautiful woman, a type of a beggar. In numismatics an historical or symbolic figure upon a coin is called a type.

Typical. That which has the character or distinguishing marks of a type.

Typography. The art of printing by means of characters or types in relief. Relief engravings, whether in zinc, copper, or wood, may be printed by the typographic process at the same time as letterpress set up in moveable type.

Typolithography. The art of printing on the same page lithograph drawings and printer's type.

U

Ultramarine. A pigment of a beautiful azure blue, which is valuable for its intensity. It was formerly obtained by the calcination of lapis lazuli, but it is nowadays artificially prepared by mixing kaolin, sodium, and sulphur.

Umber. (Paint.) Umber is found in a native state, and is a mixture of iron and manganese. The pigment derived from it is of an olive brown colour when in a raw state, but it acquires a reddish tint when it is burnt. Umbers, both raw and burnt, are useful pigments and permanent alike in oil and water.

Umbo. The point or cone, which projects from the centre of a shield. In

ancient times *umbo* sometimes denoted the whole shield. Round Italian shields of the time of the Renaissance, which were only displayed on parade, were decorated with umbos in the form of Medusa's head. In oriental shields round the central umbo, several smaller ones are found of engraved and damascened steel.

Umbrella. A white linen umbrella is one of the indispensable accessories of artists who make studies in the open air. The umbrella generally has a long handle, with an iron point at the end

which may be driven into the ground. The handle is made in pieces, so that it may be bent in all directions, and always keep the artist, and the canvas upon which he is at work, in the shade, whatever be the position of the sun.

Uncial. A term applied in manuscripts to initials or texts, consisting of capital letters, sometimes richly ornamented and gilded. Uncial writing took the place of capitals in Greek manuscripts,

and was employed until the 9th century and as late as the 12th century for the

books of the Church. In the 9th century uncials were sometimes replaced by demi-uncials, and in the 10th century, manuscripts being executed in small

letters, a much less tedious process, uncials were no longer employed except in titles and the headings of chapters.

Undé. (Her.) [Wavy.]

Undercroft. A chapel or chamber below a church. The undercroft is frequently the most ancient part of a church, as it is, for instance, at Ripon Cathedral.

Undulating Moulding. An ornament consisting of curves alternately concave

and convex. This decorative moulding is frequently met with in buildings of the Romanesque style.

Unguentarium. (Pot.) A small vase or bottle, which contained the oil used by athletes in the bath, or perfumes and scents. The *un-*

guentarium was generally simple in form

and not often provided with a foot, as is one of those engraved here.

Unhewn. Blocks of stone, rough and rugged as they were when brought from the quarry, are said to be unhewn.

Unicorn. A fabulous animal, with a horn in its brow, which figures as a charge in heraldry and sometimes as an architectural ornament. In heraldry it is generally represented *passant ;* it is said to be *salient,* when it stands on its hind legs ; and *in defence,* when its horn is lowered in a horizontal position.

Unity. A work of art is said to possess *unity* when all its parts are so arranged that they produce an harmonious effect, and when the eye of the spectator is not irritated by meaningless detail.

Urceolate. (Arch.) A term applied to capitals which are narrow at the bottom and swell towards the middle, and become still larger at the top.

Urceus. A name given to ancient vases which have handles.

Urn. A peculiar form of ancient vase with a narrow neck and swelling body and generally of large dimensions. There are *cinerary* urns, in which the ashes of the dead were placed, as well as *Bacchic* urns or craters. The body and handles of the urn were generally decorated with

bas-relief and rich ornamentations. A special kind of narrow-necked urn was used in ancient times to receive voting papers. In the present day the term urn is applied to vases of earthenware or metal with a circular body, orna-

mented with godroons (q.v.) and mounted on a foot, the outline of which recalls an Attic base placed on a square plinth.

Ursula, St. According to the very curious legend St. Ursula was a princess of Brittany, who in the company of eleven thousand virgins visited the shrines of the saints at Rome. On their return they were all cruelly put to death at Cologne by the Huns, who were at that time besieging that town. The events of her life have been treated by many artists and she is very often represented as surrounded with young girls, whom she shelters beneath her cloak. She is regarded as the patroness of schoolgirls. Her own attributes are the crown, the pilgrim's staff, and the arrow, with which she was slain. The most famous pictures dealing with events in the life of St. Ursula are by Hans Memling, and are on the shrine at Bruges which contains her relics.

V.

Vair. (Her.) One of the furs employed in heraldry. It consists of a series of small bells, upright and inverted, arranged in rows. All the upright bells are of one tincture and so arranged that their bases rest on the bases of the inverted bells which are all of another tincture, whereas in counter-vair (q.v.) inverted and upright bells of the same tincture are placed base to base.

Valley. (Arch.) The angle formed by

the intersection of two roofs inclined in opposite directions.

Value. (Paint.) Value is the force or

importance of any given tint or local hue in any given condition of distance and atmosphere. Thus a tint of orange becomes modified in the value of the orange as it recedes into bluish, greyish, or yellowish atmosphere, and the value of the local colour of flesh is always affected by change, as the surface is acted upon by the light at different angles. To put it briefly, value is the modification of colours by the action of light, air, and distance.

Vandalism. The destruction or ruin of works of art. The term was originally applied to the destruction of works of art by the Vandals, a German people who laid waste Rome, Gaul, Spain, and Africa in the first centuries of the Christian era. The expression is now used generally to denote any action whereby art suffers. For instance the useless or clumsy restoration of a picture is an act of vandalism.

Vanishing point. The vanishing point in a picture is that point in which all the

imaginary lines in the perspective converge.

Vapourous. (Paint.) Enveloped in vapour, cloudy, undecided. Thus we speak of vapourous tones, or say that a distance is vapourous when it seems bathed in atmospheric vapour.

Varied fields. (Her.) The field of an escutcheon may be either of one tincture, as *gules, argent,* &c., or it may be covered with a pattern by means of a repetition upon its surface of one of the ordinaries ; in the latter case it is said to be a *varied field.* Thus, for example, if a shield were divided into a number of partitions by a succession of *pales,* the varied field known as *paly* would be formed, and the shield would be blazoned (say) *paly of six argent and azure.* Other frequently recurring examples of varied fields are : *bendy, barry, barry-bendy, gyronny, lozengy, compony, fretty* (q.v.).

Varnish. A resinous substance dissolved in alcohol, used by painters. The quality of the varnish and the moment at which it is put on demand the utmost care on the part of the painter who is anxious for his work to be lasting. Before varnishing a picture, the artist should wait for it to be perfectly dry. However, examples are often quoted of pictures being successfully varnished when they are only just finished, and when the paint upon them is still wet. In this case the canvas is placed in a horizontal position and a liquid varnish is passed over it. This method of varnishing, though in some cases it has preserved pictures, is dangerous and not to be recommended.

—, **Lac.** A solution of gum lac in alcohol, used as a ground and also to dilute the oil colours in the process of gilding.

—, **Picture.** A varnish consisting of mastic, camphor, and Venetian terebinth. A solution of camphor and copal is also used as a varnish for pictures.

Varnishing day. A day appointed some few days previous to the opening of an exhibition of pictures at the Academy, or elsewhere, on which artists are admitted to varnish their pictures. This varnishing is sometimes quite necessary, as pictures often leave the studio too fresh to be touched with varnish.

Vase. A vessel, generally of earthenware, used among the ancients for holding liquids, and for both domestic and sacrificial purposes. The various forms

409

assumed by vases among the Greeks have been described under their various headings in the "Dictionary." Ornamental vases of various materials, and of all sorts and sizes,

are used for architectural and decorative purposes. For instance, large vases of marble or bronze, either carved or chased, are used in the decoration of gardens. On the summit of a building, on the ends of a pediment, or at the angle of a balustrade, a decorative vase of stone is frequently found. These decorative vases were particularly popular at the Renaissance and in the 17th and 18th centuries. In some buildings they are found of considerable dimensions and are surrounded with groups of children, and sometimes they are crowned with flames and smoke.

Vault. (Arch.) An arrangement of stones or bricks describing an arc of a circle of varying breadth and thickness.

—, **Annular.** A vault built upon a circular or elliptic plan. In either case the annular vault has for its point of support a detached pier and a vertical, circular, or elliptic face.

—, **Barrel.** [Barrel-vault.]

—, **Conical.** A vault of a circular plan, which is formed by a right-angled triangle turning round one of the sides of the right angle as its axis.

—, **Demi-cupola.** A vault the arched portion of which is a quarter of a sphere.

Apses and the east ends of chapels are sometimes terminated by demi-cupola vaults.

Vault, Groined. [Groined Vault.]

— **in Calotte.** A vault resembling a spherical calotte. The majority of cupolas, for instance, may be described as vaults in calotte. These vaults are also called spherical vaults. When the outline of the vault is an ellipse, it is called a spheroid vault.

—, **Pointed.** A vault the curve of which is bounded by pointed arches. Some authors give the name of pointed vault to vaults composed of transverse ribs, wall ribs, and pendentives.

—, **Rampant.** A vault of which the two springing points are not in the same horizontal line. To strengthen the steps in a staircase rampant arches are sometimes built, resting upon piers of unequal height.

—, **Semicircular.** A vault the curve, of which is determined by a semi-circle.

—, **Skew.** A vault the lateral surfaces of which are not at right angles to its piers. This vault is rarely employed in buildings, but is frequently seen in viaducts. When two roadways, situated at different levels do not meet at a right angle, to establish communication between the two portions of the road placed at the greatest height, a skew

vault must be built. The masonry of these vaults is very complicated.

Vault, Spherical. A term applied to a vault or cupola in the form of a hollow hemisphere.

—, Surbased. A vault the height of which is less than the radius of its curve.

—, Surmounted. A vault the height of which is greater than the radius of its curve.

Vaulting shaft. (Arch.) A term applied in Gothic architecture to thin, delicate pillars.

Vehicle. (Paint) The liquid with which pigments are laid on in painting is termed the vehicle. Different vehicles are used in different branches of painting. In water-colour of course the vehicle is water; in oil-painting oils of various kinds are used [Oil], while wax is the vehicle in encaustic painting.

Vein. The threads of various shades which are to be seen in marble, and which add so much to its decorative effect; also the defects which exist in stones that are to be cut, and in the white marble used by the sculptor.

Velarium. In ancient times the term velarium was applied to large awnings which were fixed with ropes to the top of masts and protected the spectators in the theatre from the heat of the sun.

Vellum. The skin of a calf. Vellum was used for illuminated books in the Middle Ages, and at a later age for miniature painting. To this purpose it is still put, any inequalities in its surface being first removed by pumice stone. Any blemishes in the absorption of colour, which is inevitable in this material, is thus avoided, and it has the advantage of being extraordinarily durable and lasting for centuries. It is also used for taking proofs of engravings and etchings.

Velum. A curtain hung over a door or window was called a *velum* by the Romans, but in modern times the word has another signification. It denotes a piece of drapery or a strip of stuff which is

suspended horizontally so as to sift the light and to intercept the rays of the sun. The *velum* is sometimes held in its position by being tied with cords to lanceheads; it then serves as a temporary shelter or decoration. In studios and exhibition galleries a *velum* is frequently stretched across the ceiling to intercept the light falling from above.

Veneer. A method of decorating pieces of furniture, by means of cutting out slips of variously coloured wood and by applying the pieces thus cut out to woods of inferior value. Veneer of mahogany is the characteristic of an epoch in the history of furniture.

Venetian shutter. (Arch.) A shutter which consists of a frame, across which pieces of wood or iron are placed horizontally at some distance from one another and inclined at such an angle that those inside a room can observe what is passing without, but cannot be seen themselves from outside.

Vent-hole. (Arch.) An opening which

admits air into subterranean rooms.

Venus. [Aphrodite.]

Verandah. (Arch.) A gallery, generally covered in with glass; a light building open to the air and provided with blinds.

The inhabitants of the East build verandahs running the whole length of their houses. In many modern buildings

verandahs take the form of greenhouses or glazed vestibules and are almost always built of iron.

Verde Antico. A patina of bronze of a beautiful clear green tone found on ancient bronzes. It is obtained artificially by applying a mixture of ammoniac vinegar and sea salt with a hair brush.

Verditer. (Paint.) A colour used chiefly in distemper. It is found in a soft stone in copper mines, and then reduced to a powder and mixed with water. Some verditers, used in the decoration of theatres, yield bright colours, while others are grey and dull.

—, Green. A pigment used in distemper painting. It is obtained from a kind of copper ochre or rust, but it has the disadvantage of turning to a brown.

Verdure. A French term applied to pieces of tapestry or other hangings representing landscapes, in which green is the dominant tone both in the central subjects and in the systems of ornament which make up the border.

Verge-board. [Barge-board.]

Vermilion. (Paint.) A bright red pigment. It is a sulphide of mercury, and is found in a natural state or is manufactured artificially. It is a useful pigment, being permanent and having a good body. It loses its too brilliant tone with time and becomes a kind of brown.

—, Chinese. A pigment used in watercolour drawing. It is of a striking red colour and should be laid on with sufficient lightness to allow the paper to be seen through it. When the vermilion is laid on too thickly, or is not sufficiently diluted, it looks dull and opaque.

Vermiculated. (Arch.) A wall or other surface is said to be vermiculated when it is covered with lines, like worms, describing irregular and sinuous curves.

Vernier. An instrument invented in the 17th century by Vernier, the geometrician. It consists of a small rule, so graduated as to allow the smallest dimensions to be measured. It is generally about nine millimetres in length, each millimetre being divided into ten equal parts. Thus fractions of a tenth of a millimetre may be measured.

Veronica, St. According to an old legend when Jesus was on the way to the cross a woman wiped His face with a napkin, upon which there appeared at once an image of the face. This image was called the *vera icon*, or true image, and the woman to whose napkin it was transferred has been known as St. Veronica. One tradition says that St. Veronica was Berenice, the niece of Herod. Pictures of St. Veronica holding up the handkerchief, upon which is an image of the face of Jesus, are common. In St. Peter's at Rome is an old picture of Christ on linen, which is regarded as the real napkin of St. Veronica.

Vert. (Her.) The heraldic *colour* green shown on a shield by diagonal lines from dexter to sinister.

Vertical. That which is perpendicular to the horizon is said to be vertical.

Vesica Piscis. A term applied to the elliptical aureole, within which Christ is sometimes represented. Its literal meaning is the bladder of a fish, and it doubtless was given this name on account of the traditional symbolism in accordance with which Christ is often represented by a fish.

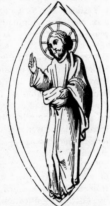

Vestibule. (Arch.) A covered space at the entrance of a building or in front of a staircase or room.

—, **Tetrastyle.** A vestibule decorated with four detached columns.

Viaduct. (Arch.) A bridge built upon piles, at some distance from one another

connected with iron girders or archways. Viaducts are built across a river or a depression in the ground.

Vibrating. (Paint.) A term applied in pictures to a strongly marked, nervous, living effect of colour, obtained by skilful contrasts.

Vice. A vice such as is seen in our cut is used by cabinet-makers to hold fast pieces of wood, which have been joined with size, as well as in many other operations of their craft. Etchers make use of a small vice with a wooden handle to hold their plates with when they are heating them before laying the etching ground.

Victor, St. In Christian art representations of two martyrs, both bearing the name of St. Victor, are found. One of them is St. Victor of Marseilles, who was put to death by being crushed by a millstone, which is therefore his attribute, in the persecution of Diocletian. St. Victor of Milan suffered in the same persecution. but the manner of his death was different. He is said to have been put into an oven, which is one of his attributes. He is frequently represented standing near a broken altar.

Victory. A deity or allegorical figure represented by artists as a girl winged, crowned with laurel, placed upon a globe and holding a palm branch in her hand.

Vidrecome. A large drinking glass used in Germany. This German glass is generally cylindrical in form and often of considerable capacity. Vidrecomes are frequently decorated with paintings in enamel, generally representing heraldic devices.

View. A picture or drawing representing a town or site. A view of London; a view of the Roman Campagna.

—, **Dioramic.** A picture or view executed to be exhibited as a diorama.

—, **Panoramic.** A view presenting the appearance of a panorama. Panoramic views are nowadays drawings taken from one and the same point of view. Sometimes in making conventional panoramic views, the point of view is supposed to be shifted parallel to itself. Many panoramic views, drawn, engraved, or photographed, are executed on this principle, and the skill in their production consists in hiding the points of junction as skilfully as possible.

Vignette. The term *vignette*, which means nothing more than a little vine, originally denoted an ornament used in Gothic architecture. It was also applied to the initial letters in manuscripts, which were decorated with the tendrils of a vine. The meaning of the word was then extended to cuts, forming head and tail pieces in a book, whether they were decorative or illustrative. Here the meaning of the word was quite lost, and now *vignette* denotes any cut or engraving illustrating a book, which is not enclosed by rigid lines, but is put in the text.

Vigorous. A work of art is said to be vigorous when it is largely conceived and boldly treated. In painting, the

term *vigorous* is especially applied to brushwork.

Vincent, St. St. Vincent is a Spanish saint, and was born in the 3rd century at Saragossa. He was persecuted by the proconsul Dacian, by whom his flesh was torn from his body by hot iron forks. His attributes are an iron fork and a crow, which bird is associated with him on account of the legend that when Dacian had thrown the body of St. Vincent to be devoured by wild beasts it was protected by a crow.

Violet. A secondary colour obtained by the mixture of red and blue.

Virgin. A picture or statue representing the mother of Christ. A virgin by Michael Angelo, for instance, or by Raphael.

Virtu. Such objects as are generally found in collections of antiquities and curiosities are termed articles of virtu.

Virtuosi. A term applied to connoisseurs and those who are capable of passing a judgment upon works of art and articles of virtu.

Visage. The human face. A visage devoid of character.

Visor. The front of a helmet, which opened and shut, so as to admit light and air to the unfortunate person condemned to wear it.

Vitalis, St. St. Vitalis was a Roman soldier, who suffered martyrdom for burying a Christian martyr, himself being buried alive. He is the patron saint of Ravenna, and is represented in the armour of a Roman soldier.

Vitrifiable. A term applied to substances which are transformed into glass by fusion.

Vitrification. The method or process by which substances are converted into glass.

Vitrine. [Glass case.]

Vitruvian Scroll. (Arch.) An extremely florid architectural decoration, which consisted of scrolls and volutes, in which animal forms were sometimes introduced. In our cut, which is from

Pompeii, the ornament circles round a lion.

Volta a padiglione. (Arch.) An Italian term denoting the intersection of

portions of vaults bounded by pointed arches.

Volute. (Arch.) In general, a system

of ornament consisting of a spiral scroll, and in particular the ornament characteristic of Ionic and Corinthian capitals. Volutes are traced by means of the compass. The simplest form of volute is made up of four quarters of circles,

meeting at one of their extremities, and described from radii, which become small and smaller.

Generally the centres of these portions of circles are placed at the four angles of a square, itself inscribed in a circle, which is termed the eye of the volute. A volute is termed *angular* when

the centre of its thickness corresponds with the diagonal of an Ionic, Corinthian, or composite capital, which, in this case, is decorated with scrolls on each of its four faces. Consoles, seen in profile, are sometimes decorated with volutes. They generally project considerably, and the leaves of the acanthus, or some other system of ornament, are applied

to the face of the console. Generally, the scroll at the top of the volute is of larger dimensions than the scroll at the bottom. Volutes are sometimes decorated with foliage or rinçeaux. Volutes of this kind are particularly common in iron work. The contour of the volute is executed in forged iron, while foliage of sheet iron, cut out, hammered, cr repoussée, is added to the volute.

Volute, Horn of. (Arch.) An ornament used in some Corinthian capitals, which apparently springs from the scroll of

the volutes, and projects abruptly from the plane of this scroll.

Vomitoria. (Arch.) A term applied to the doors, openings, and vast passages which gave access to the different portions of ancient amphitheatres. The term is still applied to the exits of large public buildings.

Votive Tablets. In all ages and in all countries small tablets have been offered

to the Deity on recovery from sickness. They are generally adorned with representations of the part affected. Of our two cuts, the former is an ancient Egyptian tablet evidently offered by one who had

suffered from a disease of the ear; the second is a Greek tablet offered by one Tertia. Similar customs prevail in Italy and elsewhere to-day.

Voussoir. (Arch.) A stone cut in the shape of a wedge, which, in juxtaposition with other stones of similar shape, forms an archway or platband. The upper and lower sides of a voussoir are termed the *extrados* and *intrados* respectively.

Voussoirs are always of an unequal num-

415

ber, and the centre one is called the keystone. Some voussoirs are so cut

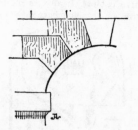

that their upper part is prolonged to fit in with a horizontal course of stones.

Voussure. (Arch.) The curve of an arch; the thickness of the intrados of an arch. In buildings of the Gothic style doors are crowned with voussures, which consist of a number of rows of niches, occupied by statuettes placed in retreat, the one below the other.

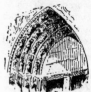

Vrilles. A system of ornament, which suggests the spiral form of vine tendrils. At certain epochs, especially in iron work, scrolls are terminated with *vrilles*. The term is also applied to the small volutes of Corinthian capitals, the scroll of which projects. The distinguishing characteristic of every form of vrille is that it has the form of a corkscrew or spiral, which gets smaller and smaller, and finally terminates in a sharp point.

Vulned. (Her.) A term applied in heraldry to a creature that is wounded not by itself, but by another.

Vulning. (Her.) A term applied to an animal which is represented on a shield as wounding itself. The correct description of our cut is, *argent, a pelican's head, erased, vulning.*

Vyse. (Arch.) A term applied to staircases so planned that their steps, whether monolithic or not, have a newel (q.v.) for their point of departure. When the steps are monolithic, each one

is supported by the one below it, and this arrangement is apparent from underneath the staircase. In another kind of vyse the masonry is so arranged that the shell of the staircase has the appearance of a

vault. These staircases are built upon a square, rectangular, or circular plan, and offer, especially in the first two cases, combinations of pointed or rampant vaults, the adjustment of which is a matter of the utmost difficulty and requires a mason of the greatest skill.

W.

Wainscot. (Arch.) A plane or covered surface, covering a wall or partition, sometimes decorated with mouldings, sometimes not. It is generally formed of panels, and though rarely found in modern buildings,

was a favourite form of decoration in old houses, and gave an opportunity for a good deal of carved ornament.

Waling. (Arch.) A method of joining, in which the pieces of wood are held together by an iron bolt. Pieces of wood thus joined are often halved.

Walling-wax. (Engrav.) Etchers sometimes instead of putting their plates in a bath, build up a wall of wax round the edge of the plate itself. The wax is

fixed in its place while still warm, and then left to cool before the acid is poured

in. By the spout, which, as our cut shows, is left, the acid may be poured off when it is done with.

Wall painting. [Mural decoration.]

—, Partition. (Arch.) A light wall, generally made of lath and plaster, which divides the interior of a building up into rooms or apartments.

— Tie. (Arch.) A piece of iron generally in the form of an S, but sometimes in the form of a scroll or cipher. It is set vertically against the surface of

a wall, and is united by a tie to the

horizontal timbers. Its purpose is to counteract the thrust.

Warm. (Paint.) A colour is said to be warm when tones of red or yellow predominate in it and produce an effect of vigour and transparency. Blues and violets, on the other hand, are always very cold colours, though they afford an opportunity for delicacy and distinction of tone. Water-colour drawings boldly coloured with burnt sienna or carmine are warm in tone. Generally speaking, a picture is said to be warm in tone when its scheme of colour is vivid and brilliant.

Warp. Panels, tables, and furniture, made of wood, which is not absolutely dry, have a tendency to lose their shape or to *warp,* as it is called. The same happens to picture frames if they are of unseasoned wood.

Wash. To wash is to spread flat tints of water-colour or Indian ink evenly upon the surface of a piece of paper. Architectural and mechanical designs, for instance, are frequently washed drawings. In washed drawings the object is to lay a uniform tint with perfect regularity upon the paper, while in water-colour, properly so-called, and artistic drawing generally, the tints are laid on freely without any attempt to attain perfect evenness. There are, however, in existence many washed drawings, which are the work of real artists, and as late as the last century some artists used washes to indicate their arrangement of light and shade. Nowadays washes are only used for plans and machine-drawings. Even architectural façades are now often executed in water-colour.

417

Watch tower. (Arch.) A tower attached to the fortified castles of the Middle Ages, in which a man was placed to keep watch.

Water-colour. (Paint.) Water-colour drawing is, if we may believe some specialists, a modern invention. It can be proved indeed that the artists of the 18th century did not use water-colours except in the form of washes or flat tints. These washes were used to mass the shadows or planes already indicated by hatchings, which did not disappear when the washes were laid on, but on the contrary gained additional strength. Water-colours, properly speaking, are transparent, and in water-colour drawing advantage is taken of the surface of the paper. Gouache (q.v.), on the other hand, is a kind of opaque water-colour and was used in the 18th century. Indeed at a far earlier date than this miniatures and illuminations in manuscripts were executed in gouache on parchment and their effect heightened by the use of gilding.

Waterfall. Artificial waterfalls are

(or were) a favourite device in the

decoration of gardens. Sometimes they

are so arranged as to fall over a succession of steps, as shown in our first cut, or they fall from a considerable height in an unbroken stream, as in our second cut.

Water-mark. A mark, which is discernible on laid paper when it is held up to the light. Water-marks generally represent some common object, such as a vase, crown, or shield; sometimes, however, they represent coats-of-arms and heraldic beasts, or they bear the name of the maker, or the date of the manufacture of the paper inscribed upon them. The water-mark on bank notes is often very complicated and consists of all sorts of combinations, in order to render forgery impossible.

Wave moulding. (Arch.) An ornament consisting of a succession of curves in the form of an S, each of the curves

being terminated at one of its ends by a volute, from which the next curve springs. This ornament may be de-

signed in several ways, and is capable of various combinations; some examples of it are quite simple, others are profusely ornamented.

Wavy. (Her.) One of the partition lines in heraldry is from its form known as *wavy*, or *undé*. Like other partition lines it may be applied to any of the honourable ordinaries, the chief, pale, cross, &c. The cut shows a shield which would be blazoned *argent, a bar wavy gules.*

Way. (Engrav.) The series of parallel paths hewn out by the rocker (q.v.)

on a mezzotint is technically termed a *way.*

Weathercock. (Arch.) A vane or pirouette in the form of a cock, the bird of vigilance, placed on the top of church spires.

Weathering. (Arch.) A slope or incline given to surfaces, which otherwise would be horizontal, to prevent rainwater from lodging on them.

Wedge. A small piece of wood placed under the heel of a living model to keep the leg foreshortened. When the model

gives an energetic movement, and the sole of the foot is not entirely placed on the ground, the wedge serves as a point of support, and enables the model to keep his pose more easily. Sometimes sculptors leave wedges under the feet of their figures; in this case the wedge serves as a tenon, and adds strength to a fragile part.

Whatman. A familiar abbreviation for Whatman paper, which is used for water-colour drawings, for taking proofs of line engravings, or for printing *editions de luxe.* [Paper, Whatman.]

Whetstone. A hard stone upon which engravers roughly grind their tools before finally sharpening them with emery powder.

White lead. (Paint.) In water-colour drawings, white lead is used in a powdered state mixed with cobalt blue and essence of terebinth, which has been exposed for some days to the air. By means of white lead the artist obtains lights upon paper already covered with a dark tint. In oil painting, white lead, which is only carbonate of lead, has the disadvantage of turning black under the influence of sulphurous vapour. White zinc is often used instead of it.

Whitewash. A mixture of chalk and size diluted with water, which is used to give a white coating to walls.

Wicket. (Arch.) A small gate to admit foot passengers, placed not far from a much larger one. Sometimes a wicket is nothing more than an opening in a large gate, which closes a courtyard. Such is the wicket represented in our cut.

Window. (Arch.) An opening through which light and air are admitted into a building. In the Romanesque period,

windows had semicircular heads, and were closed by frames of wood, stone, or marble, in which round, square, or polygonal pieces of glass were inserted. In the 12th century windows are often found two together with a round or trefoil opening in the space above them. In the

13th century, windows are more graceful, and their curves of greater delicacy. The mullions then increase in number, and quatrefoils and cinque-foils are met with. In the 15th and 16th centuries,

florid traceries appear. At the Renaissance period, windows are surbased

(q.v.) and the ribs in the upper part of the windows are sometimes carried beyond the window-head, as indicated in our fourth cut. In the 17th and 18th centuries, the subdivision by mullions disappears, and the window frames are formed of pilasters and columns.

Window, Attic. A window which contracts towards the top, and the uprights of which, instead of being vertical, are inclined obliquely to one another.

—, **Casement.** A window, the space of which is divided into four parts by two

uprights crossing one another at right angles. In some buildings, we meet with windows which, instead of having one cross-piece, have two cross-pieces, and are so divided into six compartments by a vertical mullion and two horizontal pieces placed one above the other in the upper part of the window.

—, **Dormant.** A window which does not open.

—, **Italian.** A window in three arched compartments supported by colonnettes.

—, **Mezzanine.** A window which ad-

mits light into an entresol. The distinctive feature is that its breadth is always greater

than its height.

—, **Rampant.** A window, the sill of

which is not horizontal, or of which the frame is not placed in a vertical line. In the former case the rampant window is fixed, and does not open; in the latter case it may have shutters, although its uprights are not vertical.

—, **Sham.** A window painted on the surface of a wall, an architectural abomination which is rarely seen in modern buildings.

Windscreen. (Arch.) A term applied in Gothic

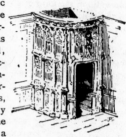

architecture to small, circular screens of wood, either pierced or consisting of carved panels, generally placed in the angle of a room or surrounding projecting staircases. In some Gothic buildings windscreens of stone are found.

Wing. (Arch.) The portions of a building which are added to the main body of a building, being constructed in

the same line as the main block or returned from it. In Greek and Roman temples the lateral porticoes were termed wings (πτέρα or *alæ*).

Wire-brush. A brush generally made of brass wire, with which gilders spread their amalgam of gold and mercury, and with which they clean gold and silver work. When the gold is being laid with the wire upon the surface of any object, it is of the utmost importance that this surface should be kept damp during the process.

Wood-block. The first essential of the wood-blocks used by wood engravers is that they should not be porous. The wood of the pear, apple, and box are generally used; and for delicate

work the last-named is by far the best.

Wood-cut. A term applied to proofs of engravings cut upon wood.

Wood-cutting. (Engrav.) The art of wood-cutting is one of the imitative arts, and it consists in drawing (or photographing) a design on the flat surface of a block of wood, generally boxwood, and in cutting away all that portion of the block upon which the strokes of the pencil do not appear. The part of the block which is left in relief is covered with ink and impressions are then struck. It will be seen that the process of wood-cutting is the reverse of that of line-engraving, in which the lines which are reproduced upon paper are incised. Wood-cutting was invented first of all by the Chinese, who employed the process in the printing of books. It was independently devised by the Germans in the 14th century for printing playing-cards, and soon after applied to the reproduction of drawings. The earliest wood-cut known to us is a St. Christopher of 1423. Wohlgemuth, Dürer, Holbein, all practised it with success, and in the earlier part of the present century the English Bewick gave the art a fresh impetus. It has been largely employed for the illustration of books and newspapers, and specimens of the art may be seen every week in the pages of *Punch.* But mechanical processes have been brought to so high a pitch of excellence of late years, that there is some chance of wood-cutting lapsing from fashion.

Woolly. (Paint.) A term applied in painting to a soft method of execution, which lacks firmness and consistence.

Work. The word *work* is used to designate a picture or statue of an artist. Thus we say Donatello's St. George is a dignified work, Raphael's Madonna della Sisto is a great work, and so on. In a different sense *work* denotes the collective productions of an artist or even his style. Thus we say the work of Rubens is considerable, and in ex-

pressing approval of an artist's style we say that we like his work.

Wyvern. (Her.) An imaginary heraldic animal. It has a serpent's head and body, and the wings and claws of a bird, while its tail terminates in another small serpent's head.

X.

Xoanon. (Sculp.) The earliest statues of gods fashioned by the Greeks were rude wooden images, resembling a pillar rather than the human form. An awkward attempt, however, was made to trace the features and outlines of a human being upon the rough pillar. Legend said that the *xoana* fell from heaven, and long after Greek sculptors had acquired technical skill over their material, the *xoana* were held in the greatest reverence.

Xyloglyphy. The art of engraving letters upon wood, and of executing ornamental letters to illustrate books.

Xylographer. One who cuts drawings upon wood.

Xylographic. That which belongs or has reference to the processes of wood cutting.

Xylography. The art of cutting drawings upon wood.

Xyst. (Arch.) A hall or portico, in which Greek and Roman athletes exercised themselves.

Y.

Yataghan. A very long Turkish poniard with a curved blade, the hilt and scabbard of which are sometimes inlaid with precious stones and decorated with arabesques of great richness.

Yellow. Yellow is one of the three primary colours. The yellow pigments, except the earths of Sienna, which are ochres or clays coloured with iron oxide,

have all a base of lead and so easily tarnish and turn black.

Yellow, Chrome. Chrome yellow, as used in water-colour drawing, is a very brilliant colour, but somewhat dusty. There is also an orange chrome, *i.e.*, a yellow chrome with a slight admixture of red. The chrome yellow used in oil-painting is nothing more or less than chromate of lead.

—, **Indian.** A colour, used in water-colour, of a very striking tone.

—. **Naples.** A yellow pigment. with a slight tendency towards green, which consists of massicot or oxide of lead.

—, **Turner.** A yellow pigment consisting of litharge and sea salt.

Yellowish. (Paint.) A colour or tonality is said to be yellowish when it approaches nearly to yellow.

Z.

Zeus. In Greek art Zeus is invariably represented as a bearded man of majestic mien. The gold and ivory statue at Olympia showed him seated on a throne, as became the king of gods and men. His attributes are the sceptre, thunderbolt and eagle. When he is not represented throned in kingly state, he is generally taking part in the war against the giants, or Athene is being born from his head. He is frequently represented side by side with Hera, who is then veiled.

Zigzag. A broken line forming angles,

which alternately project and retreat.

Architectural mouldings are sometimes decorated with zigzags.

Zinc. A metal of a bluish-white colour, upon which engravings in relief, which may be printed by the ordinary typographic processes, as well as line engravings, are produced by chemical processes. In the case of line engravings on zinc the plate is covered with a ground and bitten with aquafortis in the ordinary way, but the zinc soon wears out and only a limited number of proofs may be struck from it. Nor does zinc lend itself to the expression of fine delicate lines; but to compensate for this it yields broad and soft outlines.

Zincography. The process of engraving upon zinc.

Zinzolin. A violet colour tinged with red. The word comes from the Spanish cinzolino. Some authors write *gingeolin.*

Zodiac. (Arch.) A term applied to bas-reliefs representing the signs of the zodiac interpreted with considerable eccentricity. Numerous examples of zodiacs are to be found on the doors of churches of the Gothic style.

Zone. The portion of the surface of a sphere included within two parallel planes. The paintings in cupolas generally occupy a *zone*, the upper portion of the cupola being pierced with a circular opening.

Zoöphorus. (Arch.) A term applied by Vitruvius to friezes decorated with foliage and arabesques, in the midst of which the figures of animals are introduced.

Zotheca. (Arch.) A recess introduced in the sleeping room of Roman houses. The bed was placed in it.

SUPPLEMENT

OF

NEW TERMS

Abraded Surface. The roughened surface of an oil painting in which the oil has been rancid.

Abstract Art. Art that reduces objects to abstract patterns or relinquishes the representation of objects altogether, and depends for its aesthetic effect entirely on shape, line, and color. The most prominent representative of this movement was Wasilly Kandinsky who, in 1910, initiated this style. The movement thus created reacted in protest to Naturalism and Impressionism and took its cue from Constructivism and Cubism. In its beginnings human forms, for instance, were still recognizable; later it adhered to the stricter style of Non-Objective art.

Prominent painters: Sonja Delauney, Morgan Russel, Piet Mondrian; sculptors: Hans Arp, Constantin Brancusi, Alexander Calder, Jacques Lipchitz, Henry Moore.

Abstract Expressionism. Abstract Expressionism (tachisme) had its origin in France. Other terms for it are Action painting and Automatic painting. The beginning date of this art form is assumed to be 1950.

In this technique accidental color specks or rivulets from automatically produced smears of paint are consciously related to form a more or less expressive structure. The resulting forms are supposed to stir associations. Jackson Pollock was the most prominent American representative of this style.

Action Painting. The more vigorous continuation of Automatic painting. Pictorial effects are obtained by spilling, pouring, or shooting paint onto a canvas. The accidentally

423

resulting shapes are structured by working them over with hands, feet, or brush, until they can be assumed to evoke an aesthetic response.

Advancing Colors. In contrast to receding colors, those colors which appear to be nearer to the spectator than others on the same plane. Red, orange, and yellow give the appearance of advancing.

Aerial Perspective. The attempt to produce the impression of depth by color. Two methods are used for this purpose: 1) Paler colors and lighter shadings are applied to more distant objects. This method coincides with the appearance of distant objects in nature, the colors of which are less clearly distinguishable because of moisture and dust in the air. 2) Cool and receding colors of diminishing hues tend to appear more distant than warm, advancing colors. The latter principle was used by Matisse.

Aesthetic Moment. According to Bernard Berenson, that instant of feeling at which the spectator of a picture or a sculpture ceases to be his ordinary self and becomes an entity with the artist's creation.

African Art. Sculptures created by the natives of Africa, in particular the Negro tribes in the French Congo, became known in Europe in the 1900's. Vlaminck, Derain, and Matisse were the first artists to appreciate the aesthetic effect and the immediacy of their planes and angular forms. The influence of this style is clearly noticeable in Picasso's paintings (1907), in the sculptures of Barlach and Epstein, and more subtly in the paintings of the Fauves.

After-cast. A statue cast in molds taken from the original sculpture.

Agglutinant. The chemicals admixed to the powdered pigments which make paint adhere to the canvas or wood panel.

Aggregate. Sand or gravel which, added to cement and water, makes concrete.

Alexandrian Art. Hellenistic sculpture as it developed in Alexandria, the capital of Egypt, where it was introduced by Alexander the Great (356-323 B.C.) Alexandrian art in-

clined to naturalism, some of its preferred subjects being old women, misformed dwarfs, but also traders, dancers, slaves portrayed without idealization.

Altamira. A cave in Northern Spain, famous for paintings created in the Paleolithic Age. Twenty-five animals are presented in half their life size. The paintings are executed in black, brown, and ochre. Protrusions on the rock are used to render them more lifelike.

Analytical Cubism. The first phase of Cubism.

Anamorphosis. A trick painting in which the objects appear distorted when viewed from the front, and correct when seen from an angle. This type of early "op art" was fashionable at the turn of the 16th to the 17th century.

Anecdotal Art. Paintings or drawings that endeavor to narrate a story without regard to aesthetic form. Toward the end of the 19th century, several artists tried to revive the moral influence of art by depicting scenes expounding the bad consequences of gambling, illicit love, drinking, etc.

Apotropaic Eye. The presentation of the human eye on boats and similar objects, with the intention of magically warding off evil.

Applied Arts. An over-all term for those branches of art (industrial art, commercial art) which do not present art *per se* but endeavor to add to a utilitarian object the value of beauty.

Aquarel(le). A painting executed in thin water colors.

Architectonic. Pertaining to, or having the quality of, architecture. In painting, a monumental composition.

Armature. The metal framework used by sculptors as a skeleton for clay modelling.

Art Engagé. French term, used in the 19th century to characterize art with social or political implications, such as, for instance, drawings by Daumier or Goya. Most of the artists of the school of Naturalism belong in this category.

Art Nouveau. The French version of the German *Jugendstil* and the English Modern Art around 1890. Characteristic of its influence in the United States are the decorative patterns and serpentine lines on edifices such as Louis Sullivan's Auditorium Building in Chicago (1888).

Ashcan School. A group of American painters (Robert Henri, George Luks, Everett Shinn, William Glackens, John Sloan) who introduced city life into American painting. Their realistic paintings intended to depict their time and the wonder of life as much as human drama and the sordid aspects of existence. Their first exhibition in New York (1908) earned them the name "The Revolutionary Black Gang" because of their strong leaning toward Rembrandt's color scheme; later the influence of Renoir's treatment of light became predominant.

Asymmetry. The opposite of symmetry. Asymmetry has a certain shock effect and thus elicits an aesthetic response. Because of this function it is often used to concentrate interest on a specific feature in a work of art.

Atelier. An artist's studio or workshop.

Automatism. A technique in Surrealism. Lines and forms are produced automatically, the artist allegedly being compelled by his unconscious, and going on a "voyage of discovery" (Picasso) by following this impulse. The claim to Automatism was first made by mediumistic painters, but the technique was also employed by the painters of Abstract Expressionism.

Background. In realistic paintings or in reliefs, foreground, middleground, and background are distinguished. One of the problems in art is to connect them meaningfully; another, to convey depth and thus to conquer the space that leads into the background.

Background formed by figures or objects did not exist until artists endeavored to give the illusion of three-dimensionality on the two-dimensional plane—that is, to the beginning of the 15th century. Prior to that time a golden or a black ground had sufficed. Later this ground color was varied, then ornamented; still later it became tapestry or a curtain, until eventually it opened to reveal additional human figures, landscape, or architecture.

Balance. Proper balance is one of the psychological prerequisites for aesthetic pleasure, and hence one of the dom-

inant qualities in every artistic creation. In paintings it is produced by composition—that is, in the distribution of light, shadow, and color masses. In architecture, the parts of a building are so designed that they appear to be of equal weight on both sides of an imaginary vertical line. Perfect balance is obtained in symmetry; but since the repetition of exclusively symmetrical arrangements becomes tedious— and hence aesthetically less satisfying—architects strive for greater complexity without actually disturbing the balance. Thus, in modern "exciting" architecture symmetry often seems to have been abandoned, yet the axis is still felt to be present. The masses are almost the same, although details tend to differ, thus producing a picturesque impression.

Barbizon School. A group of landscape painters who settled in Barbizon near Fontainebleau to paint in the open air (1830). Members of this colony were Camille Corot, Charles F. Daubigny, Adolphe Monticelli, Theodore Rousseau, Diaz de la Pena, Jules Dupré, and Constantin Troyon. Being seven, they were also called the "Pleiade." The work of this group, their method of reproducing realistically the effects of light and the changing colors of the air, exerted an important influence on the subsequent movement of Impressionism.

Bateau Lavoir. An area in Montmartre, Paris, where, between 1900 and 1914, many subsequently famous painters lived, worked, and discussed their theories. Among them were Van Dongen, Picasso, Marie Laurencin, Modigliani, Juan Gris, Utrillo, Lipchitz, Leger, etc.

Batik. A technique of ornamenting textile fabrics with colorful designs. It originated in Java and Indochina and was introduced in Europe and the United States in 1900.

Bauhaus. Das Staatliche Bauhaus in Weimar (1918-1925) and in Dessau (1925-1933), with the architect Walter Gropius as its director, became one of the most important schools of architecture and the related arts. In protest against the aestheticism of the prevailing *Jugendstil,* Gropius hoped to develop artists who would not be alienated from the world around them; and at the same time to realize the ideal of the

Gesamtkunstwerk, the complete integration of the arts and technology under the primacy of architecture. Among the "masters" were Mies van de Rohe, Le Corbusier, Lyonel Feininger, Wassily Kandinsky, Paul Klee, Gerhard Marcks. Because of its progressive ideas, the Bauhaus appeared subversive to the National Socialists and was closed upon Hitler's assumption of power.

Beni-ye. Japanese two-color prints in pink and green.

Biedermeier. This disparaging term, combining the names of two Philistines into one, is applied to an art period emerging in Germany and Austria in 1815 and ending in 1848. The realistic style in painting, a reaction to romantic exuberance, depicted the cozy, quiet life of the bourgeoisie. Interior decoration and furniture show a simplification of the Empire style, solidity, and grace. Prominent painters of the period are Spitzweg and Waldmueller.

Binder. In painting, any material that binds particles of pigment together (oil, gum, etc.).

Biomorphic Art. A branch of Surrealist art in which the shapes and hollows of inanimate objects echo the forms of animals or humans. Its beginnings are found in Dali's juxtapositions of humans and rock formations in the background. In abstract sculpture the same tendency is often cultivated.

Black Mirror. A black convex glass which reflects objects in miniature. Since it also eliminates color, it allows the painter to judge the composition of his subject without distraction. The black mirror, also called Claude Glass (after the painter Claude Lorrain) was favored by landscape painters of the 17th and 18th centuries.

Blaue Reiter (Der). A group of artists which formed around Wassily Kandinsky in Munich (1911). The group rebelled against the traditional art of their day *(Jugendstil)* and propagated art that would be independent of narrative and object, yet effective through combinations of form and color. The name of the group was suggested by Kandinsky's painting of the same name. Participants were Franz Marc, August Macke, and Paul Klee. The Blaue Reiter group has certain goals in common with the French Fauves. They pre-

pared the way for Abstract art.

Blue Rider. English for Blauer Reiter.

Boulle. Ornamental inlays on furniture, usually of tortoise shells and brass. The term is derived from the name of the inventor André Charles Boulle (1642-1732).

Bronze Age. A period in European prehistoric times during which tools and weapons were made of bronze. The discovery of this then new material (about 2500 B.C.) in the near East opened up new possibilities for artistic expression (ornaments, jewelry, filigrane, etc.).

Brücke. A group of artists in Dresden, Germany, founded by Erich Heckel, Ernst L. Kirchner, Karl Schmidt-Rotluff, and Max Pechstein in 1905. The Brücke (bridge) intended to bridge the gap between art and public by emphasizing in their expressionistic work political ideas and a social outlook. They depicted urban life, the street, the café. Their interest in the graphic arts led to a revival of this branch.

Burr. The ridge of metal raised during the process of engraving. It is removed so as to leave a clean line. If the burr is left on the plate, as happens in Drypoint work, the lines become soft and slightly blurred.

California Style. The architectural style created by Frank Lloyd Wright in rebellion against the impersonal "boxes" that characterized the International Style. Wright insisted on the tenet that architecture must be a part of nature and not a denial of it. He attempted to fit private and public buildings organically into their environment (Organic Architecture), thereby creating some very interesting and picturesque entities.

Cannelated. See Flutings, page 164.

Carolingian Art. Art as practiced in the empire of Charlemagne (768-814) and his followers until about 950 A.D. Through his efforts, the works of the antique world became known to Northern and Western Europe. Stone supplanted wood as a building material, and the first pictorial representations of humans appeared in the regions of today's France and Germany. Imposing churches were built, as for example the

cathedral of Aix-la-Chapelle, and charming illuminations decorated the manuscripts produced and reproduced in monasteries.

Cartellino. The little scroll, or card, or plate, painted on a picture, upon which is inscribed the name of the artist or of the sponsor.

Cave Paintings. Paintings found on the walls of caves dating back to the Stone Age. They are the oldest representative paintings preserved and are executed in black and red or black and ochre. The subjects are animals, hunts, battles, and occasionally ceremonial scenes. The most famous are in the caves of Altamira in Spain, and Rouffignac in the Dordogne in France.

Cement. A substance which is put between two surfaces to which it adheres and which, by hardening, it binds together. It was known to the Romans and accounts for their technological progress in building. In modern architecture, Portland cement is commonly used.

Chassis. 1) The wooden frame (stretcher) to which the canvas is fixed. 2) The revolving stand on which the armature is placed.

Chinoiserie. A fashion in European architecture, interior decoration, furniture, etc., in which Chinese decorative designs were imitated. The fascination with the newly discovered art of China was instrumental in the creation of the Rococo style. Chinoiserie reached its height at about the middle of the 18th century, and then went quickly out of vogue.

Classical Abstraction. A term by means of which art critics distinguish methodically executed abstract paintings and sculptures from the abstractions produced by the followers of Action Painting or Tachisme, where accident plays the dominant role.

Classicistic Periods. 1) Roman art during the reign of Augustus (30 B.C.-14 A.D.). 2) The period between 1770 and 1830 in Europe. It exerted great influence on American architecture of that time. See also Classicism, page 90.

Claude Glass. The same as Black Mirror.

Cold Colors. Certain colors are felt to be warm and exciting, others to be cold and receding. Among the latter are the various shades of blue, green, blue-green, and bluish purple.

Collage. A technique of art. Printed material, photos, cloth, and the like are pasted on a canvas to produce a picture, or into a picture to produce a shock effect or a relation to reality. See Cubism.

Collograph. A technique that combines collage with one or the other form of the graphic arts.

Colonial Style. In 18th century America, Eastern Seaboard cities—such as Boston, Newport, New York, Philadelphia and others—expressed their affluence through the construction of fine homes and public buildings designed in the latest fashion. The modifications of the style brought over by newcomers or by returning travelers were later called Colonial Style. The new houses enclosed more rooms than before, corridors and secondary staircases separated the servant quarters from those of the family. Doors and windows were decorated with classical motifs. The building material was still predominantly wood; bricks were reserved for important structures.

Color Circle. The arrangement of the colors of the spectrum in a circle in such a manner that complementary colors occupy the segments opposite each other. If the disc is made to revolve rapidly, it appears to be white. This is the proof for the hypothesis that white is the sum of all colors of the spectrum.

Color Perspective. See Aerial Perspective.

Composite Color. In contrast to primary colors, colors which result from the mixture of two or more hues. Thus purple is a mixture of red and blue, orange is a mixture of red and yellow.

Concrete. A compound of cement, aggregate, and water, which is deposited in temporary containers while in a fluid state. When the water evaporates, it hardens to the strength of stone. It is the most important of all building materials in modern architecture. Reinforced concrete consists of steel rods and mesh embedded in concrete.

431

Constructivism. 1) A movement in England, initiated by William Morris after 1890. It strove for functionality and genuineness of material in objects of art, including commercial art. 2) An art movement originating in Russia about 1920. The name is derived from the attempts to construct aesthetic forms with modern industrial material such as wire, metal tubing, nails, sheet metal, and the like. The movement's chief representatives are Antoine Prevsner and Nahum Gabo.

Cool Colors. In contrast to warm colors, green and blue are cold, or cool, colors. On the color circle, they appear opposite the warm colors. In reality, they seem to have a soothing or cooling effect on the human nervous system.

Coptic Art. Early Christian art in Egypt, dating from the 4th to the 7th century.

Corporation Piece. A group portrait of dignitaries, as f.i. Rembrandt's Night Watch.

Cubism. A movement started by Pablo Picasso, George Braque, Ferdinand Leger, and Juan Gris between 1907 and 1914. It was inspired by Cezanne's idea that all objects in nature can be reduced to cylinders, spheres, and cones. Two phases can be distinguished in the development of Cubism: 1) Analytical Cubism (1907-1912) ; 2) Synthetical Cubism (1912-1914).

The analytic tendency results in the fragmentation of surfaces. The facets into which face and figure are broken reconcile the two-dimensionality of the canvas with the three-dimensionality of the object, since shading and traditional perspective appear inappropriate to the medium. Line and color alone must express the "true nature" of the object. Objects are often shown from different angles.

The synthetic phase does away with the last remnants of empirical illusionism and relies completely on the architecture and the rhythm of the painting. Symbols and signs take the place of verisimilitude. Cubism paved the way for Abstract and Non-Objective Art.

Cubist Realism. One of the ways in which some of the cubists tried to counter the increasing alienation of Cubism from reality. They pasted real objects, such as newspapers,

matchboxes, playing cards, and pieces of cloth, on and into their paintings.

Dada. A movement in art and literature originating in Zurich during World War I. In despair over the failure to realize long-cherished humanitarian aims, artists gave free rein to their whims ("riding the hobby horse"), thus ridiculing hypocrisy, illusions, and obsolete conventions in art and life. A number of then or subsequently famous artists joined the movement, among them Arp, Picasso, Modigliani, Kandinsky, Klee, Feininger, Kokoschka, and Breton. Dada or Dadaism is considered an important forerunner of Surrealism, and its influence can be felt in even more recent art movements, such as Pop Art.

Decadent Art. To traditionalists and those who could not follow the revolutionary artists' ideas, radical changes in art styles frequently appeared as decadent, that is to say, as indications of the dissolution of the existing culture. The art movements at the turn of the century in particular were fervently denounced in this manner. Similarly, Hitler and his followers removed all pictures and sculptures in the categories of Cubism, Expressionism, and Abstract art from the museums of Germany, declaring them to be decadent or deviant art *(entartete Kunst)*.

Decoration. The application of decorative elements in architecture. By decorative elements or decoration are meant additions to the structure, the walls, the doors, the windows, etc., that serve no function except that of providing aesthetic pleasure. This "uselessness" is best illustrated by columns. In Greek and Egyptian architecture columns constituted an important element of the structure; they supported beams and ceiling plates. In modern buildings, however, they serve no purpose except to evoke associations with the dignity of ancient temples and palaces. On the other hand, this very wastefulness is one of the original reasons for adding decorations to the structure; by this means people proclaimed, as it were, that nothing was too much to express their admiration and adoration of the deity. Princes (secular as well as

religious) thus proclaimed their wealth and power.

Since the days of Palladio (see Palladian Style) there have always been architects who considered decoration on edifices extraneous and artificial rather than artistic. Changes in style often are directly related to a general desire to get away from boastfulness and purposeless, conspicuous consumption. Thus the flamboyant Rococo style was followed by a Classicism that emphasized the austerity of the Roman heroic age ; the decorative *Jugendstil* was followed by a reaction in architecture that demanded honesty instead of ornaments — honesty shown in clearly presenting the elements of construction and materials used. This fight against masking walls with ornaments was led by H. B. Berlage in Holland, Otto Wagner and Adolf Loos in Vienna, and reached its height after World War I. Modern architecture returned to geometric principles of construction, emphasizing massing and structure, proportion, profile, volumes and their relationships. But when the new realistic architecture became too monotonous, one "glass box" rising impersonally and coldly beside another, a new generation rebelled against the ban on decoration and the over-emphasis on functionality. Among them were Wright and Saarinen. But these men avoided a repetition of the old mistake—pasting flower designs and unartistic sculptures on too-bare walls ; instead, they sought new forms which in themselves were "exciting" and "picturesque"—forms that, though spare, fascinated the eye and conveyed ideas.

Degraded Color. A pure color which has lost its original brilliance through the admixture of gray or another neutral color.

Dessus de Porte (French). A painting inserted over a door.

Deutscher Werkbund. A German association formed by manufacturers, architects, and designers in 1907, for the purpose of integrating art with industrial products. The movement affected the architectural style of factories, utensils of all kinds, and furniture, which now was required to be beautiful as well as useful. The idea spread to most European countries.

Direct Painting. A painting that has only one layer of colors; it is painted directly on the canvas.

Distortion. The deliberate deviation from the actual appearance of the model. The purpose may be either the adjustment of the object to the composition of a work of art or the intensification of emotional expression. Distortion occurs in Gothic sculpture, in El Greco's paintings, in Expressionism, Cubism, etc.

Divisionism. The attempt to obtain an intended color effect not by using a pigment similar to the model's apparent color, but by setting side by side pigments of which the local color is supposedly composed. The fusion of these specks and strokes is to take place in the observer's eye. This quasi-scientific approach characterizes the paintings of the Neo-Impressionists and Pointillists.

Drip Technique. One branch of Abstract Expressionism.

Dryer. Chemicals applied to a painting in order to increase the rate of drying.

Duecento. The thirteenth century, by Italian counting.

Early English Style. In architecture, the first of the three periods of English Gothic. The period runs from about 1190 to 1280. It is characterized by lancet windows without mullions, grouped in three's, five's, or seven's. The Salisbury Cathedral is a fairly pure example of this style.

Early Renaissance. The beginning of the tendencies marking the Renaissance. During this epoch, architecture, sculpture, and painting began to turn away from Gothic forms and toward the spirit of Antiquity and Humanism. In Italy, the Early Renaissance had its onset at about 1400.

Earth Color. Those pigments which are obtained by mining and owe their color to the presence of compounds of iron. Among them are yellow, ochre, terra verte, and umber.

Eclecticism. The tendency in any of the arts to select and mix elements of different styles and to borrow from various sources for one's own production. Eclecticism is considered a sign of lack of originality and inventiveness, and hence is not highly regarded. The architecture of the 19th century, for

435

instance, is largely an exhibition of imitated styles. This is partly so because the accomplishments of technology and industrialization had pushed ahead, whereas architecture had not yet found an adequate form of expression for commercial buildings and hospitals, and had not yet solved the problems arising out of the use of steam, oil, and electricity. The turning point came when so-called modern architecture became functional, and architects shed the need to decorate skyscrapers with towers and turrets and to adorn bank offices with columns that had nothing to support.

Empathy. A psychological term denoting the process of feeling oneself into another being's emotions. Empathy enables the spectator to bring to life within himself the painter's or sculptor's emotional experience as presented in his work.

Empire. A style in art, architecture, fashion, and furniture originating in France during the early reign of Napoleon I. The initiating architects were Charles Percier (1764-1838) and Pierre L. Fontaine (1762-1853). Empire is a classicistic style, reviving Roman form motifs.

Emulsion. A milky liquid with oily or resinous particles suspended in it. It cannot be mixed unless it is combined with an emulsifier such as albumen, casein, egg, or wax.

English Renaissance. In architecture, the Elizabethan period (1558-1603) and the Jacobean period (1603-1625). The first edifices in England erected in the Renaissance style were the Colleges of Oxford and Cambridge. Considerably later, English Renaissance was introduced to America. Among the earliest public buildings in this style is the Independence Hall in Philadelphia (1733), designed by Andrew Hamilton.

Etruscan Art. Art created by the Etruscans, a people inhabiting Etruria in Northern Italy before they were absorbed by the Romans. Sculptures, pottery, and bronzeware have been found, produced around the sixth century B.C.

Eurythmy. The harmonious relationship between all parts of a building.

Exhibition. The exhibition of works of art for the purpose of sale is a relatively recent institution. It became necessary when artists were no longer supported by aristocrats, princes

of the Church, or wealthy burghers. The first public exhibition of paintings took place in the 17th century. The trend began in the Netherlands, where the places of exhibition were fairs. In Paris, Corpus Christi day became the occasion for young artists to exhibit their paintings on the street. Later, the Academy in Paris organized annual exhibitions in the Palais Royal. London followed this example in 1768; and gradually art exhibitions became an institution all over Europe and in the United States.

Expressionism. An art movement that developed after World War I. It is characterized by a rebellion against the imitation of nature (Realism) and by the fervent desire to express emotions in dramatic form. Pain, fear, and ecstasy were represented by distorted figures, plants, and animals, with disregard of natural appearance or color. The forerunners of Expressionism are Grunewald, Brueghel, Bosch, and, among the moderns, Van Gogh, Munch, Ensor and Hodler. Important contributors are the painters Nolde, Kirchner, Kokoschka, and Rouault, and the sculptors Lehmbruck and Barlach. The term was coined by Herwarth Walden, and for some time attributed to all progressive schools, among them Cubism, Futurism, and Abstract Art.

Eye Level. The line of the horizon where, in the perspective of a painting, parallel lines converge.

Fan Vaulting. See Fan Tracery, page 156.

Fauves. This French term, meaning wild beasts, was applied to a group of painters who exhibited for the first time in 1905. Among them were Matisse, Maurice Vlaminck, Andre Derain, Raoul Dufy, Georges Braque, and Jean Metzinger. The colors and designs of their pictures stirred a violent controversy. The painters, led by Matisse, used pure and bright pigments and tended to transpose human figures and inanimate objects into decorative arrangements. Fauvism paved the way for Cubism, Expressionism, and Abstract Art.

Ferro-Concrete. Concrete, used in modern building construction, that is reinforced by steel bars or wire mesh. This

combination has greater carrying power and resistance to tension than all previously known building materials. The architect can, therefore, span larger space without the support of walls or columns.

Fin de Siècle. A term used to typify the dissolute spirit of the end of the 19th century. Traditionalists in the arts particularly deplored the era's new art forms, such as Art Nouveau, and the *L'art pour l'art* movement, which to them heralded the end of all art.

Fine Arts. Those arts which serve no utilitarian purpose and have purely aesthetic significance. Usually the term is applied to the visual arts, such as painting, drawing, etching, engraving, woodcuts, sculpture, and architecture.

Fixative. A thin varnish which is sprayed over drawings in pencil, charcoal, chalk, or crayons to prevent smudging.

Flambé. The technique of glazing pottery in an irregular manner. The irregularity is usually achieved by splashing.

Folk Art. The artistic output of an ethnic group that is traditionally passed on from generation to generation without significant modification. Folk art is always anonymous. Certain types of decorative patterns are constantly repeated. Some of the symbols used are no longer understood because they go back to ancient, often pre-Christian, times. Objects of folk art are: furniture, decoration on houses, ornaments on apparel, jewelry, weavings, embroidery, ceramics, wooden sculptures, etc.

French Window. A long window, opening like a door.

Front. The facade of a building, usually containing the main entrance. For centuries, this had been the one most elaborately decorated. Modern styles, such as *Neue Sachlichkeit* and Functionalism, emphasize the principle of giving equal attention to all sides and thus arriving at aesthetic unity. Examples are the buildings designed by Le Corbusier, Wright, and Saarinen.

The same principle applies to sculpture. It was first promulgated by Michelangelo.

Functionalism. In architecture and the applied arts, the principle that form and structure become beautiful if they

are in perfect harmony with the function of the object. The adherents of this movement decried ornamentation on buildings and objects serving a physical need. Functionalism was one of the basic principles of the Bauhaus.

Futurism. A movement originating in Italian literature (1909), which spread rapidly to painting, graphic arts, and sculpture.

The futurists sought to express dynamic action, movement, speed, strength, and violence, largely on a cubist basis. They extolled the beauty of the machine. Figures, colors, and brush strokes were all means of engendering excitement. They introduced a new spatial concept by trying to arouse in the spectator the feeling that he was in the midst of a picture rather than standing before it.

Prominent among the initiators of this style were Carlo Carra, Gino Severini, Giacomo Balla, and the painter-sculptor Umberto Boccioni.

In later years, Italian Futurism became identified with Fascism.

Georgian Period. A style of architecture, interior decoration, and furniture developed between 1702 and 1830. This period spans the reigns of Anne and the four Georges in England. Actually, three styles can be distinguished: Palladian, Neoclassical, and Regency. In the United States, the same period shows a related development: baroque Georgian and classical Georgian.

Gesamtkunstwerk. A German concept, developed between 1850 and 1870, stipulating that all forms of art—architecture, sculpture, painting, music, and literature—have so many elements in common that they could and should be combined in one big creation. Richard Wagner was one of the outstanding artists who strove to achieve this ideal.

Gesso. Plaster of Paris or Gypsum. Prepared with water and glue it provides a ground for painting on wood panels.

Glaze. A transparent or semi-transparent layer of color applied over a light dry ground.

Golden Section. An aesthetically significant space relation.

It is obtained by dividing a vertical line so that the proportion of the smaller to the greater part is the same as the proportion of the greater part to the whole line.

Gothic Revival. As a result of the Romantic movement in art and literature, the Gothic style of building was taken up again in the 19th century. In England, the Gothic revival started as early as 1750 and spread from there to European countries and to the United States. The writings of Horace Walpole were instrumental in this change. In the beginning, the Gothic style was confined mainly to churches; after 1830 it was used also for public secular buildings and, most inappropriately, for railroad stations and banking houses.

Gouache. A technique of painting. Non-translucent water colors are mixed with white and glue. The effect is similar to pastel.

Graphic Arts. A collective term for works of art executed in pencil or charcoal, as well as etchings and engravings.

Ground. The base for a painting. Its purpose is to level out the unevenness of the canvas or wood plane and to prevent the absorption of the colors.

Guild. During the Middle Ages and the Renaissance artists were organized in guilds. The organizations protected the interests of their members and laid down regulations with regard to admission to the occupation and advancement to journeyman and master. In the course of the Renaissance period, artists of fame or protected by powerful patrons tended to leave the guilds; this eventually resulted in a weakening of the organizations and finally made them useless. At the same time, it freed artists from many restrictions.

Hellenistic. Greek art from 323 B.C. to about 14 A.D. Hellenistic art and architecture are considered by many to be a deterioration of the original classic form, dignity, and balance. Forms became more varied, sculpture and architectural details more naturalistic, columns more graceful and refined. The influence of the Orient became noticeable.

Hermaphrodite. An artistic motif in the presentation of deities and human beings. The figures combine male and

female characteristics on their bodies, usually having female softness of forms, female breasts, and male genitals.

Hiding Power. The capacity of a color to cover the underpainting of a canvas.

High Cubism. Synonym for Synthetic Cubism.

High Renaissance. In distinction to Early Renaissance and Late Renaissance. The period from about 1450 to 1530, following Early Renaissance and preceding Late Renaissance. It is marked by the perfect execution of Renaissance ideals. Its chief representatives are Leonardo da Vinci, Raphael Santi, and the young Michelangelo.

Historical Paintings. A branch of painting that makes historical events or scenes gleaned from mythology or folklore its particular subject. Historical representations of sorts have been preserved in murals (Pompeii) and in medieval tapestry (Bayeux); but the systematic development of historical painting began during the Renaissance. It reached its height during periods of Romanticism and national awakening. Among its famous representatives are J. L. David, Guerin, Gros, Cornelius, and Hodler. With the decline of realistic representations, the interest in historical painting waned.

History of Art. The description and interpretation of the development of the various branches of art. It had its beginning during the Renaissance in Italy. Ghiberti was the first to write a survey of this kind (1450). The classical initiator, however, was Vasari (1550). Ancient Rome seems to have produced a literature concerned with art, but none of the works has survived to our day.

Horror Vacui. Latin for Fear of Emptiness. The term summarizes a theory that tries to explain the universal human tendency to decorate empty space with ornaments or figures because of uneasiness in the face of emptiness, and traces the origin of all art to this feeling.

Hudson River School. An American school of Romantic painters in the second quarter of the 19th century. The founders, Thomas Cole, Asher Brown Durand, Washington Allstone, and Frederick Edwin Church, took pride in the American wilderness and painted it in a dramatic style,

feeling it as poets do. Some of them subsequently turned to Neo-Classicism.

Hue. The visual response of the human eye to certain light waves resulting in the impressions of red, blue, yellow, orange, etc.

Humanism. The scientific-philosophical movement which started in the 14th century in Europe and which greatly stimulated the development of the arts in the Renaissance period. The influence of art, literature, and philosophy mutually stresses confidence in human power and self-determination. One of the great accomplishments of the Humanists was the "birth of the Individual." By this is understood the loosening, and eventually the breaking of the fetters in which the religious and economic organizations of the Middle Ages had held personal initiative and individual opinion. The upsurge of individualism in combination with a new, scientific orientation is largely responsible for the richness of Renaissance art.

Icon. In Eastern Christian art, a religious picture representing a deity or a saint.

Iconostasis (Ikonostasis). In the Eastern Christian Church, a screen that separates the sanctuary from the main body of the church, and to which icons are affixed.

Idealization. A distortion of the reality image of a person, object, or landscape intended to bring it closer to an ideal.

Indian Architecture. The architecture used for Hindu and Buddhist temples from 250 B.C. to 1750 A.D. The temples are built of granite and ornamented by sculptures of gods, humans, and animals. Many of the sculptures are erotic in nature. Modern India leans toward contemporary European styles. The French architect Le Corbusier, for instance, was entrusted with the task of designing and building the city of Chandigarh.

Indian Art. The oldest epoch of art of this ancient Eastern culture is dated about 2500 B.C. The first preserved works of Buddhist art date back to 300 B.C.; the first statues of Buddha were sculptured about 100 B.C. About 400 A.D.,

pre-Aryan folk cults supplanted Buddhistic art. They produced the so-called Hinduistic art, with murals and erotic sculptures, presentations of the deities Vishnu, Krishna, and Shiva.

Indo-Aryan Architecture. The architecture of Northern India, developed before the 10th century.

Industrial Arts. Aesthetic principles applied to the products of industry such as pottery, glass, hardware, woven fabrics, furniture, walls of rooms and outer building walls.

Infra-red Photography. Infra-red photographs, like those made by X-rays, permit the examination of the various layers of pigments in a painting. Such photography has been used in the detection of forgeries.

Intarsia. Patterns of geometrical designs made of wood, mother of pearl, metal, or ivory, laid in wooden plates of furniture for ornamentation. The craft was most highly developed in Italy, during the period from the 15th to the 18th century.

International Style. An architectural style which emerged after World War I in the designs of Mies van der Rohe, Walter Gropius, and Le Corbusier. It gave buildings the simplicity of design suited to modern mass production. Austerity and functionality became the hallmarks of modern architecture. Emphasis shifted from ostentatious decorative elements to careful treatment and construction. As in Cubist paintings, the pure figure of the cube became the basic form, the relation of differently sized cubes to each other and to the entire building providing the variations necessary to hold the interest. Intellectual calculations outweigh aesthetic considerations; and for this reason its opponents have always called this style cold and impersonal.

Islamic Art and Architecture. Islamic works of art and architecture are not tied to any specific region, but rather followed the expansion of the Islamic religion. One characteristic of Islamic art is the absence of the human figure. Ornamental designs, on the other hand, are highly cultivated. Typical of Islamic architecture is the mosque with the minaret. Of significance for the development of European

architecture was the cupola which crowns the Hagia Sophia. (532-537).

Jacobean Architecture. A type of English Renaissance style, developed during the reign of the Stuarts in the 17th century.

Jugendstil. The German version of the French *Art Nouveau*. It is an essentially decorative style applied to the ornamentation of architectural space, industrial art, and furniture. The name was taken from the title of the Munich art magazine *Jugend*. One of its characteristics in architecture as well as in representative painting was the stylization of body forms and plant motifs. The designers tended to turn away from realism and the observation of nature (Impressionism, Neo-Impressionism), and glorified the curved line. In England this style was known as the Modern Style. Among its prominent exponents were the architect Olbrich, and the painters Gustav Klimt and Egon Schiele. The style reached its peak between 1900 and 1905.

Kinetic Sculpture. A construction made of flexible material, such as a rope of fiber glass, that is set into swirling motion by a motor and bends into constantly changing shapes.

Kitsch (German, from English "sketch"). A term applied to sentimental, emotionally pretentious, insincere productions by artists or by industry.

Kore. The statue of a young female used in the decoration of ancient Greek temples.

Kouros. The statue of a young male used for decoration in ancient architecture.

L'Art pour l'art (Art for Art's Sake). In 1836 the philosopher Victor Cousin formulated a theory that the quality of art depends solely on the relationships of form and color. At the end of the 19th century artists took up this concept and tried to incorporate it into their work. They reacted, as had the impressionists before them, against paintings whose chief attraction was an historical, mythical, or religious comment.

They treated the human figure in an ornamental manner, and devoted their talent and skill to the aesthetic effect of form and color. A typical representative of this group is Aubrey Beardsley. Opponents called this style decadent art.

Lean Color. Pigments containing a minimum of oil.

Life Class. The classes in the curriculum of a school or academy of painting or sculpture in which students draw from a living model instead of copying from another work of art. The hired models frequently are nudes. Nude figures were presented also during the Middle Ages, but at that time the artists satisfied their need for correct anatomical presentation by means of wooden "mannekins." Some of the Renaissance artists occasionally drew from live models. In the 17th century life classes began to be instituted as the basis of academic training.

Limner. A name applied to any of the anonymous portrait painters of the American colonial period. The word itself is an obsolete synonym for painter. Limners painted fences, carriages, and signs as well as portraits.

Linear Perspective. See Perspective, page XXX.

Linoleum Cut. A process for producing pictorial prints, which became popular in the 1920's. Linoleum cutting or Lino cutting allows the artist somewhat more freedom than woodcutting. The effects are broad and poster-like.

Literary. A derogative term for paintings or drawings that depend for their effect on a story the picture tells or presupposes rather than on the response to its visual aesthetic elements, such as color, line, and composition.

Local Color. The presumed color of an object, unmodified by atmospheric conditions, lighting, or proximity of other colors. Local color can never be stated exactly since seeing without these modifying circumstances is not possible.

Log Cabin. Log cabins were introduced to the United States by Swedish immigrants on the lower Delaware in 1638. They came into general use after the westward expansion over the Alleghenies.

Louis Quatorze. The style of architecture and interior decoration developed during the reign of Louis XIV of

France (1643-1715). It coincides with the style termed Baroque.

Louis Quinze. The style of architecture, interior decoration, and furniture developed during the reign of Louis XV of France (1715-1774). It is typical of the Rococo period.

Louis Seize. The style of architecture, furniture, and interior decoration prevalent during the reign of Louis XVI of France. It is characterized by a definite moderation of Rococo exuberance and gradual transition to Classicism.

Lukasbrueder. See Nabis, page XXX.

Luminosity. The reflection of light from a white ground as seen through translucent pigments; hence the brilliance of the colors.

Magic Realism. A branch of post-Expressionistic art similar to metaphysical paintings. It is characterized by the fact that the artists paint realistically, but by means of light effects add a strange metaphysical or magical element. Some of the *Neue Sachlichkeit* adherents belong to this group.

Malstock, mal-stick. Mal, from German *malen* means painting. The Malstock is a long stick, padded on the upper end, so that the painter can steady his hand on it when he is painting.

Mannequin (or Mannekin). Doll-like figures with movable limbs, which were used by painters and sculptors as models for the depiction of body movements before it was permissible to draw from the live nude model.

Mannerists (Manièristes). A term denoting painters, sculptors, and occasionally also architects during the period between the Renaissance and the Baroque (16th and 17th centuries), who consistently followed a specific pattern of their own in their artistic creations. In painting, the figures have elongated, overly mobile bodies and small heads. They do not stand firmly on the ground but seem to float. Sudden changes of light and shade are frequent. The entire presentation conveys restlessness, tension, world-denial, emotional intensity. Examples are the works of Tintoretto, El Greco, Bronzino.

The style apparently grew out of the spirit of the Counter

Reformation. Many of its "mannerisms" were later taken up by the modern expressionists.

Maquette. A roughly made, small model produced by sculptors as a guide for the actual work.

Mass. Visually perceived units within a work of art. The impression of belonging together or of being a unit may be conveyed by space or by objects, by virtue of their proximity, sameness or similarity of color, or by being connected through distinct or indicated lines, light, or shading. The balance or imbalance of masses affects the aesthetic response, and establishes a center of attention as well as secondary or tertiary focal points.

Masses, depending on the brightness of the color and the distribution of light, are felt to have weight and distance value. A smaller mass of greater weight may balance a larger mass of lesser weight. A mass produced in warm colors may appear near and balance a mass of receding color; this gives the illusion of depth.

Mediumistic Painting. Paintings allegedly produced in the state of trance. Such paintings presumably depict superglobal spheres or "landscapes of the soul."

Mesolithic Age. The period between the Paleolithic Age and the Neolithic Age. Together these three periods mark the Stone Age. Art created during the Mesolithic Age is limited to objects made of bone upon which simple geometrical patterns are scratched.

Metaphysical Painting. A pre-Surrealistic movement originating with Giorgio de Chirico about 1915. The realistic presentations of landscapes, city streets, railroad stations, and the like are permeated with elements that stir feelings of fear, nostalgia, loneliness, suspense, and futility.

Mobile. A decorative object of art executed in metal, glass, or plastic which—usually in a hanging position—turns or otherwise moves in a breeze or upon touch. Alexander Calder was the initiator of this type of art.

Moderner Bund. A group of Swiss artists headed by Paul Klee and Hans Arp. Its goals were closely related to those of the Blaue Reiter group.

Modernistic. 1) In England, "modernistic" specifically denoted a style of industrial design that combined half-circles, triangles, and zig-zag lines, derived from the *Jugendstil* and *art nouveau.* 2) A pejorative term applied to commercial and industrial productions imitating and vulgarizing the styles of modern art during the 1920's and 1930's.

Modern Primitives. See Primitive Art.

Monochrome. A painting executed in only one color or shades of one color.

Monotype. Prints taken from a picture painted on glass or metal. A sheet of paper is pressed on the wet original until the colors are reproduced on it. Thus several reproductions can be obtained.

Montage. A collection of photos or prints pasted on a common background to form a design or to convey a specific meaning.

Nabis (Hebrew term, meaning Prophets). A French group of artists working between 1889 and 1897. Strongly influenced by Symbolism in literature (Maeterlinck), this group endeavored to inject religious and romantic literary ideas into their paintings. The anti-realistic spirit was further emphasized by the fact that figures were presented two-dimensionally, and landsapes were inventions based on the artists' mythological fantasies. For a time, Paul Gauguin, Pierre Bonnard, and Edouard Vuillard belonged to this group.

Naturalism. The term has three meanings. One of these merely contrasts attempts at reproduction of natural appearance with a stylized or schematized rendering of the object. These attempts then are called naturalistic. In this sense, cave paintings depicting scenes of a hunt are naturalistic, as are the Gothic paintings and sculpture of the 13th century. The second meaning is that of Realism, with which Naturalism is often confused. The third meaning denotes a definite orientation of certain artists intending to catch the essence of the model in every single, often purely accidental, item. The Naturalistic painters of the early 20th century tried to show

things "as they really are," including the misery and squalor still prevalent in a culture highly praised for its progress. They were, as a rule, politically oriented. An example is Kaethe Kollwitz (1867-1945).

Nature morte (French). Still life.

Nazarener (Nazarenes). A derisive name given the "Lukasbrueder," a group originating in Vienna in 1809, which aimed at the regeneration of art by returning to the style and subjects of Raphael, Perugino, and Duerer. The most prominent painters of this group were Peter von Cornelius (1783-1867), and Jean Dominique Ingres (1780-1867). The Pre-Raphaelites were influenced by the Nazarenes.

Neo-Classicism. European Classicism during the period from about 1770-1830.

Neo-Impressionism. The second phase in the development of Impressionism. Artists like Seurat, Signac, and Pissaro replaced the intuitive analysis of color by scientific exploration of color and vision and by systematic study of the optical fusion of prismatic hues. They raised the luminosity of the color impression by setting the composite pigments dot by dot next to each other (Pointillism). The Neo-Impressionists exhibited for the first time in 1884, in Paris.

Neolithic Age. The third and most recent period of the Stone Age, characterized by the transition from a hunters' culture to an agricultural economy. Most prehistoric art belongs to this era, although art developed at different times in different regions. The painted ornamental spiral and Maeander patterns on ceramics are characteristic of this epoch.

Neo-Plasticism. Branching off from Cubism, Piet Mondrian tried to produce "pure plastic" paintings by using exclusively simple geometrical forms in black, white, gray or primary colors. The paintings consist of vertical and horizontal lines posed at right angles on subtly shaded backgrounds. The first paintings in this style were exhibited in 1916. The movement lost impetus after Mondrian's death in 1944, but some elements of it were revived in so-called Op Art.

Neue Sachlichkeit (New Factualism). A style in painting

emerging in Germany about 1925, as a reaction to Impressionism and Expressionism. It favored cold observation of reality, but so overemphasized immobility and rigidity that the pictures achieved an impression of ghostliness. Hence the second name of this movement—Magic Realism. *Neue Sachlichkeit* in painting developed simultaneously with Surrealism. Representative painters are: Kanoldt, George Grosz, Hans Beckmann.

On architecture, and especially on interior decoration and furniture, *Neue Sachlichkeit* left a deep imprint. It tended away from the imitation of historical styles, created simple and unornamented forms, and emphasized the aesthetic value of the material itself.

Neutral Gray. A gray mixed from black and white. It is neutral because all grays resulting from mixing hues retain a color element.

New Objectivity. English for *Neue Sachlichkeit*.

Non-Colors. Black and white, and the gray resulting from their mixture, are considered non-colors.

Non-Objective Art. Although this term is often used as a synonym for Abstract Art, it was coined for the explicit purpose of distinguishing between the early phase of Abstract Art, during which the painted or sculptured forms still alluded to objects and figures, and the later phase, in which any similarity to such was avoided. The artists attempted to catch musical themes, moods, or feelings by shapes and color combinations alone, or they indulged in the aesthetic experience for its own sake.

Op Art (Optical Art). A movement of the 1960's, which bases its claim to interest on optical illusions, ambiguity of visual sensations, and the well-known phenomena produced by the involuntary shifting of attention as the spectator stares at certain patterns for some time. The canvas is covered with lines, circles, or other geometrical forms whose illusionary change causes tension or amazement.

Optical Mixing. The mixing of adjacent or coinciding colors by the eye. Thus, at a given distance blue next to red

will merge to purple. This optical law is a guiding principle in Impressionism and (especially) Pointillism.

Organic Architecture. A branch of modern architecture, especially the style created by Frank Lloyd Wright. Wright was a magnificent nonconformist who protested against the slavery of tradition. He held that a building must fit so perfectly into its environment that it appears to be organically related to it. ("A sense of the organic in nature is indispensable to an architect.") His ground plans, therefore, were free from the doctrine of geometric order; his arrangements of roofs, porches, steps, etc., often exhibited a strange, but usually fascinating, irregularity.

Paleolithic Age. The oldest period of the Stone Age with evidence of human culture. Human development in Europe during this period seems to have started with the Neanderthal man, and includes the Aurignac and Cro-Magnon race. The latter produced sculptures of animals and humans, apparently for magic purposes. Drawings scratched on cave walls and on the sides of rocks represent animals, hunting scenes, battles, and dances.

Palladian Style, Palladian Classicism. A distinct deviation from the prevailing architectural style of the Late Renaissance, introduced by Andreo Palladio of Vicenza (1508-1580). Palladio, in contrast to the tendencies of the beginning Baroque, reduced the decorative elements on palaces to a minimum, thus emphasizing clarity and beauty of architectonic proportions. His ideas assumed special significance for English architecture around 1600, and strongly influenced French architecture around 1750.

Papier Collés. The insertion of a printed piece of paper into an abstract painting. First used by Picasso and Braque, to prevent the extremely intellectualized presentations of cubistic art from becoming completely divorced from reality. Later, materials such as pieces of newspaper, playing cards, sand, and fabric were pasted on paintings and related to the picture by color strokes. The technique was adopted by the Bauhaus School, followers of Neo-Plasticism, and Pop Art.

451

Pastose. Pasty, thick brushwork.

Pattern. A decorative design that repeats itself with regularity.

Pigment. The actual substance, usually powder mixed with liquids, by means of which color is applied to wood, canvas, stone, clay, etc. In addition to the colors of the spectrum, pigment includes black and white. The primary colors of pigmentation are yellow, red, and blue; from these—in contrast to the primary colors of vision—all other shades can be derived.

Plafond Painting. A painting on the ceiling.

Pointillism. The technique by means of which some of the Neo-Impressionists tried to render the mood of a landscape more lifelike. The name derives from the fact that they completely avoided outlines, and dissolved figures, objects, and backgrounds into a swimming mass of smaller and larger dots of colors set next to each other. These specks of different colors were supposed to fuse in the eye of the beholder into the true image of the momentary appearance of the subject.

Post-Impressionism. A term applied to the work of a group of painters (Cézanne, Van Gogh, Gauguin, et al.) whose endeavors led away from the hedonistic concepts of Impressionism and Neo-Impressionism to greater emotional depth, and from the fascination with momentary impressions to more permanent values. Technically, these painters emphasized analysis of form and thus gave impetus to the development of both Cubism and Expressionism.

Pre-Columbian Art. The art created by the original inhabitants of the Latin American countries before the time of Christopher Columbus (1492).

Prehistoric Art. Art produced at a time for which no historic records are available. As a rule the Stone Age in Europe is regarded as the period in which art found its first expression. The cave paintings and sculptures are, in all probability, experienced in terms of magic rather than aesthetics, but ornaments on tools and utensils indicate a well-developed sense and need for beauty.

Primitive Art. A term of vague meaning, often denoting

prehistoric art or the art of ethnic groups living on a lower cultural level. It also denotes, however, the deliberate primitive style of painters such as Henri Rousseau, Grandma Moses, Seraphine, etc. A better distinction is made if these moderns are called "Neo-Primitives." Art of this type, emerging at various times, first came to be appreciated after 1898, when the inhabitants of the Bateau Lavoir recognized the expressive strength of "Le Douanier's" (Rousseau) uncomplicated perception and power of conveyance in presentations uncorrupted by ideology and artistry.

Psychic Automatism. A form of Surrealist painting and of subsequent art styles, in which, supposedly, the unconscious dictates the use of symbols, colors, and form combinations. Prominent examples are the paintings of Joan Miró.

Receding Colors. As opposed to red, yellow, and orange (advancing colors), blue, green, and blue-green are felt to be cold and receding. In practice this means that a mass of blue appears to be more distant than a quantitatively equal mass of red of the same brightness and on the same plane.

Reflected Color. In nature, all coloration consists of the local color, that is, the presumed hue of the object itself, and reflected color, that is the color reflected on the object from an outside source. The latter modifies the object's colors differently in varying circumstances, such as the time of the day, the intensity of light, or the proximity of colored objects. A gray pillow looks different on a blue cover and on a red one.

Regency. In England, an architectural style that developed during the regency of George III (1811-1820) and extended to the beginning of Queen Victoria's reign. Typical for it is the architectural work of John Nash.

In France, the architectural style developed during the regency of Philip of Orleans (1715-1723) (Régence). It is characterized by the transition from the heavy sumptuousness of the Louis Quatorze style to increasing lightness and elegance.

Regionalism. An art movement in the United States be-

tween 1930 and 1940. Three painters—Thomas Hart Benton, John Steuart Curry, and Grant Wood—tried to counter foreign influences as well as the domination of New York. Their paintings extolled the life and work of the rural population of the Middle West.

Reinforced Concrete. See Ferro-Concrete.

Representational Art. Paintings and sculptures which represent figures, objects, and events, as distinct from ornamental and abstract art.

Retreating Color. The same as Receding Color.

Revolutionary Black Gang. See Ashcan School.

Rhythm. The regular recurrence of, or regular alternation in, patterns such as features in a picture or in an architectural design. Rhythm is an aesthetic requisite in painting and architecture, as it is in music. In architecture, the units bear a rhythmic relation to one another if groups of the same form are repeated with a certain regularity—when large, dark masses are interrupted by a lighter mass of masonry, or when walls are broken by projecting columns; or when all of these elements are combined in regular alternation. Windows, alternation of light and shadow, ornamental designs, different materials applied intermittently—all these elements infuse a rhythmical pulsation into the inanimate mass.

Salon de Refusés. In 1863, several artists whose pictures had been rejected by the Salon des Arts in Paris, exhibited their work in a new Salon, sponsored by Napoleon III. The name of this new exhibition became famous because among the exhibitors were the great names of the succeeding decades, among them Manet, Fanlin-Latour, Pissaro, Boudin, and Whistler.

Saturation. One of the three qualities of color, saturation denotes the intensity of hue in the pigment. Thus, when glass plates of a light blue are placed upon each other, the blue gets "deeper," or more highly saturated, with every additional plate.

School. In art, the term "school" does not indicate an institute where the painter in question was a pupil, but merely

followership in style or ideas. Older anonymous paintings especially are often classified as "belonging to the school of . . ." some recognized artist, who taught apprentices in his studio. This means that these paintings are executed in the spirit or under the influence of this master's ideas and technique but not by the master himself.

Secession (Sezession). In 1897 and 1898, artists whose pictures had been refused by the official organizations seceded from the latter and organized their own exhibitions. The rebellion, called Secession, spread through practically all the art centers of Austria and Germany. It affected all branches of art and resulted in a new style. In Germany this style was the so-called *Jugendstil*. Typical of the architectural revolution is the exhibition building in Vienna, also called Sezession. The architect was Olbrich (1897). Gustav Klimt became president of the new organization in 1905.

Seicento. The seventeenth century by Italian counting.

Silverpoint. A technique of drawing which involves the use of an instrument with a fine silvertip on specially prepared paper. Silverpoint drawings are characterized by the fineness and delicacy of the lines.

Skyscraper. This product of modern architecture was first envisioned and created in Chicago by Louis Sullivan. The upward development of buildings holding offices or family dwellings was dictated by excessive real estate prices in the cities of the United States, and facilitated by the strength provided by steel and concrete.

The total design of skyscrapers is geometric; the huge masses of steel, stone, or glass are broken only by windows and an occasional terrace. In the beginning, architects complied with tradition by adding chrome spires and all manner of oriental or gothic ornaments; but soon the tendency prevailed to avoid everything personal and merely pretty, and to let the majesty of the construction and the elements involved in its erection speak for themselves. Buildings emerged that appeared like a sheet of glass stretched over a light structural web of steel.

Needless to say, skyscrapers would not have been possible

without the preceding accomplishments of engineering which solved the simultaneous heating of twenty or thirty floors, plumbing, electricity, and, of course, the elevator.

Social Consciousness. An American art movement which flourished during the Depression of the 1930's. The artists participating in it emphasized social injustice and deplorable economic conditions. Their realistic presentations also earned them the name Social Realists. They were strongly influenced by Mexican artists. Prominent representatives of this group were Gropper, Orozco, Rivera, Siqueiros, and Shan.

Social Realism. See Social Consciousness.

Socialist Realism. The officially approved style in the U.S.S.R. The painters and sculptors favoring this art form paint scenes of Soviet life.

Stabile. In contrast to a mobile, the stabile is a light, abstract construction of wire, wood, plastic, or similar materials used as a static decoration.

Staffage (French). In landscape painting, figures are sometimes added which are unnecessary as regards composition or the artist's intention. They are included as a concession to the sponsor's or the spectators' more conventional tastes.

Steel. The use of steel as a building material greatly influenced architectonic style and architectural possibilities. The great resistance of steel beams to stress allowed the spanning of wide spaces and the expansion into height (skyscrapers) without reducing width.

Iron was first used for construction in factories in 1840. In 1853, Victor Baltard used steel construction in building the Halles Centrales in Paris, and Joseph Paxton, in building the Crystal Palace in London, set up an iron skeleton that was closed with glass plates. W. L. Jenney was the first architect to employ a true skeleton frame construction of steel (Home Insurance Building in Chicago, 1884). The exterior walls were supported at each floor by steel beams, which were, in turn, supported by steel columns encased in masonry piers. The wall, no longer carrying any except its own load, thus became less bulky and, figuratively speaking, more elastic. Today, a closely knit structure of steel, reaching thirty or